LIGHTING TECHNIQUES
FOR PHOTOGRAPHERS

NORMAN KERR

AMHERST MEDIA ■ BUFFALO, NY

Published by:
Amherst Media, Inc.
P.O. Box 586
Buffalo, N.Y. 14226
Fax: 716-874-4508

Publisher: Craig Alesse
Senior Editor/Project Manager: Richard Lynch
Associate Editor: Michelle Perkins

ISBN: 0-936262-66-4
Library of Congress Card Catalog Number: 97-75209

Printed in the United States of America.
10 9 8 7 6 5 4 3 2 1

TABLE OF CONTENTS

Chapter 3 • The Light and Shade Relationship

Chapter 4 • Control of Light

BRIGHTNESS **CONTRAST** **COLOR**

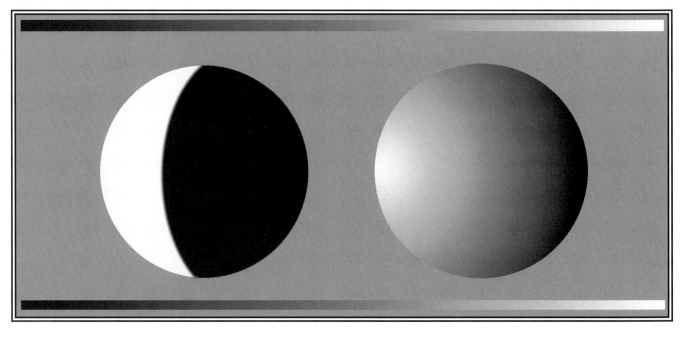

DIRECTION **SPECULAR** **DIFFUSE**

CHAPTER ONE
THE VOCABULARY OF LIGHT

Throughout this section, we will be talking about one light source, since the complex interactions of a studio full of lights would make it difficult to illustrate fundamental points. This chapter's photos are grouped to show the presence or absence of qualities. The qualities depicted are neither better nor worse, merely different.

Once the six qualities of light are recognized and understood, the photographer is best prepared to plan successful lighting strategies. He is also ready to identify and solve lighting problems, in both natural and artificial light.

Qualities

This chapter visually and verbally defines the six fundamental qualities of light.

Brightness	Diffuse
Contrast	Specular
Color	Direction

Whether it's the sun, an electric lamp, or electronic flash, every light source contains all six qualities.

Lighting consists of both the light source and the surface of the object being illuminated. On a clear, sunny day the sun's illumination will be equally bright any place on earth, but the brightness quality of lighting for a black-top parking lot is much different than for a fresh expanse of snow. All six qualities can be modified to some degree by the surface being illuminated.

Comparative Qualities

Qualities like brightness, contrast, and color are comparative and can be both named and measured. These qualities of light can be altered even after exposure. In fact, they remain changeable until the photographer decides to stop manipulating them.

Formative Qualities

Diffuse, specular, and direction are formative qualities. These qualities are fixed once the camera's shutter is clicked. Decisions about these qualities must be made at the the time of camera exposure. This is true even with digital manipulation.

LIGHT QUALITIES

COMPARATIVE
brightness
contrast
color

FORMATIVE
diffuse
specular
direction

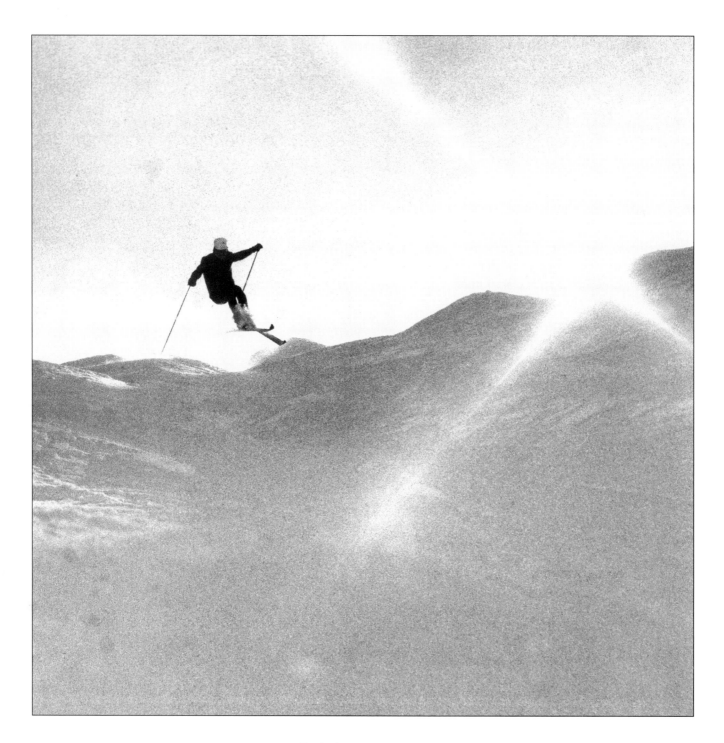

Brightness

Brightness is the intensity quality of radiating or reflecting light. We can verbally define brightness as lighter or darker. With a light meter we can accurately measure brightness. Brightness is a comparative light quality, and this means that its effects can be altered at every stage of the photographic process.

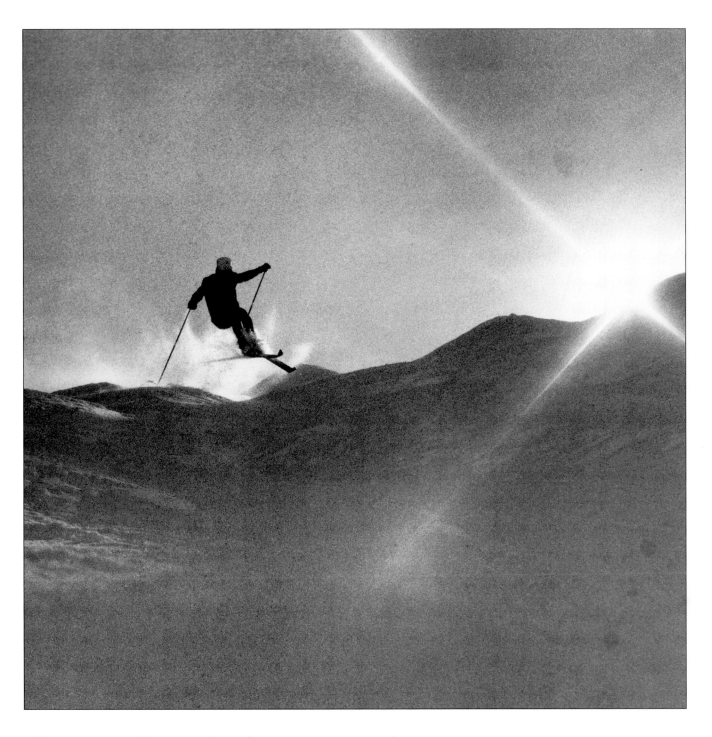

 The photos on this page and the facing page were made from the same negative, one printed lighter than the other, yet both have a rich black and a clear white. Which best interprets the brightness quality of the light? There is no correct answer here because interpretation is subjective. If the visual message is clear to others, then the interpretation of brightness quality is appropriate.

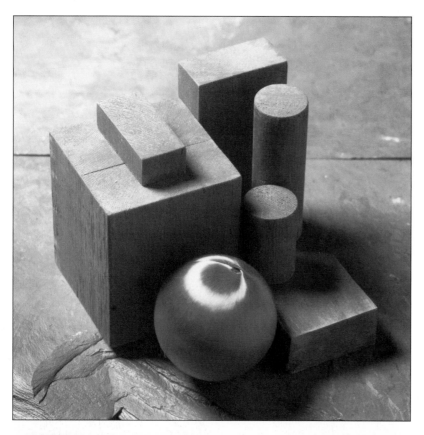

•The Two Roles of Brightness Quality are collective and local. The collective role involves all the tones, or individual brightnesses, in the scene. The local role involves just some of the tones or brightnesses in the scene. Visual emphasis can be controlled by making certain parts of a scene lighter or darker. This is local brightness control. It can be modified by aiming or restricting the light source, by adding illumination to given areas, or by shading certain parts of the scene.

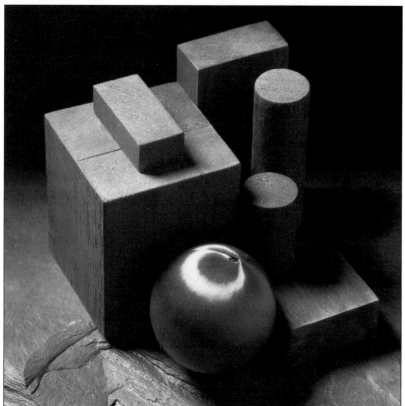

(left) This pair of photos illustrates shading. In the bottom photo, a horizontal opaque screen has been placed behind the objects to obstruct part of the light. This is the only difference in lighting between the two photos.

The pair of photos to the left (opposite page) illustrates shading. The only difference between the two photos is the shaded area created by placing a horizontal opaque screen to obstruct part of the light. Note how this shading control changes the physical structure of the scene. The blocks now stand out in vivid, three-dimensional relief against the darker background.

The pair of photos to the right shows the addition of local brightness. In one photo, the table-support is lit separately by a small spot, carefully masked to avoid illuminating the machine on top.

(right) This pair of photos illustrates the addition of local brightness. Notice how the light is carefully controlled to avoid illumination in unwanted areas.

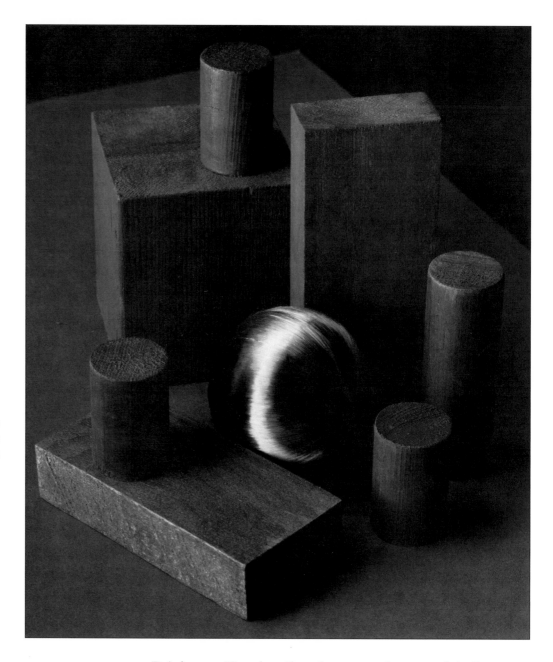

In this low key image, the only light area is the small area of reflection on the satin ball.

•**Brightness Key** describes the preponderance of similar tones in the photograph; high key has mostly light tones and low key has mostly dark tones. Generally, photos have a roughly equal mixture, or a mixed brightness key. Brightness key conveys visual and emotional commentary. High key seems bright, fresh and happy. Low key seems dark, profound and mysterious. These emotional tendencies can be altered by other factors (such as subject matter) but generally hold true.

Both photos above are illuminated by the same source. The only differences here are the tones of the objects themselves and the amount of ambient light illuminating the shadows.

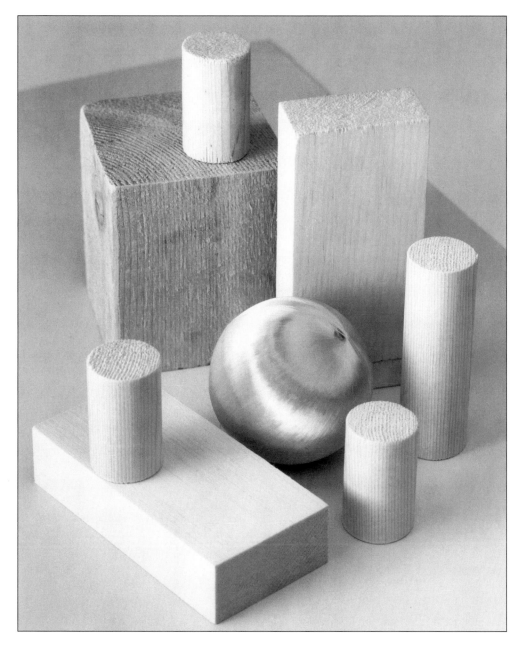

In this high key image, the only deep tone occurs in the small shadow under the satin ball.

In the low key image on the left, the only light area is the shiny reflection on the satin ball. This doesn't alter the low key effect because the area is small. The light area also helps to confirm that the effect is intentional, and not simply the result of bad technique.

The high key image on the right shows light objects on a light background. Lots of ambient light from reflectors brightens the shadows. If there is good tonal variety, deep tones or blacks aren't always necessary to avoid negative feelings about technique.

"Contrast is a word that is easily misused."

Contrast

The contrast quality of light is the difference, or rate of change, between the brightnesses of light in a scene. Contrast, like brightness, can be altered at every stage of the photographic process. Contrast is a word that is easily misused. It's important to be very specific when using it to define light quality. There are three areas which must be considered: light ratio, ambient light, and total versus local contrast.

•**Light Ratio** is the measurement of the brightness difference between light and shade. It is obtained by first measuring the brightness of the light in the illuminated area and then in the shaded area. The difference is stated as a ratio (such as 2:1) or as the difference in *f*-stops between the two meter readings. If the difference is small, the ratio is low; if great, it is high. Remember, film sees a smaller range of tones than our eyes, and thus records the scene with a higher total contrast than human vision senses.

•*2:1 light ratio* (one stop difference, as measured with an incident light meter) is weak. Film normally records full detail in both light and shade. High key needs such a ratio.

•*4:1 light ratio* (two stops difference) is a vigorous light ratio. Reasonably full visual information is normally retained in both light and shade for most photographic purposes.

•*8:1 light ratio* (three stops difference) is vivid and typical of clear, sunny days. It's too high for many subjects like common portraits or catalog illustration; fill light is usually added.

•*16:1 light ratio* (a four stop difference) is extreme. All but the lightest tones in the shadows disappear. Fill light is almost always needed unless a posterized effect is your goal.

These photos were carefully lit and printed so that each has an identical mid-tone grey background. The only visual effects depicted are the light ratios. A full range of tones was deliberately placed within the shadow areas to show that the darkest areas are affected first as light ratio increases.

2:1

4:1

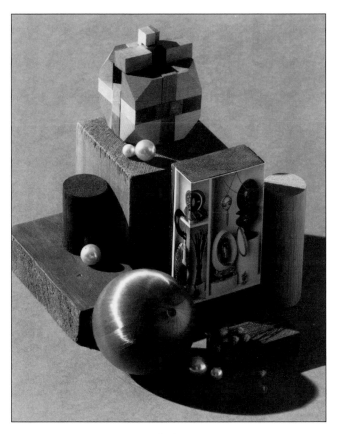

8:1

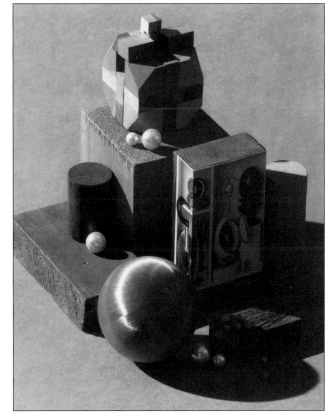

16:1

High Total, Low Local Contrast

Low Total, High Local Contrast

•**Total Contrast** encompasses the overall range of tones in a scene. It is altered by the brightness differences between light and shade and by the photographic process. Increasing total contrast may wipe out good local contrast.

•**Local Contrast** describes only adjacent tonal changes. Local contrast is controlled more by the formative qualities of light (direction, diffuse, specular).

The top photo (*left*) illustrates high total and low local contrast. This photo has strong blacks and whites, but few intermediate tones. The vivid, sharp edged shadows from a specular light source distort the actual forms of the objects. This photo has strong visual impact, but little visual information in local areas about texture and form.

The bottom photo (*left*) illustrates low total and high local contrast. It has no vivid blacks or whites, but has vigorous intermediate tonal differences. The shadows cast from a diffuse light source have no definable edges. They reveal good local contrast in textures, form and spatial relationships.

•**Ambient Light** is environmentally reflected illumination with no direction quality and no light and shade effect. When there is a lot of ambient light, the shadows are more illuminated. This decreases the light ratio and reduces the contrast quality of the light. If there is no ambient light, shadows become an opaque black. Ambient light should not be confused with available light. Available light can have strong direction and contrast qualities. Ambient light never does.

What causes a greater amount of ambient light? If there are lots of reflecting surfaces, such as in a small, white room, there will be lots of ambient light. Early morning or late day sun also provides a great deal of ambient light because the enveloping skylight is relatively strong compared to the weaker sunlight.

Color

The color quality of light includes color balance neutrality, color effects, the local and collective roles of color quality, and the identification of the primary colors. The use of color meters to measure the color balance neutrality is especially helpful for sources like fluorescent lamps.

•**Neutral Color Balance** is defined as a lack of coloration in neutral tones (grays and black or white). When this occurs all colors in the photo are accepted to be as accurate as possible. Neutral color balance is generally achieved when the color film type is matched to the type of light source — for example, daylight type film exposed in daylight. This simple match is enough for most situations. More care is needed when matching the photo with the original subject (portraiture), or when matching color in an advertising photograph. Because photographic processes modify color quality, proper handling is critical.

> "Because photographic processes modify color quality, proper handling is critical."

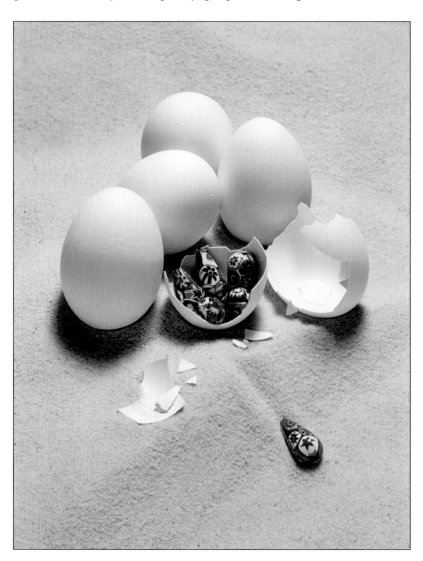

In the photo of eggs and millefleur beads, an overall lack of strong color in the environment demands careful attention to color neutrality. Otherwise, the sand and eggs could be interpreted as something else, diverting our attention from the beads.

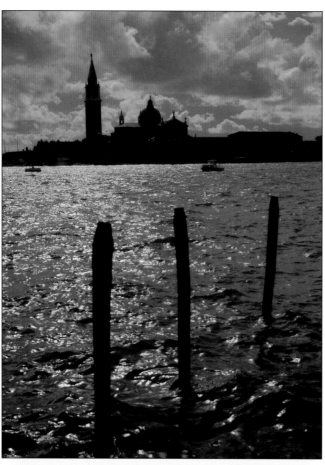

•**Color Effects** involve any deviation from neutrality to achieve a visual effect ("seeing the world through rose-colored glasses"). Sometimes subtle color effects are vital to visual communication, but avoid using them excessively.

The color effect on the Venetian photo to the left is an active color decision. Color is intriguing and seductive, and color effects are easily overdone. As a rule of thumb, don't use color effects unless you are convinced they add to your message.

Natural color effects may also occur. Every light source has its own color bias, and all natural light varies continuously according to the time of day and other conditions. These natural changes can be desirable. To the lower left, fifteen minutes after sunset, a vividly colored sky reflects back off Manhattan's gleaming towers.

West Lake in Hangzhou, China, is coolly serene through out-of-focus green foliage. This is a distinctive photo/optical color effect that we don't ordinarily sense with our eyes.

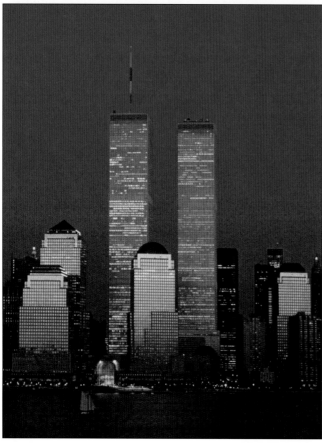

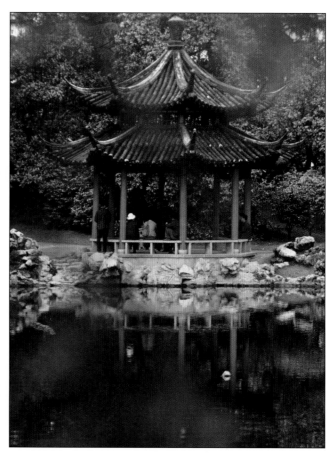

•**The Primary Photographic Colors are Red, Green, Blue, Cyan, Magenta, Yellow.** Red, green and blue (RGB) are additive primary colors. Additive primary colors are employed when light itself is used to create images. For example, color television uses tiny clusters of red, green and blue phosphors to create full color images. The absence of RGB light produces black, maximum presence produces white.

Cyan, magenta and yellow (CMY) are subtractive primary colors. Subtractive primary colors are used when images are created with dyes and inks. Light has to be shined on or through these images for them to be seen. Maximum presence of CMY dyes produce black, absence produces white.

Unequal mixtures in either set of primary colors create all the other colors.

It is important to know which pairs of colors are complementary so that color imbalance can be correctly adjusted back to neutral. To the right, equal density cyan, magenta and yellow filters are laid respectively on equal density red, green and blue filters. The overlaps are neutral gray, indicating which colors are complementary. For example, if a photo is too green, it's color can be neutralized by adding the proper density of magenta.

Precision color neutrality can be obtained with Color Compensating (CC) filters. These are made in all six primary colors. CC filters are used mostly by professional photographers when exposing transparency films, or by anyone making color prints in the darkroom. (Color enlargers have specially built-in color filtration systems with the same color neutrality logic as CC filtration. Normally, however, they employ only the CMY set of colors.)

Equal brightnesses of the additive set of red, green, and blue light overlapping one another produce white, or neutrality. Note that overlaps of RGB light also produce CMY.

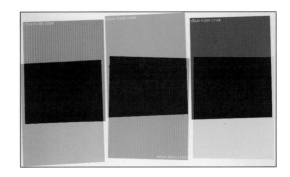

Complementary Colors

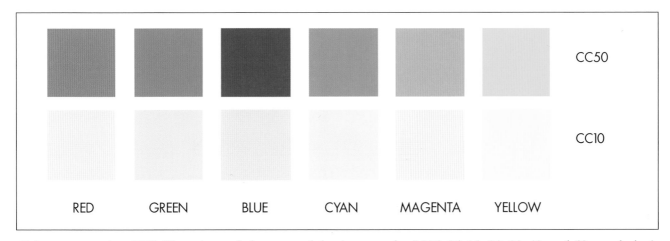

						CC50
						CC10
RED	GREEN	BLUE	CYAN	MAGENTA	YELLOW	

Color compensating (CC) filters, in precisely measured density strengths of 025, 05, 10, 20, 30, 40, and 50, are the basic tools for making precision color balance adjustments. Their color is shown here as accurately as printing inks allow.

Daylight quality fill-flash neutralizes skin tones and clothing that a color meter indicated would otherwise be rendered in cool greenish colorations.

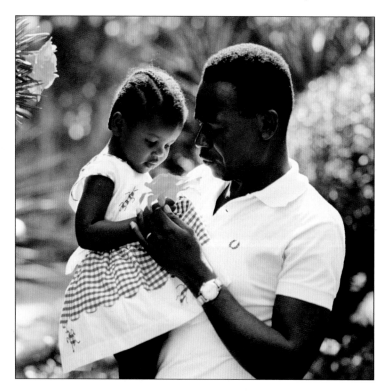

Here, an interesting color balance situation proves the exception. Neutrality as measured by a color meter would alter the charming warm glow from the flower on the child's face. Better here to let the color effect remain.

•**Color Temperature** is a numerical description of the color of light when a special kind of source, called a "black body," is heated to incandescence. When heated, the black body's glow changes from red to yellow to blue (from warm coloration to cool coloration). The heat is measured in degrees Kelvin (K), and this number defines the color temperature of the light. Color temperature describes the differences between "cool color" daylight and "warm color" electric lamps.

Daylight-type color film is balanced to 5500K, and Tungsten-type film is balanced to 3200K. When deviations from 5500K or 3200K are indicated, the color temperature meter notes an appropriate light balancing (LB) filter correction to produce neutrality with either film type.

•**Color Meters** come in two varieties. Color temperature meters have an important limitation because they give only one reading that measures the balance between "warm" and "cool" coloration. With many types of light this is not sufficient. Three-color meters provide better information. They give two readings: a red-blue comparison and a red-green comparison. Some three-color meters (such as Minolta's) give the two comparison readings as a combination of LB and color compensating (CC) filters. If stuck with fluorescent lighting in an unfamiliar location, the three-color meter is an essential tool.

Direction

Direction belongs to the formative category of light, qualities which must be decided upon at the time of exposure because they can't be altered in the darkroom. Direction quality controls the formation of shadows, which place emphasis on texture, form and space. The lack of shadows diminishes this visual information.

•**Interaction of Direction with Other Light Qualities.** The angle of incidence equals the angle of reflection. The direction influence of a light source is revealed not only by cast shadows but also by the light's reflectivity. Reflected light can be made much brighter if the light skims off a surface directly into our eyes (or camera lens). An example of this can be seen when driving towards the sun late in the day. The light skipping off the pavement is brilliant compared to the same situation observed at noontime, even though noon sunlight is actually more intense.

Direction can alter color. For example, early and late in the day sunlight goes through more of the Earth's atmosphere. This causes more of the short wavelengths to be removed, making the sunlight warmer in color. In the studio, skimming light into the camera lens causes a surface to reflect more of the light source's coloration and less of the surface color.

Direction quality can also influence contrast. As more shadow textures are formed with a directional change in the light source, local contrast increases.

In the top photo, a specular light placed directly behind the camera produces almost no shadow information. The same specular light placed at a 90° angle to the camera skims across the surface of the same Aztec plate and produces strong shadows on its surface.

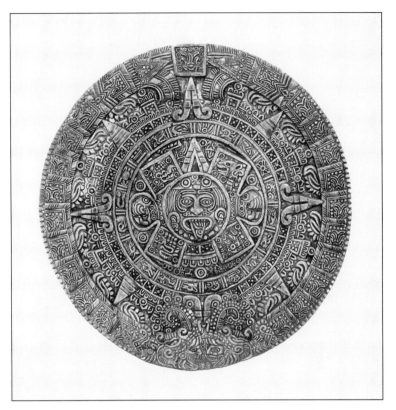

Minimum direction quality with specular light.

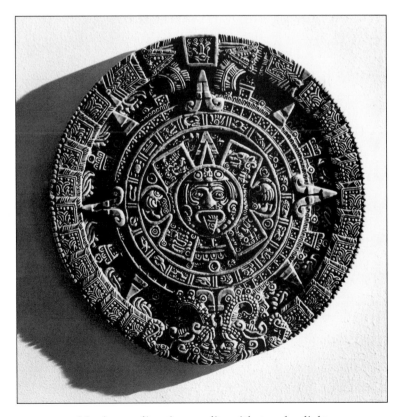

Maximum direction quality with specular light.

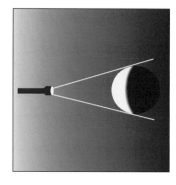

The only difference between this photo of a still life and the one on the right is that this photo is lit by a small specular source, and the one on the right is lit by a large, diffuse source. Direction influence, ambient light and total contrast (16:1), are identical in each photo.

The effect of the different light sources is readily visible in the details of the image. Notice the silver ball at the left of each image. The small glint on the lefthand ball is evidence of a small source. The broad area of highlight on the right ball indicates a large source. The tiny source also produces sharp-edged shadows on round objects (as is shown in the above diagram).

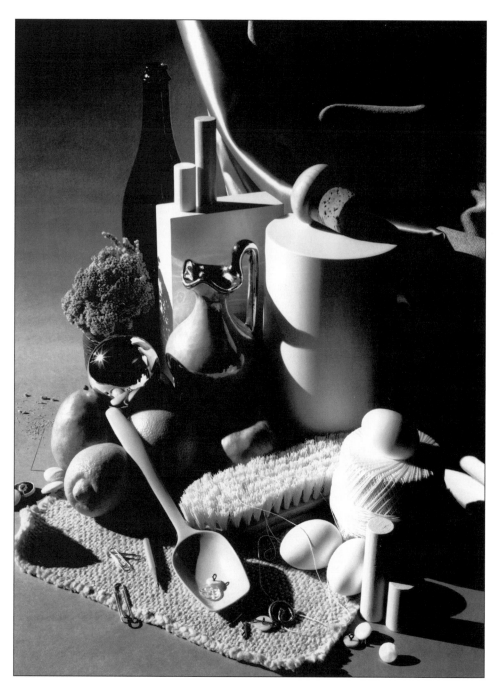

DIFFUSE AND SPECULAR

Diffuse and specular are two light quality extremes, and most lighting contains some portion of each. Diffuse light is scattered or widely dispersed; specular light is very concentrated. Diffuse and specular belong to the formative category of light qualities (rendering dimension, form and texture).

•**Specular Light** emanates from one specific point, or travels in a narrow beam. A bare light bulb is specular because it acts like a point of light. A distant spotlight in a theater projects a tight beam of light. Specular is not the same as brightness. The sun is no more specular than a small light bulb if each is the same relative size, even through the brightness differences are enormous.

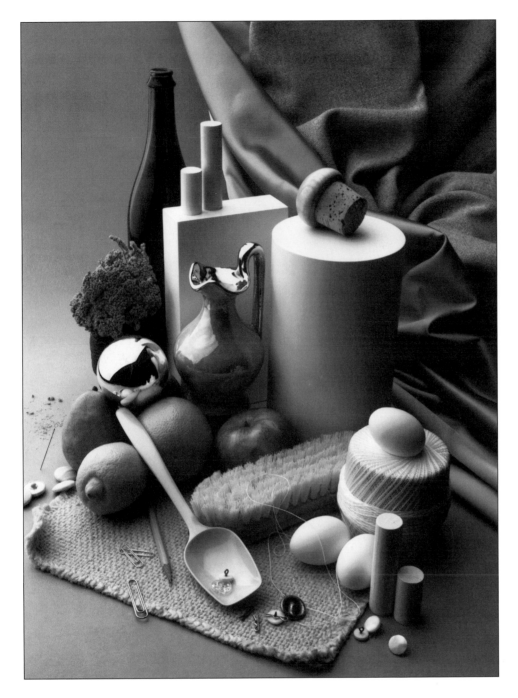

Specular light (opposite page) creates hard edged shadows and the illusion of higher total contrast, as well as vigorous local contrast on flat surfaces (where even tiny bumps cast shadows).

Diffuse light (this page) creates softer shadows and more local contrast on rounded surfaces (because its wrap-around illumination is tangent to a much greater area, as shown in the diagram above).

Finally, notice some small details which further illustrate the difference between specular and diffuse light. The shadow of the needle, the texture of the brush, the delineation of the threads, and the shiny highlights are each shown differently in specular or diffuse light.

•**Diffuse Light** emanates from a large area and scatters in all directions. A large window open to the sky is a diffuse source, as is the fabric-type lightbank used in photography. A cloudy, overcast sky is an extremely diffuse source. Diffuse quality must not be confused with brightness. A blinding expanse of snow in sunshine is just as diffuse as a dark overcast sky late in the day. Size, not brightness, is the key factor.

•**Interaction of Diffuse and Specular Quality** is seen in daylight. The sun is a highly specular source surrounded by an envelope of highly diffuse skylight. Together they produce daylight. The diffuse sky dominates very early or late in the day, whereas the specular sun dominates at midday.

•**Diffuse-Specular Progression.** Specularity and diffuseness can be altered if the relative size of the source is changed. A bare light bulb is specular at almost any distance, but the same bulb in a reflector becomes a bigger source and its diffuse quality is increased. For practical purposes, a light source that subtends an arc less than 20° will be specular and one of more than 30° will be diffuse. The real visual test, however, is to observe the shadows formed. If the shadows are sharp-edged, the source is specular. If the shadow edges are soft, the source is diffuse.

The diffuse-specular progression is illustrated on pages 46 and 47, with particular reference to light sources.

CHAPTER TWO
LIGHT AND EMOTION

Light has an emotional role to play that can alter our feelings. Our eyes may merely inform us: here are three steps to climb, I recognize this person coming towards me, this is my overcoat. As Ralph M. Evans notes in his book *Eye, Film and Camera in Color Photography*: "Perhaps the most important fact to understand about vision is the extent to which we have trained ourselves from birth to see objects rather than light." As photographers, it is our job to be aware of the effects of light on objects.

Passive and Active Illumination

When light is passive it merely illuminates. It does not draw attention to itself and seldom adds any emotional overtone. The illumination is sufficient for information purposes and plays no dramatic role in the visual communication process.

Some types of illumination tend to be more passive than others. Light on an overcast day is passive because it creates no distinctive light and shade effects. Passive illumination has a neutral color balance, low contrast quality, and moderate brightness. In other words, none of the six qualities of light are especially dominant. Everyday lighting (ordinary daylight, house or office lighting) is usually passive because it is familiar. Most standard photographic studio lighting for portraiture and advertising illustration is passive.

Passive illumination is appropriate for informative photography, straight-forward documentation, ordinary snapshots, most photos of people, catalog photography, etc. The intent is to make everything as uniformly appealing as possible and not cause emotional reactions to specific people or items.

Active illumination adds its own element to the scene (a spectacular sunset, for example). This active illumination should be used with restraint, though. Photos of sunsets out of context can become very boring. Emotionally active illumination requires careful control and keen awareness to be effective.

Diffuse light quality. Fashion photographers typically use diffuse light to illuminate feminine beauty. Do you feel this light quality choice should always be followed?

"If specular qualities are missing, our emotional reaction is frequently negative."

Light Qualities and Emotion

•**Diffuse Quality** is usually passive because its light and shade relationship creates no patterns or shapes to attract attention. Its light and shade become part of the form and space of objects in a scene. Diffuse lighting can be drab when the uniformity of its illumination is flat. Emotional overtones of softness and gentle envelopment can be expressed if the subject matter corresponds to these feelings. Thus, diffuse light works well with gentle subjects, objects like glass or sea shells whose surfaces are inherently luminous. Conversely, strong direction and contrast in a diffuse light and shade relationship greatly enhance the depiction of strength and durability. Because diffuse light reveals form and space, one gets an increased sense of reality in the subject.

•**Specular Quality** light is usually emotionally active. Specular light and shade consists of patterns and shapes, distinct edges, and vigorous feelings of texture. Specular quality adds vitality, making landscapes and architecture look more vigorous, solid and imposing. If specular qualities are missing, our emotional reaction is frequently negative. A person without specular highlights in the eyes looks dull and lifeless. Landscapes without sunshine are less inviting. Specular light can be harsh and aggressive. It can also convey feelings of artificiality or imagination. If contrast is high, we see a light and shade result that our eyes don't normally sense. Therefore, extremely contrasty specular light looks unreal.

In the top photo (*right*), specular sunlight introduces a visual dimension that echoes the geometric dress pattern.

•**Brightness Quality.** A photograph with predominantly light tones conveys feelings of brightness, gaiety, openness, and fragility. When the photograph is low in brightness the feelings are usually (but not always) the reverse. If color and contrast are strong, the image seems richer and more profound.

Many photographers deliberately underexpose transparency films because the colors become more compelling. Those areas in the photo they wish to emphasize stand out against the overall low brightness key.

The bottom image (*right*) was exposed to favor overall brightness, rather than increased color saturation.

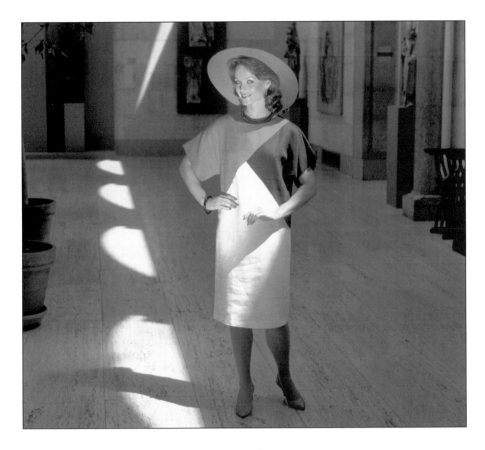

(left) **Specular Quality.**
Fashion illustrators strive to make a statement. Do you feel specular sunlight enhances this photograph? If you could digitally manipulate this photograph, what might you do to further alter the image?

(below) **Brightness Quality.**
This chrome of children among silver penny flowers in the woods was exposed in favor of overall brightness, rather than exposed less to favor increased color saturation. Was it a successful lighting strategy?

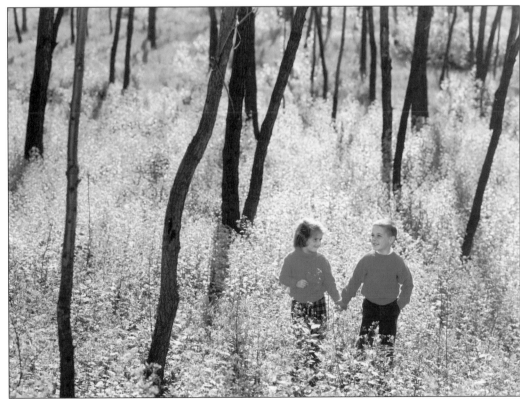

"Light with a strong direction quality enhances texture, form and space."

•**Direction Quality** says: "Look at this!" It's emotionally active because there is emphatic light and shade. The more contrast between light and shade, the more emphatic the statement becomes. The vivid direction quality of a single street lamp in old mystery movies is a cliche lighting effect. We know instantly that danger is lurking in this graphic lighting environment.

Light with a strong direction quality enhances texture, form and space. These conditions attract our interest and make all elements in the scene more substantial. They produce a light and shade relationship so full of information that it demands careful inspection.

Weak (flat, frontal) direction quality becomes more passive for the same reason that diffuse lighting is usually passive; the light and shade relationship doesn't impose itself on the scene. Weak direction quality with specular lighting on a beautiful woman is glamorous. The face looks alive while skin blemishes are minimized.

•**Contrast Quality** is much like direction quality; a strong presence commands attention. Strong contrast adds precision and strength. It can also convey feelings of harshness and rigidity. Of course low contrast is an opposite emotion generator. It supports feelings of delicacy, openness, sparkle and cleanliness.

Since film fails to record all our eyes can easily see, we must be careful about light ratio. Usually it must be much lower to record certain effects. For example, a 2:1 ratio between light and shade is seldom encountered in average sunshine. But reproduced in the photographic print, a 2:1 light ratio seems none too flat for many lighting situations.

•**Color Quality.** Color has almost infinite emotional overtones. Reds, yellows and oranges are warm colors that convey physical and emotional warmth. They tend to be "happy" colors. Conversely, cool colors like blues and greens support less upbeat feelings. Colors like pink and magenta support complex emotions too, but usually in a more positive way. Vivid colors are solid and aggressive. Pastel colors are passive and fragile. Pastel tints are often applied to a photograph through the use of color filters. Lack of color is now a visual cliche to define "yesterday."

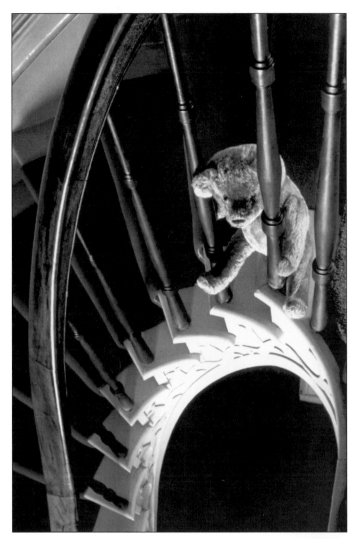

(left) **Direction Quality.** *In this photo entitled 'Teddy Bear Stays Up Late,' you can almost hear him asking "I wonder what the adults are doing downstairs?" How does light direction help animate this thought?*

(below) **Contrast Quality.** *Historical accuracy in this photo of Thomas Jefferson drafting the Declaration of Independence was assured by Independence Park's Bicentennial staff. Simulation of the early morning light was kept very contrasty to support the actor's expression of undaunted resolve.*

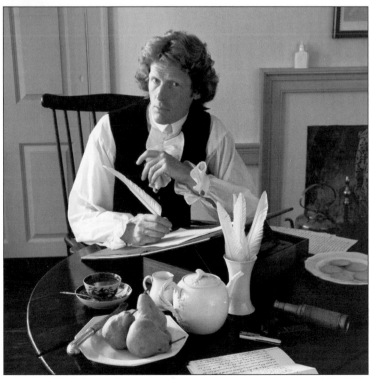

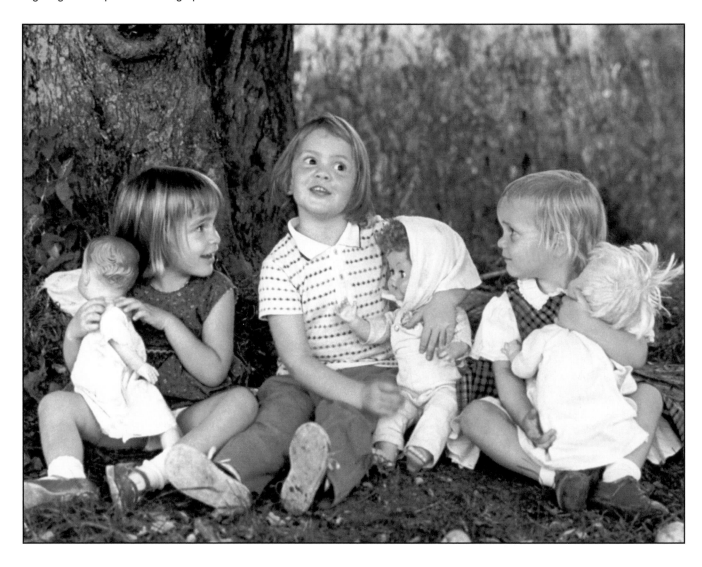

The flattering combination of diffuse and specular elements present in late day light leads many to call it "magic time." Notice how the combination of the two elements brings this image to life.

NATURAL LIGHT

Natural light comes from one side or from above, but never from below. When we see photographs made with light from below, we instinctively sense its unnaturalness. Natural light is also singular. When two light and shade relationships occur we know it's artificial (unnatural) and humans have intruded.

Natural light can be just as interesting for photographs of people as carefully arranged studio lighting. Diffuse daylight is typically the key source, derived from open shade or from sky light with the sun behind the subject's back. Also, the late day combination of specular sunshine and diffuse sky light is a magic time for people, just as for landscapes.

For the photo shown above, taken at the ancient apple tree just across the street, I waited for late-day magic light and added a neighbor family's children. Sky light amply illuminates the youngsters.

Available and Controlled Light

There is an emotional difference between lighting that is "just there" and lighting that has been carefully arranged. Available light is frequently inconsistent, while controlled light implies a lack of spontaneity during the action of the photograph. Feelings of manipulation have emotional consequences in photography.

•**Available Light** adds credibility to news photography, historical documentation, and legal evidence. These depend partly on available (environmental) light for their veracity. Because today's audiences are somewhat skeptical, it's important to let available light speak for itself in these kinds of photography.

•**Controlled Lighting** imposes itself on the environment and creates a new one. Advertising illustrators, commercial photographers and cinematographers use controlled lighting. Their photographic efforts are scripted with specific ideas in mind, and controlled lighting helps achieve these effects.

Lighting control can be as important as props and costumes when visually suggesting another era. Lemonade on a warm Sunday afternoon in 1937 (*below*) requires timing of people, action and natural light. Because the existing ambient light was not enough for film to record what an observer's eye would see, several 4'x8' white foam-core panels were laid on the lawn to reduce the 8:1 light ratio to 4:1. Technically, flash-fill near the camera could have done the same thing, but its obvious presence would have destroyed the milieu.

"Lighting control can be as important as props..."

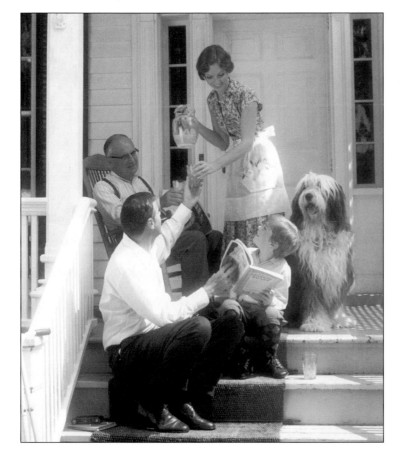

(left)Controlled lighting imposes itself upon an environment and has emotional consequences for the image. This lighting control can be as important as props or costumes.

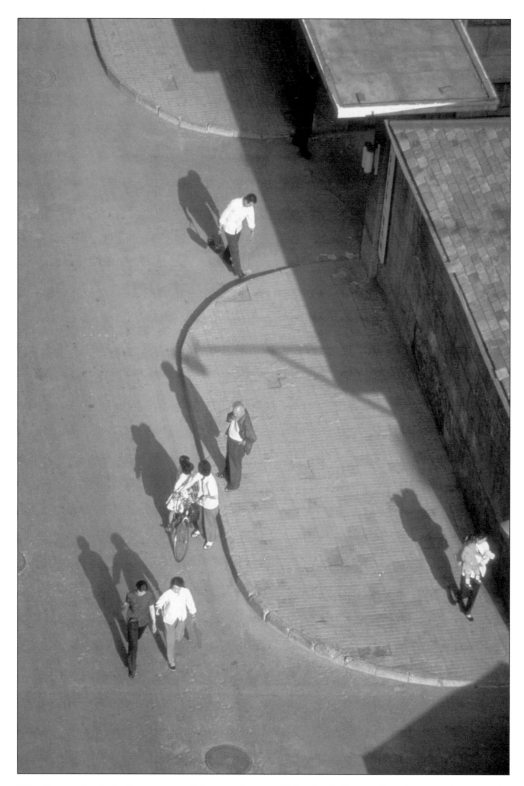

The sharp-edged shadows, created by specular sunlight, lend these pedestrians a vigorous air, and give the viewer a good sense of depth.

THE LIGHT AND SHADE RELATIONSHIP

Light is an illuminator and necessary for vision. It conveys visual information about form, space, texture and dimension. Light reveals this information by its alternating presence and absence. This is called the light and shade relationship.

The light and shade relationship exists because some areas do not receive direct illumination; a tree casts a shadow on the lawn, a blade of grass throws its shadow on the soil. The light and shade relationship is also exhibited by the many planes and changing surfaces of three dimensional objects.

It is the direction quality of light that creates the light and shade relationship. Light is reflected in various degrees of brightness because the angles of reflection vary. Even flat, frontal illumination produces a delicate light and shade relationship. The character of the light and shade relationship is also related to specular or diffuse qualities of light. Specular sources produce sharp shadows; diffuse sources produce nebulous shadows that defer to the form and surfaces of the subject itself.

Light Qualities

Shape, pattern, form, space, and texture are important to understand at this point. Shape and pattern depend on outline for identification. A silhouette is a shape; the leaves of a plant form patterns. Form and space depend on structure and spatial relationships for identification. The human body with its three dimensions and various appendages is a form; a group of dancers on a stage defines a sense of space. Texture is what a surface might feel like.

•**Specular Light Quality Effects.** Small sources, like the distant sun or a small light bulb, are specular. When the rays are interrupted, distinct, sharp-edged shadows are created — making for a distinct light and shade effect, even on rounded surfaces. This is significant because sharp-edged shadows are visually contrary to the inherent form of rounded objects. A specular light and shade relationship tends to put the visual emphasis on the shapes and patterns of the shadows.

"Light reveals this information by its alternating presence and absence."

•**Diffuse Light Quality Effects.** A strongly diffuse light source does not produce sharply cast shadows. The light and shade pattern on round surfaces is so gradual that no line of demarcation can be seen. A diffuse light and shade relationship puts the visual emphasis on the actual forms of objects in a scene, and the space that they occupy.

•**Direction Light Quality Effects.** Shadows are formed because illumination is interrupted. Shadows become larger when the light source is off to one side. When the source goes behind the subject a silhouette is produced, unless a second fill-in source is introduced. Lighting coming from below is unnatural and can cause visual confusion. Also, objects illuminated from below may appear to be floating. Because this direction effect is unnatural, it's often chosen by photographic illustrators to visually support emotional or fanciful situations.

When the direction of light skims across a surface, texture is revealed because even tiny irregularities will cast shadows. An outdoor wall receives light from the sun just before the wall goes into complete shadow – tiny details jump out where before they went unnoticed. The more specular the source, the more vivid the depiction of surface texture. However, if you want to reveal texture over a large portion of a rounded surface, use a less specular, more diffuse source with a strong direction quality.

The direction quality of light is the mechanism for molding the light and shade relationship, but direction influence is more complex than we might think. The more obvious direction influence is seen in the photo (*below*) of late afternoon light skimming across a view of Teotihuancan, Mexico. Rich architectural detail is revealed that doesn't occur at other times of day.

"Rich architectural detail is revealed that doesn't occur at other times of day."

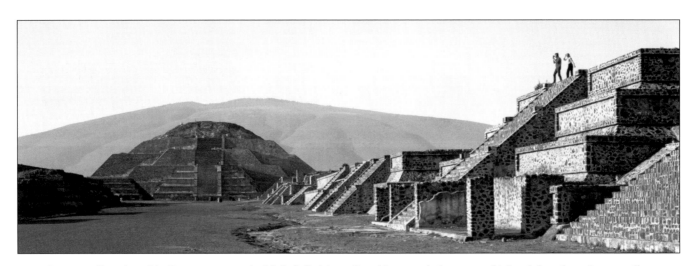

A strong directional influence creates the high definition of architectural elements which might otherwise seem flat.

A large diffuse source can cause a wrap-around direction influence. In the photo of a woman with her mailman (*right*), the source is directly behind the subject. All of the area in this photograph behind the door is the 8'x8' light source. Photographers may shy from such use because of fear of lens flare, but a precise lens shade plus inclusion of a pictorial element framing the subject will retain good tonal separation.

•**Contrast Light Quality Effects.** The amount of ambient light governs contrast quality. Less ambient light means greater light and shade contrast; more ambient light means the contrast is lower.

Contrast can be so high that the light and shade relationship is shifted from a form and space-enhancing situation to one where shapes and patterns take over. Extremely high contrast can shift diffuse quality appearances to specular. This occurs when very high contrast, lithographic-type film or paper is used, or when electronic image files are cranked up to maximum contrast. This is referred to as "posterization."

Local contrast can be enhanced without losing control over total contrast. Skimming light enhances texture (and thus local contrast) without influencing total contrast.

•**Brightness Quality Effects.** Controlling local brightness for effective visual communication includes subtracting light as well as adding it. A question very commonly directed to art students is, "How much of an apple do you have to show to say 'apple'?" In other words, revealing something in an obvious way can be boring.

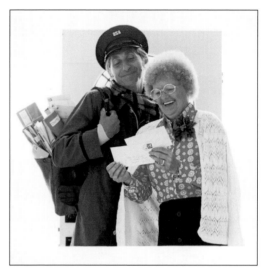

How does the large diffuse source used to create this image help to suggest the emotional tone that is indicated by the subject?

Surface Qualities

•**Surface Identity of Various Objects.** Both the surface and the source must be considered to understand the light and shade relationship. The surfaces of all objects in a scene contribute to light and shade effects. For example, a ball or other convex object usually has a dark area on its surface because its rounded surface reflects light falling on it in a continuously greater or lesser degree.

The more complex a surface, the more varied the light and shade effect caused by its reflecting surfaces, whereas a highly specular surface (such as glass) reflects light with optical precision. Specular highlights are brighter spots within areas of lighted surfaces. Such highlights add dimension, sparkle and visual appeal. For example, a portrait without catchlights in the eyes looks lifeless.

Most surfaces combine specular and diffuse qualities. A skillful user of light often tries to enhance this combination by opening up shadows in a high contrast, specular light situation, or by introducing a weak specular source into a very low contrast, diffuse lighting situation.

"... revealing something in an obvious way can be boring."

Visual Communication

Photography allows us to record even the most subtle nuances in the light and shade relationship. Consider the following questions when evaluating light and shade:

- Is the source specular or diffuse?

- Is the source a combination of the two?

- Where is the light coming from?

- Is more than one light source present?

- What happens to the direction quality if I change my position or move the light?

- Are there lots of reflecting surfaces and ambient light?

- Should the light ratio be altered in terms of how my film will respond?

- Do I need local brightness control to emphasize some areas and not others?

- Will a specific brightness key make a better visual statement?

- Looking at others' photos that I admire, how might I get a similar result?

- If I chance upon interesting lighting, how might I recreate that effect with another subject or scene?

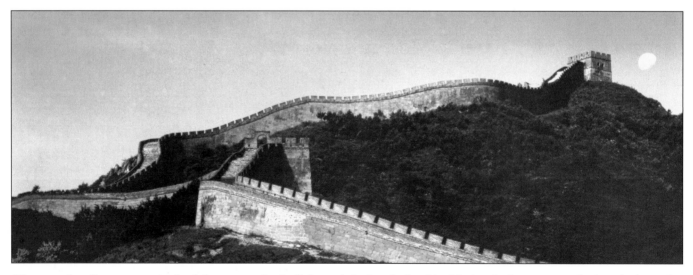

Photography allows us to record subtle nuances in the light and shade relationship. Notice the important role that the interplay of light and shade play in creating the sense of texture, and depth in this photo of the Great Wall of China.

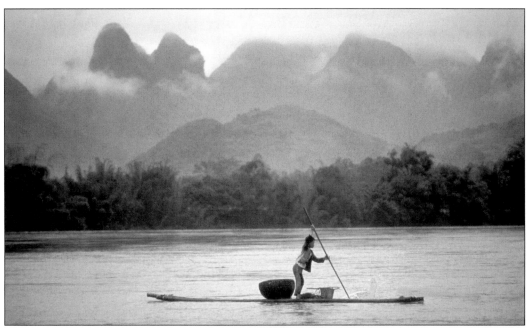

(above) Most photographers wait for a sunny day to do scenic photography, but this image was created in rainy, diffuse light. Do you feel that the diffuse quality adds to or detracts from the visual message?

(right) This Chinese cook was posed under the overhang of his outdoor kitchen at a rustic village hostel in Xingping. The vigorous, high contrast, diffuse light needs no fill and compliments the man's stolid presence.

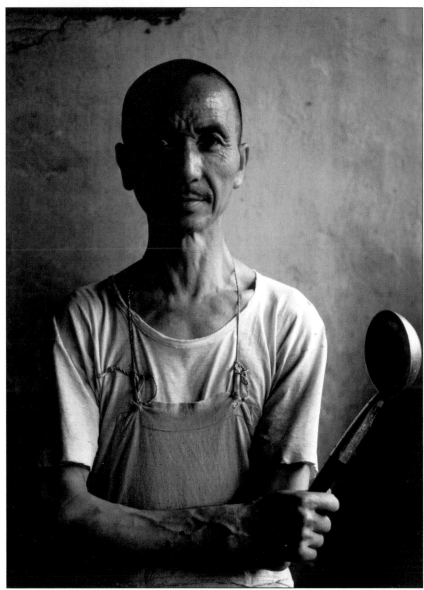

Trends in Artificial Lighting

A study of photographic techniques for *Studio Light*'s 75th anniversary issue revealed that since artificial light was invented there has been a shifting emphasis between using specular or diffuse light qualities.

•**1900's Portrait Studio.** The earliest practical artificial photographic light source was the brilliant arc lamp. It was employed, however, to mimic commonly used, diffuse, window light. The arc light was bounced off a white, hinged, free-standing corner reflector (shown here), or off an umbrella designed specially for photo studio use.

•**1930's Fashion.** When more facile tungsten lamps and fixtures became available, emphasis changed to specular, multiple lighting techniques. Shown here is a large spotlight with its rear door open and reflector off, enabling the tiny lamp filament to be the main light source. This casts a very sharp-edged shadow. A diffuse floodlight near the lens axis adds necessary fill.

Among the reasons for this are pictorial traditions, technical breakthroughs in equipment and materials, and increasing visual awareness. By adding a current situation, we have a century's retrospective.

•**1960's Fashion.** After several decades of specular, multiple source lighting techniques, studio photographers renewed their interest in diffuse lighting by returning to window light and to artificial light bounced off walls or umbrellas. Electronic flash expanded this technique by providing the huge brightness needed to expose contemporary color films that had film speeds as low as the earliest B&W films.

•**1990's Illustration.** Today photographers easily exploit all these artificial lighting techniques as they see fit. The lightbank, however, in its great variety of sizes and shapes, has become a studio standard. Today's users are not as beholden to perceived technological limitations as they once were. Still, contemporary use of light must continue to be versatile in thought and practice to be fully effective.

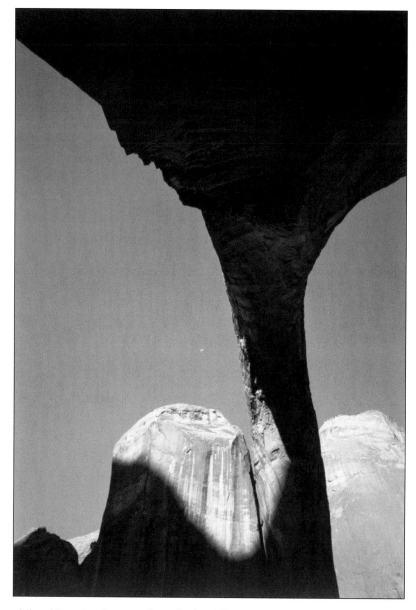

(above) For the photographer who is willing to wait or search for dynamic effects, using indirect control of light can create powerful images. Here, specular shadows on Utah's Rainbow Arch create almost abstract patterns.

(right) Unlike the above photo, this image was made after the background mountain blocked the sun, enabling the gentle glow of diffuse skylight to fully illuminate the scene.

CHAPTER FOUR
CONTROL OF LIGHT

The most effective way to control light is to control its six qualities, either directly, or indirectly. This provides a richer atmosphere for developing a lighting style and permits photographers to compartmentalize lighting problems, increasing the chance of easier solutions.

•**Direct Control** is employed to create new lighting environments. Direct control appeals to the inventor who precisely crafts the desired lighting effects, even those that others may not have imagined.

•**Indirect Control** is used for lighting that already exists. Indirect control attracts the hunter who quickly analyzes and responds, and who patiently waits or searches for expected effects to occur.

Either method of controlling light (direct or indirect) can be equally effective. Because the six qualities of light are common to each, this chapter is designed to help you become both a skilled creator and an adept analyzer.

10 Step Procedure For Controlling Light

The following working procedure applies to all lighting control. Whether you follow these steps exactly or loosely, you should establish a firm pattern. I recommend reviewing this list whenever problems arise. Often something simple has merely been overlooked.

1. **Specular/Diffuse Light Quality.** Which should be the dominant quality?

2. **Direction.** Where should the light come from?

3. **Light and Shade Relationship.** Is it satisfactory? Does it meet my needs for dimension and impact?

4. **Color.** Should I strive for color neutrality or create a color effect? Can this be modified now or later?

5. **Light Ratio.** Is the light and shade relationship suitable for this photograph? Can this be modified now or later?

6. **Number of Light Sources.** Is one light source enough? Are more needed to create the desired effects?

7. **Local Brightness.** Will lightening or darkening specific areas in the scene improve the shot?

8. **Brightness Key.** Should this photograph convey an obvious key? If so, review all the previous lighting decisions for their impact.

9. **Film Exposure.** What is the best film exposure strategy? Exacting exposure is necessary if the film is a positive (color transparency). If the film is a negative, the exposure needs to be sufficient to record the shadow details, and excess exposure is not a problem. However, exposure may need to be modified to achieve a certain brightness key.

10. **Review and Plan.** Have I overlooked anything? Do these decisions fit my style? What effects will materials and processes have on my lighting decisions? Should I plan for future image manipulation?

"The following working procedure applies to all lighting control..."

SPECULAR/DIFFUSE: BASIC CONTROL

Specular and diffuse light qualities are caused by the relative size of the light source. For example, the sun is a giant source, but because it's so far from the Earth we see it as small and specular. Light from the sky, however, is almost always enveloping, making it a very diffuse source.

Artificial light sources can be modified in much the same way, by using translucent fabric lightbanks, or modifying the distance between the artificial source and the subject. A lamp in a large reflector is diffuse when close, but specular when far away — even though its illumination will be less bright.

Surfaces also exhibit specular and diffuse qualities. Shiny surfaces are specular, but can be made diffuse with dulling sprays. Rough surfaces are diffuse, but can be made wet and shiny.

Specular light creates hard-edged shadows which become pictorial elements in the scene, and are as visually important as the objects themselves. Conversely, diffuse light creates shadows with indefinable edges that conform to the actual form and space inherent in the scene. Specular light creates the illusion (actual light measurement can prove otherwise) of higher total contrast because the light and shade demarcation is abrupt. Specular light reveals vigorous local contrast on flat surfaces — even the tiniest bumps cast vivid shadows — but not as well on rounded surfaces. Diffuse light creates more local contrast on rounded surfaces because its wrap-around illumination is tangent to a much greater area. Diffuse light combined with great overall contrast can be extremely vigorous and informative. For this reason it is often the lighting plan used for photography in high-tech product catalogs.

"Diffuse light combined with great overall contrast can be extremely vigorous..."

Never pass up unexpected gifts of natural light; they will seldom be the same another day. Here, the strong direction quality of late-day, specular sunlight balances nicely with atmospherically enhancing diffuse skylight.

The only lighting difference between the photo above and the one to the right is the natural transition of daylight. When the sunlight is strong (as in the photograph above), the lighting is specular and the shadows are distinct.

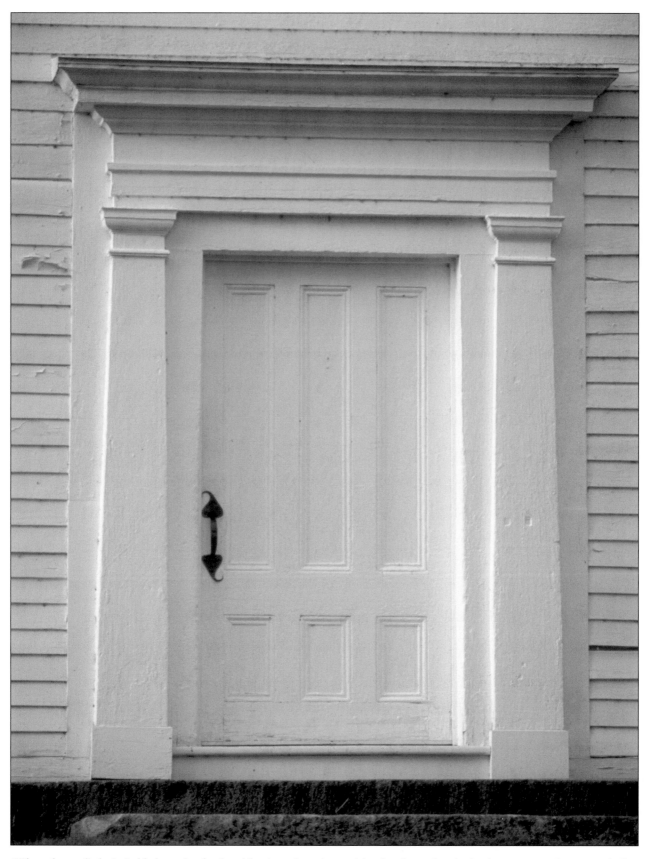

When the sunlight is feeble later in the day (the situation pictured in the above photo), the sky exerts much greater influence, the lighting is diffuse, and the shadows are nebulous and without distinct edges.

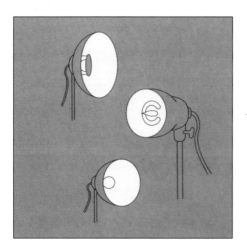

Specular/Diffuse Progression

There are an infinite number of changes within extremes of the specular-diffuse progression, from a point-size source to an enveloping sphere of brightness.

•**Point Source.**(*top*) The most specular source is a point of light. A point source will create very sharp shadows even when cast over great distances. Among sources that come close to this theoretical limit (especially when they are far away from the subject) are: the zirconium arc, bare arc lights, small filaments in clear lamp bulbs, steady candle flame and other tiny lamp filaments not modified by reflectors or lamp housings.

•**Small Sources and Optically Focused Sources.** (*center*) These begin to have measurable dimension, subtending an angle of arc of a few degrees or less. The sun subtends an arc of $\frac{1}{2}°$, and it's "small" only because it is 93 million miles away. Tiny spotlights, built-in camera electronic flash, bare household tungsten lamps, and large spotlights at great distances all qualify. Because they have dimension, their cast shadows have both an umbra and penumbra – meaning that their shadow edges are not optically sharp, they have a varying band of greyness between light and dark, depending on source distance.

•**Reflector Sources.**(*bottom*) Most lamps are placed in reflectors for greater brightness efficiency. Typical reflectors are about 6" to 24" wide. This added dimension increases diffuseness and, additionally, the S/D (specular/diffuse) difference will vary greatly depending on how close or far away the reflector is from the subject. Reflector design also modifies light; a shiny, round reflector has a noticeable specular hot-spot in the center of its illumination, while a matte, parabolic reflector casts a very even spread of light. Incidentally, differences in the spread of a reflector's illumination do not alter its S/D effect if the reflector's size remains relatively unchanged. A diffuser no larger than the reflector itself causes no S/D change, only more a even spread of that reflector's light.

•**Umbrellas, Pan Reflectors, Small Light Banks.** (*top*) Diffuseness can be increased significantly with these portable light sources. Pan reflectors and lightbanks create even illumination. Shiny, spherical umbrellas create illumination with a hot-spot in the center, while white and translucent fabric umbrellas are more even. Primary light sources altered by these devices produce much lower illumination than the same sources in reflectors (typically 2 to 3 *f*-stops less).

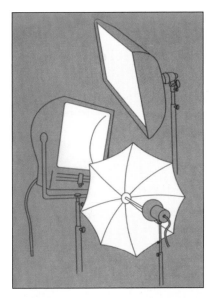

Umbrellas are extremely portable, but lightbanks and pan reflectors offer the most even illumination. Pan reflectors are used in cinematography because they are rugged and work well with incandescent lamps. Still photographers tend to prefer fabric lightbanks because they are much lighter in weight and can easily be broken down for portability.

•**Light Panels, Huge Light Banks.** (*center*) These are just bigger versions of the previous group, ranging from four feet wide to eight feet or more. Reflection from white or silvered foam-core panels falls into this category, as do full-color-spectrum fluorescent light panels. All of these sources are excellent for depicting form and dimension when direction influence is very strong. They are equally good at simulating ambient light when direction influence is very weak. Specularity virtually disappears with this group because their large size causes their shadows edges to be very nebulous.

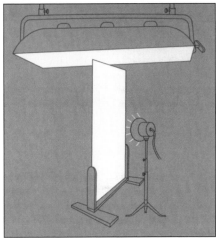

•**Non-Directional Light Sources.** (*bottom*) These light sources are so huge that their light emanates more or less equally from all directions, and their light and shade effects fail to improve the pictorial sense of dimension. Ambient light is a non-directional light source. It occurs naturally in lighting environments where there are big, bright reflecting surfaces or atmospheric diffusion. Other sources that qualify are: the sky's light (especially when overcast), small white rooms with light reflecting off all surfaces, and huge rooms with the ceiling filled with fluorescent lighting.

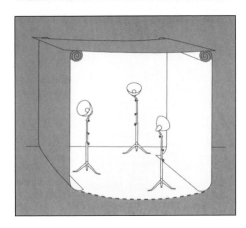

Constructing Light Diffusion Devices

Most primary, artificial light sources are specular because incandescent lamps are small. They have to be modified to become diffuse. Collapsible fabric lightbanks are the common diffusing device. Lightbanks work well with both electronic flash and its modeling lights. Umbrellas are still used for convenient portability; foam-core panels are used to increase the level of ambient light.

There are as many ways to adjust artificial light specularity to diffuseness as there are ingenious photographers. However, in natural light we must wait for natural diffusion effects to occur. Fortunately this happens every day around sunrise and sunset when the sun is low and weak relative to the skylight.

Combining Specular and Diffuse Qualities

When diffuse and specular sources of a given direction quality are combined, a new source is created — one that combines the precision of specular light and shade relationships with the form-revealing qualities of diffuse lighting. This happens naturally when the sunlight is dimmed by the atmosphere so that it is slightly brighter than the enveloping skylight.

Similar effects can be created in the studio. A small source surrounded by a high level of diffuse light is the key. One method is to use a bare-bulb light source in a small, white-walled room. Another method is to shine a specular source through a wall of material (like cheesecloth) in lots of ambient light. Both of these combinations add sparkling highlights to diffuse lighting.

(below) An expanse of snow creates lots of ambient light. In this action shot, is the natural daylight more specular or more diffuse? How does this contribute to, or detract from the image?

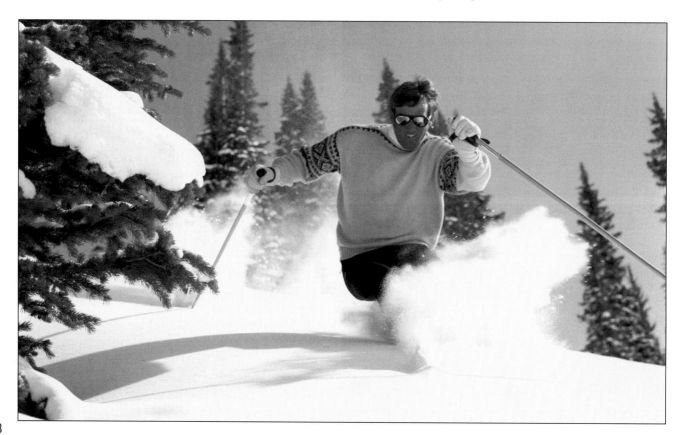

DIRECTION: BASIC CONTROL

Once a decision has been made about the specular/diffuse qualities of the source, the next step is to decide where to put it. Direction quality determines the extent of the light and shade relationship. A strong quality, with the source off to one side, produces the most shadow formation. A weak quality, with the source behind the camera or behind the subject, is the least formative.

Direction quality is controlled by moving the source or by changing the camera's or the subject's position. Begin by learning to use one light competently before committing yourself to the intricacy of handling multiple lighting.

Direction Quality with One Light

•**Angle of Incidence Equals Angle of Reflectance.** The direction of a light source is revealed not only by cast shadows, but also by its reflection. If the light source is highly specular, its reflection off a highly specular surface will be equally precise. If the light source is diffuse, it will be mirrored off a highly specular surface, but its reflection will occupy more surface area. Of course rough, diffuse surfaces will scatter the light from both kinds of light sources.

In the examples below, the source is a lightbank. With the source off to the right (*left image*), the reflections and shadows go to the left. With the source behind the subject (*right image*), its reflections and shadows come towards the camera. The shiny surfaces smoothly reflect the lightbank, giving us good information about specular surface character. Keep in mind that a specular source would be reflected only as a tiny point of light.

"Direction quality determines the extent of the light and shade relationship."

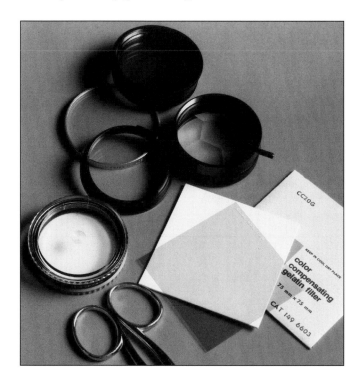
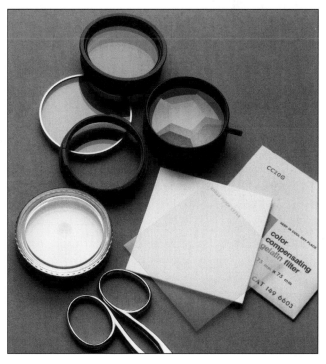

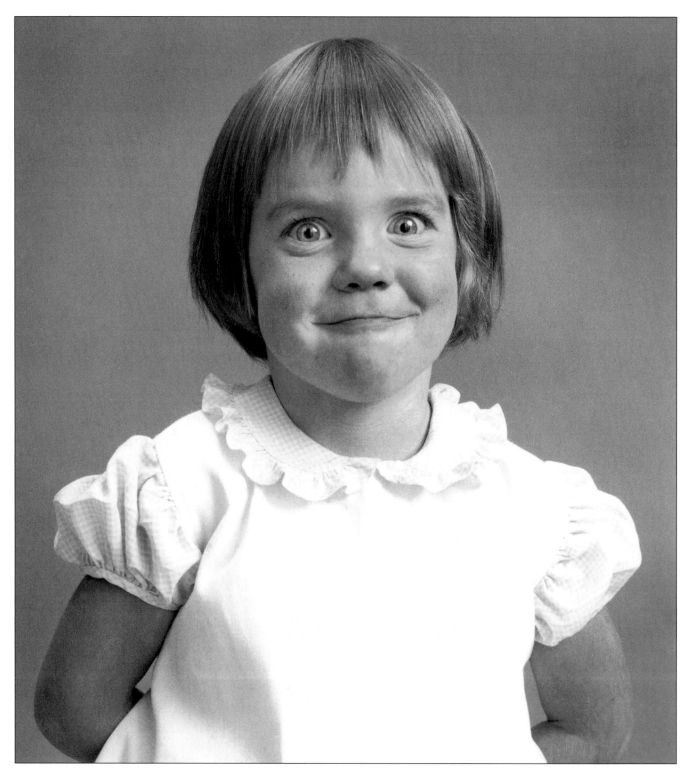

Rigid lighting plans seldom work with wiggly youngsters or pets. Keep the lighting simple. Here, a bare flashtube off to one side, another bounced off the ceiling to the rear, and lots of ambient light from large, white reflectors permit almost any action with sparkling results.

Indirect lighting control is commonly used by photojournalists. This informal portrait was created by placing the subject where the available light looked interesting. Lighting control was achieved by careful observation of the possibilities.

Minimum and Maximum Direction Effects with Specular Light

•**Extreme angles of influence** range from 90° from one side, 90° from above, 90° from below, directly behind the subject, and directly toward the subject (0° full front direction influence). Direction influence is at its maximum when the light from a specular source is moved almost 90° to one side and its light skims across the surface. Direction influence is at a minimum when a diffuse source is on the lens axis.

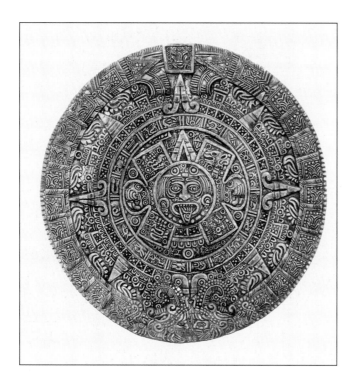 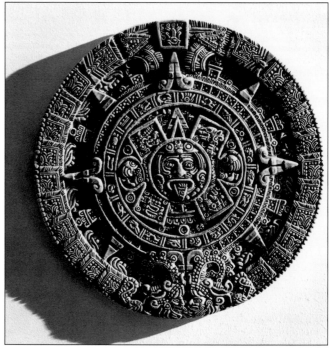

Minimum with Specular Light. The Aztec plate contains strong textures but these are minimized when the specular source is very close to the lens axis. The plate hanging on a white wall seems to float in space because the light source was well behind the camera and only a degree or two above it – thus, the plate casts no camera-visible shadow on the wall.

Maximum with Specular Light. When the same specular source is moved almost 90° to one side, we can easily see which parts of the plate protrude and which recede, even if the change is only a millimeter or two. In the original photo even subtle paint textures on the wall can be seen.

Minimum and Maximum Direction Effects with Diffuse Light

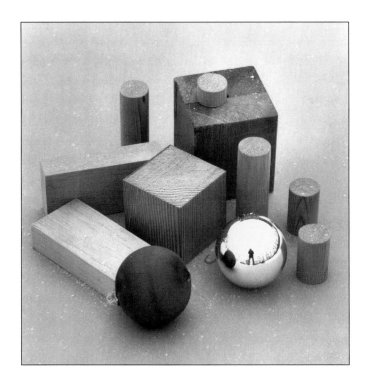 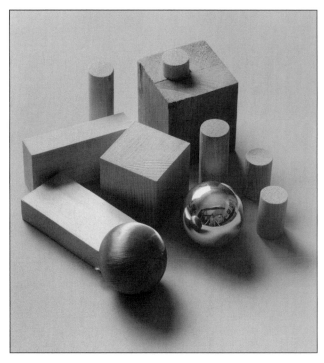

Minimum with Diffuse Light. A situation in which a diffuse source's direction influence is at a minimum is when the source is so big it globally surrounds the subject. Here, the photo was taken outside in the snow on an overcast day (note the silver ball's reflection). A similar situation occurs indoors when the subject is surrounded by very large lightbanks on all sides. The only shade results from inherent subject tones and variable reflectances off divergent surfaces.

Maximum with Diffuse Light. Diffuse shadows do not have sharp edges. Thus, three-dimensional form and spatial relationships are better revealed. A 4'x4' lightbank, used here, casts sharper shadows than a bigger one would. Note the edge of the left block casting a rather sharp shadow on its neighbor. This is one reason why lightbanks come in different sizes. When direction is strong, huge lightbanks don't flatten things out and can actually further enhance form and three-dimensional reality.

Extreme Direction Influences of One Light

These photographs are all lit with one moderately diffuse umbrella source (a 40" umbrella about 6 feet away). A separate light is used only to lighten the back wall. Ambient light was extremely low because there were no reflecting surfaces. The studio was painted black on all surfaces (walls, ceiling and floor).

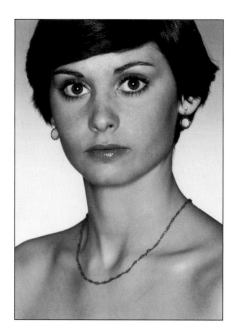

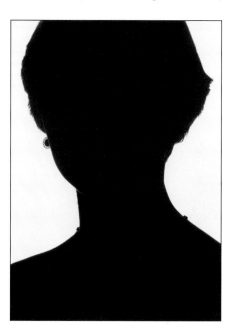

•0° **Full Front Direction Influence** produces minimum shade and maximum light. Revelations of form and texture, and the light and shade relationship are at a minimum. This direction influence is so weak that the effect is similar to ambient light and it is ideal for objects like complex machinery because its parts aren't hidden in shade. This direction also works for cosmetic ads: the full front direction minimizes facial wrinkles and blemishes while allowing the make-up to stand out.

•180° **Rearward (Silhouette Direction Influence)** is caused when the light source is directly behind the subject and there is no ambient light. This reveals the shape of the subject's outline if the light source is larger than the subject.

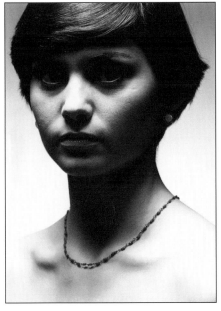

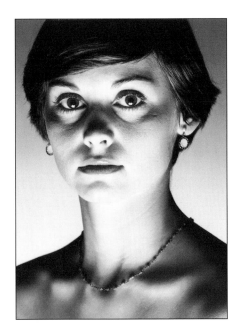

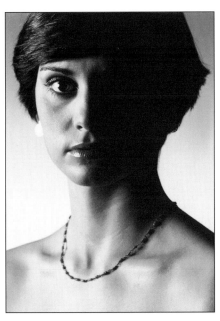

•90° Downward Influence. When ambient light is lacking, this direction influence can be unflattering on a subject's face. The bone and skull structure becomes prominent and the eyebrows shade any lively sparkle in the eyes.

•90° Upward Influence is unnatural. This direction can cause distorted and macabre effects. Depiction of form can be very misleading. However, this effect can also be provocative, suggesting mystery and romance.

•90° Side Influence skims across objects to create half light and half shade. If the surface is flat, the skimming light reveals maximum texture. If the surface is round and the source is specular, the edge between light and shade will be sharp. The larger and more diffuse the light source, the more it will wrap around the curved surface. Because the subject is half shade and half light, the overall brightness of the scene is less than with frontal illumination.

Intermediate Angle Influences of One Light

•**Intermediate (45°) Angles of Influence** are used to depict form, space and texture without the stark effects of extreme direction influences. All six of the examples seen here are lit from 45° above the subject.

•**Three Intermediate Frontal Influences.** The 45° angle from directly over the camera lens reveals modest texture on the face, especially around the eyes, nose and mouth. This is flattering for portraiture and informative for documentation of machinery. Moving the light 45° to the left may seem no different than moving it 45° to the right, but most subjects are like the human face. They have irregularities of form, and the light and shade effects can be profoundly different.

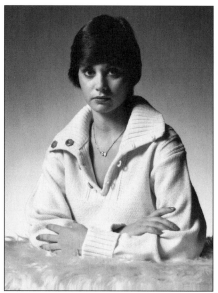
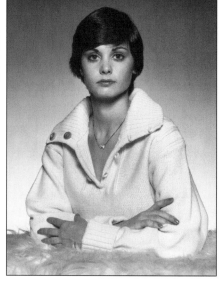
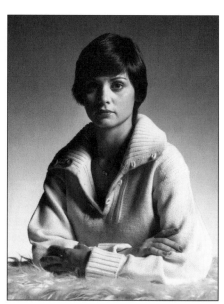

45° left frontal influence 0° frontal influence 45°right frontal influence

•**Intermediate Rearward Influences** produce more shade and less light on the subject, but act to separate the subject from the background. The edge lighting on the subject will appear brighter because the light skips off surfaces into the camera lens with greater efficiency. Rearward angles of influence are usually introduced into professional photography because they add dimensional sparkle. Rearward influences of sunshine are also ideal for making photos of people and activities come to life. Of course, exposure must be increased to show detail in the large areas of shade, or a fill light has to be added. Use a lens shade (bellows type) to avoid lens flare, especially with telephoto and zoom lenses.

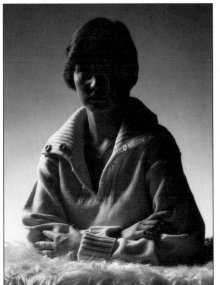 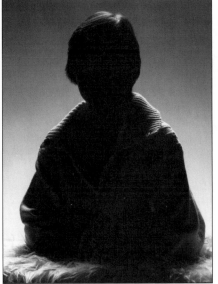 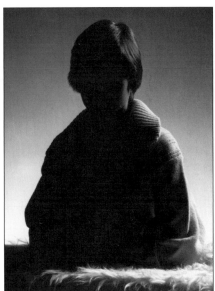

45° left rearward influence 180° left rearward influence 45° right rearward influence

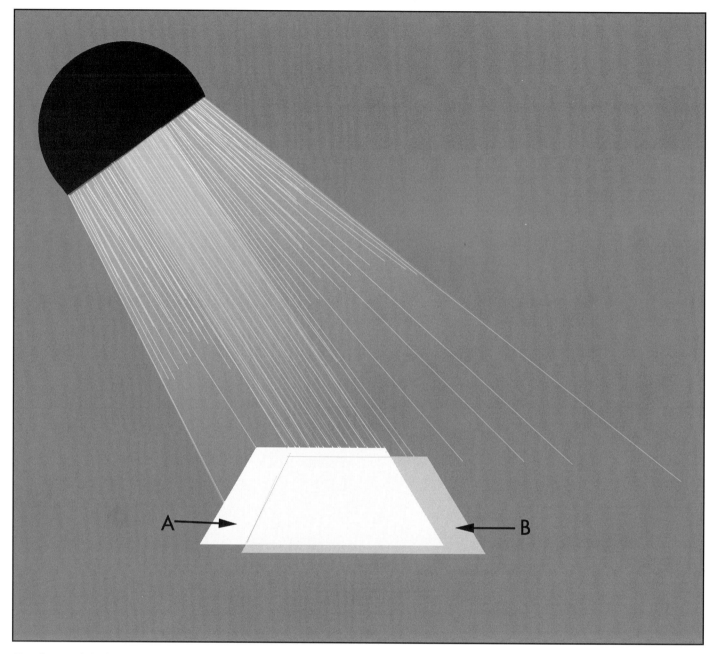

Feather a Light for Copying Art. *Laying the flat art at **A** will produce more even illumination across its surface because the reflector's hot spot of brightness in the center of its beam compensates for the greater distance. When the art is centered in the hot spot at **B**, the far portion receives relatively weaker rays, causing the far end to become darker. Even a white reflector near **B** cannot fully compensate.*

•**Feathering the Light Source** provides additional control. Instead of always aiming the light directly at the subject, aim it off center. Feathering a single light across a flat surface toward the far side will produce a more even illumination because the far side receives relatively more light to compensate for the greater distance, while the near part receives less light despite its closeness. Feathering is especially useful in doing flat-art copy work (see illustration on facing page). It is also commonly used in studio portraiture to emphasize the frontal portion of the face.

Feathering effects too subtle to the eye may readily document on film, because of its greater contrast. Nearly all light sources intermediate in the specular/diffuse progression are featherable. Spherical reflector and umbrella sources have a stronger hot-spot in their illumination for added feathering emphasis. Point sources and huge, or non-directional, sources are not featherable.

Direction Quality with More than One Light

Agreeable effects can be created when the primary light source creates the light and shade relationship and a second reduces the light ratio to the desired level. This simple combination is strong and versatile.

One main light source plus a second to fill in the shadows is the first step in multiple source direction control. Experienced professionals block out their lighting plans with source and fill light first. Then they decide what, if anything, to do next. Keep in mind that multiple source lighting is not the same as natural light.

When using many lights it is helpful to assign each one a role to play.

•**Key Light** establishes the primary light and shade relationship. All multiple source lighting decisions start here. Even if the light and shade relationship looks great on the subject, be careful to look for any disagreeable shadows falling on the background wall, or on nearby surfaces. Those shadows cannot be erased by adding extra lights. To avoid such shadows, try using a diffuse light as the key light to minimize cast shadows.

Most portrait photographers use lights with barn doors that restrain light. Professionals use screens and shading devices for the same reason. Some lighting manufacturers offer vertical blinds and honeycomb accessories to fit over lamp fixtures in order to more tightly restrict or aim the beam from the key light. With a little ingenuity, you can make devices out of black cardboard and tape (a good solution for large light banks).

"This simple combination is strong and versatile."

"...it adds separation and sparkle while unifying the action in the foreground."

• **Fill Light** illuminates the shadows. Use a large, white reflector or lightbank instead of a specular light to avoid casting conflicting shadow patterns.

• **Background Light.** If the subject looks good so far, the next step is to decide if an extra light is needed on the background. If the background is too dark the subject may blend into it. Lighting the wall separately heightens the perception of depth between it and the subject. Sometimes background lights are fitted with colored gels for further effect.

• **Edge Lights** add brightness to edges of objects in the scene and enhance separation from the background. The hair light (top light) is common in portraiture because hair photographs duller than it appears. Top edge lighting is standard for interior cinematography and professional photographic illustration because it adds separation and sparkle while unifying the action in the foreground. Cinematography sets never have full ceilings so that the lighting director can introduce top light. "Kick light" is edge lighting used to further lighten already light areas. It is commonly used in studio portraiture for added dimension in the face.

Created by careful double exposure, strong dimensionality was achieved with vigorous direction quality from an umbrella key light, a kick light and a diffused background light. Fill was provided by a 4'x8' white foam core panel.

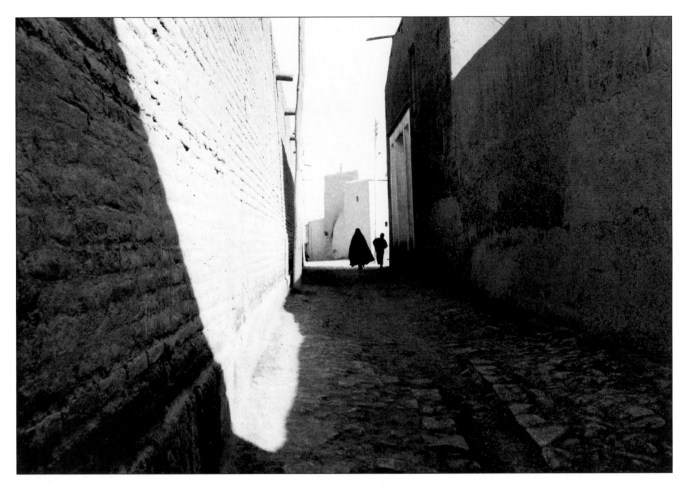

CONTRAST: BASIC CONTROL

There are two types of lighting contrast — total and local. While they are independent of one another, sometimes they occur simultaneously. Total contrast is alterable at all stages of the photographic process. Local contrast control begins with decisions about the formative qualities of light.

Strong lighting contrast increases the sense of sharpness in photographs. A precise lens shade improves contrast because lens flare is prevented. This is especially critical when using telephoto and zoom lenses. To confirm maximum shading, stop the lens down and point the camera at the sky. Extend the lens shade until it just begins to crop into the viewing area. You may be surprised at the length needed to effectively shade a telephoto lens.

Control of Local Contrast

Good local contrast produces increased textural rendition. A strong light direction skims across surfaces, revealing greater textural detail. If the surface is flat, specular light quality creates vivid textures. If the surface is rounded, a more diffuse source provides better texture rendition because it wraps around surfaces, affecting more area. Increasing total contrast when using diffuse light further enhances the rendition of local contrast.

Sharp shadows and strong contrast are important design elements in this action-moment photograph.

Local Contrast and Film Materials

The larger the film format, the greater the depiction of local contrast. Local contrast can be enhanced by adding extra lights to improve control in specific areas. Illuminated public buildings and monuments are common examples. Examine furniture catalogs too. Their need for local contrast control is utilitarian, but their ingenuity, skill and patience is worth careful examination. Also, examine B&W movies from the 1930's and 40's. Without color, and with very slow film emulsions, they were forced to use a forest of blinding spotlights. Nevertheless, they typically achieved excellent local contrast.

Control of Total Contrast

Total contrast describes the range between the lightest and darkest tones in a photo. Having a great range from crisp white to deep black is more contrasty than a smaller range from grayed-black to dirty-white. Contrast is also the rate of change between tones. A photo with only blacks or whites is more contrasty than one with blacks and whites and many shades of gray. The abrupt tonal changes of the former feel more contrasty than the latter. You may wish to refer back to page 15 to review illustrations of various light ratios.

Skiers in Snowbird, UT, were captured using a super wide-angle lens while shooting from a helicopter. The sharply etched shadows convey all the wide-open excitement of back-country skiing.

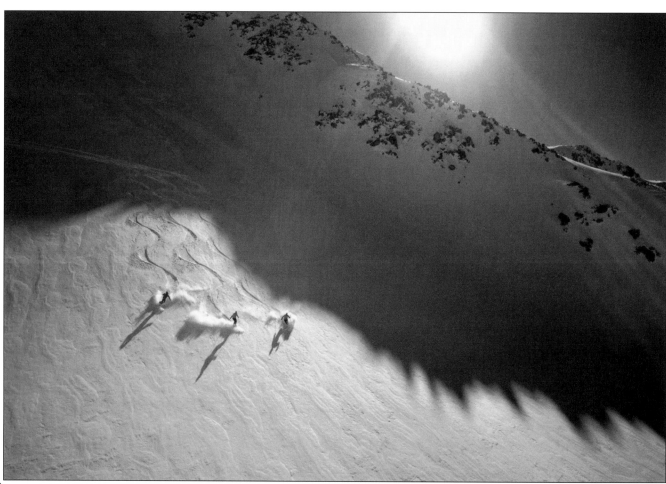

•**Light Ratio and Total Contrast.** An incident light meter is used to read light ratio. The first reading measures the light falling on the subject, and the second measures the illumination falling in the shade. This difference is commonly measured in *f*-stops. For example: 2:1 ratio (one stop difference). 4:1 ratio (two stops difference), 8:1 (three stops difference), and 16:1 (four stops difference).

1:1 Light Ratio. Here there is no measurable difference between the brightness of either light or shade. This happens on subjects lit with a totally diffuse source or with a 0° full frontal direction influence. A 1:1 light ratio is useful for depicting subjects where shade might obscure some portions or where the inherent subject tones should stay the same. This ratio conveys feelings of lightness and purity.

2:1 Light Ratio. The brightness of the light compared to shade is doubled — 1 *f*-stop difference on an incident light meter. This is a weak light and shade relationship but the standard for lighting in clothing catalogs, for example, because garment detail must be rendered. It conveys feelings of openness and sparkle.

4:1 Light Ratio. This quadruples the difference between light and shade — 2 *f*-stops difference. To the eye this looks relatively normal, but photographically it is quite strong. A 4:1 ratio is typically used for men's portraits, photographic illustration and advertising, and similar circumstances where emphasis is more important than complete visual information. Emotionally, this ratio is vigorous and emphatic.

8:1 Light Ratio. This is a 3 *f*-stop difference between light and shade. It is a typical light ratio occurring on clear, sunny days. Landscapes and architecture photograph well in such light. An 8:1 ratio supports feelings of aggressiveness, precision and power. Strongly specular sources under this light ratio can cause the light and shade relationship to become abstracted. Reality then is altered, not enhanced.

16:1 Light Ratio. This is a 4 *f*-stop difference between light and shade, and seldom encountered naturally. Beyond this light ratio little change will be recorded, although our eyes can adapt to such extremes readily. With specular lighting, this light and shade relationship can look like newspaper cartoons. With diffuse lighting, this extreme ratio records as almost super-realistic. You may wish to refer to pages 22 and 23 for two examples of 16:1 light ratios.

"With diffuse lighting, this extreme ratio records as almost super-realistic."

High light ratio. *The snowblower was placed just outside an open garage door and the light ratio was high — over 4:1. Emphasis is on the snowy scene and the shape of the machine. High total contrast attracts attention but the machine is vague.*

Low light ratio. *Addition of large, shiny reflectors reduces light ratio below 3:1 to give good detail in the shadows. The machine is more revealed but the photo is not as emphatic. To prove it to yourself, turn this page upside down and compare again.*

•**Control of Light Ratio.** Increasing ambient light is the best way to obtain more complete visual information in a photograph. Large reflectors provide more ambient light. You may also simply over-expose to gain increased shadow detail, especially if the highlight areas are small and unimportant.

Intended use helps one decide the appropriate light ratio. If the photo is meant to attract attention or convey a potent message, light ratios higher than 4:1 are appropriate; if it is meant to show full visual detail or convey pleasant feelings, light ratios lower than 3:1 are needed. Keep in mind, materials and processes tend to increase contrast beyond what our eyes see, so adjust your lighting accordingly.

Additionally, materials and processes can reduce as well as increase total contrast. This option is extremely useful because sometimes, as in landscape photography, light ratio itself can't be controlled and materials and processes become the only options. This will be discussed in more detail, shortly.

In this situation pictured to the left, most will favor the lower light ratio because the machine looks better. But, keep in mind intended use. It's possible that the high contrast example could be appropriate as a brochure cover, drawing attention to winter during a summer sale. The low contrast version could then be used inside to fully explain the machine's features.

•**Calculating Sunlight Flash-Fill** is necessary when batteries in a camera/flash metering system fail or instant photo tests aren't possible. The following procedure produces a 4:1 light ratio.

1. First you must know the flash guide number for the combination of flash and film you are using (refer to your flash instruction manual). Convert that guide number into a "4:1 Guide Number" by multiplying the guide number in the instruction manual by two. For example, if the guide number for your flash with a film speed of 100 is 80, then the "4:1 Guide Number" will be 80 x 2 = 160.

2. Control sunlight exposure by the shutter speed and the flash exposure by the *f*-stop: the flash is normally much faster than the highest shutter speed. Most flash-fill situations take place at distances of 4, 6, 8, 12, 15, 25 and 30 feet. Simply refer to your "4:1 Guide Numbers" for the *f*-stop needed at a given distance, and use your light meter to find the corresponding shutter speed that applies for correct sunlight exposure at the chosen *f*-stop. For example, given a "4:1 Guide Number" of 160 and a sunshine meter reading of 1/100 at *f*16, if your fill-flish is 15' from the subject, the camera should be readjusted to 1/200 at *f*11 (160 divided by 15 is 11).

"...materials and processes tend to increase contrast beyond what our eyes see..."

"...a specular source in a small outdoor set can create a look like late-day sunlight."

•**Increasing Light Ratio.** Occasionally, total contrast has to be increased, which is easy with artificial light. Outdoors, the best solution for increasing total contrast is to wait for a sunny day. There are, however, solutions for overcast days or indoors in flatly illuminated office buildings. Consider the existing illumination as the ambient light and introduce your own primary source. For example, on a dull day, a specular source in a small outdoor set can create a look like late-day sunlight. In fluorescent office lighting, a small electronic flash adds contrast sparkle as well as neutral coloring.

•**Control of Total Contrast by Processing and Darkroom Procedures.** The photographic process normally reduces the number of tones in the scene and increases contrast. Excess contrast can be a problem, and film processing is the best place to exert limits, especially when the light ratio is greater than 4:1.

A general solution (good for B&W roll film) is to expose for the shadows (or reduce the camera meter's film speed setting up to 1/2) and then reduce the development time in Kodak D-76 by 30%, or .7 times the manufacturer's recommended development time. This technique enables a high light ratio to be printed more easily on normal, or #2, paper.

Color transparency films like Kodak Ektachrome can sometimes be processed to specific film speed and contrast variations by professional color processing labs. Another possibility is to make a duplicate chrome. Most slide duplicators have semi-automatic pre-flash procedures that slightly reduce the contrast. The optics and duplicate films are so good today that high quality, carefully made duplicates can be barely distinguishable from originals.

Still, all of these color contrast control procedures have severe limits. It's very easy to degrade the overall image quality when total contrast has to be reduced much more than one level, for example, from more than 4:1 down to 3:1. Conversely, the same degradation occurs when contrast is increased dramatically. The main reason is that you are dealing with color as well as tone. Strong processing contrast changes in color look much more forced than the same degree of processing changes do in B&W.

Lighting contrast control by materials and processes extends much beyond this brief overview. For example, the new electronic digital imaging technology can extend to image creation itself. Nevertheless, understanding the control of light through the six qualities of light is still by far the best way to master its power.

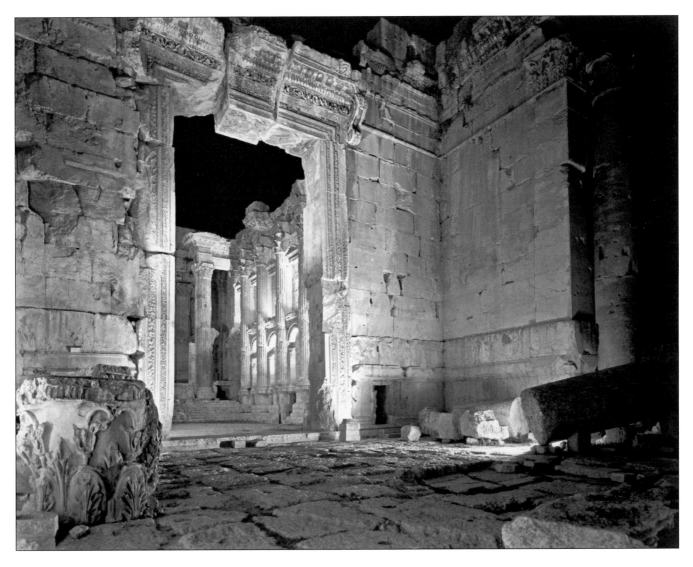

BRIGHTNESS: BASIC CONTROL

There are two basic brightness controls: overall control through proper film exposure to the brightness of the entire scene, and local control of brightness in specific areas of the scene for pictorial emphasis. These controls also work in concert to regulate brightness key, an emotional condition that describes brightness itself in the finished photograph. Brightness is a comparative light quality. It is alterable throughout the photographic process.

Overall Brightness Control

Optimum film exposure is essential to make the photographic record of reality as accurate as possible. This builds the best image base for any further changes.

Historically, film exposure was one of the most bothersome photographic problems. Aside from the possibility of receiving fatal doses of mercury or blowing yourself up with collodion in a tent darkroom, there were no light meters, no consistent emul-

Complex control of local brightness was required to illuminate the Roman temple of Baalbek in Lebanon. Chaos is avoided by meticulous organization, with each light playing a specific role in the overall effect. To photograph the scene, two No. 50 flashbulbs were placed to illuminate either side of the arch. The 8x10 negative was exposed to the f-stop for that guide number, and the shutter was kept open long enough to expose for the temple's architecturally positioned lights.

"Professionals always try to shoot extra frames of any scene."

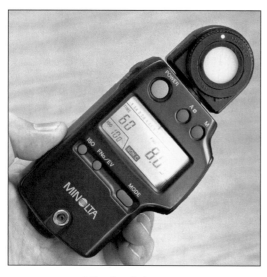

Minolta light meter.

sions and no understanding of film sensitometry. Today, with wonders like consistent film technology, sophisticated chemistry and programmed metering systems, there seems hardly any reason to bother about exposure control unless the meter's battery dies. Still, learning to understand and control the way film responds to light will invariably lead to wider possibilities, and better images.

•**Light meters.** There are two basic types commonly used: incident and reflected. There are sub-types too. Some can read electronic flash lighting, others read directly in *f* numbers and shutter speeds, some read in numbers that have to be translated. Light meters built into cameras may ignore you altogether and simply set the camera the way they want, whether you like it or not. Some meters read only tiny areas in the scene while others read an overall average.

Built-in meters and narrow view meters are reflected types, which read the light reflected back from the illuminated subjects. Reflected meters read an average of all the reflections they can see. If they are narrow in view, the photographer must decide if that narrow information is relevant to the whole scene or not.

Incident meters measure the illumination that falls on them and give exposure readings based on a built-in assumption that the subject reflects back an average brightness, specifically defined as an 18% reflectance. In practice, and statistically, this reflection assumption works reasonably well. Most hand-held meters are incident, but many can be converted to reflected by following manufacturer's instructions and using special accessories.

The newest reflected meter technology involves computer assisted programming with statistical analysis of the readings taking place even as the film is being exposed. Matrix metering is a term used by Nikon to describe its system. I know one outstanding professional who tried to "defeat" the system with every conceivable abnormal lighting situation. The system delivered a satisfactory chrome so often he generally gave up his exposure bracketing habits.

So what is the best type to use? There is no answer of course. Built-in reflected meters are by far the most common. With them, bracketing by a half stop on either side of the meter's choice is a 99.9% sure thing. Professionals always try to shoot extra frames of any scene. When this is impossible, they fail-safe themselves by under-exposing chromes and over-exposing negatives.

While incident meters are not inherently more accurate, they are far better than reflected meters for making light ratio decisions and tend to be preferred by cinematographers and professional studio photographers. Still, these professionals always make tests on instant still film, or view instant, through-the-lens-video records of the movie filming. This makes exposure adjustments self-evident as the job progresses. The best choice is to stay with the type that rewards your individual habits with dependable and repeatable results.

•**Brightness Quality and Photographic Response.** To visually communicate information about the brightness quality of light the photographer must be prepared to handle photography's interpretation of it. No photograph can literally record the blinding presence of desert sand at mid-day sun but an emotional interpretation can. I still remember a scene in the movie, *Lawrence of Arabia*, where a single camel rider slowly emerges from the desert's heat haze toward an oasis. The brightness effect could not have been more powerful if the theater's air conditioning had failed.

While analyzing my own processed transparencies, I invariably appreciate being able to scan half-stop exposure brackets. Frequently one of the three slides will look better. I'm looking at interpretations, not the real thing, because the viewing environment has changed to photographic. When making prints, my exposure judgment also swings toward interpretation, and I find myself being as fussy about 10% shifts as I was with 50% shifts in the slides. Transparencies allow more brightness interpretation leeway. That's fortunate, because prints are altered at leisure in the darkroom without time constraint.

•**Electronic Flash vs. Tungsten Considerations.** Professional photographers tend to emphasize electronic flash as their main artificial light source, even when photographing inanimate subjects. The illumination balances to daylight, is extremely dependable in brightness and color, and is battery-portable, allowing use anywhere. However, those who specialize in certain subjects may prefer tungsten-halogen lamps. These lights nearly always require the AC line voltage used in photo studios, so location use is more limited. They also deliver light at 3200°K, so they have to be filtered if combined with daylight. Still, their consistent, long life is excellent and they have special advantages over flash in that their brightness effects are continuously visible. Most studio-type electronic flash units try to solve this problem by incorporating modeling lamps. However, modeling lamps and flashtubes are far different in brightness and they vary in shape. Thus, flash combinations with existing light can't be seen by the eye; and the specular/diffuse difference between the tiny modeling lamp and the large, enveloping flashtube can cause lighting problems in fussy situations. The only precise way to control flash with existing light is to examine instant photo tests until the desired lighting effect is achieved. Professionals do this on every assignment.

"... flash combinations with existing light can't be seen by the eye..."

•**Increasing Brightness of the Illumination.** So far we've concentrated on accepting the scene's brightness level and accurately responding to it. But there are times when the brightness level of the light itself has to be altered. We should note some problems that could arise and which make it desirable to control brightness, rather than just to respond to it. Obvious conditions occur when:

1. The lighting is too weak for a given *f*-stop.

2. The available light is too feeble to stop action.

3. We want more light so we can stop down for greater depth of field.

4. The lighting is too dim for a less sensitive but sharper film.

5. One part of the scene is very bright and we must increase existing brightness in the shade.

> "... there are times when the brightness level of the light itself has to be altered."

Some solutions are obvious. For instance, outdoors we can wait for a sunny day. Indoors we can move lights closer or turn more on. However, these actions may destroy the other light qualities we want to retain. If these simple brightness adjustments still allow the others to look good, we're in good shape. If not, we might consider using a more sensitive film. Higher speed films are less contrasty, as well as much sharper and less grainy than just a few years ago (that's one reason why it's important to never give up trying new materials and processes). We can also consider using a longer shutter speed, or a larger lens aperture. These choices won't negatively effect the desirable lighting qualities we are trying to retain, but they might cause some image quality concerns such as camera shake or too little depth of sharpness.

A processing option is to increase development. This option succeeds only for speed boosts of one or two *f*-stops. Since most film speeds are accurately stated, increases with push-processing can quickly lead to image degradation: first by increasing contrast, and then by robbing it when carried too far. Occasionally, such effects can make a photo look more dramatic, but it pays to be cautious unless this effect is explicitly desired.

Convenient options with studio lighting are:

1. Generate more light by using more powerful tungsten lamps.

2. Increase the electronic flash power.

3. Use more efficient lamp reflectors.

I once had to throw sufficient electronic flash a distance of fifty feet but had limited extra power available. Another reflector in place of the standard one added almost two stops brightness — a huge difference!

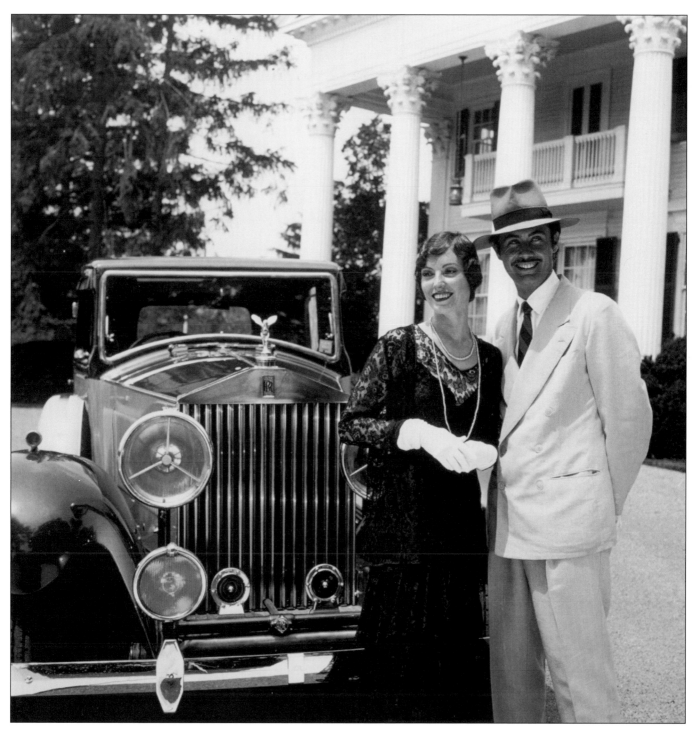

Midday sun is very specular, with a light ratio of 8:1. Three 4'x8' white foam core panels were used in this image to add sparkle and reduce the tone contrast to around 4:1. In addition a deep blue filter (No.47) was used to simulate the non-panchromatic (orthochromatic) B&W films commonly used for Hollywood promotional stills in the 1930's.

In available light and natural light, increased brightness solutions can get tougher. In this photograph of the Sphinx, the lighting effect was provided by a combination of double exposure and artificial light. First, an exposure of several seconds recorded cloud movement just before dark. Son et Lumière (a French technique for computer driven narration, sound, and lighting effects which theatrically adds life to monuments) provides the second element of the lighting. When this lighting effect appeared, several more exposures were made. With just one opportunity, the 8"x10" negative was intentionally overexposed to assure printable results.

*The photograph of the woman and the rya rug was made late in the day and each of the two 8"x10"
negatives were badly underexposed. However, an idle sandwich of them, slightly rotated, unexpectedly
revealed moire patterns caused by out-of-register alignments in the foliage. Busy specular light patterns
of the woods in sunshine could have ruined this unusual effect.*

73

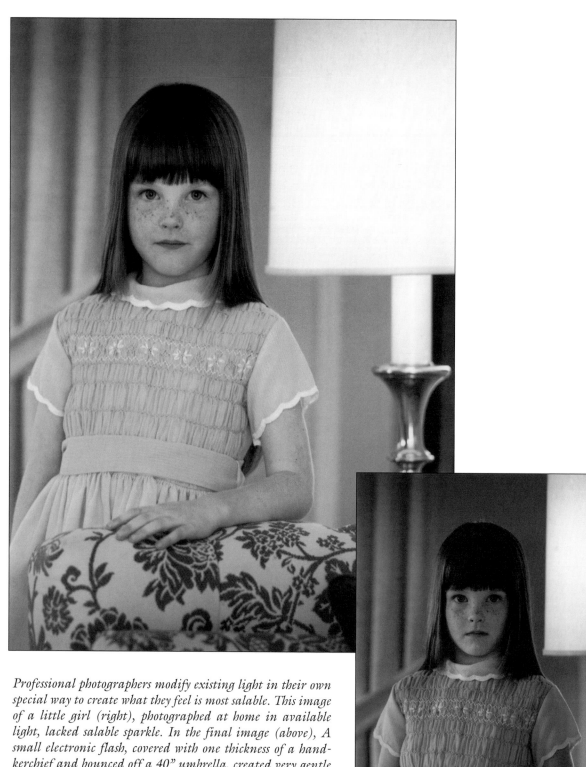

Professional photographers modify existing light in their own special way to create what they feel is most salable. This image of a little girl (right), photographed at home in available light, lacked salable sparkle. In the final image (above), A small electronic flash, covered with one thickness of a handkerchief and bounced off a 40" umbrella, created very gentle fill that didn't alter the environment. Such a complicated modification is bothersome, but most professionals will exert the effort. Proper balance can be confirmed with an instant film test.

With diffuse lighting, extra lamps can easily be added behind the existing diffusion material, producing no change in the diffuse quality. With specular lighting it's trickier to add more lights, because each lamp has prominent light and shade effects. With great care, sometimes a cluster of two or four lamps very close together will sustain a singular light and shade relationship.

In available light and natural light, increased brightness solutions are tougher. Increasing the ambient light artificially up to two *f*-stops often retains the other important light qualities. Additionally, don't overlook the basic decision of going to a slower shutter speed and using a tripod. This is no problem at all with inanimate subjects, and even normal human facial spontaneity can be captured very nicely with shutter speeds as slow as ⅛ second. Early photographic pros like Edward Steichen, Nicholas Muray and others routinely captured spontaneity with exposures of 15 seconds or more. In the mid-1800's Julia Margaret Cameron placed most of her subjects in dim, but powerful, lighting conditions requiring exposures that were minutes long!

In summary, don't be content to shove the light closer, or add a bunch more, or even use push-processing to get greater brightness. The other light qualities are likely to be ruined. As noted, there are several other good and easy options to consider.

•**Decreasing Brightness of Illumination.** Normally this is a problem we don't mind having. But, again, don't just pull the lights way back or turn them off. The other light qualities may suffer.

A solution commonly employed in the movie industry is to use a neutral density (ND) filter over the camera lens. A .3 ND filter reduces film exposure 1 stop; .6 ND 2 stops; .9 ND 3 stops; and so on. As the densities increase a yellowish color bias creeps in. I've found that 1.5 ND (5 stops increase in exposure) is a practical limit. Neutral density filters are also made in large sheets for use in front of theatrical and movie lighting fixtures. Rosco Laboratories, Inc. makes Cinegel filters for lighting control and they include four that reduce brightness by ½, 1, 2 and 3 stops. They are available in rolls 48" (1.22 m) wide. I also know of some architectural photographers who carry 4'x8' sheets of gray Plexiglass to cover windows so interiors can be more easily balanced to the much brighter outdoor natural light.

Many electronic flash units have quick power adjustments down to as little as ¹⁄₃₂ power, or less. This is especially helpful for a built-in camera flash because it can't be removed to a farther location. Reducing flash power, incidentally, has the added advantage of producing shorter flash durations for stopping action. Most manufacturers provide a table for the exact changes of flash duration produced.

Hanging a "spun glass" sheet in front of a light source works nicely if the source coloration is not unintentionally altered. Continued use causes such materials to become yellowed because hot tungsten lamps will degrade the fabric. Rheostats won't work either, except for B&W photography, because electrically dimmed

"In available light and natural light, increased brightness solutions can get tougher."

light always becomes much too yellow.

The movie industry commonly uses varying thicknesses of a stiff, black cheesecloth-looking material stretched across a metal-wire yoke. This device is called a "scrim." Thinly woven, open weave scrims enable very soft and subtle brightness reductions. The results are much like the modest dodging techniques normally employed in printing negatives. Scrims work quite well with nearly all lights when kept far enough away from the lamp's heat. With extremely tiny, specular sources, however, scrims may cast subtle check patterns.

Of course, any diffusion material over a light source reduces its brightness. I have often covered a built-in electronic flash with a handkerchief for approximately one stop reduction. If this material is held very close to the reflector the light's specularity will change little because the reflector size hasn't changed. But be careful of fire with any of these solutions. Modern photo lamps can be intensely hot, even at some distance, because lamp reflectors concentrate the beam.

Transparency films can be under-exposed or prints simply printed darker to reduce the sense of overall brightness. This can be effective as long as pure whites in the photo aren't grayed or shadow detail blackened. We are altering a limited photographic file of information and such darkening changes can quickly begin to look like a technical mistake to even casual viewers.

This convention display photograph of packaging for a chemical product, from tank car to tiny can, shows that carefully controlled lighting can set the stage, even for mundane subject matter. Here, five 22B flashbulbs in reflectors were used. Two backlight the steam, one lights the rear wall and two bounced off a wall behind the camera for ambient fill light. A sixth flashbulb was placed in a spotlight to light the containers. Flashbulbs were used for their enormous brightness and portability.

Local Brightness Control

Controlling the brightness of parts of a scene allows one to add and reduce visual emphasis. It's important to note that local brightness controls can be similar to those used for contrast control. The reason I deal with these topics separately is because visual emphasis is different from visual information. When the goals for control differ, the controls must be examined separately.

When making a written statement, one can use bold lettering to emphasize an essential word or phrase. Occasionally the photographer wants the lighting emphasis to be this boldly obvious too. More often, the photographer wants any emphasis to seem a natural component of the visual message. Therefore, adding or reducing local light can sometimes be too abruptly self-evident, and post-exposure alterations may not offer sufficient control. Therefore, it makes sense to take care with local lighting when making the original exposure. Remember, subtle lighting usually requires finesse, and many of the tools mentioned here require a deft and skillful touch.

There are two basic options to consider for local lighting control: adding light, and removing it. Each control can be broadly exercised or very tightly restricted. There are an enormous number of devices and lighting accessories to achieve these ends.

•**Panel Reflectors and Shaders.** The simplest and most subtle tools are white/silvered reflector panels or cards (to add light), and shader panels or cards (to remove light). These can be cut with scissors or razor knife and placed around and within a set.

Beer looks especially good when a silver card is carefully cut and placed directly behind the glass to reflect light back through the bubbling beverage. This subtle local brightness control adds sparkle usually achieved no other way. In still lifes, it is often easy to hide reflectors behind objects in order to add local brightness unobtrusively to other surfaces. At Kodak, I frequently had to photograph a black camera seen behind a yellow film box. It was simple to hide a white reflector card behind the box to enhance the black camera. Many photographers keep handy pre-cut mirrors of glass or chromed metal when a somewhat greater brightness increase is needed.

Occasionally, an unwanted reflection or very light area has to be eliminated. The solution is to orient a black card so that its void reflects off the offending surface. A polarizing filter seldom works because its effects are too broad.

For bigger sets 4'x8' white foam-core panels are especially useful because of their light weight. They serve to add ambient brightness. It's easy to build a quick stand-alone corner, a small room, or even cut a hole in one for the lens to peer through when photographing mirrored subjects. I always carry a large plasticized white sheet in my camera bag for quick location needs. Some manufacturers make handy, collapsible aluminum frames to hold black, white, or silvered fabric for location and studio uses.

"... many of the tools mentioned here require a deft and skillful touch."

Reducing Local Brightness. *Flags, scrims, cookies and patterns can be used to reduce or modify local brightness.*

Adding Local Brightness. *Spotlights and lamp accessories can be used to create emphatic effects. White or silvered reflectors produce more subtle enhancement.*

"...normally you'll see a forest of stands holding reflectors and shaders..."

Various shading devices block or reduce brightness. These are called flags or scrims. When used with a diffuse light source, shaders cast soft edged shadows. Use with specular lights will cause shadows with sharp edges. Softer edged shadows can be produced by moving the shader farther from the subject. Some shaders cast variegated shadows (like light through foliage or venetian blinds). These are called cookies (Cucoloris) and patterns, and require specular light for their effects to be created.

Photographic studio stands with articulated arms are frequently used to support reflectors and shaders. Pros often use a half dozen and more on a set. Professional versions of these stands are available through major photographic supply houses like Calumet Photographic, Inc. or Helix, Inc. They may also be obtained through movie and TV suppliers, such as Mole-Richardson Co. and Matthews Studio Equipment.

In summary, panel or card reflectors and shaders can be as simple and inexpensive as ingenuity invents. In many cases these primitive tools are the sole modifying agents in photographic studio set-ups. Take a look at any professional studio still life set-up and normally you'll see a forest of stands holding reflectors and shaders, generally with just one large lightbank source suspended over the subject.

•**Light Source Accessories.** Spotlights and lamp accessories (such as specially designed reflectors, barn doors, snoots, honeycombs, optical attachments, etc.) as well as portable light painting devices, all serve to concentrate illumination. Such devices normally create emphatic local brightness effects. Novices are often heavy handed using these tools because human vision senses much less emphasis than film or digital cameras normally record.

Unwanted light spill from a large lightbank can be restricted efficiently with a large honeycomb screen. Many lightbanks have Velcro fasteners to permit an easy-on, easy-off attachment of such a device. Another effective solution (and one that permits more light to pass than a honeycomb screen) is a large frame with four evenly spaced 3" to 6" slats. Think of this solution as having a couple long sets of parallel barn doors in front of the lightbank. I've seen photographers make this device with a 1"x2" frame, some black cardboard and generous applications of black tape.

Optical accessories are frequently used with spotlights to create very precise beams of light. Most permit insertion of masks to project specific light patterns or transparency images. The movie industry has a vast array of masks for optical spots, easily adapted to still photography. Several electronic flash manufacturers also have optical accessories and spotlights that permit almost as much variety and flexibility as tungsten spotlights. Slide projectors can also be excellent optical light sources for small sets but they are more cumbersome to aim than specially designed studio lights.

Fiber optics are very handy local brightness tools. Some lighting manufacturers provide flexible fiber optics for use with both

tungsten and electronic flash. Their special advantage is that tiny light beams can be directed to very tight areas, inaccessible to ordinary optical projection techniques. They also have another intriguing aspect as they can be used to paint with light.

Other accessories to change light in some way consist of colored, neutral density and polarizing filters, as well as diffusion materials. These are available in great variety from theatrical lighting suppliers such as Rosco Laboratories.

•**How Much Local Control?** As noted at the beginning of this topic, the stated aim is to exert control that is seamlessly natural. Remember, too, that brightness change is also modified by contrast. Small brightness changes in light always record photographically great, and even feeble looking reflectors can produce more substantial effects than our eyes may readily notice. Thus, excess can happen even to the most alert. For every finished advertising illustration, dozens of Polaroid test photos have been shot. Cinematographers often use a deeply tinted monochromatic viewing filter to help decide. A simple trick I have used as long as I can remember is to severely squint my eyes when viewing a scene. If vital areas get lost in darkness it's a good clue that some brightness modification may be needed.

> "...even feeble looking reflectors can produce more substantial effects than our eyes may readily notice."

A graduated neutral density filter modulates the sky brightness, placing more visual emphasis on the skyline.

"Without tonal anchors, the photograph may look accidental."

Brightness Key

The first step in selecting a brightness key is to consider the subject. A high-key photograph of a child won't happen if he is wearing dark clothes. A bridal portrait suggests using high-key instead of low key lighting because there is lots of white. Of course this can be modified by direction control, shading and by less ambient light. Therefore, the next step is to consider the light and shade relationship to see if it supports the intended brightness key. Weak direction, lots of ambient light, lower contrast and pastel coloring all support a high brightness key. Conversely, low key is supported by lots of shade, sometimes with higher contrast, and by darker or more saturated colors.

The trick is to not let the brightness key induce feelings that the final print is somehow technically deficient. Without tonal anchors, the photograph may look accidental. One way to avoid this is to be sure to achieve a long range of tonal deviation within the key chosen. This variety signals deliberate intent. Furthermore, small areas of contrasting tone outside the brightness key may be needed too. They should not draw attention away, of course. A good example would be a high key photograph of a bride with very dark eyes. This can be especially appealing because an asset is dramatized. Conversely, strategic uses of high brightness in a low key environment can be equally compelling. It will add sparkle and interest into what otherwise might be dark and depressing.

Film and processing also have to follow appropriately. Full camera exposure is best with negative film for both brightness keys because a maximum file of information is captured. With transparency films, exposure has to be more precise, with slight overexposure for high brightness key and less than normal for low-key. When using transparency film I always bracket my exposure by half stops because the final selection invariably offers some unpredictable effects.

Brightness key in photography is, to some extent, a departure from reality because our eyes always adjust automatically to enormous brightness ranges. But brightness key strongly supports emotional feelings about the subject. Deep, rich tones have a visual strength. They are not always gloomy. When rich color and texture are vivid, there can be feelings of a jewel-like glow. On the other hand, high brightness key is happy and expansive. Controlling brightness key is a very useful photographic technique.

Contrast can set the mood for an image. This photo of a church in Vermont was illuminated by a sudden shaft of sunlight which sets it apart sharply from its surroundings. How would you classify the contrast of this image? How would the mood of the image change if the church was photgraphed on an overcast day?

"Careful consideration must be given to the light source, film and processing..."

COLOR: BASIC CONTROL

Color is a unique visual phenomenon and recording it is a very intricate process. Technically good color images are so common we tend to take for granted the wizardry behind them. To properly control color quality, however, we must try to understand some of the intricacies behind the magic. A photographer may choose only casual control over color by just accepting automated exposure and standard processing. This is not necessarily bad, as we'll see. However, the photographer may also take a much more deliberate role by careful testing and individualized processing. This is the role that we'll examine much more carefully. Overall, there are two basic color control considerations: to control light for neutrality, or for color effect.

Casual Control of Color Quality

Casual control of color means simply matching film type to the type of illumination and accepting standard processing. Many outstanding photographers do little more than this to control color. Standardized results become an intuitive part of their visual awareness. For example, many pros see the world reproduced as Kodachrome slides. Instinctively, before the shutter is released, they know how Kodachrome dyes and processing will record the color qualities in the scene. This casual control precisely fits their communication goals. Some photographers have the same insights when using color negative film too. This may seem strange, because prints still have to be made, but some photographers clearly visualize in advance how the color print will look when enlarged in a standardized manner.

Sometimes, however, casual control can produce unexpectedly bad results. If the photographer is a beginner, this can be disastrous because no solution seems possible. If the photographer is more experienced, and also knows how to exert deliberate color control, a solution may be apparent. Still, the photographer may be furious if aware that someone in the photographic chain produced poor goods or failed to follow instructions.

Casual control of color is a lot like using only available light. It can create wonderful effects, and even casual control can produce truly unique color photographs. Nevertheless, all of us want more control over our destiny, so the remainder of this chapter will concentrate on deliberate control.

(top, opposite page) Backlit sun adds contrast to a monarch butterfly. Diffuse shade has much less contrast, yet the strong colors add their own vivid glow, an effect that cannot be rendered in B&W. (bottom, opposite page) On the Li River in China, strong color modification with a yellow filter turns a flat, grey scene into one that is exotic and enchanting.

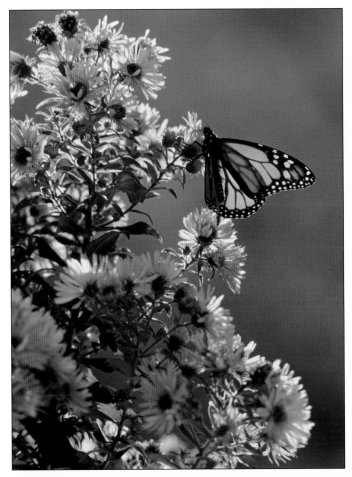

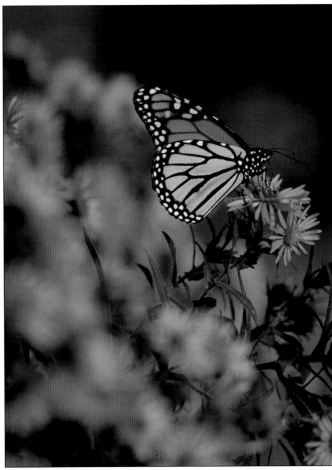

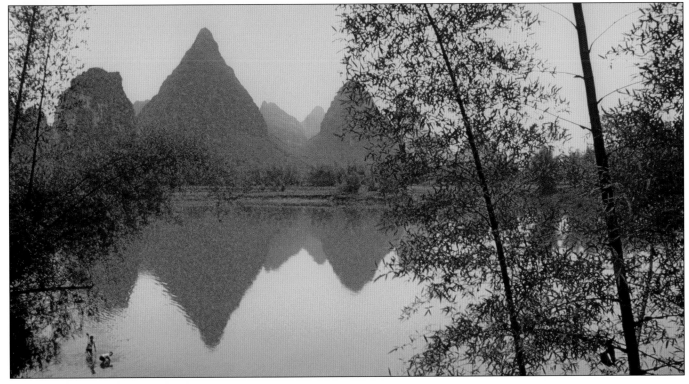

"Even the professionals sometimes forget this... "

Deliberate Control of Color Quality

Deliberate control of color has one of two objectives: balance everything for color neutrality, or bias control towards color effects.

Careful consideration must be given to the light source, film and processing, and even to evaluation of the results. Examination of color transparencies must take place under an accepted standard of illumination or it will have no practical value. Even the professionals sometimes forget this and make their color judgments under different light than used by the art director or the printer. For dependable and repeatable results one must be methodical, alert, and meticulous. Fortunately, today's color photographic materials are very dependable and one can feel reasonably confident that when a subtle change is applied, expected results will follow.

The next most important part of deliberate color control is to know and recognize the six photographic colors, even in very weak amounts. This is the basis for all color correction decisions. These can be reviewed in the first chapter of this book.

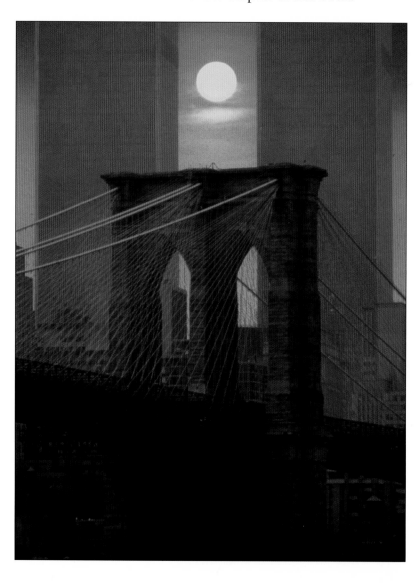

The Brooklyn Bridge at sunset turns flaming orange in the fading light. Does the coloration suggest a dynamic energy, or does this sandwich of two transparencies produce an intemperate lighting emotion?

Light and Photographic Materials

•**Color of Light Sources.** All light has a color neutrality bias. For sunlight and incandescent light, neutrality can be described in terms of color temperatures noted as degrees Kelvin (°K). The Kelvin scale of light runs from a very yellow-red (a few hundred K) to very blue (10,000°K plus). All color films are neutrally balanced for one of two Kelvin temperatures. Daylight type film is balanced to 5500°K and tungsten type film is balanced to 3200°K.

Daylight and electronic flash light have a color balance of 5500°K. Professional tungsten-halogen photographic lamps are 3200°K. Some low-voltage household and display lamps are also 3200°K. Of course all lighting doesn't conform to these two standards, but many common color reproduction deviations are so familiar that their off-color effects are acceptable in casual control situations. We accept candlelight or firelight to be "yellowish" in appearance, so we're not unhappy when film records it the same way. When very blue skylight makes shadows in the snow equally blue we don't mind that either because it seems natural.

"All light has a color neutrality bias."

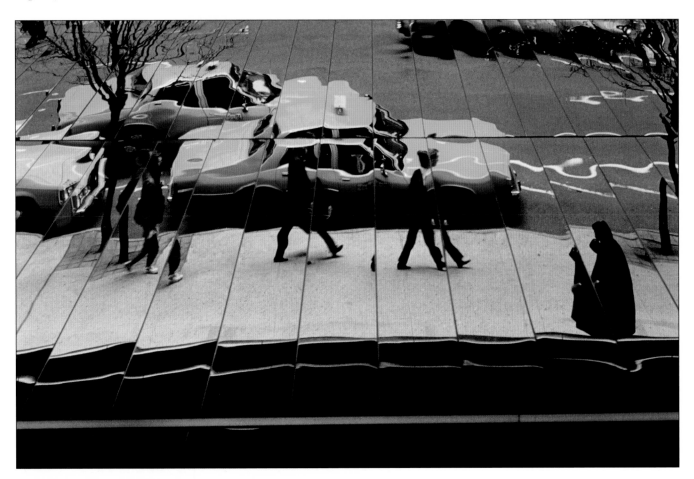

Even on a sunny day, New York's canyon-like streets are normally shaded. Such passive, flat illumination suits the mirrored image reflected by the canopy of a hotel entryway. The reflection is, of course, shown upside down.

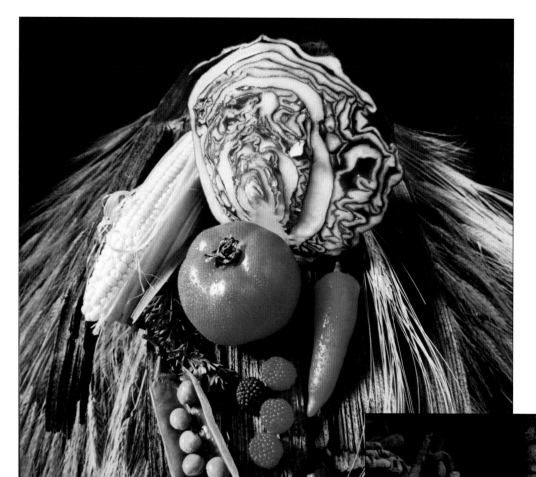

Complex subjects can appear confusing if the light and shade relationship is too busy. Simplicity usually works best. The textures of the vegetables, photographed with a fish-eye lens from inches away, could lose their design with uncontrolled, conflicting shadows from several lights.

Color does not have to be vivid to be significant. Don't be too quick to use "designer filters" and fail to record what may at first seem monochromatic and even dull. The moss greens of carved rock and woven sari at Elephant Caves near Bombay generate a cool elegance. Diffuse skylight from the cave's opening to the right helps reveal good form and texture.

There are times when deliberate color balance control is needed. We assume, for example, that household lighting is neutral, however its color temperature is several hundred K less than the 3200°K for which Tungsten Type color film is balanced. This can be corrected by using a Light Balancing (LB) filter over the camera lens. These filters are colored bluish and yellowish to compensate for specific shifts away from the two standards of 5500°K and 3200°K. The common set of ten LB filters consists of yellowish ones – 81, 81A through 81D and 81EF; and bluish ones – 82, 82A through 82C. These can compensate for a maximum total deviation of about 1000°K. By combining yellowish or bluish ones additional compensations can be achieved. The problem now is to determine which to use.

Our eyes are not able to detect color temperature shifts very well, but a color temperature meter can. It can read shifts in degrees Kelvin, or directly read necessary corrections in terms of Light Balancing filters. A color temperature meter bases its readings on the shift of color balance between "bluish" at one extreme and "yellowish" at the other. The set of ten LB filters will suffice for most color temperature shifts normally encountered. In addition, there are also two color conversion (CC) filters that convert daylight type color film to tungsten, and vice versa. The amber-colored 85B filter converts tungsten type to neutrality in 5500°K daylight; and the blue-colored 80A converts daylight type to neutrality in 3200°K tungsten. Keep in mind that all filters require exposure adjustments. Exact corrections are noted in Eastman Kodak's publication E-77, *KODAK Color Films and Papers for Professionals.* E-77's detailed explanations go beyond the scope of this book and they are essential for all serious use of color photographic materials.

Not all light sources contain a full complement of spectrum colors in smoothly differing amounts. Fluorescent lights and arc lights can be especially perverse. For these sources color temperature readings (°K) are irrelevant. The good news is that three-color meters have been developed. These read three color comparisons instead of just two (red to green as well as red to blue) and can provide reliable color correction information for daylight and tungsten, as well as discontinuous light sources such as fluorescent. These new meters are often referred to merely as color meters. Be careful on purchase, however. You'll want the more versatile three-color meter, not merely a color temperature meter.

It would seem from all this that there are a vast number of different color quality light sources to worry about. Fortunately, there are not that many in actual practice. One can balance to all the important ones with just a few filters and a little knowledge, and without necessarily needing a three-color light meter.

Using daylight or tungsten film in their corresponding types of illumination is the first major step. All professional lights, and electronic flash or daylight, are balanced to either 3200°K or 5500°K. This adequately adjusts for the vast majority of situations. Keep both 85B and 80A filters on hand when using one

"Not all light sources contain a full complement of spectrum colors in smoothly differing amounts."

"All color films have their own 'look' or feel in terms of color quality."

film type in the other's light. Once this simple match is made, any additional precision adjustments can be made with CC filters.

The other common artificial light source is fluorescent. Older fluorescent lights normally lack reds, and will photograph with a greenish cast unless there is suitable CC filter correction. The most common versions today are warm white, cool white, deluxe cool white and daylight. Cool white will record pleasantly on daylight type film with a CC30M (magenta) filter. Deluxe cool white has better color quality, and a CC10M or 10R filter usually works well. Daylight fluorescent lamps are awful for color photography; they are nowhere near actual daylight, and they require lots of correction.

Things are changing with fluorescent however. The Energy Policy Act of 1992 dictates that, as soon as practical, some existing fluorescents must be replaced with the new family of tri-phosphor fluorescent lamps. They will have Color Rendering Indexes (CRI) higher than 82 (full spectrum light is 100). This means they will look better. Still, they may not photograph better, because tri-phosphors show a degree of metamerism (the RGB portions of its spectrum are not smoothly connected). These new types will be designated as 3000°K, 3500°K and 4100°K. Deluxe cool white will still be around for some time, though, because it already has a CRI over 82.

I have found only two fluorescent lamps that give true, full-spectrum (photographic) 5500°K or 3200°K illumination. The Vita-Lite lamp has a 5500°K color balance and a CRI of 90; the Optima 32 lamp has a 3200°K balance and a CRI of 82. They are made by the Duro-Test Corp. The television and movie industries use fluorescent lamps more and more because good color is now available. They are cool (easy on air conditioning) and they consume much less electricity than tungsten. Other helpful innovations that have accelerated fluorescent lamp use are more efficient electronic ballasts that reduce flicker and hum, and compact fluorescent lamps with remote ballasts for convenient use in tight spaces.

•**Color Influence of Materials and Processes**. All color films have their own "look" or feel in terms of color quality. Pros exploit this by fitting films to their own styles. It makes a lot of sense to do so. The color complexities defy imitation, so why not take advantage of characteristics that can be so compelling?

One factor is to consider with film is repeatability. A color film may have a certain look but, if it doesn't easily occur again and again, it's a problem. Professional photographers take this aspect very seriously. Film manufacturers also spend great sums on data books for their films and processes. These publications are a bargain and they are wise investments for every serious photographer. Repeatability is a vital quality. If you pay a bit more to get it in your films, it's worth every penny.

Camera stores and photographers must do their part, too. Proper storage is essential to good repeatability. If in doubt about

future use, keep color film refrigerated at 55° or less. When you're on a trip, leave the exposed film in your hotel room where it's cooler. (If worried about hotel safety, consider soliciting help from the management.) The other tip is to buy one emulsion number of film, test a roll to assure its quality, and then store the bulk in a refrigerator or freezer until near the time you plan to use it. Repeatability will be assured.

Processing plays a vital role in repeatability too. Professionals often switch color labs when they feel processing has been allowed to deviate. My experience has been that carefully controlled chrome processing should stay within a tiny CC025 shift when comparisons are made within a few days of one another, and less than CC05 shift over longer periods. Today's color film and papers are much more likely to be neutral than in the past. A shift of CC05, or less, between different emulsion numbers of professional color products is today's standard.

Another aspect of color film quality that many professionals have begun to appreciate is that color negative film does not require color correction at the time of exposure. Color balance does not take place until the prints are made. Furthermore, the exposure latitude of color negative film is enormous, as long as there is sufficient exposure for good shadow detail. I have made excellent prints from Kodacolor negatives that were several stops over-exposed. Decisions about exposure and color balance can be deferred to the darkroom, making life much easier for those on location in unfamiliar lighting. Many photojournalists now expose on color negative, even if the photo is apt to be reproduced in B&W. Quality and sensitivity are not compromised

There is a curious reaction that many photographers have to neutral color balance. Many will readily accept the color interpretations of color slide film, yet be far more fussy about the balance of color prints. My own reaction is that, while I often fuss over a CC02 shift during color printing, a couple months later when looking at the same prints I'll wonder why. Given the leisure to carefully control color print balance, perhaps we all tend to over-do it. In the end, if shown two color balances, no matter how subtle, we tend to like "the one in the middle."

The Meaning of Color Neutrality

Color neutrality is achieved when the whites, grays and blacks in an image show no color influence. When this happens, all colors are seen in their best state of reproduction. Color neutrality provides a built-in reference point. This does not mean that all colors are "perfectly" reproduced. Photographs always interpret reality, they seldom duplicate it. This is not necessarily bad, since color photographs can be appealing precisely because of their inherent "look".

We often think of white as being pure white – until we make a direct comparison of the alternatives. Brighter lamps, for example, seem whiter. This is misleading because our eyes are fooling

"Processing plays a vital role in repeatability..."

"Sometimes an exacting color balance is not based on achieving an exact neutral."

us. Also, when viewing objects we know to be white under different illuminations we seldom note any color balance changes. It's only when we view color photos of them that we notice the color balance alterations. All lighting has a neutrality bias, and our eyes seldom recognize it.

How fussy do we have to be depends on the use of the photo. If it is meant to substitute for reality, we must be very fussy indeed. Advertising illustrators typically demand perfection to the most sensitive eye. A shift of CC02 density in any RGBCMY direction is the tolerance demanded. For normal use, when the photographic message conveys feelings and attitudes, the limit easily expands to CC10 for transparencies and CC05 for prints. Of course, artists may be much more demanding of themselves about this, but viewers will always be more tolerant because color is just one aspect of aesthetics.

Sometimes an exacting color balance is not based on achieving an exact neutral. For example, Japanese people prefer a pinkish skin balance, while Europeans prefer a slight yellow balance. Film manufacturers are aware of this and respond to it. Therefore, film bought in London may not sell in Tokyo. My own skin preference is toward pinkish, and I was very unhappy with results I once got with film bought in Hong Kong – a British Crown Colony. All subject matter exerts a special bias in our color preferences. Foliage looks better to me with a yellow shift, so the aforementioned film looked fine for landscapes. In the final analysis, we have to consider color neutrality in the context of the photo itself. If the visual message is clear, the color balance is correct.

You can review neutral color balance on page 17.

•**Color Measurement for Fussy Results.** In my experience, three-color meters can produce ±CC10 sensitivity when one has had practice with their use. When perfection is required, a test on the given emulsion number film has to be made and then carefully viewed on a standard viewer such as the Macbeth Proflite 5000, or the Graphiclite D5000, or another viewer that conforms to the ANSI (American National Standards Institute) standard PH2.30-1989. All printers, advertising agencies and professional photographic studios typically have such viewers in daily use.

Color Compensating (CC) Filters

These filters are available in optically perfect 0.1mm sheets in 75mm (3") and 100mm (4") square, or special sizes, from Eastman Kodak Co., or from professional camera houses like Calumet Photographic, Inc., or from large camera stores in most every city. The most commonly used and readily purchased size is 100mm square. There are other brands of CC filters too.

CC filters come in RGBCMY colors in densities of CC025, CC05, CC10, CC20, CC30, CC40 and CC50. For intermediate densities two or three can be sandwiched together without causing optical problems. A full set consists of 35 filters and represents

a substantial investment. My own experience has been that, carefully used, with each replaced into its own white card folder and envelope, they can last for years. Gelatin versions scratch easily, but most professional lens shades, or CC filter holders such as Nikon's, support them without damage. Some studio professionals, using a variety of large format lenses, will tape them on with black photographic tape. Again, with care, the gelatin CC filters will last for years. Calumet also offers CC filters in more durable (and less expensive) 0.1 mm thick polyester versions, or in more expensive 2mm thick resin form. You may prefer these versions instead.

A sandwich of two or three gelatin or polyester, 0.1mm thick CC filters will cause no image degradation, unless they are left unshaded and lens flare occurs. All professional lens shades permit easy insertion of gel CC filters. Some pros tape them inside view camera lenses to avoid flare. But again, be careful. Sloppily done, flare will occur anyway.

The first step in using CC filters is to know what they look like. A CC05G can look a lot like a CC05Y; cyan is different than blue; and so forth. The filters are labeled in the corner, but that's not the point. With no filter in hand, a skilled user should know what color shift is required. Sometimes the best balance is, for example, a color combination such as a CC05M and a CC10C. If you know your colors well, you'll arrive at such combined color solutions a lot more quickly.

The next step is to know what the filters actually do and how they interact. The following table of primary colors will help, and the same material can be reviewed in chapter one of this book.

> "With no filter in hand, a skilled user should know what color shift is required."

Cyan absorbs **Red**
Magenta absorbs **Green**
Yellow absorbs **Blue**

Red equals **Yellow plus Magenta***
Green equals **Yellow plus Cyan***
Blue equals **Cyan plus Magenta***

*in equal densities

Thus, for example, if a transparency looks too red, it can be corrected by using a proper density cyan filter over the lens. Additionally, a CC10B filter has the same effect as a sandwich of CC10C and CC10M.

How do we decide what to do in an actual situation? Let's assume your processed chrome viewed on an ANSI standard illuminator looks too yellowish. Now look at the chrome through one of the blue CC filters. Ignore very light areas and dark areas

"This is not a bad time for a cup of coffee."

and pay attention only to midtone areas that are neutral or close to it. You need to analyze midtones because the extremes of very light or very dark will cause you to use too little or too much color correction. This flies in the face of instinct. Even knowledgeable users must force their attention to the midtones only. Let's say that a CC10B looks better but not perfect. Try adding to it a CC05M, because in weak amounts green can look like yellow. Don't stare for long periods or your eyes will get fatigued. Flip the filters back and forth across your vision every few seconds. With this added refinement you may finally decide that a sandwich of CC10B plus a CC05M looks better than a pack of CC10B plus a CC05B. This, then, is what you'll use in front of the lens for achieving a color balance back toward neutral.

This is not a bad time for a cup of coffee. Come back to the illuminator again and see if you still agree with yourself. Don't be chagrined if a colleague thinks otherwise. You're trying for perfection, and we all have built-in color preferences. In my experience, it's very easy to get tied in knots over color balance minutiae. When tiny corrections seem the answer, I prefer to make no correction at all.

The CC filter logic noted above applies to positive color transparencies. What we see on the transparency viewer is what we get. When making color prints from negatives, color shift corrections are achieved by adding the offending color to the filter pack, instead of removing it. Furthermore, because of a built-in manufacturing bias to color paper, only combinations of yellow and magenta are needed, even though cyan is always an option on color enlargers. Printing color negatives is a separate topic, best explored by using Kodak's R-19 *Color Darkroom Dataguide*. But the color print corrections are still determined by analyzing color prints with a complete set of CC filters or equivalent color viewing filters.

CC filters and complimentary colors may be viewed on page 19.

Color Effects

•**Local and Collective Roles of Color Effects.** Sometimes a scene suggests an overall color effect, other times only parts of the scene might be affected. There are literally hundreds of camera filters manufactured to produce various effects. Tiffen and Cokin are two of the biggest manufacturers, but most camera manufacturers have their own sets too. Camera filters work best with single-lens reflex cameras because you can see the precise effect at the instant of exposure.

The local role can also be accommodated using filters over lights. A major supplier is Rosco Laboratories, Inc., which manufactures motion picture and theatrical lighting products. When using multiple source lighting, even small local colorations can be profoundly effective. Of course, coloring is easy to overdo because film naturally increases effects. Filters are often used over

lights in photographic light-painting techniques. Small areas can sometimes tolerate considerable color alteration while still retaining an overall look of neutrality in the photograph. This is an interesting pictorial avenue to explore, one that photographers have, until now, seldom considered.

•**"Odd" Color Films and Processes.** Infrared color film records illumination our eyes can't see. Red and orange filters are needed to remove the compromising blue and UV wavelengths. Such film and filter combinations make natural foliage look red, for example. Other possibilities include using duplicating films in the camera, or processing color negative film as a positive, and so on. Processing alterations are also limitless, as are "posterized" effects with photolith films and color filters, or manipulations with electronic digital image enhancement procedures.

ADDITIONAL CONTROL: MODIFIERS

Anything that interrupts or reflects light causes modification. Mirrors and lenses precisely change its direction or concentrate its beam. Reflectors, diffusers and filters intensify, scatter, color or diminish light in some way or other. Modifiers can also create effects that are entertaining and fascinating. These few examples readily suggest many light modifications that we have all experienced. In addition, photographic processing further exerts its own changes. Digital enhancement allows for many more.

•**Simple Light Modifiers.** Too often we all overlook the most obvious tools because they are right under our noses. Household cut glass is such an example. Many studio photographers I know have a bin full of glass pieces, as well as metal screens, knick-knacks, doily cutouts and just plain junk to place in front of specular lights to cast interesting light modulations onto a set. There is no formula or rule. Just pick something up and observe the result. If not quite right, whip out your scissors or slap on some black tape. Sometimes a silly looking artifact gets used again and again in differing twists or orientations because its light modification property proves to have high versatility. Trying out simple modifiers is a standard bread and butter lighting exercise for studio photographers attempting to make small, plain objects appear more interesting for catalogs or advertising illustration.

Charles Purvis, a talented photographer in upstate New York, even places simple light modifiers inside his view camera. He then frequently makes additional exposures on the same film in other view cameras on other small sets, working intuitively with Polaroid instant film, until an overall abstracted montage is created. Once satisfied, he exposes a few transparencies at bracketing exposures and strikes the sets. This is no discipline for the timid or the uptight, but it is a rich visual resource for photographic improvisations.

"Small areas can sometimes tolerate considerable color alteration..."

The key to a glowing portrait that jumps off the wall is to use a lighting modifier that restrains extraneous, lighter tones. Here, a vignette mask was placed inside a tight-shading lens hood. The effect was observed at a small aperture, but the photo was made at a large one to avoid any abrupt tonal changes. Properly done, extraneous brightness can be subdued without drawing attention to itself, a subtlety seldom as well achieved when making a print.

•Manufactured Light Modifiers. Many light modification devices can easily be manufactured at home.

Black-cloth flags are opaque and used to block light. They can have dimensions up to several feet but their light weight permits easy support.

Scrims are made of a stiff, black, cheesecloth-type material stretched across a U-shaped, stiff wire yoke. They usually come in single and double weaves and are used to subtly diminish illumination. Unless the light source is extremely specular the scrim's shading effects blend off seamlessly.

A Cucoloris, or cookie, is a doily cut-out plywood panel that, when hung in front of a specular light, casts abstract shadow patterns onto the set or background much like foliage does in sunshine. This creates a sort of lighting "atmosphere" for visual interest.

Diffusers can act like scrims to reduce illumination intensity, or they can be used to convert small specular light sources into a large diffuse ones. In the latter capacity, color neutrality of the fabric is important. Silks are less diffusing and more expensive, but their durability, strength and lighter weight make them especially attractive in the movie industry for reducing contrast on very large outdoor, sunny sets. The effect is like soft sunshine through a hazy overcast, a much more pleasant condition for actors than confronting blazing fill-spots or metal foil reflectors.

Reflectors must be neutral and maintain their whiteness. Special pigment white paints (such as titanium white) are normally used. Crumpled aluminum foil reflectors break up bounced specular light into indefinable patterns but in sunshine they can be so blinding that few people can tolerate the punishment. Foil reflectors are used instead to obtain greater reflective fill when using diffuse sources like lightbanks, or to add sparkle on overcast days.

•Studio Stands. Professional photographers and cinematographers routinely use articulated arm studio stands to adroitly hold light modifiers such as black-cloth flags, scrims, cookies, diffusers, silks, white and crumple-foil reflectors, and of course, floods, spots, and lightbanks too. To avoid tipping, so that their arms can be extended safely far out over photographic sets, studio stands are normally weighted at the base with durable 15 lb. floppy sandbags. Professional photographers often use a forest of these handy stands on their sets. Of note, two can efficiently support each end of a huge lightbank or a 9' roll of seamless background paper. This is a more conveniently adjustable option than permanently rigging either of them from the ceiling.

In my experience, the two major makers of articulated professional stands and accessories are Matthews Studio Equipment Co., and Mole-Richardson Co.. (Mole-Richardson also makes a huge variety of lighting equipment, power devices and specialty tools primarily for the motion picture and TV industries. Their catalog is a "must" lighting resource book for professional light technicians and grips.)

"Professional photographers often use a forest of these handy stands on their sets."

"Some are designed to produce a hot-spot in the center of the illumination..."

•**Lamp Reflectors.** Lamp reflectors are designed to modify the lamp's light, and this can be a science unto itself. Many are curved to geometric shapes specially designed to precisely fit an exact lamp filament's configuration. The reflecting surfaces can be carefully polished and the most efficient will reflect well over 90% of a given lamp's illumination. Other reflectors are formulated to provide a very even spread of light. Some are designed to produce a hot-spot in the center of the illumination, and some are primarily intended to reduce reflectance of infrared heat from the lamp, while others are small and intended mostly for lamp protection and only modest reflection. Know which of those that fit your equipment are the most efficient and which are the ones that give the most even spread of light. Also be aware which reflectors have hot-spots because these reflectors are especially handy tools for the application of feathering techniques.

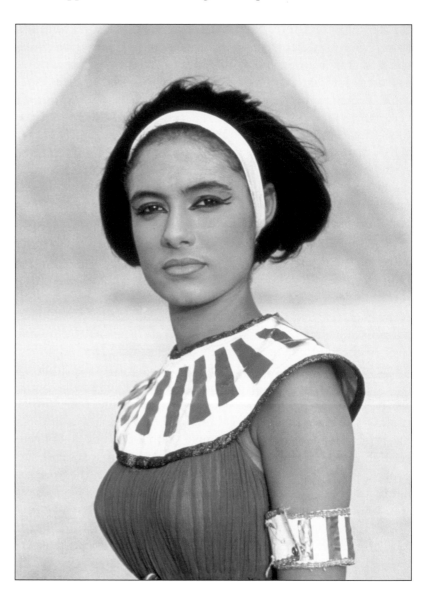

At the Pyramids, just before sunset, diffuse skylight and weak sunshine combine to create lovely lighting. The young lady's costume is agreeably lit by a natural combination of of weak sunshine, and relatively strong, late-day sunlight. Could this same effect be achieved using artificial light? What kinds of lighting sources and modifiers would be required?

•**Spotlights.** This commonly used light source demands special mention because its very design causes it to be used primarily as a lighting modifier and only secondarily for general illumination.

A spotlight consists of a tubular metal housing containing a movable lamp and reflector assembly. The light is directed out through a pyrex-glass fresnel lens. Normally a control mechanism permits the lamp and reflector assembly to be moved back and forth relative to the fresnel lens. This allows the light beam to be concentrated or widened. Some spots have their lamp reflector specially designed to more efficiently focus the lamp's light through the fresnel lens. These are referred to as ellipsoidal spots.

Standard photographic studio spots normally use a tungsten-halogen lamp. Theatrical and motion picture spots commonly use a carbon arc instead for its much greater brightness. Often the arcs are 5500°K, specially formulated for mixing with daylight. When a spot gets to be two feet in diameter it begins to exhibit diffuse characteristics, even without interjecting a larger diffusion screen. Spots this large cause relatively softer edged shadows and can be handy for controlling fill light outdoors.

Until a few years ago electronic flash spots were not generally available but now electronic flash users may wonder how they ever got along without them. In my own experience I often combined flash with daylight-filtered tungsten spots because it was the only lighting option for certain subjects. Now electronic flash spots are readily available. However, it should be noted that electronic flash spotlights photograph differently than their modeling lamp's visual effects. This is because the flashtube and modeling lamp are much different in size and shape. When using an electronic flash spotlight under demanding circumstances, Polaroid instant film tests are essential to note the exact effects.

•**Light Beam Restrainers.** There are many accessories that can restrain, modify, or somehow direct a beam of light. Many of these have already been discussed in this chapter in the section on brightness control.

There is an interesting restraining tool made for the Calumet electronic flash system. It fits over almost any round 15" reflector and consists of circular, diffuse plastic with a central opening. The "doughnut hole" can be left open, or it can be filled with various modifying devices such as a colored gel, honeycomb grid or other kinds of light modifiers. For example, with a 30° grid in the center hole the illumination effect is a central pool of brightness surrounded by somewhat dimmer and diffused light, much like a large lamp reflector having a vivid hot spot.

•**Optical Devices and Light Beam Modifiers.** Optical projector attachments for spotlights provide precision optical masking as well as the capacity to cast all kinds of imagery from silhouette cut-outs to photographic transparencies. Many of these projector attachments have adjustable internal masks for quick and easy precision masking.

"... its very design causes it to be used primarily as a lighting modifier."

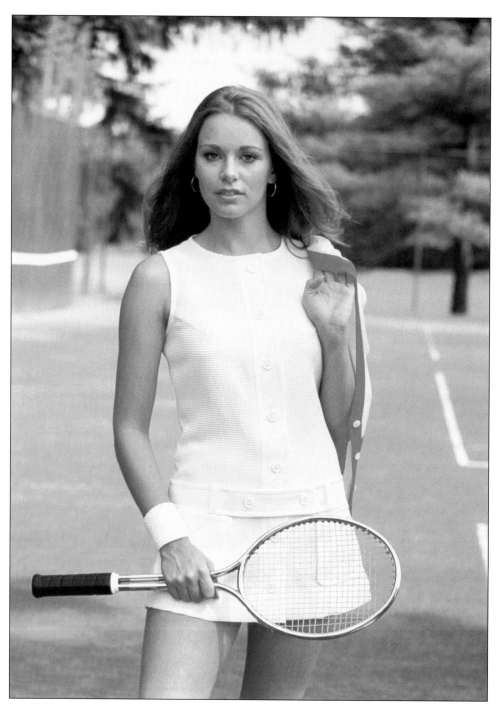

Each of the portraits (above and on the facing page) contains similar subject matter, a young woman in a white dress. How does the lighting effect vary from one photo to the other? Examine the light qualities in each image and try to evaluate their role. How does

direction quality vary? Is the lighting specular? Diffuse? A combination? How does the brightness quality change from the image on the left to the one on the right? What brightness key is each image? What about contrast?

Projecting a photograph permits easy simulation of realistic backgrounds. Projecting abstract silhouette patterns enables one to fragment the visual character of objects or human figures into abstract patterns, to precisely introduce apparently natural lighting effects, or to add atmospheric light modulations.

Rosco makes over 300 perforated metal, doily-pattern 6" diameter disks to cast patterns such as foliage, pane glass windows, clouds, stars, lightning, abstractions, etc. You can also use your own slides to create a realistic projected background. The options are enormous. Balcar and Speedotron both make electronic flash optical spotlights. An ordinary slide projector can be a very useful specialty lighting tool. Many commercial lighting manufacturers make small optical spots for display purposes. (Of interest, a mounted color print carefully lit with no spillover of light onto the wall, will look exactly like a transparency. The illusion can be so effective that one cannot detect its origin until the light beam is interrupted with a shadow from one's hand.)

"Projecting a photograph permits easy simulation of realistic backgrounds."

The special effects background of these toy animals boarding Noah's ark was created by sandwiching two negatives. One negative was an image of the toys, the other was a negative of the lightning at night. This produces a realistic, natural-looking effect with pictorial precision. Could the same effect have been achieved using a projected image of lightning on the background of an indoor studio set?

•**Painting with Light**. The most interesting new studio lighting technique is painting with light. The earliest dynamics were explored by photographer Aaron Jones who subsequently developed a whole line of lighting tools, under the name Hosemaster. There are now other equipment suppliers too.

As noted in *Photo District News*, Nov. 1991: "No matter what the 'system' being used, the basics remain the same: the effect is created through multiple exposures of a subject using 'swipes' of light to highlight certain features." This describes the technique in a nutshell but the implications go far beyond. Painting with light permits lighting manipulation that brings photography and painting much closer together. Painters for centuries have explored the visual fascination of photographic-like *trompe l'oeil*, where their painstaking illusion strives to create the sense of literal reality. Now photographers can consider pushing local lighting control methods towards those used in painting. These photographic lighting techniques are no less painstaking, and that's part of the charm; when done to perfection they are deliciously self-evident, and beguiling at the same time.

To find out whether this technique appeals to you, I'd suggest practicing with a simple flashlight. During the long time-exposures wear dark clothing. You may even want a dark ski mask and gloves if the environment has a fair amount of ambient light. An audible metronome is handy but I'd suggest using negative film anyway so over-exposure is not a concern. Experience will quickly open up the possibilities. Try lighting people as well as still-lifes. Capricious movement in a photo adds its own visual dynamic. Movement of light through space fascinates, as probably all of us have experienced when waving a sparkler on the Fourth of July. This option can be added to the others when painting with light.

Specialized light painting tools employ fiber optics so the light can be "carried" right into the set. At least one brand is powered with a Ni-cad battery for portability. Of course, in order to mask its presence the device should not be accidentally aimed into the camera lens. Some devices use tungsten light and others employ pulses of electronic flash. There are color balance and exposure control concerns with each, but a photographer familiar with handling the six qualities of light can handle either option. The decision should rest on perceived use, convenience and cost.

The effects of painting with light can go well beyond mere corrective measures. Conceivably, one could apply point-by-point painting techniques to produce an entire photographic image and still remain within the broad analog discipline of photography instead of painting. While this may not be fully practical, the visual potentials are unique nevertheless.

"Experience will quickly open up the possibilties."

"... light ratio control is especially important when using a digital camera."

•**Three Dimensional Light Control,** also developed by Aaron Jones, is a combination lighting/optical control called the Turbofilter. This device synchronizes three separate electronic flash-triggering connections to three variations of optical diffusion.

A wheel with three wedge openings (one clear and the other two with moderate and greater optical diffusion) is placed in front of the camera lens. As the wheel rotates, each segment is synched to a separate electronic flash trigger. The whole sequence is so rapid most observers sense it as one flash. Each of the three lighting set-ups is optically diffused in different ways, resulting in a photograph that has a specific area of sharpness bracketed in front and back by varying degrees of unsharpness. The effect is even more definitive than the shallow depth of field achieved with a long focal length lens at maximum aperture. Additionally, the lighting is modified too — some may see it is "dream-like" and others may describe it as "atmospheric."

This technique may be more than a fad because there are obviously many other combinations of lighting control, timing and optical modifications that can be applied to the system. Think of the procedure as a rapid timing control for multiple lighting with each segment capable of being modified in many different ways; for example, by color as well as diffusion.

Digital and Electronic Techniques

•**Lighting for Digital Camera Photography.** This book discusses lighting mostly in terms of photographic film which is analog (continuous) and seamless. Knowledgeable photographers know that film's tonal response can be plotted as a characteristic S-curve, because film compresses tonal reproduction in both the shadows and highlights of contrasty scenes. These restraints enable film to easily and smoothly interpret even extreme tonal reality, albeit at the expense of overall accuracy. Digital photography is different, and light ratio control is especially important when using a digital camera.

Digital camera's tonal response is a straight line with no compression in either the shadows or the highlights. Contrast can become excessive because digital photography lacks the tonal restraints of film's S-curve response. For example, a digital camera can accurately record tones in the shadows and midtones but quickly begin to "blow out" the highlights. If exposure is biased toward the lighter tones, shadows quickly slip into solid black. Digital camera images tend to have much more contrast than we expect with film. Digital's reproduction also tends to "fracture" into pictorial anomalies at the tonal extremes. To some extent this can be compensated for when the camera's digital data is transferred to the computer imaging program, but avoidance in the first place is important for high volume, high quality situations such as catalog and advertising photography.

The proper lighting solution for retaining good detail throughout a scene's tonal range is to expose for the lightest tones in which good detail is needed and then add enough light into the shadows so that detail doesn't disappear. A light ratio of 3:1 or less is normally necessary, and even much lower if the subject itself contains both important dark and light tones.

Digital cameras are evolving at a fast pace. Specific concerns about lighting control must be carefully addressed through each digital camera's technical manual. Nevertheless, light ratio control remains especially important because it's the most efficient way to fully capture all the visual information a given subject or scene has to offer.

•**Electronic Manipulation and Imaging.** Electronic post production modification is so powerful a tool that its light modification potentials must be examined further.

There are three stages involved. Images are digitally scanned from film, manipulated with image enhancement software, and finally transferred to an out-put device. This could be a plain-paper color copier, a digital printer for thermal-color prints or prints on silver halide paper. Data can also be used to make press-ready, graphic arts CMYK separation films and can even be transferred back again to photographic film as a modified original. Professional photographers and art directors often prefer the last

> "...it's the most efficient way to fully capture all the visual information."

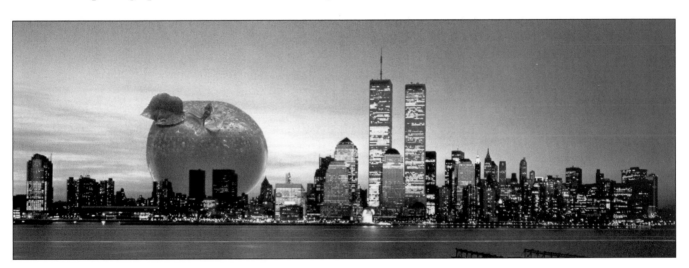

possibility because scan-outs to color transparency film are better for art direction approvals. Digital conversion is also ideal for making CMYK plates for printing and publishing. The color in this book was done that way. Scans can also be made to color negative film, permitting conventional color printing and enlarging. This appeals to photographers who like to make their own exhibition prints. The highest resolution digital output scans to color film are so good they qualify as true duplicate-originals, indistinguishable from any other high quality conventional camera film images. Most professional photographic printing firms in your city will offer the output services.

While a triple exposure worked well to record the sunset, the glow of sunset of building facades, and the city light, digital manipulation was the best tool to blend the apple into this image.

"...you're never stuck with what's been shot, and you can modify annoying mistakes."

Electronic digital technology now puts painter's techniques for image adjustments into the busy fingers of many photographers. The potential is so awesome that knowledgeable professionals are scrambling to buy and use electronic digital technology that just a few years ago was beyond the financial reach of all but large corporations. Many professional organizations and educational institutions also offer workshops and seminars on the most up-to-date electronic equipment.

The most remarkable thing about all this is not the image manipulation potential, but the precision that literally produces second generation original-duplicates. This means you're never stuck with what's been shot, and you can modify annoying mistakes.

If electronic correction is so unlimited, why bother struggling with lighting? One answer is that today's photographic films easily and instantly capture the most complex reality with amazingly beautiful results. More importantly, the real world is analog and contains a limitless file of visual information, with unexpected anomalies that defy invention. Conventional film reduces that file, of course, but photography's file is still capable of incredible enlargement before the data begins to break up and fade away. Digital imaging is amazing only as long as its enlargement remains relatively modest. Once digital files are enlarged, they quickly break up. Even ten dollar single-use cameras with film can easily outperform the same format size digital cameras costing a hundred times more. Digital is here to stay, and it is incredible, but the real world is more amazing still, and control of lighting at the source remains the place for all imaging to begin.

Digital imaging, therefore, should not be seen as a replacement but rather as a wonderful facilitator. Giant movie images, such as those in IMAX theaters, for instance, are possible only because film can record an incredible amount of detailed information per square inch, and film's gigantic range of tones permits brilliant projection to awesome dimensions. Digital imaging gives us more choices and tools, but it can't replace conventional photography.

GLOSSARY

A

Active Illumination adds its own emotional overtones to the scene. This dynamic influence should be used with restraint and requires good control and keen awareness to be effective. (See also *Passive Illumination*.)

Angle of Incidence equals Angle of Reflectance This is a fundamental law of physics and helps define the direction quality of light.

Additive Colors are employed when light itself is used to create full color images. Red, green and blue (RGB) are additive primary colors.

Ambient Light is environmentally reflected illumination with no direction quality and no light and shade effect. It should not be confused with available light which can have strong direction and contrast qualities.

Available Light is any existing illumination that is not controlled or manipulated by the photographer. (See also *Controlled Light*.)

B

Background Light illuminates the background. This secondary lighting heightens the perception of depth between the background and the subject.

Black is the maximum presence of CMY dyes, or the complete absence of RGB light.

Brightness Key describes the preponderance of similar tones in the photograph. Most photographs have a roughly even mixture of tones. (See *High Brightness Key, Low Brightness Key*.)

Brightness Quality (collective, local) of light is a comparative quality and can be altered photographically even after exposure. Collective brightness involves all the tones in the scene, local brightness involves just some of the tones in the scene.

C

CMY Colors are subtractive primary colors which are used when images are created with dyes and inks. Light has to be shined on or through these images for them to be seen. Maximum presence of CMY dyes produce black, complete absence produces white. Unequal mixtures produce all other non-primary colors.

Color Compensating (CC) Filters are made in all six primary colors and are used to create precision color neutrality when exposing films or making prints. Color enlargers have systems with the same color neutrality logic, but normally employ only the CMY set of colors.

Color Effects (natural and artificial) involve any deviation from neutrality to achieve a visual effect. Color effects may be natural (such as the rosy reflection of a lake at sunset), or artificial (such as those achieved by the use of color filters).

Color Meters come in two varieties. Color temperature meters give one reading that measures the balance between "warm" and "cool" coloration (see *Color Temperature*). With many types of light, this is not sufficient. Three-color meters provide better information, giving a red-blue comparison and a red-green comparison.

Color Neutrality (See *Neutral Color Balance.*)

Color Quality of light is a comparative quality and can be altered photographically even after exposure.

Color Temperature is a numerical description of the color of light when a black body is heated to incandescence. The heat is measured in degrees Kelvin (K), a low temperature looking redder, and a high temperature looking bluer.

Comparative Qualities of light are brightness, contrast and color. These can be both named and measured, and can be altered even after exposure. They remain changeable until the photographer decides to stop manipulating them.

Complementary Colors neutralize each other to create grey. Knowledge of complementary colors is needed to correct color imbalances.

Contrast Quality (total, local) of light is the difference, or rate of change, between the various brightnesses of light and shade. It is a comparative quality and can be altered after exposure. Total contrast encompasses the overall range of tones in a scene. Local contrast describes only adjacent tonal changes. Increasing total contrast may wipe out good local contrast.

Controlled Light is any illumination manipulated or created by the photographer. This is useful for advertising, cinematography, and commercial photography where controlled lighting helps to achieve specific, planned, effects.

Cookie (also called Cuculoris) is a plywood panel cut to look like a doily. When hung in front of a specular light, it casts abstract shadow patterns.

D

Diffuse Quality of light is a formative quality of light and cannot be changed after exposure. Diffuse light emanates from a large area and scatters widely, producing soft-edged shadows. (See also *Diffuse Surfaces* and *Diffuse-Specular Progression*.)

Diffuse-Specular Progression refers to the alteration of specular and diffuse light qualities by the changing of the relative size of the source. Diffuse sources become somewhat more specular as their distance from the subject increases. Specular sources become somewhat more diffuse as they move nearer the subject.

Diffuse Surfaces scatter light in all directions. Most rough, dry surfaces are diffuse.

Diffusers act to reduce illumination intensity, or to convert small specular sources into diffuse ones.

Direction Quality of light is a formative quality and cannot be altered after exposure. Direction quality controls the formation of shadows which place visual emphasis on texture, form and space. Direction quality can also influence perception of the other five light qualities.

E

Edge Lights add brightness to the edges of objects and enhance separation from the background. The hair light (top light) is a common edge light in portraiture.

Electronic Flash is balanced to daylight (5500°K), extremely dependable in brightness and color, and easily portable. Flash duration is quick enough to stop action, and varies inversely with the electric power used.

Existing Light is any lighting environment that is not directly controlled by the photographer. It can be natural or artifical, and may or may not be adequate, in a technical sense.

F

Feathering involves aiming a lighting source. It is a technique that takes advantage of the normally uneven light created by lamps in reflectors.

Fill Light lights shadows in a scene that would otherwise be rendered too dark.

Filters (See *Color Compensating Filters, Light Balancing Filters.*)

Flash (See *Electronic Flash.*)

Fluorescent Light is an artificial light source with a discontinuous color spectrum that is normally not neutral to color film. Color correction can be determined with a tri-color meter.

Foam-Core Panels, white or silvered, 4'x8', are useful to create ambient light for filling in shadows. (See also *Ambient Light.*)

Formative Qualities of light are diffuse, specular and direction. These remain fixed once the exposure is made. Decisions about these qualities must be made at the time of exposure.

H

Hair Light (See *Edge Light.*)

High Brightness Key describes a photograph with mostly light tones. High key photographs tend to seem bright, fresh and happy. (See also *Low Brightness Key.*)

Honeycombs can be used to restrict the unwanted spread of light from a large lightbank.

I

Infrared Color Film records light our eyes can't see. Red and orange filters are needed to remove the compromising blue and UV wavelengths.

K

Kelvin Temperature (°K) describes the redness or blueness of a "black body" heated to incandescence, and is useful for describing continuous light sources (sun, candle, electric filament lamp, etc.). It is not valuable for describing discontinuous sources (like fluorescent or arc lamps). Daylight films are balanced to 5500°K, Tungsten are balanced to 3200°K

Key Light establishes the primary light and shade relationship in an image. It can be diffuse or specular in quality. There can be more than one if the scene contain significant separate areas of interest.

L

Light Balancing (LB) Filters permit adjustments to neutral when the source has a continuous spectrum, such as sunlight or incandescent lamps.

Light Banks are enclosed, collapsible fabric lighting devices in which one or several light sources are placed. One side is made of tightly woven translucent fabric that totally diffuses the light source within, making it appear to be a smooth pane of even light. The degee of diffuseness is determined by the lightbank size.

Light Meters are of two basic types. Incident meters measure the light that falls on them and give exposure ratings based on an assumed average reflectivity of 18%. Reflected meters read the average of all the reflections they can see.

Light Ratio is the measurement of the brightness difference between light and shade. It is stated as a ratio (such as 2:1), or as the difference in *f*-stops between readings.

Low Brightness Key describes a photograph with mostly dark tones. Low key photographs tend to seem dark, profound and mysterious.

M

Magic Time occurs late or early in the day when specular sunshine and diffuse sky light are of a relatively equivalent intesity.

Modifiers interrupt, control or reflect light. (See also *Scrims, Cookies, Diffusers, Reflectors.*)

N

Natural Light comes from the sun; it comes from above and is singular. When we see two light and shade relationships, lighting looks unnatural. Simulating natural light requires great care. Even casual viewers are not easily fooled.

Neutral Color Balance is a lack of coloration in neutral tones (grays, and black or white). When this occurs, all colors in the photo are accepted to be accurate.

Non-Directional Light Sources are so big that their light emanates more or less equally from all directions. Ambient light is a non-directional light source. (See also *Ambient Light*.)

P

Pan reflectors increase diffuseness significantly and create very even illumination.

Passive Illumination does not draw attention to itself and does not add any emotional overtone to the photograph. (See also *Active Illumination*.)

Point source is a specular source of light which creates sharp-edged shadows even when cast great distances. These are the tiniest sources of light. Examples are a lamp filament in a clear bulb, a steady candle, a zirconium arc, or a bare arc light.

Primary Colors for photography are Red, Green, Blue (RGB) and Cyan, Magenta, Yellow (CMY). RGB are additive colors, while CMY are subtractive colors. (See *Subtractive Colors* and *Additive Colors*.) Unequal mixtures of either set produce all other non-primary colors. (See also *Black* and *White*.)

R

Reflectors modify light by reflecting it. A mirror reflects light almost toally, in a very specific direction; a flat, white surface reflects only some light, scattering it in all directions.

Reflector Sources are typically about 6" to 24" wide. Most lamps are placed in reflectors for greater brightness efficiency. Reflector design also modifies light.

RGB Colors are additive primary colors employed when light itself is used to create images (for example, on a color television). Unequal mixtures of RGB produce all other non-primary colors. (See also *Black* and *White*.)

S

Scrims are devices constructed of a stiff, black cheesecloth-like material stretched across a wire frame. These enable subtle brightness reductions.

Shaders are panels or cards used to remove light from some part of a scene.

Shadows are areas which do not receive direct illumination from the light source. Shadows add texture and dimension to an image. Specular light causes sharp-edged shadows, diffuse light causes soft-edged shadows.

Specular Light is a formative quality and cannot be changed after exposure. This light is very concentrated and emanates from a relatively small point or travels in a narrow beam, creating sharp-edged shadows. Specular is not the same as brightness. (See also *Brightness, Specular Surfaces* and *Diffuse-Specular Progression.*)

Specular Surfaces make diffuse light more specular because they mirror the light in a specific direction. Glass and chromed metal are specular surfaces, as are wet and oily surfaces. The more perfect the surface, the more exact the reflection.

Spotlights are optical devices that cast very concentrated beams of light that will precisely illuminate a given area, even at great distances.

Subtractive Colors are employed when dyes and inks are used to produce an image. The subtractive primary colors are Cyan, Magenta and Yellow (CMY).

Surface (See *Specular Surfaces* and *Diffuse Surfaces.*)

T

Tungsten-Halogen Lamps are highly efficient, long-lasting, filament lamps that typically deliver light at 3200°K. For exacting color quality, they must also be operated under controlled voltage, typically 110V.

U

Umbrellas increase diffuseness by providing a much larger reflecting surface than the light source itself. Umbrellas are more portable than lightbanks or pan reflectors.

W

White is the complete absence of CMY dyes, or the maximum presence of RGB light.

Index

Other Books from Amherst Media, Inc.

Basic 35mm Photo Guide
Craig Alesse

Great for beginning photographers! Designed to teach 35mm basics step-by-step — completely illustrated. Features the latest cameras. Includes: 35mm automatic and semi-automatic cameras, camera handling, *f*-stops, shutter speeds, and more! $12.95 list, 9x8, 112p, 178 photos, order no. 1051.

Profitable Portrait Photography
Roger Berg

Covers techniques integral to running a profitable portrait business. Features lighting, posing, and digital photography, as well as marketing, pricing, and boosting your business! $29.95, 8½x11, 104p, Berg, order no. 1570.

Black & White Portrait Photography
Helen Boursier

Learn to control lighting, props and setting to create superior B&W portraits and make money! Features top B&W professionals, B&W weddings, business portraits and special effects. $29.95 list, 8½x11, 128p, Boursier, order no. 1626.

Achieving the Ultimate Image
Ernst Wildi

World renowned photographer Ernst Wildi teaches you to optimize your use of film, lenses, metering, flash, filters and special camera features. Also covered are composition, soft focus and the Zone System. $29.95 list, 8½x11, 128p, Wildi, order no. 1628 .

Infrared Photography Handbook
Laurie White

Covers black and white infrared photography, focus, lenses, film loading, film speed rating, heat sensitivity, batch testing, paper stocks, and filters. Black & white photos illustrate how IR film reacts in portrait, landscape, and architectural photography. $24.95 list, 8½x11, 104p, 50 b&w photos, charts & diagrams, order no. 1419.

Build Your Own Home Darkroom
Lista Duren & Will McDonald

This classic book shows how to build a high quality, inexpensive darkroom in your basement, spare room, or almost anywhere. Information on: darkroom design, woodworking, tools, and more! $17.95 list, 8½x11, 160p, order no. 1092.

Into Your Darkroom Step-by-Step
Dennis P. Curtin

The ideal beginning darkroom guide. Easy to follow and fully illustrated each step of the way. Information on: equipment you'll need, set-up, making proof sheets and much more! $17.95 list, 8½x11, 90p, hundreds of photos, order no. 1093.

Wedding Photographer's Handbook
Robert and Sheila Hurth

The complete step-by-step guide to succeeding in the exciting and profitable world of wedding photography. Packed with shooting tips, equipment lists, must-get photo lists, business strategies, and much more! $24.95 list, 8½x11, 176p, index, b&w and color photos, diagrams, order no. 1485.

Lighting for People Photography

Stephen Crain

The complete guide to lighting. Includes: set-ups, equipment information, how to control strobe and natural lighting, and much more! Features diagrams, illustrations, and exercises for practicing the lighting techniques discussed in each chapter. $29.95 list, 8½x11, 112p, b&w and color photos, glossary, index, order no. 1296.

Camera Maintenance & Repair

Thomas Tomosy

A step-by-step, fully illustrated guide by a master camera repair technician. Sections include: testing camera functions, general maintenance, basic tools needed and where to get them, basic repairs for accessories, camera electronics, plus "quick tips" for maintenance and more! $24.95 list, 8½x11, 176p, order no. 1158.

Camera Maintenance & Repair Book 2

Thomas Tomosy

Build on the basics covered in the first book, with advanced troubleshooting and repair. Includes; mechanical and electronic SLRs, zoom lenses, medium format cameras, troubleshooting, repairing plastic and metal parts, and more. Features models not included in the first book. $29.95 list, 8½x11, 176p, 150+ photos, charts, tables, appendices, index, glossary, order no. 1558.

Big Bucks Selling Your Photography

Cliff Hollenbeck

A complete photo business package for all photographers. Includes secrets to making big bucks, starting up, getting paid the right price, and creating successful portfolios! Features setting financial, marketing and creative goals. This book will help to organize business planning, bookkeeping, and taxes. $15.95 list, 6x9, 336p, order no. 1177.

Great Travel Photography

Cliff and Nancy Hollenbeck

You can learn how to capture great travel photographs from the Travel Photographer of the Year! This volume includes many helpful travel and safety tips, equipment checklists, and much more! Packed full of photographic examples from all over the world! Part of Amherst Media's Photo-Imaging Series. $15.95 list, 7x10, 112p, b&w and color photos, index, glossary, appendices, order no. 1494.

Telephoto Lens Photography

Rob Sheppard

This is the complete guide for telephoto lenses! This book shows you how to take great wildlife photos, as well as portraits, sports and action shots, travel pics, and much more! Features over 100 photographic examples. $17.95 list, 8½x11, 112p, b&w and color photos, index, glossary, appendices, order no. 1606.

Restoring Classic & Collectible Cameras

Thomas Tomosy

A must for camera buffs and collectors! Clear, step-by-step instructions teach you how to restore a classic or vintage pre-1945 camera. Includes information on leather, brass and wood to completely restore your valuable collectibles. $34.95 list, 8½x11, 128p, b&w photos and illustrations, glossary, index, order no. 1613.

Handcoloring Photographs Step-by-Step

Sandra Laird & Carey Chambers

Learn to handcolor photographs step-by-step with the new standard handcoloring reference. Covers a variety of coloring media. Includes colorful photographic examples. $29.95 list, 8½x11, 112p, 100+ color and b&w photos, order no. 1543.

Special Effects Photography Handbook

Elinor Stecker Orel

Create magic on film with special effects! Little or no additional equipment required, use things you probably have around the house. Step-by-step instructions guide you through each effect. $29.95 list, 8½x11, 112p, 80+ color and b&w photos, index, glossary, order no. 1614.

McBroom's Camera Bluebook

Mike McBroom

Comprehensive, fully illustrated, with price information on: 35mm cameras, medium & large format cameras, exposure meters, strobes and accessories. Pricing info based on equipment condition. A must for any camera buyer, dealer, or collector! $34.95 list, 8½x11, 224p, 75+ photos, order no. 1263.

Swimsuit Model Photography

Cliff Hollenbeck

The complete guide to the business of swimsuit model photography. Includes: finding models, selecting equipment, working with models, posing, using props and backgrounds, and much more! By the author of *Big Bucks Selling Your Photography* and *Great travel Photography*. $29.95 list, 8½x11, 112p, over 100 b&w and color photos, index, order no. 1605.

Glamour Nude Photography

Robert and Sheila Hurth

Create stunning nude images! Robert and Sheila Hurth guide you through selecting a subject, choosing locations, lighting, and shooting techniques. Includes information on posing, equipment, makeup and hair styles, and much more! $24.95 list, 8½x11, 144p, over 100 b&w and color photos, index, order no. 1499.

Black & White Nude Photography

Stan Trampe

This book teaches the essentials for beginning fine art nude photography. Includes info on finding your first model, selecting equipment, and scenarios of a typical shoot, plus more! Includes 60 photos taken with b&w and infrared films. $24.95 list, 8½x11, 112p, index, order no. 1592.

The Art of Infrared Photography / 4ᵗʰ Edition

Joe Paduano

A practical, comprehensive guide to the art of infrared photography. Tells what to expect and how to control results. Includes: anticipating effects, color infrared, digital infrared, using filters, focusing, developing, printing, handcoloring, toning, and more! $29.95 list, 8½x11, 112p, order no. 1052.

The Wildlife Photographer's Field Manual

Joe McDonald

The complete reference for every wildlife photographer. A practical, comprehensive, easy-to-read guide with useful information, including: the right equipment and accessories, field shooting, lighting, focusing techniques, and more! Features special sections on insects, reptiles, birds, mammals and more! $14.95 list, 6x9, 200p, order no. 1005.

A·N·N·U·A·L E·D·I·T·I·O·N·S

Global Issues 00/01

Sixteenth Edition

EDITOR

Robert M. Jackson
California State University, Chico

Robert M. Jackson is a professor of political science and dean of the School of Graduate, International, and Sponsored Programs at California State University, Chico. In addition to teaching, he has published articles on the international political economy, international relations simulations, and political behavior. His special research interest is in the way northern California is becoming increasingly linked to the Pacific Basin. His travels include China, Japan, Hong Kong, Taiwan, Singapore, Malaysia, Portugal, Spain, Morocco, Costa Rica, El Salvador, Honduras, Guatemala, Mexico, Germany, Belgium, the Netherlands, Russia, and Czechoslovakia.

Dushkin/McGraw-Hill
Sluice Dock, Guilford, Connecticut 06437

Visit us on the Internet
http://www.dushkin.com/annualeditions/

This map has been developed to give you a graphic picture of where the countries of the world are located, the relationship they have with their region and neighbors, and their positions relative to the superpowers and power blocs. We have focused on certain areas to more clearly illustrate these crowded regions.

Scale: 1 to 125,000,000

NORTH SEA
NORWAY
SWEDEN
BALTIC SEA
ESTONIA
RUSSIA
DENMARK
LATVIA
RUSSIA
LITHUANIA
NETHERLANDS
BELARUS
GERMANY
POLAND
BELGIUM
UKRAINE
LUXEMBOURG
CZECH REPUBLIC
SLOVAKIA
FRANCE
LIECHTENSTEIN
MOLDOVA
SWITZERLAND
AUSTRIA
HUNGARY
SLOVENIA
ROMANIA
CROATIA VOJVODINA
MONACO
SAN MARINO
BOSNIA-HERZEGOVINA
SERBIA
BLACK SEA
ITALY
MONTENEGRO
KOSOVO
BULGARIA
MACEDONIA
ALBANIA
GREECE
TURKEY
MEDITERRANEAN
SEA
MALTA

GREENLAND (DK)
ARCTIC OCEAN
Arctic Circle
ICELAND
NORWAY SWEDEN FINLAND
UNITED KINGDOM
IRELAND
FRANCE
ANDORRA
PORTUGAL SPAIN
MOROCCO
WESTERN SAHARA (MO)
MAURITANIA
CAPE VERDE
RUSSIA
KAZAKHSTAN
MONGOLIA
NORTH PACIFIC OCEAN
TUNISIA
CYPRUS
SYRIA
LEBANON
TURKEY
UZBEKISTAN
KYRGYZSTAN
TURKMENISTAN
TAJIKISTAN
CHINA
NORTH KOREA
SOUTH KOREA
JAPAN
ALGERIA
LIBYA
IRAN
AFGHANISTAN
ISRAEL
IRAQ
JORDAN
KUWAIT
QATAR
PAKISTAN
NEPAL
BHUTAN
EGYPT
BAHRAIN
SAUDI ARABIA
UNITED ARAB EMIRATES
OMAN
INDIA
MYANMAR (BURMA)
TAIWAN
Tropic of Cancer
MALI
NIGER
CHAD
SUDAN
ERITREA
YEMEN
BANGLADESH
LAOS
THAILAND
VIETNAM
PHILIPPINES
MARSHALL ISLANDS
NIGERIA
DJIBOUTI
SRI LANKA
CAMBODIA (KAMPUCHEA)
MICRONESIA
CAMEROON
UGANDA
ETHIOPIA
MALDIVES
BRUNEI
MALAYSIA
CENTRAL AFRICAN REPUBLIC
SOMALIA
Equator
NAURU
KIRIBATI
SÃO TOMÉ AND PRÍNCIPE
RWANDA
BURUNDI
ZAIRE
KENYA
SINGAPORE
INDONESIA
PAPUA NEW GUINEA
SOLOMON ISLANDS
TUVALU
EQUATORIAL GUINEA
GABON
CONGO
TANZANIA
MALAWI
SEYCHELLES
INDIAN OCEAN
VANUATU
FIJI
ANGOLA
ZAMBIA
COMOROS
MOZAMBIQUE
MADAGASCAR
MAURITIUS
Tropic of Capricorn
AUSTRALIA
NAMIBIA
BOTSWANA
ZIMBABWE
SWAZILAND
SOUTH AFRICA
LESOTHO
NEW ZEALAND

MAURITANIA
SENEGAL
MALI
NIGER
GAMBIA
GUINEA-BISSAU
BURKINA FASO
GUINEA
BENIN
SIERRA LEONE
CÔTE D'IVOIRE
GHANA
NIGERIA
LIBERIA
ATLANTIC OCEAN
TOGO

RUSSIA
CASPIAN SEA
BLACK SEA
GEORGIA
AZERBAIJAN
ARMENIA
TURKEY
AZERBAIJAN
IRAN

iii

Credits

1. Global Issues in the Twenty-First Century: An Overview
Unit photo—© 2000 by Cleo Freelance Photography.
2. Population and Food Production
Unit photo—United Nations photo by Y. Lehmann.
3. The Global Environment and Natural Resources Utilization
Unit photo—United Nations photo.
4. Political Economy
Unit photo—United Nations photo by Shelley Rother.
5. Conflict
Unit photo—Courtesy of U.S. Navy.
6. Cooperation
Unit photo—United Nations photo by Milton Grant.
7. Values and Visions
Unit photo—United Nations photo.

Copyright

Cataloging in Publication Data
Main entry under title: Annual Editions: Global Issues. 2000/2001.
 1. Civilization, Modern—20th century—Periodicals. 2. Social prediction—
Periodicals. 3. Social problems—20th century—Periodicals. I. Jackson, Robert, *comp.* II.
Title: Global issues.
ISBN 0-07-236555-2 909.82'05 85-658006 ISSN 1093-278X

© 2000 by Dushkin/McGraw-Hill, Guilford, CT 06437, A Division of The McGraw-Hill Companies.

Sixteenth Edition

Cover image © 2000 PhotoDisc, Inc.

Printed in the United States of America 234567890BAHBAH543210 Printed on Recycled Paper

In publishing ANNUAL EDITIONS we recognize the enormous role played by the magazines, newspapers, and journals of the public press in providing current, first-rate educational information in a broad spectrum of interest areas. Many of these articles are appropriate for students, researchers, and professionals seeking accurate, current material to help bridge the gap between principles and theories and the real world. These articles, however, become more useful for study when those of lasting value are carefully collected, organized, indexed, and reproduced in a low-cost format, which provides easy and permanent access when the material is needed. That is the role played by ANNUAL EDITIONS.

New to ANNUAL EDITIONS is the inclusion of related World Wide Web sites. These sites have been selected by our editorial staff to represent some of the best resources found on the World Wide Web today. Through our carefully developed topic guide, we have linked these Web resources to the articles covered in this ANNUAL EDITIONS reader. We think that you will find this volume useful, and we hope that you will take a moment to visit us on the Web at **http://www.dushkin.com** to tell us what you think.

As the twenty-first century begins, the issues confronting humanity are increasingly more complex and diverse. While the mass media may focus on the latest crisis for a few days or weeks, the broad forces that are shaping the world of the twenty-first century are seldom given the in-depth analysis that they warrant. Scholarly research about these historic change factors can be found in a wide variety of publications, but these are not readily accessible. In addition, students just beginning to study global issues can be discouraged by the terminology and abstract concepts that characterize much of the scholarly literature. In selecting and organizing the materials for this book, we have been mindful of the needs of beginning students and have, thus, selected articles that invite the student into the subject matter.

Each unit begins with an introductory article providing a broad overview of the area to be explored. The remaining articles examine in more detail some of the issues presented. The unit then concludes with an article (or two) that not only identifies a problem but suggests positive steps that are being taken to improve the situation. The world faces many serious issues, the magnitude of which would discourage even the most stouthearted individual. Though identifying problems is easier than solving them, it is encouraging to know that many of the issues are being successfully addressed.

Perhaps the most striking feature of the study of contemporary global issues is the absence of any single, widely held theory that explains what is taking place. Therefore, we have made a conscious effort to present a wide variety of ideologies and theories. The most important consideration has been to present global issues from an international perspective, rather than from a purely American or Western point of view. By encompassing materials originally published in many different countries and written by authors of various nationalities, the anthology represents the great diversity of opinions that people hold on important global issues. Two writers examining the same phenomenon may reach very different conclusions. It is not a question of who is right and who is wrong. What is important to understand is that people from different vantage points have differing perceptions of issues.

Another major consideration when organizing these materials was to explore the complex interrelationship of factors that produce social problems such as poverty. Too often, discussions of this problem (and others like it) are reduced to arguments about the fallacies of not following the correct economic policy or not having the correct form of government. As a result, many people overlook the interplay of historic, cultural, environmental, economic, and political factors that form complex webs that bring about many different problems. Every effort has been made to select materials that illustrate this complex interaction of factors, stimulating the beginning student to consider realistic rather than overly simplistic approaches to the pressing problems that threaten the existence of civilization.

Included in this edition of *Annual Editions: Global Issues* are *World Wide Web* sites that can be used to further explore topics addressed in the articles. These sites are cross-referenced in the *topic guide*.

Finally, we selected the materials in this book for both their intellectual insights and their readability. Timely and well-written materials should stimulate good classroom lectures and discussions. I hope that students and teachers will enjoy using this book. Readers can have input into the next edition by completing and returning the postage-paid *article rating form* in the back of the book.

I would like to acknowledge the help and support of Ian Nielsen. I am grateful for his encouragement and helpful suggestions in the selection of materials for *Annual Editions: Global Issues 00/01*. It is my continuing goal to encourage the readers of this book to have a greater appreciation of the world in which we live. I hope each of you will be motivated to further explore the complex issues faced by the world as we enter the twenty-first century.

Robert M. Jackson
Editor

Contents

UNIT 1

Global Issues in the Twenty-First Century: An Overview

Four articles in this section present distinct views on the present and future state of life on Earth.

UNIT 2

Population and Food Production

Five selections in this section discuss the contributing factors to the world's population growth and the challenge of providing food for this added strain on the world's capacity.

The concepts in bold italics are developed in the article. For further expansion please refer to the Topic Guide, the Glossary, and the Index.

Overview 60

UNIT 3

The Global Environment and Natural Resources Utilization

Five articles in this section discuss natural resources and their effects on the world's environment.

The concepts in bold italics are developed in the article. For further expansion please refer to the Topic Guide, the Glossary, and the Index.

UNIT 4

Political Economy

Eight articles present various views on economic and social development in the nonindustrial and industrial nations.

The concepts in bold italics are developed in the article. For further expansion please refer to the Topic Guide, the Glossary, and the Index.

ix

UNIT 5

Conflict

Seven articles in this section
discuss the basis for world conflict
and the current state of peace
in the international community.

The concepts in bold italics are developed in the article. For further expansion please refer to the Topic Guide, the Glossary, and the Index.

x

Cooperation

Six selections in this section
examine patterns of international
cooperation and the social
structures that support
this cooperation.

The concepts in bold italics are developed in the article. For further expansion please refer to the Topic Guide, the Glossary, and the Index.

1

UNIT 7

Values and Visions

Nine articles discuss human rights,
ethics, values, and new ideas.

The concepts in bold italics are developed in the article. For further expansion please refer to the Topic Guide, the Glossary, and the Index.

The concepts in bold italics are developed in the article. For further expansion please refer to the Topic Guide, the Glossary, and the Index.

Topic Guide

This topic guide suggests how the selections and World Wide Web sites found in the next section of this book relate to topics of traditional concern to students and professionals involved in the study of global issues. It is useful for locating interrelated articles and Web sites for reading and research. The guide is arranged alphabetically according to topic.

The relevant Web sites, which are numbered and annotated on pages 6 and 7, are easily identified by the Web icon (◎) under the topic articles. By linking the articles and the Web sites by topic, this ANNUAL EDITIONS reader becomes a powerful learning and research tool.

TOPIC AREA	TREATED IN	TOPIC AREA	TREATED IN
Agriculture, Food, and Hunger	1. Special Moment in History 6. Breaking Out or Breaking Down 8. How Much Food Will We Need in the 21st Century? 9. Angling for 'Aquaculture' 14. We *Can* Build a Sustainable Economy ◎ *2, 7, 8, 9, 10, 19*		44. Sacred Warrior ◎ *2, 5, 6, 17, 18, 19, 20, 21, 29, 32*
		Economics	1. Special Moment in History 3. Life Is Unfair 6. Breaking Out or Breaking Down 11. Climatic Changes That Make the World Flip 12. Stumped by Trees 14. We *Can* Build a Sustainable Economy 15. Complexities and Contradictions of Globalization 16. Invention of Development 17. Crisis of Globalization 18. Beyond the Transition: China's Economy at Century's End 19. Russian Devolution 21. How Far, How Fast? 22. New Tiger 32. Globalization of Tourism 33. Ecotourism without Tears 35. Child Labour: Rights, Risks, and Realities 38. Grameen Bank 42. Future of Energy 44. Sacred Warrior ◎ *1, 2, 17, 18, 19, 20, 21, 29*
Communications	2. Many Faces of the Future 15. Complexities and Contradictions of Globalization ◎ *1, 18, 20, 24, 25, 26*		
Cultural Customs and Values	2. Many Faces of the Future 4. World Prisms 7. Misery behind the Statistics 14. We *Can* Build a Sustainable Economy 15. Complexities and Contradictions of Globalization 16. Invention of Development 20. What Pacific Century? 26. Ethnic Conflict 30. Justice Goes Global 31. Enforcing Human Rights 33. Ecotourism without Tears 35. Child Labour: Rights, Risks, and Realities 36. Universal Human Values 38. Grameen Bank 40. Is Life Really Getting Better? 42. Future of Energy 43. Women in Power: From Tokenism to Critical Mass 44. Sacred Warrior ◎ *1, 8, 12, 15, 20, 31, 32*		
		Energy: Exploration, Production, Research, and Politics	14. We *Can* Build a Sustainable Economy 42. Future of Energy ◎ *11, 12, 13, 14, 15, 16, 18, 20*
		Environment, Ecology, and Conservation	1. Special Moment in History 6. Breaking Out or Breaking Down 8. How Much Food Will We Need in the 21st Century? 9. Angling for 'Aquaculture' 10. Global Challenge 11. Climatic Changes That Make the World Flip 12. Stumped by Trees 13. Invasive Species 14. We *Can* Build a Sustainable Economy 33. Ecotourism without Tears 42. Future of Energy ◎ *11, 12, 13, 14, 15, 16*
Development: Economic and Social	3. Life Is Unfair 5. Before the Next Doubling 6. Breaking Out or Breaking Down 7. Misery behind the Statistics 10. Global Challenge 12. Stumped by Trees 14. We *Can* Build a Sustainable Economy 15. Complexities and Contradictions of Globalization 16. Invention of Development 18. Beyond the Transition: China's Economy at Century's End 19. Russian Devolution 22. New Tiger 32. Globalization of Tourism 33. Ecotourism without Tears 35. Child Labour: Rights, Risks, and Realities 36. Universal Human Values 38. Grameen Bank 41. Fourth Way? The Latin American Alternative to Neoliberalism 43. Women in Power: From Tokenism to Critical Mass	**The Future**	1. Special Moment in History 2. Many Faces of the Future 3. Life Is Unfair 4. World Prisms 5. Before the Next Doubling 6. Breaking Out or Breaking Down 7. Misery behind the Statistics 8. How Much Food Will We Need in the 21st Century? 10. Global Challenge 11. Climatic Changes That Make the World Flip

4

◉ AE: Global Issues

The following World Wide Web sites have been carefully researched and selected to support the articles found in this reader. If you are interested in learning more about specific topics found in this book, these Web sites are a good place to start. The sites are cross-referenced by number and appear in the topic guide on the previous two pages. Also, you can link to these Web sites through our DUSHKIN ONLINE support site at *http://www.dushkin.com/online/*.

The following sites were available at the time of publication. Visit our Web site—we update DUSHKIN ONLINE regularly to reflect any changes.

General Sources

1. U.S. Information Agency (USIA)
http://www.usia.gov/usis.html
USIA'S home page provides definitions, related documentation, and discussions of topics of concern to students of global issues. The site addresses today's Hot Topics as well as ongoing issues that form the foundation of the field.

2. World Wide Web Virtual Library: International Affairs Resources
http://www.etown.edu/vl/
Surf this site and its extensive links to learn about specific countries and regions, to research various think tanks and international organizations, and to study such vital topics as international law, development, the international economy, human rights, and peacekeeping.

Global Issues in the Twenty-First Century: An Overview

3. The Henry L. Stimson Center
http://www.stimson.org
The Stimson Center, a nonpartisan organization, focuses on issues where policy, technology, and politics intersect. Use this site to find varying assessments of U.S. foreign policy in the post–cold war world and to research other topics.

4. The Heritage Foundation
http://www.heritage.org
This page offers discussion about and links to many sites having to do with foreign policy and foreign affairs, including news and commentary, policy review, events, and a resource bank.

5. IISDnet
http://iisd1.iisd.ca
The International Institute for Sustainable Development presents information through links to business, sustainable development, and developing ideas. "Linkages" is its multimedia resource for policymakers.

6. The North-South Institute
http://www.nsi-ins.ca/ensi/index.html
Searching this site of the North-South Institute, which works to strengthen international development cooperation and enhance gender and social equity, will help you find information and debates on a variety of global issues.

Population and Food Production

7. The Hunger Project
http://www.thp.org
Browse through this nonprofit organization's site, whose goal is the sustainable end to global hunger through leadership at all levels of society. The Hunger Project contends that the persistence of hunger is at the heart of the major security issues threatening our planet.

8. Penn Library: Resources by Subject
http://www.library.upenn.edu/resources/websitest.html
This vast site is rich in links to information about subjects of interest to students of global issues. Its extensive population and demography resources address such concerns as migration, family planning, and health and nutrition in various world regions.

9. World Health Organization
http://www.who.int
This home page of the World Health Organization will provide you with links to a wealth of statistical and analytical information about health and the environment in the developing world.

10. WWW Virtual Library: Demography & Population Studies
http://coombs.anu.edu.au/ResFacilities/ DemographyPage.html
A definitive guide to demography and population studies can be found at this site. It contains a multitude of important links to information about global poverty and hunger.

The Global Environment and Natural Resources Utilization

11. Friends of the Earth
http://www.foe.co.uk/index.html
This nonprofit organization pursues a number of campaigns to protect Earth and its living creatures. This site has links to many important environmental sites, covering such broad topics as ozone depletion, soil erosion, and biodiversity.

12. National Geographic Society
http://www.nationalgeographic.com
This site provides links to material related to the atmosphere, the oceans, and other environmental topics.

13. National Oceanic and Atmospheric Administration (NOAA)
http://www.noaa.gov
Through this home page of NOAA, part of the U.S. Department of Commerce, you can find information about coastal issues, fisheries, climate, and more. The site provides many links to research materials and to other Web resources.

14. Public Utilities Commission of Ohio (PUCO)
http://www.puc.state.oh.us/consumer/gcc/index.html
PUCO's site serves as a clearinghouse of information about global climate change. Its links explain the science and chronology of global climate change.

15. SocioSite: Sociological Subject Areas
http://www.pscw.uva.nl/sociosite/TOPICS/
This huge site provides many references of interest to those interested in global issues, such as links to information on ecology and the impact of consumerism.

16. United Nations Environment Programme (UNEP)
http://www.unep.ch
Consult this home page of UNEP for links to critical topics of concern to students of global issues, including desertification, migratory species, and the impact of trade on the environment.

Political Economy

17. Belfer Center for Science and International Affairs (BCSIA)
http://ksgwww.harvard.edu/csia/
BCSIA is the hub of Harvard University's John F. Kennedy School of Government's research, teaching, and training in international affairs related to security, environment, and technology.

18. Communications for a Sustainable Future
gopher://csf.colorado.edu
Information on topics in international environmental sustainability is available on this Gopher site. It pays particular attention to the political economics of protecting the environment.

19. U.S. Agency for International Development
http://www.info.usaid.gov
Broad and overlapping issues such as democracy, population and health, economic growth, and development are covered on this Web site. It provides specific information about different regions and countries.

20. Virtual Seminar in Global Political Economy/Global Cities & Social Movements
http://csf.colorado.edu/gpe/gpe95b/resources.html
This site of Internet resources is rich in links to subjects of interest in regional environmental studies, covering topics such as sustainable cities, megacities, and urban planning. Links to many international nongovernmental organizations are included.

21. World Bank
http://www.worldbank.org
News, press releases, summaries of new projects, speeches), publications, and coverage of numerous topics regarding development, countries, and regions are provided at this World Bank site. It also contains links to other important global financial organizations.

Conflict

22. DefenseLINK
http://www.defenselink.mil
Learn about security news and research-related publications at this U.S. Department of Defense site. Links to related sites of interest, among other things, are provided. The information systems BosniaLINK and GulfLINK can also be found here. Use the search function to investigate such issues as land mines.

23. Federation of American Scientists (FAS)
http://www.fas.org
FAS, a nonprofit policy organization, maintains this site to provide coverage of and links to such topics as global security, peace, and governance in the post–cold war world. It notes a variety of resources of value to students of global issues.

24. ISN International Relations and Security Network
http://www.isn.ethz.ch
This site, maintained by the Center for Security Studies and Conflict Research, is a clearinghouse for information on international relations and security policy. Topics are listed by category (Traditional Dimensions of Security, New Dimensions of Security, and Related Fields) and by major world region.

25. The NATO Integrated Data Service (NIDS)
http://www.nato.int/structur/nids/nids.htm
NIDS was created to bring information on security-related matters to within easy reach of the widest possible audience. Check out this Web site to review North Atlantic Treaty Organization documentation of all kinds, to read *NATO Review*, and to explore key issues in the field of European security and transatlantic cooperation.

Cooperation

26. American Foreign Service Association
http://www.afsa.org/related.html
The AFSA offers this page of related sites as part of its Web presence. Useful sites include DiploNet, Public Diplomacy, and InterAction. Aso click on Diplomacy and Diplomats and other sites on the sidebar.

27. Carnegie Endowment for International Peace
http://www.ceip.org
An important goal of this organization is to stimulate discussion and learning among both experts and the public at large on a wide range of international issues. The site provides links to *Foreign Policy*, to the Moscow Center, to descriptions of various programs, and much more.

28. Commission on Global Governance
http://www.cgg.ch
This site provides access to *The Report of the Commission on Global Governance*, produced by an international group of leaders who want to find ways in which the global community can better manage its affairs.

29. OECD/FDI Statistics
http://www.oecd.org/daf/cmis/fdi/statist.htm
Explore world trade and investment trends and statistics on this site from the Organization for Economic Cooperation and Development. It provides links to many related topics and addresses the issues on a country-by-country basis.

30. U.S. Institute of Peace
http://www.usip.org
USIP, which was created by the U.S. Congress to promote peaceful resolution of international conflicts, seeks to educate people and to disseminate information on how to achieve peace. Click on Highlights, Publications, Events, Research Areas, and Library and Links.

Values and Visions

31. Human Rights Web
http://www.hrweb.org
The history of the human rights movement, text on seminal figures, landmark legal and political documents, and ideas on how individuals can get involved in helping to protect human rights around the world can be found in this valuable site.

32. InterAction
http://www.interaction.org
InterAction encourages grassroots action and engages government policymakers on advocacy issues. The organization's Advocacy Committee provides this site to inform people on its initiatives to expand international humanitarian relief, refugee, and development-assistance programs.

We highly recommend that you review our Web site for expanded information and our other product lines. We are continually updating and adding links to our Web site in order to offer you the most usable and useful information that will support and expand the value of your Annual Editions. You can reach us at:
http://www.dushkin.com/annualeditions/.

www.dushkin.com/online/

Unit Selections

1. **A Special Moment in History,** Bill McKibben
2. **The Many Faces of the Future,** Samuel P. Huntington
3. **Life Is Unfair: Inequality in the World,** Nancy Birdsall
4. **World Prisms: The Future of Sovereign States and International Order,** Richard Falk

Key Points to Consider

❖ Do the analyses of any of the authors in this section employ the assumptions implicit in the allegory of the balloon? If so, how? If not, how are the assumptions of the authors different?

❖ All the authors point to interactions among different factors. What are some of the relationships that they cite? How do the authors differ in terms of the relationships they emphasize?

❖ What assets that did not exist 100 years ago do people have now to solve problems?

❖ What events during the twentieth century have had the greatest impact on shaping the realities of contemporary international affairs?

❖ What do you consider to be the five most pressing global problems of today? How do your answers compare to those of your family, friends, and classmates?

 Links **www.dushkin.com/online/**

3. **The Henry L. Stimson Center**
 http://www.stimson.org
4. **The Heritage Foundation**
 http://www.heritage.org
5. **IISDnet**
 http://iisd1.iisd.ca
6. **The North-South Institute**
 http://www.nsi-ins.ca/ensi/index.html

These sites are annotated on pages 6 and 7.

Imagine a clear, round, inflated balloon. Now imagine that a person begins to brush yellow paint onto this miniature globe; symbolically, the color yellow represents *people*. In many ways the study of global issues is ultimately the study of people. Today, there are more people occupying Earth than ever before. In addition, the world is in the midst of a period of unprecedented population growth. Not only are there many countries where the majority of people are under age 16, but because of improved health care, there are also more older people alive than ever before. The effect of a growing global population, however, goes beyond sheer numbers, for a growing population has unprecedented impacts on natural resources and social services. Population issues, then, are an appropriate place to begin the study of global issues.

Imagine that our fictional artist dips the brush into a container of blue paint to represent the world of *nature*. The natural world plays an important role in setting the international agenda. Shortages of raw materials, drought and crop failures, and pollution of waterways are just a few examples of how natural resources can have global implications.

Adding blue paint to the balloon also reveals one of the most important concepts found in this book of readings. Although the balloon originally was covered by yellow and blue paint (people and nature as separate conceptual entities), the two combined produce an entirely different color: green. Talking about nature as a separate entity or about people as though they were somehow removed from the forces of the natural world is a serious intellectual error. The people-nature relationship is one of the keys to understanding many of today's most important global issues.

The third color added to the balloon is red. It represents the *meta* component (i.e., those qualities that make human beings different from animals). These include new ideas and inventions, culture and values, religion and spirituality, and art and literature. The addition of the red paint immediately changes the color green to brown, again emphasizing the relationship among all three factors.

The fourth and final color added is white. This color represents *social structures*. Factors such as whether a society is urban or rural, industrial or agrarian, planned or decentralized, and consumer-oriented or dedicated to the needs of the state fall into this category. The relationship between this component and the others is extremely important. The impact of political decisions on the environment, for example, is one of the most unusual features of the contemporary world. Historically, the forces of nature determined which species survived or perished. Today, survival depends on political decisions—or indecision. Will the whales or bald eagles survive? The answer to this question will depend on governmental activities, not evolutionary forces.

Understanding this relationship between social structure and nature (known as "ecopolitics") is important to the study of global issues. If the painter continues to ply the paintbrush over the miniature globe, a marbling effect will become evident. In some areas, the shading will vary because one element is greater than another. The miniature system appears dynamic. Nothing is static; relationships are continually changing. This leads to a number of theoretical insights: (1) there is no such thing as separate elements, only connections or relationships; (2) changes in one area (such as the weather) will result in changes in all other areas; and (3) complex relationships make it difficult to predict events accurately, so observers are often surprised by unexpected processes and outcomes.

This book is organized along the basic lines of the balloon allegory. The first unit explores a variety of perspectives on the forces that are shaping the world of the twenty-first century. Unit 2 focuses on population and food production. Unit 3 examines the environment and related issues. The next three units look at different aspects of the world's social structures. They explore issues of economics, national security, conflict, and international cooperation. In the final unit, a number of "meta" factors are discussed.

The reader should be aware that, just as it was impossible to keep the individual colors from blending into new colors on the balloon, it is also impossible to separate global issues into discrete chapters in a book. Any discussion of agriculture, for example, must take into account the impact of a growing population on soil and water resources, as well as new scientific breakthroughs in food production. Therefore, the organization of this book focuses attention on issue areas; it does not mean to imply that these factors are somehow separate.

With the collapse of the Soviet empire and the end of the cold war, the outlines of a new global agenda are beginning to emerge. Rather than being based on the ideology and interests of the two superpowers, new political, economic, and environmental factors are interacting in an unprecedented fashion. Rapid population growth, environmental decline, and uneven economic growth are all parts of a complex situation for which there is no historic parallel. As we begin the twenty-first century, signs abound that we are entering a new era. In the words of Abraham Lincoln, "As our case is new, so we must think anew." Compounding this situation, however, is a whole series of old problems such as ethnic and religious rivalries.

The authors in this first unit provide a variety of perspectives on the trends that they believe are the most important to understanding the historic changes at work at the global level. This discussion is then pursued in greater detail in the following units.

It is important for the reader to note that although the authors look at the same world, they often come to different conclusions. This raises an important issue of values and beliefs, for it can be argued that there really is no objective reality, only differing perspectives. In short, the study of global issues will challenge each thoughtful reader to examine her or his own values and beliefs.

A Special Moment in History

Bill McKibben

We may live in the strangest, most thoroughly different moment since human beings took up farming, 10,000 years ago, and time more or less commenced. Since then time has flowed in one direction—toward *more*, which we have taken to be progress. At first the momentum was gradual, almost imperceptible, checked by wars and the Dark Ages and plagues and taboos; but in recent centuries it has accelerated, the curve of every graph steepening like the Himalayas rising from the Asian steppe. . . .

But now—now may be the special time. So special that in the Western world we might each of us consider, among many other things, having only one child—that is, reproducing at a rate as low as that at which human beings have ever voluntarily reproduced. Is this really necessary? Are we finally running up against some limits?

To try to answer this question, we need to ask another: *How many of us will there be in the near future?* Here is a piece of news that may alter the way we see the planet—an indication that we live at a special moment. At least at first blush the news is hopeful. *New demographic evidence shows that it is at least possible that a child born today will live long enough to see the peak of human population.*

Around the world people are choosing to have fewer and fewer children—not just in China, where the government forces it on them, but in almost every nation outside the poorest parts of Africa. . . . If this keeps up, the population of the world will not quite double again; United Nations analysts offer as their mid-range projection that it will top out at 10 to 11 billion, up from just under six billion at the moment. . . .

The good news is that we won't grow forever. The bad news is that there are six billion of us already, a number the world strains to support. One more near-doubling—four or five billion more people—will nearly double that strain. Will these be the five billion straws that break the camel's back? . . .

LOOKING AT LIMITS

The case that the next doubling, the one we're now experiencing, might be the difficult one can begin as readily with the Stanford biologist Peter Vitousek as with anyone else. In 1986 Vitousek decided to calculate how much of the earth's "primary productivity" went to support human beings. He added together the grain we ate, the corn we fed our cows, and the forests we cut for timber and paper; he added the losses in food as we overgrazed grassland and turned it into desert. And when he was finished adding, the number he came up with was 38.8 percent. We use 38.8 percent of everything

Bill McKibben is the author of several books about the environment, including *The End of Nature* (1989) and *Hope, Human and Wild* (1995). His article in this issue will appear in somewhat different form in his book *Maybe One: A Personal and Environmental Argument for Single-Child Families*, published in 1998 by Simon & Schuster.

the world's plants don't need to keep themselves alive; directly or indirectly, we consume 38.8 percent of what it is possible to eat. "That's a relatively large number," Vitousek says. "It should give pause to people who think we are far from any limits." Though he never drops the measured tone of an academic, Vitousek speaks with considerable emphasis: "There's a sense among some economists that we're *so* far from any biophysical limits. I think that's not supported by the evidence."

For another antidote to the good cheer of someone like Julian Simon, sit down with the Cornell biologist David Pimentel. He believes that we're in big trouble. Odd facts stud his conversation—for example, a nice head of iceberg lettuce is 95 percent water and contains just fifty calories of energy, but it takes 400 calories of energy to grow that head of lettuce in California's Central Valley, and another 1,800 to ship it east. ("There's practically no nutrition in the damn stuff anyway," Pimentel says. "Cabbage is a lot better, and we can grow it in upstate New York.") Pimentel has devoted the past three decades to tracking the planet's capacity, and he believes that we're already too crowded—that the earth can support only two billion people over the long run at a middle-class standard of living, and that trying to support more is doing damage. He has spent considerable time studying soil erosion, for instance. Every raindrop that hits exposed ground is like a small explosion, launching soil particles into the air. On a slope, more than half of the soil contained in those splashes is carried downhill. If crop residue—cornstalks, say—is left in the field after harvest, it helps to shield the soil: the raindrop doesn't hit hard. But in the developing world, where firewood is scarce, peasants burn those cornstalks for cooking fuel. About 60 percent of crop residues in China and 90 percent in Bangladesh are removed and burned, Pimentel says. When planting season comes, dry soils simply blow away. "Our measuring stations pick up African soils in the wind when they start to plough."

The very things that made the Green Revolution so stunning—that made the last doubling possible—now cause trouble. Irrigation ditches, for instance, water 27 percent of all arable land and help to produce a third of all crops. But when flooded soils are baked by the sun, the water evaporates and the minerals in the irrigation water are deposited on the land. A hectare (2.47 acres) can accumulate two to five tons of salt annually, and eventually plants won't grow there. Maybe 10 percent of all irrigated land is affected.

... [F]ood production grew even faster than population after the Second World War. Year after year the yield of wheat and corn and rice rocketed up about three percent annually. It's a favorite statistic of the eternal optimists. In Julian Simon's book *The Ultimate Resource* (1981) charts show just how fast the growth was, and how it continually cut the cost of food. Simon wrote, "The obvious implication of this historical trend toward cheaper food—a trend that probably extends back to the beginning of agriculture—is that real prices for food will continue to drop.... It is a fact that portends more drops in price and even less scarcity in the future."

A few years after Simon's book was published, however, the data curve began to change. That rocketing growth in grain production ceased; now the gains were coming in tiny increments, too small to keep pace with population growth. The world reaped its largest harvest of grain per capita in 1984; since then the amount of corn and wheat and rice per person has fallen by six percent. Grain stockpiles have shrunk to less than two months' supply.

No one knows quite why. The collapse of the Soviet Union contributed to the trend—cooperative farms suddenly found the fertilizer supply shut off and spare parts for the tractor hard to come by. But there were other causes, too, all around the world—the salinization of irrigated fields, the erosion of topsoil, and all the other things that environmentalists had been warning about for years. It's possible that we'll still turn production around and start it rocketing again. Charles C. Mann, writing in *Science,* quotes experts who believe that in the future a "gigantic, multi-year, multi-billion-dollar scientific effort, a kind of agricultural 'person-on the-moon project,' " might do the trick. The next great hope of the optimists is genetic engineering, and scientists have indeed managed to induce resistance to pests and disease in some plants. To get more yield, though, a cornstalk must be made to put out another ear, and conventional breeding may have exhausted the possibilities. There's a sense that we're running into walls.

... What we are running out of is what the scientists call "sinks"—places to put the by-products of our large appetites. Not garbage dumps (we could go on using Pampers till the end of time and still have empty space left to toss them away) but the atmospheric equivalent of garbage dumps.

It wasn't hard to figure out that there were limits on how much coal smoke we could pour into the air of a single city. It took a while longer to figure out that building ever higher smokestacks merely lofted the haze farther afield, raining down acid on whatever mountain range lay to the east. Even that, however, we are slowly fixing, with scrubbers and different mixtures of fuel. We can't so easily repair the new kinds of pollution. These do not come from something going wrong—some engine without a catalytic converter, some waste-water pipe without a filter, some smokestack without a scrubber. New kinds of pollution come instead from things going as they're supposed to go—but at such a high volume that they overwhelm the planet. They come from normal human life—but there are so many of us living those normal lives that something abnormal is happening. And that something is different from the old forms of pollution that it confuses the issue even to use the word.

Consider nitrogen, for instance. But before plants can absorb it, it must become "fixed"—bonded with carbon,

hydrogen, or oxygen. Nature does this trick with certain kinds of algae and soil bacteria, and with lightning. Before human beings began to alter the nitrogen cycle, these mechanisms provided 90–150 million metric tons of nitrogen a year. Now human activity adds 130–150 million more tons. Nitrogen isn't pollution—it's essential. And we are using more of it all the time. Half the industrial nitrogen fertilizer used in human history has been applied since 1984. As a result, coastal waters and estuaries bloom with toxic algae while oxygen concentrations dwindle, killing fish; as a result, nitrous oxide traps solar heat. And once the gas is in the air, it stays there for a century or more.

Or consider methane, which comes out of the back of a cow or the top of a termite mound or the bottom of a rice paddy. As a result of our determination to raise more cattle, cut down more tropical forest (thereby causing termite populations to explode), and grow more rice, methane concentrations in the atmosphere are more than twice as high as they have been for most of the past 160,000 years. And methane traps heat—very efficiently.

Or consider carbon dioxide. In fact, concentrate on carbon dioxide. If we had to pick one problem to obsess about over the next fifty years, we'd do well to make it CO_2—which is not pollution either. Carbon *mon*oxide is pollution: it kills you if you breathe enough of it. But carbon *di*oxide, carbon with two oxygen atoms, can't do a blessed thing to you. If you're reading this indoors, you're breathing more CO_2 than you'll ever get outside. For generations, in fact, engineers said that an engine burned clean if it produced only water vapor and carbon dioxide.

Here's the catch: that engine produces a *lot* of CO_2. A gallon of gas weighs about eight pounds. When it's burned in a car, about five and a half pounds of carbon, in the form of carbon dioxide, come spewing out the back. It doesn't matter if the car is a 1958 Chevy or a 1998 Saab. And no filter can reduce that flow—it's an inevitable by-product of fossil-fuel combustion, which is why CO_2 has been piling up in the atmosphere ever since the Industrial Revolution. Before we started burning oil and coal and gas, the atmosphere contained about 280 parts CO_2 per million. Now the figure is about 360. Unless we do everything we can think of to eliminate fossil fuels from our diet, the air will test out at more than 500 parts per million fifty or sixty years from now, whether it's sampled in the South Bronx or at the South Pole.

This matters because, as we all know by now, the molecular structure of this clean, natural, common element that we are adding to every cubic foot of the atmosphere surrounding us traps heat that would otherwise radiate back out to space. Far more than even methane and nitrous oxide, CO_2 causes global warming—the greenhouse effect—and climate change. Far more than any other single factor, it is turning the earth we were born on into a new planet.

. . . For ten years, with heavy funding from governments around the world, scientists launched satellites, monitored weather balloons, studied clouds. Their work culminated in a long-awaited report from the UN's Intergovernmental Panel on Climate Change, released in the fall of 1995. The panel's 2,000 scientists, from every corner of the globe, summed up their findings in this dry but historic bit of understatement: "The balance of evidence suggests that there is a discernible human influence on global climate." That is to say, we are heating up the planet—substantially. If we don't reduce emissions of carbon dioxide and other gases, the panel warned, temperatures will probably rise 3.6° Fahrenheit by 2100, and perhaps as much as 6.3°.

You may think you've already heard a lot about global warming. But most of our sense of the problem is behind the curve. Here's the current news: the changes are already well under way. When politicians and businessmen talk about "future risks," their rhetoric is outdated. This is not a problem for the distant future, or even for the near future. The planet has already heated up by a degree or more. We are perhaps a quarter of the way into the greenhouse era, and the effects are already being felt. From a new heaven, filled with nitrogen, methane, and carbon, a new earth is being born. If some alien astronomer is watching us, she's doubtless puzzled. This is the most obvious effect of our numbers and our appetites, and the key to understanding why the size of our population suddenly poses such a risk.

STORMY AND WARM

What does this new world feel like? For one thing, it's stormier than the old one. Data analyzed last year by Thomas Karl, of the National Oceanic and Atmospheric Administration, showed that total winter precipitation in the United States has increased by 10 percent since 1900 and that "extreme precipitation events"—rainstorms that dumped more than two inches of water in twenty-four hours and blizzards—had increased by 20 percent. That's because warmer air holds more water vapor than the colder atmosphere of the old earth; more water evaporates from the ocean, meaning more clouds, more rain, more snow. Engineers designing storm sewers, bridges, and culverts used to plan for what they called the "hundred-year storm." That is, they built to withstand the worst flooding or wind that history led them to expect in the course of a century. Since that history no longer applies, Karl says, "there isn't really a hundred-year event anymore . . . we seem to be getting these storms of the century every couple of years." When Grand Forks, North Dakota, disappeared beneath the Red River in the spring of last year, some meteorologists referred to it as "a 500-year flood"—meaning, essentially, that all bets are off. Meaning that these aren't acts of God. "If you look out your window, part of what you

see in terms of weather is produced by ourselves," Karl says. "If you look out the window fifty years from now, we're going to be responsible for more of it."

Twenty percent more bad storms, 10 percent more winter precipitation—these are enormous numbers. It's like opening the newspaper to read that the average American is smarter by 30 IQ points. And the same data showed increases in drought, too. With more water in the atmosphere, there's less in the soil, according to Kevin Trenberth, of the National Center for Atmospheric Research. Those parts of the continent that are normally dry—the eastern sides of mountains, the plains and deserts—are even drier, as the higher average temperatures evaporate more of what rain does fall. "You get wilting plants and eventually drought faster than you would otherwise," Trenberth says. And when the rain does come, it's often so intense that much of it runs off before it can soak into the soil.

So—wetter and drier. *Different....*

The effects of ... warming can be found in the largest phenomena. The oceans that cover most of the planet's surface are clearly rising, both because of melting glaciers and because water expands as it warms. As a result, low-lying Pacific islands already report surges of water washing across the atolls. "It's nice weather and all of a sudden water is pouring into your living room," one Marshall Islands resident told a newspaper reporter. "It's very clear that something is happening in the Pacific, and these islands are feeling it." Global warming will be like a much more powerful version of El Niño that covers the entire globe and lasts forever, or at least until the next big asteroid strikes.

If you want to scare yourself with guesses about what might happen in the near future, there's no shortage of possibilities. Scientists have already observed large-scale shifts in the duration of the El Niño ocean warming, for instance. The Arctic tundra has warmed so much that in some places it now gives off more carbon dioxide than it absorbs—a switch that could trigger a potent feedback loop, making warming ever worse. And researchers studying glacial cores from the Greenland Ice Sheet recently concluded that local climate shifts have occurred with incredible rapidity in the past—18° in one three-year stretch. Other scientists worry that such a shift might be enough to flood the oceans with fresh water and reroute or shut off currents like the Gulf Stream and the North Atlantic, which keep Europe far warmer than it would otherwise be. (See "The Great Climate Flip-flop," by William H. Calvin, January *Atlantic*.) In the words of Wallace Broecker, of Columbia University, a pioneer in the field, "Climate is an angry beast, and we are poking it with sticks."

But we don't need worst-case scenarios: best-case scenarios make the point. The population of the earth is going to nearly double one more time. That will bring it to a level that even the reliable old earth we were born on would be hard-pressed to support. Just at the moment when we need everything to be working as smoothly as possible, we find ourselves inhabiting a new planet, whose carrying capacity we cannot conceivably estimate. We have no idea how much wheat this planet can grow. We don't know what its politics will be like: not if there are going to be heat waves like the one that killed more than 700 Chicagoans in 1995; not if rising sea levels and other effects of climate change create tens of millions of environmental refugees; not if a 1.5° jump in India's temperature could reduce the country's wheat crop by 10 percent or divert its monsoons....

We have gotten very large and very powerful, and for the foreseeable future we're stuck with the results. The glaciers won't grow back again anytime soon; the oceans won't drop. We've already done deep and systemic damage. To use a human analogy, we've already said the angry and unforgivable words that will haunt our marriage till its end. And yet we can't simply walk out the door. There's no place to go. We have to salvage what we can of our relationship with the earth, to keep things from getting any worse than they have to be.

If we can bring our various emissions quickly and sharply under control, we *can* limit the damage, reduce dramatically the chance of horrible surprises, preserve more of the biology we were born into. But do not underestimate the task. The UN's Intergovernmental Panel on Climate Change projects that an immediate 60 percent reduction in fossil-fuel use is necessary just to stabilize climate at the current level of disruption. Nature may still meet us halfway, but halfway is a long way from where we are now. What's more, we can't delay. If we wait a few decades to get started, we may as well not even begin. It's not like poverty, a concern that's always there for civilizations to address. This is a timed test, like the SAT: two or three decades, and we lay our pencils down. It's *the* test for our generations, and population is a part of the answer....

The numbers are so daunting that they're almost unimaginable. Say, just for argument's sake, that we decided to cut world fossil-fuel use by 60 percent—the amount that the UN panel says would stabilize world climate. And then say that we shared the remaining fossil fuel equally. Each human being would get to produce 1.69 metric tons of carbon dioxide annually—which would allow you to drive an average American car nine miles a day. By the time the population increased to 8.5 billion, in about 2025, you'd be down to six miles a day. If you carpooled, you'd have about three pounds of CO_2 left in your daily ration—enough to run a highly efficient refrigerator. Forget your computer, your TV, your stereo, your stove, your dishwasher, your water heater, your microwave, your water pump, your clock. Forget your light bulbs, compact fluorescent or not.

I'm not trying to say that conservation, efficiency, and new technology won't help. They will—but the help will be slow and expensive. The tremendous momentum of growth will work against it. Say that someone invented

a new furnace tomorrow that used half as much oil as old furnaces. How many years would it be before a substantial number of American homes had the new device? And what if it cost more? And if oil stays cheaper per gallon than bottled water? Changing basic fuels—to hydrogen, say—would be even more expensive. It's not like running out of white wine and switching to red. Yes, we'll get new technologies. One day last fall *The New York Times* ran a special section on energy, featuring many up-and-coming improvements: solar shingles, basement fuel cells. But the same day, on the front page, William K. Stevens reported that international negotiators had all but given up on preventing a doubling of the atmospheric concentration of CO_2. The momentum of growth was so great, the negotiators said, that making the changes required to slow global warming significantly would be like "trying to turn a supertanker in a sea of syrup."

There are no silver bullets to take care of a problem like this. Electric cars won't by themselves save us, though they would help. We simply won't live efficiently enough soon enough to solve the problem. Vegetarianism won't cure our ills, though it would help. We simply won't live simply enough soon enough to solve the problem.

Reducing the birth rate won't end all our troubles either. That, too, is no silver bullet. But it would help. There's no more practical decision than how many children to have. (And no more mystical decision, either.)

The bottom-line argument goes like this: The next fifty years are a special time. They will decide how strong and healthy the planet will be for centuries to come. Between now and 2050 we'll see the zenith, or very nearly, of human population. With luck we'll never see any greater production of carbon dioxide or toxic chemicals. We'll never see more species extinction or soil erosion. Greenpeace recently announced a campaign to phase out fossil fuels entirely by mid-century, which sounds utterly quixotic but could—if everything went just right—happen.

So it's the task of those of us alive right now to deal with this special phase, to squeeze us through these next fifty years. That's not fair—any more than it was fair that earlier generations had to deal with the Second World War or the Civil War or the Revolution or the Depression or slavery. It's just reality. We need in these fifty years to be working simultaneously on all parts of the equation—on our ways of life, on our technologies, and on our population.

As Gregg Easterbrook pointed out in his book *A Moment on the Earth* (1995), if the planet does manage to reduce its fertility, "the period in which human numbers threaten the biosphere on a general scale will turn out to have been much, much more brief" than periods of natural threats like the Ice Ages. True enough. But the period in question happens to be our time. That's what makes this moment special, and what makes this moment hard.

THE MANY FACES OF
the Future

Why we'll never have a universal civilization

By Samuel P. Huntington

Conventional Wisdom tells us that we are witnessing the emergence of what V.S. Naipaul called a "universal civilization," the cultural coming together of humanity and the increasing acceptance of common values, beliefs, and institutions by people throughout the world. Critics of this trend point to the global domination of Western-style capitalism and culture *(Baywatch,* many note with alarm, is the most popular television show in the world), and the gradual erosion of distinct cultures—especially in the developing world. But there's more to universal civilization than GATT and David Hasselhoff's pecs.

If what we mean by universal culture are the assumptions, values, and doctrines currently held by the many elites who travel in international circles, that's not a viable "one world" scenario. Consider the "Davos culture." Each year about a thousand business executives, government officials, intellectuals, and journalists from scores of countries meet at the World Economic Forum in Davos, Switzerland. Almost all of them hold degrees in the physical sciences, social sciences, business, or law; are reasonably fluent in English; are employed by governments, corporations, and academic institutions with extensive international connections; and travel frequently outside of their own countries. They also generally share beliefs in individualism, market economies, and political democracy,

From *Utne Reader,* May/June 1997, pp. 75–77, 102–103. Adapted from *The Clash of Civilizations and Remaking of World Order* by Samuel P. Huntington. © 1997 by Samuel P. Huntington. Reprinted by permission of Simon & Schuster.

which are also common among people in Western civilization. This core group of people controls virtually all international institutions, many of the world's governments, and the bulk of the world's economic and military organizations. As a result, the Davos culture is tremendously important, but it is far from a universal civilization. Outside the West, these values are shared by perhaps 1 percent of the world's population.

If a universal civilization is emerging, there should be signs of a universal language and religion. Nothing of the sort is occurring.

The argument that the spread of Western consumption patterns and popular culture around the world is creating a universal civilization is also not especially profound. Innovations have been transmitted from one civilization to another throughout history. But they are usually techniques lacking in significant cultural consequences or fads that come and go without altering the underlying culture of the recipient civilization. The essence of Western civilization is the Magna Carta, not the Magna Mac. The fact that non-Westerners may bite into the latter does not necessarily mean they are more likely to accept the former. During the '70s and '80s Americans bought millions of Japanese cars and electronic gadgets without being "Japanized," and, in fact, became considerably more antagonistic toward Japan. Only naive arrogance can lead Westerners to assume that non-Westerners will become "Westernized" by acquiring Western goods.

A slightly more sophisticated version of the universal popular culture argument focuses on the media rather than consumer goods in general. Eighty-eight of the world's hundred most popular films in 1993 were produced in the United States, and four organizations based in the United States and Europe—the Associated Press, CNN, Reuters, and the French Press Agency—

dominate the dissemination of news worldwide. This situation simply reflects the universality of human interest in love, sex, violence, mystery, heroism, and wealth, and the ability of profit-motivated companies, primarily American, to exploit those interests to their own advantage. Little or no evidence exists, however, to support the assumption that the emergence of pervasive global communications is producing significant convergence in attitudes and beliefs around the world. Indeed, this Western hegemony encourages populist politicians in non-Western societies to denounce Western cultural imperialism and to rally their constituents to preserve their indigenous cultures. The extent to which global communications are dominated by the West is, thus, a major source of the resentment non-Western peoples have toward the West. In addition, rapid economic development in non-Western societies is leading to the emergence of local and regional media industries catering to the distinctive tastes of those societies.

The central elements of any civilization are language and religion. If a universal civilization is emerging, there should be signs of a universal language and a universal religion developing. Nothing of the sort is occurring. Despite claims from Western business leaders that the world's language is English, no evidence exists to support this proposition, and the most reliable evidence that does exist shows just the opposite. English speakers dropped from 9.8 percent of the world's population in 1958 to 7.6 percent in 1992. Still, one can argue that English has become the world's lingua franca, or in linguistic terms, the principal language of wider communication. Diplomats, business executives, tourists, and the service professionals catering to them need some means of efficient communication, and right now that is largely in English. But this is a form of *intercultural* communication; it presupposes the existence of separate cultures. Adopting a lingua franca is a way of coping with linguistic and cultural differences, not a way of eliminating them. It is a tool for communication, not a source of identity and community.

The linguistic scholar Joshua Fishman has observed that a language is more likely to be accepted as a lingua franca if it is not identified with a particular ethnic group, religion, or ideology. In the past, English carried many of those associations. But more recently, Fishman says, it has been "de-ethnicized (or minimally ethnicized)," much like what happened to Akkadian, Aramaic, Greek, and Latin before it. As he puts it, "It is part of the relative good fortune of English as an additional language that neither its British nor its American fountainheads have been widely or deeply viewed in an ethnic or ideological context for the past quarter century or so." Resorting to English for intercultural communication helps maintain—

and, indeed, reinforce—separate cultural identities. Precisely because people want to preserve their own culture, they use English to communicate with people of other cultures.

A universal religion is only slightly more likely to emerge than a universal language. The late 20th century has seen a resurgence of religions around the world, including the rise of fundamentalist movements. This trend has reinforced the differences among religions, and has not necessarily resulted in significant shifts in the distribution of religions worldwide.

Of course, there have been increases during the past century in the percentage of people practicing the two major proselytizing religions, Islam and Christianity. Western Christians accounted for 26.9 percent of the world's population in 1900 and peaked at about 30 percent in 1980, while the Muslim population increased from 12.4 percent in 1900 to as much as 18 percent in 1980. The percentage of Christians in the world will probably decline to about 25 percent by 2025. Meanwhile, because of extremely high rates of population growth, the proportion of Muslims in the world will continue to increase dramatically and represent about 30 percent of the world's population by 2025. Neither, however, qualifies as a universal religion.

The argument that some sort of universal civilization is emerging rests on one or more of three assumptions: that the collapse of Soviet communism meant the end of history and the universal victory of liberal democracy; that increased interaction among peoples through trade, investment, tourism, media, and electronic communications is creating a common world culture; and that a universal civilization is the logical result of the process of global modernization that has been going on since the 18th century.

The first assumption is rooted in the Cold War perspective that the only alternative to communism is liberal democracy, and the demise of the first inevitably produces the second. But there are many alternatives to liberal democracy—including authoritarianism, nationalism, corporatism, and market communism (as in China)—that are alive and well in today's world. And, more significantly, there are all the religious alternatives that lie outside the world of secular ideologies. In the modern world, religion is a central, perhaps *the* central, force that motivates and mobilizes people. It is sheer hubris to think that because Soviet communism has collapsed, the West has conquered the world for all time and that non-Western peoples are going to rush to embrace Western liberalism as the only alternative. The Cold War division of humanity is over. The more fundamental divisions of ethnicity, religions, and civilizations remain and will spawn new conflicts.

The Real World

The civilizations shaping the new global order

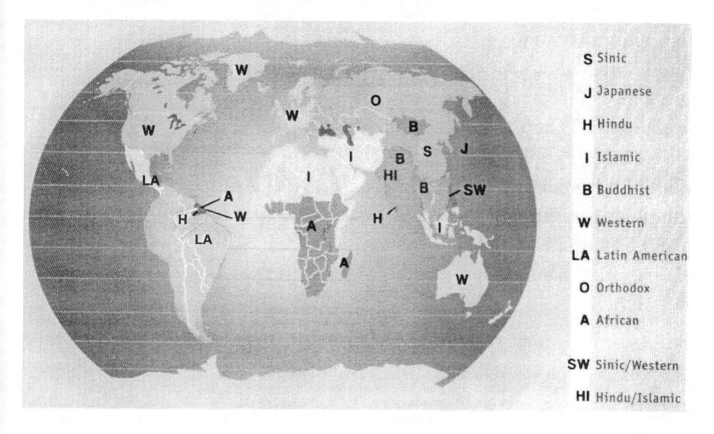

S Sinic
J Japanese
H Hindu
I Islamic
B Buddhist
W Western
LA Latin American
O Orthodox
A African

SW Sinic/Western
HI Hindu/Islamic

The new global economy is a reality. Improvements in transportation and communications technology have indeed made it easier and cheaper to move money, goods, knowledge, ideas, and images around the world. But what will be the impact of this increased economic interaction? In social psychology, distinctiveness theory holds that people define themselves by what makes them different from others in a particular context: People define their identity by what they are not. As advanced communications, trade, and travel multiply the interactions among civilizations, people will increasingly accord greater relevance to identity based on their own civilization.

Those who argue that a universal civilization is an inevitable product of modernization assume that all modern societies must become Westernized. As the first civilization to modernize, the West leads in the acquisition of the culture of modernity. And as other societies acquire similar patterns of education, work, wealth, and class structure—the argument runs—this modern Western culture will become the universal culture of the world. That significant differences exist between modern and traditional cultures is beyond dispute. It doesn't necessarily follow, however, that societies with modern cultures resemble each other more than do societies with traditional cultures. As historian Fernand Braudel writes, "Ming China . . . was assuredly closer to the France of the Valois than the China of Mao Tse-tung is to the France of the Fifth Republic."

Yet modern societies could resemble each other more than do traditional societies for two reasons. First, the increased interaction among modern societies may not generate a common culture, but it does facilitate the transfer of techniques, inventions, and practices from one society to another with a speed and to a degree that were impossible in the traditional world. Second, traditional society was based on agriculture; modern society is based on industry. Patterns of agriculture and the social structure that goes with them are much more dependent on the natural environment than are patterns of industry. Differences in industrial organization are likely to derive from differences in culture and social structure rather than geography, and the former conceivably can converge while the latter cannot.

Modern societies thus have much in common. But do they necessarily merge into homogeneity? The argument that they do rests on the assumption that modern society must approximate a single type, the Western type. This is a totally false assumption. Western civilization emerged in the 8th and 9th centuries. It did not begin to modernize until the 17th and 18th centuries. The West was the West long before it was modern. The central characteristics of the West—the classical legacy, the mix of Catholicism and Protestantism, and the separation of spiritual and temporal authority—distinguish it from other civilizations and antedate the modernization of the West.

In the post–Cold War world, the most important distinctions among people are not ideological, political, or economic. They are

In today's world, the most important distinctions among people are not ideological, political, or economic. They are cultural. People identify with cultural groups: tribes, ethnic groups, religious communities, nations, and civilizations.

cultural. People and nations are attempting to answer a basic human question: Who are we? And they are answering that question in the traditional way, by reference to the things that mean the most to them: ancestry, religion, language, history, values, customs, and institutions. People identify with cultural groups: tribes, ethnic groups, religious communities, nations, and, at the broadest level, civilizations. They use politics not just to advance their interests but also to define their identity. We know who we are only when we know who we are not, and often only when we know who we are against.

Nation-states remain the principal actors in world affairs. Their behavior is shaped, as in the past, by the pursuit of power and wealth, but it is also shaped by cultural preferences and differences. The most important groupings are no longer the three blocs of the Cold War but rather the world's major civilizations (*See* map):

S Sinic
All scholars recognize the existence of either a single distinct Chinese civilization dating back at least to 1500 B.C., or of two civilizations—one succeeding the other—in the early centuries of the Christian epoch.
J Japanese
Some scholars combine Japanese and Chinese culture, but most recognize Japan as a distinct civilization, the offspring of Chinese civilization, that emerged between A.D. 100 and 400.
H Hindu
A civilization—or successive civilizations—has existed on the Indian subcontinent since at least 1500 B.C. In one form or another, Hinduism has been central to the culture of India since the second millennium B.C.
I Islamic
Originating on the Arabian peninsula in the 7th century A.D., Islam spread rapidly across North Africa and the Iberian Peninsula and also eastward into central Asia, the Indian subcontinent, and Southeast Asia. Many distinct cultures—including Arab, Turkic, Persian, and Malay—exist within Islam.
W Western
The emergence of Western civilization—what used to be called Western Christendom—is usually dated at about 700 A.D. It has two main components, in Europe and North America.
LA Latin American
Latin America, often considered part of the West, has a distinct identity. It has had a corporatist, authoritarian culture, which Europe had to a much lesser degree and North America did not have at all. Europe and North America both felt the effects of the Reformation and have combined Catholic and Protestant cultures, while Latin America has been primarily Catholic. Latin American civilization also incorporates indigenous cultures, which were wiped out in North America.
O Orthodox
This civilization, which combines the Orthodox tradition of Christianity with the Slav cultures of Eastern Europe and Russia, has resurfaced since the demise of the Soviet Union.
A African
There may be some argument about whether there is a distinct African civilization. North Africa and the east coast belong to Islamic civilization. (Historically, Ethiopia constituted a civilization of its own.) Elsewhere, imperialism brought elements of Western civilization. Tribal identities are pervasive throughout Africa, but Africans are also increasingly developing a sense of African identity. Sub-Saharan Africa conceivably could cohere into a distinct civilization, with South Africa as its core.
B Buddhist
Beginning in the first century A.D., Buddhism was exported from India to China, Korea, Vietnam, and Japan, where it was assimilated by the indigenous cultures and/or suppressed. What can legitimately be described as a Buddhist civilization, however, does exist in Sri Lanka, Burma, Thailand, Laos, Cambodia; and Tibet, Mongolia, and Bhutan. Overall, however, the virtual extinction of Buddhism in India and its incorporation into existing cultures in other major countries means that it has not been the basis of a major civilization. (Modern India represents a mix of Hindu and Islamic civilizations, while the Philippines is a unique Sinic-Western hybrid by virtue of its history of Spanish, then American rule.)

As Asian and Muslim civilizations begin to assert the universal relevance of *their* cultures, Westerners will see the connection between universalism and imperialism and appreciate the virtues of a pluralistic world. In order to preserve Western civilization, the West needs greater unity of purpose. It should incorporate into the European Union and NATO the western states of central Europe; encourage the Westernization of Latin America; slow the drift of Japan away from the West and toward accommodation with China; and accept Russia as the core state of Orthodoxy and a power with legitimate interests.

The main responsibility of Western leaders is to recognize that intervention in the affairs of other civilizations is the single most dangerous source of instability in the world.

The main responsibility of Western leaders is to recognize that intervention in the affairs of other civilizations is the single most dangerous source of instability in the world. The West should attempt not to reshape other civilizations in its own image, but to preserve and renew the unique qualities of its own civilization.

Samuel P. Huntington is Albert J. Weatherhead III University Professor at Harvard University.

Life Is Unfair: Inequality in the World

by Nancy Birdsall

Exactly 150 years after publication of the *Communist Manifesto,* inequality looms large on the global agenda. In the United States, the income of the poorest 20 percent of households has declined steadily since the early 1970s. Meanwhile, the income of the richest 20 percent has increased by 15 percent and that of the top 1 percent by more than 100 percent. In Asia, the high concentrations of wealth and power produced by strong growth have been given a new label: crony capitalism. In Russia and Eastern Europe, the end of communism has brought huge income gaps. In Latin America, wealth and income gaps—already the highest in the world in the 1970s—widened dramatically in the 1980s, a decade of no growth and high inflation, and have continued to increase even with the resumption of growth in the 1990s.

At the global level, it seems that the old saw is still correct: The rich get richer and the poor get children. The ratio of average income of the richest country in the world to that of the poorest has risen from about 9 to 1 at the end of the nineteenth century to at least 60 to 1 today. That is, the average family in the United States is 60 times richer than the average family in Ethiopia. Since 1950, the portion of the world's population living in poor countries grew by about 250 percent, while in rich countries the population increased by less than 50 percent. Today, 80 percent of the world's population lives in countries that generate only 20 percent of the world's total income (see charts on next page).

Ironically, inequality is growing at a time when the triumph of democracy and open markets was supposed to usher in a new age of freedom and opportunity. In fact, both developments seem to be having the opposite effect. At the end of the twentieth century, Karl Marx's screed against capitalism has metamorphosed into post-Marxist angst about an integrated global market that creates a new divide between well-educated élite workers and their vulnerable unskilled counterparts, gives capital an apparent whip hand over labor, and pushes governments to unravel social safety nets. Meanwhile, the spread of democracy has made more visible the problem of income gaps, which can no longer be blamed on poor politics—not on communism in Eastern Europe and the former Soviet Union nor on military authoritarianism in Latin America. Regularly invoked as the handmaiden of open markets, democracy looks more and more like their accomplice in a vicious circle of inequality and injustice.

Technology plays a central role in the drama of inequality, and it seems to be making the situation worse, not better. The television and the airplane made income gaps more visible, but at least the falling costs and increasing accessibility of communication and transportation reduced actual differences in living standards. The computer, however, represents a whole new production process and creates a world in which the scarce commodities commanding the highest economic returns are information and skills. As information technology spreads (see chart "Unplugged: The Rich and the Poor of the Information Age"), will some fundamental transformation take place that permanently favors an agile and educated minority? Or are we simply in the midst of a prolonged transition, analogous to the one that fooled Marx, to a postindustrial world with an expanded information age middle class?

In fact, postwar progress toward free trade and free politics has been dominated by the expectation of "convergence"—that those now lagging behind, whether na-

NANCY BIRDSALL *is executive vice-president of the Inter-American Development Bank.*

Reprinted with permission from *Foreign Policy,* Summer 1998, pp. 76-93. © 1998 by the Carnegie Endowment for International Peace.

tions or groups within nations, will inevitably catch up. But what happens if that expectation fails to materialize? How would the end of convergence affect conduct among nations? Can open and democratic societies endure the strains of high inequality? Will inequality become a lightning rod for dangerous populist rhetoric and self-defeating isolation? Even as we talk of disappearing national borders, is the worldwide phenomenon of inequality creating instead a new set of global rifts?

WHAT ARE THE FACTS?

In the United States, where the impact of global integration and the information revolution is probably the most widespread, the facts are sobering. Income inequality in the United States is increasing, not only because of gains at the top, but more disturbingly, because of losses at the bottom (see box on next page). The average wage of white male high-school graduates fell 15 percent from 1973 to 1993, and the number of men aged 25 to 54 years earning less than $10,000 a year grew. Possibly for the first time in the nation's history, educational gains may be reinforcing rather than offsetting income inequality: Higher education has become a prerequisite for economic success, but because access to it depends on family income, the poor are at a distinct disadvantage.

Elsewhere, the forces of change—whether the spread of capitalism and global integration, or simply the march of technological progress—have at best reinforced, or at worst exacerbated, high inequality. In Latin America, the ratio of income of the top 20 percent of earners to the bottom is about 16 to 1 (almost 25 to 1 in Brazil, probably the world's most unequal country, compared with about 10 to 1 in the United States and about 5 to 1 in Western Europe). The wage gap between the skilled and the unskilled increased in this decade by more than 30 percent in Peru, 20 percent in Colombia, and nearly 25 percent in Mexico. Ironically, these were the countries with the greatest wage increases.

The situation is less clear but no more heartening in other parts of the world. In China, the liberalization of agricultural and other markets has spurred growth, yet large segments of the population have been left behind. In the affluent countries of northern Europe, increases in poor immigrant populations, growing unemployment, and the stricter fiscal demands of the Maastricht Treaty are undermining the historic commitment of these nations to address inequality.

Economic growth (and for that matter lack of growth) in the postwar era has seemed everywhere to be accompanied by persistent, often high, and sometimes worsening, inequality within countries. The few exceptions include Hong Kong, Korea, Malaysia, Singapore, Taiwan, and Thailand in East Asia—where several decades of extraordinarily high growth saw low and even declining levels of inequality. Even when income distribution does improve, it does so painfully slowly. A study that examined income distribution in 45 countries found that only eight, including Japan and three European nations, showed any improvement in income distribution over any time period, and this progress was minimal.

The idea of convergence of income across countries—that poor countries will ultimately catch up to the rich—has also gone by the wayside. China and India illustrate the difficulties of arguing for the eventual convergence in income of poor and rich countries. For the last 15 years, these two nations have experienced faster income growth than the rich countries, yet it would take them almost a century of constant growth at rates higher than those in today's industrialized countries just to reach current U.S. income levels.

While Rich Nations Get Richer...

Estimated GDP (in 1980 dollars)

RICH
POOR

56% of World GDP 44% of World GDP

1800
World GDP: 229,095,000,000

83% of World GDP 17% of World GDP

1950
World GDP: 2,626,407,000,000

20% of World GDP 80% of World GDP

1995
World GDP: 17,091,479,000,000

the Poor Population Continues to Grow

World Population

RICH
POOR

74% of World Population 26% of World Population

1800
World Population: 944,000,000

67% of World Population 33% of World Population

1950
World Population: 2,417,000,000

20% of World Population 80% of World Population

1995
World Population: 5,716,000,000

Sources: 1984 World Development Report (Washington: World Bank, 1984), UN World Population Prospects, The 1994 Revision (New York: United Nations, 1994), and author's calculations.

WHAT MAKES THE WORLD UNFAIR?

Inequality is nobody's fault and cannot be fixed in our lifetime. Understanding its causes helps us determine what can be done about it and what might actually make it worse. But what are the causes of inequality across and within countries?

History

Inequality begets inequality. Therefore, history matters. Consider Latin America. The combination of mineral wealth, soils and climate suitable for sugar production, and imported slave labor, or conquered indigenous labor, helped produce two castes: large landowners and politically unarmed workers. In 1950, just 1.5 percent of farm owners in Latin America accounted for 65 percent of all agricultural land; unequal land distribution, then the highest in the world, has risen since. Wealth in natural resources invited concentration of income. History and politics subsequently conspired to produce economic and institutional arrangements that have perpetuated that concentration.

The Poor's Rational Decisions

A source of some inequality lies in predictable human behavior. Because the rich and educated marry each other, as do the poor and uneducated, family income gaps widen. Rational differences in human behavior between the rich and the poor also add to inequality. In many countries, the poor are members of ethnic or racial groups. If they suffer discrimination in the labor market, their gains from schooling and job skills are small, prompting them to respond by investing little in these income-producing assets. But by handicapping their children economically, the sum of these parents' sensible decisions can lock society as a whole into another generation of inequality.

The same happens with fertility. For good reasons, the poor and the less educated tend to have more children. As is to be expected in these poor households, spending per child on nutrition, health, and education declines with the number of children. Less spending on the children of the poor creates a new generation in which the number of unskilled workers grows faster than skilled workers, bringing down wages for the former and thus perpetuating the cycle. In societies with high population growth (Africa, for example), the education levels of mothers are a major determinant of fertility rates. As poorly educated mothers have many more children than their well-educated sisters, the cycle of high fertility and poor opportunities for their children continues, helping perpetuate inequality in their societies.

East Asia provides an example of how fertility change can break this vicious cycle. A dramatic decline in infant mortality in the region after World War II was followed in the early 1960s by an equally dramatic, and very rapid, decline in fertility—which spread quickly to the poor and less educated. These changes had major demographic consequences: In Korea, for example, the percent of the population in the prime working ages of 25 to 59 rose from less than 35 percent to close to 50 percent between 1965 and 1990, while the percent of children between ages 0 and 14 fell. With this demographic growth in the work force came dramatic increases in savings and investment (from about 15 to 35 percent in

The Not-So-Great Leveler

Income inequality has been worsening in the United States since the early 1970s. Before 1973, all groups enjoyed healthy income gains, particularly the middle class. However, since 1979, the rich have gained far more than the middle class, while the income of the poor has fallen in absolute terms.

A recent study found that the richest 1 percent of families (average annual income: $800,000 for a family of four) captured 70 percent of the total rise in family income in the United States between 1977 and 1989.

America has always been considered a land of opportunity, where parents believe in the possibility of a "better life" for their children. Does upward mobility mean growing inequality is unimportant, since, with effort and a bit of luck, those at the bottom can still move toward the top?

Not exactly. First of all, we know that historically high rates of mobility in the United States resulted from fast economic growth that was shared across the board. Today, growth benefits the wealthy far more than the middle class, let alone the poor.

Second, although many families do move from one income category to another over time, individuals have suffered larger downward, and smaller upward, income changes since the 1970s—with the exception of the rich, whose earnings have jumped dramatically.

Third, though education has always been seen as the great leveler, it now reinforces initial advantages instead of compensating for initial handicaps. Because most elementary and secondary schools fail to provide students with basic skills, they no longer effectively make up for deep inequalities among children—in terms of their home environments, parents' help and expectations, preschool experiences, and out-of-school activities.

In addition, the high-school diploma—once a ticket to the job market for the working class—has lost its value. U.S. employers now insist on a college education as a measure of competence. And the children of the rich have always been more likely to go on to college. In 1995, 83 percent of high-school graduates from the wealthiest families (the top 20 percent of all households) enrolled in college, compared with 34 percent from the poorest (the bottom 20 percent).

So, if America is to remain the land of opportunity, elementary and secondary education must work for the poor. Otherwise, inequality of income will come to reflect not just differences in motivation, work effort, and sheer luck among players in a fair game, but different rules for rich and poor.

—*N.B.*

Korea and Indonesia) that helped fuel growth. Compared with those of other regions, East Asia's private and household savings and investment rates were especially high—including among poor households that invested heavily in the more affordable education of their fewer children.

Prosperity

Prosperity can produce inequality—an outcome that, within limits, may be economically justifiable. After all, some inequality may encourage innovation and hard work. Newfound inequality in China and in the economies of Eastern Europe may simply mean that new economic incentives are not only inducing growth but also creating opportunities for some individuals to excel and profit.

But the market reforms that bring prosperity also may not give all players an equal shot at the prize. In the short run, privatization and public-sector downsizing will penalize some workers; and open trade, because it hurts formerly protected industries and makes their inefficiencies unsustainable, can lead to wage reductions and higher unemployment. If corruption infects the privatization process, as in Russia, such reforms will provide windfalls to insiders. More insidious for the poor over the long run are the effects of reforms on the value of assets. During the Latin American debt crisis of the 1980s, many high-income citizens of indebted countries were able to store most of their financial assets abroad, even as their governments (and thus, their fellow taxpayers) assumed the bad debts incurred by enterprises either owned or controlled by the rich. Today's lower inflation and more realistic exchange rates mean dollar accounts held abroad can now buy more at home. Similarly, well-connected individuals in emerging markets who had previously profited from cheap credit, subsidized prices for hard foreign currency, or government regulatory exceptions (say, on the use of urban land) benefited again, as economic reforms raised the market value of assets that they had been able to acquire at low cost.

Bad Economic Policy

The most avoidable and thus most disappointing source of inequality are policies that hamper economic growth and fuel inflation—the most devastating outcome of all for the poor. Most populist programs designed to attract the political support of the working class hurt workers in the long run. When financed by unsustainable fiscal largesse, they bring the inflation or high interest rates that exacerbate inequality. Inflation worsens inequality because the poor are forced to hold money and cannot acquire the debts that inflation devalues. High interest rates, driven by unsustainable public debt, crowd out investments and jobs in small and medium enterprises, while encouraging easy gains in government bonds for those with plenty of money. Price controls, usually imposed on the products most consumed by the poor, often lead to their disappearance from stores, as they are hoarded and resold at higher prices. The imposition of a minimum wage temporarily benefits those who have formal jobs but makes it harder for the unemployed to find work. Finally, regulatory privileges, trade protection, and special access to cheap credit and foreign exchange—all bad economic policies—will inevitably increase the profits of a wealthy minority. For all these reasons, IMF-style reforms, often attacked for hurting the poor majority, are key to ending corrupt practices that usually benefit only a few.

Bad policy also includes what governments fail to do. Failure to invest in the education and skills of the poor is a fundamental cause of inequality. When adequate education does not reach enough of any population, educated workers become scarce, and employers compete for them by offering higher wages. The widening wage gap between college graduates and others in the United States indicates that the demand for graduates still exceeds the supply, feeding inequality. In Brazil, during the 1970s, the salaries of scarce university graduates rose rapidly, worsening wage inequality. In contrast, wage differences in Korea between those with university education and their less-educated colleagues fell, as more and more students completed secondary school and attended universities. In fact, above-average spending on education characterizes each of the few countries that have managed high growth with low inequality in the postwar period.

TEMPTING AND DANGEROUS REMEDIES

Paradoxically, the rhetoric of fairness can encourage policies that worsen global and local inequalities. Some examples of these self-defeating policies include:

Protectionism

Protection from global competition is a dangerous nonremedy, whether it involves import barriers, high import tariffs, or currency controls. Developing countries that have been most open to trade have had the fastest growth, reducing global inequality; those least integrated into global markets, such as many African economies, have remained among the world's poorest. Historically, the same pattern holds. Those countries that aggressively sought commercial links to the outside world—Japan, beginning in the Meiji Era, and the East Asian countries after World War II—whether via technology licensing, openness to foreign investment or an export push, have had the fastest growth. Trade (along with mass migration) explains most of the convergence in income among the countries of Europe and between them and the United States in the late nineteenth century. Convergence of incomes in Europe stalled as economic links disintegrated from 1914 to 1950 and then

resumed in force in the postwar period, when European economies became more integrated.

But does global integration create worsening inequality within countries, rich and poor alike? The growing wage gap in the United States coincides with increasing imports from developing countries that have large pools of unskilled labor. But most research shows that technology is more to blame than trade for most of the U.S. wage gap: Few U.S. workers (probably less than 5 percent) are in industries competing with low-wage goods from developing countries, and the wages of workers without a high-school diploma have fallen as much if not more in nontrade as in trade industries. True, more subtle forces are also at play—for example, the ability of firms to threaten to move jobs overseas may be undermining American unions. But a recourse to protectionism would almost surely hurt poor consumers more than it would help low-skilled workers.

Growing wage inequality is associated with increased trade and integration into global markets even in developing countries. One reason: Foreign capital inflows and higher domestic capital investment create new jobs for skilled workers, and skilled workers' wages then rise faster than average wages. But the bottom line is that international trade and open markets are less of a problem than worldwide changes in the technology of production that favor skilled workers everywhere.

Indeed, increases in trade and economic integration in poor countries, though associated with high wage inequality, may actually reduce inequality of income and consumption. There are two possible reasons: First, as obstacles to imports fall and price competition intensifies, prices drop—a boon for the poor, who use most of their income for consumption. Second, trade liberalization and open markets in general weaken the unfair advantages enjoyed by the rich and connected,

undermining the economic privileges and monopolies (reflected in wealth not wage gaps) that otherwise perpetuate high inequality.

Special Worker Entitlements

President Franklin Roosevelt's New Deal legislation set countrywide wage rates and labor standards for U.S. workers during the 1930s depression. Could a global minimum wage and global labor standards force up wages of the unskilled in poor countries, reducing in-country and worldwide wage gaps?

Advocates of a global New Deal have a point: Property rights remain elaborately protected in the complex codes of international trade agreements, while labor rights remain unacknowledged. Almost all countries can agree on some standards of behavior: the prohibition of slavery and debt bondage, assurance of a reasonable measure of safety in the workplace, a guarantee of rights to collective bargaining. The problem is that in developing countries, even standards that look noncontroversial (the prohibition of child labor, for example) may hurt those they are meant to protect. Most standards, including collective bargaining rights, which might increase wages in some firms, would affect only the usually small proportion of workers in the formal urban sector, thus increasing the gap between them and the majority of workers in rural and informal jobs. This result might do little harm if it helped a few without hurting others. But harm to many is likely because higher labor costs would then induce employers to invest in labor-saving technologies. The loss of new jobs would hurt mostly the poor and unskilled, whose main asset, after all, is their own labor.

Weaker infrastructure, unreliable judicial and regulatory regimes, and less education mean workers in developing countries produce less—even in well-equipped export firms. A global New Deal will only work when it is no longer needed: that is, when development progress in poor countries brings worker productivity—now as low as one-third the U.S. level—much closer to rich country levels. Only with convergence of worker productivity (and worker pay) across and within nations—as was the case across the United States in Roosevelt's time—could global rules on workers' rights help rather than hurt those now worse off.

Underpricing Public Services

For decades, governments have monopolized delivery of such public services as water, sanitation, electricity, and health care. They have also charged industries and households much less for these services than they actually cost—all in the name of helping the poor. Mountains of evidence demonstrate two virtually universal results:

First, in the face of any scarcity at all, prices that are too low reduce public supply of the underpriced

Unplugged: The Rich and Poor of the Information Age

Source: *1997 World Development Indicators* (Washington: World Bank, 1997).

service. India's public resources will never be sufficient to cover hospital care for its entire population. Short of privatization and adequate meter-based customer charges, electricity services in cities such as Lagos and Karachi will never catch up to demand, and "brownouts" (scheduled times without electricity) will continue.

Second, in the face of any kind of rationing, the poor will be last in line. The guarantee of free university education in Egypt and France, for example, is a false entitlement: Low-income families cannot afford the secondary schooling and tutoring needed to pass the university admissions test. In the Philippines, cheap electricity and water are available to powerful industrial interests, while the poor in the slums rely on jerrybuilt connections and buy bottled water at high prices from private trucks. In Mexico, for decades, general food subsidies benefited the urban middle class and created the incentives for food producers to bribe the politicians and government officials who controlled allocation of these subsidies. Meanwhile, the poor in rural areas and indigenous communities received little if any benefit.

Laissez-Faire Economics

Because trade protection, worker rights, and cheap public services can in fact hurt the poor does not mean the inequality problem can be left to the market. It is one mistake for government to restrict and distort market activity, reducing competition and perpetuating privileges; it is another to assume that market forces will automatically create opportunities for those at the margin.

Every society has some interest in avoiding the worst forms of inequality and injustice. That means in every society there is a role for government—not only to avoid the creation of unfair advantages for the rich and powerful, but to guarantee equal opportunities that market forces will naturally neglect, especially for those individuals who will otherwise be left on the sidelines. But this brings us to the question of what does work.

WHAT DOES WORK

The false remedies have short-run political appeal. Unfortunately, what does work takes time and patience.

Worker-Based Growth

Economic growth that is based on the intensive use of labor reduces income inequality—within as well as across countries. Oil-rich countries such as Venezuela and Nigeria have grown quickly at times, but the advantages of oil, bauxite, copper, and other mineral wealth can be short-lived. An abundance of natural resources invites concentration of income and discourages reliance on people, technology, and skills. Lack of natural resources, meanwhile, can be a hidden blessing, as the sustained and equitable growth of Switzerland and Hong Kong show. The labor-using growth of Taiwan and Singapore has reduced income gaps in those economies and

propelled their convergence toward industrial-country income levels over the last three decades.

Worker-based growth is best encouraged by avoiding the wrong policies—those that directly or indirectly raise employers' cost of labor. In countries such as Costa Rica and Ghana, where agriculture is labor-using and generates exports, the correction of overvalued exchange rates (which make imports cheaper for urban consumers) has increased rural jobs and income. In England, and now in Venezuela, relaxation of onerous severance-pay rules has encouraged hiring, inducing employers to substitute people and skills for energy and environmentally costly production inputs. The United States could also encourage more hiring of unskilled workers by reducing payroll tax rates and raising the threshold at which these rates are applied.

Education: The People's Asset

In the increasingly service-oriented global economy, education and skills represent a kind of wealth. They are key assets—and once acquired cannot be taken away, even from those who are otherwise powerless. Moreover, as education is shared more broadly, other assets such as land, stocks, or money will become less important.

It should be no surprise that the best predictor of a child's education is her parents' education and income. The poor, especially in developing countries, are last in line for education, as well as other publicly financed services. (Among 13 industrialized countries studied, only in Sweden and the Netherlands have educational opportunities become less stratified by socioeconomic class during this century.) So without a jump-start from public policy, the rich will become educated and stay rich, and the poor will not, perpetuating the inequality of assets and income across generations. In the United States, Europe, and in today's poor developing countries, the single best weapon against income equality is educating the poor.

Other mechanisms to distribute and redistribute assets, including land reform and microcredit programs, can also improve the pattern by which income is distributed. Pension reforms in Chile, Mexico, Peru, and elsewhere in Latin America have the potential to reduce the disequalizing characteristics of traditional pay-as-you-go systems and to create stakeholders in a market economy among those once excluded from its benefits. In the United States, the current arguments against "privatizing" social security reflect in part the myth that traditional systems are highly redistributive. Much evidence suggests that this is not necessarily true.

Democracy

Relatively low levels of income inequality in China, Cuba, and the former Soviet Union seem to suggest that authoritarian politics can at least produce equality. But in fact, it is the Western democracies that have over time generated sustained and equalizing economic growth. In economically unequal societies, the one-person, one-vote

system can offset the ability of the economically power-ful to perpetuate their privileges by buying political power. Perhaps this is why the market today sees greater risk of social disorder fed by political privilege in Indo-nesia than in its more democratic neighbors, such as Thailand and Korea. In today's global market, good poli-tics is good for equalizing growth.

Opportunities, Not Transfers

Although transfers and income subsidies to help the poor or reduce inequality make sense on paper, they are not long-run solutions. As declining spending on income-tied welfare programs in the United States shows, transfers and subsidies tied to low income are politically difficult to sus-tain. In fact, because the poor tend to be less organized and politically effective, redistributive programs often respond to more vocal entrenched interests, transforming these in-itiatives into a regressive tax rather than a safety net. For example, Senegal's program to cushion the effects of its economic reforms channeled state money to privileged groups within the system (civil servants and university graduates), while doing nothing to protect the urban and rural poor from rising consumer prices and unemploy-ment. Often, even those subsidies originally meant for the poor are quickly captured by the middle class and the rich, as ample public spending on university education in Cali-fornia suggests. Finally, the taxes that pay for large transfer programs are increasingly regressive. Because global com-petition puts pressure on governments to reduce taxes on footloose capital and highly mobile skilled labor, workers and consumers must bear more of the tax burden associ-ated with redistributive transfers, mainly in the form of growing payroll and sales taxes.

Public spending for the poor is more effective in the long run and politically more attractive when it enhances opportunities. But for such public spending to be effec-tive, two rules must prevail: First, spending should con-centrate on programs that reach everyone but benefit the poor most—in the United States, secondary education, child care, and immunizations. Second, the poor's access to opportunities should be improved not by directly pro-viding services, but by giving them tax breaks and vouchers for school, health, and housing, which would help them become effective consumers. In Chile, public spending on universal services and on voucher-like pro-grams ensures that more than 80 percent of all public health-care services and 60 percent of all education serv-ices go to the poorest 40 percent of household—raising the total income of the poorest one-fifth of households by nearly 50 percent.

Strengthen Domestic Policies for Global Integration

It bears repeating that the poorest countries of the world are those least integrated into global markets; the facts are so obvious that most poor developing countries have joined the bandwagon of unilateral trade opening. Since global markets reward skilled over unskilled labor, poor countries are adjusting to their growing wage inequality by increasing spending on education and training.

Then again, industrial countries are highly integrated among themselves but still relatively closed to poor country products and services. Rich countries could sig-nificantly ease global inequality by lifting their barriers to imports of agriculture and manufactured textiles. But progress against protection often implies visible short-run costs to communities and workers. Programs to re-train those workers hurt by opening markets in rich countries, and to top up their wages if they accept a lower-paying job, would reduce income inequality at home and indirectly around the world.

LEARNING TO LIVE WITH INEQUALITY

Any hopes for a quick fix to inequality are misplaced. Belying Marx, the biggest story of the last 150 years has been the emergence in the West of a prosperous and sta-ble middle class. But it took time. During a long transi-tion from agriculture to industry, changes in production and in the structure of employment caused wrenching inequality. Much inequality today may be the natural outcome of what is an analogous transition from an in-dustrial to an information age.

Still, there is no reason to despair. Some inequality is healthy and will speed the transition. The rapidly grow-ing wages of the educated and skilled are making edu-cation and training much more attractive personal investments. As more people get greater access to edu-cation, their relative income advantage over the unskilled will decline. Meanwhile, the high cost of skilled workers should eventually induce technological change that relies more on unskilled labor, increasing the demand for workers with less training.

More fundamentally, people may care less about their current ranking in a static picture of global income dis-tribution than about just and fair access to a better future, especially for their children. In an unequal world, good opportunities represent fair rules and matter at least as much as current status. Greater opportunities—which can be delivered today—are a better guarantee of a so-cially coherent global community than improved distri-bution tomorrow.

The real danger is that growing inequality may become a lightning rod for populist rhetoric and self-defeating isolation. It would be unfortunate if such tempting but false remedies eclipsed the more promising policies—interna-tional and domestic—that can help the world manage the long transition to a less-divided postindustrial future.

WANT TO KNOW MORE?

For a thoughtful treatment of equity issues, consult Gosta Esping-Andersen's *The Three Worlds of Welfare*

Capitalism (Princeton: Princeton University Press, 1990). For a discussion of convergence—whether poor countries are catching up to their rich counterparts—see Jeffrey Williamson's **"Globalization, Convergence, and History"** (*Journal of Economic History*, June 1996) and Lant Pritchett's **"Forget Convergence: Divergence, Past, Present, and Future"** (*Finance and Development*, June 1996). Covering it all in a tour de force is David Landes' *The Wealth and Poverty of Nations* (New York: W.W. Norton & Company, 1998). Readers interested in more on inequality in the United States should see Daniel McMurrer and Isabel Sawhill's *Getting Ahead: Economic and Social Mobility in America* (Washington: Urban Institute Press, 1998) and Paul Krugman's **"The Right, the Rich, and the Facts: Deconstructing the Income Distribution Debate"** (*American Prospect*, Fall 1992). For more on income inequality in other parts of the world, refer to Michael Bruno, Martin Ravallion, and Lyn Squire's working paper, *Equity and Growth in Developing Countries: Old and New Perspectives on the Policy Issues* (Washington: World Bank, 1996) and Nancy Birdsall, David Ross, and Richard Sabot's **"Inequality and Growth Reconsidered: Lessons from East Asia"** (*World Bank Economic Review*, September 1995). For essays on reconciling growth and equity objectives, see Birdsall, Sabot, and Carol Graham, eds., *Beyond Trade-Offs: Market Reforms and Equitable Growth in Latin America* (Washington: Brookings Institution and Inter-American Development Bank, 1998, forthcoming). For views on the impact of trade on wage inequality and income distribution, consult William Cline's *Trade and Income Distribution* (Washington: Institute for International Economics, 1997); Dani Rodrik's *Has Globalization Gone Too Far?* (Washington: Institute for International Economics, 1997); Adrian Wood's *North-South Trade, Employment & Inequality* (Cambridge: Oxford University Press, 1995); and Ethan Kapstein's *"Workers and the World Economy"* (*Foreign Affairs*, May/June 1996). For perspectives on child labor, consult Christiaan Grootaert and Ravi Kanbur's *Child Labor, A Review* (Washington: World Bank, 1995). Finally, Estelle James offers the single best assessment of pension systems in *Averting the Old Age Crisis* (Washington: World Bank, 1994) and Martin Feldstein argues for individual accounts in **"The Pension Crisis: The Case for Privatization"** (*Foreign Affairs*, July/August 1997).

World Prisms

The Future of Sovereign States and International Order

BY RICHARD FALK

A s this century closes, the contradictory organizational energies associated with globalization and fragmentation are mounting concerted attacks on the primacy of the sovereign, territorial state as the sole building block of world order. To begin with, transnational social forces seem on the verge of forming some kind of global civil society over the course of the next several decades, providing a foundation for the project of "global democracy." Also significant is the resurgence of religion, and closely linked, the rise of civilizational consciousness.

At the same time, the resilience of the state and its twin, the ideology of nationalism, strongly suggest that we have yet to experience the definitive waning of the state system, which is the form of world order that has dominated political imagination and history books for several centuries. And let us not overlook, in this preliminary examination of the world order, the potential of regionalism, which is often underestimated. Our dualistic mental habits lead many of us to think only of "states" and "the world," which involves comparing the most familiar part of our experience to an imagined whole while excluding from consideration all other possibilities.

Several salient issues warrant attention. Given the potent dynamic of economic globalization, how can market forces become effectively regulated in the future? The mobility of capital and the relative immobility of labor will challenge governments to balance their interest in promoting trade and profits against their concern with the well-being of their citizenry. At the same time, economic globalization and the information revolution, with their accompanying compression of time and space, could encourage an emerging political globalization; the processes and institutional and ethical consequences associated with this transformation

RICHARD FALK is Albert G. Milbank Professor of International Law and Practice at Princeton University.

have many ramifications for the future of a globalized international community. Within this changing global milieu, world cities are becoming political actors that form their own networks of transnational relationships that are producing a new layer of world order.

Other lines of inquiry point to the uncertain nature of international institutions in today's world. Is there a crucial role for regional institutions as a halfway house between utopian globalism and outmoded statism? Also at issue is whether the current eclipse of the United Nations is merely a temporary phenomenon associated with the high incidence of civic violence, or rather a more durable development that reflects the peculiarities of the current phase of peace and security issues dominated by civil wars and ethnic strife. Are the main political actors, especially states, adapting their roles in response to new challenges and realities, or are they being superseded and outflanked by alternative problem-solving and institutional frameworks? What is the impact of the particular style and substance of global leadership provided by the United States, and is this likely to change due to internal developments, lessons learned, and external challenges?

Building Pressures

These trends will exert pressure on existing institutions, creating receptivity and resistance to various proposals for institutional

innovation, as well as encouraging a variety of regressive withdrawals from interstate cooperation. Perhaps the most ominous of these trends relates to the pressure of an expected population increase of more than two billion over the next two decades, more than 90 percent of which will be concentrated in developing countries. Such a pattern will impact many political arrangements and will challenge the adequacy of food and freshwater supplies in many settings that are already economically disadvantaged. Comparably serious concerns relate to the impacts of greenhouse gas emissions on climate change, deforestation and desertification, the extinction of species, ozone depletion, and the further spread, development, and retention of weapons of mass destruction. Such trends suggest that existing managerial and adaptive capacities will be badly overstretched, thresholds of ecological and social balance will likely be crossed, and tensions and conflicts will abound. The increased incidence of conflicts will prompt contradictory forms of reliance on hyper-modern and primitive types of coercion—that is, on super-smart weaponry of great technical sophistication and on terrorist violence. Both types of violence deeply challenge basic assumptions about legal, moral, and political limits on conflict.

Against such an ominous background, it is important to identify several potentially promising developments that could mitigate,

From *Harvard International Review*, Summer 1999, pp. 30-35. © 1999 by Harvard International Review. Reprinted by permission.

if not overcome, these mounting dangers. None of these developments is free of ambiguity, and the overall prospect of the future is embedded in the fluidity of the historical present.

The Eclipse of the UN

Ever since its founding in 1945, many of the hopes for a more peaceful and benign world have reflected confidence in the United Nations. The United Nations was created as a response to World War II in a climate of resolve to erase the memories of failure associated with the League of Nations. The new organization was promoted as embodying a new approach to world order based on the commitment of leading states to establish and enact "collective security." With the onset of the Cold War, this undertaking by leading states to ground global security upon the collective mechanisms of the United Nations became untenable, and balance-of-power politics was retrofitted to serve the security needs of bipolar conflict in the nuclear age. Although the United Nations managed to accomplish many useful tasks on behalf of the peoples of the world, including a variety of peace-keeping ventures at the edges of world politics, it was sidelined in relation to its central peace-and-security mission by the effects of East-West gridlock. When Mikhail Gorbachev came to power in Moscow in the mid-1980s, a flurry of UN activity ensued, enabling the organization to play a leading role in the resolution of a series of regional conflicts, including those in Afghanistan, El Salvador, Angola, Cambodia, Iran, and Iraq. This suggested a bright future for the organization when and if the superpowers tempered their opposition to each other.

After the surprisingly abrupt end of the Cold War in 1989, there emerged a strong expectation that a golden age for the United Nations lay just beyond the horizon. The Gulf War of 1991 confirmed this optimistic view for many observers of the global scene, demonstrating for the first time that the Security Council could organize an effective collective response to aggression, precisely along the lines envisaged by the drafters of the UN Charter so long ago. It should be noted, however, that this reinvigorated United Nations also aroused concern in some quarters, as some argued that the Security Council was becoming a geopolitical instrument in the hands of the United States and its allies. With the restoration of Kuwaiti sovereignty, the debate about the benefits and burdens of UN potency reached its climax, and was soon over-shadowed in the mid-1990s by a revived sense of futility, initially in reaction to Somalia, but most definitively with respect to ethnic cleansing in Bosnia and genocide in Rwanda. It then became evident that the United Nations had

File Photo

Alternatives to the United Nations as a global security organization may be needed.

been used as a convenient mobilizing arena in the specific setting of strategic interests at risk in the Gulf Crisis. In contrast, where strategic interests were trivial or not present—as was the case in Somalia, Rwanda, and Bosnia—the political will of the Permanent Five was far too weak to support effective forms of humanitarian intervention under UN auspices.

Arguably, the United Nation's military role had been carefully confined, reflecting considerations of prudence and legal doctrine, to addressing warfare between states. When established, the organization was endowed with neither the competence nor the capability to respond to matters of civil strife. Nevertheless, neither governments nor the media made such a distinction in the early 1990s. Unable to meet these new demands, the United Nations was seriously discredited and once again sidelined in matters of peace and security. The new approach to global security at the end of the 1990s seems to be a mixture of old-fashioned geopolitics—that is, unilateralism by the leading military power—and coalition diplomacy under the aegis of NATO, as seen in this year's Kosovo intervention. If collective action on a world community scale has been seen as a world-order goal since World War I, then it would seem that the century is ending on a regressive note; a retreat to traditional methods of maintaining international order that depend on the strong-arm tactics of dominant states and their allies with little or no attention to international law.

The future of the United Nations as the basis of global security is not currently bright, but such an outlook could change rapidly. Memories are short, and if there are setbacks associated with US-NATO initiatives, a revived reliance on an augmented UN Security Council could materialize

quickly. Even a change in the form and substance of US political leadership in the White House and Congress could rather abruptly confer upon the United Nations a new opportunity to play an important global security role. From the present vantage point, however, this outcome is not too likely. If the main security challenges continue to arise from intrastate violence, it seems unlikely that the United Nations, as presently constituted, could respond in a consistently useful manner. Also, the US approach to global leadership, given such recently hyped challenges as biowar and international terrorism, seems likely to avoid being constrained by the collective procedures of the United Nations.

Prospects for Reform

For these reasons, it seems appropriate not to expect too much from the United Nations in the peace-and-security area over the course of the next decade. At the same time, the United Nations remains a vital actor in relation to a wide range of global concerns: environment, food, health, humanitarian relief, human rights, refugees, lawmaking, and development.

It is also helpful to keep in mind that the United Nations was established by states to serve states—that it was international in conception and operation, and not supranational or intranational. As such, it has been difficult for the United Nations to accommodate the various strands of transnational activity that together compose the phenomenon of "globalization." Neither the private sector nor global civil society can gain meaningful access to the main arenas of the United Nations, an exclusion that has resulted in high-profile activity engaging grassroots par-

European regionalism remains the most dramatic challenge to the state system. The historical irony is evident: the region that invented the modern state and its diplomacy is taking the lead in establishing a form of world order that is sufficiently different to qualify as a sequel.

ticipation beyond the normal arenas of the United Nations. If the United Nations were constitutionally recreated in the year 2000, it would not likely resemble the organization set up in 1945. The awareness of such a discrepancy between what was done then and what is needed now is made even more serious due to the inability to reform the organization in even minimal respects. It has not been possible to agree on how to alter the composition of the Security Council to take account of the enormous changes in the makeup of international society over the course of the last half-century. It is evident to even casual observers that to retain permanent seats on the Security Council for both Great Britain and France, while denying such a presence to India and Brazil, or Japan and Germany, is to mock the current distribution of influence in world politics. The legitimacy of the United Nations, and its credibility as an actor, depends on its own structures of authority more or less mirroring the structure of relations among states and regions.

It is far too soon to write off the United Nations as a viable global security organization, but there are few reasons to believe that it will play a central role in peace, security, and development activity over the course of the next decade or so. Fortunately, there are more promising alternatives.

Learning from Europe

The most daring world-order experiment of this century had undoubtedly been the European regional movement. It has encroached on the sovereign rights of territorial states far more than anything attempted by the United Nations, even though regional organizations are formally subordinated to the UN Security Council with respect to the use of force. The European Union has used its authority structures, its institutional implementing procedures, and the integrative political will of government leaders to put a variety of supranational moves into operation: the supremacy of European Community Law; the external accountability of governments in relation to human-rights claims; the minimalization of obstacles to intra-regional trade, investment, customs, immigration, and travel controls; the existence of a common currency and central bank; and a directly

elected regional parliament. The cumulative effect of these developments over the course of more than 50 years has been to bring into existence a distinctive European entity that is far from being either a single European superstate or merely a collaborative framework for a collection of states in Europe. Europe continues to evolve. Its final shape will not be known for several more decades.

The European Union is something quite new and different; it is likely to keep changing. If it is perceived outside of Europe as a success in these latest supranationalizing moves, it will provide Asia, Africa, and Latin America, or portions thereof, with positive models that they will be tempted to imitate and adapt to their regional conditions. The regional model is so promising that by 2025 and 2030 it might become natural to speak of "a world of regions" as an overarching successor metaphor to "a world of states."

At the same time, there are uncertainties associated with these European develop-

ments. The present turmoil in the Balkans could spread beyond the former Yugoslavia—and even if it does not, it could stimulate some drastic rethinking concerning the security implications of a regional approach, especially if linked, as in the Cold War, to US leadership. The NATO operation in Kosovo, besides suggesting the abandonment of the United Nations in the setting of global security, may discourage any further transfers of sovereignty by European states or contrarily provide momentum for the creation of an all-European security system. The Kosovo ordeal may also be regarded outside Europe as an indirect reaffirmation of the state as the basic ordering framework for most peoples in the world. It is also possible that Europeans will reevaluate NATO itself, since it is increasingly perceived as an alliance arrangement that belongs anachronistically to an era of old geopolitics—it is neither regional in orientation, nor collective in operation, nor responsive to the historical

File Photo

The effectiveness of the United Nations as an international actor remains in doubt.

File Photo

Cities are becoming transnational actors with their own worldviews, interests, and networks.

realities of Europe after the Cold War. If this type of revisionist thinking takes hold, a pooling of European security resources and at least a partial disengagement from dependence on the United States will follow, clarifying for a time the character of European regionalism.

However the Balkan crisis is eventually resolved, European regionalism remains the most fundamental challenge to the state system. The historical irony is that Europe, as the region that invented the modern state and its diplomacy, is taking the lead in establishing a form of world order that may soon turn out to be sufficiently different as to qualify as a sequel. Non-European forms of regionalism have also been moving ahead in this period, and need to be brought much more explicitly into our thinking about order, security, development, and justice as aspects of an emergent system of global governance.

The Re-empowered State

As I explained in greater detail in my work *Predatory Globalization: A Critique*, the effects of neo-liberal globalization have been to disempower the state with respect to solving both internal social and cultural problems. This generalization pertains to such external challenges as those arising from environmental deterioration, scarcity of renewable resources, and protection of the global commons for future generations. The idea of capital mobility on a regional and global scale in response to market factors offers the main insight into the disempowerment of the state, converting governments into capital facilitators and limiting the space for responsible political debate and party rivalry. Other important sources of this phe-

nomenon of disempowerment have resulted from the weakening of organized labor as a source of societal pressure and the revolutionary impacts of information technology, the computer, and the internet, all tendencies that alter the role and identity of the state and weaken its disposition toward innovation and problem-solving.

Re-empowerment of the state implies reversing these trends, especially finding ways to offset the presiding influence of global market forces on the outlook and behavior of governing elites. Such a rebalancing of contending social force could result from the further mobilization of civil society in relation to such shared objectives as environmental quality, human rights, demilitarization, labor and welfare policy, and regulation of global capital flows. The Asian financial crisis which began in 1997, combined with the troubles in a series of other important countries such as Japan, Russia, and Brazil, has already caused a partial ideological retreat from extreme versions of neoliberal globalization. Further retreat could be prompted by instability generated in part by a spreading sense that the benefits of economic globalization are being unfairly distributed, with a steady increase in income and wealth disparities (a pattern clearly documented in the annual volumes of the *Human Development Report*).

Another reason for re-empowerment might arise from a growing anxiety, including among business elites, of backlash threats ranging from extremist religions, micro-nationalisms, and neo-fascist political movements. It may come to be appreciated by economic elites that the global economy needs to be steered with a greater attentiveness to social concerns and to the global public good, as well as in relation to effi-

ciency of returns on capital. Otherwise, a new round of dangerous and costly revolutionary struggles looms menacingly on the horizon. A further supportive tendency is the appearance of "a new internationalism" in the form of various coalitions among many "normal" governments (those without extraregional global claims) and large numbers of transnational civic associations. This type of coalition was integral to the campaigns to ban anti-personnel landmines, to establish an international criminal court, and to call into question the legality and possession of nuclear weaponry. This set of initiatives put many governments in an activist mode and in opposition to the policy positions taken by the geopolitical leadership of the world, mainly the US government.

There is another somewhat silent re-empowerment taking place in the form of an extension of the authority of the state to manage the world's ocean's and outer space. The 1982 Law of the Sea Treaty, for example, validated an enormous expansion of coastal authority in the form of a 200-mile Exclusive Economic Zone. The magnitude of this re-empowerment can be appreciated when it is realized that 95 percent of the beneficial use of the ocean lies within these coastal waters.

The re-empowerment of the state is not meant to negate the benefits or reality of economic globalization. It is instead a matter of making the state more of a regulative mechanism in relation to market forces, and less of a facilitative force. Out of such re-empowerment might yet emerge an informal global social contract that could help provide the world economy with the sort of political and social stability that will be needed if "sustainable development" is to become a credible future reality.

Coordinating World Cities

It is not possible to do more than highlight this formidable frontier for ordering relations among peoples in ways that elude traditional and familiar frameworks. With an increasing proportion of wealth, culture, people, and innovation concentrated in or appropriated by world cities, these entities are more and more self-consciously becoming transnational actors with their own agendas, worldviews, and networks. The economic and political success of such city-states as Singapore and Hong Kong is also suggestive of the possibility that world order need not be premised on territorial dominion in the future. Whether states will successfully contain this disempowering trend or appropriate it for their own goals remains largely uncertain, as is the impact of deepening European-style regionalism. China's relationship to Hong Kong will be a test of whether the city as a political actor can withstand the challenges to its autonomy being posed by Bei-

jing. In any event, the role and future of city-states in the next century is definitely an idea worth including on any chart depicting emergent forms of world order.

Creeping Functionalism

Among the most evident world-order trends is the impulse of governmental and other bureaucracies to coordinate specialist activities across state boundaries by way of consultation, periodic meetings, and informal codes of conduct. Through banking, shipping, and insurance specialists, an enormous proliferation of ad hoc functional arrangements are being negotiated and implemented in a wide variety of international arenas. Some interpreters of the global scene have identified the proliferation of such undertakings as the wave of the future, as a disaggregating response of sovereign states to the complexity of a highly interconnected world. Anne-Marie Slaughter articulates this position and gives it a positive spin in the 75th Anniversary Issue of *Foreign Affairs*. In a basic sense, this extension of functional modes of coordination to address a dazzling array of technical and commercial

issues represents a series of practical adjustments to the growing complexity of international life. The role of the state is being tailored to work more on behalf of common economic interests associated with globalization and to be less preoccupied with the promotion of exclusively national economic interests.

In some circles, this devolution and dispersion of authority, with more direct rulemaking participation by private-sector representatives, along with the overall erosion of public-private sector distinctions, is sometimes referred to as "the new medievalism." Such a terminology deliberately recalls the world order of feudal Europe with its overlapping patterns of authority and the importance of both local and universal institutional actors. It was the territorial consolidation of this confusing reality that gave rise initially to the absolute state ruled by a monarch, and later to a constitutional government legitimized by the consent of the governed. The postmodern state is in the process of formation, and is as varied in character and orientation as are the circumstances of differing cultures, stages of development, degrees of integration, and respect for human rights that exist around the world.

A New World Order?

It is evident that in the institutional ferment of the moment, several trends and counter-trends make it impossible to depict the future shape of the world order with any confidence. Central to this future is the uncertain degree to which the sovereign state can adapt its behavior and role to a series of deterritorializing forces associated with markets, transnational social forces, cyberspace, demographic and environmental pressures, and urbanism. Also critical to the future is the fate of the European Union and the way in which it is reflected in non-European opinion. Seemingly less crucial, but still of interest, is whether the United Nations can find ways to retrieve its reputation as relevant to peace and security while continuing to engineer a myriad of useful activities beyond the gaze of the media. At issue, finally, is the sort of global leadership provided by the United States, and the nature of leadership alternatives, if any exist. Crossing the millennial threshold is likely to clarify the mix of these developments, but probably not in a definitive enough pattern to be worthy of being labeled "a new world order," at least for several decades.

Unit Selections

5. **Before the Next Doubling,** Jennifer D. Mitchell
6. **Breaking Out or Breaking Down,** Lester R. Brown and Brian Halweil
7. **The Misery behind the Statistics: Women Suffer Most,** Diana Brown
8. **How Much Food Will We Need in the 21st Century?** William H. Bender
9. **Angling for 'Aquaculture,'** Gary Turbak

Key Points to Consider

❖ What are the basic characteristics of the global population situation? How many people are there?

❖ How fast is the world's population growing? What are the reasons for this growth? How do population dynamics vary from one region to the next?

❖ What regions of the world are attracting large numbers of international immigrants?

❖ How does rapid population growth affect the quality of the environment, social structures, and the ways in which humanity views itself?

❖ How does a rapidly growing population affect a poor country's ability to plan its economic development?

❖ How can economic and social policies be changed in order to reduce the impact of population growth on environmental quality?

❖ In an era of global interdependence, how much impact can individual governments have on demographic changes?

❖ How much food will we need in the twenty-first century and can current technologies meet this need?

❖ How is agricultural production a function of many different aspects of a society's economic and political structure?

 Links **www.dushkin.com/online/**

7. **The Hunger Project**
 http://www.thp.org
8. **Penn Library: Resources by Subject**
 http://www.library.upenn.edu/resources/websitest.html
9. **World Health Organization**
 http://www.who.int
10. **WWW Virtual Library: Demography & Population Studies**
 http://coombs.anu.edu.au/ResFacilities/DemographyPage.html

These sites are annotated on pages 6 and 7.

After World War II, the world's population reached 2 billion people. It had taken 250 years to triple to that level. In the 55 years since the end of World War II, the population has tripled again to 6 billion. When the typical reader of this book reaches the age of 50, experts estimate that the global population will have reached 8½ billion! By 2050, or about 100 years after World War II ended, the world may be populated by 10 to 12 billion people. A person born in 1946 (a so-called baby boomer) who lives to be 100 could see a sixfold increase in population.

Nothing like this has ever occurred before. To state this in a different way: In the next 50 years there will have to be twice as much food produced, twice as many schools and hospitals built, and twice as much of everything else provided just to maintain the current and rather uneven standard of living. We live in an unprecedented time in human history.

One of the most interesting aspects of this unprecedented population growth is that there is little agreement about whether this is good or bad. For example, the government of China has a policy that encourages couples to have only one child. In contrast, there are a few governments that use various financial incentives to promote large families.

The lead article in this section provides a historical overview of the demographic realities of the contemporary world. The unit continues with a discussion of conflicting perspectives on the implications of population growth. Some experts view population growth as the major problem facing the world, while others see it as secondary to social, economic, and political problems. The theme of conflicting views, in short, has been carried forward from the introductory unit of the book to the more specific discussion of population.

This broad discussion is followed by a series of articles that examine specific issues such as the movement of people from developing to industrial countries. This raises interesting questions about how a culture maintains its identity when it must absorb large numbers of new people, or how a government will obtain the resources necessary to integrate these new members into the mainstream of society.

As the world begins a new millennium, there are many population issues that transcend numerical and economic issues.

The disappearance of indigenous people is a good example of the pressures of population growth on people who live on the margins of modern society. Finally, while demographers develop various scenarios forecasting population growth, it is

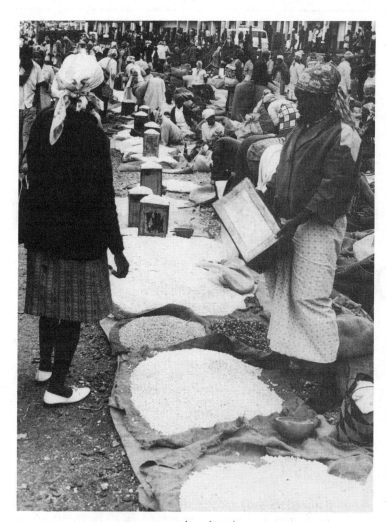

important to remember that there are circumstances that could lead not to growth but to a significant decline in global population. The spread of AIDS and other infectious diseases reveals that confidence in modern medicine's ability to control these scourges may be premature. Nature has its own checks and balances to the population dynamic that are not policy instruments of some governmental organization. This factor is often overlooked.

There is no greater check on population growth than the ability to produce an adequate food supply. Some experts question whether current technologies are sustainable over the long run. How much food are we going to need in the decades to come, and how are farmers going to produce it? This fundamental question is the focus of the final articles in the unit.

Making predictions about the future of the world's population is a complicated task, for there are a variety of forces at work and considerable variation from region to region.

The danger of oversimplification must be overcome if governments and international organizations are going to respond with meaningful policies. Perhaps one could say that there is not a global population problem but rather many challenges that vary from country to country and region to region.

Before the Next Doubling

Nearly 6 billion people now inhabit the Earth—almost twice as many as in 1960. At some point over the course of the next century, the world's population could double again. But we don't have anything like a century to prevent that next doubling; we probably have less than a decade.

by Jennifer D. Mitchell

In 1971, when Bangladesh won independence from Pakistan, the two countries embarked on a kind of unintentional demographic experiment. The separation had produced two very similar populations: both contained some 66 million people and both were growing at about 3 percent a year. Both were overwhelmingly poor, rural, and Muslim. Both populations had similar views on the "ideal" family size (around four children); in both cases, that ideal was roughly two children smaller than the actual average family. And in keeping with the Islamic tendency to encourage large families, both generally disapproved of family planning.

But there was one critical difference. The Pakistani government, distracted by leadership crises and committed to conventional ideals of economic growth, wavered over the importance of family planning. The Bangladeshi government did not: as early as 1976, population growth had been declared the country's number one problem, and a national network was established to educate people about family planning and supply them with contraceptives. As a result, the proportion of couples using contraceptives rose from around 6 percent in 1976 to about 50 percent today, and fertility rates have dropped from well over six children per woman to just over three. Today, some 120 million people people live in Bangladesh, while 140 million live in Pakistan—a difference of 20 million.

Bangladesh still faces enormous population pressures—by 2050, its population will probably have increased by nearly 100 million. But even so, that 20 million person "savings" is a colossal achievement, especially given local conditions. Bangladeshi officials had no hope of producing the classic "demographic transition," in which improvements in education, health care, and general living standards tend to push down the birth rate. Bangladesh was—and is—one of the poorest and most densely populated countries on earth. About the size of England and Wales, Bangladesh has twice as many people. Its per capita GDP is barely over $200. It has one doctor for every 12,500 people and nearly three-quarters of its adult population are illiterate. The national diet would be considered inadequate in any industrial country, and even at current levels of population growth, Bangladesh may be forced to rely increasingly on food imports.

All of these burdens would be substantially heavier than they already are, had it not been for the family planning program. To appreciate the Bangladeshi achievement, it's only necessary to look at Pakistan: those "additional" 20 million Pakistanis require at least 2.5 million more houses, about 4 million more tons of grain each year, millions more jobs, and significantly greater investments in health care—or a significantly greater burden of disease. Of the two nations, Pakistan has the more robust economy—its

From *World Watch* magazine, January/February 1998, pp. 20-27. © 1998 by the Worldwatch Institute, Washington, DC. Reprinted by permission.

per capita GDP is twice that of Bangladesh. But the Pakistani economy is still primarily agricultural, and the size of the average farm is shrinking, in part because of the expanding population. Already, one fourth of the country's farms are under 1 hectare, the standard minimum size for economic viability, and Pakistan is looking increasingly towards the international grain markets to feed its people. In 1997, despite its third consecutive year of near-record harvests, Pakistan attempted to double its wheat imports but was not able to do so because it had exhausted its line of credit.

And Pakistan's extra burden will be compounded in the next generation. Pakistani women still bear an average of well over five children, so at the current birth rate, the 10 million or so extra couples would produce at least 50 million children. And these in turn could bear nearly 125 million children of their own. At its current fertility rate, Pakistan's population will double in just 24 years—that's more than twice as fast as Bangladesh's population is growing. H. E. Syeda Abida Hussain, Pakistan's Minister of Population Welfare, explains the problem bluntly: "If we achieve success in lowering our population growth substantially, Pakistan has a future. But if, God forbid, we should not—no future."

The Three Dimensions of the Population Explosion

Some version of Mrs. Abida's statement might apply to the world as a whole. About 5.9 billion people currently inhabit the Earth. By the middle of the next century, according to U.N. projections, the population will probably reach 9.4 billion—and all of the net increase is likely to occur in the developing world. (The total population of the industrial countries is expected to decline slightly over the next 50 years.) Nearly 60 percent of the increase will occur in Asia, which will grow from 3.4 billion people in 1995 to more than 5.4 billion in 2050. China's population will swell from 1.2 billion to 1.5 billion, while India's is projected to soar from 930 million to 1.53 billion. In the Middle East and North Africa, the population will probably more than double, and in sub-Saharan Africa, it will triple. By 2050, Nigeria alone is expected to have 339 million people—more than the entire continent of Africa had 35 years ago.

Despite the different demographic projections, no country will be immune to the effects of population growth. Of course, the countries with the highest growth rates are likely to feel the greatest immediate burdens—on their educational and public health systems, for instance, and on their forests, soils, and water as the struggle to grow more food intensifies. Already some 100 countries must rely on grain imports to some degree, and 1.3 billion of the world's people are living on the equivalent of $1 a day or less.

But the effects will ripple out from these "front-line" countries to encompass the world as a whole. Take the water predicament in the Middle East as an example. According to Tony Allan, a water expert at the University of London, the Middle East "ran out of water" in 1972, when its population stood at 122 million. At that point, Allan argues, the region had begun to draw more water out of its aquifers and rivers than the rains were replenishing. Yet today, the region's population is twice what it was in 1972 and still growing. To some degree, water management now determines political destiny. In Egypt, for example, President Hosni Mubarak has announced a $2 billion diversion project designed to pump water from the Nile River into an area that is now desert. The project—Mubarak calls it a "necessity imposed by population"—is designed to resettle some 3 million people outside the Nile flood plain, which is home to more than 90 percent of the country's population.

Elsewhere in the region, water demands are exacerbating international tensions; Jordan, Israel, and Syria, for instance, engage in uneasy competition for the waters of the Jordan River basin. Jordan's King Hussein once said that water was the only issue that could lead him to declare war on Israel. Of course, the United States and the western European countries are deeply involved in the region's antagonisms and have invested heavily in its fragile states. The western nations have no realistic hope of escaping involvement in future conflicts.

Yet the future need not be so grim. The experiences of countries like Bangladesh suggest that it is possible to build population policies that are a match for the threat. The first step is to understand the causes of population growth. John Bongaarts, vice president of the Population Council, a non-profit research group in New York City, has identified three basic factors. (See figure on the next page.)

Unmet demand for family planning. In the developing world, at least 120 million married women—and a large but undefined number of unmarried women—want more control over their pregnancies, but cannot get family planning services. This unmet demand will cause about one-third of the projected population growth in developing countries over the next 50 years, or an increase of about 1.2 billion people.

Desire for the large families. Another 20 percent of the projected growth over the next 50 years, or an increase of about 660 million people, will be caused by couples who may have access to family planning services, but who choose to have more than two children. (Roughly two children per family is the "replacement rate," at which a population could be expected to stabilize over the long term.)

Population momentum. By far the largest component of population growth is the least commonly understood. Nearly one-half of the increase projected for the next 50 years will occur simply because the next reproductive generation—the

group of people currently entering puberty or younger—is so much larger than the current reproductive generation. Over the next 25 years, some 3 billion people—a number equal to the entire world population in 1960—will enter their reproductive years, but only about 1.8 billion will leave that phase of life. Assuming that the couples in this reproductive bulge begin to have children at a fairly early age, which is the global norm, the global population would still expand by 1.7 billion, even if all of those couples had only two children—the longterm replacement rate.

Meeting the Demand

Over the past three decades, the global percentage of couples using some form of family planning has increased dramatically—from less than 10 to more than 50 percent. But due to the growing population, the absolute number of women not using family planning is greater today than it was 30 years ago. Many of these women fall into that first category above—they want the services but for one reason or another, they cannot get them.

Sometimes the obstacle is a matter of policy: many governments ban or restrict valuable methods of contraception. In Japan, for instance, regulations discourage the use of birth control pills in favor of condoms, as a public health measure against sexually transmitted diseases. A study conducted in 1989 found that some 60 countries required a husband's permission before a woman can be sterilized; several required a husband's consent for all forms of birth control.

Elsewhere, the problems may be more logistical than legal. Many developing countries lack clinics and pharmacies in rural areas. In some rural areas of sub-Saharan Africa, it takes an average of two hours to reach the nearest contraceptive provider. And often contraceptives are too expensive for most people. Sometimes the products or services are of such poor quality that they are not simply ineffective, but dangerous. A woman who has been injured by a badly made or poorly inserted IUD may well be put off by contraception entirely.

In many countries, the best methods are simply unavailable. Sterilization is often the only available nontraditional option, or the only one that has gained wide acceptance. Globally, the procedure accounts for about 40 percent of contraceptive use and in some countries the fraction is much higher: in the Dominican Republic and India, for example, it stands at 69 percent. But women don't generally resort to sterilization until well into their childbearing years, and in some countries, the procedure isn't permitted until a woman reaches a certain age or bears a certain number of children. Sterilization is therefore no substitute for effective temporary methods like condoms, the pill, or IUDs.

There are often obstacles in the home as well. Women may be prevented from seeking family planning services by disapproving husbands or in-laws. In Pakistan, for example, 43 percent of husbands object to family planning. Frequently,

Population of Developing Countries, 1950–95, with Projected Growth to 2050

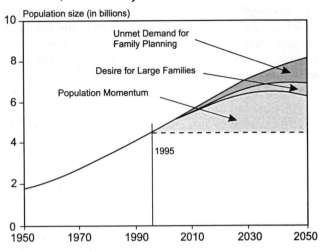

Source: U.N., *World Population Prospects: The 1996 Revision* (New York: October 1998); and John Bongaarts, "Population Policy Options in the Developing World," *Science*, 11 February 1994.

such objections reflect a general social disapproval inculcated by religious or other deeply-rooted cultural values. And in many places, there is a crippling burden of ignorance: women simply may not know what family planning services are available or how to obtain them.

Yet there are many proven opportunities for progress, even in conditions that would appear to offer little room for it. In Bangladesh, for instance, contraception was never explicitly illegal, but many households follow the Muslim custom of *purdah*, which largely secludes women in their communities.

Since it's very difficult for such women to get to family planning clinics, the government brought family planning to them: some 30,000 female field workers go door-to-door to explain contraceptive methods and distribute supplies. Several other countries have adopted Bangladesh's approach. Ghana, for instance, has a similar system, in which field workers fan out from community centers. And

even Pakistan now deploys 12,000 village-based workers, in an attempt to reform its family planning program, which still reaches only a quarter of the population.

Reducing the price of contraceptives can also trigger a substantial increase in use. In poor countries, contraceptives can be an extremely price-sensitive commodity even when they are very cheap. Bangladesh found this out the hard way in 1990, when officials increased contraceptive prices an average of 60 percent. (Under the increases, for example, the cheapest condoms cost about 1.25 U.S. cents per dozen.) Despite regular annual sales increases up to that point, the market slumped immediately: in 1991, condom sales fell by 29 percent and sales of the pill by 12 percent. The next year, prices were rolled back; sales rebounded and have grown steadily since then.

Additional research and development can help broaden the range of contraceptive options. Not all methods work for all couples, and the lack of a suitable method may block a substantial amount of demand. Some women, for instance, have side effects to the pill; others may not be able to use IUDs because of reproductive tract infections. The wider the range of available methods, the better the chance that a couple will use one of them.

Planning the Small Family

Simply providing family planning services to people who already want them won't be enough to arrest the population juggernaut. In many countries, large families are still the ideal. In Senegal, Cameroon, and Niger, for example, the average woman still wants six or seven children. A few countries have tried to legislate such desires away. In India, for example, the Ministry of Health and Family Welfare is interested in promoting a policy that would bar people who have more than two children from political careers, or deny them promotion if they work within the civil service bureaucracy. And China's well-known policy allows only one child per family.

But coercion is not only morally questionable—it's likely to be ineffective because of the backlash it invites. A better starting point for policy would be to try to understand why couples want large families in the first place. In many developing countries, having lots of children still seems perfectly rational: children are a source of security in old age and may be a vital part of the family economy. Even when they're very young, children's labor can make them an asset rather than a drain on family income. And in countries with high child mortality rates, many births may be viewed as necessary to compensate for the possible deaths (of course, the cumulative statistical effect of such a reaction is to *over*-compensate).

Religious or other cultural values may contribute to the big family ideal. In Pakistan, for instance, where 97 percent of the population is Muslim, a recent survey of married women found that almost 60 percent of them believed that the number of children they have is "up to God." Preference for sons is another widespread factor in the big

family psychology: many large families have come about from a perceived need to bear at least one son. In India, for instance, many Hindus believe that they need a son to perform their last rites, or their souls will not be released from the cycle of births and rebirths. Lack of a son can mean abandonment in this life too. Many husbands desert wives who do not bear sons. Or if a husband dies, a son is often the key to a woman's security: 60 percent of Indian women over 60 are widows, and widows tend to rely on their sons for support. In some castes, a widow has no other option since social mores forbid her from returning to her birth village or joining a daughter's family. Understandably, the fear of abandonment prompts many Indian women to continue having children until they have a son. It is estimated that if son preference were eliminated in India, the fertility rate would decline by 8 percent from its current level of 3.5 children per woman.

Yet even deeply rooted beliefs are subject to reinterpretation. In Iran, another Muslim society, fertility rates have dropped from seven children per family to just over four in less than three decades. The trend is due in some measure to a change of heart among the government's religious authorities, who had become increasingly concerned about the likely effects of a population that was growing at more than 3 percent per year. In 1994, at the International Conference on Population and Development (ICPD) held in Cairo, the Iranian delegation released a "National Report on Population" which argued that according to the "quotations from prophet Mohammad . . . and verses of [the] holy Quran, what is standing at the top priority for the Muslims' community is the social welfare of Muslims." Family planning, therefore, "not only is not prohibited but is emphasized by religion."

Promotional campaigns can also change people's assumptions and behavior, if the campaigns fit into the local social context. Perhaps the most successful effort of this kind is in Thailand, where Mechai Viravidaiya, the founder of the Thai Population and Community Development Association, started a program that uses witty songs, demonstrations, and ads to encourage the use of contraceptives. The program has helped foster widespread awareness of family planning throughout Thai society. Teachers use population-related examples in their math classes; cab drivers even pass out condoms. Such efforts have paid off: in less than three decades, contraceptive use among married couples has risen from 8 to 75 percent and population growth has slowed from over 3 percent to about 1 percent—the same rate as in the United States.

Better media coverage may be another option. In Bangladesh, a recent study found that while local journalists recognize the importance of family planning, they do not understand population issues well enough to cover them effectively and objectively. The study, a collaboration between the University Research Corporation of Bangladesh and Johns Hopkins University in the United States, recommended five ways to improve coverage: develop easy-to-use information for journalists (press releases, wall charts, research summaries), offer training and workshops,

present awards for population journalism, create a forum for communication between journalists and family planning professionals, and establish a population resource center or data bank.

Often, however, the demand for large families is so tightly linked to social conditions that the conditions themselves must be viewed as part of the problem. Of course, those conditions vary greatly from one society to the next, but there are some common points of leverage:

Reducing child mortality helps give parents more confidence in the future of the children they already have. Among the most effective ways of reducing mortality are child immunization programs, and the promotion of "birth spacing"—lengthening the time between births. (Children born less than a year and a half apart are twice as likely to die as those born two or more years apart.)

Improving the economic situation of women provides them with alternatives to child-bearing. In some countries, officials could reconsider policies or customs that limit women's job opportunities or other economic rights, such as the right to inherit property. Encouraging "micro-leaders" such as Bangladesh's Grameen Bank can also be an effective tactic. In Bangladesh, the Bank has made loans to well over a million villagers—mostly impoverished women—to help them start or expand small businesses.

Improving education tends to delay the average age of marriage and to further the two goals just mentioned. Compulsory school attendance for children undercuts the economic incentive for larger families by reducing the opportunities for child labor. And in just about every society, higher levels of education correlate strongly with small families.

Momentum: The Biggest Threat of All

The most important factor in population growth is the hardest to counter—and to understand. Population momentum can be easy to overlook because it isn't directly captured by the statistics that attract the most attention. The global growth rate, after all, is dropping: in the mid-1960s, it amounted to about a 2.2 percent annual increase; today the figure is 1.4 percent. The fertility rate is dropping too: in 1950, women bore an average of five children each; now they bear roughly three. But despite these continued declines, the absolute number of births won't taper off any time soon. According to U.S. Census Bureau estimates, some 130 million births will still occur annually for the next 25 years, because of the sheer number of women coming into their child-bearing years.

The effects of momentum can be seen readily in a country like Bangladesh, where more than 42 percent of the population is under 15 years old—a typical proportion for many poor countries. Some 82 percent of the population growth projected for Bangladesh over the next half century will be caused by momentum. In other words, even if from now on, every Bangladeshi couple were to have only two children, the country's population would

still grow by 80 million by 2050 simply because the next reproductive generation is so enormous.

The key to reducing momentum is to delay as many births as possible. To understand why delay works, it's helpful to think of momentum as a kind of human accounting problem in which a large number of births in the near term won't be balanced by a corresponding number of deaths over the same period of time. One side of the population ledger will contain those 130 million annual births (not all of which are due to momentum, of course), while the other side will contain only about 50 million annual deaths. So to put the matter in a morbid light, the longer a substantial number of those births can be delayed, the longer the death side of the balance sheet will be when the births eventually occur. In developing countries, according to the Population Council's Bongaarts, an average 2.5-year delay in the age when a woman bears her first child would reduce population growth by over 10 percent.

One way to delay childbearing is to postpone the age of marriage. In Bangladesh, for instance, the median age of first marriage among women rose from 14.4 in 1951 to 18 in 1989, and the age at first birth followed suit. Simply raising the legal age of marriage may be a useful tactic in countries that permit marriage among the very young. Educational improvements, as already mentioned, tend to do the same thing. A survey of 23 developing countries found that the median age of marriage for women with secondary education exceeded that of women with no formal education by four years.

Another fundamental strategy for encouraging later childbirth is to help women break out of the "sterilization syndrome" by providing and promoting high-quality, temporary contraceptives. Sterilization might appear to be the ideal form of contraception because it's permanent. But precisely because it is permanent, women considering sterilization tend to have their children early, and then resort to it. A family planning program that relies heavily on sterilization may therefore be working at cross purposes with itself: when offered as a primary form of contraception, sterilization tends to promote early childbirth.

What Happened to the Cairo Pledges?

At the 1994 Cairo Conference, some 180 nations agreed on a 20-year reproductive health package to slow population

growth. The agreement called for a progressive rise in annual funding over the life of the package; according to U.N. estimates, the annual price tag would come to about $17 billion by 2000 and $21.7 billion by 2015. Developing countries agreed to pay for two thirds of the program, while the developed countries were to pay for the rest. On a global scale, the package was fairly modest: the annual funding amounts to less than two weeks' worth of global military expenditures.

Today, developing country spending is largely on track with the Cairo agreement, but the developed countries are not keeping their part of the bargain. According to a recent study by the U.N. Population Fund (UNFPA), all forms of developed country assistance (direct foreign aid, loans from multilateral agencies, foundation grants, and so on) amounted to only $2 billion in 1995. That was a 24 percent increase over the previous year, but preliminary estimates indicate that support declined some 18 percent in 1996 and last year's funding levels were probably even lower than that.

The United States, the largest international donor to population programs, is not only failing to meet its Cairo commitments, but is toying with a policy that would undermine international family planning efforts as a whole. Many members of the U.S. Congress are seeking reimposition of the "Mexico City Policy" first enunciated by President Ronald Reagan at the 1984 U.N. population conference in Mexico City, and repealed by the Clinton administration in 1993. Essentially, a resurrected Mexico City Policy would extend the current U.S. ban on funding abortion services to a ban on funding any organization that:

- funds abortions directly, or
- has a partnership arrangement with an organization that funds abortions, or
- provides legal services that may facilitate abortions, or
- engages in any advocacy for the provision of abortions, or
- participates in any policy discussions about abortion, either in a domestic or international forum.

The ban would be triggered even if the relevant activities were paid for entirely with non-U.S. funds. Because of its draconian limits even on speech, the policy has been dubbed the "Global Gag Rule" by its critics, who fear that it could stifle, not just abortion services, but many family planning operations involved only incidentally with abortion. Although Mexico City proponents have not managed to enlist enough support to reinstate the policy, they have succeeded in reducing U.S. family planning aid from $547 million in 1995 to $385 million in 1997. They have also imposed an unprecedented set of restrictions that meter out the money at the rate of 8 percent of the annual budget per month—a tactic that *Washington Post* reporter Judy Mann calls "administrative strangulation."

If the current underfunding of the Cairo program persists, according to the UNFPA study, 96 million fewer couples will use modern contraceptives in 2000 than if commitments had been met. One-third to one-half of these couples will resort to less effective traditional birth control methods; the rest will not use any contraceptives at all. The result will be an additional 122 million unintended pregnancies. Over half of those pregnancies will end in births, and about 40 percent will end in abortions. (The funding shortfall is expected to produce 16 million more abortions in 2000 alone.) The unwanted pregnancies will kill about 65,000 women by 2000, and injure another 844,000.

Population funding is always vulnerable to the illusion that the falling growth rate means the problem is going away. Worldwide, the annual population increase had dropped from a high of 87 million in 1988 to 80 million today. But dismissing the problem with that statistic is like comforting someone stuck on a railway crossing with the news that an oncoming train has slowed from 87 to 80 kilometers an hour, while its weight has increased. It will now take 12.5 years instead of 11.5 years to add the next billion people to the world. But that billion will surely arrive—and so will at least one more billion. Will still more billions follow? That, in large measure, depends on what policymakers do now. Funding alone will not ensure that population stabilizes, but lack of funding will ensure that it does not.

The Next Doubling

In the wake of the Cairo conference, most population programs are broadening their focus to include improvements in education, women's health, and women's social status among their many goals. These goals are worthy in their own right and they will ultimately be necessary for bringing population under control. But global population growth has gathered so much momentum that it could simply overwhelm a development agenda. Many countries now have little choice but to tackle their population problem in as direct a fashion as possible—even if that means temporarily ignoring other social problems. Population growth is now a global social emergency. Even as officials in both developed and developing countries open up their program agendas, it is critical that they not neglect their single most effective tool for dealing with that emergency: direct expenditures on family planning.

The funding that is likely to be the most useful will be constant, rather than sporadic. A fluctuating level of commitment, like sporadic condom use, can

end up missing its objective entirely. And wherever it's feasible, funding should be designed to develop self-sufficiency—as, for instance, with UNFPA's $1 million grant to Cuba, to build a factory for making birth control pills. The factory, which has the capacity to turn out 500 million tablets annually, might eventually even provide the country with a new export product. Self-sufficiency is likely to grow increasingly important as the fertility rate continues to decline. As Tom Merrick, senior population advisor at the World Bank explains, "while the need for contraceptives will not go away when the total fertility rate reaches two—the donors will."

Even in narrow, conventional economic terms, family planning offers one of the best development investments available. A study in Bangladesh showed that for each birth prevented, the government spends $62 and saves $615 on social services expenditures—nearly a tenfold return. The study estimated that the Bangladesh program prevents 890,000 births a year, for a net annual savings of $547 million. And that figure does not include savings resulting from lessened pressure on natural resources.

Over the past 40 years, the world's population has doubled. At some point in the latter half of the next century, today's population of 5.9 billion could double again. But because of the size of the next reproductive generation, we probably have only a relatively few years to stop that next doubling. To prevent all of the damage—ecological, economic, and social—that the next doubling is likely to cause, we must begin planning the global family with the same kind of urgency that we bring to matters of trade, say, or military security. Whether we realize it or not, our attempts to stabilize population—or our failure to act—will likely have consequences that far outweigh the implications of the military or commercial crisis of the moment. Slowing population growth is one of the greatest gifts we can offer future generations.

Jennifer D. Mitchell is a staff researcher at the Worldwatch Institute.

Breaking *Out* or Breaking *Down*

*In some parts of the world, the historic trend toward
longer life has been abruptly reversed.*

by Lester R. Brown and Brian Halweil

On October 12 of this year, the world's human population is projected to pass 6 billion. The day will be soberly observed by population and development experts, but media attention will do nothing to immediately slow the expansion. During that day, the global total will swell by another 214,000—enough people to fill two of the world's largest sports stadiums.

Even as world population continues to climb, it is becoming clear that the several billion additional people projected for the next half century are not likely to materialize. What is not clear is how the growth will be curtailed. Unfortunately, in some countries, a slowing of the growth is taking place only partly because of success in bringing birth rates down—and increasingly because of newly emergent conditions that are raising death rates.

Evidence of this shift became apparent in late October, 1998, when U.N. demographers released their biennial update of world population projections, revising the projected global population for 2050. Instead of rising in the next 50 years by more than half, to 9.4 billion (as computed in 1996), the 1998 projection rose only to 8.9 billion. The good news was that two-thirds of this anticipated slow-down was expected to be the result of falling fertility—of the decisions of more couples to have fewer children. But the other third was due to rising death rates, largely as a result of rising mortality from AIDS.

This rather sudden reversal in the human death rate trend marks a tragic new development in world demography, which is dividing the developing countries into two groups. When these countries embarked on the development journey a half century or so ago, they followed one of two paths. In the first, illustrated by the East Asian nations of South Korea, Taiwan, and Thailand, early efforts to shift to smaller families set in motion a positive cycle of rising living standards and falling fertility. Those countries are now moving toward population stability.

In the second category, which prevails in sub-Saharan Africa (770 million people) and the Indian subcontinent (1.3 billion), fertility has remained high or fallen very little, setting the stage for a vicious downward spiral in which rapid population growth reinforces poverty, and in which some segments of society eventually are deprived of the resources needed even to survive. In Ethiopia, Nigeria, and Pakistan, for example, demographers estimate that the next half-century will bring a doubling or near-tripling of populations. Even now, people in these regions each day awaken to a range of daunting conditions that threatens to drop their living standards below the level at which humans can survive.

We now see three clearly identifiable trends that either are already raising death rates or are likely to do so in these regions: the spread of the HIV virus that causes AIDS, the depletion of aquifers, and the shrinking amount of cropland available to support each person. The HIV epidemic is spiraling out of control in sub-Saharan Africa. The depletion of aquifers has become a major threat to India, where water tables are falling almost everywhere. The shrinkage in cropland per person threatens to force reductions in food consumed per person, increasing malnutrition—and threatening lives—in many parts of these regions.

Containing one-third of the world's people, these two regions now face a potentially dramatic shortening of life expectancy. In sub-Saharan Africa, mortality rates are already rising, and in the Indian subcontinent they could begin rising soon. Without clearly defined national strategies for quickly lowering birth rates in these countries, and without a commitment by the international community to support them in their efforts, one-third of humanity could slide into a demographic black hole.

From *World Watch,* September/October 1999, pp. 20-29. © 1999 by The Worldwatch Institute. Reprinted by permission.

Birth and Death

Since 1950, we have witnessed more growth in world population than during the preceding 4 million years since our human ancestors first stood upright. This post-1950 explosion can be attributed, in part, to several developments that reduced death rates throughout the developing world. The wider availability of safe drinking water, childhood immunization programs, antibiotics, and expanding food production sharply reduced the number of people dying of hunger and from infectious diseases. Together these trends dramatically lowered mortality levels.

But while death rates fell, birth rates remained high. As a result, in many countries, population growth rose to 3 percent or more per year—rates for which there was no historical precedent. A 3 percent annual increase in population leads to a twenty-fold increase within a century. Ecologists have long known that such rates of population growth—which have now been sustained for close to half a century in many countries—could not be sustained indefinitely. At some point, if birth rates did not come down, disease, hunger, or conflict would force death rates up.

Although most of the world has succeeded in reducing birth rates to some degree, only some 32 countries—containing a mere 12 percent of the world's people—have achieved population stability. In these countries, growth rates range between 0.4 percent per year and minus 0.6 percent per year. With the exception of Japan, all of the 32 countries are in Europe, and all are industrial. Although other industrial countries, such as the United States, are still experiencing some population growth as a result of a persistent excess of births over deaths, the population of the industrial world as a whole is not projected to grow at all in the next century—unless, perhaps, through the arrival of migrants from more crowded regions.

Within the developing world, the most impressive progress in reducing fertility has come in East Asia. South Korea, Taiwan, and Thailand have all reduced their population growth rates to roughly one percent per year and are approaching stability. (See table, this page.) The biggest country in Latin America—Brazil—has reduced its population growth to 1.4 percent per year. Most other countries in Latin America are also making progress on this front. In contrast, the countries of sub-Saharan Africa and the Indian subcontinent have lagged in lowering growth rates, and populations are still rising ominously—at rates of 2 to 3 percent or more per year.

Graphically illustrating this contrast are Thailand and Ethiopia, each with 61 million people. Thailand is projected to add 13 million people over the next half century for a gain of 21 percent. Ethiopia, meanwhile, is projected to add 108 million for a gain of 177 percent. (The U.N.'s projections are based on such factors as the number of children per woman, infant mortality, and average life span in each country—factors that could change in time, but meanwhile differ sharply in the two countries.) The deep poverty among those living in sub-Saharan Africa and the Indian subcontinent has been a principal factor in their rapid population growth, as couples lack access to the kinds of basic social services and education that allow control over reproductive choices. Yet, the population growth, in turn, has only worsened their poverty—perpetuating a vicious cycle in which hopes of breaking out become dimmer with each passing year.

After several decades of rapid population growth, governments of many developing countries are simply being overwhelmed by their crowding—and are suffering from what we term "demographic fatigue." The simultaneous challenges of educating growing numbers of children, creating jobs for the swelling numbers of young people coming into the job market, and confronting such environmental consequences of rapid population growth as deforestation, soil erosion, and falling water tables, are undermining the capacity of governments to cope. When a major new threat arises, as has happened with the HIV virus, governments often cannot muster the leadership energy and fiscal resources to mobilize effectively. Social problems that are easily contained in industrial societies can become humanitarian disasters in many developing ones. As a result, some of the latter may soon see their population growth curves abruptly flattered, or even thrown into decline, not because of falling birth rates but because of fast-rising death rates. In some countries, that process has already begun.

Projected Population Growth in Selected Developing Countries, 1999 to 2050

	1999 (millions)	2050 (millions)	Growth From 1999 to 2050 (millions)	(percent)
Developing Countries That Have Slowed Population Growth:				
South Korea	46	51	5	+11
Taiwan	22	25	3	+14
Thailand	61	74	13	+21
Developing Countries Where Rapid Population Growth Continues:				
Ethiopia	61	169	108	+177
Nigeria	109	244	135	+124
Pakistan	152	345	193	+127

Source: *United Nations, Global Population Projections, 1998.*

Shades of the Black Death

Industrial countries have held HIV infection rates under 1 percent of the adult population, but in many sub-Saharan African countries, they are spiraling upward, out of control. In Zimbabwe, 26 percent of the adult population is infected; in Botswana, the rate is 25 percent. In South Africa, a country of 43 million people, 22 percent are infected. In Namibia, Swaziland, and Zambia, 18 to 20 percent are. (See table, this page.) In these countries, there is little to suggest that these rates will not continue to climb.

In other African nations, including some with large populations, the rates are lower but climbing fast. In both Tanzania, with 32 million people, and Ethiopia, with its 61 million, the race is now 9 percent. In Nigeria, the continent's largest country with 111 million people, the latest estimate now puts the infection rate also at 9 percent and rising.

What makes this picture even more disturbing is that most Africans carrying the virus do not yet know they are infected, which means the disease can gain enormous momentum in areas where it is still largely invisible. This, combined with the social taboo that surrounds HIV/AIDS in Africa, has made it extremely difficult to mount an effective control effort.

Barring a medical miracle, countries such as Zimbabwe, Botswana, and South Africa will lose at least 20 percent of their adult populations to AIDS within the next decade, simply because few of those now infected with the virus can afford treatment with the costly antiviral drugs now used in industrial countries. To find a precedent for such a devastating region-wide loss of life from an infectious disease, we have to go back to the decimation of Native American communities by the introduction of small pox in the sixteenth century from Europe or to the bubonic plaque that claimed roughly a third of Europe's population in the fourteenth century (see table, next page).

Reversing Progress

The burden of HIV is not limited to those infected, or even to their generation. Like a powerful storm or war that lays waste to a nation's physical infrastructure, a growing HIV epidemic damages a nation's social infrastructure, with lingering demographic and economic effects. A viral epidemic that grows out of control is likely to reinforce many of the very conditions—poverty, illiteracy, malnutrition—that gave it an opening in the first place.

Using life expectancy—the sentinel indicator of development—as a measure, we can see that the HIV virus is reversing the gains of the last several decades. For example, in Botswana life expectancy has fallen from 61 years in 1990 to 44 years in 1999. By 2010, it is projected to

Countries Where HIV Infection Rate Among Adults Is Greater Than Ten Percent

Country	Population (millions)	Share of Adult Population Infected (percent)
Zimbabwe	11.7	26
Botswana	1.5	25
South Africa	43.3	22
Namibia	1.6	20
Zambia	8.5	19
Swaziland	0.9	18
Malawi	10.1	15
Mozambique	18.3	14
Rwanda	5.9	13
Kenya	28.4	12
Central African Republic	3.4	11
Cote d'Ivoire	14.3	10

Source: UNAIDS

drop to 39 years—a life expectancy more characteristic of medieval times than of what we had hoped for in the twenty-first century.

Beyond its impact on mortality, HIV also reduced fertility. For women, who live on average scarcely 10 years after becoming infected, many will die long before they have reached the end of their reproductive years. As the symptoms of AIDS begin to develop, women are less likely to conceive. For those who do conceive, the likelihood of spontaneous abortion rises. And among the reduced number who do give birth, an estimated 30 percent of the infants born are infected and an additional 20 percent are likely to be infected before they are weaned. For babies born with the virus, life expectancy is less than 2 years. The rate of population growth falls, but not in the way any family-planning group wants to see.

One of the most disturbing social consequences of the HIV epidemic is the number of orphans that it produces. Conjugal sex is one of the surest ways to spread AIDS, so if one parent dies, there is a good change the other will as well. By the end of 1997, there were already 7.8 million AIDS orphans in Africa—a new and rapidly growing social subset. The burden of raising these AIDS orphans falls first on the extended family, and then on society at large. Mortality rates for these orphans are likely to be much higher than the rates for children whose parents are still with them.

As the epidemic progresses and the symptoms become visible, health care systems in developing countries are being overwhelmed. The estimated cost of providing antiviral treatment (the standard regimen used to reduce symptoms, improve life quality, and postpone death) to all

Profiles of Major Epidemics Throughout Human History

Epidemic and Date	Mode of Introduction and Spread	Description of Plague and Its Effects on Population
Black Death in Europe, 14th century	Originating in Asia, the plague bacteria moved westward via trade routes, entering Europe in 1347; transmitted via rats as well as coughing and sneezing.	One fourth of the population of Europe was wiped out (an estimated 25 million deaths); old, young, and poor hit hardest.
Smallpox in the New World, 16th century	Spanish conquistadors and European colonists introduced virus into the Americas, where it spread through respiratory channels and physical contact.	Decimated Aztec, Incan, and native American civilizations, killing 10 to 20 million.
HIV/AIDS, worldwide, 1980 to present	Thought to have originated in Africa; a primate virus that mutated and spread to infect humans; transmitted by the exchange of bodily fluids, including blood, semen, and breast milk.	More than 14 million deaths worldwide thus far; an additional 33 million infected; one-fifth of adult population infected in several African nations; strikes economically active populations hardest.

Source: Jared Diamond, *Guns, Germs, and Steel: The Fates of Human Societies,* 1997; UNAIDS.

infected individuals in Malawi, Mozambique, Uganda, and Tanzania would be larger than the GNPs of those countries. In some hospitals in South Africa, 70 percent of the beds are occupied by AIDS patients. In Zimbabwe, half the health care budget now goes to deal with AIDS. As AIDS patients increasingly monopolize nurses' and doctors' schedules, and drain funds from health care budgets, the capacity to provide basic health care to the general population—including the immunizations and treatments for routine illnesses that have underpinned the decline in mortality and the rise in life expectancy in developing countries—begins to falter.

Worldwide, more than half of all new HIV infections occur in people between the ages of 15 and 24—an atypical pattern for an infectious disease. Human scourges have historically spread through respiratory exposure to coughing or sneezing, or through physical contact via shaking hands, food handling, and so on. Since nearly everyone is vulnerable to such exposure, the victims of most infectious diseases are simply those among society at large who have the weakest immune systems—generally the very young and the elderly. But with HIV, because the primary means of transmission is unprotected sexual activity, the ones who are most vulnerable to infection are those who are most sexually active—young, healthy adults in the prime of their lives. According to a UNAIDS report, "the bulk of the increase in adult death is in the younger adult ages—a pattern that is common in wartime and has become a signature of the AIDS epidemic, but that is otherwise rarely seen."

One consequence of this adult die-off is an increase in the number of children and elderly who are dependent on each economically productive adult. This makes it more difficult for societies to save and, therefore, to make the investments needed to improve living conditions. To make matters worse, in Africa it is often the better educated, more socially mobile populations who have the highest infection rate. Africa is losing the agronomists, the engineers, and the teachers it needs to sustain its economic development. In South Africa, for example, at the University of Durban-Westville, where many of the country's future leaders are trained, 25 percent of the students are HIV positive.

Countries where labor forces have such high infection levels will find it increasingly difficult to attract foreign investment. Companies operating in countries with high infection rates face a doubling, tripling, or even quadrupling of their health insurance costs. Firms once operating in the black suddenly find themselves in the red. What has begun as an unprecedented social tragedy is beginning to translate into an economic disaster. Municipalities throughout South Africa have been hesitant to publicize the extent of their local epidemics or scale up control efforts for fear of deterring outside investment and tourism.

The feedback loops launched by AIDS may be quite predictable in some cases, but could also destabilize societies in unanticipated ways. For example, where levels of unemployment are already high—the present situation in most African nations—a growing population of orphans and displaced youths could exacerbate crime. Moreover, a country in which a substantial share of the population suffers from impaired immune systems as a result of AIDS is much more vulnerable to the spread of other infectious diseases, such as tuberculosis, and waterborne illness. In

Zimbabwe, the last few years have brought a rapid rise in deaths due to tuberculosis, malaria, and even the bubonic plague—even among those who are not HIV positive. Even without such synergies, in the early years of the next century, the HIV epidemic is poised to claim more lives than did World War II.

Sinking Water Tables

While AIDS is already raising death rates in sub-Saharan Africa, the emergence of acute water shortages could have the same effect in India. As population grows, so does the need for water. Home to only 358 million people in 1950, India will pass the one-billion mark later this year. It is projected to overtake China as the most populous nation around the year 2037, and to reach 1.5 billion by 2050.

As India's population has soared, its demand for water for irrigation, industry, and domestic use has climbed far beyond the sustainable yield of the country's aquifers. According to the International Water Management Institute (IWMI), water is being pumped from India's aquifers at twice the rate the aquifers are recharged by rainfall. As a result, water tables are falling by one to three meters per year almost everywhere in the country. In thousands of villages, wells are running dry.

In some cases, wells are simply drilled deeper—if there is a deeper aquifer within reach. But many villages now depend on trucks to bring in water for household use. Other villages cannot afford such deliveries, and have entered a purgatory of declining options—lacking enough water even for basic hygiene. In India's western state of Gujarat, water tables are falling by as much as five meters per year, and farmers now have to drill their wells down to between 700 and 1200 feet to reach the receding supply. Only the more affluent can afford to drill to such depths.

Although irrigation goes back some 6,000 years, aquifer depletion is a rather recent phenomenon. It is only within the last half century or so that the availability of powerful diesel and electric pumps has made it possible to extract water at rates that exceed recharge rates. Little is known about the total capacity of India's underground supply, but the unsustainability of the current consumption is clear. If the country is currently pumping water at double the rate at which its aquifers recharge, for example, we know that when the aquifers are eventually depleted, the rate of pumping will necessarily have to be reduced to the recharge rate—which would mean that the amount of water pumped would be cut in half. With at least 55 percent of India's grain production now coming from irrigated lands, IWMI speculates that aquifer depletion could reduce India's harvest by one-fourth. Such a massive cutback could prove catastrophic for a nation where 53 percent of the children are already undernourished and underweight.

Impending aquifer depletion is not unique to India. It is also evident in China, North Africa and the Middle East,

as well as in large tracts of the United States. However, in wealthy Kuwait or Saudi Arabia, precariously low water availability per person is not life-threatening because these countries can easily afford to import the food that they cannot produce domestically. Since it takes 1,000 tons of water to produce a ton of grain, the ability to import food is in effect an ability to import water. But in poor nations, like India, where people are immediately dependent on the natural-resource base for subsistence and often lack money to buy food, they are limited to the water they can obtain from their immediate surroundings—and are much more endangered if it disappears.

In India—as in other nations—poorer farmers are thus disproportionately affected by water scarcity, since they often cannot get the capital or credit to obtain bigger pumps necessary to extract water from ever-greater depths. Those farmers who can no longer deepen their wells often shift their cropping patterns to include more water-efficient—but lower-yielding—crops, such as mustard, sorghum, or millet. Some have abandoned irrigated farming altogether, resigning themselves to the diminished productivity that comes with depending only on rainfall.

When production drops, of course, poverty deepens. When that happens, experience shows that most people, before succumbing to hunger or starvation, will migrate. On Gujarat's western coast, for example, the overpumping of underground water has led to rapid salt-water intrusion as seawater seeps in to fill the vacuum left by the freshwater. The groundwater has become so saline that farming with it is impossible, and this has driven a massive migration of farmers inland in search of work.

Village communities in India tend to be rather insular, so that these migrants—uprooted from their homes—cannot take advantage of the social safety net that comes with community and family bonds. Local housing restrictions force them to camp in the fields, and their access to village clinics, schools, and other social services is restricted. But while attempting to flee, the migrants also bring some of their troubles along with them. Navroz Dubash, a researcher at the World Resources Institute who examined some of the effects of the water scarcity in Gujarat, notes that the flood of migrants depresses the local labor markets, driving down wages and diminishing the bargaining power of all landless laborers in the region.

In the web of feedback loops linking health and water supply, another entanglement is that when the *quantity* of available water declines, the *quality* of the water, too, may decline, because shrinking bodies of water lose their efficacy in diluting salts or pollutants. In Gujarat, water pumped from more than 700 feet down tends to have an unhealthy concentration of some inorganic elements, such as fluoride. As villagers drink and irrigate with this contaminated water, the degeneration of teeth and bones known as fluorosis has emerged as a major health threat. Similarly, in both West Bengal, India and Bangladesh, receding water tables have exposed arsenic-laden sediments to oxygen, converting them to a water-soluble form. Ac-

cording to UNDP estimates, at least 30 million people are exposed to health-impairing levels of arsenic in their drinking water.

As poverty deepens in the rural regions of India—and is driven deeper by mutually exacerbating health threats and water scarcities—migration from rural to urban areas

AIDS attacks whole communities, but unlike other scourges it takes its heaviest toll on teenagers and young adults—the people most needed to care for children and keep the economy productive.

is likely to increase. But for those who leave the farms, conditions in the cities may be no better. If water is scarce in the countryside, it is also likely to be scarce in the squatter settlements or other urban areas accessible to the poor. And where water is scarce, access to adequate sanitation and health services is poor. In most developing nations, the incidence of infectious diseases, including waterborne microbes, tuberculosis, and HIV/AIDS, is considerably higher in urban slums—where poverty and compromised health define the way of life—than in the rest of the city.

In India, with so many of the children undernourished, even a modest decline in the country's ability to produce or purchase food is likely to increase child mortality. With India's population expected to increase by 100 million people per decade over the next half century, the potential losses of irrigation water pose an ominous specter not only to the Indian people now living but to the hundreds of millions more yet to come.

Shrinking Cropland Per Person

The third threat that hangs over the future of nearly all the countries where rapid population growth continues is the steady decline in the amount of cropland remaining per person—a threat both of rising population and of the conversion of cropland to other uses. In this analysis, we use grainland per person as a surrogate for cropland, because in most developing countries the bulk of land is used to produce grain, and the data are much more reliable. Among the more populous countries where this trend threatens future food security as Nigeria, Ethiopia, and Pakistan—all countries with weak family-planning programs.

As a limited amount of arable land continues to be divided among larger numbers of people, the average amount of cropland available for each person inexorably shrinks. Eventually, it drops below the point where people can feed themselves. Below 600 square meters of grainland per person (about the area of a basketball court), nations typically begin to depend heavily on imported

grain. Cropland scarcity, like, water scarcity, can easily be translated into increased food imports in countries that can afford to import grain. But in the poorer nations of sub-Saharan Africa and the Indian subcontinent, subsistence farmers may not have access to imports. For them, land scarcity readily translates into malnutrition, hunger, rising mortality, and migration—and sometimes conflict. While most experts agree that resource scarcity alone is rarely the cause of violent conflict, resource scarcity has often compounded socioeconomic and political disruptions enough to drive unstable situations over the edge.

Thomas Homer-Dixon, director of the Project on Environment, Population, and Security at the University of Toronto, notes that "environmental scarcity is, without doubt, a significant cause of today's unprecedented levels of internal and international migration around the world." He has examined two cases in South Asia—a region plagued by land and water scarcity—in which resource constraints were underlying factors in mass migration and resulting conflict.

In the first case, Homer-Dixon finds that over the last few decades, land scarcity has caused millions of Bangladeshis to migrate to the Indian states of Assam, Tripura, and West Bengal. These movements expanded in the late 1970s after several years of flooding in Bangladesh, when population growth had reduced the grainland per person in Bangladesh to less than 0.08 hectares. As the average person's share of cropland began to shrink below the survival level, the lure of somewhat less densely populated land across the border in the Indian state of Assam became irresistible. By 1990, more than 7 million Bangladeshis had crossed the border, pushing Assam's population from 15 million to 22 million. The new immigrants in turn exacerbated land shortages in the Indian states, setting off a string of ethnic conflicts that have so far killed more than 5,000 people.

In the second case, Homer-Dixon and a colleague, Peter Gizewski, studied the massive rural-to-urban migration that has taken place in recent years in Pakistan. This migration, combined with population growth within the cities, has resulted in staggering urban growth rates of roughly 15 percent a year. Karachi, Pakistan's coastal capital, has seen its population balloon to 11 million. Urban services have been unable to keep pace with growth, especially for low-income dwellers. Shortages of water, sanitation, health services and jobs have become especially acute, leading to deteriorating public health and growing impoverishment.

"This migration . . . aggravates tensions and violence among diverse ethnic groups," according to Homer-Dixon and Gizewski. "This violence, in turn, threatens the general stability of Pakistani society." The cities of Karachi,

Hyderabad, Islamabad, and Rawalpindi, in particular, have become highly volatile, so that "an isolated, seemingly chance incident—such as a traffic accident or short-term breakdown in services—ignites explosive violence." In 1994, water shortages in Islamabad provoked widespread protest and violent confrontation with police in hard-hit poorer districts.

the form of soil erosion or of the waterlogging and salinization of irrigated land, is also claiming cropland.

Epidemics, resource scarcity, and other societal stresses thus do not operate in isolation. Several disruptive trends will often intersect synergistically, compounding their effects on public health, the environment, the economy, and the society. Such combinations can happen anywhere, but the effects are likely to be especially pernicious—and sometimes dangerously unpredictable—in such places as Bombay and Lagos, where HIV prevalence is on the rise, and where fresh water and good land are increasingly beyond the reach of the poor.

> When people of parenting age die, the elderly are often left alone to care for the children. Meanwhile, poverty worsens with the loss of wage-earners. In other situations, poverty is worsened by declines in the amounts of productive land or fresh water available to each person and here, too, death may take an unnatural toll.

Regaining Control of Our Destiny

Without efforts to step up family planning in Pakistan, these patterns are likely to be magnified. Population is projected to grow from 146 million today to 345 million in 2050, shrinking the grainland area per person in Pakistan to a miniscule 0.036 hectares by 2050—less than half of what it is today. A family of six will then have to produce its food on roughly one-fifth of a hectare, or half an acre—the equivalent of a small suburban building lot in the United States.

Similar prospects are in the offing for Nigeria, where population is projected to double to 244 million over the next half century, and in Ethiopia, where population is projected to nearly triple. In both, of course, the area of grainland per person will shrink dramatically. In Ethiopia, if the projected population growth materializes, it will cut the amount of cropland per person to one-third of its current 0.12 hectares per person—a level at which already more than half of the country's children are undernourished. And even as its per capita land shrinks, its long-term water supply is jeopardized by the demands of nine other rapidly growing, water-scarce nations throughout the Nile River basin. But even these projections may underestimate the problem, because they assume an equitable distribution of land among all people. In reality, the inequalities in land distribution that exist in many African and South Asian nations mean that as the competition for declining resources becomes more intense, the poorer and more marginal groups face even harsher deprivations than the averages imply.

Moreover, in these projections we have assumed that the total grainland area over the next half-century will not change. In reality this may be overly optimistic simply because of the ongoing conversion of cropland to nonfarm uses and the loss of cropland from degradation. A steadily growing population generates a need for more homes, schools, and factories, many of which will be built on once-productive farmland. Degradation, which may take

The threats from HIV, aquifer depletion, and shrinking cropland are not new or unexpected. We have known for at least 15 years that the HIV virus could decimate human populations if it is not controlled. In each of the last 18 years, the annual number of new HIV infections has risen, climbing from an estimated 200,000 new infections in 1981 to nearly 6 million in 1998. Of the 47 million people infected thus far, 14 million have died. In the absence of a low-cost cure, most of the remaining 33 million will be dead by 2005.

It may seem hard to believe, given the advanced medical knowledge of the late twentieth century, that a controllable disease is decimating human populations in so many countries. Similarly, it is hard to understand how falling water tables, which may prove an even greater threat to future economic progress, could be so widely ignored.

The arithmetic of emerging resource shortages is not difficult. The mystery is not in the numbers, but in our failure to do what is needed to prevent such threats from spiraling out of control.

Today's political leaders show few signs of comprehending the long-term consequences of persistent environmental and social trends, or of the interconnectedness of these trends. Despite advances in our understanding of the complex—often chaotic—nature of biological, ecological, and climatological systems, political thought continues to be dominated by reductionist thinking that fails to target the root causes of problems. As a result, political action focuses on responses to crises rather than prevention.

Leaders who are prepared to meet the challenges of the next century will need to understand that universal access to family planning not only is essential to coping with resource scarcity and the spread of HIV/AIDS, but is likely to improve the quality of life for the citizens they serve. Family planning comprises wide availability of contraception and reproductive healthcare, as well as im-

proved access to educational opportunities for young women and men. Lower birth rates generally allow greater investment in each child, as has occurred in East Asia.

Leaders all over the world—not just in Africa and Asia—now need to realize that the adverse effects of global population growth will affect those living in nations such as the United States or Germany, that seem at first

Overwhelmed by multiple attacks on its health, the society falls deeper into poverty and as the cycle continues, more of its people die prematurely.

glance to be relatively protected from the ravages now looming in Zimbabwe or Ethiopia. Economist Herman Daly observes that whereas in the past surplus labor in one nation had the effect of driving down wages only in that nation, "global economic integration will be the means by which the consequences of overpopulation in the Third World are generalized to the globe as a whole." Large infusions of job-seekers into Brazil's or India's work force that may lower wages there may now also mean large infusions into the global workforce, with potentially similar consequences.

As the recent Asian economic downturn further demonstrates, "localized instability" is becoming an anachronistic concept. The consequences of social unrest in one nation, whether resulting from a currency crisis or an environmental crisis, can quickly cross national boundaries. Several nations, including the United States, now recognize world population growth as a national security issue. As the U.S. Department of State Strategic Plan, issued in September 1997, explains, "Stabilizing population growth is vital to U.S. interests. . . . Not only will early stabilization of the world's population promote environmentally sustainable economic development in other countries, but it will benefit the United States by improving trade opportunities and mitigating future global crises."

One of the keys to helping countries quickly slow population growth, before it becomes unmanageable, is

expanded international assistance for reproductive health and family planning. At the United Nations Conference on Population and Development held in Cairo in 1994, it was estimated that the annual cost of providing quality reproductive health services to all those in need in developing countries would amount to $17 billion in the year 2000. By 2015, the cost would climb to $22 billion.

Industrial countries agreed to provide one-third of the funds, with the developing countries providing the remaining two-thirds. While developing countries have largely honored their commitments, the industrial countries—and most conspicuously, the United States—have reneged on theirs. And in late 1998, the U.S. Congress—mired in the quicksand of anti-abortion politics—withdrew all funding for the U.N. Population Fund, the principal source of international family planning assistance. Thus was thrown aside the kind of assistance that helps both to slow population growth and to check the spread of the HIV virus.

In most nations, stabilizing population will require mobilization of domestic resources that may now be tied up in defense expenditures, crony capitalism or government corruption. But without outside assistance, many nations many still struggle to provide universal family planning. For this reason, delegates at Cairo agreed that the immense resources and power found in the First World are indispensable in this effort. And as wealth further consolidates in the North and the number living in absolute poverty increases in the South, the argument for assistance grows more and more compelling. Given the social consequences of one-third of the world heading into a demographic nightmare, failure to provide such assistance is unconscionable.

Lester Brown is president of the Worldwatch Institute and Brian Halweil is a staff researcher at the Institute.

The Misery Behind

WOMEN SUFFER MOST

the Statistics

DIANA BROWN

Today three jumbo jets crashed, killing everyone on board. You didn't hear about it? That's funny. Perhaps it was because nearly everyone killed was from the so-called third world. Or perhaps it was because they were all women. But perhaps the most likely explanation was that it wasn't really "news" because the same thing happened yesterday and the day before that and will go on happening tomorrow and the next day and the day after.

I am sure that by now you know that I am not writing about real jumbo jets, but an equivalent number of passengers. Every year, year in, year out, 600,000 women are dying, nearly all in the third world, from pregnancy-related causes, nearly all of which are preventable.[1] How many of us in the comfortable first world know? How many care? Some of us find it easier to worry about the impact on the global environment of explosive population growth than about the apparently hopeless difficulties of day-to-day life and death in distant countries of which we know little.

The problems are, however, related. Women are dying unnecessarily because they lack basic human rights and particularly because they lack full reproductive rights. These deficiencies fuel rapid population growth. There is plenty of evidence that many women in developing countries are having more children than they really want, but as Kalimi Mworia of the International Planned Parenthood Foundation (IPPF) in Nairobi has said, many third world women "do not own their own bodies."

Diana Brown represents the International Humanist and Ethical Union at the United Nations in Geneva and is a former chairman of Population Concern in London.

ABUSE AND INEQUALITY

Nowhere in the world do women enjoy full equality with men. A recent study by Agnes Wold and Christine Wennerås of peer review in the Swedish Medical Research Council[2] has shown that even in enlightened Scandinavia there is considerable bias against women in science. In a large number of less-developed countries, however, women and girls have to cope with gross inequalities.

Discrimination starts before birth.[3] In many countries sons are valued much more highly than daughters, and, in some, female fetuses are selectively aborted. Although female infanticide is much less prevalent than in the past, severe neglect of girl children can have an equivalent effect. Girls and women often have to work harder than boys and men and yet may be denied equal access to nutrition, health care, and education. In some countries young girls are sold into prostitution, and in quite a few they can be forced into early marriage. The adult woman may be unable to own land or inherit property. She may be denied access to credit and may have little hope of economic independence. Worldwide, girls and women are the victims of violent attacks and rapes. It is even possible for the victim of a rape to be jailed while her attacker goes free.

All of these abuses constitute a denial of human rights, and many are enshrined in law, despite countries' stated commitment to the Universal Declaration of Human Rights. Even where laws uphold equality or embody protective measures such as forbidding child marriage, they are not necessarily enforced. Laws often seem ineffective in combating strongly entrenched cultural practices, such as female genital mutilation or early marriage. (We also see from the example in Sweden quoted above that, even with full equality guaranteed by law, a male hierarchy is able to hold onto power by subtle means.)

From *Free Inquiry,* Spring 1999, pp. 25-27. © 1999 by *Free Inquiry.* Reprinted by permission.

Nevertheless, legal equality is an important first step in improving the position of women. We in the developed world should be working energetically to achieve it. A 1992 UNICEF report referred to "the apartheid of gender" and pointed out that discrimination against women was an injustice on a far greater scale than the apartheid system. Apartheid was rightly opposed by the international community on the ground that "a people's rights and opportunities—where they can live, what education and health care they will receive, what job they can do, what income they can earn, what legal standing they will have—should not depend on whether they were born black or white. Yet it seems that the world is prepared to accept, with none of the depth and breadth of opposition that has been seen during the apartheid years, that all of these things can depend on the accident of being born male or female."[4]

EMPOWERING WOMEN

It has been widely recognized that raising the status of women and giving them more control over their lives is an essential step on the road to population stabilization. If women are valued for themselves, son preference is reduced, with a consequent lowering of average family size. Educated women marry later and have smaller, better-spaced families who are

Every year, year in, year out, 600,000 women are dying, nearly all in the third world, from pregnancy-related causes, nearly all of which are preventable.

more likely to be healthy and survive. This in turn leads to lower birthrates. Women with a measure of economic independence have more say in their reproductive lives and can (and do) choose to have smaller families.

The International Conference on Population and Development (ICPD) held in Cairo in 1994 reached agreement on the need for the empowerment of women and the improvement of their status. In particular, governments were urged to eliminate all forms of discrimination against female children and to work to eliminate preferences for sons. The achievements of Cairo were trammelled by the obstructive, antichoice behavior of the Vatican, which greatly weakened the international community's commitment to eliminating unsafe abortion, but it was notable for cooperative between the population lobby and feminists, groups who had previously been suspicious of one another, but who were now to some extent able to unite against a common enemy for the advancement of women.

FEMINIST SUSPICIONS

Even after Cairo, however, suspicions remained. Many feminists have viewed population advocates as fanatically wedded to "population control" and prepared to countenance any

means to achieve this end. It is quite true that in the past some population programs have been coercive and insensitive to the reproductive needs of both men and women. A few still are. One problem is that, in countries where the power structure is overwhelmingly male, official programs can be run without a real understanding of the needs and problems of women. It is also possible to run population programs by focusing on the goal of eventual population stabilization and various intermediate targets without paying much attention to what people really want in the present.

Those concerned about population growth are also criticized for putting demographic goals first and "pursuing public policies that are likely to have the most direct impact on reducing birthrates even if they are not the most important in terms of improving the quality of people's lives."[5] The same critic also points out that family planning may be divorced from basic health care and funded at the latter's expense. Given the dramatic improvement that has resulted in quality of life wherever birthrates have been reduced, it is hard to see the validity of the first claim. According to UNICEF, "the responsible planning of births is one of the most effective and least expensive ways of improving the quality of life on earth," and "family planning could bring more benefits to more people at less cost than any other single technology now available to the human race."[6]

The second charge is clearly true in certain countries, but it is difficult to see how really poor countries can do otherwise. Given their very limited resources, they are never going to be able to provide all the services to their people that we would like to see. They are forced to prioritize. Faced with a rapidly growing population and therefore ever-increasing needs, it seems to make sense to give priority to slowing down population growth, provided that human rights are respected and that the measures taken do genuinely benefit the people who are affected by them.

THE NEED TO TALK NUMBERS

I have personally been attacked by certain feminists for daring to "talk numbers" in the context of population. There seems to be a misconception that, if one uses statistics in discussions about groups of people, then one is ceasing to think of them as people and must also be wedded to coercive methods of "population control." I disagree profoundly. A baby dies, and everyone who knows the family is sad. The world in general, however, knows nothing of that baby or its death. A mother dies as a result of an unsafe abortion, trying to terminate an unwanted pregnancy. This is a tragedy for her family, and particularly for her surviving children, who may even die as a result of their loss. The world remains ignorant. Statistics tell us that each year about 4 million newborn babies die. Each year there are about 20

million unsafe abortions.[7] These statistics help us to understand the scale of the problems and the human misery they embody. They make us realize that the problems need to be tackled urgently.

In the same way, the knowledge that a country's population is likely to double in only 25 years shows us that it is facing an uphill struggle to improve the lot of its people and that its standard of living may even deteriorate as a result of population pressure. This should galvanize us to action.

The real problem is not the population researchers statistics, but that the statistics are brushed aside. Except at international conferences, most developed countries have shown great insensitivity to the pain behind the figures and have been unwilling to live up to the funding commitments they made at Cairo, leaving the poorer countries to stagger along as best they can, parceling out their inadequate resources. Development aid is seen as a way of promoting the commerce of the donor country—only a week before I write, the British Minister for International Development was heavily criticized for saying that it was not part of her job to help British businesses achieve contracts overseas. Only a very few rich countries are meeting the U.N. target of 0.7% of gross national product go-

ing to overseas aid, with 4% of that money being devoted to population programs.

So much needs to be done. My hope is that population advocates and feminists can unite in the common cause of working for reproductive rights and empowerment of women. We may never agree in the details, but we should not fight one another. If we succeed, the prize will be a better quality of life for all humanity.

Notes

1. Data from World Health Organization. See also http://safemotherhood.org.
2. A. Wold and C. Wennerås, *Nature,* 387 (1997): 341–343.
3. For an accessible account of discrimination against girls, see *People and the Planet,* 7 (1998): 3. Their Web site is www.oneworld.org/patp/.
4. *The State of the World's Children,* UNICEF, 1992.
5. B. Hartmann, "Cairo Consensus Sparks New Hopes, Old Worries," *Forum for Applied Research and Public Policy,* Summer 1997.
6. *State of the World's Children,* UNICEF, 1992.
7. Data from World Health Organization.

How Much Food Will We Need in The 21st Century?

By William H. Bender

Seldom has the world faced an unfolding emergency whose dimensions are as clear as the growing imbalance between food and people.[1]

The world food situation has improved dramatically during the past 30 years and the prospects are very good that the 20-year period from 1990 to 2010 will see further gains. . . . If Malthus is ultimately to be correct in his warning that population will outstrip food production, then at least we can say: Malthus Must Wait.[2]

Ever since Malthus, society has worried periodically about whether it will be able to produce enough food to feed people in the future. Yet until recently, most of the debate surrounding the issue of food scarcity focused on the potential for increasing the food supply. The key questions were whether there would be enough land and water to produce the amount of food needed and whether technology could keep increasing the yields of food grains. Now, however, scientists are growing concerned that the intensive use of land, energy, fertilizer, and pesticides that modern agriculture seems to require jeopardizes the health of the environment. This anxiety has

been integrated into the general debate about food scarcity, but interestingly enough, the question of the demand for food—including the specific physiological needs and dietary desires of different peoples—has not. In fact, relatively little attention has been paid to the issue of demand despite the fact that like energy and water, food can be conserved and the demand for it adjusted to meet human needs and lessen the burden that modern agriculture places on the environment.

Unlike with many other forms of consumption, there are limits to the physical quantity of food that people can consume. In a number of high-income countries, that limit seems to have been reached already. If global population does double by 2050, as many have predicted, providing everyone with a rich and varied diet (equivalent to that enjoyed by today's wealthiest countries) would only require a tripling of food production. Alternatively, with sufficient improvements in efficiency and adoption of a healthier diet in high-income countries, it would be possible to provide such a diet for the entire global population with just a doubling of food production. But even a doubling of current production could strain Earth's ecosystems, as critics of modern agriculture's intensive use of resources will attest. Clearly, then, in-

creases in food demand will have to be slowed if we hope to achieve a sustainable agricultural system. Central to the issue of demand, however, is the question of how much food the world really needs.

From an analytical standpoint, the amount of food a given population (be it a country, a region, or the world) actually *needs* is the product of two factors: the number of people and the average (minimal) food requirement per person. The amount of food the population *consumes,* however, is determined not only by its basic needs but also by its income and dietary preferences. This difference is particularly important in high-income countries, where crops that could be consumed directly are instead fed to animals to produce eggs, meat, and milk. Finally, the amount of food a given population *requires* (i.e., has to produce or import) depends on how much is wasted in going from farm to mouth as well as on its level of consumption. In mathematical terms,

$$Req = Pop \cdot PFR \cdot Diet \cdot Eff,$$

where *Req* is the total number of food calories that has to be produced, *Pop* is population, *PFR* is the number of calories per person that is needed to sustain life and health, *Diet* is a factor reflecting

From *Environment,* March 1997, 7–11, 27–28. Reprinted with permission of the Helen Dwight Reid Educational Foundation. Published by Heldref Publications, 1319 Eighteenth St., N.W., Washington, D.C. 20036-1802. © 1997.

Table 1. World population supportable under different conditions

Conditions in	Population (billions)
United States	2.3
Europe	4.1
Japan	6.1
Balgladesh	10.9
Subsistence only	15.0
Addendum: Actual 1990 population	5.3

NOTE: This table shows the number of people that could be fed at the 1990 level of agricultural production if the dietary preferences and food system efficiencies in the countries (or area) shown prevailed throughout the world. Dietary preferences reflect both income and the extent to which cereal grains are fed to animals instead of being consumed directly. Food system efficiencies reflect the extent to which food is spoiled or wasted in going from farm to mouth.

SOURCE: Author's calculations.

the conversion of some plant calories to animal calories, and *Eff* is the ratio of calories available in the retail market to those consumed.

This article will address the neglected issue of food demand in terms of the four variables of this equation. In the process, it will question some of the assumptions previous analysts have made, particularly with regard to desirable diets and food system efficiency. Though not definitive, the analysis strongly suggests that the right policy choices can reduce the growth in the global demand for food. Indeed, the potential scope of such a reduction appears to be substantial: As Table 1 on this page shows, vastly different numbers of people can be supported by a given amount of agricultural production depending on dietary habits and degrees of efficiency.

Population

Global population will play an important role in determining how much food we will require in the future. For this reason, attempts to calculate future food requirements depend upon projections of population growth. Although demographers generally agree that the current global population will double by the middle of the next century, considerable uncertainty accompanies these projections.

The United Nations' estimates of the world's population in 2050, for example, vary from 7.9 billion to 11.9 billion. If global population reaches the higher value rather than the lower one, global food requirements will be 50 percent higher.

National and international policies that provide family planning services, maternal education, and social support systems can affect population growth, and these policies will undoubtedly have the single largest effect on food requirements in the 21st century. The availability of food will also play a role, however. Famine—the most dramatic example of lack of food—has fortunately been largely eliminated (except during wars) and no longer ranks as a major factor in global population growth. Even so, the relative abundance of food has a direct effect on the other key factors that influence population growth, and combined with the subtle influences exerted by the food and agriculture sector, it can have a significant impact. For example, in rural agricultural societies, the demand for agricultural labor affects fertility rates, while reductions in child mortality (which are influenced by food availability) usually precede reduction in fertility rates.

Physiological Requirements

Physiological food requirements, represented by PFR in the equation, are determined by several factors, including the population's age and gender distribution, its average height and weight, and its activity level. One may compute such requirements in two different ways, using either actual circumstances or normative ones (such as desired heights and weights or activity levels).[3]

Around the world, actual per capita caloric consumption varies from a low of 1,758 calories per day in Bangladesh to a high of 2,346 calories per day in the Netherlands. Caloric consumption is higher in the Netherlands for several reasons. First, the population is generally older, and adults require more food than children. Second, people in the Netherlands are on average taller and heavier than those in Bangladesh and therefore need more food. (Lower activity levels in the Netherlands partially offset these factors, however.) If the actual consumption levels in these two countries were to change, either the weights of individuals or their activity levels would have to change accordingly. Caloric consumption levels vary by no more than one-third on a national basis—far less than the variation in caloric availability.

When making future projections, normative considerations can also be very important. A population's general health, for instance, affects the amount of food it needs. Parasites and disease can substantially increase an individual's energy requirements, with fever, for example, raising his or her basal metabolic rate (the number of calories he or she uses when at rest) approximately 10 percent for every one degree C increase in body temperature.[4] Disease can also impair the body's ability to absorb nutrients, while parasites siphon away food energy for their own use. Although not important globally, health factors are highly significant in certain low-income countries. In fact, in localized situations health interventions may be more effective than merely increasing the food supply in helping people to satisfy basic physiological food requirements.

Of course, to qualify as truly sustainable, the world's agricultural system has to produce enough calories to ensure food security around the globe. This is a normative concept, as is clear in the commonly accepted definition of food security: "access by all people at all times to enough food for an active, healthy life."[5] Thus, for future projections, we could consider a world with lower levels of undernutrition and stunting, leading to higher food requirements.

Table 2 shows estimates of physiological food requirements for the world as a whole, for high-income countries, and for low-income countries, all based on current circumstances. (The box on the next page discusses the way in which these estimates were prepared). High-income countries use much more than twice as much food per person. This variation is not due to differences in calories actually consumed but to differences in diet and the lower efficiency of food systems in those countries.

Dietary Patterns

Diets are largely determined by economic factors, particularly prices and incomes. In Africa, for example, people derive two-thirds of their calories from less expensive starchy staples (including cereals, roots, and tubers) and only 6 percent from animal products. In Europe, on the other hand, people derive 33 percent of their calories from animal products and less than one-third from starchy staples. The global diet falls somewhere in the mid-range between these two extremes.

As people's level of income increases, the share of starchy staples in their diet declines, and the shares of animal products, oils, sweeteners, fruits, and vegetables increase.[6] In fact, the absolute quantities of these products that people

Table 2. Numerical estimates for key food variables, 1991

Variable	World	High-income countries	Low-and middle-income countries	Best practice/ medically preferred
Calories per person per day				
Total food available[a]	3,939	6,964	3,007	n/a
Food available in retail markets	2,693	3,255	2,520	n/a
Physiological food requirements[b]	2,179	2,231	2,169	n/a
Ratio				
Dietary conversion factor[c]	1.46	2.14	1.19	1.5
End-use efficiency factor[d]	1.24	1.46	1.16	1.3

n/a Not applicable
[a]Includes animal feed
[b]1990 estimate
[c]Line 1 divided by line 2, except for last column, which is author's estimate
[d]Line 2 divided by line 3, except for last column, which is author's estimate

NOTE: Computational methods are described in the box on this page.

SOURCES: Line 1: Author's calculations; Line 2: United Nations Food and Agriculture Organization at http://www.foa.org; Line 3: Author's calculations.

eat increase even faster than the shares because caloric availability overall also increases as incomes increase. This growing dietary diversity provides a substantial health benefit for people at the low to medium income level.

The overall increase in food availability over the last several decades, while a welcome development, has created problems of its own. As people consume more animal products, they tend to consume more animal fats than recent medical research has shown to be healthy. Currently, the World Health Organization (WHO) recommends that people limit their dietary intake of fat to no more than 30 percent of calorie consumption, and some foresee a revision to no more than 25 to 20 percent in the future.[7]

At present, 16.8 percent of the global population lives in high-income countries, where, on average, fat consumption exceeds the 30 percent level. But health concerns have clearly begun to affect consumption patterns in those countries: Despite rising incomes and relatively stable prices, beef consumption has declined in a number of countries since the mid-1970s. In the United States, for instance, per capita beef consumption has dropped 25 percent.[8] (Overall meat consumption in the United States has remained approximately constant, however, because people merely shifted to eating poultry.)

Clearly, public policy that encourages people to reduce their consumption of animal fat has two benefits. It improves the health of the population while reducing the pressure that increased food production places on the global agricultural system. Table 3 shows the conversion rates of grain to animal products in terms of two common measures: kilograms and calories. For the past 30 years, approximately 40 percent of all cereal grains produced globally have been used for feed, with 50 percent being used for food. (The remaining 10 percent have gone to seed, been used in processing, or ended up as waste.) As Table 2 shows, however, the use of grain for feed is much higher in high-income countries.

A NOTE ON COMPUTATIONS

Physiological food requirements. Estimating the number of calories that the average person in a given population actually consumes (as distinct from the number that is available in the retail market) entails a five-step procedure.[1] The first step is to determine the age-gender structure of the population, placing children in single-year age groups and adults in five-year age groups. The second step is to estimate the basal metabolic rates for each group based on group members' average heights and weights. The third step is to estimate the different groups' physical activity patterns and combine them with their basal metabolic rates to determine each group's energy requirements. The fourth step is to make allowances for such factors as pregnancy and infection rates and then multiply the average energy requirement for each group by the number of people in the group. The final step is to sum the energy requirements for the different groups and divide by the total population. Normative food requirements (i.e., the number of calories needed to maintain desired heights, weights, and activity levels) can then be determined by adjusting appropriately for heights, weights, and activity levels.

Dietary conversion factor. This factor reflects the number of calories "lost" in using grain to produce animal products. It is computed as the ratio of the total number of calories produced to the number available (in final form) in the retail market. The denominator is usually per capita caloric availability as estimated by the United Nations Food and Agriculture Organization (FAO).[2] The numerator is more difficult to determine because some animals graze rather than being fed grain. The procedure used in this article was to sum three factors: the number of plant calories available, excluding cereals, starchy roots, and tubers; the number of plant calories available from cereals, starchy roots, and tubers, whether used for feed or for human consumption; and the estimated number of animal calories derived from range feeding.

End-use efficiency factor. End-use efficiency—the proportion of calories produced that actually ends up in human mouths—is computed as the ratio of calories available in the retail market (from FAO) to calories consumed (as computed above).

1. See W. P. T. James and E. C. Schofield, Human Energy Requirements (Oxford, U.K.: Oxford University Press by arrangement with the United Nations Food and Agriculture Organization, 1990).
2. Available at http://www.fao.org.

Efficiency

The last factor affecting global food requirements is the efficiency with which food moves from farms to human mouths. Efficiency actually has two components, one pertaining to marketing and distribution and one pertaining to "end use." Losses in marketing and distribution, such as those due to rodents and mold, are important in low-income countries but decline steadily with increases in income.[9] Inefficiencies in end use, which include losses due to spoilage, processing and preparation waste, and plate waste, are most significant in high-income countries, however.

The United Nations Food and Agriculture Organization (FAO) estimates that per capita caloric availability (i.e., the amount of food that appears in the retail market) ranges from a low of 1,667 calories in Ethiopia to a high of 3,902 calories in Belgium-Luxembourg. These two figures differ by 234 percent—much more than the 33 percent difference in physiological consumption. Because it is physiologically impossible for the population of an entire country to consume an average of 3,902 calories, we know that a substantial amount of food in high-income countries is never consumed. According to estimates, losses from end-use inefficiencies equal 30 to 70 percent of the amount of food actually consumed.[10] With the exception of Belgium-Luxembourg, it is middle-income countries such as Greece, Ireland, Yugoslavia, Hungary, Bulgaria, Egypt, and Libya that have the highest levels of waste. But in every country where per capita income is more than $1,500 (U.S.), at least 20 percent more food is used than is consumed. The computed values for the end-use efficiency factor in Table 2 also reflect the discrepancy between high- and low-income countries.

It is unclear to what extent these losses are a necessary component of increased standards of living because little analysis has been done on the sources of this waste. Some intercountry comparisons provide useful insights, however. The Netherlands, Finland, Japan, and Sweden, which have comparable levels of income, waste only about 35 percent (on a per capita caloric basis), while the United States, Belgium-Luxembourg, Switzerland, and Italy waste nearly 60 percent.[11] This suggests that there is scope for reducing food requirements without lowering standards of living, much as high-income countries have done with energy use since the 1970s.

Given the current distribution of food consumption and food system efficiency, if every middle- and high-income country were to reduce its level of waste to 30 percent, global food requirements would decline 7.4 percent. (If consumption of animal products were to decrease in proportion, requirements would decline 12.5 percent owing to the lower demand for feed.) Clearly, as global incomes increase and the number of people living in countries with low food system efficiency continues to grow, the level of end-use waste will become an increasingly important part of overall food requirements.[12]

Final Thoughts

By its very nature, agricultural production has significant impacts upon natural ecosystems and the environment. There is little question that agricultural production must increase to meet population growth, but the magnitude of the increase necessary to improve human welfare is very much a question of policy tradeoffs between demand management and supply promotion.

Food is the only sector of the economy that has reached satiation for a large portion of the world's population. Tripling world food production would provide sufficient food for a doubled global population to have a varied, nutritious, and healthy diet comparable to today's European diet. The same goal could be reached by slightly more than doubling agricultural production if an effort were made to improve food system efficiencies and if diets low in fat became commonplace. This change will only take place if public policy creates explicit incentives for healthier diets and more efficient food systems, however.

It is environmentally and medically prudent to prevent the levels of waste and fat consumption in the wealthier developing economies from rising to those seen in North America today. It is also fiscally prudent: Grain imports tend to rise rapidly in maturing developing economies, so that decreased food system efficiency and increased fat consumption can lead directly to the loss of vital foreign exchange. Therefore, self-interest can be used to dramatically improve the long-term sustainability of the global agricultural system.

William H. Bender is an economist with extensive international experience in food and nutrition. He has consulted with the United Nations Children's Fund, the United Nations Food and Agriculture Organization, the World Bank, the United States Agency for International Development, the European Community, and many other organizations. His address is P.O. Box 66036, Auburndale, MA 02166 (telephone: (617) 647-9210; e-mail: bender@tiac.net).

NOTES

1. L. Brown et al., *State of the World, 1994* (New York: W. W. Norton & Company, 1994), 196.

2. D. O. Mitchell and M. D. Ingco, *The World Food Outlook* (Washington, D.C.: World Bank, 1993), 232.

3. Requirements are usually measured in terms of calories, both because food analysts tend to focus on producing sufficient calories and because even with a cereal-based diet, people can get adequate protein if they consume enough calories. (The exception to this rule lies in groups, such as infants, who have special nutritional needs.) Of course, consuming enough calories does not guarantee getting enough micronutrients such as iron, vitamin A, and iodine. To obtain those nutrients, people have to eat fruit, vegetables, and fat in addition to starchy staples. However, the inputs (e.g., land, water,

Table 3. Conversion rates of grain to animal products

Animal product	Kilograms of feed/ kilograms of output	Calories of feed/ calories of output
Beef	7.0	9.8
Pork	6.5	7.1
Poultry	2.7	5.7
Milk	1.0	4.9

NOTE: These conversions are very approximate, as the caloric density of both feeds and animal products can vary greatly. Furthermore, data units are often not specified or precisely comparable.

SOURCE: Column 1: Office of Technology Assessment, *A New Technological Era for American Agriculture*, OTA-F-474 (Washington, D.C., 1992); Column 2: Author's estimates.

and fertilizer) needed to provide a diverse diet are minor compared with those needed to provide enough calories.

4. R. E. Behrman and V. C. Vaughn, *Nelson Textbook of Pediatrics,* 13th ed. (Philadelphia: W. B. Saunders Company, 1987).

5. World Bank, *Poverty and Hunger: Issues and Options for Food Security in Developing Countries* (Washington, D.C., 1986).

6. Calculations of income elasticities reflect how consumption patterns change as income increases. Income elasticity is the percentage change in the demand for a particular good that results from a 1 percent increase in income. Demand is considered elastic when the percentage change is greater than 1, inelastic when it is less than 1. Animal products, for instance, are income-elastic goods because their share in diets tends to increase more rapidly than income. Researchers at or-ganizations like the World Bank, the International Food Policy Research Institute, and the International Institute for Applied Systems Analysis use such elasticities in global models that attempt to simulate future developments in the world agricultural system. Models like these can help provide insight into questions such as the effect increased demand for animal products is likely to have on grain production.

7. World Health Organization Study Group on Diet, Nutrition and Prevention of Non-communicable Diseases, *Diet, Nutrition and the Prevention of Chronic Diseases: Report of a WHO Study Group,* World Health Organization Technical Report Series 797 (Geneva: World Health Organization, 1992), 109.

8. L. A. Duewer, K. R. Krause, and K. E. Nelson, *U.S. Poultry and Red Meat Consumption, Prices, Spreads, and Margins,* Agriculture Information Bulletin Number 684 (Washington, D.C.: United States Department of Agriculture, Economic Research Service, 1993).

9. In low-income countries, such losses are as high as 15 percent for cereals and 25 percent for roots and tubers; in high-income countries they are less than 4 percent. See, for example, D. Norse, "A New Strategy for Feeding a Crowded Planet," *Environment,* June 1992, 6; and W. Bender, "An End Use Analysis of Global Food Requirements," *Food Policy* 19, no. 4 (1994): 381.

10. Bender, note 9 above, pages 388–90. In these countries, of course, data accuracy is also highest, giving us the most confidence in these estimates.

11. Ibid.

12. Ibid.

Angling for 'aquaculture'

Fish farms emerge as a viable alternative to dwindling sea harvests.

by Gary Turbak

For centuries, many viewed the seas as an inexhaustible source of food. High-tech breakthroughs increased the amount of fish harvested worldwide from 1959 to 1989 almost five-fold to nearly 100 million tons (90.7 million metric tons). Then suddenly, once abundant stocks of cod, bluefin tuna, salmon, and other species began disappearing from fish finder screens. The world's fishing fleets had accomplished the unthinkable—they had virtually depleted the oceans.

According to the Food and Agriculture Organizations (FAO) of the United Nations, 70 per-cent of the world's fish stocks are fully exploited, depleted, or in the process of rebuilding. It calls the situation "globally nonsustainable" and says that "major ecological and economic damage is already visible." Current shortages have resulted in fishing bans, antagonism among fishermen and nations for territorial rights, and the use of habitat-damaging harvesting methods like dynamite. But most worrisome is the potential loss of protein for a rising human population.

With oceans becoming increasingly barren, dinner plates are being filled by an industry almost as ancient as fishing itself—aquaculture, or fish farming. Since 1991, aquaculture's output has shot up from a million (907,000 metric) tons annually to more than 16 million (14.5

Examples of fish farming: salmon hatchery in Maine, U.S.A., salmon farm off Norway's coast.

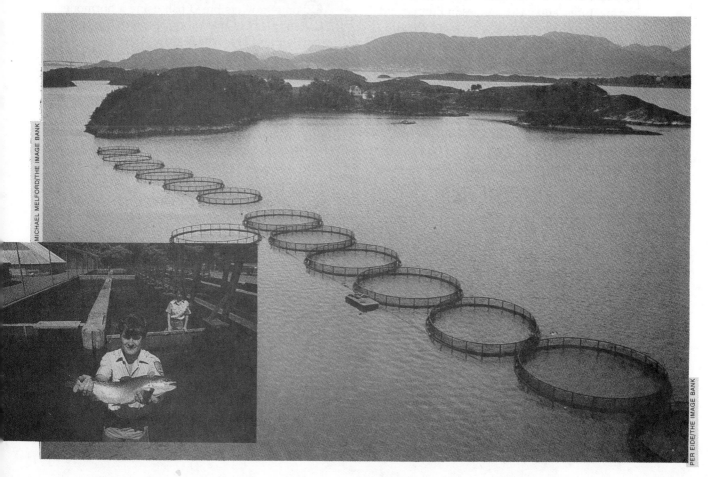

MICHAEL MELFORD/THE IMAGE BANK

PER EIDE/THE IMAGE BANK

From *The Rotarian*, December 1997, pp. 16–19. © 1997 by Rotary International. Reprinted by permission.

million metric) tons in 1994. Globally, this $26 billion industry already accounts for 22 percent of all fish production, and by 2010, will account for four of every five fish consumed. Among freshwater species, farms already produce more fish than traditional harvesting methods.

Culturing fish is actually a centuries-old practice. The Egyptians raised tilapia 4,000 years ago, and Roman fish reservoirs predate the birth of Christ. In 460 B.C., a Chinese entrepreneur named Fen Li wrote "Fish Culture Classics" to describe his country's carp-raising endeavors. European noblemen often kept fish in the moats encircling their castles, and pools near the Washington Monument in the U.S. capital once harbored carp.

Modern aquaculture encompasses a variety of marine animal life. Carp and shrimp are common crops in many Asian countries, while salmon, crawfish, trout, bass, and the "king"—catfish—are popular in the U.S. Other underwater livestock include oysters, clams, redfish, tilapia, abalone, turbot, cod, and lobster. Virtually no aquatic creature is exempt—even eel ranching is big business in Japan and Taiwan. The Japanese annually eat 150 million pounds (68 million kilograms) of these snake-like creatures, and gastronomes in Europe and elsewhere are developing a taste for them.

Various species have been added to the roster as ocean stocks decline and technology improves. Salmon farming, for example, started in the 1960s in Norway, when researchers dammed some estuaries and turned loose a few million fingerlings. The practice later spread to other nations such as Chile, Canada, the United Kingdom, and the United States. Canada and Norway are now in the process of building efficient halibut-growing operations.

Fish farming booms in developing nations—especially those in Asia, home to more than 80 percent of the global total. China alone is responsible for half the worldwide production, followed by India and Japan. Europe produces about nine percent of the total, North America about four percent, and South America about three percent.

But even in regions with relatively low production, aquaculture boosts national economies. Chile has become the world's second leading producer of domestic salmon (after Norway), producing nearly 200 million pounds (90.8 million kilograms) annually. In Ecuador, exports of commercially raised shrimp now surpass even coffee, bananas, and cocoa. And for the last two decades, fish farming has been the fastest growing agricultural industry in the U.S.

Fish can be raised in various manmade habitats—flooded natural lowlands, inland ponds filled with well water, or coastal enclosures anchored near shore. Aquaculture even exists in the open sea (where it is referred to as "mariculture"). In the Gulf of Mexico, Sea Pride Industries plans a futuristic, sunken cage-like system capable of producing five million pounds (2.7 million kilograms) of red snapper, bass, and other species annually. Configured like spokes on a wheel, the tubular cages will be 40 feet (12.2 metres) in diameter and 172 feet (52.4 metres) long. Feeding pipes will run the length of each spoke, and air tanks at the hub will permit the entire apparatus to be raised and lowered. Gulf growers have even experimented with stretching tent-shaped net enclosures around the legs of offshore oil rigs.

Other methods feature high technology. In California, Solar Aquafarms raises tilapia in a sprawling operation covered by greenhouses and warmed by solar heaters. Computers control feeding, water temperatures, and levels of oxygen and nitrogen. The water is continually cleaned and reused with the resulting waste products turned into fertilizer.

Some growers breed fish using a hormone supplement that produces predominantly female offspring, which grow faster and produce better filets. Norwegian aquaculturists have even developed gene-altering techniques that make fish grow faster, help them better withstand disease, and produce a higher-quality taste. Another technique alters genes so that fish can survive in colder temperatures.

Retailers and restauranteurs like farm-raised fish for their standard reliable quality and year-round availability. Due to regulations or migratory behavior, some wild stocks—Alaskan salmon for example—can only be purchased during certain months.

Farm fish also stand head and fin above other livestock when it comes to efficiency. Chickens require five and a half pounds of feed to produce a single pound of meat. For pigs, the ratio is seven to one; for cattle, it's 15 to 1. Salmon, however, will produce a pound of filets from just two pounds of feed.

Although epicures argue about the taste of cultured versus wild fish, the former are generally thought to possess piscatorial palatability because they are raised in a controlled environment, fed a prescribed diet, and treated for diseases. Cultured fish can be processed in minutes, instantly

'King' Catfish

In the United States, catfish is the king of aquaculture. Today, this species accounts for more of the U.S. industry than all other fish combined—an annual production of nearly 500 million pounds (227 million kilograms). At one time a southern specialty, catfish is now available nationwide and per-capita consumption has doubled since 1985.

As with other livestock, catfish production begins with the mating of selected breeding animals. The resulting eggs are placed in environmentally controlled hatching tanks, where a week later they become infant catfish called fry. After two or three weeks, the fry have grown to an inch (2.5 centimetres) in length and become hardy enough to survive in outdoor maturing ponds.

Maturing ponds vary in size from a few to more than 20 acres (8.1 hectares), and a large farm operation may have several such reservoirs. A one-acre (.405 hectare) pond that is four to five feet (1.2 to 1.5 metres) deep can hold from 70,000 to 200,000 fry. In four states (Mississippi, Alabama, Arkansas, and Louisiana), there are an estimated 144,000 such ponds.

Catfish generally dine on commercially prepared pellets served via a computerized machine. This high-protein food consists of fish meal combined with ground soybeans or corn and a smattering of other nutrients. The pellets float, keeping the fish from feeding off the pond's bottom and allowing ranchers to see their herd.

After 18 months, catfish reach their ideal weight of one and a quarter to one and a half pounds (.56 to .68 kilograms). They are then scooped from the water into tank trucks for live shipment to processing plants. A few of the fish go into a frying pan immediately upon arriving. If they pass muster with taste testers, the entire load is processed; if not, they go back to the pond for a few days of "flavor improvement."

Renowned for their mild flavor, firm texture, and versatility as a cooking ingredient, catfish can be baked, grilled, stewed, broiled, poached —or batter-dipped and deep-fried, as nature intended.

—G.T.

frozen or shipped immediately to market. Many consumers, especially Americans, prefer their relatively mild flavor and "non-fishy" taste.

But not everything is rosy down on the old fish farm. "Much of the current expansion of aquaculture is creating an expensive product which only richer people and nations can afford," writes investigative journalist Alex Wilks in the British journal *The Ecologist*. One specific problem is that predatory fish such as salmon, trout, shrimp, bass, and others require a diet high in animal protein, which invariably comes from fish meal composed of herring and other less profitable species. Consequently, the raising of carnivorous fish may actually reduce the amount of fish protein available for human consumption.

Then there is the environmental issue. Fish farming requires large quantities of clean water, another endangered commodity. A 20-acre (8.1-hectare) salmon operation can produce as much organic waste as a city of 10,000 people. Disposal at sea can pollute surrounding waters and has in some cases made the area [un]inhabitable for native species.

Shrimp are typically raised in flooded coastal areas, but in some places this practice has destroyed thousands of acres of mangroves. "Half the world's mangrove forests have now been cut down, and in many cases, aquaculture is the lead cause," says Wilks. Such destruction is especially acute in Ecuador and Thailand.

Another problem occurs when farm fish escape and pollute the natural gene pool by breeding with their wild kin. And even in confinement, captive fish can spread diseases to their free-swimming cousins. Researchers in Ireland, for example, traced the demise of local trout fisheries to lice larvae coming from nearby salmon farms. When growers attacked the problem with a pesticide, it killed off much of the wild shellfish population.

Environmental questions notwithstanding, fish will continue to play an important role in human nutrition. Most seafood is low in cholesterol and high in calcium, phosphorous, potassium, and Vitamin A. "Worldwide, people eat more fish than beef and chicken combined," says Worldwatch Institute researcher Hal Kane, "and in many low-income countries fish provide most of the protein people get from animal sources." Advocates describe fish farming as a "blue revolution" that will do for aquatic food production what the green revolution did for terrestrial agriculture.

Currently, every man, woman, and child on the planet consumes an average of more than 30 pounds (13.6 kilograms) of seafood per year. With the human population expected to grow by more than eight billion over the next few decades, the demand will only increase. Thanks to aquaculture, much of that sustenance will come not from the ocean but from "down on the farm."

• *Frequent contributor Gary Turbak lives and fishes in Missoula, Montana, U.S.A.*

Unit Selections

Key Points to Consider

❖ How is the availability of natural resources affected by population growth?

❖ Do you think that the international community has adequately responded to problems of pollution and threats to our common natural heritage? Why or why not?

❖ What is the natural resource picture going to look like 30 years from now?

❖ How is society, in general, likely to respond to the conflicts between economic necessity and resource conservation?

❖ What is the likely future of energy supplies in both the industrial and the developing world?

❖ What transformations will societies that are heavy users of fossil fuels have to undergo in order to meet future energy needs?

❖ Can a sustainable economy be organized and what changes in behavior and values are necessary to accomplish this?

 Links **www.dushkin.com/online/**

11. **Friends of the Earth**
 http://www.foe.co.uk/index.html
12. **National Geographic Society**
 http://www.nationalgeographic.com
13. **National Oceanic and Atmospheric Administration (NOAA)**
 http://www.noaa.gov
14. **Public Utilities Commission of Ohio (PUCO)**
 http://www.puc.state.oh.us/consumer/gcc/index.html
15. **SocioSite: Sociological Subject Areas**
 http://www.pscw.uva.nl/sociosite/TOPICS/
16. **United Nations Environment Programme (UNEP)**
 http://www.unep.ch

These sites are annotated on pages 6 and 7.

Beginning in the eighteenth century, the concept of the modern nation-state was conceived and developed. These legal entities were viewed as separate, self-contained units that independently pursued their national interests. Scholars envisioned the world as a political community of independent units, which interacted or "bounced off" each other (a concept that has often been described as a billiard ball model).

This concept of self-contained and self-directed units, however, has undergone major rethinking in the past 30 years, primarily because of the international dimensions of the demands being placed on natural resources. National boundaries are becoming less and less valid. The Middle East, for example, contains a majority of the world's known oil reserves; Western Europe and Japan are very dependent on this source of energy. Neither resource dependency nor problems such as air pollution recognize political boundaries on a map. Therefore, the concept that independent political units control their own destiny makes less sense than it may have 100 years ago. In order to understand why this is so, one must first look at how Earth's natural resources are being utilized and how this may be affecting the global environment.

The initial articles in the unit examine the broad dimensions of the uses and abuses of natural resources. The central theme in these articles is whether or not human activity is in fact bringing about fundamental changes in the functioning of Earth's self-regulating ecological systems. In many cases a nonsustainable rate of usage is under way, and, as a consequence, an alarming decline in the quality of the natural resource base is taking place.

An important conclusion resulting from this analysis is that contemporary methods of resource utilization often create problems that transcend national boundaries. Global climate changes, for example, will affect everyone, and if these changes are to be successfully addressed, international collaboration will be required. The consequences of basic human activities such as growing and cooking food are profound when multiplied billions of times every day. A single country or even a few countries working together cannot have a significant impact on redressing these problems. Solutions will have to be conceived that are truly global in scope. Just as there are shortages of natural resources, there are also shortages of new ideas for solving many of these problems.

The unit continues by examining specific natural resources. These case studies explore in greater detail new technologies, potential new economic incentives, and the impact that traditional power

politics has on how natural resources are developed and for whose benefit.

The unit concludes with a discussion of the issues involved in moving from a perspective of the environment as simply an economic resource to be consumed to a perspective that has been defined as "sustainable development." This change is easily called for, but in fact it goes to the core of social values and basic economic activities. Implementing it, therefore, will be a challenge of unprecedented magnitude.

Nature is not some object "out there" to be visited at a national park. It is the food we eat and the energy we consume. Human beings are joined in the most intimate of relationships with the natural world in order to survive from one day to the next. It is ironic how little time is spent thinking about this relationship. The pressures that rapidly growing numbers of people are placing on Earth's carrying capacity suggest that this oversight will not continue much longer.

The Global Challenge

M<small>ICHAEL</small> H. G<small>LANTZ</small>

Circulating freely around the planet, the atmosphere and oceans are shared resources whose resiliency is being tested by ever-growing human demands.

The atmosphere and the oceans are fluids that encircle the globe. Their movements can be described in physical and mathematical terms, or even by some popular adages: "what goes up, must come down" and "what goes around, comes around."

The atmosphere and oceans are two of Earth's truly global commons. In cycles that vary from days to centuries to millions of years, air and water circulate interactively around the globe irrespective of national boundaries and territorial claims.

With regard to the first adage, pollutants emitted into the atmosphere must come down somewhere on Earth's surface—unless, like the chlorofluorocarbons (CFCs), they can escape into the stratosphere until they are broken down by the Sun's rays. Depending on the form of the pollutant (gaseous or particulate), its size, or the height at which it has been ejected into the atmosphere, it can stay airborne for short or long periods. So, pollutants expelled into the air in one country and on one continent may make their way to other countries and continents. The same can be said of the various pollutants that are cast into the ocean. "What goes around, comes around" clearly applies to the global commons.

As human demands on the atmosphere and oceans escalate, the pressures on the commons are clearly increasing. Defining the boundaries between acceptable human impacts and crisis impacts is a demanding and rather subjective task.

The Atmosphere

The atmosphere is owned by no nation, but in a sense it belongs to all nations. Several types of human activity interact with geophysical processes to affect the atmosphere in ways that engender crisis situations. The most obvious example of local effects is urban air pollution resulting from automobile emissions, home heating and cooling, and industrial processes. The Denver "brown cloud" is a case in point, as is the extreme pollution in Mexico City. Such pollution can occur within one political jurisdiction or across state, provincial, or international borders. Air pollution is one of those problems to which almost everyone in the urban area contributes.

Acid rain is an example of pollution of a regional atmospheric commons. Industrial processes release pollutants, which can then interact with the atmosphere and be washed out by rainfall. Acid rain has caused the health of forest ecosystems to deteriorate in such locations as the northeastern part of North America, central Europe, and Scandinavia. The trajectories of airborne industrial pollutants moving from highly industrialized areas across these regions have been studied. The data tend to support the contention that while acid rain is a regional commons problem, it is also a problem of global interest.

A nation can put any chemical effluents it deems necessary for its well-being into its own airspace. But then the atmosphere's fluid motion can move those effluents across international borders. The purpose of the tall smokestack, for example, was to put effluents higher into the air, so they would be carried away and dispersed farther from their source. The tall stacks, in essence, turned local air pollution problems into regional ones. In many instances, they converted national pollution into an international problem.

Climate as a Global Commons

There is a difference between the atmosphere as a commons and the climate as a commons. Various societies have emitted a wide range of chemicals into the atmosphere, with little understanding of their potential effects on climate. For example, are industrial processes that produce large amounts of carbon dioxide

(which contributes to atmospheric warming) or sulfur dioxide (which contributes to atmospheric cooling and acid rain) altering global climate? There seems to be a growing consensus among scientists that these alterations manifest themselves as regional changes in the frequencies, intensities, and even the location of extreme events such as droughts and floods.

Not all pollutants emitted in the air have an impact on the global climate system. But scientists have long known that some gases can affect global climate patterns by interacting with sunlight or the heat radiated from Earth's surface. Emission of such gases, especially CO_2, can result from human activities such as the burning of fossil fuels, tropical deforestation, and food production processes. The amount of CO_2 in the atmosphere has increased considerably since the mid 1700s and is likely to double the preindustrial level by the year 2050. Carbon dioxide is a highly effective greenhouse gas. Other greenhouse gases emitted to the atmosphere as a result of human activities include CFCs (used as refrigerants, foam-blowing agents, and cleansers for electronic components), nitrous oxide (used in fertilizers), and methane (emitted during rice production). Of these trace gases, the CFCs are produced by industrial processes alone; and others are produced by both industrial and natural processes.

The increase in greenhouse gases during the past two centuries has resulted primarily from industrial processes in which fossil fuels are burned. Thus, a large proportion of the greenhouse gases produced by human activity has resulted from economic development in the industrialized countries (a fact that developing countries are not reluctant to mention when discussing the global warming issue).

National leaders around the globe are concerned about the issue of climate change. Mandatory international limits on the emissions of greenhouse gases could substan-

tially affect their own energy policies. Today, there are scientific and diplomatic efforts to better understand and deal with the prospects of global atmospheric warming and its possible impacts on society. Many countries have, for a variety of motives, agreed that there are reasons to limit greenhouse gas emissions worldwide. National representatives of the Conference of Parties meet each year to address this concern. In the meantime, few countries, if any, want to forgo economic development to avoid a global environmental problem that is still surrounded by scientific uncertainty.

The Oceans

The oceans represent another truly global commons. Most governments have accepted this as fact by supporting the Law of the Sea Treaty, which notes that the seas, which cover almost 70 percent of Earth's surface, are "the common heritage of mankind." In the early 1940s, Athelstan Spilhaus made a projection map that clearly shows that the world's oceans are really subcomponents of one global ocean.

There are at least three commons-related issues concerning the oceans: pollution, fisheries, and sea level. Problems and possible crises have been identified in each area.

The oceans are the ultimate sink for pollutants. Whether they come from the land or the atmosphere, they are likely to end up in the oceans. But no one really owns the oceans, and coastal countries supervise only bits and pieces of the planet's coastal waters. This becomes a truly global commons problem, as currents carry pollutants from the waters of one country into the waters of others. While there are many rules and regulations governing

pollution of the oceans, enforcement is quite difficult. Outside a country's 200-mile exclusive economic zone are the high seas, which are under the jurisdiction of no single country.

In many parts of the world, fisheries represent a common property resource. The oceans provide many countries with protein for domestic food consumption or export. Obtaining the same amount of protein from the land would require that an enormous additional amount of the land's surface be put into agricultural production. Whether under the jurisdiction of one country, several countries, or no country at all, fish populations have often been exploited with incomplete understanding of the causes of variability in their numbers. As a result, most fish stocks that have been commercially sought after have collapsed under the combined pressures of natural variability in the physical environment, population dynamics, and fish catches. This is clearly a serious problem; many perceive it to be a crisis.

Bound Together by Air and Water

- "What goes up must come down" describes the fate of most pollutants ejected into the atmosphere. Taller smokestacks were used to assure that the pollutants did not come down "in my backyard."

- Fish stocks that naturally straddle the boundary between a country's protected zone and the open seas are a global resource requiring international protection measures.

- Sea level in all parts of the world would quickly rise some 8 meters (26 feet) if the vast West Antarctic ice sheet broke away and slid into the sea.

- Scientific controversy still surrounds the notion that human activities can produce enough greenhouse gases to warm the global atmosphere.

In many parts of the world, fisheries represent a common property resource.

For example, an area in the Bering Sea known as the "Donut Hole" had, until recently, also been suffering from overexploitation of pollack stocks. In the midst of the Bering Sea, outside the coastal zones and jurisdictions of the United States and Russia, there is an open-access area that is subject to laws related to the high seas, a truly global commons. Fishermen from Japan and other countries were overexploiting the pollack in this area. But these stocks were part of the same population that also lived in the protected coastal waters of the United States and Russia. In other words, the pollack population was a straddling stock—it straddled the border between the controlled coastal waters and the high seas.

To protect pollack throughout the sea by limiting its exploitation, the two coastal states took responsibility for protecting the commons (namely, the Donut Hole) without having to nationalize it. They did so by threatening to close the Bering Sea to "outsiders," if the outsiders were unable to control their own exploitation of the commonly shared pollack stock. There are several other examples of the overexploitation of straddling stocks, such as the recent collapse of the cod fishery along the Georges Bank in the North Atlantic.

Another commons-related issue is the sea level rise that could result from global warming of the atmosphere. Whereas global warming, if it were to occur, could change rainfall and temperature patterns in yet-unknown ways both locally and regionally, sea level rise will occur everywhere, endangering low-lying coastal areas worldwide. Compounding the problem is the fact that the sea is also an attractor of human populations. For example, about 60 percent of the U.S. population lives within a hundred miles of the coast.

This would truly be a global commons problem because *all* coastal areas and adjoining estuaries would suffer from the consequences of global warming. Concern about sea level rise is highest among the world's small island states, many of which (e.g., the Maldives) are at risk of becoming submerged even with a modest increase in sea level. In sum, there are no winners among coastal states if sea level rises.

Antarctica always appears on the list of global commons. Although it is outside the jurisdiction of any country, some people have questioned its classification as a global commons. It is a fixed piece of territory with no indigenous human population, aside from scientific visitors. It does have a clear link to the oceans as a global commons, however. One key concern about global warming is the possible disintegration of the West Antarctic ice sheet. Unlike Arctic sea ice, which sits in water, the West Antarctic ice sheet would cause sea level to rise an estimated eight meters if it broke away and fell into the Southern Ocean. Viewed from this perspective, the continent clearly belongs on the list of global commons. It is up to the global community to protect it from the adverse influences of human activities occurring elsewhere on the globe.

What's the Problem?

Are the changes in the atmosphere and oceans really problems? And if so, are they serious enough to be considered crises?

The consequences of the greenhouse effect are matters that scien-

ATHELSTAN SPILHAUS/COURTESY OF CELESTIAL PRODUCTS, PHILMONT, VA.

Our one-ocean world: The oceans are but one body of water, as highlighted by the World Ocean Map developed more than 50 years ago by oceanographer Athelstan Spilhaus.

In 5 or 10 years incremental changes can mount into a major environmental crisis.

tists speculate about. But changes in the environment are taking place *now*. These changes are mostly incremental: low-grade, slow-onset, long-term, but gradually accumulating. They can be referred to as "creeping environmental problems." Daily changes in the environment are not noticed, and today's environment is not much different from yesterday's. In 5 or 10 years, however, those incremental changes can mount into a major environmental crisis [see "Creeping Environmental Problems," THE WORLD & I, June 1994, p. 218].

Just about every environmental change featuring human involvement is of the creeping kind. Examples include air pollution, acid rain, global warming, ozone depletion, tropical deforestation, water pollution, and nuclear waste accumulation. For many such changes, the threshold of irreversible damage is difficult to identify until it has been crossed. It seems that we can recognize the threshold only by the consequences that become manifest

after we have crossed it. With regard to increasing amounts of atmospheric carbon dioxide, what is the critical threshold beyond which major changes in the global climate system might be expected? Although scientists regularly refer to a doubling of CO_2 from preindustrial levels, the truth of the matter is that a doubling really has little scientific significance except that it has been selected as some sort of marker or milestone.

Policymakers in industrialized and developing countries alike lack a good process for dealing with creeping environmental changes. As a result, they often delay action on such changes in favor of dealing with issues that seem more pressing. Creeping environmental problems tend to be put on the back burner; that is, they are ignored until they have emerged as full-blown crises. The ways that individuals and societies deal with slow-onset, incremental adverse changes in the environment are at the root of cop-

ing effectively with deterioration and destruction of local to global commons.

Societal concerns about human impacts on commonly owned or commonly exploited resources have been recorded for at least 2,500 years. Aristotle, for example, observed "that which is common to the greatest number has the least care bestowed upon it." How to manage a common property resource, whether it is a piece of land, a fish population, a body of water, the atmosphere, or outer space, will likely confound decisionmakers well into the future.

Michael H. Glantz is program director of the Environmental and Societal Impacts Group at the National Center for Atmospheric Research (NCAR) in Boulder, Colorado. NCAR is sponsored by the National Science Foundation.

CLIMATIC CHANGES THAT MAKE THE WORLD FLIP

▶ Robert Matthews

Global warming's impact on the environment is not necessarily a drawn-out affair. Recent evidence shows that dramatic changes or 'climatic flips' could happen virtually overnight.

The once-green land of Ireland turned into a frozen wilderness. Harp seals swimming among ice-floes off the coast of France. Polar bears prowling the streets of Amsterdam. These are the images conjured up by the latest research into global warming.

Yes, you read that correctly: global warming—the rise in the world's average temperature caused by the trapping of the sun's heat by pollution in the atmosphere.

If you are baffled by that, then prepare to be shocked. For the same research is now suggesting that such dramatic changes in the climate of northern Europe could take place in as few as 10 years.

Again, this figure is not a misprint: no zero has gone missing. Scientists have recently uncovered compelling evidence that global warming can have a devastating impact on timescales far shorter than anyone believed possible. Not centuries, not even decades, but years, in what are being called "climatic flips". One leading expert has recently gone on record to warn that some north Atlantic countries could find themselves plunged into

Arctic conditions over the space of just 10 years.

Risk of sudden upheaval

In geological terms, that is as fast as the blink of an eye. But even in human terms, such a rate of climatic change is incredibly—and quite probably intolerably—rapid. It is far from clear whether any economy or agricultural system could cope with such sudden upheaval.

By analysing icy sediments (ice-cores) extracted from deep beneath the earth's surface scientists can plot the course of climate change thousands of years ago.

Yet evidence is now mounting that such "climatic flips" not only can happen, but have happened in the past. It is evidence that adds new urgency to the global warming debate, which has lost much of its momentum in recent

▶ Science correspondent of the London *Sunday Telegraph*

 Reprinted with permission from the *Unesco Courier*, November 1999, pp. 10-13.

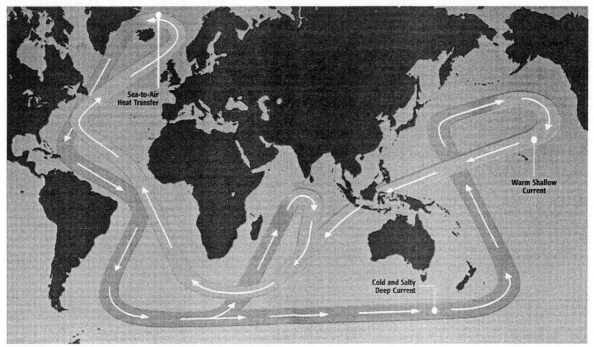

© WOCE, Southampton

Ocean currents continually transport heat around the globe like a liquid conveyor belt. Above, simplified chart of the circulation process.

years. It also highlights the frightening complexity of the task facing scientists trying to predict the earth's response to human activity.

Arguments about climatic change typically focus on how increasing levels of so-called greenhouse gases—principally carbon dioxide from burning fossil fuels—in the earth's atmosphere trap ever more of the sun's heat.

Huge efforts have been put into predicting the likely global temperature rise caused by the extra greenhouse gases, and current best estimates point to a rise of 1.5 degrees Celsius or so over the next century.

But while scientists warn that even so apparently small a rise in temperature could cause upheaval in everything from agricultural practices to the spread of disease, the *rate* of change hardly seems terrifying. Surely we can cope and have coped with events that change over several generations?

Such arguments are buttressed by another, apparently compelling, argument against rapid climate change. The earth's oceans have colossal thermal inertia, and would surely iron out any sudden upheaval: weight for weight, it takes ten times more energy to heat water than it does solid iron.

Small wonder, then, that scientists were unsurprised when they failed to find any signs of rapid climatic changes when they first studied ancient ocean sediments, the isotope levels of which retain a record of past temperatures.

The end of the Ice Age: a puzzling discovery

But this apparently comforting confluence of theory and data is now known to contain two huge loopholes. The first reared its head in the early 1980s, when a joint U.S.-European team of scientists working in Greenland made a puzzling discovery. They had extracted an ice-core from a site in the southern part of the country, and had measured isotope levels in the gas trapped at different depths in an attempt to gauge the temperature in the region over thousands of years.

Because the ice builds up relatively rapidly, the ice-core was expected to give the researchers the most fine-detailed picture yet of temperature changes in the region. Plotting out the corresponding temperatures, the researchers discovered something puzzling and disturbing.

As expected, the core showed the rise in temperature corresponding to the end of the last Ice Age around 11,000 years ago. But it also showed that the bulk of that warm-up had taken place in the space of just 40 years.

At the time, no one knew what to make of the result, which flew in the face of everything

scientists then knew about climate change—or thought they knew. In the years that followed, however, further ice-cores were extracted, and they revealed an even more dramatic story: a 5- to 10-degree increase in temperature and doubling of precipitation over Greenland in the space of just 20 years.

Nothing in the earlier ocean sediment core data had prepared scientists for such a finding—nor could it. For this was the first loophole in the argument against sudden climatic flips: the absence of evidence from the original ocean sediment cores simply reflected the very broad-brush picture they gave of temperature change. They lacked the detail offered by ice-cores.

The history of science shows that finding evidence for some astonishing phenomenon is often only part of the story. To convince the scientific community at large, the evidence has to be backed up by a more comprehensive explanation.

Prompted by the Greenland findings, scientists have since tracked down locations where ocean sediment builds up fast enough to give a record of temperature comparable in detail to that from the ice-cores. And, sure enough, they reveal the same story of rapid climatic change in locations as far apart as California and India.

The history of science shows that finding evidence for some astonishing phenomenon is often only part of the story. To convince the scientific community at large, the evidence has to be backed up by a more comprehensive explanation. And for many years the standard explanation for why Ice Ages begin and end provided yet more reasons for thinking all climatic change must be slow and graceful.

That explanation rests on work by a Serbian scientist named Milutin Milankovitch, who in 1920 linked Ice Ages to changes in the shape of the earth's orbit. Caused by the push and pull of the other planets, these orbital changes altered the concentration of sunlight reaching the planet. Such changes would naturally take place very gradually, on timescales of many thousands of years—a recipe for climatic change that is anything but abrupt.

A global heat transporter

Yet, once again, there is a loophole in this comforting argument—as Wallace Broecker of Columbia University, New York State, realized around the time climate experts were puzzling over the ice-core data.

This loophole centres on a very specific feature of the earth's oceans: their circulation patterns. Ocean currents transport heat around the globe like a vast conveyor belt. In the Atlantic, for example, warm water travels northwards from the Gulf of Mexico, passing its heat to the air by evaporation as it goes. This makes the current progressively cooler, saltier and denser until eventually, near Iceland, the water is so heavy that it sinks, and begins a long journey southward, along the ocean floor.

Broecker realized that this complex, subtle process—which he called "The Conveyor"—could be the Achilles heel of the earth's climate, allowing subtle changes to be turned into dramatic upheaval. For instead of having to alter the whole body of the oceans, just a small change in temperature might be enough to alter the behaviour of the Conveyor—and trigger radical and rapid climatic change over a large area.

For example, gradually melting ice from the Arctic could dilute the saltiness of the Conveyor to a critical density where it no longer sinks and begins its journey southward to pick up more heat. The Conveyor would, in effect, be switched off, isolating the north Atlantic from the warming waters of the tropics.The result would then be distinctly paradoxical, with a slight warming of the Arctic causing temperatures of north Atlantic countries to plunge.

Broecker's explanation is now widely believed to lie at the heart of rapid climate change in the past. Worryingly, however, global warming is predicted to have precisely the type of warming effect on the Arctic ice that threatens the existence of the Conveyor. Computer projections of the effect of pollution on global temperatures predict an inflow of

cold, fresh water into the northern Atlantic—water that could dilute the Conveyor enough to switch it off.

The Achilles heel of the earth's climate

If that happened, says Broecker, winter temperatures in the north Atlantic region would fall by 10 or more degrees Celsius within 10 years, giving places like Dublin the climate of Spitsbergen, 400 km north of the Arctic Circle. "The consequences could be devastating," he says.

It is a scenario that gains credibility from ice-core data, according to climate expert Kendrick Taylor of the Desert Research Institute in Reno, Nevada. He says that many cores suggest that around 8,000 years ago there was a sudden plunge back to a "mini Ice Age" which lasted around 400 years. The most likely cause, says Taylor, was the release of melted ice-water from lakes in Canada into the Atlantic, which switched off the heat-transporting Conveyor.

"The change in freshwater flux to the oceans was large, but not that much different from what greenhouse-induced changes may produce in the future," he said in a recent paper in American Scientist. "It is ironic that greenhouse warming may lead to rapid cooling in eastern Northern America, Europe and Scandinavia."

So just how close is the Conveyor to switching off once again? The short answer is: no one knows. Computer models have still to identify the critical density of seawater at which the Conveyor will switch off, or the greenhouse gas concentrations needed to release the requisite amount of melt-water.

Cutting pollution buys time

What computer models have shown, says Taylor, is that reducing pollution emissions buys time—both by slowing the rate of global

A MUDDY MYSTERY

The effects that scientists now believe can shape the earth's climate are astonishingly subtle, and one of the most bizarre centres on the connection between Ice Ages, earthquakes, and mud.

Last year a team from the Southampton Oceanography Centre in Britain announced in the journal *Nature* the discovery of a 450-billion-cubic-metre deposit on the sea-floor off the coast of Sardinia—the aftermath of a truly enormous slide of mud: enough to engulf the whole of France to a depth of a metre.

Carbon dating of the plankton above and below the mud bed suggest that the slide took place around 20,000 years ago—at the height of the last Ice Age. This was a time when so much water had been turned to ice that sea-levels were 120 metres lower than they are today—a fact that the team suspects is crucial to the cause of the colossal mud-slide.

Formed out of thousands of years of river deposits, the mud would have been rich in organic matter—material that rots to produce huge amounts of methane gas. Normally this gas would have been locked into the mud by the huge pressure of sea-water lying over the submerged sediments.

But as the Ice Age deepened and sea-levels fell, the mud deposits would find themselves exposed, and thus able to release their pent-up methane gas.

This gas is a very potent source of global warming, and the sudden release of huge amounts of it might have helped push the earth back out of the Ice Age.

Certainly the timing of the Sardinian mudslide—at the height of the last Ice Age—is intriguing, says team member professor Euan Nisbet of London's Royal Holloway College: "It is possible that a big slide could have released enough methane to act as a warming trigger."

It is an idea that has gained strength from a recent discovery by researchers at Duke University in North Carolina. In a paper also published in *Nature* last year, they argue that the sheer weight of ice pressing down on the earth's crust may have triggered huge earthquakes during the Ice Age.

Could these have triggered massive submarine mudslides, releasing methane that led to the end of Ice Age? As yet, no one knows. But it points to yet another astonishingly subtle link between the environment, climate—and us.

warming, and also by driving the climate more gently, which seems to increase its stability against rapid change.

But while scientists struggle to capture the full complexity of the climate on their supercomputers, evidence of other causes of dramatic climate change is beginning to emerge.

Last July, Professor Martin Claussen and his colleagues at the Potsdam Institute for Climate Science, Germany, reported evidence that today's Sahara desert was created in a sudden climatic "flip" that took place just 5,500 years ago, turning vast areas of lush grassland into an arid wilderness and devastating ancient civilizations.

Using a sophisticated computer model of the land, sea and atmosphere, the team has discovered just how subtle are some of the effects that can turn Milankovitch-style changes in the earth's orbit into major climate upheaval.

The Sahara's quick-change act

They found that over the last 9,000 years the gravitational pull of the planets has altered the tilt of the earth's axis by about half a degree, and changed the timing of earth's closest approach to the sun by around five months.

'The change in freshwater flux to the oceans was large, but not that much different from what greenhouse-induced changes may produce in the future. It is ironic that greenhouse warming may lead to rapid cooling in eastern Northern America, Europe and Scandinavia'

By themselves, such subtle changes should not cause major climatic effects. But when Claussen and his colleagues included the effect of vegetation in their computer model, they found that it caused rainfall levels to plummet over the Sahara region.

They traced the cause to "feedback" effects, in which a slight drop in vegetation level makes the earth's surface slightly better at reflecting sunlight, which causes rainfall levels to drop—prompting more vegetation loss, and so on.

According to Claussen, these feedback effects turned the vast, once-green Sahara into a brown wasteland within just 300 years. "It was the largest change in land cover during the last 6,000 years," he says. "It was very severe, ruining ancient civilizations."

The discovery is likely to force historians to rethink their explanations of events in the region. For according to Claussen, it contradicts the long-held belief that the collapse of agriculture in the region was caused by an-

cient farmers exhausting the soil: "Although humans lived in the Sahara and used the land to some extent, we think that ancient land use played only a negligibly small role."

The findings are also being seen as another warning of just how unstable even today's climate may be. "It is capable of changing very abruptly," says climate expert Andrew Goudie of Oxford University. "We've known that the extent of the Sahara has yo-yoed back and forwards for millions of years, and that about 8,000 years ago it was much wetter than today, with big rivers feeding into the Nile. But I hadn't realized just how rapid the changeover had been. It is salutary."

Temperature nose-dives

Also in July, a team of researchers from the universities of Illinois and Minnesota reported the discovery of another climatic "flip" in the northern hemisphere around 9,000 years ago, which temporarily plunged the region back into an Ice Age.

Using lake sediments from Minnesota, the team confirmed the existence of the cold snap around 8,200 years ago, as revealed by the ice core data. But they also found evidence for another dive in temperatures around 8,300 to 8,900 years ago. The team thinks this older cold snap was linked to the release of melted ice from lakes into the Atlantic—which may have switched off the Conveyor. But the researchers now think that the more recent flip most likely had another—and as yet unknown—origin.

What is clear is that until we know much more about the complexity of climate change, all bets about how much time we have to take action are definitely off. What evidence we do have increasingly points to the stark possibility that we may have far less time than we thought.

"I used to believe that change in climate happened slowly and would never affect me," admits Taylor. "Now I know that our climate could change significantly in my lifetime."

Stumped by trees

*Even for poor countries, destroying forests
rarely makes economic sense*

PARAGOMINAS, a sweltering, mosquito-ridden town in the north of Brazil, is the stuff of an environmentalist's nightmares. The air is bitter with sawdust and smoke. Dozens of sawmills are slicing up prime rainforest tree-trunks, and each is surrounded by dozens of charcoal kilns spewing out black smoke. For hundreds of miles around, the landscape is bare of trees except for the odd stump. No one takes any notice of government regulations that restrict logging, explains a manager at one of the sawmills; and if officials try to enforce them, they can easily be bribed. "Everyone is out for a quick buck here," he says.

Yet Brazilians get annoyed when environmentalists from developed countries start moaning about the destruction of the rainforests. Most of the arguments for preserving the forests, they point out, are something of a rich man's luxury. They are about nebulous worries for the medium-term future, not about a developing country's crying need, here and now, to improve its people's living standards. Besides, satellite pictures show that despite decades of exploitation, over 85% of Brazil's Amazon jungle region is still covered in trees. So why, ask Brazilians, should they not be allowed to put some of their forests to commercial use?

The best answer is that rapid deforestation is rarely in the economic interest of the country concerned. More often it is due to a combination of bad policies, population growth and poverty. In some parts of the world, such as the highlands of Bolivia, Peru and Nepal, and in the countryside surrounding many fast-growing cities in Africa, trees are lost because the poor use wood for fuel. Elsewhere the culprit is war. During Cambodia's long civil war, both the government and the Khmers Rouges financed their military operations partly through logging. Since the 1970s, around half of Cambodia's forests have disappeared. Another reason for forest depletion is the slash-and-burn method of cultivation employed by the poorest farmers. In East Asia, environmentalists think that the recent economic troubles will hurt the forests as poor families lose their city jobs and return to the countryside.

More intensive farming technology can help, by reducing the amount of land that poor families need to reclaim from forests to feed themselves. In parts of the Brazilian Amazon, where smallholders' farming techniques are still very basic, a local environmental group has helped reduce forest loss in one community by getting farmers to adopt a few simple improvements, such as planting their crops in rows rather than scattering seeds, and using hoes for weeding. The biggest potential gains from applying existing

Where the rainforests are

Existing rainforest Former areas of rainforest

farming technology could be achieved in sub-Saharan Africa, where the use of fertiliser, for example, is running at only a quarter the level in India.

Perverse incentives

Commercial logging, too, is a big cause of deforestation. Demand for industrial timber is expected to increase from around 1.6 billion cubic metres a year in 1995 to 1.9 billion cubic metres in 2010, driven by rising standards of living. Developing countries with hot climates have a competitive advantage in this market, simply because trees grow much faster than in temperate climates. But plantation forestry can be as profitable as chopping trees from virgin forest, and has the obvious advantage that growers can choose which species to cultivate. The main reason why virgin forest is being cut down is not so much the simple pursuit of profit but a set of perverse economic incentives.

In the Brazilian Amazon, between the 1960s and the early 1990s the forest shrank largely because the government intended it to. Brazil's military rulers saw the region as a safety valve for the overpopulation, landlessness and poverty in the country's crowded coastal region; they also feared that a thinly inhabited Amazon was an invitation to foreign invaders.

In their attempt to give "the land without people to the people without land", the authorities colonised the region and built roads and schools. Newcomers qualified for ownership of a plot of land simply by clearing the trees on it. But usually the soil of cleared Amazon rainforest proved unsuitable for agriculture: after a few years crops would begin to fail, forcing farmers to deforest yet more land. The government also offered tax breaks to companies spending money on approved development schemes in the region. Firms poured in, many of them setting up giant cattle ranches.

In the early 1990s some of the more obvious incentives to wreak environmental havoc were dismantled. Partly to appease the green lobby abroad, the Brazilian government also passed a series of increasingly tough laws—first prohibiting landowners from logging more than 50% of their land, then lowering the limit to 20%. Yet satellite data released at the beginning of this year show that deforestation in the Brazilian Amazon in 1995 reached an all-time high of 29,000 square kilometres, an area about the size of Belgium. The figure for 1996 was down, but at 18,100 square kilometres still substantial. Why the continuing destruction?

On the face of it, the problem appears to be that existing rules are simply not enforced. Ibama, Brazil's environment agency, has a small number of officials to police a vast region. Last year it collected just 6% of the fines it levied. The Brazilian government has estimated that 80% of the timber in the region is harvested illegally. But a visit to a town such as Paragominas suggests that effective enforcement would take a lot more than hiring extra inspectors. The atmosphere is that of a frontier region where no one quite knows who owns the land and property disputes are often settled by violence. Everyone milks the forest for what they can get.

Because of confusion over land titles, conflicts often flare between Indians, squatters and loggers. Many owners deliberately do not register their property with the authorities because they fear it might restrict their logging. But they also burn trees as a sign of occcupation to discourage invasions from the country's militant landless.

Insecurity of land tenure explains the continuing popularity of cattle ranching in the region: if someone else takes the land, at least the cattle can be moved on. That same insecurity of tenure also means that plantation forestry, however sensible in theory, does not stand a chance in practice. Landowners would have to wait perhaps 20 years to harvest the trees, during which time squatters or accidental fires could easily wipe out their investment.

Deforestation in Indonesia—which last year caught the world's attention by producing a series of catastrophic smogs—has a similar tangle of causes. As in Brazil, the government had an official programme encouraging millions of people to move from the crowded islands of Java and Bali to less densely populated but heavily forested islands such as Kalimantan, Sumatra and Irian Jaya. And as in Brazil, property rights in the forests are often ill-defined, leading to violent conflicts between locals, migrants and forestry firms. Traditional *adat* law, which has governed the use of forest lands until the past few decades, clashes with more recent logging concessions handed out by the government in Jakarta, and fire is used as a weapon by both sides. Small farmers sometimes burn trees planted by big forestry companies, and large firms have in turn burnt land to drive out smallholders.

But whereas Brazil has abandoned government policies that explicitly encourage deforestation, Indonesia is further behind. The government levies high export taxes on unprocessed logs to help the domestic wood-processing industry. This has kept domestic timber prices below world levels, providing forestry firms with an implicit subsidy estimated at over $2 billion a year, but also encouraging them to use logs inefficiently. Government concessions to log a particular area have been handed out in what development bankers call "a non-transparent fashion" (ie, to friends of President Suharto's family), and for periods too short to give the firms an incentive to look after the forest. Only now, under pressure from the IMF, has the government promised to reform the timber trade.

In sum, the sort of policies that might help developing countries to reduce their rate of deforestation are also the sort of policies that are likely to promote economic growth: upholding the rule of law, securing property rights, weeding out corruption and reducing subsidies. That may seem obvious, but it challenges an assumption still widely held in rich and poor countries alike: that rapid development and rapid deforestation must go hand in hand.

As long as that belief persists, the pleas of the rich world's environmentalists will be seen as somewhat otherworldly. They want to preserve the forests for two main reasons: because burning them could eventually contribute to world climate change, and because they know that forest loss will reduce biodiversity. Both are worries for the longer term, although recent research suggests that burning trees is now beginning to affect the local climate of the Brazilian rainforest too, making it drier and more liable to accidental fires.

A loss of biodiversity will not start to show up until well into the next century, but it is an issue that gets environmentalists really excited. According to one estimate, tropical rainforests contain around half of all the world's species—far more than the temperate forests of Europe and America. (The Amazon forests also contain about 400 human tribes, which are gradually being squeezed out.) The depletion of rainforests is being blamed for the increasingly rapid rate at which the world is losing species. But scientific understanding of species loss, and its potential dangers, is riddled with uncertainties.

Life's rich pattern

Scientists have little idea how many species exist in the first place. Recent estimates range from 7m to 20m. According to the Global Biodiversity As-

sessment, a UN-sponsored report in which about 1,000 scientists have had a hand, a good working estimate is between 13m and 14m species. But of that number, says the report, only about 1.75m have been scientifically described.

If scientists have no clear idea how many species exist in the first place, rates of loss are necessarily even harder to divine. Since 1600, over 480 animal species and 650 plant species are recorded as having become extinct. But since the vast majority of all species are unknown, rates of loss of known species are not much of a guide to anything. Besides, species thought to be extinct occasionally pop up from nowhere. So scientists rely on a crude calculation. They have a very rough idea, from a number of detailed studies, how many species are likely to be lost if the size of a particular habitat—a tropical forest, say—is reduced by a certain amount. They then apply this number to the total area of tropical forest lost each year (another very approximate figure, often derived from incomplete satellite data). Using this method, scientists working on the Global Biodiversity Assessment have estimated that, if current rates of forest loss continue over the next 30 years, the

number of species in tropical forests will fall by 5–10%.

Losing species, even bugs and spiders, might matter for a number of reasons. Ecosystems containing a broad diversity of species and genes are generally better able to adapt to changing conditions than those with just a handful of species, however abundant. Genetic variation is nature's insurance against all sort of eventualities. It might help cushion, for example, the impact of a sudden change in the world's climate. It also can help reduce the effect of disease. The Irish potato famine was so devastating because in the 19th century only a few varieties of potato were planted in Ireland, and these all happened to be vulnerable to the same disease. At present almost all the world's food crops are based on a mere nine species of plants, but in the future any of thousands of other species might prove invaluable. Today's apparently useless species may contain tomorrow's medicine.

To rich-world inhabitants, the best arguments for preserving the rainforests are spiritual: that the diversity of

More than meets the eye 8
Approximate numbers of species in major groups

Number of described species

Estimated total number of species in group

Source: UNEP

life is a wonder of nature, whether it has a practical application or not; and that it is good to hold on to some wildernesses in the world. But for developing countries trying to lift themselves out of poverty, such arguments seem utterly irrelevant.

Invasive Species: Pathogens of Globalization

by Christopher Bright

World trade has become the primary driver of one of the most dangerous and least visible forms of environmental decline: Thousands of foreign, invasive species are hitch-hiking through the global trading network aboard ships, planes, and railroad cars, while hundreds of others are traveling as commodities. The impact of these bioinvasions can now be seen on every landmass, in nearly all coastal waters (which comprise the most biologically productive parts of the oceans), and probably in most major rivers and lakes. This "biological pollution" is degrading ecosystems, threatening public health, and costing billions of dollars annually. Confronting the problem may now be as critical an environmental challenge as reducing global carbon emissions.

Despite such dangers, policies aimed at stopping the spread of invasive "exotic" species have so far been largely ineffective. Not only do they run up against far more powerful policies and interests that in one way or another encourage invasion, but the national and international mechanisms needed to control the spread of non-native species are still relatively undeveloped. Unlike chemical pollution, for instance, bioinvasion is not yet a working category of environmental decline within the legal culture of most countries and international institutions.

In part, this conceptual blindness can be explained by the fact that even badly invaded landscapes can still look healthy. It is also a consequence of the ancient and widespread practice of introducing exotic species for some tangible benefit: A bigger fish makes for better fishing, a faster-growing tree means more wood. It can be difficult to think of these activities as a form of ecological corrosion—even if the fish or the tree ends up demolishing the original natural community.

The increasing integration of the world's economies is rapidly making a bad situation even worse. The continual expansion of world trade—in ways that are not shaped by any real understanding of their environmental effects—is causing a degree of ecological mixing that appears to have no evolutionary precedent. Under more or less natural conditions, the arrival of an entirely new organism was a rare event in most times and places. Today it can happen any time a ship comes into port or an airplane lands. The real problem, in other words, does not lie with the exotic species themselves, but with the economic system that is continually showering them over the Earth's surface. Bioinvasion has become a kind of globalization disease.

CHRISTOPHER BRIGHT *is a research associate at the Worldwatch Institute in Washington, DC, and author of* Life Out of Bounds: Bioinvasion in a Borderless World *(New York: W.W. Norton & Company, 1998).*

THEY CAME, THEY BRED, THEY CONQUERED

Bioinvasion occurs when a species finds its way into an ecosystem where it did not evolve. Most of the time when this happens,

conditions are not suitable for the new arrival, and it enjoys only a brief career. But in a small percentage of cases, the exotic finds everything it needs—and nothing capable of controlling it. At the very least, the invading organism is liable to suppress some native species by consuming resources that they would have used instead. At worst, the invader may rewrite some basic ecosystem "rules"—checks and balances that have developed between native species, usually over many millennia.

Although it is not always easy to discern the full extent of havoc that invasive species can wreak upon an ecosystem, the resulting financial damage is becoming increasingly difficult to ignore. Worldwide, the losses to agriculture might be anywhere from $55 billion to nearly $248 billion annually. Researchers at Cornell University recently concluded that bioinvasion might be costing the United States alone as much as $123 billion per year. In South and Central America, the growth of specialty export crops—upscale vegetables and fruits—has spurred the spread of whiteflies, which are capable of transmitting at least 60 plant viruses. The spread of these viruses has forced the abandonment of more than 1 million hectares of cropland in South America. In the wetlands of northern Nigeria, an exotic cattail is strangling rice paddies, ruining fish habitats, and slowly choking off the Hadejia-Nguru river system. In southern India, a tropical American shrub, the bush morning glory, is causing similar chaos throughout the basin of the Cauvery, one of the region's biggest rivers. In the late 1980s, the accidental release into the Black Sea of *Mnemiopsis leidyi*—a comb jelly native to the east coast of the Americas—provoked the collapse of the already highly stressed Black Sea fisheries, with estimated financial losses as high as $350 million.

Controlling such exotics in the field is difficult enough, but the bigger problem is preventing the machinery of the world trading system from releasing them in the first place. That task is becoming steadily more formidable as the trading system continues to grow. Since 1950, world trade has expanded sixfold in terms of value. More important in terms of potential invasions is the vast increase in the volume of goods traded. Look, for instance, at the ship, the primary mechanism of trade—80 percent of the world's goods travel by ship for at least part of their journey from manufacturer to consumer. From 1970 to 1996, the volume of seaborne trade nearly doubled.

Ships, of course, have always carried species from place to place. In the days of sail, shipworms bored into the wooden hulls, while barnacles and seaweeds attached themselves to the sides. A small menagerie of other creatures usually took up residence within these "fouling communities" Today, special paints and rapid crossing times have greatly reduced hull fouling, but each of the 28,700 ships in the world's major merchant fleets represents a honeycomb of potential habitats for all sorts of life, both terrestrial and aquatic.

Controlling invasive species is difficult enough, but the bigger problem is preventing the machinery of the world trading system from releasing them in the first place.

The most important of these habitats lies deep within a modern ship's plumbing, in the ballast tanks. The ballast tanks of a really big ship—say, a supertanker—may contain more than 200,000 cubic meters of water—equivalent to 2,000 Olympic-sized swimming pools. When those tanks are filled, any little creatures in the nearby water or sediment may suddenly become inadvertent passengers. A few days or weeks later, when the tanks are discharged at journey's end, they may become residents of a coastal community on the other side of the world. Every year, these artificial ballast currents move some 10 billion cubic meters of water from port to port. Every day, some 3,000 to 10,000 different species are thought to be riding the ballast currents. The result is a creeping homogenization of estuary and bay life. The same creatures come to dominate one coastline after another, eroding the biological diversity of the planet's coastal zones—and jeopardizing their ecological stability.

Some pathways of invasion extend beyond ships. Another prime mechanism of trade is the container: the metal box that has revolutionized the transportation of just about every good not shipped in bulk. The con-

tainer's effect on invasion ecology has been just as profound. For centuries, shipborne exotics were largely confined to port areas—but no longer. Containers move from ship to harbor crane to the flatbed of a truck or railroad car and then on to wherever a road or railroad leads. As a result, all sorts of stowaways that creep aboard containers often wind up far inland. Take the Asian tiger mosquito, for example, which can carry dengue fever, yellow fever, and encephalitis. The huge global trade in containers of used tires—which are, under the right conditions, an ideal mosquito habitat—has dispersed this species from Asia and the Indo-Pacific into Australia, Brazil, the eastern United States, Mozambique, New Zealand, Nigeria, and southern Europe. Even packing material within containers can be a conduit for exotic species. Untreated wood pallets, for example, are to forest pests what tires are to mosquitoes. One creature currently moving along this pathway is the Asian longhorn beetle, a wood-boring insect from China with a lethal appetite for deciduous trees. It has turned up at more than 30 locations around the United States and has also been detected in Great Britain. The only known way to eradicate it is to cut every tree suspected of harboring it, chip all the wood, and burn all the chips.

As other conduits for global trade expand, so does the potential for new invasions. Air cargo service, for example, is building a global network of virtual canals that have great potential for transporting tiny, short-lived creatures such as microbes and insects. In 1989, only three airports received more than 1 million tons of cargo; by 1996, there were 13 such airports. Virtually everywhere you look, the newly constructed infrastructure of the global economy is forming the groundwork for an ever-greater volume of biological pollution.

THE GLOBAL SUPERMARKET

Bioinvasion cannot simply be attributed to trade in general, since not all trade is "biologically dirty." The natural resource industries—especially agriculture, aquaculture, and forestry—are causing a disproportionate share of the problem. Certain trends within each of these industries are liable to exacerbate the invasion pressure. The migration of crop pests can be attributed, in part, to a global agricultural system that has become increasingly uniform and integrated. (In China, for example,

there were about 10,000 varieties of wheat being grown at mid-century; by 1970 there were only about 1,000.) Any new pest—or any new form of an old pest—that emerges in one field may eventually wind up in another.

The key reason that South America has suffered so badly from white-flies, for instance, is because a pesticide-resistant biotype of that fly emerged in California in the 1980s and rapidly became one of the world's most virulent crop pests. The fly's career illustrates a common dynamic: A pest can enter the system, disperse throughout it, and then develop new strains that reinvade other parts of the system. The displacement of traditional developing-world crop varieties by commercial, homogenous varieties that require more pesticide, and the increasing development of pesticide resistance among all the major pest categories—insects, weeds, and fungi—are likely to boost this trend.

Similar problems pertain to aquaculture—the farming and exporting of fish, shellfish, and shrimp. Partly because of the progressive depletion of the world's most productive fishing grounds, aquaculture is a booming business. Farmed fish production exceeded 23 million tons by 1996, more than triple the volume just 12 years before. Developing countries in particular see aquaculture as a way of increasing protein supply.

But many aquaculture "crops" have proved very invasive. In much of the developing world, it is still common to release exotic fish directly into natural waterways. It is hardly surprising, then, that some of the most popular aquaculture fish have become true cosmopolitans. The Mozambique tilapia, for example, is now established in virtually every tropical and subtropical country. Many of these introductions—not just tilapia, but bass, carp, trout, and other types of fish—are implicated in the decline of native species. The constant flow of new introductions catalogued with such enthusiasm in the industry's publications are a virtual guarantee that tropical freshwater ecosystems are unraveling beneath the surface.

Aquaculture is also a spectacularly efficient conduit of disease. Perhaps the most virulent set of wildlife epidemics circling the Earth today involves shrimp production in the developing world. Unlike fish, shrimp are not a subsistence crop: They are an extremely lucrative export business that has led to the bulldozing of many tropical coasts to make way for shrimp ponds. One of the biggest current

developments is an Indonesian operation that may eventually cover 200,000 hectares. A horde of shrimp pathogens—everything from viruses to protozoa—is chasing these operations, knocking out ponds, an occasionally ruining entire national shrimp industries: in Taiwan in 1987, in China in 1993, and in India in 1994. Shrimp farming has become, in effect, a form of "managed invasion." Since shrimp are important components of both marine and freshwater ecosystems worldwide, it is anybody's guess at this point what impact shrimpborne pathogens will ultimately have.

Managed invasion is an increasingly common procedure in another big biopolluting industry: forestry. Industrial roundwood production (basically, the cutting of logs for uses other than fuel) currently hovers at around 1.5 billion cubic meters annually, which is more than twice the level of the 1950s. An increasing amount of wood and wood pulp is coming out of tree plantations (not inherently a bad idea, given the rate at which the world is losing natural forests). In North America and Europe, plantation forestry generally uses native species, so the gradation from natural forest to plantation is not usually as stark as it is in developing countries, where exotics are the rule in industrial-plantation development.

For the most part, these developing-country plantations bear about as much resemblance to natural forests as corn fields do to undisturbed prairies. And like corn fields, they are maintained with heavy doses of pesticides and subjected to a level of disturbance—in particular, the use of heavy equipment to harvest the trees—that tends to degrade soil. Some plantation trees have launched careers as king-sized weeds. At least 19 species of exotic pine, for example, have invaded various regions in the Southern Hemisphere, where they have displaced native vegetation and, in some areas, apparently lowered the water tables by "drinking" more water than the native vegetation would consume. Even where the trees have not proved invasive, the exotic plantations themselves are displacing natural forest and traditional forest peoples. This type of tree plantation is almost entirely designed to feed wood to the industrialized world, where 77 percent of industrial roundwood is consumed. As with shrimp production, local ecological health is being sacrificed for foreign currency.

There is another, more poignant motive for the introduction of large numbers of exotic trees into the developing world. In many countries severely affected by forest loss, reforestation is recognized as an important social imperative. But the goal is often nothing more than increasing tree cover. Little distinction is made between plantation and forest or between foreign and native species. Surayya Khatoon, a botanist at the University of Karachi, observes that "awareness of the dangers associated with invasive species is almost nonexistent in Pakistan, where alien species are being planted on a large scale in so-called afforestation drives."

The industrial sources of biological pollution are very diverse, but they reflect a common mindset. Whether it is a tree plantation, a shrimp farm, or even a bit of landscaping in the back yard, the Earth has become a sort of "species supermarket"; if a species looks good for whatever it is that you have in mind, pull it off the shelf and take it home. The problem is that many of the traits you want the most—adaptability, rapid growth, and easy reproduction—also tend to make the organism a good candidate for invasion.

LAUNCHING A COUNTER-ATTACK

Since the processes of invasion are deeply embedded in the globalizing economy, any serious effort to root them out will run the risk of exhausting itself. Most industries and policymakers are striving to open borders, not erect new barriers to trade. Moreover, because bioinvasion is not yet an established policy category, jurisdiction over it is generally badly fragmented—or even absent—on both the national and international levels. Most countries have some relevant legislation—laws intended to discourage the movement of crop pests, for example—but very few have any overall legislative authority for dealing with the problem. (New Zealand is the noteworthy exception: Its Biosecurity Act of 1993 and its Hazardous Substances and New Organisms Act of 1996 do establish such an authority.) Although it is true that there are many treaties that bear on the problem in one way or another—23 at least count—there is not such thing as a bioinvasion treaty.

Even agreements that focus specifically on ecological problems have generally given bioinvasion short shrift. Agenda 21, for example—the blueprint for sustainable development that emerged from the 1992 Earth Summit in Rio de Janeiro—reflects little awareness of the dangers of exotic forestry

and aquaculture. Among international agencies, only certain types of invasion seem to get much attention. There are treaties—such as the 1951 International Plant Protection Convention—that limit the movement of agricultural pests, but there is currently no clear international mechanism for dealing with ballast water releases. Obviously, in such a context, you need to pick your fights carefully. They have to be important, winnable, and capable of yielding major opportunities elsewhere. The following three-point agenda offers some hope of slowing invasion over the near term.

Even international agreements that focus specifically on ecological problems have generally given bioinvasion short shrift.

The first item: Plug the ballast water pathway. As a technical problem, this objective is probably just on the horizon of feasibility, making it an excellent policy target. Strong national and international action could push technologies ahead rapidly. At present, the most effective technique is ballast water exchange, in which the tanks of a ship are pumped out and refilled in the open sea. (Coastal organisms, pumped into the tanks at the ship's last port of call, usually will not survive in the open ocean; organisms that enter the tanks in mid-ocean probably will not survive in the next port of call.) But it can take several days to exchange the water in all of a ship's ballast tanks, so the procedure may not be feasible for every leg of a journey, and the tanks never empty completely. In bad weather, the process can be too dangerous to perform at all. Consequently, other options will be necessary—filters or even toxins (that may not sound very appealing, but some common water treatment compounds may be environmentally sound). It might even be possible to build port-side ballast water treatment plants. Such a mixture of technologies already exists as the standard means of controlling chemical pollution.

This objective is drifting into the realm of legal possibility as well. As of July 1 this year, all ships entering U.S. waters must keep a record of their ballast water management. The United States has also issued voluntary guidelines on where those ships can release ballast water. These measures are a loose extension of the regulations that the United States and Canada have imposed on ship traffic in the Great Lakes, where foreign ballast water release is now explicitly forbidden. In California, the State Water Resources Control Board has declared San Francisco Bay "impaired" because it is so badly invaded—a move that may allow authorities to use regulations written for chemical pollution as a way of controlling ballast water. Australia now levies a small tax on all incoming ships to support ballast water research.

Internationally, the problem has acquired a high profile at the UN International Maritime Organization (IMO), which is studying the possibility of developing a ballast management protocol that would have the force of international law. No decision has been made on the legal mechanism for such an agreement, although the most likely possibility is an annex to MARPOL, the International Convention for the Prevention of Pollution from Ships.

Within the shipping industry, the responses to such proposals have been mixed. Although industry officials concede the problem in the abstract, the prospect of specific regulations has tended to provoke unfavorable comment. After an IMO meeting last year on ballast water management, a spokesperson for the International Chamber of Shipping argued that rigorous ballast exchange would cost the industry millions of dollars a year—and that internationally binding regulations should be avoided in favor of local regulation, wherever particular jurisdictions decide to address the problem. Earlier this year in California, a proposed bill that would have essentially prohibited foreign ballast water release in the state's ports provoked outcries from local port representatives, who argued that such regulations might encourage ship traffic to bypass California ports in favor of the Pacific Northwest or Mexico. Of course, any management strategy is bound to cost something, but the important question is: What impact will this additional cost have? It may not have much impact at all. In Canada, for example, the Vancouver Port Authority reported that its ballast water program has had no detectable effect on port revenues.

The second item on the agenda: Fix the World Trade Organization (WTO) Agreement on the Application of Sanitary and Phytosanitary Measures. This agreement, known as the SPS, was part of the diplomatic package that created the WTO in 1994. The SPS is supposed to promote a common set of procedures for evaluating risks of contamination in internationally traded commodities. The contaminants can be chemical (pesticide residues in food) or they can be living things (Asian longhorn beetles in raw wood).

One of the procedures required by the SPS is a risk assessment, which is supposed to be done before any trade-constricting barriers are imposed to prevent a contaminated good from entering a country. If you want to understand the fundamental flaw in this approach as it applies to bioinvasion, all you have to do is recall the famous observation by the eminent biologist E.O. Wilson: "We dwell on a largely unexplored planet." When it comes to the largest categories of living things—insects, fungi, bacteria, and so on—we have managed to name only a tiny fraction of them, let alone figure out what damage they can cause. Consider, for example, the rough, aggregate risk assessments done by the United States Department of Agriculture (USDA) for wood imported into the United States from Chile, Mexico, and New Zealand. The USDA found dozens of "moderate" and "high" risk pests and pathogens that have the potential for doing economic damage on the order of hundreds of millions of dollars at least—and ecological damage that is incalculable. But even with wide-open thoroughfares of invasion such as these, the SPS requirement in its current form is likely to make preemptive action vulnerable to trade complaints before the WTO.

Another SPS requirement intended to insure a consistent application of standards is that a country must not set up barriers against an organism that is already living within its borders unless it has an "official control program" for that species. This approach is unrealistic for both biological and financial reasons. Thousands of exotic species are likely to have invaded most of the world's countries and not even the wealthiest country could possibly afford to fight them all. Yet it certainly is possible to exacerbate a problem by introducing additional infestations of a pest, or by boosting the size of existing infestations, or even by increasing the genetic vigor of a pest population by adding more "breeding stock." The SPS does not like "inconsistencies"—if you are not controlling a pest, you have no right to object to more of it; if you try to block one pathway of invasion, you had better be trying to block all the equivalent pathways. Such an approach may be theoretically neat, but in the practical matter of dealing with exotics, it is a prescription for paralysis.

In the near term, however, any effort to repair the SPS is likely to be difficult. The support of the United States, a key member of the WTO, will be critical for such reforms. And although the United States has demonstrated a heightened awareness of the problem—as evidenced by President Bill Clinton's executive order to create an Invasive Species Council—it is not clear whether that commitment will be reflected in the administration's trade policy. During recent testimony before Congress, the U.S. Trade Representative's special trade negotiator for agricultural issues warned that the United States was becoming impatient with the "increasing use of SPS barriers as the 'trade barrier of choice.' " In the developing world, it is reasonable to assume that any country with a strong export sector in a natural resource industry would not welcome tougher regulations. Some developed countries, however, may be sympathetic to change. The European Union (EU) has sought very strict standards in its disputes with the United States over bans on beef from cattle fed with growth hormones and on genetically altered foods. It is possible that the EU might be willing to entertain a stricter SPS. The same might be true of Japan, which has attempted to secure stricter testing of U.S. fruit imports.

The third item: Build a global invasion database. Currently, the study of bioinvasion is an obscure and rather fractured enterprise. It can be difficult to locate critical information or relevant expertise. The full magnitude of the issue is still not registering on the public radar screen. A global database would consolidate existing information, presumably into some sort of central research institution with a major presence on the World Wide Web. One could "go" to such a place—either physically or through cyberspace—to learn about everything from the National Ballast Water Information Clearinghouse that the U.S. Coast Guard is setting up, to the database on invasive woody plants in the tropics that is being assembled at the University of Wales. The database would also stimulate the production of new media to encourage additional research

and synthesis. It is a telling indication of how fragmented this field is that, after more than 40 years of formal study, it is just now getting its first comprehensive journal: *Biological Invasions*.

Better information should have a number of practical effects. The best way to control an invasion—when it cannot be prevented outright—is to go after the exotic as soon as it is detected. An emergency response capability will only work if officials know what to look for and what to do when they find it. But beyond such obvious applications, the database could help bring the big picture into focus. In the struggle with exotics, you can see the free-trade ideal colliding with some hard ecological realities. Put simply: It may never be safe to ship certain goods to certain places—raw wood from Siberia, for instance, to North America. The notion of real, permanent limits to economic activity will for many politicians (and probably some economists) come as a strange and unpalatable idea. But the global economy is badly in need of a large dose of ecological realism. Ecosystems are very diverse and very different from each other. They need to stay that way if they are going to continue to function.

Want to Know More?

Although the scientific literature on bioinvasion is enormous and growing rapidly, most of it is too technical to attract a readership outside the field. For a nontechnical, broad overview of the problem, readers should consult Robert Devine's *Alien Invasion: America's Battle with Non-Native Animals and Plants* (Washington: National Geographic Society, 1998) or Christopher Bright's *Life Out of Bounds: Bioinvasion in a Borderless World* (New York: W.W. Norton & Company, 1998).

If you have a long-term interest in bioinvasion, you will want to get acquainted with the book that founded the field: Charles Elton's *The Ecology of Invasions by Animals and Plants* (London: Methuen, 1958). A historical overview of bioinvasions can be found in Alfred Crosby's book *Ecological Imperialism: The Biological Expansion of Europe, 900–1900* (Cambridge: Cambridge University Press, 1986).

Many studies focus on invasion of particular regions. The focus can be very broad, as in P.S. Ramakrishnan, ed., *Ecology of Biological Invasions in the Tropics*, proceedings of an international workshop held at Nainital, India, (New Delhi: International Scientific Publications, 1989). Generally, however, the coverage is much narrower, as in Daniel Simberloff, Don Schmitz, and Tom Brown, eds., *Strangers in Paradise: Impact and Management of Nonindigenous Species in Florida* (Washington: Island Press, 1997). The other standard research tack has been to look at a particular type of invader. The most accessible results of this exercise are encyclopedic surveys such as Christopher Lever's *Naturalized Mammals of the World* (London: Longman, 1985) and his companion volumes on naturalized birds and fish. In the plant kingdom, the genre is represented by Leroy Holm, et al., *World Weeds: Natural Histories and Distribution* (New York: John Wiley and Sons, 1997).

There are many worthwhile documents available for anyone who is interested not just in the ecology of invasion, but also in its economic, social, and epidemiological implications. Just about every aspect of the problem is discussed in Odd Terje Sandlund, Peter Johan Schei, and Aslaug Viken, eds., *Proceedings of the Norway/UN Conference on Alien Species* (Trondheim: Directorate for Nature Management and Norwegian Institute for Nature Research, 1996). A groundbreaking study of invasion in the United States, with particular emphasis on economic effects, is *Harmful Nonindigenous Species in the United States* (Washington: Office of Technology Assessment, September 1993). An assessment of the ballast water problem is available from the National Research Council's Commission on Ships' Ballast Operations' *Stemming the Tide: Controlling Introductions of Nonindigenous Species by Ships' Ballast Water* (Washington: National Academy Press, 1996). Readers who are interested in exotic tree plantations as a form of "managed invasion" might look through Ricardo Carrere and Larry Lohmann's *Pulping the South: Industrial Tree Plantations and the World Paper Economy* (London: Zed Books, 1996) and the World Rainforest Movement's *Tree Plantations: Impacts and Struggles* (Montevideo: WRM, 1999). Unfortunately, there are no analogous studies of shrimp farms.

For links to relevant Web sites, as well as a comprehensive index of related FOREIGN POLICY articles, access **www.foreignpolicy.com**.

We *Can* Build a Sustainable Economy

The keys to securing the planet's future lie in stabilizing both human population and climate. The challenges are great, but several trends look promising.

By Lester R. Brown

The world economy is growing faster than ever, but the benefits of this rapid growth have not been evenly distributed. As population has doubled since mid-century and the global economy has nearly quintupled, the demand for natural resources has grown at a phenomenal rate.

Since 1950, the need for grain has nearly tripled. Consumption of seafood has increased more than four times. Water use has tripled. Demand for beef and mutton has tripled. Firewood demand has tripled, lumber demand has more than doubled, and paper demand has gone up sixfold. The burning of fossil fuels has increased nearly fourfold, and carbon emissions have risen accordingly.

These spiraling human demands for resources are beginning to outgrow the earth's natural systems. As this happens, the global economy is damaging the foundation on which it rests.

To build an environmentally sustainable global economy, there are many obstacles, but there are also several promising trends and factors in our favor. One is that we know what an environmentally sustainable economy would look like. In a sustainable economy:

• Human births and deaths are in balance.

• Soil erosion does not exceed the natural rate of new soil formation.

• Tree cutting does not exceed tree planting.

• The fish catch does not exceed the sustainable yield of fisheries.

• The number of cattle on a range does not exceed the range's carrying capacity.

• Water pumping does not exceed aquifer recharge.

• Carbon emissions and carbon fixation are in balance.

• The number of plant and animal species lost does not exceed the rate at which new species evolve.

We know how to build an economic system that will meet our needs without jeopardizing prospects for future generations. And with some trends already headed in the right direction, we have the cornerstones on which to build such an economy.

Stabilizing Population

With population, the challenge is to complete the demographic transition, to reestablish the balance between births and deaths that characterizes a sustainable society. Since populations are rarely ever precisely stable, a stable population is defined here as one with a growth rate below 0.3%. Populations are effectively stable if they fluctuate narrowly around zero.

Thirty countries now have stable populations, including most of those in Europe plus Japan. They provide

From *The Futurist*, July/August 1996, pp. 8–12. © 1996 by The World Future Society, Bethesda, MD; http://www.wfs.org/wfs. Reprinted by permission.

the solid base for building a world population stabilization effort. Included in the 30 are all the larger industrialized countries of Europe—France, Germany, Italy, Russia, and the United Kingdom. Collectively, these 30 countries contain 819 million people or 14% of humanity. For this goal, one-seventh of humanity is already there.

The challenge is for the countries with the remaining 86% of the world's people to reach stability. The two large nations that could make the biggest difference in this effort are China and the United States. In both, population growth is now roughly 1% per year. If the global food situation becomes desperate, both could reach stability in a decade or two if they decided it were important to do so.

The world rate of population growth, which peaked around 2% in 1970, dropped below 1.6% in 1995. Although the rate is declining, the annual addition is still close to 90 million people per year. Unless populations can be stabilized with demand below the sustainable yield of local ecosystems, these systems will be destroyed. Slowing growth may delay the eventual collapse of ecosystems, but it will not save them.

The European Union, consisting of some 15 countries and containing 360 million people, provides a model for the rest of the world of an environmentally sustainable food/population balance. At the same time that the region has reached zero population growth, movement up the food chain has come to a halt as diets have become saturated with livestock products. The result is that Europe's grain consumption has been stable for close to two decades at just under 160 million tons—a level that is within the region's carrying capacity. Indeed, there is a potential for a small but sustainable export surplus of grain that can help countries where the demand for food has surpassed the carrying capacity of their croplands.

As other countries realize that continuing on their current population trajectory will prevent them from achieving a similar food/population balance, more and more may decide to do what China has done—launch an all-out campaign to stabilize population. Like China, other governments will have to carefully balance the reproductive rights of the current generation with the survival rights of the next generation.

Very few of the group of 30 countries with stable populations had stability as an explicit policy goal. In those that reached population stability first, such as Belgium, Germany, Sweden, and the United Kingdom, it came with rising living standards and expanding employment opportunities for women. In some of the countries where population has stabilized more recently, such as Russia and other former Soviet republics, the deep economic depression accompanying economic reform has substantially lowered birth rates, much as the Great Depression did in the United States. In addition, with the rising number of infants born with birth defects and deformities since Chernobyl, many women are simply afraid to bear children. The natural decrease of population (excluding migration) in Russia of 0.6% a year—leading to an annual population loss of 890,000—is the most rapid on record.

Not all countries are achieving population stability for the right reasons. This is true today and it may well be true in the future. As food deficits in densely populated countries expand, governments may find that there is not enough food available to import. Between fiscal year 1993 and 1996, food aid dropped from an all-time high of 15.2 million tons of grain to 7.6 million tons. This cut of exactly half in three years reflects primarily fiscal stringencies in donor countries, but also, to a lesser degree, higher grain prices in fiscal 1996. If governments fail to establish a humane balance between their people and food supplies, hunger and malnutrition may raise death rates, eventually slowing population growth.

Some developing countries are beginning to adopt social policies that will encourage smaller families. Iran, facing both land hunger and water scarcity, now limits public subsidies for housing, health care, and insurance to three children per family. In Peru, President Alberto Fujimori, who was elected overwhelmingly to his second five-year term in a predominantly Catholic country, said in his inaugural address in August 1995 that he wanted to provide better access

World Fertilizer and Grainland
(Per Person, 1950-94)

SOURCES: USDA, FAO, IFA

to family-planning services for poor women. "It is only fair," he said, "to disseminate thoroughly the methods of family planning to everyone."

Stabilizing Climate

With climate, as with population, there is disagreement on the need to stabilize. Evidence that atmospheric carbon-dioxide levels are rising is clear-cut. So, too, is the greenhouse effect that these gases produce in the atmosphere. That is a matter of basic physics. What is debatable is the rate at which global temperatures will rise and what the precise local effects will be. Nonetheless, the consensus of the mainstream scientific community is that there is no alternative to reducing carbon emissions.

How would we phase out fossil fuels? There is now a highly successful "phase out" model in the case of chlorofluorocarbons (CFCs). After

two British scientists discovered the "hole" in the ozone layer over Antarctica and published their findings in *Nature* in May 1985, the international community convened a conference in Montreal to draft an agreement designed to reduce CFC production sharply. Subsequent meetings in London in 1990 and Copenhagen in 1992 further advanced the goals set in Montreal. After peaking

World Wind Energy
(Generating Capacity, 1980-94)

SOURCES: Gipe and Associates, BTM Consulting

in 1988 at 1.26 million tons, the manufacture of CFCs dropped to an estimated 295,000 tons in 1994—a decline of 77% in just six years.

As public understanding of the costs associated with global warming increases, and as evidence of the effects of higher temperatures accumulates, support for reducing dependence on fossil fuels is building. At the March 1995 U.N. Climate Convention in Berlin, environmental groups were joined in lobbying for a reduction in carbon emissions by a group of 36 island communities and insurance industry representatives.

The island nations are beginning to realize that rising sea levels would, at a minimum, reduce their land area and displace people. For some low-lying island countries, it could actually threaten their survival. And the insurance industry is beginning to realize that increasing storm intensity can threaten the survival of insurance companies as well. When Hurricane Andrew tore through Florida in 1992, it took down not only thousands of buildings, but also eight insurance firms.

In September 1995, the U.S. Department of Agriculture reported a sharp drop in the estimated world grain harvest because of crop-withering heat waves in the northern tier of industrial countries. Intense late-summer heat had damaged harvests in Canada and the United States, across Europe, and in Russia. If farmers begin to see that the productivity of their land is threatened by global warming, they, too, may begin to press for a shift to renewable sources of energy.

As with CFCs, there are alternatives to fossil fuels that do not alter climate. Several solar-based energy sources, including wind power, solar cells, and solar thermal power plants, are advancing rapidly in technological sophistication, resulting in steadily falling costs. The cost of photovoltaic cells has fallen precipitously over the last few decades. In some villages in developing countries where a central grid does not yet exist, it is now cheaper to install an array of photovoltaic cells than to build a centralized power plant plus the grid needed to deliver the power.

Wind power, using the new, highly efficient wind turbines to convert wind into electricity, is poised for explosive growth in the years ahead. In California, wind farms already supply enough electricity to meet the equivalent of San Francisco's residential needs.

The potential for wind energy is enormous, dwarfing that of hydropower, which provides a fifth of the world's electricity. In the United States, the harnessable wind potential in North Dakota, South Dakota, and Texas could easily meet national electricity needs. In Europe, wind power could theoretically satisfy all the continent's electricity needs. With scores of national governments planning to tap this vast resource, rapid growth in the years ahead appears inevitable.

A Bicycle Economy

Another trend to build on is the growing production of bicycles. Human mobility can be increased by investing in public transportation, bicycles, and automobiles. Of these, the first two are by far the most promising environmentally. Although China has announced plans to move toward an automobile-centered transportation system, and car production in India is expected to double by the end of the decade, there simply may not be enough land in these countries to support such a system and to meet the food needs of their expanding populations.

Against this backdrop, the creation of bicycle-friendly transportation systems, particularly in cities, shows great promise. Market forces alone have pushed bicycle production to an estimated 111 million in 1994, three times the level of automobile production. It is in the interest of societies everywhere to foster the use of bicycles and public transportation—to accelerate the growth in bicycle manufacturing while restricting that of automobiles. Not only will this help save cropland, but this technology can greatly increase human mobility without destabilizing climate. If food becomes increasingly scarce in the years ahead, as now seems likely, the land-saving, climate-stabilizing nature of bicycles will further tip the scales in their favor and away from automobiles.

The stabilization of population in some 30 countries, the stabilization of food/people balance in Europe, the reduction in CFC production, the dramatic growth in the world's wind power generating capacity, and the extraordinary growth in bicycle use are all trends for the world to build on. These cornerstones of an environmentally sustainable global economy provide glimpses of a sustainable future.

Regaining Control of Our Destiny

Avoiding catastrophe is going to take a far greater effort than is now

being contemplated by the world's political leaders. We know what needs to be done, but politically we are unable to do it because of inertia and the investment of powerful interests in the status quo. Securing food supplies for the next generation depends on an all-out effort to stabilize population and climate, but we resist changing our reproductive behavior, and we refrain from converting our climate-destabilizing, fossil-fuel-based economy to a solar/hydrogen-based one.

As we move to the end of this century and beyond, food security may well come to dominate international affairs, national economic policy making, and—for much of humanity—personal concerns about survival. There is now evidence from enough countries that the old formula of substituting fertilizer for land is no longer working, so we need to search urgently for alternative formulas for humanly balancing our numbers with available food supplies.

Unfortunately, most national political leaders do not even seem to be aware of the fundamental shifts occurring in the world food economy, largely because the official projections by the World Bank and the U.N. Food and Agriculture Organization are essentially extrapolations of past trends.

If we are to understand the challenges facing us, the teams of economists responsible for world food supply-and-demand projections at these two organizations need to be replaced with an interdisciplinary team of analysts, including, for example, an agronomist, hydrologist, biologist, and meteorologist, along with an economist. Such a team could assess and incorporate into projections such things as the effect of soil erosion on land productivity, the effects of aquifer depletion on future irrigation water supplies, and the effect of increasingly intense heat waves on future harvests.

The World Bank team of economists argues that, because the past is the only guide we have to the future, simple extrapolations of past

trends are the only reasonable way to make projections. But the past is also filled with a body of scientific literature on growth in finite environments, and it shows that biological growth trends typically conform to an S-shaped curve over time.

The risk of relying on these extrapolative projections is that they are essentially "no problem" projections. For example, the most recent World Bank projections, which use 1990 as a base and which were published in late 1993, are departing further and further from reality with each passing year. They show the world grain harvest climbing from 1.78 billion tons in 1990 to 1.97 billion tons in the year 2000. But instead of the projected gain of nearly 100 million tons since 1990, world grain production has not grown at all. Indeed, the 1995 harvest, at 1.69 billion tons, is 90 million tons below the 1990 harvest.

One of the most obvious needs today is for a set of country-by-country carrying-capacity assessments. Assessments using an interdisciplinary team can help provide information needed to face the new realities and formulate policies to respond to them.

Setting Priorities

The world today is faced with an enormous need for change in a period of time that is all too short. Human behavior and values, and the national priorities that reflect them, change in response to either new information or new experiences. The effort now needed to reverse the environmental degradation of the planet and ensure a sustainable future for the next generation will require mobilization on a scale comparable to World War II.

Regaining control of our destiny depends on stabilizing population as well as climate. These are both key to the achievement of a wide array of social goals ranging from the restoration of a rise in food con-

sumption per person to protection of the diversity of plant and animal species. And neither will be easy. The first depends on a revolution in human reproductive behavior; the second, on a restructuring of the global energy system.

Serving as a catalyst for these gargantuan efforts is the knowledge that if we fail our future will spiral

Bicycles vs. Cars
(Worldwide Production, 1950-94)

SOURCES: U.N., Interbike Directory

out of control as the acceleration of history overwhelms political institutions. It will almost guarantee a future of starvation, economic insecurity, and political instability. It will bring political conflict between societies and among ethnic and religious groups within societies. As these forces are unleashed, they will leave social disintegration in their wake.

Offsetting the dimensions of this challenge, including the opposition to change that is coming from vested interests and the momentum of trends now headed in the wrong direction, are some valuable assets. These include a well-developed global communications network, a growing body of scientific knowledge, and the possibility of using fiscal policy—a potentially powerful instrument for change—to build an environmentally sustainable economy.

Policies for Progress

Satisfying the conditions of sustainability—whether it be reversing the deforestation of the planet, converting a throwaway economy into a reuse-recycle one, or stabilizing cli-

mate—will require new investment. Probably the single most useful instrument for converting an unsustainable world economy into one that is sustainable is fiscal policy. Here are a few proposals:

• **Eliminate subsidies for unsustainable activities.** At present, governments subsidize many of the very activities that threaten the sustainability of the economy. They support fishing fleets to the extent of some $54 billion a year, for example, even though existing fishing capacity already greatly exceeds the sustainable yield of oceanic fisheries. In Germany, coal production is subsidized even though the country's scientific community has been outspoken in its calls for reducing carbon emissions.

• **Institute a carbon tax.** With alternative sources of energy such as wind power, photovoltaics, and solar thermal power plants becoming competitive or nearly so, a carbon tax that would reflect the cost to so-

ciety of burning fossil fuels—the costs, that is, of air pollution, acid rain, and global warming—could quickly tip the scales away from further investment in fossil fuel production to investment in wind and solar energy. Today's fossil-fuel-based energy economy can be replaced with a solar/hydrogen economy that can meet all the energy needs of a modern industrial society without causing disruptive temperature rises.

• **Replace income taxes with environmental taxes.** Income taxes discourage work and savings, which are both positive activities that should be encouraged. Taxing environmentally destructive activities instead would help steer the global economy in an environmentally sustainable direction. Among the activities to be taxed are the use of pesticides, the generation of toxic wastes, the use of virgin raw materials, the conversion of cropland to nonfarm uses, and carbon emissions.

The time may have come also to limit tax deductions for children to two per couple: It may not make sense to subsidize childbearing beyond replacement level when the most pressing need facing humanity is to stabilize population.

The challenge for humanity is a profound one. We have the information, the technology, and the knowledge of what needs to be done. The question is, Can we do it? Can a species that is capable of formulating a theory that explains the birth of the universe now implement a strategy to build an environmentally sustainable economic system?

About the Author
Lester R. Brown is president of the Worldwatch Institute, 1776 Massachusetts Avenue, N.W., Washington, D.C. 20036. Telephone 202/452-1999; fax 202/296-7365.

Unit 4

Key Points to Consider

❖ Are those who argue that there is in fact a process of globalization overly optimistic? Why or why not?

❖ What are some of the impediments to a truly global political economy?

❖ How are the political economies of traditional societies different from those of the consumer-oriented societies of the West?

❖ How are the developing countries dependent on the highly developed industrialized nations?

❖ Discuss some of the barriers that make it difficult for nonindustrial countries to develop.

❖ The international political economy is faced with unprecedented problems. What are some of these, and what are some of the proposals for addressing these problems?

❖ How are China, India, and other newly industrialized countries trying to alter their ways of doing business in order to meet the challenges of globalization? Are they likely to succeed?

 Links **www.dushkin.com/online/**

17. **Belfer Center for Science and International Affairs (BCSIA)**
 http://ksgwww.harvard.edu/csia/
18. **Communications for a Sustainable Future**
 gopher://csf.colorado.edu
19. **U.S. Agency for International Development**
 http://www.info.usaid.gov
20. **Virtual Seminar in Global Political Economy/Global Cities & Social Movements**
 http://csf.colorado.edu/gpe/gpe95b/resources.html
21. **World Bank**
 http://www.worldbank.org

These sites are annotated on pages 6 and 7.

An underlying debate that shaped much of the twentieth century's social history focused on dramatically opposing views about how economic systems should be organized and what role government should play in the management of a country's economy. For some, the dominant capitalist economic system appeared to be organized for the benefit of the few, with the masses trapped in poverty, supplying cheap labor to further enrich the wealthy. This economic system, they argued, could be changed only by gaining control of the political system and radically changing the ownership of the means of production. In striking contrast to this perspective, others argued that the best way to create wealth and eliminate poverty was to encourage entrepreneurs with the motivation of profits and to allow a competitive marketplace to make decisions about production and distribution.

The debate between socialism/communism on the one hand and capitalism on the other (with variations in between) has been characterized by both abstract theorizing and very pragmatic and often violent political conflict. The Russian and Chinese revolutions overthrew the old social order and created radical changes in the political and economic systems in these two giant countries. The political structures created to support the new systems of agricultural production, along with the planning of all other aspects of economic activity, eliminated most private ownership of property; they were, in short, unparalleled experiments in social engineering.

The collapse of the Soviet Union and the dramatic reforms that have taken place in China have recast the debate about how to best structure contemporary economics. Some believe that with the end of communism and the resulting participation of hundreds of millions of new consumers in the global market economy, an unprecedented era has been entered. Proponents of this view argue that a new global economy is emerging, setting into motion a series of processes that will ultimately result in a single economic system characterized by interdependence and increased prosperity.

Many have noted that this process of "globalization" is being accelerated by the revolution in communication and computer technologies. Others are less optimistic about the prospects of globalization. They argue that the creation of a single economic system where there are no boundaries to impede the flow of capital does not mean a closing of the gap between the world's rich and poor.

The use of the term "political economy" for the title of this unit is a recognition that modern economic and political systems are not separable. All economic systems have some type of marketplace where goods and services are bought and sold. The government in most cases regulates these transactions, that is, it sets the rules that govern the marketplace. In addition, the government's power to tax in order to pay for defense and other public activities directly affects all economic activities (i.e., by determining how much money remains for other expenditures).

One of the most important concepts in thinking about the contemporary political economy is "development." If a group of experts were gathered to discuss this concept, it would soon be apparent that many define the word "development" in various ways. For some, development means becoming industrialized—like the United States or Japan. To others, development means having a growing economy, which is usually measured in terms of the expansion of the so-called gross domestic product (GDP). To still others, development is primarily a political phenomenon. They question how a society can change its economy if it cannot first establish collective goals and successfully administer their implementation. And to still others, development means attaining a certain quality of life, based on the establishment of adequate health care, leisure time, and a system of public education, among other things.

For the purposes of this unit, the term "development" will be defined as an improvement in the basic aspects of life: lower infant mortality rates, greater life expectancy, lower disease rates, higher rates of literacy, healthier diets, and improved sanitation. Judged by these standards, some groups of people are more developed than others. A fundamental question that the thoughtful reader must consider is whether the apparent trend toward greater globalization is resulting in increased development not only for a few people but for most of those participating in the global political economy.

The unit is organized into two subsections. The first is a general discussion of the concept of globalization. How do different people define the term, and what are their various perspectives on it? For example, is the idea of a global economy merely wishful thinking by those who sit on top of the power hierarchy, self-deluded into believing that globalization is an inexorable force that will evolve in its own way, following its own rules? Or will there always be traditional issues of power politics between the rich, those who are ascending in power, and the ever-present poor, which will result in clashes of interests just like those that have characterized history since the early years of civilization?

The second subsection focuses on case studies. These have been selected to help the reader draw his or her own conclusions about the validity of the globalization concept. What in fact is taking place in countries that have not participated directly in the industrial revolution? In addition, can countries like China and India find a significant economic role in the contemporary world? Does the contemporary political economy result in winners and losers, or can all benefit from its system of wealth creation and distribution?

Political Economy

Globalization, we are told, is what every business should be pursuing, and what every nation should welcome. But what, exactly, is it? James Rosenau offers a nuanced understanding of a process that is much more real, and transforming, than the language of the marketplace expresses.

The Complexities and Contradictions of Globalization

JAMES N. ROSENAU

The mall at Singapore's airport has a food court with 15 food outlets, all but one of which offering menus that cater to local tastes; the lone standout, McDonald's, is also the only one crowded with customers. In New York City, experts in *feng shui,* an ancient Chinese craft aimed at harmonizing the placement of man-made structures in nature, are sought after by real estate developers in order to attract a growing influx of Asian buyers who would not be interested in purchasing buildings unless their structures were properly harmonized.

Most people confronted with these examples would probably not be surprised by them. They might even view them as commonplace features of day-to-day life late in the twentieth century, instances in which local practices have spread to new and distant sites. In the first case the spread is from West to East and in the second it is from East to West, but both share

JAMES N. ROSENAU *is University Professor of International Affairs at George Washington University. His latest book is* Along the Domestic-Foreign Frontier: Exploring Governance in a Turbulent World *(Cambridge: Cambridge University Press, 1997). This article draws on the author's "New Dimensions of Security: The Interaction of Globalizing and Localizing Dynamics,"* Security Dialogue, *September 1994, and "The Dynamics of Globalization: Toward an Operational Formulation,"* Security Dialogue, *September 1996).*

a process in which practices spread and become established in profoundly different cultures. And what immediately comes to mind when contemplating this process? The answer can be summed up in one word: globalization, a label that is presently in vogue to account for peoples, activities, norms, ideas, goods, services, and currencies that are decreasingly confined to a particular geographic space and its local and established practices.

Indeed, some might contend that "globalization" is the latest buzzword to which observers resort when things seem different and they cannot otherwise readily account for them. That is why, it is reasoned, a great variety of activities are labeled as globalization, with the result that no widely accepted formulation of the concept has evolved. Different observers use it to describe different phenomena, and often there is little overlap among the various usages. Even worse, the elusiveness of the concept of globalization is seen as underlying the use of a variety of other, similar terms—world society, interdependence, centralizing tendencies, world system, globalism, universalism, internationalization, globality—that come into play when efforts are made to grasp why public affairs today seem significantly different from those of the past.

Such reasoning is misleading. The proliferation of diverse and loose definitions of globalization as well as the readiness to use a variety of seemingly comparable labels are not so much a reflection of evasive confusion as they are an early

Reprinted with permission from *Current History* magazine, November 1997, pp. 360–364. © 1997 by Current History, Inc.

stage in a profound ontological shift, a restless search for new ways of understanding unfamiliar phenomena. The lack of precise formulations may suggest the presence of buzzwords for the inexplicable, but a more convincing interpretation is that such words are voiced in so many different contexts because of a shared sense that the human condition is presently undergoing profound transformations in all of its aspects.

WHAT IS GLOBALIZATION?

Let us first make clear where globalization fits among the many buzzwords that indicate something new in world affairs that is moving important activities and concerns beyond the national seats of power that have long served as the foundations of economic, political, and social life. While all the buzzwords seem to cluster around the same dimension of the present human condition, useful distinctions can be drawn among them. Most notably, if it is presumed that the prime characteristic of this dimension is change—a transformation of practices and norms—then the term "globalization" seems appropriate to denote the "something" that is changing humankind's preoccupation with territoriality and the traditional arrangements of the state system. It is a term that directly implies change, and thus differentiates the phenomenon as a process rather than as a prevailing condition or a desirable end state.

Conceived as an underlying process, in other words, globalization is not the same as globalism, which points to aspirations for a state of affairs where values are shared by or pertinent to all the world's more than 5 billion people, their environment, and their role as citizens, consumers, or producers with an interest in collective action to solve common problems. And it can also be distinguished from universalism, which refers to those values that embrace all of humanity (such as the values that science or religion draws on), at any time or place. Nor is it coterminous with complex interdependence, which signifies structures that link people and communities in various parts of the world.

Although related to these other concepts, the idea of globalization developed here is narrower in scope. It refers neither to values nor to structures, but to sequences that unfold either in the mind or in behavior, to processes that evolve as people and organizations go about their daily tasks and seek to realize their particular goals. What distinguishes globalizing processes is that they are not hindered or prevented by territorial or jurisdictional barriers. As indicated by the two examples presented at the outset, such processes can readily spread in many directions across national boundaries, and are capable of reaching into any community anywhere in the world. They consist of all those forces that impel individuals, groups, and institutions to engage in similar forms of behavior or to participate in more encompassing and coherent processes, organizations, or systems.

Contrariwise, localization derives from all those pressures that lead individuals, groups, and institutions to narrow their horizons, participate in dissimilar forms of behavior, and withdraw to less encompassing processes, organizations, or systems. In other words, any technological, psychological, social,

economic, or political developments that foster the expansion of interests and practices beyond established boundaries are both sources and expressions of the processes of globalization, just as any developments in these realms that limit or reduce interests are both sources and expressions of localizing processes.

Note that the processes of globalization are conceived as only *capable* of being worldwide in scale. In fact, the activities of no group, government, society, or company have never been planetary in magnitude, and few cascading sequences actually encircle and encompass the entire globe. Televised events such as civil wars and famines in Africa or protests against governments in Eastern Europe may sustain a spread that is worldwide in scope, but such a scope is not viewed as a prerequisite of globalizing dynamics. As long as it has the potential of an unlimited spread that can readily transgress national jurisdictions, any interaction sequence is considered to reflect the operation of globalization.

Obviously, the differences between globalizing and localizing forces give rise to contrary conceptions of territoriality. Globalization is rendering boundaries and identity with the land less salient while localization, being driven by pressures to narrow and withdraw, is highlighting borders and intensifying the deep attachments to land that can dominate emotion and reasoning.

In short, globalization is boundary-broadening and localization is boundary-heightening. The former allows people, goods, information, norms, practices, and institutions to move about oblivious to despite boundaries. The boundary-heightening processes of localization are designed to inhibit or prevent the movement of people, goods, information, norms, practices, and institutions. Efforts along this line, however, can be only partially successful. Community and state boundaries can be heightened to a considerable extent, but they cannot be rendered impervious. Authoritarian governments try to make them so, but their policies are bound to be undermined in a shrinking world with increasingly interdependent economies and communications technologies that are not easily monitored. Thus it is hardly surprising that some of the world's most durable tensions flow from the fact that no geographic borders can be made so airtight to prevent the infiltration of ideas and goods. Stated more emphatically, some globalizing dynamics are bound, at least in the long run, to prevail.

The boundary-expanding dynamics of globalization have become highly salient precisely because recent decades have witnessed a mushrooming of the facilities, interests, and markets through which a potential for worldwide spread can be realized. Likewise, the boundary-contracting dynamics of localization have also become increasingly significant, not least because some people and cultures feel threatened by the incursions of globalization. Their jobs, their icons, their belief systems, and their communities seem at risk as the boundaries that have sealed them off from the outside world in the past no longer assure protection. And there is, of course, a basis of truth in these fears. Globalization does intrude; its processes do shift jobs elsewhere; its norms do undermine traditional mores. Responses to these threats can vary considerably. At

one extreme are adaptations that accept the boundary-broadening processes and make the best of them by integrating them into local customs and practices. At the other extreme are responses intended to ward off the globalizing processes by resort to ideological purities, closed borders, and economic isolation.

THE DYNAMICS OF FRAGMEGRATION

The core of world affairs today thus consists of tensions between the dynamics of globalization and localization. Moreover, the two sets of dynamics are causally linked, almost as if every increment of globalization gives rise to an increment of localization, and vice versa. To account for these tensions I have long used the term "fragmegration," an awkward and perhaps even grating label that has the virtue of capturing the pervasive interactions between the fragmenting forces of localization and the integrative forces of globalization.[1] One can readily observe the unfolding of fragmegrative dynamics in the struggle of the European Union to cope with proposals for monetary unification or in the electoral campaigns and successes of Jean-Marie Le Pen in France, Patrick Buchanan in the United States, and Pauline Hanson in Australia—to mention only three examples.

It is important to keep in mind that fragmegration is not a single dynamic. Both globalization and localization are clusters of forces that, as they interact in different ways and through different channels, contribute to more encompassing processes in the case of globalization and to less encompassing processes in the case of localization. These various dynamics, moreover, operate in all realms of human activity, from the cultural and social to the economic and political.

In the political realm, globalizing dynamics underlie any developments that facilitate the expansion of authority, policies, and interests beyond existing socially constructed territorial boundaries, whereas the politics of localization involves any trends in which the scope of authority and policies undergoes contraction and reverts to concerns, issues, groups, and institutions that are less extensive than the prevailing socially constructed territorial boundaries. In the economic realm, globalization encompasses the expansion of production, trade, and investments beyond their prior locales, while localizing dynamics are at work when the activities of producers and consumers are constricted to narrower boundaries. In the social and cultural realms, globalization operates to extend ideas, norms, and practices beyond the settings in which they originated, while localization highlights or compresses the original settings and thereby inhibits the inroad of new ideas, norms, and practices.

It must be stressed that the dynamics unfolding in all these realms are long-term processes. They involve fundamental human needs and thus span all of human history. Globalizing dynamics derive from peoples' need to enlarge the scope of their self-created orders so as to increase the goods, services,

[1] For an extensive discussion of the dynamics of fragmegration, see James N. Rosenau, *Along the Domestic-Foreign Frontier: Exploring Governance in a Turbulent World* (Cambridge: Cambridge University Press, 1997), ch. 6.

There is no inherent contradiction between localizing and globalizing tendencies.

and ideas available for their well-being. The agricultural revolution, followed by the industrial and postindustrial transformations, are among the major sources that have sustained globalization. Yet even as these forces have been operating, so have contrary tendencies toward contraction been continuously at work. Localizing dynamics derive from people's need for the psychic comforts of close-at-hand, reliable support—for the family and neighborhood, for local cultural practices, for a sense of "us" that is distinguished from "them." Put differently, globalizing dynamics have long fostered large-scale order, whereas localizing dynamics have long created pressure for small-scale order. Fragmegration, in short, has always been an integral part of the human condition.

GLOBALIZATION'S EVENTUAL PREDOMINANCE

Notwithstanding the complexities inherent in the emergent structures of world affairs, observers have not hesitated to anticipate what lies beyond fragmegration as global history unfolds. All agree that while the contest between globalizing and localizing dynamics is bound to be marked by fluctuating surges in both directions, the underlying tendency is for the former to prevail over the latter. Eventually, that is, the dynamics of globalization are expected to serve as the bases around which the course of events is organized.

Consensus along these lines breaks down, however, over whether the predominance of globalization is likely to have desirable or noxious consequences. Those who welcome globalizing processes stress the power of economic variables. In this view the globalization of national economies through the diffusion of technology and consumer products, the rapid transfer of financial resources, and the efforts of transnational companies to extend their market shares is seen as so forceful and durable as to withstand and eventually surmount any and all pressures toward fragmentation. This line acknowledges that the diffusion that sustains the processes of globalization is a centuries-old dynamic, but the difference is that the present era has achieved a level of economic development in which it is possible for innovations occurring in any sector of any country's economy to be instantaneously transferred to and adapted in any other country or sector. As a consequence,

when this process of diffusion collides with cultural or political protectionism, it is culture and protectionism that wind up in the shop for repairs. Innovation accelerates. Productivity increases. Standards of living improve. There are setbacks, of course. The newspaper headlines are full of them. But we believe that the time required to override these setbacks has shortened dramatically in the developed world. Indeed, recent

experience suggests that, in most cases, economic factors prevail in less than a generation. . . .

Thus understood, globalization—the spread of economic innovations around the world and the political and cultural adjustments that accompany this diffusion—cannot be stopped. . . . As history teaches, the political organizations and ideologies that yield superior economic performance survive, flourish, and replace those that are less productive.[2]

While it is surely the case that robust economic incentives sustain and quicken the processes of globalization, this line of theorizing nevertheless suffers from not allowing for its own negation. The theory offers no alternative interpretations as to how the interaction of economic, political, and social dynamics will play out. One cannot demonstrate the falsity—if falsity it is—of the theory because any contrary evidence is seen merely as "setbacks," as expectable but temporary deviations from the predicted course. The day may come, of course, when event so perfectly conform to the predicted patterns of globalization that one is inclined to conclude that the theory has been affirmed. But in the absence of alternative scenarios, the theory offers little guidance as to how to interpret intervening events, especially those that highlight the tendencies toward fragmentation. Viewed in this way, it is less a theory and more an article of faith to which one can cling.

Other observers are much less sanguine about the future development of fragmegration. They highlight a litany of noxious consequences that they see as following from the eventual predominance of globalization: "its economism; its economic reductionism; its technological determinism; its political cynicism, defeatism, and immobilism; its de-socialization of the subject and resocialization of risk; its teleological subtext of inexorable global 'logic' driven exclusively by capital accumulation and the market; and its ritual exclusion of factors, causes, or goals other than capital accumulation and the market from the priority of values to be pursued by social action."[3]

Still another approach, allowing for either desirable or noxious outcomes, has been developed by Michael Zurn. He identifies a mismatch between the rapid extension of boundary-crossing activities and the scope of effective governance. Consequently, states are undergoing what is labeled "uneven denationalization," a primary process in which "the rise of international governance is still remarkable, but not accompanied by mechanisms for . . . democratic control; people, in addition, become alienated from the remote political process. . . . The democratic state in the Western world is confronted with a situation in which it is undermined by the process of globalization and overarched by the rise of international institutions."[4]

While readily acknowledging the difficulties of anticipating where the process of uneven denationalization is driving the world, Zurn is able to derive two scenarios that may unfold:

"Whereas the pessimistic scenario points to instances of fragmentation and emphasizes the disruption caused by the transition, the optimistic scenario predicts, at least in the long run, the triumph of centralization." The latter scenario rests on the presumption that the increased interdependence of societies will propel them to develop ever more effective democratic controls over the very complex arrangements on which international institutions must be founded.

UNEVEN FRAGMEGRATION

My own approach to theorizing about the fragmegrative process builds on these other perspectives and a key presumption of my own—that there is no inherent contradiction between localizing and globalizing tendencies—to develop an overall hypothesis that anticipates fragmegrative outcomes and that allows for its own negation: *the more pervasive globalizing tendencies become, the less resistant localizing reactions will be to further globalization.* In other words, globalization and localization will coexist, but the former will continue to set the context for the latter. Since the degree of coexistence will vary from situation to situation (depending on the salience of the global economy and the extent to which ethnic and other noneconomic factors actively contribute to localization), I refer, borrowing from Zurn, to the processes depicted by the hypothesis as *uneven fragmegration*. The hypothesis allows for continuing pockets of antagonism between globalizing and localizing tendencies even as increasingly (but unevenly) the two accommodate each other. It does not deny the pessimistic scenario wherein fragmentation disrupts globalizing tendencies; rather it treats fragmentation as more and more confined to particular situations that may eventually be led by the opportunities and requirements of greater interdependence to conform to globalization.

For globalizing and localizing tendencies to accommodate each other, individuals have to come to appreciate that they can achieve psychic comfort in collectivities through multiple memberships and multiple loyalties, that they can advance both local and global values without either detracting from the other. The hypothesis of uneven fragmegration anticipates a growing appreciation along these lines because the contrary premise, that psychic comfort can only be realized by having a highest loyalty, is becoming increasingly antiquated. To be sure, people have long been accustomed to presuming that, in order to derive the psychic comfort they need through collective identities, they had to have a hierarchy of loyalties and that, consequently, they had to have a highest loyalty that could only be attached to a single collectivity. Such reasoning, however, is a legacy of the state system, of centuries of crises that made people feel they had to place nation-state loyalties above all others. It is a logic that long served to reinforce the predominance of the state as the "natural" unit of political organization and that probably reached new heights during the intense years of the cold war.

But if it is the case, as the foregoing analysis stresses, that conceptions of territoriality are in flux and that the failure of states to solve pressing problems has led to a decline in their

[2] William W. Lewis and Marvin Harris, "Why Globalization Must Prevail," *The McKinsey Quarterly*, no. 2 (1992), p. 115.
[3] Barry K. Gills, "Editorial: 'Globalization' and the 'Politics of Resistance,'" *New Political Economy*, vol. 2 (March 1997), p. 12.
[4] Michael Zurn, "What Has Changed in Europe? The Challenge of Globalization and Individualization," paper presented at a meeting on What Has Changed? Competing Perspectives on World Order (Copenhagen, May 14–16, 1993), p. 40.

capabilities and a loss of legitimacy, it follows that the notion that people must have a "highest loyalty" will also decline and give way to the development of multiple loyalties and an understanding that local, national, and transnational affiliations need not be mutually exclusive. For the reality is that human affairs are organized at all these levels for good reasons; people have needs that can only be filled by close-at-hand organizations and other needs that are best served by distant entities at the national or transnational level.

In addition, not only is an appreciation of the reality that allows for multiple loyalties and memberships likely to grow as the effectiveness of states and the salience of national loyalties diminish, but it also seems likely to widen as the benefits of the global economy expand and people become increasingly aware of the extent to which their well-being is dependent on events and trends elsewhere in the world. At the same time, the distant economic processes serving their needs are impersonal and hardly capable of advancing the need to share with others in a collective affiliation. This need was long served by the nation-state, but with fragmegrative dynamics having un-

dermined the national level as a source of psychic comfort and with transnational entities seeming too distant to provide the psychic benefits of affiliation, the satisfactions to be gained through more close-at-hand affiliations are likely to seem ever more attractive.

THE STAKES

It seems clear that fragmegration has become an enduring feature of global life; it is also evident that globalization is not merely a buzzword, that it encompasses pervasive complexities and contradictions that have the potential both to enlarge and to degrade our humanity. In order to ensure that the enlargement is more prevalent than the degradation, it is important that people and their institutions become accustomed to the multiple dimensions and nuances as our world undergoes profound and enduring transformations. To deny the complexities and contradictions in order to cling to a singular conception of what globalization involves is to risk the many dangers that accompany oversimplification.

"Development was—and continues to be for the most part—a top-down, ethnocentric, and technocratic approach that treats people and cultures as abstract concepts, statistical figures to be moved up and down in the charts of 'progress.' . . . It comes as no surprise that development became a force so destructive to third world cultures, ironically in the name of people's interests."

The Invention of Development

ARTURO ESCOBAR

One of the many changes that occurred in the early post-World War II period was the "discovery" of mass poverty in Asia, Africa, and Latin America. Relatively inconspicuous and seemingly logical, this discovery was to provide the anchor for an important restructuring of global culture and political economy. The discourse of war was displaced onto the social domain and to a new geographic terrain: the third world. Left behind was the struggle against fascism as the "war on poverty" in the third world began to occupy a prominent place. Eloquent facts were adduced to justify this new war: "Over [1.5 billion] people, something like two-thirds of the world population," Harold Wilson noted in *The War on World Poverty,* "are living in conditions of acute hunger, defined in terms of identifiable nutritional disease. This hunger is at the same time the cause and effect of poverty, squalor, and misery in which they live."

Statements like Wilson's were uttered throughout the late 1940s and 1950s. The new emphasis was spurred by the recognition of the chronic conditions of poverty and social unrest existing in poor countries and the threat they posed for more-developed countries. This led to the realization that something had to be done before the overall levels of instability in the world became intolerable. The destinies of the rich and poor parts of the world were seen to be closely linked. "Genuine world prosperity is indivisible," stated a panel of academic experts in 1948. "It cannot last in one part of the world if the other parts live under conditions of poverty and ill health."

If within market societies the poor were defined as lacking what the rich had in terms of money and material possessions, poor countries came to be similarly defined in relation to the

ARTURO ESCOBAR *is a professor of anthropology at the University of Massachusetts, Amherst. He is the author of* Encountering Development: The Making and Unmaking of the Third World *(Princeton, N.J.: Princeton University Press, 1995), from which this article is excerpted with permission.*

standards of wealth of the more economically advantaged nations. This economic conception of poverty found an ideal yardstick in one statistic: annual per capita income. Almost by fiat, nearly 70 percent of the world's peoples were transformed into poor subjects in 1948 when the World Bank defined as poor those countries with an annual per capita income below $100. And if the problem was one of insufficient income, the solution was clearly economic growth.

Thus poverty became an organizing concept and the object of a new problematization. That the essential trait of the third world was its poverty and that the solution was economic growth and development became self-evident, necessary, and universal truths.

Rich countries were believed to have the financial and technological capacity to secure progress the world over. A look at their own past instilled in them the firm conviction that this was not only possible—let alone desirable—but perhaps even inevitable. Sooner or later, the poor countries would become rich, and the underdeveloped world would be developed. A new type of economic knowledge and an enriched experience with the design and management of social systems made this goal look even more plausible. Now it was a matter of creating an appropriate strategy to do it, of setting in motion the right forces to ensure progress and world happiness.

Behind the humanitarian concern and the positive outlook of the new strategy, new forms of power and control, more subtle and refined, were put in operation. Poor people's ability to define and take care of their own lives was eroded in a deeper manner than perhaps ever before. The poor became the target of more sophisticated practices, of a variety of programs that seemed inescapable. From the new institutions of power in the United States and Europe; from the offices of the International Bank for Reconstruction and Development and the United Nations; from North American and European campuses, research centers, and foundations; and from the new planning offices in the major capitals of the underdeveloped world—this was the type of development that was actively

promoted and that in a few years was to extend its reach to all aspects of society. Let us now see how this set of historical factors resulted in the new discourse of development.

DEVELOPMENT DISCOURSE

What does it mean to say that development functioned as a discourse—that it created a space in which only certain things could be said and even imagined? We can begin to answer that question by examining the basic premises of development as they were formulated in the 1940s and 1950s. Fundamental was the belief in modernization as the only force capable of destroying archaic superstitions and relations. Industrialization and urbanization were seen as the inevitable and necessarily progressive routes to modernization. Only through material advancement could social, cultural, and political progress be achieved. This view led to the belief that capital investment was the most important ingredient in economic growth and development. The advance of poor countries was thus seen from the outset as depending on ample supplies of capital to provide for infrastructure, industralization, and the overall modernization of society. From where was this capital to come? One possible answer was domestic savings. But because these countries were seen as trapped in a "vicious circle" of poverty and lack of capital, much of that capital would have to come from abroad. Moreover, it was absolutely necessary that governments and international organizations take an active role in promoting and orchestrating the efforts to overcome general backwardness and economic underdevelopment.

What, then, were the most important elements that went into the formulation of development theory? There was the process of capital formation, and the various factors associated with it: technology, population and resources, monetary and fiscal policies, industrialization and agricultural development, commerce and trade. There were also a series of factors linked to cultural considerations, such as education and the need to foster modern cultural values. Finally, there was the need to create adequate institutions for carrying out the complex task ahead: international organizations (such as the World Bank and the IMF, created in 1944, and most of the UN technical agencies, also a product of the mid-1940s); national planning agencies (which proliferated in Latin America, especially after the inauguration of the Alliance for Progress in the early 1960s); and technical agencies of various kinds.

Yet development was not merely the result of the combination, study, or gradual elaboration of these elements (some of these topics had existed for some time); nor the product of the introduction of new ideas (some of which were already appearing or perhaps were bound to appear); nor the effect of the new international organizations or financial institutions (which had some predecessors, such as the League of Nations). It was rather the result of the establishment of a set of relations among these elements, institutions, and practices and the systematization of these relations to form a whole.

To understand development as a discourse, one must look at this system of relations, relations that define the conditions under which objects, concepts, theories, and strategies can be incorporated into the discourse. The system of relations establishes a discursive practice that sets the rules of the game: who can speak, from what points of view, with what authority, and according to what criteria of expertise; it determines the rules that must be followed for this or that problem, theory, or object to emerge and be named, analyzed, and eventually transformed into a policy or a plan.

DISSECTING THE THIRD WORLD

The concerns development began to deal with were numerous and varied. Some of them, such as poverty, insufficient technology and capital, rapid population growth, inadequate public services, archaic agricultural practices, stood out clearly, whereas others were introduced with more caution or even in surreptitious ways (cultural attitudes and values and the existence of racial, religious, geographic, or ethnic factors believed to be associated with backwardness).

Everything was subjected to the eye of the new experts: the poor dwellings of the rural masses, the vast agricultural fields, cities, households, factories, hospitals, schools, public offices, towns and regions, and, in the last instance, the world as a whole. The vast surface over which the discourse moved at ease practically covered the entire cultural, economic, and political geography of the third world.

Not all the actors distributed throughout this surface could identify objects to be studied and have their problems considered. Clear principles of authority were in operation. They concerned the role of experts, from whom certain criteria of knowledge and competence were asked; institutions such as the UN, which had the moral, professional, and legal authority to name subjects and define strategies; and the international lending organizations, which carried the symbols of capital and power. These principles of authority also concerned the governments of poor countries, which commanded the legal political authority over the lives of their subjects, and the position of leadership of the rich countries, who had the power, knowledge, and experience to decide on what was to be done.

Economists, demographers, educators, and experts in agriculture, public health, and nutrition elaborated their theories, made their assessments and observations, and designed their programs from these institutional sites. Problems were continually identified, and client categories brought into existence. Development proceeded by creating "abnormalities" (such as the "illiterate," the "undeveloped," the "malnourished," "small farmers," or "landless peasants"), which it would later treat and reform. New problems were progressively and selectively incorporated; once a problem was incorporated into the discourse, it had be to be categorized and further specified. Some problems were specified at a given level (such as local or regional), or at a variety of these levels (for instance, a nutritional deficiency identified at the level of the household could be further specified as a regional production shortage or as affecting a given population group), or in relation to a particular institution. But these refined specifications did not seek so much to illuminate possible solutions as to give "problems" a visible reality amenable to particular treatments. Approaches

that could have had positive effects in terms of easing material constraints became, linked to this type of rationality, instruments of power and control.

Other historical discourses also clearly influenced particular representations of development. The discourse of communism, for instance, influenced the promotion of those choices that emphasized the role of the individual in society and, especially, those approaches that relied on private initiative and private property. The emphasis on this issue in the context of development, and so strong a moralizing attitude, probably would not have existed without the persistent anticommunist preaching that originated in the cold war.

In a similar vein, patriarchy and ethnocentrism influenced the form development took. Indigenous populations had to be "modernized," where modernization meant the adoption of the "right" values, namely those held by the white minority or a mestizo majority and, in general, those embodied in the ideal of the cultivated European (programs for industrialization and agricultural development, however, not only have made women invisible in their role as producers, but also have tended to perpetuate their subordination). Forms of power in terms of class, gender, race, and nationality thus found their way into development theory and practice.

By 1955, a discourse had emerged that was characterized not by a unified object but by the formation of a vast number of objects and strategies; not by new knowledge but by the systematic inclusion of new objects under its domain. The most important exclusion, however, was and continues to be what development was supposed to be about: people. Development was—and continues to be for the most part—a top-down, ethnocentric, and technocratic approach that treats people and cultures as abstract concepts, statistical figures to be moved up and down in the charts of "progress." Development was conceived not as a cultural process (culture was a residual variable, to disappear with the advance of modernization) but instead as a system of more or less universally applicable technical interventions intended to deliver some "badly needed" goods to a "target" population. It comes as no surprise that development became a force so destructive to third world cultures, ironically in the name of people's interests.

CALLING IN THE PROFESSIONALS

Development thus was a response to the problematization of poverty that took place in the years following World War II, not a natural process of knowledge that gradually uncovered problems and dealt with them; as such, it must be seen as a historical construct that provides a space in which poor countries are known, specified, and intervened upon. To speak of development as a historical construct requires an analysis of the mechanisms through which it becomes an active, real force. These mechanisms are structured by forms of knowledge and power and can be studied in terms of processes of institutionalization and professionalization.

The concept of professionalization refers here mainly to the process that brings the third world into the politics of expert knowledge and Western science in general. This is accomplished through a set of techniques, strategies, and disciplinary practices that organize the generation, validation, and diffusion of development knowledge, including the academic disciplines, methods of research and teaching, criteria of experts, and manifold professional practices: in other words, those mechanisms through which a politics of truth is created and maintained, through which certain forms of knowledge are given the status of truth. This professionalization was effected through the proliferation of development sciences and subdisciplines. It made possible the progressive incorporation of problems into the space of development, bringing them to light in ways congruent with the established system of knowledge and power.

The professionalization of development also made it possible to remove all problems from the political and cultural realms and to recast them in terms of the apparently more neutral realm of science. It resulted in the establishment of development studies programs in most major universities in the developed world and conditioned the creation or restructuring of third world universities to suit the needs of development. The empirical social sciences, on the rise since the late 1940s, especially in the United States and Britain, were instrumental in this regard. So were the area studies programs, which became fashionable after the war in academic and policymaking circles.

An unprecedented will to know everything about the third world flourished unhindered, growing like a virus. Like the landing of the Allied forces in Normandy, the third world witnessed a massive landing of experts, each in charge of investigating, measuring, and theorizing about, as was noted earlier, this or that little aspect of third world societies. The policies and programs that originated from this vast field of knowledge inevitably carried with them strong moralizing components. At stake was a politics of knowledge that allowed experts to classify problems and formulate policies, to pass judgments on entire social groups and forecast their future—to produce, in short, a regime of truth and norms about them.

Overlapping the processes of professionalization was the creation of an institutional field from which discourses are produced, recorded, stablized, modified, and put into circulation. The institutionalization of development took place at all levels, from the international organizations and national planning agencies in the third world to local development agencies, community development committees, private voluntary agencies, and nongovernmental organizations. Starting in the mid-1940s, with the creation of the great international organizations, this process has continued to spread, resulting in the consolidation of an effective network of power. It is through the action of this network that people and communities are bound to specific cycles of cultural and economic production and through which certain behaviors and rationalities are promoted. This field of intervention relies on myriad local centers of power, in turn supported by forms of knowledge that circulate at the local level.

The knowledge produced about the third world is used and promoted by these institutions through applied programs, conferences, international consultant services, and local extension

practices. A corollary of this process is the establishment of an ever-expanding development business. Poverty, illiteracy, and even hunger became the basis of a lucrative industry for planners, experts, and civil servants. This is not to deny that the work of these institutions might have benefited people at times. It is to emphasize that the work of development institutions has not been a innocent effort on behalf of the poor. Rather, development has been successful to the extent that it has been able to integrate, manage, and control countries and populations in increasingly detailed and encompassing ways. If it has failed to solve the basic problems of underdevelopment, it can be said—perhaps with greater pertinence—that it has succeeded in creating a type of underdevelopment that has been, for the most part, politically and technically manageable.

THE PERSISTENCE OF "UNDERDEVELOPMENT"

The crucial threshold and transformation that took place in the early postwar era were the result not of a radical epistemological or political breakthrough, but of the reorganization of factors that allowed the third world to display a new visibility and to erupt into a new realm of language. This new space was carved out of the vast and dense surface of the third world, placing it in a field of power. Underdevelopment became the subject of political technologies that sought to erase it from the face of the earth but that ended up, instead, multiplying it to infinity.

Development fostered a way of conceiving of social life as a technical problem, as a matter of rational decision and management to be entrusted to that group of people—the development professionals—whose specialized knowledge allegedly qualified them for the task. Instead of seeing change as a process rooted in the interpretation of each society's history and cultural tradition—as a number of intellectuals in various parts of the third world had attempted to do in the 1920s and 1930s (Gandhi being the best known of them)—these professionals sought to devise mechanisms and procedures to make societies fit a preexisting model that embodied the structures and functions of modernity. Like sorcerers' apprentices, the development professionals awakened once again the dream of reason that, in their hands, as in earlier instances, produced a troubling reality.

At times, development grew to be so important for third world countries that it became acceptable for those rulers to subject their populations to an infinite variety of interventions, to more encompassing forms of power and systems of control; so important that first and third world elites accepted the price of massive impoverishment, of selling third world resources to the most convenient bidders, of degrading their physical and human ecologies, of killing and torturing, of condemning their indigenous population to near extinction; so important that many in the third world began to think of themselves as inferior, underdeveloped, and ignorant and to doubt the value of their own culture, deciding instead to pledge allegiance to the banners of reason and progress; so important, finally, that the achievement of development clouded the awareness of the impossibility of fulfilling the promise that development seemed to be making.

After four decades of this discourse, most forms of understanding and representing the third world are still dictated by the same basic tenets. The forms of power that have appeared act not so much by repression but by normalization; not by ignorance but by controlled knowledge; not by humanitarian concern but by the bureaucratization of social action. As the conditions that gave rise to development became more pressing, it could only increase its hold, refine its methods, and extend its reach. That the materiality of these conditions is not conjured up by an "objective" body of knowledge but is charted out by the rational discourses of economists, politicians, and development experts of all types should already be clear. What has been achieved is a specific configuration of factors and forces in which the new language of development finds support. As a discourse, development is thus a very real historical formation, albeit articulated around an artificial construct (underdevelopment) and upon a certain materiality (the conditions baptized as underdevelopment), which must be conceptualized in different ways if the power of the development discourse is to be challenged or displaced.

To be sure, there is a situation of economic exploitation that must be recognized and dealt with. Power is too cynical at the level of exploitation and should be resisted on its own terms. There is also a certain materiality of life conditions that is extremely preoccupying and that requires great effort and attention. But those seeking to understand the third world through development have long lost sight of this materiality by building upon it a reality that has haunted us for decades. Understanding the history of the investment of the third world through Western forms of knowledge and power is a way to shift the ground somewhat so that we can start to view that materiality with different eyes and in different categories.

The coherence of effects that the development discourse achieved is the key to its success as a hegemonic form of representation: the construction of the poor and underdeveloped as universal, preconstituted subjects, based on the privilege of the representers; the exercise of power over the third world made possible by this discursive homogenization (which entails the erasure of the complexity and diversity of third world peoples, so that a squatter in Mexico City, a Nepalese peasant, and a Tuareg nomad become equivalent to each other as poor and underdeveloped); and the colonization and domination of the natural and human ecologies and economies of the third world.

Development assures a teleology to the extent that it proposes that the "natives" will sooner or later be reformed. At the same time, however, it reproduces endlessly the separation between reformers and those to be reformed by keeping alive the premise of the third world as different and inferior, as having a limited humanity in relation to the accomplished Europeans. Development relies on this perpetual recognition and disavowal of difference, a feature inherent to discrimination. The signifiers of "poverty," "illiteracy," "hunger," and so forth have already achieved a fixity as signifieds of "underdevelopment" that seems impossible to sunder.

The Crisis of Globalization

James K. Galbraith

THE DOCTRINE known as the Washington Consensus was the Apostle's Creed of globalization. It was an expression of faith that markets are efficient, that states are unnecessary, that the poor and the rich have no conflicting interests, that things turn out for the best when left alone. It held that privatization and deregulation and open capital markets promote economic development, that governments should balance budgets and fight inflation and do almost nothing else.

This faith has now proved totally unfounded.

The truth is that people need to eat every day. Policies that guarantee that they can do so, and with steadily improving diets and housing and health and other material conditions of life over long time spans, are good policies. Policies that foster instability directly or indirectly, that prevent poor people from eating in the name of efficiency or liberalism or even in the name of freedom, are not good policies. And it is possible to distinguish policies that meet this minimum standard from policies that do not.

The push for competition, deregulation, privatization, and open capital markets has undermined economic prospects for many millions of the world's poorest people. It is therefore not merely a naive and misguided crusade. To the extent that it undermines the stable provision of daily bread, it is dangerous to the safety and stability of the world, including ourselves. The greatest single danger right now is in Russia, a catastrophic example of the failure of free market doctrine. But serious dangers have also emerged in Asia and Latin America and they are not going to go away soon.

There is, in short, a crisis of the Washington Consensus.

The crisis of the Washington Consensus is visible to everybody. But not everybody is willing to admit it. Indeed, as bad policies produced policy failures, those committed to the policies developed a defense mechanism. They saw every unwelcome case as an unfortunate exception. Mexico was an exception—there was a revolt in Chiapas, an assassination in Tijuana. Then Korea, Thailand, Indonesia became exceptions: corruption, crony capitalism on an unimaginably massive scale, was discovered, but *after* the crisis hit. And then there came the Russian exception. In Russia, we are told, Dostoyevskian criminality welled up from the corpse of Soviet communism to overcome the efficiencies and incentives of free markets.

But when the exceptions outnumber the examples, there must be trouble with the rules. Where are the success stories of liberalization, privatization, deregulation, sound money, and balanced budgets? Where are the emerging markets that have emerged, the developing countries that have developed, the transition economies that have truly completed a successful and happy transition? Look closely. Look hard. They do not exist.

In each of the supposed exceptions—Russia, Korea, Mexico, and also Brazil—state-directed development programs have been liberalized, privatized, deregulated. But then, capital inflows led to currency overvaluation, making imports cheap but exports uncompetitive. As early promises of "transformation" proved unrealistic, the investor mood soured. A flight to quality began, usually following moves to raise interest rates in the "quality" countries—notably the United States in 1994 and in early 1997. A very small move in U.S. interest rates in March 1997 precipitated the outflows of capital from Asia that led to the Thai crisis.

The Russian case is especially sad and dramatic. In 1917 the Bolshevik revolution promised a war-weary Russian people liberation and deliverance from oppression. It took them seventy years to forget the essential lesson of

Originally appeared in *Dissent* magazine, Summer 1999, pp. 12-16. © 1999 by Dissent. Reprinted by permission.

that experience, which is that there are no easy, sudden, miraculous transitions. In 1992, the advocates of shock therapy followed the Bolshevik path, against the good sense of much of the Russian political order, by Bolshevik means. This was the true meaning of Boris Yeltsin's 1993 military assault on the Russian Parliament, an act of violence that we in the West tolerated, to our shame, in the name of "economic reform."

Privatization and deregulation in Russia did not create efficient and competitive markets, but instead large and pernicious private monopolists, the oligarchs, and the mafiosi, with control over competing industrial empires and the news media. And these empires sponsored their own banks, which were not banks at all but rather simply speculative pools, serving none of the essential functions of commercial banks. Meanwhile, the state followed a rigid policy of limiting expenditures, so that even wages and pension obligations duly incurred were not paid—as if the United States government were to refuse to pay Social Security checks because of a budget deficit! The private sector literally ran out of money. The payments system ceased to function; tax collection became impossible because there was nothing to tax. The state financed itself through a pyramid scheme of short-term debts—the GKO market—which collapsed as pyramids must on August 17, 1998. This was the end of free-market radicalism in Russia—and still, the Washington Consensus holds that Russia must "stay the course" on "economic reform."

Throughout Asia in the 1990s, stable industrial growth gave way to go-go expansions based heavily on real-estate speculation and commercial office development. Many more office towers went up, in Bangkok, Djakarta, Hong Kong and Kuala Lumpur, than could reasonably be put to use, Once finished, these towers do not go away; they stay empty but available, and so remain a drug on the market, inhibiting new construction. Recovery from the crash of such bubbles is a slow process. It took five years or longer in the Texas of the mid-1980s.

As for Brazil, through the early fall of 1998 it was said that the International Monetary Fund (IMP) would restore confidence and keep the Brazilian *real* afloat. But the *real* has since been devalued and Brazil is heading for a deep recession. The problem here does not originate with Brazil, and cannot be resolved by any actions the Brazilians alone might take.

It lies, rather, in the international capital markets. Investors with exposure in Asia, and with losses in Russia, must reduce their lending to other large borrowers, irrespective of conditions in those countries. It is this imperative that is Brazil's problem today.

ARE THERE alternatives? Yes. The grim history I've just outlined is not uniform. Over the past half-century, successful and prolonged periods of strong global development have always occurred in countries with strong governments, mixed economic structures and weakly developed capital markets. This was the case of Europe and Japan following World War II, of Korea and Taiwan in the eighties and nineties, of China after 1979. These cases, and not the free market liberal examples—such as, say, Argentina after the mid-1970s or Mexico after 1986 or the Philippines or Bolivia—are the success stories of global economic development in our time.

In Korea, for instance, the great period of economic development was, indeed, a time of repressive crony capitalism. After 1975, the Korean government took note of the fate of South Vietnam, drew its own conclusions about the depth of American commitment and embarked on a program of heavy and chemical industrialization that emphasized dual-use technologies: the first major product of Hyundai Heavy Industries, for example, was a knock-off of the M-60 tank.

The Korean industrialization policy was not, in any static sense, efficient. No market would have chosen this course of action. The major players in the Korean economy—the state, the banks, the conglomerates known as *chaebols*—were yoked together in pursuit of their goals. Workers and their wage demands were repressed. And the initial search for markets was by no means entirely successful. There wasn't a big demand for those tanks, and so Hyundai decided to try building passenger cars instead.

Yet, when one adds up the balance sheet of the Korean model, can anyone seriously argue that the country would be richer today if it had done nothing in 1975? That it would be more middle class or more democratic?

It is true that Korea experienced the first harsh blows of the Asian financial crisis. But why? By 1997, the industrial policy was a thing of the distant past. Korean banks had become deregulated in 1992. What they did

was to diversify—supporting vast expansion and industrial diversification schemes of the *chaebol* (Samsung's adventure into motor cars, for example) and lending to such places as Indonesia, where the Koreans evidently bought paper recommended to them by their American counterparts. The crash of Indonesia spread to Korea by these financial channels. It was not a crisis of crony capitalism, but of crony banking—deregulated and globalized.

One can multiply cases, but let us look at just one other, that of China.

China is a country with a fifty-year tradition of one-party government. For thirty of those years, it was a case study in regimentation, ideology, and economic failure. At one point, there occurred an entirely avoidable, catastrophic famine during which twenty or thirty million people perished. In the first years of the Great Proletarian Cultural Revolution, village rations amounted to less than a pound of rice per day.

Beginning in 1979, however, China embarked on reforms that changed the face of the country. These began with the most massive agricultural reform in human history, reforms that effectively ended food poverty in China in five years. After that, policies that welcomed long-term direct investment, that fostered township and village enterprises, joint ventures, and private enterprises, put into place a vast and continuing improvement in human living standards. Over twenty years, average living standards quadrupled; indeed growth has been so rapid that many people can perceive the improvement in their standard of living from month to month.

China's case demonstrates the potential effectiveness of sustained development policies—of policies that emphasize the priority of steady improvement over long periods of time. Unlike Russia, China made the mistake of the Great Leap Forward only once. And it never liberalized its capital markets or its capital account, for fear that such actions would prove a fatal lure, unleashing a cycle of boom and bust that a poor nation cannot tolerate for long.

China is no democracy. It is not politically free. But one must also acknowledge that the Chinese government has delivered on the essential economic demands of the Chinese people, namely food and housing, and that an alternative regime that did not deliver on these needs would not have been able to deliver internal peace, democracy, or human rights either.

So, what can the United States do now? To begin with, we can recognize that globalized finance makes the Federal Reserve the central banker to much of the developing world. Interest rate cuts last fall had an important stabilizing effect on global markets. But this effect is temporary; and the Fed's powers are limited. After a cut, another one is eventually required; and the cut from one to one-half percent lacks the force of the reduction from six percent to four. There is a strong case for lower interest rates, but we must also remember that the long term arrives when such short-term policies run out of steam.

Then there is fiscal policy. If it is a good idea for Japan to run a deficit to fight the global recession, why is it wise for the United States to be running a surplus that vastly offsets the deficit in Japan? It isn't. The United States should expand its own economy using all the tools available for this purpose.

Then there is the matter of what we preach to the world and the policies we support. If it is a good idea for the government of the United States to grow in line with our economy, then it is also a good idea for the governments of other countries to grow as their economies do. Global development policy should be geared toward strengthening that capacity, not crippling it.

Every functional private economy has, and needs, a core of state, regional, and municipal enterprises and distribution channels to assure food and basic necessities to low-income populations. Such systems stabilize the market institutions, which work better for people with higher incomes. They help prevent criminal monopolization of critical distribution networks by setting up an accountable alternative. International assistance should seek to strengthen these public networks where they exist and to build them where they do not. Efforts to do just this in Russia today, under the present government, should be supported and not opposed.

There is an obvious conflict between pro-growth policies and "investor confidence." Investors like to be repaid in the short run. But given that conflict, it is a fool's bargain to place investor confidence above the pursuit of development. Strong national governments have a sovereign right to regulate capital flows and banks operating on their soil—as much right as any nation has to control the flow of people across its national frontiers and to regulate their activities at home. A Tobin

Tax on foreign exchange should be enacted here, not only to slow speculation in the United States, but also to signal our acceptance of this principle for other countries, for whom different mechanisms of capital control may be more suitable in different cases.

Beyond this, a major reconstruction of world financial practices, aimed at restoring stability and strengthening the regulatory and planning capacities of national governments, is in order. The IMF needs new leadership, not tied to recent dogmas. But the IMF is also too small, and too thinly spread, to be useful in helping countries with the design and implementation of effective national development schemes. Regional financial institutions, as suggested for Asia by Japanese Deputy Finance Minister Eisuke Sakakibara, are therefore also needed, and U.S. opposition to them should be dropped.

MOST OF ALL, we must give up illusions. The neoliberal experiment is a failure. And it is a failure not because of unforeseeable events, but because it was and is systematically and fundamentally flawed. We need many changes from this naive and doomed vision of an ungoverned world order. We need large changes, and the need is great while time, I believe, is short. We must bring the Reagan era to a final end. We must return to development policies for the people whose needs matter most in the large scheme of things, namely the millions of hard-working people in poor countries who need to eat every day.

JAMES K. GALBRAITH is the author of *Created Unequal: The Crisis in American Pay*. He is working on a new book on global inequality.

"China is not scrambling to dismantle socialism; it is scrambling to regulate a market system that it has—for better or worse, intentionally or inadvertently—adopted thoroughly."

Beyond the Transition: China's Economy at Century's End

EDWARD S. STEINFELD

In the early months of 1999, the negotiations over China's entry into the World Trade Organization were dramatically transformed. For 13 years Chinese negotiators had steadfastly attempted to gain China's admittance to the WTO on terms that would have permitted China to protect its vast state-owned industrial sector and seal off its most lucrative markets from foreign competition. For 13 years the developed member economies of the WTO—especially the United States—had fought equally hard to ensure the opposite: that China would gain entry on only the strictest of free market terms.

For both parties, the negotiations were a concrete expression of longer-term visions of China's internal development and external relations. For Americans, WTO accession had become a vehicle to force China to relinquish its special status as an economy neither wholly planned, wholly marketized, nor wholly subject to international norms of competition. For Chinese, accession had become a way to formalize in the global arena China's unique blend of socialism and capitalism, a blend that generated vast exports while preserving the domestic institutions of state socialism—state banks, state firms, and

extensive state monopolies in key manufacturing and service sectors.

In early 1999 all this changed. Just months before Prime Minister Zhu Rongji's scheduled April visit to the United States, Chinese representatives to the WTO accession talks suddenly offered extraordinary concessions on nearly every issue previously contested. China pledged to throw open to foreign competition its agricultural and industrial markets. Tariffs on most goods would fall by nearly three-fifths, matching levels maintained by most developed trading nations, and tariffs on information-technology products imported from abroad would be eliminated entirely. Foreign firms operating in China would, after a three-year phase-in period, be granted full trading and distribution rights. Key service sectors such as banking and insurance—long protected by the Chinese government, and long sought after by Western business concerns—would be thrown open to foreign competitors within three to five years. Even in the sensitive area of telecommunications, foreigners would be granted unprecedented access to fixed-line and wireless operations in the largest Chinese markets.

The concessions embodied something entirely new: an emerging belief among Chinese leaders that modernization required not protection, but the exposure of Chinese firms to foreign competition and foreign markets. Yet far more certain were the short-term economic costs that WTO accession would

EDWARD S. STEINFELD *is an assistant professor at MIT's Sloan School of Management and author of* Forging Reform in China *(New York: Cambridge University Press, 1998).*

surely impose. By the late 1990s, approximately half of China's 75,000 state-owned industrial enterprises were officially operating in the red. Perhaps even more troubling, many nominally profitable firms were in real terms incurring huge losses and facing insolvency. With the elimination of government subsidies and the introduction of foreign competition mandated by WTO membership, many of these state firms, would be driven out of business. Millions of Chinese urban workers would be threatened with unemployment in a nation that has only the barest of social safety nets. While fully integrating China into the global economy might make sense over the long term, the short-term costs—whether measured economically, socially, or even politically—would be monumental.

That Chinese leaders were willing to absorb such costs underscores the depth of the policy reversals they were undertaking. Encouraging precisely this kind of change has been the aim of America's Asia policy for well over a decade, and across several administrations. It is especially unfortunate—indeed, incomprehensible—that the Clinton administration failed to close a deal on China's WTO accession during Zhu Rongji's April visit. Long-term American interests were clearly permitted to be sidetracked by short-term political wrangling in Washington.

THE UNPLANNED MARKET

Given the downward slide in Sino-American relations since the NATO air campaign against Yugoslavia this spring, the bombing of the Chinese embassy in Belgrade during that campaign, and the publication of the Cox committee report on Chinese espionage in the United States, the time frame for China's entry into the WTO is uncertain at best. Still, the concessions offered by Zhu in April—and repeated in July—signal a fundamental turning point in the logic of Chinese reform policy. Since the last 1970s, Chinese policymakers had attempted to tweak the socialist system by gradually introducing market forces. The basic idea was to preserve the economy's socialist core—state firms and state banks—by introducing change along the margins. These incremental measures over time saw markets established, state planning effectively eliminated, prices liberalized, and non-state-owned industry allowed to prosper, but the underlying logic remained constant. Reforms would be introduced, but always as part of an overriding effort to preserve the traditional core of the economy.

The concessions of 1999 represented a thorough reversal of course. Instead of reform serving to sustain the core, the core itself would be destroyed to save reform, along with the growth, prosperity, and stability that reform has brought China. In the new view, instead of using market forces to save state socialism, state socialism itself would have to be sacrificed to preserve the market economy.

Free market forces are reigning, but in ways that now threaten sustained economic growth.

What explains this shift? Why would policy-makers change course so substantially and at such apparent risk? Why take a 20-year strategy of gradualism, incrementalism, and partial market reform—one that had brought unprecedented growth—and replace it with something far more radical and potentially destabilizing?

The answer relates to a fundamental realization by China's leaders, namely Prime Minister Zhu Rongji and his advisers. In contrast to many observers, Zhu's group has come to understand that the Chinese economy today is not simply transitioning from plan to market. Nor is the policy challenge simply to dismantle the old machinery of state intervention so that free market forces can somehow spontaneously prevail. Rather, the Chinese system today after two decades of incremental reform already is a market economy, albeit one desperately lacking the governance mechanisms that make modern market economies function smoothly. Many aspects of the Chinese market have the feel of "Dodge City" capitalism. Free market forces are reigning, but in ways that now threaten sustained economic growth.

China today is not wrestling with the same problems it faced two decades ago at the dawn of reform. The challenge then was to dismantle the command plan, create markets, free up prices, and empower individual economic producers. The appropriate comparisons were with nations like the Soviet Union, Yugoslavia, Hungary, or any others that had attempted—or were attempting—to reform socialism.

Through two decades of policy experimentation China did dismantle the plan, did create markets, did free up prices, and did empower producers. In so doing, the country managed to shift itself from the institutional problems of socialism to the institutional problems of capitalism. The nation, in effect, was pulled from one pole of the economic spectrum all the way over to the other. China today has complex, market-oriented firms, but they operate in a setting utterly devoid of appropriate mechanisms of corporate governance. The nation also has a vast and varied banking system, but it operates in an environment of desperately distorted rules and regulations.

China is not scrambling to dismantle socialism; it is scrambling to regulate a market system that it has—for better or worse, intentionally or inadvertently—adopted thoroughly. In this sense, the appropriate comparisons are with South Korea, Thailand, Indonesia, and even Japan—all nations that achieved phenomenal success through markets but have slammed into trouble when underlying institutions of market governance have failed to keep pace with growth.

Indeed, the urgency of changes pursued by Chinese policymakers stems directly from lessons drawn from the East Asian financial crisis. Before the crisis, "sustaining the core" in China did not imply the absence of a market environment; it did suggest efforts within a market context to protect state firms—and by extension, state employees—from competition and the threat of bankruptcy. Protecting state firms, in turn,

implied subsidization through the state-owned banking system. Funds pumped in by individual depositors simply were pumped out to firm-level borrowers who—although they may have been utterly unsustainable in commercial terms—happened to have been favored by the government.

As Chinese leaders came to understand in 1998 and 1999, a similar phenomenon led to trouble in market economies across Asia. Whether in South Korea, Japan, Thailand, or Indonesia, large firms throughout the late 1980s and 1990s—despite plummeting commercial prospects—were showered with loans from banks that were often themselves agents of the state. As levels of nonperforming loans accumulated and patterns of capital misallocation deepened, the risks of long-term economic decline—and short-term panic—intensified. Since 1997 the costs have been obvious even to the most casual observers of East Asia.

What is so interesting is not that these events have overtaken the Asian "dragons," the rapidly developing market economies of the region; after all, boom-bust cycles and financial panic have been the bane, and perennial ailment, of capitalist systems throughout history. The real curiosity is that these phenomena, which are so closely related to developed market systems, are occurring in China. Hence, Chinese policymakers are moving rapidly, and radically, to undertake what was unthinkable just five years ago: the dismantlement of the Chinese economy's traditional state-owned core.

GROWTH ON THE "INSTITUTIONAL CHEAP"

At the dawn of reform in 1978, the Chinese economy embodied the basic logic of socialist command economies worldwide. China's political economy in the late 1970s had been shaped by leadership decisions 25 years earlier to pursue forced-draft industrialization. Responding to both ideological and national security imperatives, policymakers in the 1950s were determined to lift China from its agricultural past and build heavy industry as rapidly as possible. Unfortunately, neither China's natural factor endowments nor its societal institutions favored heavy industrial growth. Capital was scarce, and therefore relatively expensive. Furthermore, China lacked the financial institutions to transfer capital, via the market, from those who had it—individual savers—to those who could use it—industrial enterprises.

Policymakers circumvented the problem by deliberately intervening and distorting prices. The costs of capital, basic industrial inputs, energy, and wages were drastically suppressed below market-clearing levels. The suppression of prices also committed the government to direct involvement in allocation, for only through allocation plans could the state ensure that factors that had been artificially priced low ended up in key heavy industrial sectors. Similarly, the government was forced to step in and micromanage individual enterprises. This occurred because managers—operating under conditions of distorted prices, allocation by plan, and annual output targets—faced systemic incentives to overconsume and underproduce.

Simply to govern enterprises in such an environment, the state was pushed in two related directions. First, it would directly control the hiring and firing of managerial personnel in the firm. Second, it would constrain managers through compulsory production plans and output targets. By economic necessity, the industrial firm became little more than an extension of the state, the production arm of a vast industrial bureaucracy. The pattern was then reinforced by political necessity, since the industrial employer served as the main vehicle for state coercive power and the prime arena in which the state interacted with citizen.

The system, despite its faults, achieved some success, especially in basic industrial growth. During the first five year plan (1953–1957), national income expanded at an average annual rate of 8.9 percent while industrial output surged annually by 18.7 percent. The results were especially dramatic in heavy industrial sectors. From 1952 through the mid-1960s, the gross value of industrial output in the machinery sector expanded annually by more than 25 percent.

Besides fostering growth, the command system allowed China to channel investment capital, collect taxes, and govern enterprises on the "institutional cheap." By distorting prices accordingly, the government could ensure that virtually all savings in the economy went to the state sector. Government-set prices guaranteed that state-owned enterprises earned substantial profits, which were remitted almost in their entirety to the government budget. Central planners then decided to whom these savings would flow back down as investment, and the banks simply disbursed funds accordingly. Instead of requiring a complex fiscal apparatus to collect revenue from society at large, the state could simply remove the profits accumulating in state-owned enterprises and reallocate them through the investment plan. Similarly, little need in any market sense existed for banks or other financial intermediaries, since the price mechanism itself—when supplemented by government allocation—channeled financial resources to industrial end-users. Finally, in the area of enterprise governance, the state could exert substantial authority over a wide array of economic producers simply by controlling the flow of investment and material inputs. The control may have been faulty, and always subject to the manipulation of producers, but ultimately the government determined which assets flowed to which producers.

Unfortunately for China, growth on the institutional cheap came at tremendous long-term cost. Between the 1950s and the 1970s, the amount of gross investment required to achieve a given increase in output rose by more than 80 percent. Because of inherent inefficiencies, the system eventually achieved less bang for its investment buck. In the fifth five year plan (1976–1980), the investment cost of producing a kilowatt hour of electricity had tripled since the third five year plan (1966–1970), while the investment cost of producing a ton of steel had nearly doubled. Meanwhile, by the mid- to late 1970s, levels of inventories and unfinished construction were soaring. Between 1976 and 1978, inventories in the state-owned sector exceeded 95 percent of national income.

ENTER THE MARKET

The Chinese economy by the late 1970s was thus in deep trouble, and aspects of the command system bore a significant share of the blame. Clearly, the immediate answer involved economic liberalization: the phase-out of state price controls, the opening up of product markets, the exposure of industrial sectors to competition, and the extension of autonomy to economic producers. Whether rapidly or gradually, barriers to marketization and entrepreneurship had to be pushed aside and something entirely new allowed to come forth. Indeed, this removal of market impediments is precisely what occurred during the first decade and a half of reform.

Policymakers through the 1980s and 1990s introduced a broad array of market-enhancing measures. Whether China should have moved more quickly than it did is a matter of debate, but the key point is that it did indeed move. Economic transactions were encouraged to flow horizontally between producers and consumers rather than vertically between producers and the state. Prices for nearly all goods—from industrial inputs to finished consumer products—were liberalized, and product markets were allowed to thrive. An entire export-oriented, non-state-owned industrial sector was permitted to emerge in China's rural areas, often with the eager support and under the careful tutelage of local government. Partly as a result of this development, savings in the economy shifted from the state sector to the household sector, and banks started to play a real role in financial intermediation. The monobank system of the prereform era was allowed to give way to the diversified set of banking institutions generally found in middle-income market economies. Today, in addition to a central bank, China has three state policy banks, four wholly state-owned commercial banks, and eleven joint-stock commercial banks, most with extensive national or regional branch networks.

At the individual enterprise level, managers even in the state sector were granted unprecedented freedom to run their operations, deciding everything from product mix to long-term investment strategies. Whether from the micro or macro perspective, one would be hard pressed to characterize this system as anything but marketized.

Still the state—despite its encouragement of markets—persisted in defending key players in the traditional system. The old system of planning may have been aggressively dismantled, and the old incentives and behaviors forced into retreat, but the players themselves were protected. Throughout the reform era, state-owned enterprises were rarely if ever put out of business. A particular kind of market system resulted, one that shared most of the attributes of developing capitalist economies, but one also set up to devote extensive resources to the sustenance of a vast number of commercially nonviable firms.

On the positive side, this particular system achieved impressive and sustained macro-level growth. Since 1978, China's GDP has expanded at an average annual rate of 9.5 percent, with particularly noteworthy gains in the non-state-owned portion of the economy. At the start of reform, almost 80 percent of total annual industrial output (by value) was produced by traditional state firms. By 1997, in a substantially larger overall economy, that figure had declined to approximately 25 percent. New industrial entrants have steadily chiseled away at the state's monopoly over production.

On the more negative side, however, is the particular pattern of credit expansion and financial intermediation that has emerged through the 1980s and 1990s. As noted earlier, the elimination of state-controlled prices and the opening of many industrial sectors to new nonstate entrants led to a dramatic shift in the locus of national economic savings. In the prereform economy, almost all savings occurred in the state sector, mostly in the form of financial surpluses accumulating in state-owned manufacturing enterprises. Today, savings accumulate in the household sector: households deposit their funds in banks, and the banking system channels those funds as investment into industrial firms. It is not entirely surprising, therefore, that the reform era has been marked by a massive expansion of credit. In 1978 total lending by Chinese financial institutions stood at just over 50 percent of GDP; that figure grew to over 100 percent by 1997.

THE COSTS OF GROWTH

While nothing is intrinsically wrong with an expansion of credit, the real question is to whom credit is directed and how it is employed. It is used to achieve real returns and an expansion of assets, or is it simply frittered away in value-destroying activities? Unfortunately for China, the latter outcome has systematically dominated the former. As long as the Chinese government remained adamantly committed to supporting the state-owned enterprises, most domestic credit was directed toward state industry. In other words, traditional borrowers—many of whom are today insolvent—have been eating up the vast bulk of available investment capital in the Chinese system. Chinese banks continue to channel the bulk of their funds toward the least productive portion of the industrial economy, the state-owned sector. By the mid-1990s, state-owned enterprises accounted for under 35 percent of industrial output value, but were consuming almost 75 percent of national industrial investment.

The central role state banks play in financial intermediation in China stems directly from the government's commitment to sustaining state firms. By severely restricting the growth of alternative channels of intermediation—whether private commercial banks, stock markets, or corporate bond markets—the government ensured that state-owned banks would become the primary repositories for savings accumulating in the economy. Moreover, the government could then use its control over state banks to channel those savings to favored borrowers, namely state firms. The more that industrial firms were showered with capital, the softer their budget constraints became, and the fewer the incentives for productive, asset-expanding behavior. Declining performance simply increased the need for bailout loans. As pressure on the banking system expanded, the government was forced to tighten control to ensure a sufficient flow of capital both into the banks and onward to favored

borrowers. A vicious circle developed, one at least generally comparable to the situation in Japan or South Korea.

As in South Korea or Japan, this pattern in China recently has led to a rapid escalation of indebtedness in the modern industrial sector. The liabilities of industrial state-owned enterprises in China soared from approximately 11 percent of total assets in 1978 to almost 80 percent of assets by 1994, and the Chinese state sector as a whole by 1995 was exhibiting debt-to-equity ratios of over 500 percent. That liabilities were rising so quickly suggests not only that firms were borrowing, but also that the borrowed funds tended to be devoted to nonproductive investment. A significant portion of loans funded the operating expenses of loss-making firms, many of which—because of poorly enforced accounting standards—remained only nominally profitable. Funds were also being devoted to capacity expansion, even in the absence of tangible demand for industrial outputs.

In the midst of such extensive borrowing by the state sector, nonperforming loans in the Chinese banking system have sky-rocketed. By the mid-1990s, government estimates placed the level of nonperforming loans in the state banking system at approximately 20 percent of all assets. Such levels imply that the Chinese banking system today is technically insolvent. Of course, whether insolvency constitutes as much of a problem in state-owned systems as it does in private ones is debatable, and given China's high levels of household savings, the banking system remains liquid for now.

Nevertheless, China today clearly is wrestling with a significant and potentially unsustainable problem of capital misallocation. The bulk of national investment is directed toward the least productive portion of the economy, often with little or no return. It is difficult to imagine that this will not adversely affect overall growth over the long term. Indeed, it is precisely this concern that accounts for the centrality of state-owned enterprise and banking reform on the current policy agenda. The question is not so much whether the current pattern of capital allocation will adversely affect growth, but to what extent and what to do about it.

The Russian Devolution

The country has spent the years since Communism spiraling downward. Who is to blame? That's becoming a highly charged question in American politics.

By John Lloyd

SEATED AROUND THE LONG TABLE ON THE FIRST floor of the modest dacha, the young men were relaxed, laughing a lot, talking excitedly, sometimes all together. They barely noticed as, guided by their chairman, I skirted the table and took a seat in a little room off their conference chamber to wait for a break in the proceedings. As I sat there, I marveled at the hilarity and occasional cacophony that fairly shook the wooden walls.

It was October 1991; the Soviet Union still existed. Yet next door, this little band of brothers was writing the economic program for an independent Russia. When the chairman joined me and began to describe what they were doing, I could not at first take it in. We were seated in a dacha in a little colony of state dachas some 30 miles from Moscow. The scope of the task contrasted oddly with the participants' youth and high spirits. Something graver seemed called for—a hushed conference hall with graybeards attended by aides, perhaps. This seemed so . . . light.

In his soft voice, with the attitude of calm certainty that had made him the natural leader of these men, the chairman explained that the Soviet Union was finished. Any policy, whether organized by the West or pursued within the Soviet Union to save it from disintegration and collapse, would fail. The other 14 Soviet republics wished to go their own ways, and they should. Russia must find itself again, he said, and become a part of the modern, civilized world.

Within three months of the meeting, many of these men were ministers in the first Government of an independent Russia in more than seven decades. Pyotr Aven, an academic researcher, was Minister of Foreign Trade; Konstantin Kagalovsky, an academic researcher, was leading negotiations with the International Monetary Fund; Anatoly Chubais, a former academic researcher, was Minister for Privatization. My guide and their chairman, Yegor Gai-

dar, director of a small academic institute, was soon to become acting Prime Minister. Their mission: to make Russia a free, democratic, capitalist state.

FOR MOST OF THIS DECADE, RUSSIA HAS BEEN CONsumed by the quest for these goals. Billions of dollars of aid have poured into reforms. Bitter struggles have been waged between free-market radicals and their Communist or nationalist foes, most significantly in 1993, when armed struggle broke out between the Parliament and the President. Great privations have been visited on the country in the name of necessary sacrifice. Yet what has changed for the better?

Russians, free to get rich, are poorer. The wealth of the nation has shrunk—at least that portion of the wealth enjoyed by the people. The top 10 percent is reckoned to possess 50 percent of the state's wealth; the bottom 40 percent, less than 20. Somewhere between 30 and 40 million people live below the poverty line—defined as around $30 a month. The gross domestic product has shrunk every year of Russia's freedom, except perhaps one—1997—when it grew, at best, by less than 1 percent. Unemployment, officially nonexistent in Soviet times, is now officially 12 percent and may really be 25 percent. Men die, on average, in their late 50's; diseases like tuberculosis and diphtheria have reappeared; servicemen suffer malnutrition; the population shrinks rapidly.

This is the Russia that many in the West now say we have lost. Lost not in the sense of having mislaid, by accident, but through our own actions and mistakes. Lost as a selfish, thoughtless man loses a woman who loves him—through indifference or by pushing her away. Lost, the critics say, because we pursued agendas that were hopelessly wrong for Russia, and lost because we encouraged and supported precisely these men in the Government dacha, who were also hopelessly wrong for Russia.

These are the charges now being made in the West. Some of those who make them want the critique to be part of George W. Bush's election campaign. It is already becoming one of the most charged foreign-policy debates in America.

George Kennan, the venerable diplomat, former Ambassador to the Soviet Union and scholar, says in an in-

John Lloyd, a writer living in London, was the Moscow bureau chief for The Financial Times from 1991 to 1996.

terview in The New York Review of Books of Aug. 12 that "this whole tendency to see ourselves as the center of political enlightenment and as teachers to a great part of the rest of the world strikes me as unthought-through, vainglorious and undesirable." The case that we lost Russia begins with America's insistence on exporting the free market and takes in everything up to the NATO bombing of Serbia, an act that seems to have completed Russia's retreat from Washington—a retreat with as many victims as Napoleon's from Moscow. The claim that we have lost Russia, in short, is a proxy for Clintonite failure to reshape Russia as an idealized America.

In Russia, the charge is that the New Russian reformers, abetted by the West, have destroyed the country's economy while enriching themselves. Many of those who make these charges (and who would like to see those they judge guilty locked up) will be candidates for the Duma (parliamentary) elections in December. And this critique may well be a major plank in the platform of one or more contenders for Boris Yeltsin's mantle in the presidential elections next summer. At the end of a century in which Russia has been raped by Bolsheviks, the country now seems to have been raped by capitalists. The stakes in this debate are very high.

THE WEST'S INVOLVEMENT IN RUSSIAN REFORM was deep and early. Even before the reforms began, the big names in Western economics were debating how they should be managed. One issue overarched all others and would haunt the policy and its implementation down to the present. It was whether reform should push, hell for leather, the privatization of state assets or if institutions and a market infrastructure should be developed first.

"There was a debate about institutions and infrastructure back in 1990," says Joseph Stiglitz, the chief economist at the World Bank, whose earlier work on imperfect information and markets has put him in line for a Nobel. "I remember talking to a conference in Prague in 1991 on the theme of 'Quis Custodiet Ipsos Custodes?' (Who guards the guards themselves?') in a situation of rapid privatization. There were already differences between us then."

His major opponents were Jeffrey Sachs, a Harvard economics professor, and Lawrence Summers, a colleague of Sachs and now the Treasury Secretary. "They thought you needed to pursue privatization rapidly and that infrastructure would follow," Stiglitz says. "It was a divide then."

But it was Sachs and Summers who seemed to carry the argument. Sachs was at the height of his reputation following his success in breaking Bolivia's 24,000 percent inflation rate. In Warsaw in 1989, he explained market economics to the Solidarity activists about to be thrust into power. That December, the first post-Communist Government was quailing before price liberalization. Sachs got on the phone late at night in the office of Poland's Finance Minister, and harangued American officials until they promised to nudge the I.M.F. into providing $1 billion

in support for the Polish currency. His myth as the economic liberator was born, and with it a mechanism known as "shock therapy." This was shorthand for a raft of measures—price liberalization, budget stabilization, a slashing of subsidies—undertaken more or less simultaneously to "shock" the economy into a therapeutic, market-driven recovery. The young reformers in Russia heard about it, and saw in Sachs and his mechanism their way forward.

When Bill Clinton came to the Presidency in early 1993, Summers was appointed Under Secretary of the Treasury for International Affairs. The official who covered the former Soviet Union and Eastern Europe was David Lipton, who had worked closely with Sachs on Polish and Russian reform. Sachs, on a leave of absence from Harvard, had installed himself and his team in the Finance Ministry—where he spent a large part of one morning chiseling away a portrait of Lenin that had been embedded in the plaster of a colleague's office wall. Both men proselytized for shock therapy—Sachs, vocally and impatiently, and Summers, behind the scenes, nagged and pushed the I.M.F. and the World Bank to lend, lend, lend. The money, tens and tens of billions of dollars, would be used for the essential first step in the reform, making the ruble convertible on world markets. Only with a hard currency, they believed, would investors commit the substantial sums needed to transform the Russian economy.

That never happened. Yegor Gaidar needed much more help than the Clinton Administration—or any other Western government—was willing to give him. He had come to Government at a time of collapse. At the end of 1991, as Mikhail Gorbachev left office and the Soviet banner was pulled down from the Kremlin tower, most Russians were lining up around the block for the basics. As Gaidar tells it, he had no choice but to let prices rise to increase supply and to scrap trade barriers so that foreign commodities could begin to fill store shelves.

Though Russia never did adopt the full menu of shock therapy, the release of prices and the soaring of inflation, with its effect of wiping out the average person's modest savings, was shock enough—without, as the United States Deputy Secretary of State, Strobe Talbott, was to observe later, any therapy. The shock was such that by April 1992 the slender parliamentary majority the Government commanded for its measures evaporated. With that, Gaidar and Yeltsin began what has characterized Russian reform ever since—a guerrilla struggle with a hostile, often violently hostile, legislature.

The reformers had hoped that the West would back them as soon as they took office. But it did not. This, for many insiders, was and remains the key mistake. Sachs ran himself ragged, zipping between Moscow, Cambridge and Washington, begging and demanding a big loan to stabilize the economy and give reform a chance. In retrospect, it was a fool's errand.

HERE, AT THE VERY BEGINNING OF REFORM, IS THE first charge that we lost Russia—and it is made by the

'What the United States Treasury and the I.M.F. were doing was financing and licensing a Great Grab and calling it reform. And there was so much in Russia to steal that was so precious: oil, diamonds, nickel. It was the kind of opportunity that comes once in a millennium.'

economic radicals, East and West. They blame the Western Governments' lack of vision; Sachs loudly and bitterly, others still in Government more mildly and often unattributably. In Moscow, Yegor Gaidar has no doubt—the West blew it. "There was a massive failure of imagination on the part of the West," he says. "There was no one statesman then in power who could grasp the enormity of the events happening here. The first delegation of high-level Westerners with whom I had to deal in office was that led by David Mulford, then the United States Under Secretary of the Treasury, on behalf of the Group of Seven richest countries in the world. He impressed on us backward Russians that our first responsibility was to repay the Soviet debt."

Says Sachs, who resigned as an adviser to the Russian Government in 1994: "I think in this debate the people with the power and the money, the governments of the West, must take the responsibility. It was going to be a major concerted effort to do anything, by the Russians and the West. I understood the challenge, I think, better than anybody. I never thought that the markets would do it by themselves—never. We were never engaged. The dereliction of responsibility was massive. It does make you wonder. Were there people in the Administration who wanted Russia to fail, to be weak?"

Summers, who more than any other single official was in charge of Clinton economic policy on Russia, would not be interviewed for this article. But Lipton, who worked closely with him and has now left the Government, says that "in '91-'92, it was Bush's last year. There surely was a failure to embrace the process of reform. I would agree that more could have been done. I think that people lacked the vision to see the consequences of the end of the cold war. The Bush Administration didn't grasp it. But it wasn't going to be a sure thing, whatever we did. The key thing was the Russians themselves—the lack of people who knew what to do, the absence of a consensus on a Russian national identity. Poland wanted to be in Europe. Russia had no such consensus."

As the macroeconomic measures faltered for lack of foreign and domestic support, the first privatization program took off. Gaidar, assailed on every side by enterprise managers screaming for a continuation of subsidies, gave in inch by inch. But he was determined to proceed with the privatization of state assets, which all the reformers agreed would break the power of the Communist-era bosses and was, accordingly, at least as much a political as an economic policy. It was an article of faith that privatization would foster honest dealings and civic behavior by creating a middle class with a stake in the country, while cleaning out the Augean stables of the bureaucracy.

The opposition was ferocious. I went to one of the first auctions of state-owned shops, in the city of Nizhni Novgorod, in late 1992. Demonstrators organized by the local Communist Party jostled Government officials on their way in and protested that their common heritage was being taken from them. They carried banners with a slogan that would soon become a commonplace: "Privatisatsiya (privatization) = Prikhvatisatsiya (grabbing)."

As the auction got under way, a master of ceremonies dressed in a dinner jacket came on stage—an exotic sight in a country where formal evening wear had been pronounced bourgeois and shunned for decades. He spoke fluent Russian, but he was a Czech who had developed his skills in his country's state property auctions. These, based on vouchers distributed to the population that entitled them to shares in the privatized companies, were the model for the Russian sell-off.

As each lot came up, the auctioneer described the shop in glowing terms and then threw it open to the audience. As he did so, it became obvious that the groups had already settled among themselves which was to bid for each shop under the hammer; there was little bidding up of the price. Some of the groups were men with darker skins than the fair Russians; a couple of matrons near me said, loudly, "Blacks!" (the Russian derogatory expression for people from the Caucasus), and then, "Mafia!"

I realized then, with a start, that the freedoms Russia had accomplished over the past few years were seen quite differently on the ground. This was no gathering of economically knowledgeable actors. The majority were puzzled and hostile citizens raised in a Soviet culture, with a few sharp customers thrown in—perhaps already accustomed to cutting corners and wheeling and dealing in the many cracks in the command economy—who were taking advantage of an incredible stroke of luck.

THE POLITICIAN WHO EMERGED TO EFFECT A privatization that still dwarfs every other such exercise many times over is one of the most remarkable figures of post-Communist politics. Anatoly Chubais, who had come to Moscow with little preparation, no money and not even an apartment, rose in the next seven years to become second in power only to Yeltsin himself. He also became, for the majority in the political class, the target of extraordinary hatred—some of

'The key thing was the Russians themselves—the lack of people who knew what to do, the absence of a consensus on a Russian national identity. Poland wanted to be in Europe. Russia had no such consensus.'

which, in less virulent form, has crossed to the West. He has retained the protection of Yeltsin and thus keeps a place in the informal power structure. On a trip to Washington in May, he saw Robert Rubin, then the Treasury Secretary, and Larry Summers; Secretary of State Madeleine Albright and Strobe Talbott; Stanley Fischer of the I.M.F., and the national security adviser, Sandy Berger—a level of access that some Russian officials found disturbing. Yet no single figure is more vulnerable if power in Russia goes to one who owes him nothing, or wishes him ill.

In 1992, Chubais confronted an economy that was virtually wholly state owned (Gorbachev had permitted the growth of a few "co-operatives"), a distrustful Parliament and high-level managers who had effectively taken control of their enterprises and wished to enjoy their fruits undisturbed. "What is never remembered," Chubais said in a 1995 interview, "is that even before the collapse of the Soviet Union, the managers were stealing everything they could, in association with the state bureaucrats. You could not stop it. You could not get the managers—the insiders—out. They were powerful enough to block everything. The only way you could get the property into the private sector was to get the insiders motivated and rewarded. You could dream up 100 schemes that were better or purer than the ones we brought in, but this was actually the only way you could do it."

This huge and sudden transfer of assets is a major area of the debate on Western strategy toward Russia. It has attracted the most prestigious—and for Western Governments and the international financial institutions the most embarrassing—critique, coming as it does from within their own ranks.

That attack came in the spring of this year, from Joseph Stiglitz. In papers given in May and June, the World Bank's chief economist argued that much of the responsibility must be taken by the advocates of shock therapy. "The standard Western advice . . . the 'Washington consensus'," he wrote, took "an ideological, fundamental and root-and-branch approach to reform-mongering as opposed to an incremental, remedial, piecemeal and adaptive approach. . . . Some economic cold warriors seem to have seen themselves on a mission to level the 'evil' institutions of Communism and to socially engineer in their place the new, clean and pure 'textbook institutions' of a private property market."

In a probably unconscious echo of the signs held by the demonstrators in Nizhni Novgorod, Stiglitz said that the Western and Russian radicals had a particular view of government—that it was a "grabbing hand," always seeking rents from corporations, always interfering to make things worse. "The grabbing hand theory," he wrote, "sees the state as being irredeemably corrupt—while the private sector is viewed through rose-colored glasses. Yet the resulting program of transferring assets to the private sector without regulatory safeguards has only succeeded in putting the 'grabbing hand' into the 'velvet glove' of privatization."

Stiglitz, with other critics of shock therapy and Western aid to economic reform, believes that assets should be put into private hands at a deliberate pace, and only after effective laws and working markets have been established. In a passage that infuriated reformers, he said that China, with no I.M.F. program and little outside advice, has achieved high growth rates over the past decade while Russia, with a number of I.M.F. programs and endless outside advice, has steadily declined.

"Sachs and Summers were right when they said that you can't live with hyperinflation," Stiglitz says now. "Though even the fight against inflation can be taken too far. But those who thought that macroeconomic changes alone were sufficient were wrong. And those who put privatization above all else were clearly wrong. Summers and Sachs and others thought that you had to pursue privatization, and infrastructural change would follow. They thought that the new owners of private property would demand that this happen. But instead they took their money out."

This is a direct challenge to the Clinton team. Stiglitz has used his prestige and his office to strike at the center of the strategy promoted by Summers and Talbott in the Government and by Sachs and others in their advisory roles. He has said they were fundamentally and damagingly wrong in the view he attributes to them—that the first issue was putting state property into private hands.

Lipton will have none of this critique: "Anyone who says that privatization ignored the real conditions of Russia's reform is totally wrong. Russia needed what we tried to assist putting into place—laws, property rights, banking institutions, capital markets. The privatization did give too much to insiders, but Chubais had to compromise. The first wave of privatization created a new class and a capital market, and these are achievements which have endured."

YET FOR THE MOST PART, WHEN THE NEW RUSSIAN *biznismeny* got hold of the properties, their first thought was not how to spruce them up or extend their product lines or retrain the staff in post-Communist customer relations. Rather, it was how to realize the assets in cash,

change the cash into dollars and get it out of the country. Capitalism became capital flight. Just how much money has left Russia in the past seven years isn't known precisely, but estimates vary from $200 billion to $500 billion.

"This process, we now know, is going to take a long time—maybe a generation," says Harry Broadman, a World Bank economist. "Because of what's happened in the last seven years, vested interests have been created that were not present before and that make it more difficult to reform to get growth and economic democracy."

At the top, there was an increasing absence of authority. Yeltsin declined in health and in coherence. He drank in binges, as we know from the many memoirs of his courtiers. Even more disabling were his depressions, when he stared at the wall of his office, immobilized for hours, even days. His periods of triumph—in 1991, over the coup plotters, and in 1993, over his own Parliament in a bloody shootout—were followed by inaction and withdrawal.

In 1994, he seemed drunk in public at a solemn ceremony in Berlin to mark the Soviet Army's withdrawal. He then slept through a brief visit with a waiting Irish Cabinet on a stopover en route home from Washington. The memoirs of his bodyguard, Aleksandr Korzhakov, claim he suffered a heart attack. The intervention in the rebel province of Chechnya got under way in December 1994 and from the start went horribly wrong. Yeltsin's ratings slumped to low single figures and stayed that way into 1995.

Throughout these years, the Russians perceived the West as supporting what to most of them seemed a Government of criminality and inefficiency. After Yeltsin won the 1993 battle with Parliament by bringing in the tanks, Strobe Talbott—the political counterpart on Russia policy to Summers in Treasury—sent a message of congratulations that is still interpreted by the opposition as glorying in the blood of those who died as the Parliament building was shelled.

Much later than the radicals had hoped, the I.M.F. and the World Bank began substantial lending. So long as Yeltsin was President and a few reformers remained in Government—Chubais was the constant figure until 1995, sporadically thereafter—the official view in the West was that reform was on track and our money was keeping it so. In background briefings from World Bank and I.M.F. officials, I was told of the anguish they felt when money disappeared and public silk purses had to be made out of private sows' ears.

The officials knew what was happening, but the West was locked into a desperate struggle to preserve reform and to keep the Communists out of power. They would not give up as long as "our guys" had a chance. "The I.M.F. should have shown more guts in resisting political pressure," one official said. "The big mistake was not realizing soon enough that the reformers lacked the levers of power to do what they had agreed and to keep on lending. We should have been tougher."

On the ground in Russia, Western advisers worked with the reformers to set up market institutions. But it was a fraught undertaking: the Westerners themselves were caught in—or constructed—webs of patronage.

A key text in the critics' armory is a book by Janine R. Wedel, published late last year, called "Collision and Collusion." Wedel, an anthropologist at George Washington University, had worked for many years in Poland and moved east to Russia in 1994. She came to realize that the Western "clan," as Russians called it, around Chubais was a very close-knit group indeed. Most of the more than $300 million provided for privatization by the Agency for International Development went directly to or was controlled by the Harvard Institute of International Development, run by Chubais's aides. Two of its Western members, Andrei Shleifer and Jonathan Hay, both then of Harvard, are now under investigation for allegedly undertaking "activities for personal gain."

"In a country like Russia," Wedel says, "it was exactly the wrong thing to do to choose a particular group of people—the New Russians in politics. They were seen as embodying our ideas. They talked the talk. They were very savvy operators. It was fascinating how people from the West latched on to the features in their Russian counterparts they wanted to see."

IN THIS FEBRILE ATMOSPHERE, AS RUSSIA VEERED between a success always just around the corner and the reality of a plunging economy, there emerged, in 1995, the bones of a plan that became the most important element in the reform process—what has come to be called "loans for shares." Regarded today almost universally as an act of colossal criminality, it has defined the Russian economy and Russian business to the world. It completed Boris Yeltsin's retreat into an isolation from his country and created billionaires without the tedious process of building wealth from below. For Anatoly Chubais, it was a "pact with the devil."

Though most of the enterprises had been privatized by then, the richest pickings had not. These included the energy companies, the telecoms and natural-resource corporations like Norilsk Nickel, the biggest nickel producer in the world. The emerging financial class—already building themselves streamlined glass and steel offices and roaring about the boulevards of the capital in armor-plated Mercedes flanked by armed guards—wanted what they felt was their own. They wanted to be Morgans, Carnegies, Rockefellers. They wanted to transform Russia into a market they would dominate.

The loans-for-shares scheme was the brainchild of Vladimir Potanin, one of the new Russian businessmen. Potanin had built up a bank, Uneximbank, from the ruins of the Soviet Vneshtorgbank. Norilsk Nickel was a client, and he thought he could run it better than the managers who kept it going in the bleak Arctic Circle city that was its home. In the mid-1990's, he conceived the idea that the state would give him the right to manage it; in return, he would grant the state—strapped for cash, as ever—a large loan.

The idea had immediate appeal. The Government still controlled a dozen vast enterprises, mainly in the oil sector, that were abysmally managed. Potanin's fellow financiers, most of them fierce competitors, were eager to extend their empires. So, he proposed, why not offer loans for shares? He gathered them together for what became a series of exploratory meetings—Mikhail Khodorkovsky of the Menatep group, Boris Berezovsky, who had made a fortune from car production and sales, Mikhail Fridman and Pyotr Aven (the former Foreign Trade Minister) of Alfa Group, Aleksandr Smolensky of Stolichny Bank and Vladimir Gusinsky of the MOST banking and construction group. These men were not accustomed to co-operating with one another. But the bonanza promised by Potanin's plan was too tempting to allow the usual rivalries and feuds to take precedence. If it worked, they would become masters of the land. Potanin was persuasive, and Chubais, at first scornful of the idea, agreed to it at a Cabinet meeting in March 1995.

But there was—as always in Russia—a catch. The deal presupposed a continuity of Government. By the end of 1995, Yeltsin remained deeply unpopular, as well as remote and ailing, and 1996 was a presidential election year. His rival for the presidency was Gennadi Zyuganov, leader of a Communist Party he had built up from near extinction to win a strong representation in the parliamentary elections of December 1993 and a dominant one in the elections of 1995. Zyuganov was scoring way above Yeltsin, and he was trying to talk the Yeltsin talk—stressing the need to create an attractive business climate. This was the kind of Communist whom capitalists might grow to like.

In February 1996, with presidential elections looming in the summer, Zyuganov went off with a raft of Russian V.I.P.'s to Davos, where the world's high and mighty gather annually at the World Economic Forum. Everyone seemed to want to meet him, to shake his hand.

Things were looking grim for the Russian bankers. The financier George Soros reportedly told them over coffee that the Communists were going to win and that they should ready their private jets for takeoff. According to Chrystia Freeland, a journalist who is completing a book on the new Russian capitalists, the bankers say he turned to them and said: "Boys, your time is over. You've had a few good years, but now your time is up." The bankers were horrified. They had a habit of putting their money abroad, but they did not want to follow it. Yet what to do?

Hanging out in Davos was Anatoly Chubais, by now an out-of-work politician. Too hot, after a huge parliamentary victory by the Communists, to keep in the Government, he had seen his loyalty to Yeltsin rewarded by being fired. Sitting there, solitary and depressed, his spirits began to revive as he sensed a new political opening. He called a news conference in which he scolded the Western businessmen for flocking to Zyuganov. "If Zyuganov wins the Russian presidency in June, he will undo several years of privatization and this will lead to bloodshed and civil war," he said.

If the foreign businessmen were not overly impressed, the Russians were. There, at Davos, a pact was formed between the bankers and Chubais. Desperate to avoid a Government that would threaten their wealth, they made him an offer: lead the campaign against the Communists, and we will open our purses and our influence to you. He was paid, some of the bankers told Freeland, a $3 million fee in the form of an interest-free loan.

In the crucible of the 1996 election campaign, the shape of Russian power today was finally molded. The bankers controlled the main TV channels and newspapers; indeed, Berezovsky had been given control of the oil company Sibneft in order to help finance the main state TV channel ORT, which became a mouthpiece for the President. Gusinsky's NTV, a trenchant critic of Yeltsin during the Chechen war, turned on a kopeck to support him.

Yeltsin, who had sunk into inactivity and had all but decided to provoke a crisis in order to cancel the elections, was roused by Chubais and Yeltsin's daughter, Tatyana Dyachenko, who became and remained the main gatekeeper for her father. Money was poured into advertising campaigns, into regional tours, into bribing journalists. Yeltsin, through Chubais, called in the chips. And he won. Communism was confounded, for a second time in a decade, by the forces of freedom and democracy.

But that is not how it looked then to Russians, or looks now to anyone else. The bankers—or oligarchs, as even they call themselves—consolidated their power, but they did not invest, reverting to their past practice of asset stripping and banking abroad. Reforms, which Chubais and others pushed from a position of, at first, unrivaled power after the elections, once more foundered on a recalcitrant bureaucracy and a sullen country. Successive Governments grappled in vain with a tax system that could not develop a reliable framework for taxing the new capitalism.

Last August, the financial crises in Southeast Asia touched off a collapse in Russia; the currency fell 40 percent, and with it the Russians' already miserable living standards. Chubais was expelled from Government once more; he is now head of Unified Energy Systems, the main electricity utility—an oligarch in his own right.

NO ONE NOW DEFENDS THE LOANS-FOR-SHARES scheme. One World Bank official called it a "tragedy." Lipton, choosing his words with obvious care, says that it was an "unwise political compromise—to let a few of your guys have a lot of resources. It fed the asset-stripping instincts of the oligarchs. Because it was linked to the campaign contributions of the oligarchs, it cemented them into the state. But you must put yourself in the place of the policy makers. Chubais was fighting for a second phase of privatization like the first phase. He needed to make a deal. But I'm willing to condemn Chubais for this. He realizes it was unwise. His argument is, it was either that or no privatization."

But its effect has been to complete the corruption of the state. "The fish rots from the head," says the famous

Greek proverb, and the head and heart of Russia are seen as deeply corrupt—and worse, deeply ineffective. Boris Yeltsin's approval ratings have been in low single figures for more than a year. He is seen as a mixture between an invalid and a puppet, his strings jerked by masters behind his throne.

The domestic puppet masters are now simply—if sourly—accepted as a fact of Russian life. The circle around Yeltsin is tight and powerful; it comprises his daughter Tatyana Dyachenko; his former chief of staff, Valentin Yumashev, and Boris Berezovsky and his protege, Roman Abramovich, who controls his Sibneft oil company.

Berezovsky has been the main beneficiary of the "devil's pact" struck with Chubais (though the two are bitter rivals now). He, with Abramovich, had the major say in the naming of the present Russian Cabinet. They insisted on the appointment of their friend, the former railway boss Nikolai Aksyonenko, as First Deputy Prime Minister. Sergei Stepashin, the Prime Minister, was told to take it or leave: he stayed. Stepashin, whom Chubais promoted to American officials during his May visit as a future President, is at present hardly in command of his Cabinet. Nor is he, as the fourth Prime Minister within 12 months, secure in his office.

What happens in the Kremlin happens in the street. In Moscow researching this article, I was arrested for drunk driving, given a Breathalyzer test whose "positive" results I was not allowed to see and confronted with the threat of a disruption to my work so large that I took the usual way out for a foreigner or New Russian. I paid the fine on the spot—with a $100 bill for which no receipt was issued—and I was allowed to drive off in a "dangerously drunk" condition. (To add piquancy to the sting, I was lectured by the traffic policeman who "fined" me on NATO's criminality in bombing the Serbs.)

IN MOSCOW, I WENT TO SEE KONSTATIN KAGALOVSKY, one of the young men I had met in the state dacha eight years and a lifetime before. He was the first reformer I had got to know when I went to live in Russia early in 1991. Back then, he lived in a two-room, comfortless flat in one of the massive projects that ring Moscow. Thin and intense, he had sat me down at the kitchen table and, battling with his halting English and my halting Russian, talked of Adam Smith and Milton Friedman and Jeffrey Sachs (whom he asked to join the dacha group soon after I had met them). He told me of the futility of Gorbachev's reforms, the need for policies of the strictest monetarist provenance and of the pure evil of Communism.

The man who came out of his office to meet me—after I had gone through two careful security checks and several soft-carpeted corridors in an expensively renovated 19th-century Moscow mansion—had put on some weight and wore a well-cut suit and rich tie. On the wall behind him were photographs of him meeting with Margaret Thatcher and George Bush. On leaving Government service, he had joined Mikhail Khodorkovsky's Menatep—then one of the biggest of the new banks—and now was vice chairman of the Yukos oil company, which Menatep had acquired in the loans-for-shares deal.

"In 1991 and into 1992," he said, "we were still in our romantic period. Our views and feelings were based on our readings, discussions, ideas—some of them childish, it seems now. After that"—he smiled a little—"life changed all of us. It's very difficult to be effective in politics and keep your basic values. Even Yeltsin—in the beginning the major decisions were based on these basic values he had. Not now, not now. After the 1996 elections, things changed fundamentally. Chubais was the best organizer of all of us, but what he did to win the 1996 election was to say, 'The aim is good—anything goes.' Everyone closed their eyes. But in Government afterward, the main thing that had to be done was paying back the bankers, and economic reform got a low priority.

"We now see such simple truths: that a country that is based on stealing and corruption is much less efficient than a normal society. And that the end doesn't justify the means. After 1996, corruption became a systematic element of the state. It went to the core of the new Russian state." He paused and then said something that, coming from one for whom anti-Communism had been an article of faith, still gives me a shock. "If the Communists had won in 1996," he said, "I'm not sure we would be in a worse situation than now."

Corruption is seen by many as the greatest factor in Russia's loss, and those who see it most clearly (because they make a living studying it) are intelligence officers. Fritz Ermarth, who spent his professional life in the Central Intelligence Agency and did two tours with the National Security Council, now spends much of his time in Congress huddling with staff members over how to stop what he sees as the rot in Russia policy. He believes that Russia has become so corrupt that, in certain essential respects, business cannot be done with it at all, and he blames, in large part, the high officials whom he served.

"We followed the dictates of a theory that was made for countries with some trouble because of temporary government profligacy, not for a country melting down," Ermarth says. "In fact, what the United States Treasury and the I.M.F. were doing was financing and licensing a Great Grab and calling it reform. And there was so much in Russia to steal that was so precious: oil, diamonds, nickel. It was the kind of opportunity that comes once in a millennium."

In November last year, unnamed C.I.A. officials told The New York Times that in 1995 they had compiled a large dossier on Viktor Chernomyrdin, then the Russian Prime Minister. They sent the material to Vice President Al Gore, co-chairman of the Gore-Chernomyrdin Commission, in which much of the government-to-government business between the countries was handled. It came back, said the officials, with what was described as "a barnyard epithet" scrawled on it. The lesson they reportedly took away was that evidence of high-level corruption

'Our big mistake was in assuming we would have a strategic partnership,' says Condoleezza Rice, the principal foreign-policy adviser to George W. Bush. 'In that regard, we were spoiled—by getting so much from them so early. What we now face ... is a Russia more dangerous than it has been, because it is coming apart.'

was not wanted. Thus, when they established that a German businessman had been asked for $1 million to see Chernomyrdin, they did not circulate the report.

But Chernomyrdin—now back as president of Gazprom, the energy monopoly he created and partially privatized and whose huge revenues, vast holdings and large exemptions from taxes now make it a state within the Russian state—was for years a key interlocutor with the man who seeks to prolong Democratic rule in the White House, Al Gore. Gore was deeply involved in Russian policy through the Gore-Chernomyrdin Commission, which dealt with economic issues. He was a strong advocate of more aid and assistance to Russia, harshly criticizing the World Bank and I.M.F.'s reluctance to lend. He exhorted American business to invest in the country and lauded Chernomyrdin, whose personal fortune, held abroad, is estimated by Russian security sources in the billions of dollars—an allegation he denies. When this checkered record is eventually held up to the light during a Presidential campaign, Gore will have much to answer for.

ALREADY, THESE ISSUES ARE BOILING UP IN POLITICAL circles. Politicians like Curt Weldon, a Republican Representative from Pennsylvania, now barrage the Administration with questions and criticisms on their handling of Russia, drawing strength from an increasingly cohesive "Lost Russia" lobby.

And this lobby now looks as if it will have a powerful mouthpiece: the front-runner in next year's Presidential race. The main foreign-policy adviser to George W. Bush, Condoleezza Rice, former provost of Stanford University, is pressing to make the charge that the Clinton-Gore Administration lost Russia a major part of the Presidential campaign. Rice, who will shape Bush's policy and probe Gore's weak spots, poses a special danger for the Democrats—she has been an expert on Russia for decades.

Rice admits to the difficulty of the transition from Soviet Communism, that the fault lies largely with the Russians. She also acknowledges the hazards of retrospective wisdom. "When all that's said," she says, "you are left with a policy that leaned very far toward accepting the mere rhetoric of reform. It didn't recognize how mercurial Yeltsin is. It didn't react to the fact that an awful lot of money has been siphoned off. This gave a false sense of security to the Russians. They felt that no matter what reforms they

didn't do, they would get the I.M.F. money. No matter what behavior they showed, they would get friendship.

"I think what's called for now is a major disengagement from Russian domestic policies. The corruption reached into very high places, to people with whom we dealt and are dealing. I know that international politics has to deal with issues like corruption, but we should have confronted them with what we knew, and I doubt this was done. The Administration equated Boris Yeltsin with democracy, and you can't do that now.

"Russia is a huge country with foreign-policy aims that will sometimes coincide with ours and sometimes won't. Our big mistake was in assuming we would have a strategic partnership. In that regard, we were spoiled—by getting so much from them so early. What we now face in international politics is a Russia more dangerous than it has been, because it is coming apart. And so one must ask, given what we tried to do and hoped for in 1991, What went wrong? How could it have happened? What is our responsibility?"

It is the same question again: Who lost Russia? Is it so lost that corruption has eaten into the very fabric of the state and that it is now doomed to repeat its past deep into its future? Has the President we in the West supported, feted, lauded become worse than the Communists we helped him to overcome? Have the market reforms that we promoted and helped pay for been so counterproductive that we have helped create a Frankenstein's monster of a state, which lost its way out of gradualist reformism in the 80's into a shock no society could bear?

The most dismal "proof" that Russia is lost is that Russians now proclaim that they wish to be lost to us. The NATO action in Kosovo has produced a bitter reaction, the more so for emphasizing to the Russians their relative weakness. In Moscow, I called on an old contact and friend, Boris Fyodorov, who though never one of Gaidar's gang had been a tough radical as the Deputy Prime Minister for finance. Kosovo came up, and his geniality vanished. He said that the bombing of Kosovo was a preparation for a NATO raid on Russia. "That's absurd!" I said. "NATO is absurd!" he shot back.

STROBE TALBOTT HAS HAD TO TAKE MORE RUSSIAN GRIEF over Kosovo than anyone else in the West. In his time in office since 1993, he has reached deep into his command of superlatives to describe Western joy at the liberations

we thought we were witnessing. Life is tougher now. On the night the Russian troops were dispatched to dash into the Kosovan capital of Pristina ahead of the NATO forces, Talbot was in the Russian Defense Ministry being harangued till dawn by the Defense Minister, Igor Sergeyev, and his colleagues on the impossibility of Russian troops submitting to NATO command. This was an argument he had heard for weeks, in his relentless shuttle to and from Moscow trying to get an agreed position on a settlement of the war. At 3 in the morning he was informed that CNN was reporting on the Russians' dash to Pristina—something his hosts had not found time to mention.

In an interview, Talbott made his case: that Kosovo marks a breach, but not an unbridgeable one. Business has gone on, agreements keep being made and the I.M.F.

There must be a large element of hope in that last remark, but perhaps hope was all we could have offered in the first place. Russia's 20th century has been unimaginable in its horror, uniquely awful for any major country in modern times. "Oh children, if you only knew/The cold and gloom of days ahead," Alexander Blok wrote in 1914. At the end of the century, the "children" know it. They know that Communism worked best in destroying most remnants of civil society, leaving a people deeply distrustful of everything, especially one another.

Two last snapshots, one from near the beginning of Russia's century, one from nearer to its close: Isaac Steinberg, a uniquely freethinking Bolshevik who was briefly Commissar for Justice, noted in 1920 that the effect of the terror his party was waging on its fellow Russians was to produce a mutually hateful misery. "See . . . how this mass of humanity, accidentally chained together, seems to lack all sense of mutual sympathy and understanding, how everyone sees in his fellow man only a rival!"

'The real question is the overall direction. Nothing that has happened over the last seven years makes me think that they . . . are about to be submerged in a red-brown tide of fascism.'

is preparing a new program. Withdrawing—as Condoleezza Rice advises—would be to "put Russia in a corner with a dunce's cap on its head and ignore it, which is not an option for any Administration." Its re-entry into the world is indeed a vast endeavor, he says, but one to which we are if not central, not marginal either.

"Russia is a great, big, spiraling, complex country," Talbott continued. "It is undergoing perhaps the most extraordinary and comprehensive transformation of any country that did not lose a war. It is finding itself both in the modern world as an economy and in the planet as a physical entity. It is doing so in a way that is very much its own, and must be."

Talbott waxed a little poetic, quoting, he said, no one, not even himself. "Our policy toward Russia must be that of a lighthouse, because Russia is going through a very rough sea. They can locate themselves against this light. The real question is the overall direction. Nothing that has happened over the last seven years makes me think that they have reversed course or are about to be submerged in a red-brown tide of fascism. This is decades long. The judgment of history on any question is not yet."

But politics do not wait on history's judgment. The judgment that Russia was lost through Western action or inaction is being made now, and is increasingly politicized. Talbott, whose 1993 book (with Michael Beschloss), "At the Highest Levels," is a detailed and sympathetic account of United States-Soviet relations in the last years of the Soviet Union, had a first-rate training for Russia policy. Nevertheless, as Talbott himself says, "this was unprecedented. There was no recipe book or users' manual. We were experimenting as we went along. Yet, even now, Russia is not failing. It has moved and will keep on moving."

The contemporary witness comes from Norilsk, where the oligarch Vladimir Potanin has his nickel works. Beginning in 1937, Jadwiga Malewicz served 10 years at Norilsk for "anti-Soviet activity," and she is there still. In an interview for Angus McQueen's limpid and horrifying documentary film "Gulag," she said: "We built Norilsk from nothing; truly, it was built on bones. Once, I told a girl working with me to stop working so hard, or she'd kill herself. Someone informed on me. I got 10 days in a freezing punishment cell, a piece of bread each day. I nearly died. I no longer trust anyone. I have never done a good deed since then."

Russia suffered from our mistakes and preconceptions but—barring catastrophe—ultimately will make its own accommodation. It never was ours to lose. Russia lost, not itself but the trust that makes societies civil and functioning.

The competing Western visions of how to bring it into the contemporary world are important more for what they have said about our hopes and fears than about Russia's possibilities. We can't know whether we have "lost" Russia by prescribing the wrong medicine or have helped save it by administering a nasty potion that, however unpleasant, will ultimately bring health.

It seems unlikely that the potion will be wholly rejected. Russia will make of it what its history allows. It must find itself; until then, we can do little more than watch, offering an occasional bit of encouragement from the sidelines.

Editor's note: Since this article was written, Boris Yeltsin has stepped down as president, and appointed Vladimir Putin as prime minister and president-elect pending presidential elections in 2000.

What Pacific Century?

For years the futurists declared that Asia would rule the world economy in the 21st century. That isn't likely to happen. What's getting in the way? Asian values.

Louis Kraar

Judging from the confident forecasts by a chorus of experts, the Pacific Century should be dawning about now. Nearly 30 years ago, futurist Herman Kahn argued that by the year 2000, Japan was sure to become the world's No. 1 nation. His influential book *The Emerging Japanese Superstate* depicted the triumph of a new brand of capitalism, under which wise government bureaucrats set the course while diligent workers who respected authority labored to create national wealth. More recently, trend forecaster John Naisbitt roamed the lecture circuit trumpeting that "Asia will become the dominant region of the world—economically, politically, and culturally." Many Asian leaders, of course, echoed that idea.

Well, it hasn't happened. Economic stagnation for most of the past decade has made Japan—still Asia's biggest economy by far—look more like a supermess lately. And the Asian financial crisis in mid-1997 has hampered the rest of East Asia.

And yet the predictions keep coming, this time about China. Says Fred Hu in a new Goldman Sachs report: "It is likely that within the first two to three decades of the next millennium, China will overtake the U.S. as the largest economy." He also predicts that by then Chinese consumers will have a purchasing power "larger than all of Europe's."

Even if China does grow that large, it is unlikely to dominate the world economy in the next century. And the same holds true for the rest of East Asia too. Why? Fundamentally, the old Asian success formula has failed miserably as a model for Asia as well as for the rest of us. The government bureaucrats and autocrats who claimed to have all the answers for spurring economic growth stumbled over their own inherent weaknesses—rampant corruption, collusion with favored companies, and cronyism that funneled questionable loans to friends and family of government leaders. Says Kishore Mahbubani, Singapore's cerebral ambassador to the United Nations: "The key lesson that all East Asian economic managers have learned [from the financial crisis] is that they are accountable not only to domestic actors but to the international financial markets and their key players."

That doesn't mean, though, that we should count Asia out. Over the next century it will continue to play a huge and cru-

cial role. The region's remarkable progress over the past three decades is genuine. Never before in history have nations climbed from poverty to prosperity in one generation—as South Korea did—an accomplishment that indeed seemed like a miracle. The Asian financial crisis, a mere blip in the span of a century, has forced the region to start reforming its worst weaknesses—from shaky banking systems to corrupt business practices. Most crisis-afflicted economies, such as Thailand and Korea, are already growing again. Moreover, the fundamental strengths that originally ignited much excitement about Asia's prospects are alive and well. They include high savings rates, robust investment in education, relatively young populations, and ambitious entrepreneurs.

Over much of the next century East Asian economies almost certainly will continue expanding faster than mature Western economies. The region will serve as both a major production base and a voracious market. Asia today is the world's dominant producer (and a significant consumer) of steel, ships, semiconductors, and notebook computers. Judging from the speed at which Asia is plugging into the digital world, it will stay at the forefront in applying new technologies for communications and electronic commerce. Taiwan, for instance, is a supplier and designer of sophisticated components for computers and mobile phones. Hong Kong and Singapore are hurrying to become hubs for cyber-commerce.

So Asia may someday be able to lay claim to a Pacific Century. Trouble is, to get there it must first change some of its vaunted "Asian values." These include a respect for authority and a willingness to sacrifice individualism for the good of the society. It turns out, however, that these supposedly special values—which some government leaders still claim to be potent economic drivers—are glaring weaknesses. In fact, they get in the way of economic development.

It is true that Asian values served the region well for years. Says Ungsuh Kenneth Park, a thoughtful Korean economist: "East Asian societies achieved rapid growth with strong governments, meek people, and wide cooperation for achieving national goals. This is the sine qua non for every society, anywhere in the history of mankind, at an early stage of economic

and social mobilization." But the world is changing, and Asia must change with it. Park continues, "Once basic needs are met, people everywhere demand greater participation in the decisions that shape their lives."

The "Asian values" argument has often served as a convenient justification for authoritarian regimes. "It is altogether shameful to cite Asian values as an excuse for autocratic practices and denial of basic rights and civil liberties," Malaysia's former Deputy Premier Anwar Ibrahim, a reform-minded Muslim intellectual, has said repeatedly. He should know, having been removed from office last year, jailed, beaten by the police, and convicted of dubious corruption charges. His real crime apparently was challenging Malaysia's Prime Minister Mahathir Mohamad, who claims that Asian values are superior to the "moral degeneration" of the West. Mahathir is on the wrong side of history, though.

In the next century Asia will travel slowly and fitfully down the long road toward democracy and the rule of law. Its educated and ever-increasing middle class will no longer bow to the will of strong-man regimes. This assertive spirit is clearly visible in Thailand, Taiwan, Indonesia, and South Korea, which over the past decade have replaced dictatorial regimes with various forms of representative government. The sharp pains caused by the Asian economic crisis last year, for example, prompted Indonesians to dump President Suharto, who made all the big decisions for three decades and enriched his friends and family but allowed no audible dissent. Indonesians are struggling to build a more open society, in which officials are accountable to the public.

Even China, where the Communist Party has maintained a monopoly on power for 50 years, will need to rely on the consent of the governed in the 21st century. Chinese leaders argue that stability is what counts. But a society going through the traumatic changes of rapid development, which produce many losers as well as winners among its citizens, especially needs honest administration and an independent legal system. Without the rule of law, foreign investors as well as Chinese citizens are subject to the shifting whims of officials. Lee Kuan Yew, who built modern Singapore and is no champion of Western-style democracy, foresees China's going "from a centralized to a more participatory system of governance" within the next 50 years. Lee also warns that China must clean up its "most pernicious problem," corruption embedded in its administrative culture, or face a dangerous political powder keg.

Japan will suffer for decades to come from a tribal reluctance to disturb its own social harmony by freely allowing failing corporations to restructure. Americans and Europeans, who once eagerly studied Japanese management techniques in the '80s, have belatedly discovered the dark side of the system. Even the most troubled Japanese companies are pressured to continue employing surplus workers and retaining inefficient suppliers, while collusion between government and business often hides the true financial state of banks and corporations. Allowing bureaucrats to set industrial priorities has left Japan surprisingly uncompetitive in such growth fields as financial services and computer software.

A new challenge for the Japanese lies just ahead. By the year 2025, Japan will become the world's leading geriatric nation, with nearly 26% of its people age 65 or older. Karel Van Wolferen, a Japan expert who once viewed the country as almost omnipotent, now hopes that Japan somehow will succeed in "reinventing" itself. Perhaps as a retirement community?

So the new century, it seems, will belong not to Asia, America, or any other single geographic entity but to an increasingly interdependent world economy. Welcome to the Global Century, in which innovative Asians will flourish, but not dominate.

How Far, How Fast?

Is Central Europe ready to join the EU?

For the well-heeled business folk and bankers who crowd the Bristol Hotel's opulent bar in downtown Warsaw, it's as if communism never existed. No one ever talks about martial law anymore. The Berlin Wall is all but forgotten. These days, the hottest topics are the latest Mercedes S Class or fashionable vacation spots in the Seychelles. And when it comes to business, it's all about the European Union and the future, never Russia and the past. "Socialism is history," says Zofia Gaber, president of Agros Holding, a now privately run food processing conglomerate that makes and distributes vodka. "What concerns us now is when Poland will be accepted into the EU," she adds.

The same message echoes across Central Europe's other strong economies. Not only Poland but also Hungary, the Czech Republic, Slovenia, and even tiny Estonia— once a reluctant republic of the Soviet Union— expect to join the EU as early as 2003. They have already been preparing: The lion's share of their exports now goes to Western Europe. The rules and regulations governing their economic life increasingly come from Brussels. Their economies are rapidly being integrated into the vast and prosperous EU market. "That's only natural," says Hanna Gronkiewicz-Waltz, president of Nardowy Bank Polski, the Polish central bank. "When communism collapsed, it was obvious we would want to join the EU to guarantee our freedom and ensure our prosperity."

LOOMING BOOM? As that moment nears, some analysts believe the region's leading economies could be poised for a prolonged boom. Annual economic growth could reach 7% to 8% over the next decade, predicts Charles Robertson, an economist at ING Barings in London. "A convergence of factors would send growth through the roof," he says. Not least of these could be higher growth in the euro zone itself, as countries return to relatively expansionary policies now that the single currency has been introduced. That could provide a powerful locomotive effect for Eastern neighbors.

Yet even if this bright scenario plays out, the EU will be welcoming into its fold five countries that still lag desperately behind their Western European neighbors. It's the paradox of Central Europe: The region's best-governed countries have tackled the task of creating free markets with surprising vigor. But even after a decade of growth, the dead hand of communist-era economics weighs heavily on these lands.

Poland, Hungary, the Czech Republic, Slovenia, and Estonia have privatized large swaths of their economies, knocked state finances into shape, freed prices, deregulated markets, and curbed inflation. The living standards of their populations far exceed those of their counterparts in Romania and Bulgaria—not to mention Bosnia or Kosovo or corrupt Ukraine and Russia.

Even so, analysts predict that it could take 25 to 30 years before the gross domestic product of a Poland or a Hungary approaches the EU average. "A decade ago many Central Europeans thought they would catch up with the EU by the end of the century," says Jan Svejnar,

POLAND

Although rising, living standards in Poland and other Central European countries lag far behind those in the EU

the Prague-born executive director of the William Davidson Institute, an affiliate of University of Michigan Business School specializing in transitional economies. "But they underestimated the difficulty of changing from one system to another."

This shortfall between promise and reality could create serious problems for the New Europe as the EU embraces even its strongest neighbors to the East. The EU accession talks set to begin next year could become bogged down on major issues such as agricultural subsidies or the extent to which citizens of other former East Bloc countries should be able to visit or work in the EU. Even if there's political will to resolve such difficulties, the economic gap between eastern and western countries could pose longer-term problems for an expanded EU.

Indeed, if the Central European countries are admitted, the EU will have to live with a large group of low-income countries on its eastern flank for a generation to come. Integrating Portugal, Spain, and Greece into the

EU in the 1980s was hard enough. But bringing in five backward Central European countries could prove overwhelming. Most worrying, it could strain the $100 billion annual EU budget almost to the breaking point and paralyze decision-making, especially if individual member states retain the right to veto decisions that affect their national interest.

HUNGARY

Pharmaceuticals outfit Egis is producing a range of new drugs for sale in the EU

Two of the most pressing problems are likely to be Central Europe's low wage levels and joblessness. Technically unknown in the communist era, joblessness is at or near double digits in the five leading economies. That is only the official statistic. A layer of hidden unemployment, the legacy of overstaffing in industry and state bureaucracies, tops it off. It's also the result of government efforts to lure people out of the workforce through early retirement to keep unemployment figures down. Workers who leave their jobs receive up to 80% of their pay. But even full-time salaries are miserly compared with Western levels. The average Hungarian takes in about $10,000 before taxes, far below the average $27,000 income just across the border in Austria.

No wonder some EU politicians and trade unionists fear an onslaught of cheap Central European labor once the Poles, Czechs, and Hungarians are free to live and work in any EU state. The result could be lower wages and higher unemployment among the locals. Already, many of the workers on German construction sites come from Central Europe. "A lot of them are paid below the official rate," complains Antonio Pitolo, a 45-year-old Italian who works on a building site in Frankfurt.

Even more Western European jobs will be lost if companies from the EU keep investing in lower-cost Central Europe. This year, a total of $11 billion will be invested in Poland, Hungary, the Czech Republic, Estonia, and Slovenia (chart). That's four times as much as in 1991. The amount could rise by 20% next year.

Jobs are not the only issue. Integrating the Central Europeans in the EU will be particularly difficult if new members adopt the euro quickly. Poland's Gronkiewicz-Waltz talks about introducing the euro two years after accession. Gyorgy Suranyi, head of the National Bank of Hungary, plans to link Hungary's forint to the euro from Jan. 1, 2000.

MOMENTUM. But to qualify for the euro, Poland, Hungary, and other nearby states will need even more austerity to bring their budgets under control. Worse, these weak economies may suffer under a fairly strong currency like the euro, which could make exports far less competitive. Introducing the euro to Central Europe would also complicate policy-making at the European Central Bank. "It is difficult enough for the EU to manage a single monetary policy for the euro zone now," says Wolfgang Matis, managing director of European fixed income at Deutsche Bank in Frankfurt. "Imagine what it will be like with five more countries with far less advanced economies."

Despite the hazards, the momentum seems strongly in favor of expanding the EU to the east. A recent EU report warmly supported expansion. And most Central European politicians want to anchor their countries firmly to the free world. The enthusiasm, however, is not shared by all Central Europeans. Many workers, for example, worry that Western investors will buy their companies and restructure them out of their jobs. Employees at Ursus, the giant tractor factory on the outskirts of Warsaw, recently burned EU flags and protested violently against government plans to privatize the company, a move the factory hands fear will result in layoffs.

FOREIGN INVESTMENT

CZECH REPUBLIC

ESTONIA

HUNGARY

POLAND

ROMANIA

SLOVENIA

0 2 4 6
▶ 1999, BILLIONS OF DOLLARS

DATA: EUROPEAN BANK FOR RECONSTRUCTION & DEVELOPMENT

In Poland, farmers fear that their livelihood will be destroyed by EU membership. EU officials say it is likely that only large Polish farms will be entitled to subsidies under the EU's $45 billion-a-year Common Agricultural Policy. Small-scale farmers probably won't qualify. That's a serious issue in Poland because 27% of the population make their living from small farms. Farmers have taken to the streets against heavily subsidized food imports from the EU, which they say are undercutting them. "We will never agree for Poland to be a dumping ground for the EU's farm surpluses." says Andrzej Lepper, head of the radical Samoobrona peasants' union. He has called for an all-out strike from mid-November, which he hopes will paralyze the country. "If I were a Polish farmer or miner, I would have mixed feelings," acknowledges Horst Kuhler, president of the European Bank for Reconstruction & Development (EBRD). "It's understandable they should want to fight to protect their living standards."

Even some entrepreneurs are nervous about the greater competition that will come with EU membership. Ryszard Posyniak, president of the small, Warsaw-based

PC Express travel agency, has done well selling to Polish executives eager for corporate travel. "But now the global corporations are coming," he says. "We are very much afraid of this."

CZECH REPUBLIC

German capital and expertise have revitalized the once sluggish Skoda auto maker

The prospect is not all gloomy. Other private companies stand a real chance of surviving—or benefiting—if their countries join the EU. More than a quarter of privatized Hungarian enterprises now number strategic Western investors among their shareholders. The same companies generate 75% of the country's annual $23 billion in exports, with many of these sales going to parent companies in the EU.

Some are becoming real players on the European stage. Hungarian pharmaceutical company Egis, for example, is producing a range of new anti-hypertension drugs for sale primarily in the EU and the U.S. In the Czech Republic, Volkswagen says that its Skoda Automobilova is thriving. German capital and expertise coupled with relatively cheap Czech labor have revitalized the once sluggish auto maker. Sales are predicted to grow 8% this year, to $2.6 billion. Meanwhile, in Poland, 22 companies have launched initial public offerings this year on the Warsaw Stock Exchange. Among them is ComArch, a six-year-old Krakow-based company that produces software for financial and telecom firms. After going public earlier this year, ComArch now boasts a market cap of some $80 million.

NEW BLOOD. But there's no doubt the next few years will pose major challenges for Central Europe's strongest economies. As governments struggle to bring their legal and economic frameworks closer to Western European levels, businesses will be scrambling to profit from new opportunities—or simply trying to cope. The good news is that members of the market-oriented generation of young people who have entered the job market since 1989 are now making it into managerial positions. That should lead to a massive injection of entrepreneurship into the economy, and perhaps even into political leadership.

In recent weeks, European Commission President Romano Prodi has made it clear that expanding the European Union to the east is a top priority. Few observers doubt that the front-runners will be admitted by the middle of the next decade. For countries shackled by communism just a decade ago, that is a tremendous achievement. "Stand back from the day-to-day frustrations, and you realize just how much has been done by these countries," says the EBRD's Kuhler. But it will still take plenty of political will, sacrifice, and time for them to live up to the expectations unleashed by communism's collapse.

By David Fairlamb in London, with Dawn Smith in Warsaw and Christopher Condon in Budapest

A NEW TIGER

India used to pride itself on poverty-stricken self-sufficiency. Now it seeks growth, exports and foreign investment, and the economy is booming.

BY STEVEN STRASSER AND SUDIP MAZUMDAR

TRAVEL INTO THE DEPTHS OF Bihar, India's poorest state, along the dirt paths that connect its stagnant pools of humanity, past government signs touting chimerical health and education programs, into the hopeless heart of a subcontinent where the squalid villages might remind you of sub-Saharan Africa—except that the poorest Africans fare better than the destitute of Bihar. Eventually you will stumble onto the village of Kalipahari, blessed with electricity thanks to a nearby hydroelectric dam. Here you will see, in practically every hovel, an incongruous sight: a television set, pulling down American soap operas and Scotch whisky ads from Hong Kong. This is the Indian dream at ground level. As the vision of "Baywatch" filters through Bihar, so even the poorest of the poor finally begin to rise from the depths of rotted isolation.

And so does poor old India. For 50 years the national identity has depended on isolation from perceived enemies—from plotting neocolonialists in the West, from greedy multinational companies, even from those intrepid Indians who resisted the official creed of self-sufficiency. But now satellite TV has come to Bihar, and Coca-Cola, too. Health and education will one day follow. The leaders in New Delhi have a new national ideal—rapid growth—and, at least in spirit, they have thrown open the doors to multinationals everywhere. More important, they are forging a national identity more suited to modern times. India, at last, has begun to see itself as another Asian nation dedicated to the accumulation of wealth and the spread of prosperity. In the next century that vision will hold infinitely more power than the old asceticism. "Perhaps our industrialization is not complete," says Srini Rajam, head of the Texas Instruments branch in booming Bangalore, "but we can leapfrog into the Information Age."

India has always had pride. Now it has ambition. In the early years of independence, Jawaharlal Nehru's government rejoiced in standing apart, the epitome of the "non-aligned" nation. As a conglomeration of peoples with seven major religions and 18 official languages, India made its own rules: a democracy on a continent ruled by despots, a planned economy whose bureaucratic stewards were satisfied to creep along at a 3 or 4 percent "Hindu rate of growth." Only when the New Delhi elite squarely acknowledged that its hubris had put the nation on the sidelines of the global economy—while India's great rival China was getting rich—did real reforms begin. Now, six years into India's opening to the world, the economy is growing by nearly 7 percent a year, a rate that by 2020 will transform its economy into the world's fourth largest (after China, the United States and Japan). "There is a lot of political cacophony," says Finance Minister P. Chidambaram, who has served under two coalition governments in the last 14 months. "But we are on course."

There is no lilt to his optimism. A visitor to urban China (which is churning along at a growth rate of 9.5 percent a year) can almost hear the hum of enterprise in a nation that is fairly bursting to build a better life. The reformers of India, by contrast, tend to bow under the weight of their nation's great poverty. Even now, 52 percent of their people still live on incomes of less than $1 a day, according to World Bank figures. Nearly two thirds of Indian children younger than 5 are malnourished, and those who reach school age can count on an average of only 3.5 years of education if they are boys, 1.5 if they are girls. By the time they reach adulthood, half are still illiterate. Think of it: India is trying to accelerate onto the Information Superhighway with nearly 300 million adults who cannot read road signs.

Comparisons between India and the economic tigers of East Asia are equally dismal. Pacific Rim economies that once ranked far below India and its South Asian neighbors now enjoy per capita incomes 27 times greater, according to the Human Development Centre, a Pakistani think tank that studies regional economic trends. The blunt reality of India's failures is now driving its reforms, and most Indians agree on what must be done. From the Marxists running Calcutta to the Hindu nationals running Bombay (they call it Mumbai), the bywords of the new India are growth, foreign investment and, most hallowed of all, exports.

The strategy, formed in 1991 by the then prime minister P. V. Narasimha Rao and his finance minister, Manmohan Singh, was ruthlessly simple: to dismantle the stifling bureaucracy that once ruled India as intrusively as Moscow's planners once ran the Soviet Union. Rao and Singh cut much of the bureaucracy's "license raj" of red tape, then went on to simplify taxes, reduce the scope of the state sector (which provided everything from power to motor scooters), liberalize foreign investment and cut tariffs. From the earliest days, says Singh, "our goal has been to show the world that India can compete with any country in Southeast Asia in our hospitality to investment and our spirit of enterprise."

India's culture has also been a force for reaching out to the world. The film industry turns out both masterpieces and tawdry B movies in astonishing profusion. Using the imported English language in their own unique way, novelists like Arundhati Roy, 37, a former actress and screenwriter, have become international best sellers. The literary tradition has deep roots; Hindu poet and philosopher Rabindranath Tagore won the Nobel Prize in Literature as long ago as 1913.

From *Newsweek*, August 4, 1997, pp. 42-44,46. © 1997 by Newsweek, Inc. All rights reserved. Reprinted by permission.

Neither culture nor industry has done anything yet for the dregs of Indian society, the 200 million or so people at the very bottom of the ladder. But for the first time in history, economic growth and the spread of communications are working a revolution among many millions of India's other poor. New Delhi's program of teaming with foreign investors to string out copper wire for telephones is proceeding in fits and starts. Even in the capital, the wait for a new phone can still stretch to three years. Nonetheless, the government's decision to let in foreign satellite television has led to an explosion of more than 20 million cable-TV connections within the last two years. That alone had helped to spur demand among low-income consumers to unprecedented levels. A manufacturer of $1.20 bottles of shampoo for middle-class Indians found a huge new market for two-cent packets of the brand in poor areas. The race is on to produce cheap television sets and appliances. One entrepreneur found a way to convert devices for making lassi (a yogurt drink) into cheap washing machines. And the first developer of a good $50 refrigerator, suggests economist S. L. Rao, would now find a huge new market in rural India.

More important, India's poor are beginning to find their political voice. Indian democracy has always been hobbled by the primitive state of its grass-roots politics. Too many local leaders bubbled up to national power on their ability to buy votes and deliver favors—and subsequently used their national platforms mainly to enrich themselves. But the rural awakening that came with reform also has revived state and local politics. State competition for the spoils of reform is now common. Tamil Nadu attracted a Ford plant by waiving state sales taxes and offering land at a concessionary price. Uttar Pradesh won the battle to lure an electronics project set up by the Korean giant Daewoo.

The southern city of Bangalore, India's Silicon Valley, stands as the glittering tiara of the new India. Indians themselves own only 1.8 million installed personal computers—about a third the number in New York City. But what the info-tech companies stand for is vitally important. The homegrown firms and those allied with all the big names, from IBM to Intel, have exuberantly cut through red tape and protectionism, welcoming competition while becoming successful software exporters themselves. "If we can't compete with international brands in our own country, we can't hope to ever compete in other countries," says software-industry spokesman Dewang Mehta.

As India streamlines its bureaucracy and unclogs its courts, New Delhi and Mumbai may become more attractive to multinational corporations than the regulatory wilds of Beijing and Shanghai. If India can mobilize its hundreds of millions of young, cheap workers at a time when the work force of the developed world is aging, a boom of Chinese magnitude might not be out of the question. "Just think of the economic output we can generate from this population when our per capita income of $330 doubles early in the next century," says Mukesh Ambani, vice chairman of Mumbai's Reliance Industries. "That will clearly boost us into range of becoming an economic superpower."

Somehow the mantle of "superpower" does not quite fit the personality of a huge, poor country that will continue to regard itself, culturally and politically, as the world's great exception. Nor will India likely become a classic Asian tiger. As a vibrant democracy that must always tend to its own first, the nation will never produce a Deng Xiaoping to dictate its strategy from on high. The new Indian dynamo will muddle along, sure of its direction but never of its strategy, obsessed always with the myriad demands from within. "We will take one sector at a time, show that it works and build confidence," says Manmohan Singh. "There can be no big-bang theory of growth."

An outsider can gauge India's progress by measuring the market's success at shifting resources to the government's neediest constituents—something the centralized bureaucracy never could accomplish. How will life change in the most desolate regions of Bihar? At the absolute end of the line, in the village of Devnagra, a foreign donor recently gave $7,000 for a new well, the kind of gesture that short-circuits India's inefficiencies (to put it politely) rather than validating reform. Nonetheless, once fresh water comes to the village, it will be less hard to imagine a school, a clinic, even a road—and along that road, a thin copper wire connecting the darkest corner of India to the riches of the world.

With RON MOREAU *in Mumbai,* TONY CLIFTON *in New Delhi and* JOSHUA KWAN *in Hong Kong*

Unit 5

Key Points to Consider

❖ Are violent conflicts and warfare increasing or decreasing today? Explain your response.

❖ What changes have taken place in recent years in the types of conflicts that occur and in who participates?

❖ How is military doctrine changing to reflect new political realities?

❖ How is the role of the United States in global security likely to change? What about Russia and China?

❖ What institutional structures can be developed to reduce the danger of nuclear war?

 Links **www.dushkin.com/online/**

These sites are annotated on pages 6 and 7.

Do you lock your door at night? Do you secure your personal property to avoid theft? These are basic questions that have to do with your sense of personal safety and security. Most people take steps to protect what they have, including their lives. The same is true for groups of people, including countries.

In the international arena, governments frequently pursue their national interest by entering into mutually agreeable "deals" with other governments. Social scientists call these types of arrangements "exchanges" (i.e., each side gives up something it values in order to gain something it values even more). In simple terms, it functions like this: "I have the oil that you need. I will sell it to you if in turn you will sell me the agricultural products that I lack." Whether on the governmental level or the personal level ("If you help me with my homework, then I will drive you home this weekend"), this is the process used by most individuals and groups to "secure" and protect what is of value. The exchange process, however, can break down. When threats and punishments replace mutual exchanges, conflict ensues. Neither side benefits, and there are costs to both. Each side may use threats and hope that the other will capitulate, but if efforts at intimidation and coercion fail, the conflict may escalate into violent confrontation.

With the end of the cold war, the issues of national security are changing for the world's major powers. Old alliances are collapsing or being redefined, not only in Europe but in the Middle East and Asia as well. These changes have significant policy implications not only for the major powers but also for regional powers. Agreements between the leadership of the now-defunct Soviet Union and the United States led to the elimination of support for participants in low-intensity conflicts in Central America, Africa, and Southeast Asia. Fighting the cold war by proxy is now a thing of the past. Nevertheless, there is no shortage of conflicts in the world today.

The unit begins with a discussion of the emerging patterns of conflict in the post–cold war era. This is followed by a description of the types of conflicts that are likely to dominate and the challenges of keeping them from escalating into warfare. Then, specific case studies address ethnic violence, terrorism, and China's and Russia's security issues.

The unit concludes by examining one of the most important issues in history—the avoidance of nuclear war. Many experts initially predicted that the collapse of the Soviet Union would decrease the threat of nuclear war. However, many now believe that the threat has increased as control of nuclear weapons has become less centralized and the command structure less reliable. In addition, the proliferation of nuclear weapons into South Asia is a new security issue. What these changing circumstances mean for strategic weapons policy in the United States is also a topic of considerable debate. With this changing political context as the backdrop, the prospects for arms control and increased international cooperation are reviewed.

Like all the other global issues described in this anthology, international conflict is a dynamic problem. It is important to understand that conflicts are not random events, but, indeed, reveal patterns and trends. Forty-five years of cold war established a variety of patterns of international conflict as the superpowers contained each other with vast expenditures of money and technological know-how. The consequence of this stalemate was a shift to the developing world as the arena of conflict by superpower proxy. With the end of the cold war, these patterns are changing. A series of important questions are generated by these changing circumstances. Will there be more nuclear proliferation, or will there be less? Will the emphasis be shifted to low-intensity conflicts related to the interdiction of drugs or will some other issue determine the world's hot spots? Will economic problems turn the industrial world inward and allow a new round of ethnically motivated conflicts to become brutally violent, as we have seen in Yugoslavia and its former republics? The answers to these and related questions will determine the patterns of conflict in the post–cold war era.

Conflict

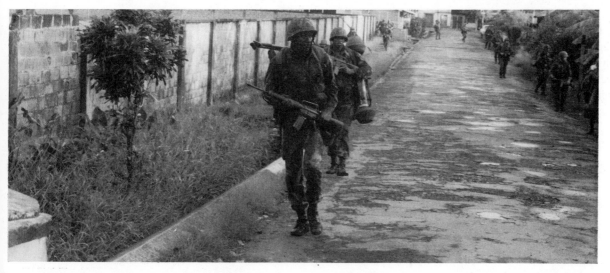

Life after Pax Americana

Charles A. Kupchan

This decade has been a relatively easy one for American strategists. America's preponderant economic and military might has produced a unipolar international structure, which has in turn provided a ready foundation for global stability. Hierarchy and order have devolved naturally from power asymmetries, making less urgent the mapping of a new international landscape and the formulation of a new grand strategy. The Bush and Clinton administrations do deserve considerable credit for presiding over the end of the Cold War and responding sensibly to isolated crises around the globe. But America's uncontested hegemony has spared them the task of preserving peace and managing competition and balancing among multiple poles of power—a challenge that has consistently bedeviled statesmen throughout history.

The coming decade will be a far less tractable one for the architects of U.S. foreign policy. Although the United States will remain atop the international hierarchy for the near term, a global landscape in which power and influence are more equally distributed looms ahead. With this more equal distribution of power will come a more traditional geopolitics and the return of the competitive balancing that has been held in abeyance by America's preponderance. Economic globalization, nuclear weapons, new information technologies, and the spread of democracy may well tame geopolitics and dampen the rivalries likely to accompany a more diffuse distribution of power. But history provides sobering lessons in this respect. Time and again, postwar lulls in international competition and pronouncements about the obsolescence of war have given way to the return of power balancing and eventually to great-power conflict.

The foreign policy team that takes office in 2001 will therefore face the onerous task of piecing together a grand strategy for managing the return to multipolarity. The challenge will be as demanding politically as it is intellectually. Recognizing that new power centers are emerging and adjusting to their rise will meet political resistance after 50 years of American primacy. Politicians and strategists alike will have to engage in long-term planning and pursue policies that respond

Charles A. Kupchan is associate professor of international affairs at Georgetown University and a senior fellow at the Council on Foreign Relations. He is the author, among other works, of The Vulnerability of Empire.

to underlying trends rather than immediate challenges. But American elites must rise to the occasion. The coming decade represents a unique window of opportunity; the United States should plan for the future while it still enjoys preponderance, and not wait until the diffusion of power has already made international politics more competitive and unpredictable.

In the next section I explain how and why a transition to a multipolar world is likely to come about in the near term. The United States will not be eclipsed by a rising challenger, as is usually the case during transitions in international hierarchy. Instead, a shrinking American willingness to be the global protector of last resort will be the primary engine of a changing global landscape. The key challenge, I then argue, will not be in preparing for battle with the next contender for hegemony but in weaning Europe and East Asia of their excessive dependence on the current hegemon, the United States. Europeans and East Asians alike have found it both comfortable and cheap to rely on American power and diplomacy to provide their security. Americans have gone along with the deal for decades because of the importance of containing the Soviet Union and the profitability of being at the center of global politics.

But now that communist regimes are a dying breed and the Cold War is receding into the past, America's protective umbrella will slowly retract. If this retrenchment in the scope of America's engagement abroad is not to result in the return of destructive power balancing to Europe and East Asia, the United States and its main regional partners must start now to prepare for life after Pax Americana.

Benign Power

Most analysts of international politics trace change in the distribution of power to two sources: the secular diffusion over time and space of productive capabilities and material resources; and balancing against concentrations of power motivated by the search for security and prestige. Today's great powers will become tomorrow's has-beens as nodes of innovation and efficiency move from the core to the periphery of the international system. In addition, reigning hegemons threaten rising secondary states and thereby provoke the formation of countervailing coalitions. Taken together, these dynamics drive the cyclical pattern of the rise and fall of great powers.[1]

In contrast to this historical pattern, neither the diffusion of power nor balancing against the United States will be important factors driving the coming transition in the international system. It will be decades before any single state can match the United States in terms of either economic or military capability. Current power asymmetries are extreme by historical standards. The United States spends more on defense than all other great powers combined and more on defense research and development than the rest of the world combined. Its gross economic output dwarfs that of most other countries and its expenditure on R&D points to a growing qualitative edge in a global economy increasingly dominated by high-technology sectors.[2] Nor is balancing against American power likely to provoke a countervailing coalition. The United States is separated from both Europe and Asia by large expanses of water, making American power less threatening. Furthermore, it is hard to imagine that the United States would engage in behavior sufficiently aggressive to provoke opposing alliances. Even in the wake of NATO's air campaign against Yugoslavia, U.S. forces are for the most part welcomed by local powers in Europe and East Asia. Despite sporadic comments from French, Russian, and Chinese officials about America's overbearing behavior, the United States is generally viewed as a benign power, not as a predatory hegemon.[3]

The Rise of Europe

The waning of unipolarity is therefore likely to stem from two novel sources: regional amalgamation in Europe and shrinking internationalism in the United States. Europe is in the midst of a long-term process of political and economic integration that is gradually eliminating the importance of borders and centralizing authority and resources. To be sure, the European Union is not yet an amalgamated polity with a single center of authority. Nor does Europe have a military capability commensurate with its economic resources.

But trend lines do indicate that Europe is heading in the direction of becoming a new pole of power. Now that its single market is accompanied by a single currency, Europe has a collective weight on matters of trade and finance rivaling that of the United States. The aggregate wealth of the European Union's 15 members is already roughly equal to America's, and the coming entry of the new democracies of Central Europe will tilt the balance in the EU's favor.

Europe has also recently embarked on efforts to forge a common defense policy and to acquire the military wherewithal to operate independently of U.S. forces. The European Union has appointed a high representative to oversee security policy, is establishing a policy planning unit, and is starting to lay the political groundwork for revamping its forces. It will be decades, if ever, before the EU becomes a unitary state, especially in light of its impending enlargement to the east, but as its resources grow and its decision-making becomes more centralized, power and influence will become more equally distributed between the two sides of the Atlantic.

American Reluctance

The rise of Europe and its leveling effect on the global distribution of power will occur gradually. Of more immediate impact will be a diminishing appetite for robust internationalism in the United States. Today's unipolar landscape is a function not just of America's preponderant resources but also of its willingness to use them to underwrite international order. Accordingly, should the will of the body politic to bear the costs and risks of international leadership decline, so too would America's position of global primacy.

On the face of it, the appetite of the American polity for internationalism has diminished little, if at all, since the collapse of the Soviet Union. Both the Bush and Clinton administrations have pursued ambitious and activist foreign policies. The United States has taken the lead in building an open international economy and promoting financial stability, and it has repeatedly deployed its forces to trouble spots around the globe. But American internationalism is now at a high-water mark and, for three compelling reasons, it will begin to dissipate in the years ahead.

First, the internationalism of the 1990s has been sustained by a period of unprecedented economic growth in the United States. A booming stock market, an expanding economy, and substantial budget surpluses have created a political atmosphere conducive to trade liberalization, expenditure on the military, and repeated engagement in solving problems in less fortunate parts of the globe.

Yet, even under these auspicious conditions, the internationalist agenda has shown signs of faltering. Congress, for example, has mustered only a fickle enthusiasm for free trade, approving NAFTA in 1993 and the Uruguay Round in 1994, but then denying President Clinton fast-track negotiating authority in 1997. Congress has also been skeptical of America's interventions in Bosnia and Kosovo, tolerating them, but little more. When the stock market sputters and growth stalls (and this is a matter of when, not if), these inward-looking currents will grow much stronger. The little support for free trade that still exists will dwindle. And such stinginess is likely to spread into the security realm, intensifying the domestic debate over burden sharing and calls within Congress for America's regional partners to shoulder increased defense responsibilities.

Second, although the United States has pursued a very activist defense policy during the 1990s, it has done so on the cheap. Clinton has repeatedly authorized the use of force in the Balkans and in the Middle East. But he has relied almost exclusively on air power, successfully avoiding the casualties likely to accompany the introduction of ground troops in combat. In Somalia, the one case in which U.S. ground troops suffered significant losses, Clinton ordered the withdrawal of U.S. forces from the operation. In NATO's campaign against Yugoslavia, week after week of bombing only intensified the humanitarian crisis and increased the likelihood of a southward spread of the conflict. Nevertheless, the United States blocked the use of ground forces and insisted that aircraft bomb from 15,000 feet to avoid being shot down.

Congress revolted despite these operational constraints minimizing the risks to U.S. personnel. A month into the campaign, the House of Representatives voted 249 to 180 to refuse funding for sending U.S. ground troops to Yugoslavia without congressional permission. Even a resolution that merely endorsed the bombing campaign failed to win approval (the vote was 213 to 213). In short, the American polity appears to have near zero tolerance for casualties. The illusion that internationalism can be maintained with no or minimal loss of life will likely come back to haunt the United States in the years ahead, limiting its ability to use force in the appropriate manner when necessary.

Third, generational change is likely to take a toll on the character and scope of U.S. engagement abroad. The younger Americans already rising to positions of influence in the public and private sectors have not lived through the formative experiences—the Second World War and the rebuilding of Europe—that serve as historical anchors of internationalism. Individuals schooled in the 1990s and now entering the work force will not even have first-hand experience of the Cold War. These Americans will not necessarily be isolationist, but they will certainly be less interested in and knowledgeable about foreign affairs than their older colleagues—a pattern already becoming apparent in the Congress. In the absence of a manifest threat to American national security, making the case for engagement and sacrifice abroad thus promises to grow increasingly difficult with time. Trend lines clearly point to a turning inward, to a nation tiring of carrying the burdens of global leadership.

Bad News and Good News

The bad news is that the global stability that unipolarity has engendered will be jeopardized as power becomes more equally distributed in the international system. The good news is that this structural change will occur through different mechanisms than in the past, and therefore *may* be easier to manage peacefully.

The rising challenger is Europe, not a unitary state with hegemonic ambitions. Europe's aspirations will be moderated by the self-checking mechanisms inherent in the EU and by cultural and linguistic barriers to centralization. In addition, the United States is likely to react to a more independent Europe by stepping back and making room for an EU that appears ready to be more self-reliant and more muscular. Unlike reigning hegemons in the past, the United States will not fight to the finish to maintain its primacy and prevent its eclipse by a rising challenger. On the contrary, the United States will cede leadership willingly as its economy slows and it grows weary of being the security guarantor of last resort.

The prospect is thus not one of clashing titans, but of no titans at all. Regions long accustomed to relying on American resources and leadership to preserve the peace may well be left to fend for themselves. These are the main reasons that the challenge for American grand strategy as the next century opens will be to wean Europe and East Asia of their dependence on the United States and put in place arrangements that will prevent the return of competitive balancing and regional rivalries in the wake of an American retrenchment.

Europe on Its Own

It is fortunate that the near-term challenge to U.S. primacy will come from Europe. After decades of close cooperation, Europe and North America enjoy unprecedented levels of trust and reciprocity. European states have gone along with U.S. leadership not just because they have not had the power and influence to do otherwise; despite cavils, they also welcome the particular brand of international order sustained by the United States. A more equal distribution of power across the Atlantic will no doubt engender increased competition between a collective Europe and the United States. But such conflict is likely to be restricted to economic matters and muted by the mutual benefits reaped from high levels of trade and investment. Furthermore, the underlying coincidence of values between North America and Europe means that even when interests diverge, geopolitical rivalry is not likely to follow. Efforts to preserve an Atlantic consensus may well lead to a lowest common denominator and produce inaction (as has occurred repeatedly in the Balkans). But it is hard to imagine the United States and Europe engaging in militarized conflict.

In this sense, the key concern for the coming decade is not the emergence of balancing between Europe and the United States, but the reemergence of balancing and rivalries *within* a Europe no longer under American protection. The European Union is well

on its way to erecting a regional order that can withstand the retraction of American power. Through a steady process of pooling sovereignty, Europe has nurtured a supranational character and identity that make integration irreversible. Nevertheless, guaranteeing a self-sustaining and coherent European polity requires that Europe and the United States together pursue three initiatives.

A Window of Opportunity

To begin, Europe must follow through with the initial steps it has taken to create a military establishment capable of carrying out major missions without the assistance of U.S. forces. The United States should be far more forthcoming in welcoming this initiative, and stop worrying that an independent European military would undercut the transatlantic security link by fueling calls in Congress for the withdrawal of U.S. troops. NATO will be in much better shape five years hence if Europe is carrying a fair load than if Congress continues to see a Europe free-riding on American soldiers. Far from expediting a U.S. departure from the continent, a serious European military will only increase the chances that a mature and balanced transatlantic partnership emerges and that America maintains a presence in Europe.

Europe now has a window of opportunity to make serious progress on the defense front. A number of factors afford this opening: British willingness to take the lead on forging a collective defense policy; recognition within the EU of Europe's excessive dependence on U.S. capability (made clear by the campaign against Yugoslavia); and the appointment of a new European Commission, with Romani Prodi as its president and Javier Solana as its high representative for security policy.

The top priorities for EU members include moving to all-volunteer forces so that defense expenditures can go toward buying capability and force-projection assets, not paying poorly trained conscripts. Europe's defense industry must be consolidated to improve economies of scale, and more funding should go toward research and development and improving the technological sophistication of weapons and intelligence systems. Europe must also make tough decisions about an appropriate division of labor among its member states if it is to build a balanced and capable force structure.

Promoting a stable peace in southeastern Europe is the second key piece of unfinished business for Europe and the United States. The task of halting ethnic conflict in the Balkans repeatedly paralyzed both NATO and the EU throughout the decade. The European enterprise would have been set back grievously had NATO failed to act in Bosnia and Kosovo. Now that the fighting has stopped, the international community must take advantage of the opportunity to construct a lasting peace. That goal ultimately means drawing the Balkans into the European Union. Rapprochement between Greece and Turkey and resolution of the Cyprus problem are no less important if Europe is to avoid being engulfed in persistent crises in its southeast. In its quest to help ensure that Europe does not again fall prey to national rivalries, the United States should make southeastern Europe a top regional priority.

Embracing Russia in a wider Europe is the third step needed to prevent the return of rivalries and shifting balances of power to the continent. Russia in the years ahead will gradually reassume its position as one of Europe's great powers. If Russia is included in the European enterprise, its resources and influence will likely be directed toward furthering continent-wide integration. If it is excluded from the European project, Russia will likely seek a coalition to balance against Europe. Indeed, the enlargement of NATO has already increased the likelihood of such balancing by raising the prospect that Russia's entire western flank will abut the Atlantic Alliance.

Instead of using NATO to protect against a threat that no longer exists, its members should use the organization as a vehicle for anchoring Russia in Europe.[4] The EU is the more appropriate vehicle for this task, but its enlargement is lagging way behind NATO's because of the institutional changes and financial costs entailed in adding new members. Furthermore, the integration of Russia into the Atlantic community, in part because of European resistance on cultural grounds, will require considerable American influence and leadership—assets that NATO provides. While it is still Europe's chief peacemaker and protector, the United States needs to ensure that Russia is included in Europe's historic process of pacification and integration.

East Asia Estranged

Preparing East Asia to rely less on American power is far more complicated and dangerous than the parallel task in Europe. The key difference is that European states took advantage of America's protective umbrella to pursue reconciliation, rapprochement, and an ambitious agenda of regional cooperation and integration. Europeans have accordingly succeeded in fashioning a regional order that is likely to withstand the retraction of American power. In contrast, states in East Asia have hidden behind America's presence, pursuing neither reconciliation nor regional integration. East Asia's major powers remain estranged.

The United States therefore faces a severe trade-off in East Asia between the balancing provoked by its predominant role in the region and the intraregional

balancing that would ensue in the wake of an American retrenchment. America's sizable military presence in East Asia keeps the peace and checks regional rivalries. But it also alienates China and holds in place a polarized political landscape.

As China's economy and military capability grow, its efforts to balance against the United States could become more pronounced. Were the United States to back off from its role as regional arbiter and protector, relations with China would improve, but at the expense of regional stability. Japan and Korea would no doubt increase their own military capabilities, risking a regionwide arms race and spiraling tensions.

If the United States is to escape the horns of this dilemma, it must help repair the region's main cleavage and facilitate rapprochement between East Asia's two major powers: Japan and China. Just as reconciliation between France and Germany was the critical ingredient in building a stable zone of peace in Europe, Sino-Japanese rapprochement is the sine qua non of a self-sustaining regional order in East Asia.

Primary responsibility for improving Sino-Japanese ties lies with Japan. With an economy and political system much more developed than China's, Japan has far more latitude in exploring openings in the relationship. Japan can also take a major step forward by finally acknowledging and formally apologizing for its behavior during the Second World War. The United States can further this process by welcoming and helping to facilitate overtures between Tokyo and Beijing.

Washington should also help dislodge the inertia that pervades politics in Tokyo by making it clear to the Japanese that they cannot indefinitely rely on American guarantees to ensure their security. Japan therefore needs to take advantage of America's protective umbrella while it lasts, pursuing the policies of reconciliation and integration essential to constructing a regional security order resting on cooperation rather than deterrence.

If overtures from Tokyo succeed in reducing tensions between China and Japan, the United States would be able to play a less prominent role in the region, making possible an improvement in its own relations with China. As it buys time for Sino-Japanese rapprochement to get underway, Washington should avoid the rhetoric and policies that might induce China to intensify its efforts to balance against Japan and the United States. Talk of an impending Chinese military threat is both counterproductive and misguided; the Chinese military is nowhere near world-class.[5] The United States should also avoid provocative moves, such as deploying antimissile defenses in the Western Pacific theater or supporting a Taiwanese policy of moving toward formal independence. China can do its part to strengthen its relationship with the United States by containing saber-rattling over Taiwan, halting the export of weapons to rogue states, and avoiding actions and rhetoric that could inflame territorial disputes in the region.

A Global Directorate

If my analysis is correct, the most dangerous consequence of a return to multipolarity is not balancing between North America, Europe, and East Asia, but the reemergence of national rivalries and competitive balancing within Europe and East Asia as American retrenchment proceeds. It is for this reason that American grand strategy should focus on facilitating regional integration in Europe and East Asia as a means of preparing both areas to assume far more responsibility for managing their own affairs.

The ultimate vision that should guide U.S. grand strategy is the construction of a concert-like directorate of the major powers in North America, Europe, and East Asia. These major powers would together manage developments and regulate relations both within and among their respective regions.

Mustering the political will and the foresight to pursue this vision will be a formidable task. The United States will need to begin ceding influence and autonomy to regions that have grown all too comfortable with American primacy. Neither American statesmen, long accustomed to calling the shots, nor statesmen in Europe and East Asia, long accustomed to passing the buck, will find the transition an easy one.

But it is far wiser and safer to get ahead of the curve and shape structural change by design, than to find unipolarity giving way to a chaotic multipolarity by default. It will take a decade, if not two, for a new international system to evolve. But the decisions taken by the first American administration of the twenty-first century will play a critical role in determining whether multipolarity reemerges peacefully or brings with it the competitive jockeying that in the past has so frequently led to great-power war.

Notes

1. See Robert Gilpin, *War and Change in World Politics* (Cambridge: Cambridge University Press, 1981); Paul M. Kennedy, *The Rise and Fall of the Great Powers* (New York: Random House, 1987); and Christopher Layne, "The Unipolar Illusion: Why New Great Powers Will Rise," *International Security*, vol. 17 (spring 1993).
2. William C. Wohlforth, "The Stability of a Unipolar World," *International Security*, vol. 24 (summer 1999).
3. On the concept of benign power, see Charles Kupchan, "After Pax Americana: Benign Power, Regional Integration, and the Sources of a Stable Multipolarity," *International Security*, vol. 23 (fall 1998).
4. See Charles Kupchan, "Rethinking Europe," *The National Interest*, no. 56 (summer 1999).
5. See Bates Gill and Michael O'Hanlon, "China's Hollow Military," *The National Interest*, no. 56 (summer 1999); and Gerald Segal, "Does China Matter?" *Foreign Affairs*, vol. 78 (September/October 1999).

The Post-Modern State and the World Order

Robert Cooper

ROBERT COOPER, A BRITISH DIPLOMAT BASED IN BONN, IS PERHAPS THE MOST INSIGHTFUL GEOPOLITICAL THINKER OF THE PRESENT MOMENT. THIS ARTICLE, THE FIRST PART OF WHICH APPEARED IN THE SUMMER 1997 ISSUE OF *NPQ*, HAS BEEN PUBLISHED IN PAMPHLET FORM BY DEMOS, A THINK TANK AND PUBLISHING HOUSE IN LONDON.

A COPY MAY BE OBTAINED BY CONTACTING DEMOS BY PHONE AT 011-44-171-353-4479 OR BY FAX AT 011-44-171-353-4481 OR E-MAIL @ DEMOS.CO.UK, WEBSITE: WWW.DEMOS.CO.UK.

THE OPINIONS EXPRESSED IN THIS ARTICLE ARE THE AUTHOR'S OWN AND SHOULD NOT BE TAKEN AS AN EXPRESSION OF OFFICIAL GOVERNMENT POLICY.

BONN—This is a new world, but there is neither a new world order—to use the phrase that was fashionable in the early 1990s; nor is there a new world disorder—to use the phrase that is more fashionable today. Instead there is a zone of safety in Europe, and outside it a zone of danger and a zone of chaos.

A world divided into three needs a threefold security policy and a threefold mindset. Neither is easy to achieve.

Before we can think about the security requirements for today and tomorrow, we have to forget the security rules of yesterday. The 20th century has been marked by absolutes. The war against Hitler and the struggle against communism had to be won. The only possible policy was absolute victory, unconditional surrender.

In the more complex and more ambiguous post–Cold War world we shall not face the same total threats or need to use the same total war against them. We have to forget therefore that the only purpose of the military is to win complete victories. In none of the three worlds that we live in will this be appropriate.

SECURITY AND THE POST-MODERN ZONE

There may be no new world order but there is a new European security order. Our task must be to preserve and extend it. Broadly speaking that is what European countries are doing. The task is to promote open democratic institutions, open market economies and open multilateral/transnational diplomacy with as many of our neighbors as possible. Among ourselves we have to maintain these habits and to improve them in the hope that the key transnational institutions—the EU and NATO—will eventually acquire some of the permanence and solidity that our national institutions enjoy. That means essentially acquiring more loyalty and more legitimacy.

> There is a zone of safety in Europe, and outside it a zone of danger and a zone of chaos.

The key question for European security, in the narrow sense, will be how Russia turns out. It must be our central interest to draw Russia into the post-modern European system. That means not just exporting democracy and markets but also bringing Russia into our system of multilateral diplomacy. This cannot be achieved overnight; for the moment, our goal should not be to close off any options. If the Russians decide to retreat to the old system of security by military power, that, regrettably, is their business. Our policy should be to do everything possible to make the alternative course of security by confidence and cooperation—that is to say post-modern security—possible and attractive to them.

Advice for the post-modern state: Never forget that security can be achieved more by cooperation than by competition.

SECURITY AND THE MODERN WORLD

Dealing with the modern world, the world of ambitious states, requires a different approach. If eventually these states decide to join a post-modern system of open diplomacy, so much the better; but this will take time, and between now and then lie many dangers. The Gulf War provides an illustration both of the dangers and of how they should be dealt with. One ambitious state attacks another, threatening vital Western interests. In the case of the Gulf War, the interests in question were twofold: first, the maintenance of a plurality of states in an area of the world containing vital oil supplies (in global energy terms this is a policy similar to the traditional British requirement that there should be a plurality of powers on the European continent). The second interest was to ensure that a dangerous and ambitious state did not get its hands on weapons that could ultimately threaten the West itself. Had Saddam Hussein been allowed to retain Kuwait, he would have become the geopolitical master of the Gulf; and the wealth available to him would have financed whatever weapons program he desired.

The Western response was precisely as it should be: build the most powerful coalition possible, reverse the aggression, punish the aggressor, deal with the weapons programs. These limited goals required limited means. They did not imply that Iraq should be invaded or occupied or that Saddam Hussein should be removed from power (attractive is that idea undoubtedly is). The reference point for a war of this nature is the 18th or 19th century, not the 20th-century wars of absolutes. The Gulf War was a war of interests, not a clash of ideologies.

Note that the reasons for fighting this war were not that Iraq had violated the norms of international behavior. Unfortunately, the reality of the world is that if you invade a country which lies some way outside the vital interests of the powerful, you will probably get away with it. Very likely you will be condemned and your gains will not be recognized (if you choose to keep them); you will

> Never forget that security can be achieved more by cooperation than by competition.

lose trust and reputation; you may suffer economic sanctions for a while. But you will not be attacked by the powerful. If India were to invade Nepal, for example, or Argentina Paraguay, it is unlikely that a Gulf War coalition would be put together to reverse the result.

The initial enthusiasm for the idea of a new world order that followed the Gulf War was based on the hope that the UN was going to function as originally intended: a world authority policing international law, that is to say a collective-security organization. In one sense that hope was not unreasonable. The end of the Cold War took us back to 1945. Institutions which had grown up because of or against the background of the Cold War, such as NATO or the EU, began to look in need of radical change. The UN was a pre–Cold War institution and, therefore, might become a workable post–Cold War institution. Up to a point this proved to be the case. The UN is more active today than it ever was during the Cold War (between 1946 and 1990 there were 683 Security Council Resolutions; in the period since then there have been more than 350; and, at the same time, there are some half a million UN troops in the field today).

> The reality of the world is that if you invade a country which lies some way outside the vital interests of the powerful, you will probably get away with it.

The UN is, however, active in peacekeeping and humanitarian work rather than as a collective-security organization.

A collective-security order is one in which the international community enforces international law on recalcitrant states. This would certainly be a new order in the sense that we have never seen anything of the kind in the history of international relations. Unfortunately we are never likely to see it either.

The complaint of many people about the UN's role in Yugoslavia is precisely that it is not enforcing international law. But then it is quite clear that no one is willing to do that. Perhaps that is just as well. War is a serious business. It is dangerous to get involved in wars for principles; one risks finding oneself in the position of the Americans in Vietnam, that "sometimes you have to kill people in order to save them." And in the end, because wars fought for other people are difficult to

sustain in domestic opinion, one may end up not even saving them. War is, and should be, a last resort: The world would surely be a safer and more peaceful place if countries fought only when there are vital interests to defend. Some mistook the Gulf War as a war for principles or a collective-security action—and indeed the political rhetoric at the time fostered this impression. In fact, it was a collective defense of interests by the West. The Gulf War was fought to protect an old order, not to create a new one.

In a different sense though, a collective-security order would not really be new. Collective security is a combination of two old ideas: stability through balance and stability through hegemony. The *status quo* is maintained by a world body of overwhelming power (the hegemonic element), which throws its weight on the side of a state which is the victim of aggression—the balance of power, that is, with the world community as the balancing actor. This is the old world of state sovereignty in which others do not interfere, of coalitions, of security through military force. The UN-as-a-collective-security-organization, is there to defend the *status quo* and not to create a new order.

> The UN-as-a-collective-security-organization, is there to defend the status quo and not to create a new order.

For the post-modern state there is, therefore, a difficulty. We need to get used to the idea of double standards. Among ourselves we operate on the basis of laws and open cooperative security. But when dealing with more old-fashioned kinds of states we need to revert to the rougher methods of an earlier era—force, preemptive attack, deception, whatever is necessary for those who still live in the 19th-century world of every state for itself.

Advice for post-modern states: Those who have friendly, law-abiding neighbors should not forget that in other parts of the world the law of the jungle reigns. Among ourselves, we keep the law but when we are operating in the jungle, we also must use the laws of the jungle. In the coming period of peace in Europe there will be a temptation to neglect our defenses, both physical and psychological. This represents one of the great dangers for the post-modern state.

SECURITY AND THE PRE-MODERN WORLD

What of the pre-modern chaos? What should we do with that? On the basis of rational calculation of interest, the answer should be: as little as possible. Chaos does not represent a threat, at least not the kind that requires a conventional military response. One may need to bar one's door against its byproducts—drugs, disease, refugees—but these are not threats to vital interests that call for armed Western intervention. To become involved in a zone of chaos is risky—if the intervention is prolonged it may become unsustainable in public opinion; if the intervention is unsuccessful it may be damaging to the government that ordered it.

Besides, what form should intervention take? The most logical way to deal with chaos is by colonization, or hegemony. But this is unacceptable to post-modern states. So if the goal is not colonization, what should it be? Usually the answer will be that the goals will be ambiguous.

> The most logical way to deal with chaos is by colonization, or hegemony.

The risk of "mission creep" is therefore considerable. Those who become involved in the pre-modern world run the risk that ultimately they will be there because they are there. All the conventional wisdom and all realistic doctrines of international affairs counsel against involvement in the pre-modern world.

And yet such "realistic" doctrines, for all their intellectual coherence, are not realistic. The post–Cold War, post-modern environment is one where foreign policy will be driven by domestic politics; and these will be influenced by the media and by moral sentiment. We no longer live in the world of pure national interest. Human rights and humanitarian problems inevitably play an important part in our policy-making.

A new world order may not be a reality but it is an important aspiration, especially for those who live in a new European order. The wish to protect individuals, rather than to resolve the security problems of states, is a part of the post-modern ethos. In a world where many states suffer breakdowns there is wide scope for humanitarian intervention. Northern Iraq, Somalia, Yugoslavia and Rwanda are only the beginning of a trend. Operations in these areas are a halfway house between the calculation of interest which tells you not to

get involved and the moral feeling which tells the public that something must be done. In different ways all these operations have been directed toward helping civilians—against the military, the government or the chaos. The results are not always impressive and the interventions are in some respects half-hearted. That is because they dwell in the ambiguous half-world where interest tells you to stay out and conscience tells you to go in—between Hobbes and Kant. Such interventions may not solve problems, but they may salve the conscience. And they are not necessarily the worse for that.

> Advice to post-modern states: accept that intervention in the pre-modern is going to be a fact of life.

Thus we must reconcile ourselves to the fact that we are going to get involved in situations where interest and calculation would tell us to stay out. In this case there are some rules to observe. The first is to moderate the objectives to the means available. The wars of ideology called for total victory; in the pre-modern world victory is not a relevant objective.

Victory in the pre-modern world would mean empire. The post-modern power that is there to save the lives of individual civilians wants to stop short of that. In consequence, goals must be even more carefully defined than in wars of interest. They will be goals of relatives and not of absolutes: more lives saved, lower levels of violence among the local populations; and these must be balanced by low casualties for the interveners. At the same time we must be prepared to accept, indeed we must expect, failure a good deal of the time. And then we must be prepared to cut our loses and leave. The operation in Somalia was not a success for anybody. And yet it was not unreasonable to try (though perhaps the trial might have been better organized). It gave those responsible in Somalia a breathing space, a chance to sort themselves out. That they failed to take that chance was not the fault of the intervention force. It follows also that when intervening in the pre-modern world, Clausewitz doctrine still applies: War is the pursuit of politics by other means. Military intervention should always be accompanied by political efforts. If these fail, or if the cost of the military operation becomes too great, then there is no alternative but to withdraw.

Advice to post-modern states: accept that intervention in the pre-modern is going to be a fact of life. To make it less dangerous and more sustainable in the long run, there are four requirements: clear, limited objectives; means also with clear limits attached to them; a political process to parallel the military operation; and a decision, taken in advance, to withdraw if objectives are not achieved in a given time.

THE NEW EUROPEAN ORDER

This essay is intended to say many things, but especially to say this one thing. That there is no new world order is a common conception. But it is less widely understood that there is a new European order, new in that it is historically unprecedented and also new because it is based on new concepts. Indeed the order has to a large extent preceded the concepts. One commentator who fails to understand this—though he understands most other things better than the rest of us and describes them with great elegance and clarity—is Henry Kissinger. In a recent speech he said the following: "In a world of players of operationally more or less equal strength, there are only two roads to stability. One is hegemony and the other is equilibrium." This was the choice in the past, but today it no longer works. Balance is too dangerous; hegemony is no longer acceptable in a liberal world that values human rights and self-determination.

> Hegemony is no longer acceptable in a liberal world that values human rights and self-determination.

Instead there is a third possibility. In fact there have been three sets of alternatives: first came the choice between chaos and empire, or instability or hegemony. Then it was a choice between empire and nationalism, or hegemony or balance. Finally, today we have a choice between nationalism and integration, or balance or openness. Chaos is tamed by empire; empires are broken up by nationalism; nationalism gives way, we hope, to internationalism. At the end of the process is the freedom of the individual, first protected by the state and later protected from the state.

The kind of world we have depends on the kind of states that compose it. For the pre-modern world success is empire and failure is disorder; in the modern system success is

balance and failure means falling back into war or into empire. For the post-modern state success means openness and transnational cooperation. The open state system is the ultimate consequence of the open society. Failure, we shall come to in a moment.

This categorization is not intended to be exclusive—the future is full of surprises (and so indeed is the past). Nor is it intended to represent some inevitable Hegelian progression. Progress it certainly represents, but there is nothing inevitable about it. In particular there is nothing inevitable about the survival of the post-modern state in what remains basically a hostile environment.

> It may be that in Western Europe the era of the strong state— 1648 to 1989— has now passed.

The post-modern order faces three dangers. First there is the danger from the pre-modern. The risk here is one of being sucked in for reasons of conscience and then being unwilling either to conquer or to get out. In the end the process may be debilitating for morale and dangerous for military preparedness.

In that case the coup de grace would be administered from the modern world. States reared on raison d'état and power politics make uncomfortable neighbors for the post-modern democratic conscience. Supposing the world develops (as Kissinger suggests it might) into an intercontinental struggle. Would Europe be equipped for that? That is the second danger—the danger from the modern.

The third danger comes from within. A post-modern economy can have the result that people live only for themselves, and not at all for the community—the decline of birth rates in the West is already evidence of this tendency. There is a risk too that the deconstruction of the state may spill over into the deconstruction of society. In political terms an excess of transparency and an over-diffusion of power could lead to a state and to an international order in which nothing can be done, because there is no central focus of power or responsibility. We may all drown in complexity.

It may be that in Western Europe the era of the strong state—1648 to 1989—has now passed, and we are moving toward a system of overlapping roles and responsibilities with governments, international institutions and the private sector all involved but none of them entirely in control. Can it be made to work? We must hope so, and we must try.

EUROPE at Century's End

The Challenge Ahead

BY RICHARD N. HAASS

The year 1999 marks the end of the first decade of the post–Cold War world. For Europe, a region central to the Cold War—where it both began and ended—1999 is also proving to be a year of historic import, the most important on the continent since 1989, when the wall came down and Europe's division came to an abrupt and for the most part unanticipated end.

This claim can be justified by pointing to many events and trends, including the fitful progress toward reconciliation in Northern Ireland and Germany's emergence as a more "normal" country, one able to use military force beyond its borders as part of a nondefensive NATO action. Still, four developments in 1999 stand out: European Monetary Union and the launch of the euro; the entry of Poland, Hungary, and the Czech Republic into NATO and the articulation of a new strategic concept for the Alliance

Richard N. Haass, vice president and director of the Brookings Foreign Policy Studies program, is the author of The Reluctant Sheriff: The United States after the Cold War *(Brookings, 1997) and editor of* Transatlantic Tensions: The United States, Europe, and Problem States *(Brookings, 1999).*

From *The Brookings Review,* Summer 1999, pp. 4-9. © 1999 by the Brookings Institution. Reprinted by permission.

Membership and Alliances

- NATO AND EMU
- EMU ONLY
- NATO ONLY
- NEITHER

GLENN PIERCE

as it passed the half-century mark; the continuing deterioration of conditions within Russia and in U.S.-Russian relations; and the Kosovo conflict, the largest military clash on the continent since the Second World War.

Bearish on Russia

Russia is in many ways the most vexing, significant, and unexpected problem to cloud Europe's horizon. Russian weakness is proving a more complex challenge to Europe and the United States than did Soviet strength. The stakes are great, not so much in the economic sphere, where the actual or potential global impact is limited given Russia's small and increasingly barter-driven economy, but rather strategically, given Russia's ability to influence events in Europe through its political and military power and its nuclear arsenal.

But Russia's economic situation has grave strategic implications. An economically weak Russia is much more likely to pose a strategic threat, be it through arms sales to problem countries, authorized (or unauthorized) provision of technology to the

unconventional weapons programs of so-called rogue states, a greater reliance on nuclear weapons to offset a growing inferiority in conventional arms, and, most worrisome, a loss of control over its own nuclear arsenal.

There is no single answer to the challenge posed by a weak Russia. It is, however, possible to rule out some alleged answers that are

clearly misguided, including neglect. Russia needs help from the outside, but only on a conditional basis. Conditionality is necessary if economic assistance is to gain the required political support within donor societies and if funds are to do anything more than enrich corrupt individuals within Russia. Among the other lessons of the past few years is that market economic reform cannot occur (much less be sustained) in a vacuum if it is to be something other than crony capitalism;

basic infrastructure improvements—property rights, securities regulation, generally accepted accounting practices, bankruptcy proceedings, and so on—are essential.

All this will take time, though, something that does not square with the urgent challenges posed by Russia's enormous but unsafe nuclear arsenal. Bruce Blair and

> **The United States cannot have it both ways, urging that Europe do more, but do America's bidding and no more.**

Clifford Gaddy suggest a range of measures, from the relatively modest—a U.S.-Russian accord to reduce the alert status of their weapons to lessen the chance of crisis instability, a cut in the number of deployed strategic nuclear systems to well below START II levels—to the ambitious, including a grand bargain in which the United States and Europe would buy much of the Russian nuclear stockpile. The latter would be costly but so would the alternatives—modernizing

U.S. nuclear forces or building large defensive systems to protect against a Russian attack. Moreover, trading bombs for dollars would improve American and European security and bolster Russia's economy. Such thinking may be too "outside the box" for many but it is hard to see where staying the course—and seeing conditions within Russia or in U.S.-Russian relations continue to worsen—would serve any American or European interest.

Working out a constructive relationship with Russia over the past decade has been complicated by differences over how best to promote peace and security throughout Europe. Until 1999, much of the disagreement centered on Western plans to enlarge NATO by offering membership to former members of the Warsaw Pact, among others.

These differences caused strains but not a breach in relations with Russia, as evidenced by Russian willingness to sign an agreement—the so-called Founding Act—that institutionalized NATO-Russian consultations. Russia's participation in the Bosnia peacekeeping effort was another sign that it was prepared to contribute to European security despite its unhappiness over NATO's growth.

Whether such a restrained "agreement to disagree" can continue if NATO enlargement proceeds is less clear. Bringing Russia into NATO at some point is an option, but one that would require the emergence of a very different Russia—and result in the emergence of a very different NATO. But regardless of whether Russia ever formally joins NATO, James Goodby is correct when he argues that European security will benefit directly and dramatically from a Russia that is democratic, prosperous, and stable—and not alienated from the United States and the countries of Western Europe. Avoiding such alienation, Goodby suggests, will require sensitivity and compromise on both sides: the West will have to keep Russian concerns in mind as it uses force in Europe and proceeds with NATO enlargement; Russia for its part must work with the United States and Europe in combating the proliferation of weapons of mass destruction, terrorism, and threats to innocent peoples from their governments. The only thing that is certain is that making Europe "whole and free"—not to mention peaceful and prosperous—promises to be a long-term, difficult proposition. For the immediate future, James Goldgeier puts forward the logical and, to many, persuasive argument that it makes no sense to stop NATO enlargement now. To do so would only redraw the line dividing Europe and deny the advantages of NATO membership to other deserving states. But further enlargement is hardly problem free. Beyond its economic costs and the risk that it would further complicate Alliance decisionmaking is the risk that adding Baltic states to the

Alliance could trigger a crisis with Russia—and within Russia.

Alas, one need not wait for a decision on NATO enlargement to set off a crisis with Russia; the war in Kosovo has done that. Russians are unhappy and angry over the attacks on their fellow Slavs. That these attacks were carried out without UN Security Council authorization and by an enlarged NATO from which they are thus far excluded makes matters that much worse. The Russian reaction is both deep and wide, reflecting widespread frustration in that country over its reduced circumstances at home and its reduced status abroad.

The war in Kosovo is also a crisis for NATO. For the 40 years of the Cold War, NATO unity was forged around a common threat; under Article 5 of the NATO treaty, Alliance members pledged to defend one another against external attack. With the demise of the Soviet Union and the end of the Cold War, many analysts and politicians believe that NATO must evolve or risk fading away. They argue that NATO remains valuable—especially in keeping the United States involved in Europe's security, given the limits on what Europeans are able and willing to do in the defense realm, the potential primacy of a unified Germany and uncertainty over how Russia will evolve—but that a continued focus on defending against a nonexistent threat is not enough.

Alliance's cohesion just at a time it is seeking to define a new purpose.

Economic Europe

Few if any observers predicted at the outset of 1999 that NATO would be the European or transatlantic institution that would most come under strain during the year. The European Union (EU) was the more obvious candidate. Indeed, the year began with the launch of the 11-member European Monetary Union and its common currency, the euro. This is the latest and one of the most important of the many steps Europe has taken toward integration over the past half century—and, as Robert Solomon points out, the first time since the fall of the Roman Empire that much of Western Europe has had a single currency

Creation of the euro effectively brings about a single European financial market, which should facilitate economic activity and, with it, growth. Still, the euro is not without its skeptics. Many question whether member governments can and will maintain the necessary fiscal discipline if they are faced with high unemployment or recession. The euro and EMU are the products of a continent that is increasingly controlled collectively in the economic sphere—while governments and politicians are still mostly

> The Russian reaction to the NATO attacks on Yugoslavia is both deep and wide, reflecting widespread frustration in that country over its reduced circumstances at home and its reduced status abroad.

The principal alternative mission for NATO, as set forth by Ivo Daalder, is to broaden its mandate from combating external threats to countries within the treaty area to promoting peace and security throughout all of Europe. The change could come about in two ways: through continued enlargement and through taking on the sorts of challenges that developed in Bosnia and Kosovo.

When leaders of NATO's 19 member states convened in Washington last April, they agreed to such a new strategic concept. That they did so amidst the war in Kosovo, however, highlighted the gap between rhetoric and reality. It is one thing to talk about meeting challenges to European peace, quite another to do it. The risk for NATO is that the experience of Kosovo will jeopardize the

elected in national and local contexts. Whether this tension can be managed remains to be seen.

On the American side of the Atlantic, there are those who doubt whether the euro is good for the United States. Some fear it will make Europe more of a closed market or weaken the role and value of the dollar. Others predict it will lead to greater European political and military unity—and greater independence from the United States. Elizabeth Pond takes a relatively sanguine view of these possibilities—but points out that the euro is likely to promote economic reform within Europe and make Europe more like America, benefiting some American investors and exporters but posing severe hardships for others who lose out to new

competitors. As the U.S.-European skirmish over bananas indicates, trade frictions and protectionist pressures are never less than dormant and can surface with a vengeance, bearing adverse consequences for transatlantic political and economic relations.

In trade as in other matters, it is obvious that the United States and Europe, though drawn together in many ways, do not always or automatically see eye to eye. One specific disagreement involves Turkey a country the EU has kept at arm's length for a host of reasons, including dissatisfaction with Turkey's handling of its Kurdish problem and human rights more generally, tensions between Turkey and EU member Greece, and concern that Turkish entry into the EU could have adverse consequences for agricultural policy and labor markets. The United States has for the most part taken a more sympathetic approach to Turkey, a country viewed as vital not only for its contributions to European security but also for its links to the greater Middle East. As Heinz Kramer explains, bridging these transatlantic differences will require new flexibility in European thinking—and internal reform in Turkey itself, something that its domestic politics threaten to make more not less difficult.

The Way Ahead

The challenges facing Europe in 1999 and beyond are enormous. Indeed, the agenda could hardly be more crowded or daunting: Kosovo and the broader problem of bringing stability to the former Yugoslavia; ensuring the success of EMU; enlarging and deepening both the EU and NATO; and promoting Russian democracy, economic revival, and integration with the rest of the continent.

Many of these challenges are as much transatlantic as European in nature and will require close collaboration between the United States and Europe—whether as individual states, within NATO, within the EU, or within some other forum. Consultations using all these frameworks will remain essential—and would be more useful if Europe begins to speak with one voice on matters of security. Also useful would be a transatlantic commitment to open trade, to meet the norms and adhere to the decisions of the World Trade Organization; trade can be a source of prosperity or discord but not both.

But consultation and even compromise will not be sufficient. For the transatlantic tie to work and for Europe to prosper, Europeans must be prepared to assume a greater share of the burden of action, especially in the military domain. They must be ready not just to spend somewhat more on their military capacity, but to spend it on forces that are relevant for the post–Cold War world rather than its predecessor. Europeans will need, too, to resist the temptation to oppose American leadership simply out of resentment.

At the same time, the United States will have to accept that a greater European willingness and capacity to share the burdens of European and global security will translate into enhanced European influence, especially if Europe is prepared to act politically and militarily under EU rather than NATO auspices. The United States cannot have it both ways, urging that Europe do more, but do America's bidding and no more. In addi-

tion, the United States will need to curb its enthusiasm for economic sanctions in general and for secondary sanctions—those imposed on countries (often European) who do not support U.S. sanctions against such countries as Iran Libya, or Cuba—in particular.

But whatever the specific changes and compromises, it is critical that the two sides get it right. Europe and the United States remain essential to one another. It is not simply a matter of economics, although transatlantic trade and investment count for a lot. Nor is it simply a shared interest in Europe's stability, although this too obviously matters a great deal to both Europeans and Americans. Rather, it is that both Americans and Europeans have a major stake in what sort of a world emerges in the aftermath of the Cold War. Their ability to help bring about a world to their liking—one that promotes their common interests and values alike—depends on their ability to agree on a set of common priorities and work together on their behalf. Transatlantic cooperation proved central to the successful outcome of the Cold War; continued partnership is likely to prove no less central to the course of 1999 and the years that follow.

The research on Europe and Russia was made possible by the German Marshall Fund of the United States, the Carnegie Corporation of New York, the John M. Olin Foundation, and the John D. and Catharine T. MacArthur Foundation.

ETHNIC CONFLICT

Ethnic conflict seems to have supplanted nuclear war as the most pressing issue on the minds of policymakers. But if yesterday's high priests of mutually assured destruction were guilty of hyper-rationality, today's prophets of anarchy suffer from a collective hysteria triggered by simplistic notions of ethnicity. Debates about intervention in Rwanda or stability in Bosnia demand a more sober perspective.
—by Yahya Sadowski

The Number of Ethnic Conflicts Rose Dramatically at the End of the Cold War

Nope. The idea that the number of ethnic conflicts has recently exploded, ushering us into a violent new era of ethnic "pandaemonium," is one of those optical illusions that round-the-clock and round-the-world television coverage has helped to create. Ethnic conflicts have consistently formed the vast majority of wars ever since the epoch of decolonization began to sweep the developing countries after 1945. Although the number of ethnic conflicts has continued to grow since the Cold War ended, it has done so at a slow and steady rate, remaining consistent with the overall trend of the last 50 years.

In 1990 and 1991, however, several new and highly visible ethnic conflicts erupted as a result of the dissolution of the Soviet Union and Yugoslavia. The clashes between the armies of Croatia, Serbia, and Slovenia, and the agonizing battle that pitted Bosnia's Croats, Muslims, and Serbs against each other, occurred on Europe's fringes, within easy reach of television cameras. The wars in Azerbaijan, Chechnya, Georgia, and Tajikistan, while more distant, were still impressive in the way that they humbled the remnants of the former Soviet colossus. Many observers mistook these wars for the start of a new trend. Some were so impressed that they began to reclassify conflicts in Angola, Nicaragua, Peru, and

Somalia—once seen as ideological or power struggles—as primarily ethnic conflicts.

The state-formation wars that accompanied the "Leninist extinction" now appear to have been a one-time event—a flash flood rather than a global deluge. Many of these battles have already been brought under control. Indeed, the most striking trend in warfare during the 1990s has been its decline: The Stockholm International Peace Research Institute documented just 27 major armed conflicts (only one of which, India and Pakistan's slow-motion struggle over Kashmir, was an interstate war) in 1996, down from 33 such struggles in 1989. Once the Cold War ended, a long list of seemingly perennial struggles came to a halt: the Lebanese civil war, the Moro insurrection in the Philippines, regional clashes in Chad, the Eritrean secession and related battles in Ethiopia, the Sahrawi independence struggle, fratricide in South Africa, and the guerrilla wars in El Salvador and Nicaragua.

The majority of the wars that survive today are ethnic conflicts—but they are mostly persistent battles that have been simmering for decades. They include the (now possibly defunct) IRA insurgency in the United Kingdom; the struggle for Kurdish autonomy in Iran, Iraq, and Turkey; the Israeli-Palestinian tragedy; the Sri Lankan civil war; and long-standing regional insurrections in Burma, India, and Indonesia.

Most Ethnic Conflicts Are Rooted in Ancient Tribal or Religious Rivalries

No way. The claim that ethnic conflicts have deep roots has long been a standard argument for not getting involved. According to political journalist Elizabeth Drew's famous account, President Bill Clinton in 1993 had intended to intervene in Bosnia until he read Robert Kaplan's book *Balkan Ghosts*, which, as Drew said, conveyed the notion that "these people had been killing each other in tribal and religious wars for centuries." But the reality is that most ethnic conflicts are expressions of "modern hate" and largely products of the twentieth century.

The case of Rwanda is typical. When Europeans first stumbled across it, most of the country was already united under a central monarchy whose inhabitants spoke the same language, shared the same cuisine and culture, and practiced the same religion. They were, however, divided into several castes. The largest group, the Hutus, were farmers. The ruling aristocracy, who collected tribute from all other groups, was recruited from the Tutsis, the caste of cattle herders. All groups supplied troops for their common king, and intermarriage was not unusual. Social mobility among castes was quite possible: A rich Hutu who purchased enough cattle could climb into the ranks of the Tutsi; an impoverished Tutsi could fall into the ranks of the Hutu. Anthropologists considered all castes to be members of a single "tribe," the Banyarwanda.

Then came the Belgians. Upon occupying the country after World War I, they transformed the system. Like many colonial powers, the Belgians chose to rule through a local élite—the Tutsis were eager to collaborate in exchange for Belgian guarantees of their local power and for privileged access to modern education. Districts that had been under Hutu leadership were brought under Tutsi rule. Until 1929, about one-third of the chiefs in Rwanda had been Hutu, but then the Belgians decided to "streamline" the provincial administration by eliminating all non-Tutsi chiefs. In 1933, the Belgians issued mandatory identity cards to all Rwandans, eliminating fluid movement between castes and permanently fixing the identity of each individual, and his or her children, as either Hutu or Tutsi. As the colonial administration pene-

Ethnic Africa

"Europe's imperial cartographers have been criticized for more than a century for casually drawing up borders that separated ethnic groups or placed long-time rivals in the same colony," observed the *New York Times* in the wake of civil war in Somalia and the breakup of Ethiopia. But as this map of Africa's ethnic groups demonstrates, redrawing borders would be no simple task. This predicament represents the greatest challenge to resolving ethnic conflicts worldwide: There are often no agreed boundaries to retreat behind.

Source: Map reprinted, by permission, from *Why in the World? Adventures in Geography*, by George J. Demko, with Jerome Agel and Eugene Boe, produced by Jerome Agel. © 1992 by Jerome Agel. Published in trade paperback by Anchor Books/Doubleday.

trated and grew more powerful, Belgian backing allowed the Tutsis to increase their exploitation of the Hutus to levels that would have been impossible in earlier times.

In the 1950s, the Belgians came under pressure from the United Nations to grant Rwanda independence. In preparation, Brussels began to accord the majority Hutus—the Tutsis constituted only 14 percent of the population—a share of political power and greater access to education. Although this policy alarmed the Tutsis, it did not come close to satisfying the Hutus: Both groups began to organize to defend their interests, and their confrontations became increasingly militant. Centrist groups that included both Hutu and Tutsi were gradually squeezed out by extremists on both sides. The era of modern communal violence began with the 1959 attack on a Hutu leader by Tutsi extremists; Hutus retaliated, and several hundred people were killed. This set in motion a cycle of violence that culminated in December 1963, when Hutus massacred 10,000 Tutsis and drove another 130,000–150,000 from the country. These tragedies laid the seeds for the genocide of 1994.

The late emergence of ethnic violence, such as in Rwanda, is the norm, not an exception. In Ceylon, riots that pitted Tamils against Sinhalese did not erupt until 1956. In Bosnia,

Major Genocides since World War II

COUNTRY	DATES	VICTIMS	NUMBER OF DEATHS (IN THOUSANDS)
USSR	1943–47	Repatriated nationals and ethnic minorities	500–1,100
China	1950–51	Landlords	800–3,000
Sudan	1955–72	Southern nationalists	100–500
Indonesia	1965–66	Communists and ethnic Chinese	80–1,000
China	1966–75	Cultural revolution victims	400–850
Uganda	1971–79	Opponents of Idi Amin	100–500
Pakistan	1971	Bengali nationalists	1,250–3,000
Cambodia	1975–79	Urbanites	800–3,000
Afghanistan	1978–89	Opponents of the regime	1,000
Sudan	1983–98	Southern nationalists	100–1,500
Iraq	1984–91	Kurds	100–282
Bosnia	1991–95	Bosnian Muslims and Croats	25–200
Burundi	1993–98	Hutu, Tutsi	150+
Rwanda	1994	Tutsi	500–1,000

Sources: Barbara Harff, "Victims of the State: Genocides, Politicides and Group Repression since 1945," *International Review of Victimology.* 1 (1989): 23–41; Conflict Resolution Program, *1995–1996 State of World Conflict Report* (Atlanta: Carter Center, 1997); *Los Angeles Times;* and the *Encyclopaedia Britannica.*

Serbs and Croats coexisted with one another, and both claimed Muslims as members of their communities, until World War II—and peaceful relations resumed even after the bloodshed of that conflict. Turks and Kurds shared a common identity as Ottomans and wore the same uniforms during World War I; in fact, the first Kurdish revolt against Turkish rule was not recorded until 1925. Muslims and Jews in Palestine had no special history of intercommunal hatred (certainly nothing resembling European anti-Semitism) until the riots of 1921, when nascent Arab nationalism began to conflict with the burgeoning Zionist movement. Although Hindu-Muslim clashes had a long history in India, they were highly localized; it was only after 1880 that the contention between these two groups began to gel into large-scale, organized movements. Of course, the agitators in all these conflicts tend to dream up fancy historic pedigrees for their disputes. Bosnian Serbs imagine that they are fighting to avenge their defeat by the Ottoman Turks in 1389; Hutus declare that Tutsis have "always" treated them as subhumans; and IRA bombers attack their victims in the name of a nationalist tradition they claim has burned since the Dark Ages. But these mythologies of hatred are themselves largely recent inventions.

Ethnic Conflict Was Powerful Enough to Rip Apart the USSR

Yeah, right. The idea that the Soviet Union was destroyed by an explosion of ethnic ata-vism has been put forth by a number of influential thinkers, most notably Senator Daniel Patrick Moynihan. But this theory is not only historically inaccurate, it has misleading policy implications. The collapse of states is more often the cause of ethnic conflicts rather than the result.

Prior to 1991, ethnic consciousness within the Soviet Union had only developed into mass nationalism in three regions: the Baltic states, Transcaucasia, and Russia itself. Russian nationalism posed no threat to Soviet rule: It had been so successfully grafted onto communism during World War II that even today Leninists and Russian ultranationalists tend to flock to the same parties. In Transcaucasia, the Armenians and Georgians had developed potent national identities but were much more interested in pursuing local feuds (especially with Muslims) than in dismantling the Soviet Union. Only in the Baltic states, which had remained sovereign and independent until 1940, was powerful nationalist sentiment channeled directly against Moscow.

When the August 1991 coup paralyzed the Communist Party, the last threads holding the Soviet state together dissolved. Only then did rapid efforts to spread nationalism to other regions appear. In Belarus, Ukraine, and across Central Asia, the *nomenklatura*, searching for new instruments to legitimate their rule, began to embrace—and sometimes invent—nationalist mythologies. It was amidst this wave of post-Soviet nationalism that new or rekin-

Tribal Wisdom

"For centuries, [Yugoslavia] marked a tense and often violent fault line between empires and religions. The end of the Cold War and the dissolution of that country . . . surfaced all those ancient tensions again. . . ."

—U.S. president Bill Clinton, addressing the U.S. Naval Academy in 1994

"We are confronted by contradictory phenomena in which both the factors of integration and cooperation and the tendencies of division and dispersal are both apparent. The technological and communications revolution is offset by the eruption of nationalist conflicts and ethnic hatreds."

—Egyptian foreign minister Amr Moussa, before the UN General Assembly in 1996

"In this Europe of ours, where no one would have thought a struggle between ethnic groups possible, tragically this has come about. It may serve to open people's eyes to the unspeakable possibilities in the future, even in unexpected places. Today we are threatened by the danger . . . of racial, religious, and tribal hatred."

—Italian president Oscar Luigi Scalfaro in 1997

"Yet even as the waves of globalization unfurl so powerfully across our planet, so does a deep and vigorous countertide. . . . What some have called a 'new tribalism' is shaping the world as profoundly on one level as the 'new globalism' is shaping it on another."

—His Highness the Aga Khan, at the Commonwealth Press Union Conference in Cape Town in 1996

" . . . all over the world, we see a kind of reversion to tribalism. . . . We see it in Russia, in Yugoslavia, in Canada, in the United States. . . . What is it about, all this globalization of communication that is making people return to more—to smaller units of identity?"

—Neil Postman, chair of the department of culture and communication at New York University, in 1995

dled ethnic conflicts broke out in Chechnya, Moldova, Ukraine, and elsewhere. Yet even amid the chaos of state collapse, ethnonationalist movements remained weaker and less violent than many had expected. Despite the predictions of numerous pundits, revivalist Islamic movements only took root in a couple of places (Chechnya and Tajikistan). Relations between indigenous Turkic peoples and Russian immigrants across most of Central Asia remained civil.

Ethnic Conflicts Are More Savage and Genocidal Than Conventional Wars

Wrong. Although this assumption is inaccurate, the truth is not much more comforting. There appears to be no consistent difference between ethnic and nonethnic wars in terms of their lethality. In fact, the percentage of civilians in the share of total casualties is rising for all types of warfare. During World War I,

civilian casualties constituted about 15 percent of all deaths. That number skyrocketed to 65 percent during World War II, which, by popularizing the use of strategic bombing, blockade-induced famine, and guerrilla warfare, constituted a real, albeit underappreciated, watershed in the history of human slaughter. Ever since, the number of civilian dead has constituted two-thirds or more of the total fatalities in most wars. Indeed, according to UNICEF, the share of civilian casualties has continued to grow since 1945— rising to almost 90 percent by the end of the 1980s and to more than 90 percent during this decade.

Furthermore, ethnic wars are less likely to be associated with genocide than "conventional" wars. The worst genocides of modern times have not been targeted along primarily ethnic lines. Rather, the genocides within Afghanistan, Cambodia, China, the Soviet Union, and even, to a great extent, Indonesia and Uganda, have focused on liquidating political dissidents: To employ the emerging vocabulary, they were politicides rather than ethnicides. Indeed, the largest genocides of this century were clearly ideologically driven politicides: the mass killings committed by the Maoist regime in China from 1949 to 1976, by the Leninist/Stalinist regime in the Soviet Union between 1917 and 1959, and by the Pol Pot regime in Cambodia between 1975 and 1979.

Finally, some pundits have claimed that ethnic conflicts are more likely to be savage because they are often fought by irregular, or guerrilla, troops. In fact, (a) ethnic wars are usually fought by regular armies, and (b) regular armies are quite capable of vicious massacres. Contrary to the stereotypes played out on television, the worst killing in Bosnia did not occur where combatants were members of irregular militias, reeling drunk on *slivovitz*. The core of the Serb separatist forces consisted of highly disciplined troops that were seconded

from the Yugoslav army and led by a spit-and-polish officer corps. It was precisely these units that made the massacres at Srebrenica possible: It required real organizational skill to take between 6,000 and 10,000 Bosnian troops prisoner, disarm and transport them to central locations, and systematically murder them and distribute their bodies among a network of carefully concealed mass graves. Similarly, the wave of ethnic cleansing that followed the seizure of northern and eastern Bosnia by the Serbs in 1991 was not the spontaneous work of crazed irregulars. Transporting the male Bosnian population to concentration camps at Omarska and elsewhere required the talents of men who knew how to coordinate military attacks, read railroad schedules, guard and (under-) supply large prison populations, and organize bus transport for expelling women and children.

Globalization Makes Ethnic Conflict More Likely

Think again. The claim that globalization—the spread of consumer values, democratic institutions, and capitalist enterprise —aggravates ethnic and cultural violence is at the core of Samuel Huntington's "clash of civilizations" hypothesis, Robert Kaplan's vision of "the coming anarchy," and Benjamin Barber's warning that we face a future of "Jihad vs. McWorld." Although these suggestions deserve further study, the early indications are that globalization plays no real role in spreading ethnic conflict and may actually inhibit it.

Despite the fears of cultural critics that the broad appeal of "Baywatch" heralds a collapse of worldwide values, there is not much concrete evidence linking the outbreak of ethnic wars to the global spread of crude materialism via film, television, radio, and boombox. Denmark has just as many television sets as the former Yugoslavia but has not erupted into ethnic carnage or even mass immigrant bashing. Meanwhile, Burundi, sitting on the distant outskirts of the global village with only one television set for every 4,860 people, has witnessed some of the worst violence in this decade.

The spread of democratic values seems a slightly more plausible candidate as a trigger for ethnic violence: The recent progress of democracy in Albania, Armenia, Croatia, Georgia, Moldova, Russia, Serbia, and South Africa

has been attended by ethnic feuding in each country. But this is an inconsistent trend. Some of the most savage internal conflicts of the post-Cold War period have occurred in societies that were growing less free, such as Egypt, India (which faced major secessionist challenges by Kashmiris, Sikhs, Tamils, etc.), Iran, and Peru. For that matter, many of the worst recent ethnic conflicts occurred in countries where the regime type was unstable and vacillated back and forth between more and less free forms, as in Azerbaijan, Bosnia, Lebanon, Liberia, Nigeria, and Tajikistan. Conversely, in numerous cases, such as the so-called third wave of democratization that swept Latin America and East Asia during the 1980s, political liberalization seems to have actually reduced most forms of political violence.

Investigating the impact of economic globalization leads to three surprises. First, the countries affected most by globalization—that is, those that have shown the greatest increase in international trade and benefited most significantly from foreign direct investment—are not the newly industrializing economies of East Asia and Latin America but the old industrial societies of Europe and North America. Second, ethnic conflicts are found, in some form or another, in every type of society: They are not concentrated among poor states, nor are they unusually common among countries experiencing economic globalization. Thus, the bad news is that ethnic conflicts do not disappear when societies "modernize."

The good news, however, lies in the third surprise: Ethnic conflicts are likely to be much less lethal in societies that are developed, economically open, and receptive to globalization. Ethnic battles in industrial and industrializing societies tend either to be argued civilly or at least limited to the political violence of marginal groups, such as the provisional IRA in the United Kingdom, Mohawk secessionists in Canada, or the Ku Klux Klan in the United States. The most gruesome ethnic wars are found in poorer societies—Afghanistan and Sudan, for example—where economic frustration reinforces political rage. It seems, therefore, that if economic globalization contributes to a country's prosperity, then it also dampens the level of ethnic violence there.

Fanaticism Makes Ethnic Conflicts Harder to Terminate

Not really. Vojislav Seselj, the commander of one of the most murderous Serb paramili-

tary groups in Bosnia, once warned that if U.S. forces were used there, "the war [would] be total. . . . We would have tens of thousands of volunteers, and we would score a glorious victory. The Americans would have to send thousands of body bags. It would be a new Vietnam." Of course, several years later, after Serb forces had been handily defeated by a combination of Croat ground forces and NATO airpower, the president of the Serb separatists, Radovan Karadzic, admitted their leadership had thought all along that "if the West put in 10,000 men to cut off our supply corridors, we Serbs would be finished." Militarily, ethnic conflicts are not intrinsically different from any other type of combat. They can take on the form of guerrilla wars or conventional battles; they can be fought by determined and disciplined cadres or by poorly motivated slobs. How much military force will be required to end the fighting varies widely from one ethnic conflict to the next.

However, achieving a military victory and building a durable peace are two very different matters. Sealing the peace in ethnic conflicts may prove harder for political—not military—reasons. Ethnic conflicts are fought among neighbors, among people who live intermingled with one other, forced to share the same resources and institutions. When two states end a war, they may need only to agree to stop shooting and respect a mutual border. But in ethnic conflicts there are often no established borders to retreat behind. Sometimes, ethnic disputes can be resolved by drawing new borders—creating new states (such as Bangladesh and "rump" Pakistan) that allow the quarreling groups to live apart. Other times, they can be terminated by convincing the combatants that they must share power peaceably and learn to coexist. This is the objective of the Dayton accord on Bosnia.

In either case, ending ethnic warfare often requires the expensive and delicate construction of new political institutions. Not only may this be more difficult than terminating a "normal" interstate war, it may also take much longer. Building truly effective states takes time. For this reason, ethnic wars whose participants are already organized into states or protostates (which was true of the combatants in Croatia and Bosnia) are probably easier to bring to a conclusion than battles in regions—Afghanistan, for example, not to speak of Somalia where real states have yet to congeal.

WANT TO KNOW MORE?

The classic introduction to the study of ethnic conflict is still Donald Horowitz, *Ethnic Groups in Conflict* (Berkeley: University of California Press, 1985). The Stockholm International Peace Research Institute (SIPRI) inventories changing patterns of warfare in the *SIPRI Yearbook* (Oxford: Oxford University Press, annual). For a specialist's tally of particular ethnic conflicts, see Ted Robert Gurr, *Minorities at Risk: A Global View of Ethnopolitical Conflicts* (Washington: U.S. Institute of Peace, 1993). An absorbing overview of the evolving relations between Tutsi and Hutu is Gérard Prunier, *The Rwanda Crisis: History of a Genocide* (New York: Columbia University Press, 1995). The Human Rights Watch report, *Slaughter among Neighbors: The Political Origins of Communal Violence* (New Haven: Yale University Press, 1995), provides a broader survey of modern hate. An excellent account of the diversity of forms that ethnicity and nationalism have taken in territories of the former Soviet Union is Ronald Grigor Suny's *The Revenge of the Past: Nationalism, Revolution and the Collapse of the Soviet Union* (Stanford: Stanford University Press, 1993). Neal Ascherson reflects upon issues of nationality and ethnicity in his book *Black Sea* (New York: Hill & Wang, 1995), which chronicles the expansive history of a region that has been a nexus of several Asian and European cultures. David Rohde's chilling *Endgame: The Betrayal and Fall of Srebrenica* (New York: Farrar Straus & Giroux, 1997) documents the careful organizational planning underlying the genocide in Bosnia. A recent work that dissects the question of whether, or how, the United States should intervene in ethnic conflicts is David Callahan's *Unwinnable Wars: American Power and Ethnic Conflict* (New York: Hill & Wang, 1998).

For links to relevant Web sites, as well as a comprehensive index of related articles, access **www.foreignpolicy.com**.

AP/WIDE WORLD

May 7, 1996: A member of Charles Taylor's National Patriotic Front steps on the body of a victim in Monrovia, Liberia.

The Kalashnikov Age

By Michael Klare

When Charles Taylor invaded Liberia, he unleashed the most deadly combat system of the current epoch—the adolescent human male equipped with an AK-47 assault rifle.

Reprinted by permission of *The Bulletin of the Atomic Scientists,* January/February 1999, pp. 18-22. © 1999 by the Educational Foundation for Nuclear Science, 6042 South Kimbard, Chicago, IL 60637. A one-year subscription is $28.

ON CHRISTMAS EVE 1989, CHARLES Taylor marched into Liberia with a ragtag invasion force of some 150 amateur soldiers–members of the self-styled National Patriotic Front of Liberia (NPFL)–and set out to conquer the country. In the months that followed, Taylor seized control of the Liberian hinterland, exacting tribute from its inhabitants, recruiting additional soldiers, and killing all who stood in his way. As many as 200,000 people died in the cataclysm, and millions more were driven from their homes. Taylor had unleashed the most deadly combat system of the current epoch: the adolescent human male equipped with a Kalashnikov–an AK-47 assault rifle.

Since Taylor's invasion of Liberia, this deadly system has been employed with devastating effect in more than a dozen countries, producing a casualty rate normally associated with all-out war between modern, mechanized armies. In Algeria, Angola, Bosnia, Burundi, Cambodia, Chechnya, Colombia, Congo, Haiti, Kashmir, Mozambique, Rwanda, Sierra Leone, Somalia, Sri Lanka, Sudan, and Uganda, young men (and some women) equipped solely or primarily with AK-47s and other "light" weapons have produced tens of thousands—and sometimes hundreds of thousands—of fatalities.

Most of the casualties in these conflicts are non-combatants. Civilians constituted only five percent of the casualties in World War I, but they constitute about 90 percent of all those killed or wounded in more recent wars. Children have been particularly victimized by these conflicts: According to the U.N. Development Program, as many as two million children are

Michael Klare is a professor of Peace and World Security Studies at Hampshire College in Amherst, Massachusetts, and a member of the Bulletin's Board of Directors. He is the editor, with Jeffrey Boutwell, of Light Weapons and Civil Conflict: Controlling the Tools of Violence *which was published in 1999.*

believed to have been killed–and 4.5 million disabled–in armed conflict since 1987; another million have been orphaned, and some 12 million left homeless.[1]

The widespread slaughter of civilians in recent conflicts forces us to rethink what we mean by the concept of war. In the past, "war" meant a series of armed encounters between the armed forces of established states, usually for the purpose of territorial conquest or some other clearly defined strategic objective. But the conflicts of the current era bear little resemblance to this model: most take place within the borders of a single state and entail attacks by paramilitary and irregular forces on unarmed civilians for the purpose of pillage, rape, or ethnic slaughter–or some combination of all three.

Ethnic and internal warfare is the most common form of armed violence in the late twentieth century, and it is likely to remain the dominant form for some time to come. The proliferation of this strife will produce massive human tragedy, stretch the capacity of the United Nations and other international peacekeeping organizations to their limits, and erase all hope of economic and social development for hundreds of millions of desperate people. It is essential, therefore, that we come to terms with this phenomenon–and, most important, devise strategies for its prevention and control.

The pathology of contemporary conflict

Although each of the conflicts that fall into this model has its own origin and trajectory, all exhibit some common characteristics. In almost every case, unscrupulous and ambitious demagogues have sought power and/or wealth by arousing the ethnic prejudices of their kinfolk, forming militias and paramilitary bands, and conducting attacks on civilian targets–usually neighborhoods or villages inhabited by members of a dif-

ferent ethnic group. Although the fighters may espouse a particular ideology or religious dogma, ethnic hostility, poverty, and a craving for booty usually fuel these conflicts.

Violent attacks on unarmed civilians, including women and children, are common. Although seemingly random and senseless to outside observers, the violence has a purpose: to exact tribute from the population (to acquire additional arms and ammunition); to obtain fresh recruits (often young boys who are enticed or dragooned into combat or young women who are used for sex); to destroy people's faith in the ability of the established government to protect them; to drive members of another ethnic group from their ancestral lands; or to exact revenge for earlier acts of resistance.[2]

Although violence of this sort is usually associated with ethnic militias and other non-state actors, government forces often behave in a generally similar manner. In many countries, the national army is just another ethnic or sectarian faction in a highly fragmented society; in others, the army serves largely to protect the privileged status of the ruling family or elite. (In Rwanda, for instance, the army was once a tool of Hutu domination; now it is an instrument of Tutsi domination. In Haiti the army was for decades the exclusive instrument of a small wealthy elite.) In these situations, violence against civilians is routinely employed to discourage public support for insurgents, to disrupt insurgent supply lines (villagers cannot provide food to the rebels if they have no food to provide), and to punish members of the ethnic group, political party, or social class from which the rebels are drawn.

All too often, war becomes a permanent way of life for combatants, whether they belong to the insurgent or the government side. Usually deprived of an education or training in marketable skills, the young recruits who make up these armies often find that soldiering is the only occupation for which they

are equipped. In societies where food and shelter are scarce, membership in an armed band that preys on the civilian population is a plausible route to survival. It is not surprising that many of these bands continue their violent activities long after the original, strategic rationale for their formation has ceased to have meaning.

In a significant number of cases, the dividing line between political warfare and outright banditry disappears. Under these circumstances, armed militias sell their services to local warlords or go into business for themselves—extorting money or goods from civilians, trafficking in drugs, or fighting for control over valuable resources (such as diamond mines, virgin forests, or rare animal skins).

These conflicts occur only when certain preconditions have been satisfied. These include a weak or unrepresentative government, a history of ethnic and social antagonisms, economic hardship and uncertainty, widespread corruption, and a lack of safeguards for targeted minorities. But such conflicts require one more element: access to large quantities of small arms and light weapons.

The centrality of small arms

Light weapons are the weapons of choice in contemporary conflicts–the weapons most often used in battle and in attacks on civilians. Some 80–90 percent of all casualties in recent wars have been produced by such weapons, which include rifles, grenades, machine guns, light mortars, land mines, and other "man-portable" systems.[3]

It is true, of course, that a militant gang or a frenzied mob can inflict great damage on a community with clubs and knives alone. But these groups quickly melt away when faced with any type of organized resistance. It is the unique combination of adolescent male fighter and modern assault rifle that gives these paramilitary groups their lethal potency: equipped with AK-47s alone, a small band of teen-aged combatants can

enter a village and kill or wound hundreds of people in a matter of minutes.

The November 1997 attack at the Temple of Hatshepsut at Luxor in Egypt provides a gruesome example of this capability: in a period of just 30 minutes, six youthful gunmen equipped with automatic rifles stormed into the temple area, killing two armed guards and then mowing down 58 foreign tourists. Each of the gunmen reportedly fired hundreds of rounds of ammunition at the cowering tourists before they themselves were shot by police reinforcements.

In some instances, paramilitary groups will supplement their light weapons with limited numbers of heavy weapons—tanks, artillery pieces, aircraft, and so on. Rarely, however, can irregular forces pay for weapons of this type; and, even if they can, it is almost impossible to operate and maintain major weap-

ons in the rugged, back-country environment in which many of these forces operate. Then, too, the teen-aged combatants who make up most of these forces lack the training and discipline to operate large, complex weapons systems.

In most instances, then, assault rifles and other light weapons are the weapons of choice. These weapons have attained this position of prominence for a number of critical reasons:

■ They are cheap and easily accessible. As a result of the Cold War's end, millions of weapons have been declared surplus by their original owners and dumped on the world market–often falling into the hands of corrupt or criminal dealers with no compunctions about selling them to groups like Charles Taylor's NPFL.

■ They are rugged and easy to use. AK-47s and M-16s left over from the Vietnam War (and earlier conflicts) remain in widespread use,

A vicious circle

"While there are some agreed global norms and standards against weapons of mass destruction, there are no such norms or standards that can be used in reducing the excessive and destabilizing accumulation of small arms and light weapons. These are the weapons increasingly used as primary instruments of violence in the internal conflicts dealt with by the United Nations, they are responsible for large numbers of deaths and the displacement of citizens around the world, and they consume large amounts of United Nations resources.

"The excessive and destabilizing accumulation and transfer of small arms and light weapons is closely related to the increased incidence of internal conflicts and high levels of crime and violence. It is, therefore, an issue of legitimate concern for the international community. Groups and individuals operating outside the reach of state and government forces make extensive use of such weapons in internal conflicts. Insurgent forces, irregular troops, criminal gangs, and terrorists groups are using all types of small arms and light weapons. . . .

"Accumulations of small arms and light weapons by themselves do not cause the conflicts in which they are used. The availability of these weapons, however, contributes toward exacerbating conflicts by increasing the lethality and duration of violence, by encouraging a violent rather than a peaceful resolution of differences, and by generating a vicious circle of a greater sense of insecurity, which in turn leads to a greater demand for, and use of, such weapons."

—United Nations, *General and Complete Disarmament: Small Arms*, U.N. document A/52/298, August 27, 1997, pp. 9–10.

requiring only simple maintenance. With only a few hours' training, a young teenager can learn all he or she needs to know in order to aim and fire them into a crowd of people.

■ They are easy to hide and carry. A single pack-horse can carry a dozen or so rifles through dense jungles or over high mountain passes, bypassing government checkpoints; a column of horses can supply a small army. Because paramilitary groups often operate in remote areas behind government lines, portability is essential.

■ They can inflict enormous damage. A modern assault rifle fires hundreds of rounds per minute, allowing a handful of combatants to spray a village square and kill or wound everyone in sight. Even when used with relatively light ammunition (.22 caliber or 5.56 millimeter is standard), these weapons expel bullets at such high velocity that impact on any part of the human body can produce massive trauma or death.

For all of these reasons, these weapons have become the principal tool of combat in the overwhelming majority of conflicts in the post-Cold War era. Of the 49 regional conflicts that have broken out since 1990, light weapons were the only arms used in 46; only one conflict—the Gulf War— was dominated by heavy weapons.

Global availability

The widespread popularity of light weapons has generated enormous demand for their production and sale. Unfortunately, no government or private agency publishes statistics on their manufacture and distribution, so it is impossible to calculate the exact number in worldwide circulation. Estimates of the total number of firearms—handguns, rifles, carbines, submachine guns, and so on—in global use range from 500 million to a billion, of which some 200-250 million are thought to be owned by private individuals and public agencies in the United States.[4]

> # Since 1990, light weapons were the only arms used in 46 of 49 conflicts.

Of greatest concern is the global spread of military-type automatic weapons. An estimated 60-70 million AK-47s and other AK-type weapons have been produced since 1947 (the origin of its numerical suffix), and more are manufactured every year in Russia, China, Bulgaria, Egypt, Iraq, Poland, Romania, and North Korea. In addition, some eight million copies of the U.S. M-16 rifle have been produced in recent decades, along with seven million German G-3s, 5-7 million Belgian FALs, and 10 million Israeli Uzi machine pistols. All in all, perhaps 125 million automatic weapons are currently in circulation around the world.[5]

Keeping track of the worldwide supply of small arms is complicated by the fact that so many countries now produce them. Only a handful of nations manufacture major weapons systems—tanks, jet aircraft, warships, and so on—but about 50 countries produce small arms and ammunition. They include most of the industrialized nations, as well as Argentina, Brazil, Chile, Egypt, India, Iran, Iraq, Israel, Mexico, Pakistan, Peru, Singapore, South Africa, Taiwan, Turkey, and the two Koreas. Many of these countries also produce grenades, mortars, and machine guns.[6]

Although the total worldwide trade in conventional weapons has declined since the end of the Cold War—from an estimated $88.5 billion in 1987 to $46.3 billion in 1997 (in constant 1997 U.S. dollars)—the small arms portion of the trade is thought to have grown. This reflects heavy buying of firearms and coun-

terinsurgency gear by states facing internal conflict (Algeria, Angola, Burma, Colombia, India, Indonesia, Mexico, the Philippines, Serbia, Sri Lanka, Sudan, and Turkey, for instance). All told, sales of light weapons probably total $5–10 billion per year, or 10–20 percent of the total worldwide trade in conventional arms.[7]

Large quantities of small arms and ammunition have also been funneled through black-market channels to ethnic and insurgent forces, including the NPFL of Liberia, the Tamil Tigers of Sri Lanka, the Kurds of Turkey and Iraq, UNITA of Angola, RENAMO of Mozambique, and the SPLA of Sudan. Most clandestine arms transactions are relatively small, only a few million dollars, but some are substantial: UNITA, for example, is believed to have spent as much as $250–500 million in the mid–1990s on black-market munitions, using funds obtained from the illicit sale of diamonds.[8]

Many more weapons fall into the hands of belligerents through theft from government arsenals, purchases from corrupt military and police personnel, gifts from members of their ethnic group living abroad, or from friendly governments. Again, it is impossible to calculate the exact numbers of weapons involved, but these transactions are a fairly reliable source for ethnic militias and other irregular forces.

The imperative of control

With the dawn of a new century only months away, the world faces a continuing epidemic of ethnic, sectarian, and criminal violence. Millions of people are at risk of death and dismemberment, and millions more face hunger, homelessness, and psychological trauma. No combination of private and public agencies is equipped to handle the resulting humanitarian disaster. We must, therefore, find ways to reduce the incidence and intensity of armed conflict.

The conflicts of the current period have many causes, of which poverty, corruption, and demagoguery are paramount. Addressing these factors will require a concerted and imaginative effort. However, conflicts last only so long as belligerents receive a steady stream of arms and ammunition. By shutting off that stream, it should be possible to reduce both the duration and the severity of contemporary combat.

Curbing the international production, stockpiling, and diffusion of small arms and light weapons must be a central feature of any strategy for preventing and controlling armed conflict. This does not mean cutting off the flow of arms altogether—established governments enjoy a right to self-protection under the U.N. Charter, and most will continue to produce or import some weapons for this purpose. But it should be possible to choke off the flow of black-market munitions to irregular forces and to significantly restrict the conditions under which governments can acquire arms through legal channels. Ultimately, it should be possible to block all but a small

trickle of weapons to current and prospective belligerents in areas of persistent conflict.

In the essays that follow, [The Bulletin of the Atomic Scientists, January/February 1999] a distinguished group of scholars and journalists examines the structure and dynamics of the light-weapons trade, and provides case studies of its actual operation. In addition, specific strategies are proposed for curbing the trade. Although they require further refinement, these strategies provide a sound basis for developing and imposing new international measures for the control and significant reduction of the global flow of small arms and light weapons.

Notes

1. U.N. Development Program, *Human Development Report 1998* (New York and Oxford: Oxford University Press, 1998), p. 35.
2. For discussion, see David Keen, *The Economic Function of Violence in Civil Wars*, Adelphi Paper no. 320 (Oxford: Oxford University Press, 1998); William Reno, *Warlord Politics and African States* (Boulder, Colo.: Lynne Rienner, 1998). See also Human Rights Watch (HRW), *Sierra Leone: Sowing Terror* (New York and Washington: HRW, 1998).
3. For background on light weapons and their effects, see Jeffrey Boutwell, Michael Klare, and Laura Reed, eds., *Lethal Commerce: The Global Trade in Small Arms and Light Weapons* (Cambridge, Mass.: American Academy of Arts and Sciences, 1995); Michael Renner, *Small Arms, Big Impact* (Washington, D.C.: Worldwatch Institute, 1997); Jasjit Singh, ed., *Light Weapons and International Security* (New Delhi: Indian Pugwash Society and British-American Security Information Council, 1995); United Nations, *General and Complete Disarmament: Small Arms*, UN document A/52/298, August 27, 1997.
4. The estimate of 500 million light arms in worldwide circulation is from Singh, *Light Weapons and International Security*, p. viii; the estimate of a billion is the author's. Estimates for the United States are from Renner, *Small Arms, Big Impact*, p. 21.
5. See Renner, *Small Arms, Big Impact*, p. 20.
6. For data on the worldwide production of small arms and light weapons, see Jane's Information Group, *Jane's Infantry Weapons* (annual).
7. For discussion and additional data, see Michael Klare and David Andersen, *A Scourge of Guns* (Washington, D.C.: Federation of American Scientists, 1996).
8. For data on black-market arms deliveries, see reports published by the Human Rights Watch Arms Project, including *Angola: Arms Trade and Violations of the Laws of War Since the 1992 Elections* (1994); *Stoking the Fires: Military Assistance and Arms Trafficking in Burundi* (1997); and *Sudan: Global Trade, Local Impact* (1998).

Birth Of A Superpower

China wants to be a world power on a par with the U.S., but it has a lot of catching up to do

BY FRANK GIBNEY JR.

If you're looking to understand better why Chinese spies have been so eagerly vacuuming the U.S. for military secrets during the past three decades, you could do worse than start in China with the People's Liberation Army. China's military today is so outdated that much of its equipment might well have seen action in the Korean War, and many of its troops are semiliterate. The country's strategic nuclear arsenal is 300 times as small as that of the U.S. The entire arsenal packs about as much explosive power as what the U.S. stuffs into one Trident submarine. China's ballistic-missile sub (singular, not plural) hasn't been to sea for a year and would be sunk in minutes in a battle with a U.S. attack sub. The People's Republic has no aircraft carriers (the U.S. maintains 11 carrier battle groups), no long-range strategic bombers (the U.S. has 174) and funds this stumbling juggernaut with a budget of 14 cents for every dollar the U.S. spends on defense. The P.L.A., says the Pentagon, is "still decades away from possessing a comprehensive capability to engage and defeat a modern adversary beyond China's boundaries."

Beijing desperately wants to change that perception, not because China's leaders have an enemy in their sights but because they seek the kind of credibility that a truly modern military brings. Capitol Hill rhetoric aside, China doesn't covet nuclear missiles so it can lob them at Los Angeles. It wants them so that it can be a legitimate player on the international stage, a nation fully in control of its own military destiny. So, as its entrepreneurs have embraced StarTacs and Yahoo!, Beijing's generals now want to trade their antique weaponry and cold war tactics for the PlayStation power they see in NATO's arsenal.

For the first time since the People's Revolution succeeded 50 years ago, Beijing is finally struggling to recast its military priorities. The process began in the early 1990s, at the very top of the armed forces, when politicians pushed the military to streamline its command-and-control structure. The old model for communications, logistics and war fighting was an astonishingly inefficient hybrid that mixed the ideological militarism of the Long March with old-style Soviet doctrines about how to fight on land. Instead the Chinese are toying with a far more flexible-force structure, one that would rely more on highly mobile, highly modernized soldiers. Overall goal: a military that could fight "a limited war under high-tech conditions"— read Desert Storm in Asia. Out would be the old-style model of "military regions" and "group armies" that were designed to support massive human waves in punishing ground attacks. It would be a joint-forces model copied, in many respects, from what currently sits in that five-sided building on the Potomac. Insiders in Beijing say top Chinese brass tried to sell the idea to President Jiang Zemin last year, but he vetoed the plan as too radical—especially on top of all the other changes he had instituted in the P.L.A.

The big shift that Jiang must have had in mind was his firm push to get the P.L.A. out of business. For more than a decade, P.L.A. generals have been fighting to make money, not war. At one point, the military controlled nearly 20,000 companies employing more than 16 million people. Top P.L.A. brass, often ditching combat boots for tasseled loafers, were common sights at properties that included hotels, telecommunications services, pharmaceutical concerns and even airlines. Less public was the fact that some of the nation's vital naval and air bases had become smuggling hubs for everything from cigarettes to cement. The handsome profits—more than $10 billion a year—were used to improve the paltry living conditions of the rank and file.

But arming the nation's warriors with Camcorders wasn't exactly what Jiang had in mind. So after repeatedly failing to get the message across in speeches and memos, Jiang last year issued an order: by Dec. 31, the P.L.A. was supposed to unload the businesses and get back to the barracks. While the effort may never be completely successful— the P.L.A. still controls such high-profile properties as Beijing's Poly Plaza complex—it seems at least to have separated the soldiers from the swindlers. Today's army is filled with men and women who want to emulate MacArthur, not Trump.

But building a world-class military is still going to be a challenge. Largely, it's a matter of money. Though the P.L.A.'s budget shot up 13% last year, that cash went to help the army get leaner, not meaner. From a mid-1970s high of 4 million soldiers, the army now fields some 2 million. And even that massive khaki swarm is armed mostly with Mao-era weapons. Explains Brookings Institution China expert David Shambaugh: "They have no, repeat no, 1990s weapons in their inventory." Though China's procurement officials are easy to spot working the Paris Air Show and other military fests, they are mostly window shopping. The P.L.A. has sampled some 1970s-era high-tech toys like Soviet Su-27 jets, but most of the cool new Nintendo military gear is out of its price range or on forbidden export lists in the West. In the aftermath of the Cox report, it will probably be even harder for China to buy sophisticated weapons systems. And that's why the missile technology China stole from the U.S. is so important: it helps the Chinese advance toward the head of the class in terms of military credibility. A popular phrase in slogan-crazy China captures the idea: yibu daowei, one step and you're there. Instead of taking years to build carriers and subs, the Chinese are keen on constructing a sophisticated missile force that could pack a punch tomorrow. The Pentagon says China is developing sophisticated short-range ballistic missiles and lethal antiship cruise missiles. And though the Chinese have yet to adopt many of the tricks they picked up by stealing U.S. secrets—how to cram multiple warheads on a single missile, for instance— Representative Christopher Cox is not alone

in his fear that the spying may have helped accelerate an Asian arms race.

China's primary military aim may be to look and not act muscular, but that hasn't stopped others from wondering under what scenarios Beijing would actually use its muscles. It's a question the Chinese themselves are struggling to answer. To begin with, China is surrounded by several other regional powers: Russia, Japan, South Korea and India. And it has special security worries with each nation. Russia's internal chaos could spill into China's already uneasy Western provinces. An India-Pakistan war—something that didn't look too farfetched as the two nations shelled each other last week—would take place right along China's southwestern border, a nervous-making event for any government.

There are also more nuanced worries that some Chinese planners surely suspect could be clarified if China becomes stronger. Exhibit A is China's complex relationship with Japan. While the two nations have extensive trade and technology links, there is a lingering mutual distrust. In both countries there is a passionate sense that one of them ought to be first among political equals in Asia.

No place is a more likely target for Chinese missiles than Taiwan, which Beijing insists is still its own. Recent discussions between Japan, Taiwan and the U.S. about an antimissile defense network in eastern Asia have infuriated Beijing. Even though such a shield is decades away, a "missile-proof" Taiwan would surely continue—and flaunt—its independence, possibly triggering Asia's next war.

As China's generals are all too aware, the only force that really prevents them from exercising their muscles in Asia is the U.S. And one of Washington's few consistent foreign policy goals since the end of the cold war has been to maintain a major presence in Asia. American bases and security arrangements currently weave a net throughout the region from Okinawa to Diego Garcia. While China's navy can get away with minor adventures—barging around the South China Sea establishing outposts on little atolls is a favorite—there is no doubt that Uncle Sam still rules the waves. If China wants to dominate the region, it will need to unseat the U.S.

Even Jiang Zemin probably isn't sure whether that's a viable goal. To be sure, it would take decades. But just about every military mind in China agrees that China does need to start arming, and soon. This doesn't mean an inevitable cold war with the U.S. The possibility of a world held hostage by the threat of mutual assured destruction is still far away. But no one expects China to put its military ambitions aside anytime soon. In fact, as the country matures, its high-tech military hopes may grow as well. If the Cox report is even partly accurate, China has data that will make it much easier to turn those hopes to reality.

—Reported By William Dowell/New York, Jaime A. Florcruz/Beijing And Douglas Waller/Washington

Stepping Back
from the Nuclear Cliff

BY ARJUN MAKHIJANI

Contrary to widespread public opinion, the danger of a nuclear confrontation between the United States and Russia has not receded.

During the NATO-Yugoslavia war, the tension between the two powers rose to some of the highest levels since the Cuban missile crisis. "I told NATO, the Americans, the Germans: 'Don't push us toward military action. Otherwise, there will be a European war for sure and possibly world war,'" said Russian President Boris Yeltsin on April 6.

"You have to understand that if we want to cause you a problem over this, we could," said Vladimir Lukin, chairman of the Russian State Duma Foreign Policy Committee. "Someone, we don't know who, could send up a missile from a ship or a submarine and detonate a nuclear weapon high over the United States. The EMP [electromagnetic pulse that destroys electronic and computer equipment] would take away all your capability."

"If NATO goes from air force to ground force, it will be a world catastrophe," said Anatoly Chubais, the former First Deputy Russian Prime Minister.

Former President Mikhail Gorbachev, the individual who did more than anyone else to end the Cold War, said that U.S. ambitions to exercise global hegemony were risking "even, perhaps, a hot war."

"If the question is to be or not to be for Russia, we must use everything we have in the armed forces, including nuclear weapons," said Anatoly Kvashin, chief of the Russian General Staff, in response to the bombing.

Arjun Makhijani is the president of the Institute for Energy and Environmental Research in Takoma Park, Maryland. IEER's web site is www.ieer.org.

Yeltsin, erratic and in failing health, also threatened world war over the bombing of Iraq last December.

Such comments should not be dismissed as mere rhetoric or hot-headed talk.

Russia is going through a volatile period, and its instability makes the United States and the rest of the world less secure. The country is in grievous economic distress, has no practical recourse to conventional military capability, and has a deteriorating nuclear weapons command-and-control infrastructure. Russia has little money to maintain its equipment, to train its forces, or to replace broken and defective machinery. It cannot even pay its armed forces personnel regularly. Mistreatment of ordinary soldiers is so rife that people are afraid to send their sons into the military. The suicide rate among recruits is high.

In response to this military weakness, Yeltsin in April approved "a blueprint for the development and use of nonstrategic nuclear weapons," which would modernize some of the tactical and short-range weapons Russia removed from its arsenal several years ago. This is a major step backwards.

We are witnessing severe setbacks for arms control and disarmament. The gains of the hopeful first years after the fall of the Berlin Wall, when U.S. and Russian leaders could act in concert, are being rapidly eroded.

There is little prospect that START II, the treaty that would reduce Russia's nuclear arsenal from 6,000 to about 3,000 warheads, will be ratified by Russia in the absence of new actions by the United States. While negotiations between the United States and Russia are set to resume in the aftermath of the NATO-Yugoslavia war, the Russian reliance on nuclear weapons is unlikely to change without a move on the part of the United States that is more sensitive to Rus-

sian security concerns. Even Gorbachev's removal of battlefield nuclear weapons from Russia's arsenal may be reversed. In the Russian military, there is a widespread feeling that in the event of a conflict with NATO, the country has no usable military muscle other than nuclear weapons.

In its new strategic doctrine announced at the April summit, NATO, in turn, did not rule out deploying tactical nuclear weapons of its own. "Sub-strategic nuclear weapons will, however, not be deployed in normal circumstances on surface vessels and attack submarines," it said. Evidently, NATO retains the option to redeploy tactical nuclear weapons in abnormal circumstances.

But nuclear war between Washington and Moscow may be more likely to arise not from a command decision but from accidents, miscommunications, or computer foul-ups during times of tension.

Only four years ago, a communications error between the two countries almost did lead to nuclear war. In 1995, Russian radar detected an incoming missile fired from Norway, and this set off a nuclear alert. The black suitcase for the initiation of a nuclear attack reached President Yeltsin. The world was only a few minutes away from annihilation.

The initial trajectory of the rocket seemed to be that of a missile fired from a forward-based U.S. Trident submarine. The alert was called off when the rocket began to follow a course that turned away from Russia. In this case, Russian radar and command systems actually worked. What did not work properly was the U.S.-Russian communication system. The United States had issued only a routine warning of a joint U.S.-Norwegian research rocket launch, even though it was aware that the rocket resembled a Trident missile. On the Russian side, the warning was lost in the bureaucracy.

"We all found ourselves under stress," Antoly Solokov, the commander of the Russian radar forces, told *The Washington Post*. "An officer on duty reported detecting a ballistic missile which started from the Norwegian territory. What kind of missile is it? What is its target? We were not informed."

This was not the only time a mistake nearly started a nuclear war. A look at past crises shows that misunderstandings and false nuclear alerts are more likely to occur during times of tension:

• November 1956 (the Suez Crisis): The U.S. nuclear command received information that unidentified aircraft were in Turkish air space, that a British jet had been shot down, and that a Russian fleet was moving into the Mediterranean from the Black Sea. But the unidentified aircraft were a flight of swans, the Russian fleet was doing previously scheduled routine exercises, and the British bomber had been forced to land because of mechanical problems.

• November 9, 1979 (in the aftermath of the Iranian revolution): Duty officers at four different command centers saw a full-scale missile attack on the United States, and preparations began for a counter-attack. The President's airborne nuclear command center was launched, but without the President. After six minutes, the attack was discovered to be a false alarm caused by an exercise tape that was running on the computer system as part of a demonstration for Senator Charles Percy. During this false alarm, William Odom, military assistant to Zbigniew Brzezinski, President Carter's National Security Adviser, telephoned Brzezinski at three in the morning to report that the Soviet Union had launched more than 200 missiles at the United States. Brzezinski was preparing to notify the President when Odom called to say there were 2,200 missiles coming in. Just as Brzezinski was about to telephone the President, Odom called again, saying it was a false alarm.

• June 1980 (in the midst of the Iranian hostage crisis): A faulty computer chip caused the false detection of missiles by the United States, and it prepared to counterattack. The pattern of numbers on the screen then indicated that the attack was, in fact, a malfunctioning computer.

• September 26, 1983 (at the height of U.S.-Soviet tensions during the first term of President Reagan and less than four weeks after the Soviets shot down Korean Airlines Flight 007): Russian radar detected incoming missiles. But a full alert was not declared because a launch control officer decided that there were too few missiles to constitute a real attack. The apparent cause of the error was that the satellite transmitting the missile attack signal mistook the reflection of the sun's rays for incoming missiles.

On top of all these problems comes the Year 2000 (Y2K) bug. By all accounts, nuclear warheads or missiles will not go off due to malfunctions of computer chips or software. They will require some human command. But the communications infrastructure—including the satellites that detect incoming missiles and the radars that receive satellite and other communications—is vulnerable to the Y2K bug.

Communications equipment depends on calculations of time intervals and on digital clocks, which could be thrown off at the end of the year 1999 if computers sense the time as the start of the year 1900 instead of the start of 2000. For some computers, that glitch will come earlier than December 31, 1999, since some satellite clocks are quirkily programmed to change years on the night of August 31.

A communications crash could result in a faulty diagnosis of incoming missiles, or in blank screens—increasing the risk of an erroneous launch command.

Until March 24, 1999, when the NATO bombing of Yugoslavia began, Russia and the United States had a program to address potential nuclear command-and-control Y2K problems. They were planning to create a computer communications center. The center was to have been jointly staffed by U.S. and Russian military personnel so as to reduce the risk of misunderstanding and miscommunication. This project has now been put on hold.

U.S.-Russian cooperation has improved since the end of the NATO bombing, but work on the joint communication center continues to be suspended. So far as Russian equipment is concerned, the most urgent need is funding to fix the problems. There is widespread concern that there may be electric power and telecommunications failures. While nuclear military officials claim that they are successfully addressing the problems that exist, it is difficult to be confident of such pronouncements, given the lack of funds, difficulties of organization, and deteriorating infrastructure in Russia.

The first step the United States and Russia should take to reduce the risk of nuclear weapons is to move them off of hair-trigger alert. Today, U.S. and Russian nuclear weapons continue to be in a "launch-on-warning" posture, as they were during the Cold War. This hair-trigger alert stance allows only about fifteen minutes between the detection of incoming missiles on a radar screen and a decision to fire missiles from their silos and submarine launch tubes.

Because of this alert status, the nuclear powers have created a "use it or lose it" policy dilemma for themselves. If one power believes it sees incoming missiles, it has an incentive to launch its stockpile because if it doesn't, that stockpile will be destroyed. Russia is far more vulnerable to such a first strike than is the United States because, unlike the United States, Russia cannot afford to maintain its strategic submarines at undersea patrol locations, which are more difficult to find. Russian strategic submarines are based in port with open missile launch tubes.

Russian nervousness arising from this insecurity is all the worse because the United States continues to maintain forward naval patrols, including Trident nuclear submarines near Russia. These forward-based submarines reduce the amount of time that Russia has to respond to any suspected U.S. attack.

Russia is also threatened by U.S. precision munitions—such as nonnuclear cruise missiles—since they, too, could destroy some of Russia's nuclear arsenal.

These factors have substantially upped the nuclear ante.

A launch-on-warning posture does not allow time for negotiations. There is little leeway for the human survival instinct to come into play. All is preprogrammed except for the judgment of the few people who are giving the commands. For everyone else, the world will be quite normal one moment; in the next it will be over. Literally.

In 1994, Presidents Clinton and Yeltsin announced, with much fanfare, that they were "de-targeting" nuclear weapons. This is not the same as de-alerting. In fact, de-targeting barely makes a difference. "De-targeting" changes the coordinates in the programmed commands of a nuclear weapons system away from the intended target, but this can be reversed in less than one minute by simply punching new target coordinates into a keyboard. De-targeting is a small gain, but it is entirely unequal to the task of reducing nuclear risk.

It will take politically courageous action to reduce these grave nuclear dangers. The preeminent example of

such action in the post-Cold War nuclear arena was set by President George Bush in the wake of the attempted coup in August 1991 that was the prelude to the collapse of the Soviet Union.

For a few days, no one knew who, if anyone, was in command of Soviet nuclear weapons. And there was no telling the fate of Soviet tactical nuclear weapons located in many republics of the former Soviet Union. Would there suddenly be many nuclear weapon states? Would these especially portable nuclear weapons wind up in black markets to nonnuclear states or to nongovernmental parties, such as organized crime or terrorist groups? There was no time for treaties.

President Bush unilaterally took U.S. nuclear bombers off alert; he ordered the removal of almost all tactical nuclear weapons from the U.S. arsenal, including all nuclear weapons on surface ships and a variety of land-based weapons in Europe. President Gorbachev responded with a similar initiative of his own in a week.

Without bold new moves on the part of the United States, serious nuclear dangers are likely to persist. While current U.S. law prevents President Clinton from reducing strategic nuclear forces below START II limits of 3,000-3,500 strategic warheads, he can still take a number of initiatives.

He can declare that the United States will not initiate a first strike.

He can assure Moscow that NATO expansion is not aimed at Russia and specifically not intended to bring nuclear weapons closer to that country's borders.

He can remove all the nuclear bombs that the United States has stationed in Europe. These are the only nuclear weapons that any state has placed within the territories of other countries. This step might even revive the prospects of START II ratification. It would also reassure nonnuclear weapons states that believe the U.S. nuclear policy of keeping bombs in other countries violates the spirit of the Nuclear Non-Proliferation Treaty.

The United States should also stop positioning its Trident submarines near Russian waters. Such forward deployment is very dangerous and provocative.

But above all, President Clinton should place nuclear weapons on de-alert status to eliminate, as much as technically possible, the danger of nuclear war by accident or miscalculation. Physical and political fire breaks are needed. The time for consultation and verification should be lengthened from fifteen minutes to hours, days, or weeks. De-alerting measures should be substantial and robust enough to inspire the level of confidence that will avert mistakes and false alerts. Examples of such measures include:

- Prolonging land-based missile firing time in various ways, such as by pinning open the missile motor ignition switches;
- Removing the pneumatic systems that enable the missile covers of land-based missiles to be opened automatically;
- Covering missile silos with mounds of earth sixty or seventy feet high;
- Lengthening preparation time for launch of submarine-based missiles to many hours;
- Stuffing a piece of removable wire into the hollow nuclear trigger of each nuclear warhead so that it will not detonate unless the wire is removed;
- Removing the bottle containing radioactive tritium gas that is essential to detonation of the thermonuclear secondary part of a nuclear warhead and hence to its use in a first strike. Removal of the tritium bottle still allows for a nuclear explosion (in all warhead designs but one), but at a far lower explosive yield. Thus, retaliatory capacity is maintained while first strike capacity is removed.

It is impossible to predict with confidence the risks attendant on the Y2K bug, especially given the wobbly nature of the U.S.-Russian relationship and the lack of funds and time to address the issue in Russia. But the risks of launch due to communication failure must be eliminated, no matter how small officials feel it might be. The surest way to do that is for the United States to take the initiative to de-alert its nuclear weapons before the end of the year and work with Russia to get reciprocity. The specific measures taken in the coming weeks and months should be the sort that would make it physically impossible to rapidly launch a nuclear strike in response to detection of an incoming missile.

Such measures would ensure that Y2K-related problems do not result in a mistaken nuclear launch and that nuclear risk reduction will endure after December 31, 1999. Even with such protective measures, the United States would retain retaliatory capacity, since it has submarines on patrol that are essentially invulnerable to detection and destruction.

De-alerting nuclear weapons has wide support within the United States and outside it. Those who have called for substantial or complete de-alerting include former CIA chief Admiral Stansfield Turner, former head of the Strategic Air Command Lee Butler, former Senator Sam Nunn (Democrat of Georgia, who headed the Senate Armed Services Committee), former missile control officers like Bruce Blair of the Brookings Institute, the majority of countries that are parties to the Nuclear Non-Proliferation Treaty, and grassroots groups around the United States and the world.

The best guarantee of safety from accidental launch is to remove warheads from their delivery systems and to store them separately under multilateral monitoring—that is, monitoring for verification purposes by some combination of nuclear and possibly nonnuclear weapons states, and/or an ad hoc international agency created for that purpose. The warheads would still be part of the nuclear arsenal of the individual states. But their withdrawal from monitored storage would be politically very difficult. This de-alerting measure is the closest in spirit to nuclear disarmament, but for that reason it will also be the most difficult to accomplish. Moreover, Russia does not currently have secure storage for all its warheads, and so could not safely separate its warheads from their delivery systems.

De-alerting is essential for safeguarding the planet, and it is a big step toward complete nuclear disarmament. But disarmament is highly unlikely to come about until Russia, China, India, and other countries are satisfied that the United States would not use nonnuclear advanced weapons to destroy their economies. That is one of the lessons of the NATO-Yugoslavia war that many have drawn: If you don't have nuclear weapons, the United States, acting alone or in concert with other Western countries, could pound you without prior authority of or even reference to the United Nations.

Nuclear disarmament requires a profound change in political, military, and moral culture worldwide. Such change may not come quickly.

But in the meantime, the least we can do is to ensure that nuclear war does not break out because of a computer malfunction, an accidental launch, or some miscommunication. The best way to ensure that this doesn't happen is to de-alert nuclear weapons. The time to do that is now.

Unit 6

Key Points to Consider

❖ Itemize the products you own that were manufactured in another country.

❖ What recent contacts have you had with people from other countries? How was it possible for you to have these contacts?

❖ How can the conflict and rivalry between the United States and Russia be transformed into meaningful cooperation?

❖ What are the prospects for international governance? How would a trend in this direction enhance or threaten American values and constitutional rights?

 Links **www.dushkin.com/online/**

These sites are annotated on pages 6 and 7.

An individual at just about any location in the world can write a letter to another person just about anywhere else, and if it is properly addressed, the sender can be relatively certain that the letter will be delivered. This is true even though the sender pays for postage only in the country of origin and not in the country where it is delivered. A similar pattern of international cooperation is true when an individual boards an airplane in one country and never gives a second thought to the issues of potential language and technical barriers, even though the flight's destination is halfway around the world.

Many of the most basic activities of our lives are the result of international cooperation. International organizational structures to monitor public health on a global scale or to evaluate changing weather conditions scientifically are additional examples of governments recognizing that their self-interest directly benefits from cooperation (i.e., the creation of international governmental organizations, or IGOs).

Transnational activities are not limited to the governmental level. There are now literally tens of thousands of international nongovernmental organizations (INGOs). These organizations stage the Olympic Games or actively discourage the hunting of whales and seals, to illustrate just two of the diverse activities of INGOs. The number of these international organizations along with their influence has grown tremendously in the past 40 years.

In the same time period in which we have witnessed the growth in importance of IGOs and INGOs, there has been a parallel expansion of corporate activity across international borders. Most consumers are as familiar with products with a Japanese brand name as they are with products made in the United States, Germany, or elsewhere. The multinational corporation (MNC) is an important nonstate actor in the world today. The value of goods and services produced by the biggest MNCs is far greater than the gross domestic product (GDP) of many countries. The international structures that make it possible to buy a Swedish automobile in Sacramento or a Swiss watch in Singapore have been developed over many years. They are the result of governments negotiating treaties and creating IGOs to implement these agreements. The manufacturers engaged in these activities have created networks of sales, distribution, and service that grow more complex with each passing day.

These trends at a variety of levels indicate to many observers that the era of the nation-state as the dominant player in international politics is passing. Others have observed these trends and have concluded that the state system has a monopoly of power and that the diverse transnational organizations depend on the state system and in significant ways perpetuate it.

In many of the articles that appear elsewhere in this book, the authors have concluded by calling for greater international cooperation to solve the world's most pressing problems. The articles in this section show examples of successful cooperation. In the midst of a lot of bad news, it is easy to overlook the fact that we are surrounded by international cooperation and that basic day-to-day activities in our lives often benefit from it.

Justice Goes Global
(International Criminal Court Is Created)

More than 160 nations voted to establish the International Criminal Court, which will be located in The Hague, Netherlands. The U.S. refused to sign the treaty to create the global tribunal to judge war crimes because of reservations about sovereignty and jurisdiction.

Despite U.S. dissent the world community finally creates a new court to judge the crimes of war.

The spectre of the century's slaughtered millions haunted Rome as the world's nations struggled for five weeks to create the first permanent international body dedicated to punishing the crimes of war. "Victims of past crimes and potential victims are watching us," said U.N. Secretary-General Kofi Annan. "They will not forgive us if we fail."

They did not fail. Cheers and applause echoed as representatives of some 160 nations, assisted by more than 200 non-governmental organizations, gathered last week in the plush maze of the U.N. Food and Agriculture Organization's building, voted overwhelmingly to create the International Criminal Court (I.C.C.). But success came only after frantic last-minute negotiations to bridge philosophical divides that left the U.S. in opposition to the treaty and at odds with most of its major allies. Just how viable the court will be if the world's superpower carries out its threat to "actively oppose" the new institution remains to be seen, but 18 judges will gather in The Hague within the next few years, ready to try cases of genocide, war crimes and crimes against humanity.

The duality of mankind's urges to both wage war and curb its own bellicosity is virtually as old as warfare itself. But it was only in the 19th century that refinements in the technology of battle concentrated minds on serious attempts to find judicial ways to combat their brutality. The laws and customs of war were codified at Conventions in The Hague in 1899 and 1907, and efforts continued between the two World Wars. But those laudable agreements were impotent in face of the unprecedented carnage of the 20th century's first half, when an estimated 58 million died in Europe alone. After World War II, international tribunals at Nuremburg and Tokyo tried and convicted the conflict's instigators for war crimes, crimes against peace and against humanity itself. But these judgments were carried out within a temporary judicial framework imposed by the victors.

The Geneva Conventions of 1949 continued to build a body of international law governing the conduct of war, but the problem of applying the provisions remained. The newly formed U.N. had commissioned a study in 1948 to look into establishing a permanent tribunal, but the cold war prevented any real progress. The topic surfaced again only in 1989, when the International Law Commission began preparing a draft statute for an International Criminal Court. But what really galvanized the international community was the chaotic disintegration of Yugoslavia and the atrocities that accompanied it.

The U.N. eventually moved to create an ad hoc criminal tribunal on the crimes committed during the Bosnian war in 1993, followed a year later by another one-off body for Rwanda. The distinguished South African jurist Richard Goldstone, the original chief prosecutor for both tribunals, says that those courts represented "the first real international attempt to enforce international humanitarian law." But establishing those bodies took up to two years of preparatory work and negotiation. "The thing is to avoid having to spend six months looking for a prosecutor," notes Theodor Meron, professor of international law at New York University Law School, "and a year looking for a building."

Even though Bosnia's most notorious accused war criminals have not yet been brought before The Hague tribunal, it has indicted some 60 people, holds 27 men in custody and has handed down two judgments. This month the court launched the first genocide prosecution in Europe. Deputy Prosecutor Graham Blewitt says that "We have been a model for the creation of the new court."

International law has always involved an inherent tension between national sovereignty and accountability. But the continuing carnage since 1945—another 18 million dead and the likes of Idi Amin, Pol Pot and Saddam Hussein reigning in terror—reinforced the U.N.'s determination to act. As it did so, Washington began to fret. Michael Scharf, currently professor of law at New England Law School, was the State Department's point man on the court under President George Bush. "One of my jobs, which I did not enjoy," recalls Scharf, "was to find ways to stall it forever." President Clinton has been far more supportive, but his administration, too, developed serious qualms. Recalling the invasions of Grenada and Panama, and the bombing of Libya, the U.S. worried that similar actions in the future could involve officials all the way up the chain of command being hauled before the I.C.C.

 From *Time*, July 27, 1998, pp. 46-51. © 1998 by Time Inc. Magazine Company. Reprinted by permission.

As the conference convened in Rome on June 15, it was beset by disagreement. The most divisive questions revolved around the precise definition of the crimes to be within the court's jurisdiction, the breadth of that jurisdiction and just who would determine which cases should be brought. The U.S. went in with goals that allied it uncomfortably with China, Russia and India, as well as Libya and Algeria, but put it at odds with most of its usual friends who gathered among the so-called Like-Minded Nations seeking a strong and independent Court. "We are not here," said Washington's U.N. ambassador, Bill Richardson, "to create a court that sits in judgment on national systems." The U.S. is concerned that its many soldiers serving overseas could become involved in confrontations that would make them vulnerable to what an Administration official called "frivolous claims by politically motivated governments."

The Washington negotiators—who rejected universal jurisdiction, subjecting any state, signatory or not, to the court's remit—agreed that the court should have automatic jurisdiction in the case of genocide, giving it the ability to prosecute individuals of any country that had signed the treaty. But they sought a clause allowing countries to opt out of the court's jurisdiction on war crimes and crimes against humanity for 10 years. The agreed statute allows states to opt out of the court's jurisdictions only on war crimes and

only for seven years. It also includes the crime of "aggression" within the court's jurisdiction, subject to a precise definition of aggression. Washington had also wanted to give only the Security Council and states party to the agreement the right to bring cases to the court. The statute, however, also empowers the prosecutor to initiate cases. The U.S. did manage to get a compromise, promoted by Singapore, allowing the Security Council to call a 12-month renewable halt to investigations and prosecutions included in the text. "If states can simply opt in or out when they want, the court will be unworkable," said a senior official in the German delegation. Without an independent prosecutor, he added, "crimes will be passed over for political reasons."

Although conference chairman Philippe Kirsch of Canada had already successfully chaired at least eight international conferences—brokering agreements on issues such as terrorism and the protection of war victims—all his undoubted mediation skills failed to resolve the disputes. As Washington became increasingly isolated, a copy of U.S. "talking points" circulated among the delegations, suggesting that if the court did not meet U.S. requirements Washington might retaliate by withdrawing its troops overseas, including those in Europe. Although few believed in that possibility and the Administration downplayed it, State Department spokesman Jamie Rubin explained that "The U.S. has a

special responsibility that other governments do not have."

After all the wrangling, what emerged was a court to be located in The Hague—where the International Court of Justice already deals with cases brought on a civil basis by states against other states. It is to contain four elements: a Presidency with three judges; a section encompassing an appeals division, trial and pre-trial divisions; a Prosecutor's office; and a Registry to handle administration. The court, which will act only when national courts are "unwilling or unable genuinely" to proceed, will confine its maximum penalty to life imprisonment.

How the court will fare without the support of the U.S. is unclear. Washington has provided vital political backing for the Yugoslav and Rwanda tribunals and continues to be their leading financier. "We have shown that the only way to get war criminals to trial is for the U.S. to take a prominent role," said one Administration official last week. "If the U.S. is not a lead player in the creation of this court, it doesn't happen."

Nevertheless, the fact that a court with teeth has actually been created was an unprecedented move by the world community to make the rule of law finally prevail over brute force—a step towards fulfilling Secretary-General Annan's pledge that "At long last we aim to prove we mean it when we say 'Never Again.'"

● Enforcing Human Rights

Karl E. Meyer

In the century's surprising finale, human rights in its many guises has become a pervasive global cause, culminating in the most unusual of modern wars, the NATO intervention in Kosovo. As never before, the foreign news is seemingly dominated by demands for basic political rights and protests against internal repression. Stories involving human rights, or their absence, flow from lands of every description, ranging from the Vale of Kashmir to tiny East Timor in Asia, from every region of Africa, and from almost every ex-Soviet republic from the Baltic to the Caspian Sea. So strong is the tide that human rights offenses long past are being tried anew, either in British courts in the case of Chile's General Augusto Pinochet, or in American films and academic treatises in the case of African slavery.

Politics and technology help explain this development. Public diplomacy abhors a void, and with the end of the Cold War, there has been a palpable hunger for a unifying doctrine. Thus, the long ignored and most blatantly flouted of international covenants, the Universal Declaration of Human Rights, adopted by the United Nations in 1948, has assumed a robust second life. Its principles are advanced by an aggressive phalanx of nongovernmental organizations, notably Amnesty International, Doctors Without Borders, and Human Rights Watch. With an assist from pop stars and British royals, most Westerners are now con-

Karl E. Meyer has written extensively on human rights as a member of the New York Times *Editorial Board, 1979–98. He is the author, with Shareen Brysac, of* Tournament of Shadows: The Great Game and Race for Empire in Central Asia, *published in November by Counterpoint.*

versant with the current vocabulary of human rights: boat people, "ethnic cleansing," Free Tibet, land mines, Live Aid, female mutilation, and that most misleading media mantra, the "international community." For Westerners, what happened in Kosovo was a good deal more than "a quarrel in a far away country between people of whom we know nothing," as Neville Chamberlain said of Czechoslovakia in 1938 (a phrase echoed by Secretary of State Warren Christopher, speaking about Bosnia in 1993).

For non-Westerners stifled by authoritarian regimes, human rights have acquired a different resonance. They provide a weapon of opposition that can generate foreign attention and even in some cases (Kosovo, for example) trigger intervention. On its face, prospects for moving forward appear promising. Earlier debates on the alleged conflict between "Asian values" and the U.N. declaration have abated, and the consensus on universal norms seems broad and hopeful. The failure of communism has given widespread and practical luster to such democratic values as free speech, civil society, the rule of law, and electoral accountability. Propitiously, new technologies have bored holes in closed frontiers. Fax machines, cellular telephones, and the Internet now feed the agitation against the hard-line ayatollahs of Iran and the Burmese jailers of Aung San Suu Kyi.

Yet however welcome to human rights activists, these favorable developments have raised expectations that cannot plausibly be realized. The American role is critical. No forward movement is possible without Washington's support and leadership, but the very exercise of such leadership stirs an outcry against U.S. hegemony abroad and a backlash from left and right

at home. In truth, American policy has neither direction nor strategy but is a melange of bromidic phrases. At a recent panel discussion in New York, a Peruvian human rights worker confessed he could not understand why the Clinton administration, having uttered the right sentiments about repression in his country, went on to help finance a draconian narcotics sweep by the hated security police, bent U.S. laws to sell advanced warplanes to the all-too powerful military, and gave its blessing to fiscal measures that punish the poor and undermine Peruvian democracy. Asked what he most sought from Washington, he offered a one-word answer: "Coherence."

Wilsonian Trappings in the Real World

The rebuke is valid, but in the circumstances, inescapable. There is no "international community" in any meaningful sense, only its simulacrum in the form of an enfeebled (and insolvent) United Nations and a toothless World Court. Despite all the Wilsonian trappings, the world today substantially resembles that of 1900: one global superpower (America, in place of Britain), a dozen or so pivotal powers (Britain, Germany, France, Russia, China, Japan, India, Brazil, Indonesia, Israel, Turkey, Pakistan, and South Africa), and upward of 150 lesser entities, most of them poor and dependent. Granted, the old colonial empires have melted away, but from the human rights vantage, this is not always a plus. For reasons of crass self-interest, colonial powers maintained a monopoly on the use of force, put down regional and ethnic separatists, and imposed a rough Hobbesian peace. As we have seen in Rwanda, Bosnia, and Somalia, the "international community" has failed to devise a more acceptable, and effective, substitute.

In the nineteenth century, it is worth recalling, a "power" was defined as a country strong enough to resist foreign intervention. The distinction still holds. It is highly unlikely, putting it mildly, that the "international community" would ever intervene forcibly on human rights grounds against any of the pivotal powers. To be sure, sanctions of various degrees of severity are feasible, and can have teeth, as in the case of South Africa during the apartheid era. But this was an exception. In the post—Cold War era, pivotal powers generally get a human rights pass: consider Turkey and the Kurds, China and the Tibetans, Russia and the Chechens. Thus, harsher measures invariably apply to the weak, the poor, and the pariah (Serbia and Iraq). There is no equal justice under world law.

All this is known to policymakers. As the writer David Rieff usefully reminds us, officials reserve their lofty phrases for the public pulpit, and in private employ terms that Bismark would have no trouble understanding.[1] In that realistic spirit, one should attempt

to sort out the policy choices for the United States in the coming decades. In my view, they boil down to three. Washington could dispense with cant and unilaterally proclaim a Pax Americana, dispatching Marines or cruise missiles, when necessary, to rush in humanitarian aid, prevent massacres, and punish tyrants. A second option would be to heed George Kennan's advice: abjure interventionist meddling, address our own neglected ills, and lead by moral example. Or Washington could, for the first time, make a serious commitment to collective action, building on structures that already exist, and thereby give some meaning to the hollow phrase "international community."

The perils of the first course were apparent in the Clinton administration's punitive air strikes in 1998 against presumed terrorists in Afghanistan and Sudan. The suspicion that President Clinton was trying to change the subject during the impeachment proceedings against him sharpened when the Pentagon could not confirm that a factory it destroyed in Khartoum actually produced chemical weapons. To the peril of seeming cynical and incompetent when operations misfire is added the peril of seeming a hegemonic bully when missions succeed. In any case, unilateral military adventures are easier to initiate than to end. Previous American "police actions" in Haiti, the Dominican Republic, and Nicaragua turned into occupations that endured through six American administrations, from William Howard Taft to Franklin D. Roosevelt (who is still remembered in Latin America as the good neighbor who pulled out the Marines).

The problem with George Kennan's prescription is its unfeasibility in a multiethnic democracy in which legislators play so important a role in foreign policy. One may sympathize with Kennan's distaste for moralizing bombast from members of Congress, but that is the price of popular democracy. Indeed, examined more closely, our melting-pot diplomacy, whatever its periodic excesses, has also had its triumphs. While serving as secretary of state, Henry Kissinger deplored the Jackson-Vanik Act that attached human rights conditions to most-favored-nation trade benefits, and he was at best lukewarm about the human rights provisions in the 1975 Helsinki Accords that gave all signatories the right to inquire into and judge compliance—yet both helped to legitimize internal opposition to Soviet repression. We tend as well to forget that in enacting economic sanctions against South Africa, Congress overrode President Reagan's veto—an instance in which a legislative measure palpably fostered peaceful change in another country. All these measures were attributable to human rights agitation and melting-pot politics, and all involved the kind of moralizing intervention that George Kennan too indiscriminately deplores.

If popular involvement in foreign policy is integral to our system, why not turn this to advantage? Why

not tap the undoubted reserves of American goodwill and generosity, as evidenced in the continuing vitality of the Peace Corps? For starters, the next president could reverse course and support the 1998 Rome Statute creating an International Criminal Court, ending the need for ad hoc tribunals to try accused war criminals. Why not take the braver course—sign the statute and address its shortcomings while moving forward to full ratification? It is hard to believe that Americans lack the legal wit to safeguard U.S. troops from frivolous prosecutions—cited by the Clinton administration as a major reason for refusing to sign. Had Harry Truman heeded similar warnings from lawyers, to whom every precedent is a slippery slope, the Nuremberg Tribunal would never have been established. (Indeed, a British initiative to give the tribunal permanent status was among the sadder political casualties of the Cold War.)

Additionally, the next president could call upon the country to join with willing foreign partners, notably Canada and the Netherlands, finally to establish a voluntary standby force under the United Nations capable of responding swiftly when genocidal disasters threaten. Of the regrettable features of the NATO intervention in Kosovo, two stand out: the reliance on massive air power to avoid NATO casualties, thus all but destroying the country that was to be saved, and the use of a regional military alliance to bypass authorization by the U.N. Security Council. These were precedents far graver than any of the claimed pitfalls in the Rome Statute, and it would require courage for a presidential contender to say as much. But absent that kind of courage, it is hard to see how anything like a real "international community" will ever emerge.

Washington's Frosty Response

In George Kennan's telling phrase, American support for human rights has been declaratory in nature, not contractual. This was so from the outset. The Truman administration was delighted when Eleanor Roosevelt gained unanimous General Assembly approval in 1948 for the Universal Declaration of Human Rights (48 in favor, none opposed, two absent, and eight abstentions, mostly Soviet bloc delegates). As the first chairman of the U.N. Human Rights Commission, Mrs. Roosevelt adroitly coaxed support for language that emphasized individual rights, while it also recognized social and economic rights. Article One paraphrases Jefferson's Declaration, *sans* Creator: "All human beings are born free and equal in dignity and rights. They are endowed with reason and conscience and should act toward one another in the spirit of brotherhood."

Yet when Mrs. Roosevelt, "the First Lady of the World," pressed for ratification of implementing cove-

nants, she met with a frosty response in Washington. As the writer Michael Ignatieff has remarked, American human rights policy is distinctive and paradoxical, "a nation with a great rights tradition that leads the world in denouncing human rights violations but which behaves like a rogue state in relation to international legal conventions."[2] The Senate has refused to approve, or has imposed demeaning reservations on, nearly every important U.N. covenant with respect to human rights. The U.S. Senate, typically enough, deliberated for nearly four decades before ratifying, with qualifying conditions, the 1948 Genocide Convention. (It needs adding that Sen. William Proxmire for three years took the floor daily to express his dismay at this shaming lassitude.)

To be sure, the constitutional requirement of a two-thirds vote for ratifying treaties gives inordinate leverage to a Senate minority. Granted as well, during the Cold War's glacial phase, the United Nations fell so far in American esteem that a Reagan administration delegate invited the organization to sail into the sunset (a geographic impossibility from New York harbor), a sentiment seconded by Mayor Ed Koch, a Democrat. Many Americans, not all of them conservatives, found it unconscionable to be lectured on human rights by members of the Soviet bloc and the Third World majority in the General Assembly. This is now history. The Soviet Union no longer exists, the General Assembly has rescinded its resolution equating Zionism with racism, most of the basic fiscal and management reforms demanded by Washington have been undertaken—yet the Clinton administration and the U.S. Congress still regard the United Nations as something like an unfriendly foreign power, unworthy of real trust, or even indeed of its $1.6 billion in treaty-mandated back dues and assessments.

The result, in the words of Brian Urquhart, is a weak, divided and underfinanced international system, on which the world must prayerfully count to prevent wars (internal and regional), genocide, nuclear proliferation, and environmental calamities. Urquhart, a former undersecretary general of the United Nations, offers a gloomy but accurate summary of what this means: "More than ever it is clear that there is a large hole in this ramshackle international structure—the absence of consistent and effective international authority in vital international matters. The very notion of international authority is anathema to many governments, great and small, until they are looking disaster in the face, by which time it is usually too late for useful international action.[3]

The next president has a history-given opportunity to treat Americans as grownups, by stating plainly that this country has neither the wit nor the resources to be the world's sheriff, that sharing global obligations makes political and fiscal sense, that a new administration wishes to work with others to clear out

land mines everywhere, that it welcomes proposals for training international police, and indeed would even consider (as David Rieff suggests) some form of long-term authority in places like Kosovo, where creating stable political arrangements may take a generation.

A specific and useful proposal is already on the table: the creation of a multinational standby force that could be rapidly deployed to check genocidal massacres. No matter that such crises are infrequent: when they occur, the aftershocks endure for decades. Interestingly, when such a force was first proposed in 1992, it was endorsed by candidate Bill Clinton: "We should explore the possibility of creating a standby, voluntary U.N. rapid deployment force to deter aggression against small states and to protect humanitarian relief shipments."

The standby proposal originated in "An Agenda for Peace," a report to the Security Council by Egypt's Boutros Boutros-Ghali, a smart, abrasive, and unpopular U.N. secretary general. As he was at pains to emphasize, he was not suggesting the formation of a U.N. army but instead asking as many nations as possible to make available troops on a standby basis, so operations could get underway in days, not months. Such a force was envisioned in Article 43 of the U.N. Charter, under which all members "undertake to make available to the Security Council, on its call and in accordance with a special agreement...armed forces, assistance, and facilities, including rights of passage, necessary for the purpose of maintaining international peace and security."

Fatal Timing

Boutros-Ghali's proposal had merit, but his timing was fatal. In 1993, the untested Clinton team inherited from the Bush administration a muddled humanitarian mission in Somalia meant to feed a stricken people without taking sides in a civil war. Although nominally under U.N. auspices, Operation Restore Hope was directly controlled by the United States, which provided most of the troops. On October 3, 1993, eighteen U.S. Rangers were killed in a skirmish, a shaken President Clinton pulled back and out, and hopes for a multinational standby force died in the mean streets of Mogadishu.

The need for such a force was underscored with horrific finality in April 1994, with the outbreak of ethnic massacres in Rwanda. A small U.N. force of 2,500 troops was instantly withdrawn from the Rwandan capital, Kigali, and Washington blocked Security Council authorization for a stronger force, among the gravest foreign affairs mistakes by the Clinton White House. Around 800,000 Rwandans were slain; the slaughter was followed by the exodus of 2.5 million

refugees and a cycle of violence in Central Africa whose end is not in sight. In his memoirs, Boutros-Ghali recalls a White House meeting in May 1994 at which, to his surprise, the president all but shrugged off Rwanda to discuss the appointment of an inspector general at the United Nations and the naming of his candidate as the director of the United Nations International Children's Emergency Fund (UNICEF). (Years later, it should be noted, President Clinton more creditably acknowledged American culpability in failing to respond to the Rwanda genocide.)

The Canadian commander of the U.N. force in Kigali, Gen. Romeo Dallaire, asserts that even with two or three thousand troops he could have substantially limited the killings—a judgment supported by Scott R. Fell in a report to the Carnegie Commission on Preventing Deadly Conflict. Fell estimates that a trained force of 5,000 soldiers, deployed in April 1994 could have significantly reduced the toll.[4]

In its indifference to the United Nations, the Clinton administration expressed Washington's abiding bipartisan distaste for multilateral operations in any form, unless there is clear demonstration of American national interest (for example, the Desert Storm operation against Iraq) or an American is in charge (as at the World Bank and UNICEF). Even so, the case for a standby force has gained converts in Washington. In 1998, the Department of Defense quietly won approval for providing $200,000 as seed money for a fund to finance a rapid deployment mission headquarters under Bernard Miyet, the undersecretary general for peacekeeping.

The fund grows out of a Canadian proposal in 1995 for the establishment of such a force, a suggestion strongly seconded by the Dutch. Interestingly, as of July 1999, 85 countries, ranging from Argentina to Zambia, have officially expressed willingness to participate in standby arrangements. The French and the British have offered to make available 5,000 and 10,000 troops respectively. Participants would be obliged to train and pay costs while the forces remained on standby, with the U.N. providing reimbursements after the deployed troops left their country. Of the 85 volunteers, 24 states have already signed a memorandum of understanding with the United Nations, 14 have provided planning data, 23 (including the United States) have listed their capabilities, and 24 have expressed a willingness to take part. Adding the first three groups together, the United Nations on paper could mobilize 84,000 reserves, 56,700 support troops, 1,600 military observers, and 2,050 civilian police.

This is not a standing U.N. army. Its American equivalent is a trained volunteer fire department, able to respond quickly in emergencies. Deployment would be subject to approval of the Security Council, whose five permanent members—the United States,

Russia, China, Britain, and France—each wield a veto. Even so, given America's resistance to multilateral operations, winning approval for such a volunteer standby army would require a fair measure of presidential imagination, persuasiveness, and courage.

How refreshing it would be if the next chief executive reported to Americans on the world as it really is, warned human rights activists that frustration and disappointments were unavoidable, acknowledged that double standards exist and that the "international community" has yet to be created, added that the most likely threats to peace and human rights will arise from civil strife within sovereign frontiers, that to deal with this threat the world needed both regional and international standby reserves, that Washington would do what it could to help, and that as a first step he or she would seek to persuade Americans that it was in their interest to pay the dues owed an organization inspired by American ideals and located in the world's most ethnically diverse city. How refreshing, and how necessary

Notes

1. See David Rieff, "A New Age of Liberal Imperialism?" *World Policy Journal*, vol. 16 (summer 1999).

2. Michael Ignatieff, "Human Rights: The Midlife Crisis," *New York Review of Books*, May 20, 1999.

3. Brian Urquhart, "Looking for the Sheriff," *New York Review of Books*, July 16, 1998.

4. See *Preventing Genocide: How the Early Use of Force Might Have Succeeded in Rwanda*, which is available, along with the Carnegie Commission's final report on Rwanda, at http://www.ccpdc.org. For Boutros Boutros-Ghali's version of the U.S. response to Rwanda, see his memoir, *Unvanquished: A United States-United Nations Saga* (New York: Random House, 1999). For the pros and cons of the Rome Statute, see the monograph, *Toward an International Court* (New York: Council on Foreign Relations, 1999).

The globalization of tourism

Americas to Europe: 23.6

Europe to Americas: 19.5

Europe to East Asia/Pacific: 10.4

Asia to Europe: 14.3

Europe to Africa: 6.9

Africa to Europe: 3.5

Middle East to Europe: 1.9

Asia to East Asia/Pacific: 1.3

Asia to Americas: 10.1

Americas to East Asia/Pacific: 6.2

Major intercontinental tourism flows (millions)　　　**1997**

2020

Americas to Europe: 44

Europe to East Asia/Pacific: 47

Europe to Americas: 65

East Asia/Pacifique to Europe: 47

Europe to Asia: 10

Europe to Middle East: 22

Europe to Africa: 19

Africa to Europe: 11

Esat Asia/Pacific to Americas: 42

Americas to East Asia/Pacific: 20

Source: World Tourism Organization

Reprinted with permission from the *Unesco Courier,* July/August 1999, pp. 26-27.

The top spenders, 1997 — Expenditures* (US$ billion)

United States: 51.2
Germany: 46.2
Japan: 33
United Kingdom: 27.7
Italy: 16.63
France: 16.57
Canada: 11.3
Austria: 11
Netherlands: 10.23
China**: 10.17

The top earners, 1998 — Revenues* (US$ billion)

United States: 74.2
Italy: 30.4
France: 29.7
Spain: 29.6
United Kingdom: 21.3
Germany: 16.8
China**: 12.5
Austria: 12.2
Canada: 9.1
Australia: 8.6

* Excluding international transport. ** Excluding Hong Kong. Source: World Tourism Organization

If the World Tourism Organization's forecasts are on target, international tourist arrivals will climb from the present 625 million a year to 1.6 billion in 2020. By this date, travellers will spend over US$2 trillion, (against US$445 billion today), making tourism the world's leading industry. These projections are based on annual growth rates of 4.3% for arrivals and 6.7% for spending, well above the maximum expected expansion of 3% per year in world GDP. Already in 1997, tourism receipts accounted for a little over 8% of the world's exports in goods and almost 34% of global services exports.

Electronic technology is facilitating this growth by offering access to fare and hotel information and online reservation services. Despite a modest annual growth rate (3.1%), Europe will remain, by far, the most popular destination (it can expect 717 million international arrivals in 2020, double the 1998 figure), though its market share will decline from 50 to 45%. Growth on the continent will be led by Central and Eastern European countries, where arrivals are expected to increase by 4.8% per year. At the same time, almost half of the world's tourists will be coming from Europe. Give this dominance, it is not surprising to find that six European countries count among the top ten tourism earners and spenders. The United States holds first place in both categories.

With a 7% per annum growth in international arrivals, the East Asia/Pacific region will overtake the Americas as the second most popular destination, holding a 27% market share in 2020 against 18% by the Americas. But the industry will also be doing its utmost to court the Asian traveller, since East Asia/Pacific is forecast to become the world's second most important generator of tourists, with a 7% annual growth rate, pushing the Americas into third position. China is expected to become the fourth largest source of tourists on the world market, while it is not even among the first twenty today. Both arrivals to and departures from Africa (and especially Southern Africa), the Middle East and South Asia are expected to grow by above 5% per year.

While France has held its place as the top destination throughout the 1990s, it will be dethroned in the next decades, with China (excluding Hong Kong) expected to top the list by 2020 even though it is not even featured on it today. Also making an entry into the top ten are the Russian Federation, Hong Kong and the Czech Republic.

Despite this growth forecast, tourism is and will remain the privilege of a few: WTO forecasts that only 7% of the world population will travel abroad by 2020—that's double the 1996 figure (3.5%).

The destinations

Country/Territory	Arrivals* (millions) 1998	Country/Territory	Arrivals* (millions) 2020
France	70	China*	137.1
Spain	47.7	United States	102.4
United States	47.1	France	93.3
Italy	34.8	Spain	71
United Kingdom	25.5	Hong Kong, China**	59.3
China**	24	Italy	52.9
Mexico	19.3	United Kingdom	52.8
Poland	18.8	Mexico	48.9
Canada	18.7	Russian Fed.	47.1
Austria	17.3	Czech Rep.	44

*International, excluding same-day visitors. **Excluding Hong Kong.
Source: World Tourism Organization

*Excluding Hong Kong.**Hong Kong has been a Special Administrative Region of China since 1997.
Source: World Tourism Organization

Ecotourism without tears

Sylvie Blangy

From Ecuador to Namibia, indigenous communities are striking up innovative partnerships with tour operators to promote ecotourism on their own terms—a strategy to bring in revenue and protect their culture and environment

In the heart of Ecuador's rain forest, forty-five minutes by foot away from their own village, a small group of Huaorani, an Amazon indigenous people, built a palm-thatched roof cabin for eight. Fearing that too much tourism could disrupt their traditional hunter-gatherer lifestyle and bring in unwelcome consumer habits, the Huaorani only accept one group of visitors per month, for two to six days.

But during this time, they are given full attention. Community representatives greet visitors upon their arrival and discuss some of their people's social and environmental concerns. During this first meeting, a per-night fee is paid to the head of the community for each visitor and the money is distributed evenly among all the families. Salaries for the various jobs (guides, maintenance, canoe paddlers etc) are calculated by doubling what a person would earn as a labourer for an oil company, the main alternative source of income. Huaorani guides accompany visitors on

Sylvie Blangy is responsible for the ecotourism department at Seca, a French consulting firm specializing in the protection and management of natural sites

hikes and teach them about medicinal plants, the rainforest's ecology, their spiritual relationship with the environment, and local handicrafts. At the end of their trip, visitors are invited to raise awareness in their own countries about the Huaorani's efforts to defend their land and culture. This initiative has led to donations that have financed training workshops, high frequency radios and solar panels.

The fact that such a vulnerable population living in a region prone to outside encroachment—from unscrupulous jungle tour operators to petroleum companies—managed to set up a project that won a prize for the best ecotourism programme at the 1998 Berlin Tourism Expo is not a product of chance. It took nine months of planning and orientation meetings for the Huaorani to finetune a tourism strategy, a task carried out hand in hand with TROPIC Ecological Adventures, a tour operator with a long experience in working with indigenous communities, notably on bringing the Huaorani's problems with the oil industry to international attention. Not only has this community defined its own rules for tourism, but it has gained indispensable exposure on the international travel market through a fruitful business partnership.

Reprinted with permission from the *Unesco Courier,* July/August 1999, pp. 32-33.

A strong conservationist slant

Just as importantly, the Huaorani have opted for a self-managed community-based activity that represents a potential economic alternative to oil and logging. Many indigenous communities see ecotourism as the most rational way of protecting the rainforest, creating jobs for the young and generating revenue for education, community health and transportation. They also see it as a way of maintaining their cultural integrity. Ecuador is a veritable laboratory for community-based ecotourism, with some environmentalists contending that revenues earned from tourism in the Amazon rainforest could eventually outstrip oil earnings.

The tourist is a child of the 20th century who only travels to comfort his prejudices.

Joaquín Luna

Spanish journalist

The Cofan indigenous people have developed a fairly sophisticated management system in Zabalo, under the guidance of Randy Borman, the son of an American missionary who grew up with the Cofan and has played a leading role in resisting the efforts of oil companies to prospect on their territory. In 1992, Borman established a community-run company in Zabalo with ten Cofan associates who invested their labour in building guest cabins. Other community members are paid for doing various jobs while a small co-operative craft store also brings in income.These various initiatives provide the Cofan of Zabalo with an estimated $500 annually per person.The project also has a strong conservationist slant: the community has defined separate zones for hunting and ecotourism, with fines levied on members for taking certain species such as toucans and parrots (particularly coveted by tourists), or for exceeding quotas in the hunting zones.

Besides the need for a close relationship with a partner who has a sound knowledge of the travel market and a sensitivity toward indigenous communities, such projects need at least five years before they can become commercially viable. Training is the backbone of any succcessful enterprise. Even though these trips are no-frills experiences, some basic notions such as punctuality and hygiene in food preparation have to be understood by the community. Just as important, if a real exchange is to happen during the trip, guides have to know how to speak to visitors about their lifestyle and natural surroundings, and realize that they may have to slow down their pace when leading hikes along rainforest trails. All this requires dialogue and a community that is united around a respected leader. Although NGOs have also assisted communities in developing tourism projects, experience shows that they often lack contacts on the travel market to make these initiatives viable.

'Unlike oil, tourism is sustainable'

Other countries and continents are also boosting their presence on this niche market which is attracting more and more North American and European travellers. Take the case of Venezuela. Here, one indigenous group, the Pemons, does not flinch at accepting 100 tourists a day who fly in from a beach resort on Margarita Island to visit Salto Angel, the world's highest waterfall, in the southeast of the country. Besides accompanying visitors to the falls and serving them a meal, the Pemons have also built a village (an hour by road away from their own) of ten traditional cabins for overnight groups. Tourism revenue (the Pemons receive about $25 per day per visitor, the total package costing $70) has served to set up a school and a health dispensary and make up for declining state subsidies. Another group, the Ye'Kuanas, won rights from the government to manage land-use of a forest reserve. Part of it, beyond a natural barrier formed by a waterfall over the Caura river, is off limits to visitors, while in another, they have built guest cabins and developed itineraries for tourists in partnership with Natura Raid, an operator based in Caracas.

As awareness of environmental issues has spread over the past decade, a growing number of travellers are looking into how the adventure/discovery-style trips they choose benefit communities. In response, the latter are joining forces in an effort to better promote their projects and design common standards. In Ecuador, the CONFENIAE, a confederation of

indigenous groups from the Amazon basin, has published guidelines for managing ecotourism.The Ecuadorian Ecotourism Association has designed tools for evaluating the environmental policies of tour operators, which are now used in other Latin American countries. In Africa, Namibia formed a national association for community-based tourism (NACOBTA) in 1995 which groups 41 communities from a range of ethnic groups. It provides advice and training to communities seeking to start up projects, but also keeps a high profile in international travel fairs. Many experts see NACOBTA as one of the most rational ways for promoting and defending this tourism, which by nature, is small in scale and highly personalized.

The challenge today lies in designing national strategies that put the accent on training, access to markets and capital, and safety norms—issues that will be on the agenda of the Ecotourism Society's general assembly, to be held in December 1999 in Quito, upon the invitation of the Ecuadorian government. Clearly, this gesture is another sign that indigenous groups have gained a voice at national level, and tourism is just one way in which they are being heard. As one Ecuadorian ecotourism operator put it, "Unlike oil, tourism is sustainable."

• **Megan Epler-Wood,** *Meeting the Global Challenge of Community Participation in Ecotourism: Case Studies and Lessons from Ecuador,* USAID, The Nature Conservancy, 1998
• **Judy Karwacki, "Indigenous Ecotourism: Overcoming the Challenge," The Ecotourism Society Newsletter, first quarter 1999**
• **The Nacobta Community Based Tourism Association at nacobta@ iafrica.com.na,**
• **Andy Drumm,** *New Approaches to Community-based Ecotourism Management; Learning from Ecuador, Ecotourism, A Guide for Planners and Managers,* **vol. 2. The Ecotourism Society 1998.**

Peace Prize Goes to Land-Mine Opponents

By **CAREY GOLDBERG**

PUTNEY, Vt., Oct. 10—The Nobel Peace Prize was bestowed today on the International Campaign to Ban Landmines and on Jody Williams, an American who coordinates it—and the newly minted laureate immediately wielded the award to step up political pressure on recalcitrant countries, including the United States.

Barefoot in her rustic yard here, and bare-knuckled as ever in her approach, Ms. Williams taunted President Clinton today, saying he would be branded a coward if the United States continued to refuse to sign the international treaty banning land mines.

"If President Clinton wants the legacy of his administration to be that he did not have the courage to be the Commander in Chief of his military, that is his legacy, and I feel sorry for him," she said. "I think it's tragic that President Clinton does not want to be on the side of humanity."

Just hours after the award was announced, President Boris N. Yeltsin unexpectedly declared that Russia had decided to sign the accord.

But the United States and China remain the big holdouts, and the White House spokesman said today that President Clinton's refusal to sign the treaty, based on his insistence that it contain exceptions for the Korean peninsula, still stands.

In awarding the prize to the group and to Ms. Williams, the Nobel committee said it was openly trying to influence the treaty process. "This could be interpreted as a message to the great powers that we hope they also will eventually choose to sign the treaty," Francis Sejersted, the committee chairman, said in Oslo.

He and others also praised the anti-land-mine campaign as an exciting new form of post-cold-war political action in which a broad, grassroots coalition of citizens' groups and smaller nations, working on their own outside the bounds of major institutions like the United Nations, led to world change.

The agreement would outlaw land mines, which are estimated to kill or maim 26,000 people a year, and require countries to clean up those already on their soil. Nearly 100 governments approved a draft of the treaty last month, and world figures ranging from Diana, Princess of Wales, to President Nelson Mandela of South Africa have supported the campaign.

The treaty, to be signed in Ottawa in December, is to go into effect after 40 nations have ratified it.

The International Campaign to Ban Landmines is a coalition of more than 1,000 organizations in more than 60 countries, and argues that with more than 100 million buried mines around the world taking such a high human toll, they must be banned.

Ms. Williams, 47, first became politically active protesting the Vietnam War, and later focused her efforts on influencing American policy in Central America and providing aid there. She joined the Vietnam Veterans of America Foundation, which began the land mines campaign, at the end of 1991.

The campaign is a descendant of the anti-war movement. It was the idea of Robert Muller, a Marine veteran who lost the use of his legs during the Vietnam War and started organizing to improve conditions at the veterans' hospitals where he was treated. He then moved into anti-war activism, and also fought for compensation for veterans who had been exposed to Agent Orange.

During the 1980's he returned to Vietnam and set up projects to provide wounded Vietnamese veterans with prosthetics. When he went to Cambodia to do similar work in 1991, Mr. Muller found that the victims were largely civilians and that their injuries were more recent—from land mines still embedded in the countryside.

He realized, he said, "that there is more we got to do—just putting on legs don't cut it." And the campaign to ban land mines was born.

Men and Women of Peace, 1971–1997

By The Associated Press

1997—The International Campaign to Ban Landmines.

1996—Filipe Ximenes Belo and José Ramos-Horta of East Timor.

1995—Joseph Rotblat and the Pugwash Conference on Science and World Affairs, Britain.

1994—Yasir Arafat of the Palestine Liberation Organization and Yitzhak Rabin and Shimon Peres of Israel.

1993—Nelson Mandela and F. W. de Klerk, South Africa.

1992—Rigoberta Menchu, Guatemala.

1991—Aung San Suu Kyi, Burma.

1990—Mikhail S. Gorbachev, Soviet Union.

1989—The Dalai Lama, Tibet.

1988—The United Nations peacekeeping operations.

1987—Oscar Arias Sanchez, Costa Rica.

1986—Elie Wiesel, United States.

1985—International Physicians for the Prevention of Nuclear War.

1984—Bishop Desmond Tutu, South Africa.

1983—Lech Walesa, Poland.

1982—Alva Myrdal, Sweden, and Alfonso Garcia Robles, Mexico.

1981—The United Nations High Commission for Refugees.

1980—Adolfo Pérez Esquivel, Argentina.

1979—Mother Teresa, Calcutta.

1978—Anwar el-Sadat, Egypt, and Menachem Begin, Israel.

1977—Amnesty International, London.

1976—Betty Williams and Mairead Corrigan, Northern Ireland.

1975—Andrei Sakharov, Soviet Union.

1974—Sean MacBride, Ireland, and Eisaku Sato, Japan.

1973—Henry A. Kissinger, United States, and Le Duc Tho, North Vietnam.

1972—No prize awarded.

1971—Willy Brandt, Germany.

It started with Mr. Muller and the Vietnam Veterans of America Foundation and a German group. "That way, we could call ourselves international," Mr. Muller said. Soon the movement was growing quickly enough to hire a coordinator, Ms. Williams.

While efforts in the United Nations stagnated, the anti-land-mine campaign found support from such figures as Lloyd Axworthy, the Canadian Foreign Minister; Senator Patrick J. Leahy, Democrat of Vermont, and Gen. Norman Schwarz-

kopf. The International Committee of the Red Cross also helped, with a worldwide publicity campaign beginning in 1995.

The campaign and Ms. Williams are to share the $1 million Nobel monetary award equally.

Today Ms. Williams was praised by Susannah Sirkin, deputy director of Physicians for Human Rights, a campaign member, as "an extraordinarily determined individual."

"She is fearless," Ms. Sirkin said. "She has never been reluctant to stand in front of a general or world

leader with a conviction that she was right on this issue, and tell them what needs to be done."

But at her Vermont home, set near a beaver pond among trees glowing ruby and gold in the autumn sunlight, Ms. Williams adamantly refused to take the prize as a personal tribute, focusing her remarks instead on the campaign's progress and the work it has yet to do.

The group plans to focus its pressure on hold-out countries, she said, and hopes to have all countries on board by 2000. She has not decided what issue she will work on next, she said, but assumes something will evolve.

The overall message of the campaign against land mines, she said, was not only the damage the mines cause but also the concept that in this post-cold-war world, "the military cannot operate with impunity."

"I hope to educate the world that while war may not go away in our lifetime, that there are rules about how you conduct yourself in war," she said, "that if the military think they have to fight with each other, they should point the guns at each other; they should not involve all of civil society."

And entire countries should not become battlefields, she said, citing Cambodia and Angola. Cambodia is believed to harbor more than 10 million land mines, Angola 9 million.

For all her serious arguments, however, and for all her solemn appreciation of the honor inherent in joining the ranks of Nobel recipients, Ms. Williams retains a streak of irrepressible irreverence, particularly in regard to the President of the United States, whom she referred to as "Billy" and "a weenie."

When, by midafternoon, he still had not called to congratulate her, she complained comically, "He has time to call the winners of the Super Bowl, but the winner of the Nobel Peace Prize he can't call?"

Of course, she added, he probably had not called because, "If he calls me, he knows I'm going to say, 'What's your problem?'"

Child Labour: Rights, risks, and realities

by Carol Bellamy

"Dust from the chemical powders and strong vapours in both the storeroom and the boiler room were obvious ... We found 250 children, mostly below 10 years of age, working in a long hall, filling in a slotted frame with sticks. Row upon row of children, some barely five years old, were involved in the work."

The description could come from an observer appalled at the working conditions endured by children in the 19th century in British mills and factories.

But the quote is from a report on the matchstick-making industry of modern day Sivakasi, in India.

Similar descriptions of children at work in hazardous conditions can be gathered from countries across the world. In Malaysia, children may work up to 17-hour days on rubber plantations, exposed to insect- and snakebites. In the United Republic of Tanzania, they pick coffee beans, inhaling pesticides. In Portugal, children as young as 12 are subject to heavy labour and the myriad dangers of the construction industry. In Morocco, they hunch at looms for long hours and little pay, knotting the strands of luxury carpets for export. In the United States, children are exploited in garment-industry sweatshops. In the Philippines, young boys dive in dangerous conditions to help set nets for deep-sea fishing. Statistical data on child labour is scarce, but our most reliable estimates indicate about 250 million child labourers (ages 10–14) in developing countries alone.

The world should, indeed, have outgrown the many forms of abuse that labouring children endure. But it hasn't, although not for lack of effort. Child labour was one of the first and most important issues addressed by the international community, resulting in the 1919 Minimum Age Convention of the International Labour Organization.

Early efforts were hobbled, in part, because campaigners struggling to end child labour appealed to morality and ethics, values easily sidelined by the drive for profit and hard realities of commercial life.

C-88 UNICEF/L. GOODSMITH

A domestic servant in Mauritania

From *The Rotarian*, September 1997, pp. 26-29. Adapted from *The State of the World's Children* by Carol Bellamy. © 1997 by Oxford University Press. Reprinted by permission.

86-147 UNICEF/YANN GAMBLIN

Herding cattle in Kenya

Child labourers were objects of charity and humanitarian concern, but they had no rights.

Today's world is somewhat different. Children have rights established in international laws, not least in the Convention on the Rights of the Child, which has now been ratified by 191 countries—all but the U.S. and Somalia—making it the most universally embraced human rights instrument in history. One provision—Article 32—obligates governments to protect children "from economic exploitation and from performing any work that is likely to be hazardous or to interfere with the child's education, and/or to be harmful to the child's health or physical, mental, spiritual, moral, or social development."

Children's exploitation in work also contravenes many more of the rights enshrined in the Convention, among them children's rights to parental care, to compulsory and free primary education, to the highest attainable standard of health, to social security, and to provisions for rest and recreation.

Looking at children's work through the lens of the Convention on the Rights of the Child offers not only new ways of understanding the problem of child labour, but also provides new impetus and direction to the movement against it.

Child labour is often a complex issue. Powerful forces sustain it, including many employers, vested interest groups, economists proposing that the market must be free at all costs, and traditionalists who believe that the low caste or class of certain children denudes them of rights.

The overriding consideration must always be the best interests of the child. It can never be in the best interests of a child to be exploited or to perform heavy and dangerous forms of work. No child should labour under hazardous and exploitative conditions, just as no child should die of causes that are preventable.

Work that endangers children's physical, mental, spiritual, moral, or social development must end. Hazardous child labour is a betrayal of every child's rights as a human being and is an offence against civilization.

Most children who work do not have the power of free choice. They do not choose between career options with varying advantages, drawbacks, and levels of pay. A fortunate minority have sufficient material means behind them to be pulled toward work as an attractive option offering them even more economic advantages.

But the vast majority are pushed into work that is often damaging to their development for three reasons: the exploitation of poverty, the absence of education, and the restrictions of tradition.

The exploitation of poverty

The most powerful force driving children into hazardous, debilitating labour is the exploitation of poverty. Where society is characterized by poverty and inequity, the incidence of child labour is likely to increase, as does the risk that it is exploitative.

For poor families, the small contribution of a child's income or assistance at home that allows the parents to work can make the difference between hunger and a bare sufficiency. Survey after survey makes this clear. A high proportion of child employees give all their wages to their parents. Children's work is considered essential to maintaining the economic level of the household.

If employers were not prepared to exploit children, there would be no child labour. The parents of child labourers are often unemployed or underemployed, desperate for secure employment and income. Yet it is not they but their children who are offered the jobs. Why? Because children can be paid less, of course. (In Latin America, for example, children ages 13 to 17 earn on average half the pay of a wage-earning adult with seven years of education.) Because children are more malleable, they will do what they are told without questioning authority. Because children are largely powerless before adults, they are less likely to organize against oppression and can be physically abused without striking back.

Put simply, children are employed because they are easier to exploit.

Exploitation of the poor and the powerless not only means that adults are denied jobs that could better have sustained their families. It not only means that children are required to work in arduous, dangerous conditions. It also means a life of unskilled work and ignorance not only for the child, but often for the children of generations to come. Any small, short-term financial gain for the family is at the cost of an incalculable long-term loss. Poverty begets child labour begets lack of education begets poverty.

A serious attack on poverty will reduce the number of children vulnerable to exploitation at work. Social safety nets are essential for the poor, as are access to credit and income-generating schemes, technology, education, and basic health services. Budgetary priorities need to be re-examined in this light.

Tackling the exploitation itself does not have to wait until some future day when world poverty has been brought to an end. Hazardous child labour provides the most powerful of arguments for equality and social justice. It can and must be abolished here and now.

The lack of relevant education

Cuts in social spending worldwide have hit education—the most important single factor in ending child labour—particularly hard.

In all regions, spending per student for higher education fell during the 1980s, and in Africa and Latin America, spending per pupil also fell for primary education.

A pilot survey, sponsored by the United Nations Educational, Scientific, and Cultural Organization (UNESCO) and the United Nations Children's Fund (UNICEF) and carried out in 1994 in 14 of the world's least-developed countries, reinforced concerns about the actual conditions of primary schools. In half of these countries, classrooms for the equivalent of first grade have sitting places for only four in 10 pupils. Half the pupils have no textbooks and half the classrooms have no chalkboards. Teachers commonly have to attempt

88-002 UNICEF/ASLAK AARBUS

Picking cotton in El Salvador

to handle huge classes—an average of 67 pupils per teacher in Bangladesh and nearly 90 per teacher in Equatorial Guinea. In 10 of the 14 countries, most children are taught in a language not spoken at home. And most homes, of course, have no books or magazines in any language.

Education everywhere is clearly underfunded, but the school system as it stands in most developing countries of the world is blighted by more than just a lack of resources. It is often too rigid and uninspiring in approach, promoting a curriculum that is irrelevant to and remote from children's lives.

Education has become part of the problem. It has to be reborn as part of the solution.

Traditional expectations

The economic forces that propel children into hazardous work may be the most powerful of all. But traditions and entrenched social patterns play a part, too.

In industrialized countries, it is now almost universally accepted that if children are to develop normally and healthily, they must not perform disabling work. In theory at least, education, play and leisure, friends, good health, and proper rest must all have an important place in their lives. This idea emerged only relatively recently. In the early decades of industrialization, work was thought to be the most effective way of teaching children about life and

the world. Some residue of this notion remains in the widespread expectation that teenage children should take on casual jobs alongside school, both to gain an understanding of the way the world functions and to earn spending money of their own.

There is a darker side to the expectations about children's work. The harder and more hazardous the jobs become, the more they are likely to be considered traditionally the province of the poor and disadvantaged, the lower classes, and ethnic minorities. In India, for example, the view has been that some people are born to rule and to work with their minds while others, the vast majority, are born to work with their bodies. Many traditionalists have been unperturbed about lower-caste children failing to enroll in or dropping out of school. And if those children end up doing hazardous labour, it is likely to be seen as their lot in life.

Understanding all the various cultural factors that lead children into work is essential. But deference to tradition is often cited as a reason for not acting against intolerable forms of child labour. Children have an absolute, unnegotiable right to freedom from hazardous labour—a right now established in international law and accepted by every country that has ratified the Convention on the Rights of the Child. Respect for diverse cultures should not deflect us from using all the means at our disposal to make every

society, every economy, every corporation, regard the exploitation of children as unthinkable.

Mobilizing society

Nongovernmental organizations, such as Rotary International, have a vital role to play both in raising levels of public concern and in protecting children. You can monitor the conditions in which children work and help launch the long, indispensable process of changing public attitudes.

R.I. President Glen W. Kinross has asked Rotarians this year to "strike out at the root causes of child abuse and abandonment and child labour. Children are our most precious treasure and the future belongs to them." And we know that today many Rotary clubs are working to improve the lives of children by striving to fight poverty and hunger, provide education, and prevent child abuse and exploitation. On behalf of the world's children, thank you, Rotarians, for your concern and actions.

As we step into the next millennium, hazardous child labour must be left behind, consigned to history as completely as those other forms of slavery that it so closely resembles.

• *Carol Bellamy is Executive Director of the United Nations Children's Fund (UNICEF).*

Unit 7

Unit Selections

Key Points to Consider

❖ Comment on the idea that it is naive to speak of international politics and economics in terms of ethics. What role can governments, international organizations, and the individual play in making the world a more ethical place?

❖ How easily are the values of democracy transferred to new settings such as Russia?

❖ What are the characteristics of leadership?

❖ In addition to the ideas presented here, what other new ideas are being expressed, and how likely are they to be widely accepted?

❖ How do the contemporary arts reflect changes in the way humanity views itself?

❖ How will the world be different in the year 2030? What factors will contribute to these changes? What does your analysis reveal about your own value system?

 Links **www.dushkin.com/online/**

31. **Human Rights Web**
 http://www.hrweb.org

32. **InterAction**
 http://www.interaction.org

These sites are annotated on pages 6 and 7.

The final unit of this book considers how humanity's view of itself is changing. Values, like all other elements discussed in this anthology, are dynamic. Visionary people with new ideas can have a profound impact on how a society deals with problems and adapts to changing circumstances. Therefore, to understand the forces at work in the world today, values, visions, and new ideas must be examined.

Novelist Herman Wouk, in his book *War and Remembrance*, observed that many institutions have been so embedded in the social fabric of their time that people assumed that they were part of human nature. Slavery and human sacrifice are two examples. However, forward-thinking people opposed these institutions. Many knew that they would never see the abolition of these social systems within their own lifetimes, but they pressed on in the hope that someday these institutions would be eliminated.

Wouk believes the same is true for warfare. He states, "Either we are finished with war or war will finish us." Aspects of society such as warfare, slavery, racism, and the secondary status of women are creations of the human mind; history suggests that they can be changed by the human spirit.

The articles of this unit have been selected with the previous six units in mind. Each explores some aspect of world affairs from the perspective of values and alternative visions of the future.

New ideas are critical to meeting these challenges. The examination of well-known issues from new perspectives can yield new insights into old problems. It was feminist Susan B. Anthony who once remarked that "social change is never made by the masses, only by educated minorities." The redefinition of human values (which, by necessity, will accompany the successful confrontation of other global issues) is a task that few people take on willingly. Nevertheless, in order to deal with the dangers of nuclear war, overpopulation, and environmental degradation, educated people must take a broad view of history. This is going to require considerable effort and much personal sacrifice.

When people first begin to consider the challenges of contemporary global problems, they often become disheartened and depressed. They might ask: What can I do? What does it matter? Who cares? There are no easy answers to these questions, but people need only look around to see good news as well as bad. How individuals react to the world in which they live is not a function of that world but a reflection of themselves. Different people react differently to the same world. The study of global issues, therefore, is the study of people, and the study of people is the study of values. Ideally, people's reactions to these issues will help provide them with some insight into themselves as well as the world at large.

UNIVERSAL HUMAN VALUES

Finding an Ethical Common Ground

Rushworth M. Kidder

Rushworth M. Kidder, former senior columnist for The Christian Science Monitor, *is president of the Institute for Global Ethics, Box 563, Camden, Maine 04843. Telephone 207/236-6658. He has spoken at several World Future Society conferences and at "Toward the New Millennium: Living, Learning, and Working," July 24–26, 1994, in Cambridge, Massachusetts.*

In the remote New Zealand village of Panguru, tucked into the mountains at the end of a winding gravel road, a Maori woman nearly a century old pauses for a moment as she talks about the moral values of her people. "This is God's country!" says Dame Whina Cooper with great feeling, gesturing toward the flowers blooming among the bird songs outside her modest frame house. "Only, we the people running it must be doing something wrong."

Halfway around the world, in a United Nations office perched under the eaves of a fifteenth-century building in Florence, a leading journalist from Sri Lanka is asked what will happen if the world enters the twenty-first century with the ethics of the twentieth. "I feel it will be disastrous," Varindra Tarzie Vittachi replies simply.

Midway between, in his well-appointed residence in San Jose, Costa Rica, former president Oscar Arias explains that our global survival "will become more complicated and precarious than ever before, and the ethics required of us must be correspondingly sophisticated."

Turn where you will in the world and the refrain is the same. The ethical barometer is falling, and the consequences appear to be grave. That, at least, is one of the impressions to be drawn from the two dozen individuals from 16 nations interviewed over the past few years by the Institute for Global Ethics.

These interviews did not seek to discover the ethical failings of various nations, but rather to find the moral glue that will bind us together in the twenty-first century. These voices speak powerfully of an underlying moral presence shared by all humanity—a set of precepts so fundamental that they dissolve borders, transcend races, and outlast cultural traditions.

There is a pressing need for shared values in our age of global interdependence without consensus. But there is one very real question unanswered: Is there in fact a single set of values that wise, ethical people around the world might agree on? Can there be a global code of ethics? If there is a common core of values "out there" in the world, it ought to be identifiable through examination of contemporary modes of thought in various cultures around the world. Can it be found?

On that topic, the two dozen "men and women of conscience" interviewed had a clear point of view. "Yes," they said, "there is such a code, and it can be clearly articulated." These interviewees were chosen not because they necessarily know more about ethics than their peers—although some do, having made it a lifelong study. Nor were they chosen because they are the single most exemplary person of their nation or community—though some could easily be nominated for that honor. They are, however, ethical thought-leaders within their different cultures, each viewed by his or her peers as a kind of ethical stan-

dard-bearer, a keeper of the con-
science of the community, a center
of moral gravity.

Each of the interviews began with
a common question: If you could
help create a global code of ethics,
what would be on it? What moral
values, in other words, would you
bring to the table from your own
culture and background?

In an ideal world, one would
have assembled all the interviewees
around a table, had each talk for an
hour, had each listen intently to all
the others, and finally had them ar-
rive at a consensus. If they could
have done so, here's the core of
moral values upon which they prob-
ably would have agreed:

LOVE

Despite the concern of foundation
executive James A. Joseph in Wash-
ington that "the L-word, Love," is
falling sadly into disuse, it figured
prominently in these interviews.
"Love, yes," said children's author
Astrid Lindgren in Stockholm. "This
is the main word for what we
need—love on all stages and with all
people."

"The base of moral behavior is
first of all solidarity, love, and mu-
tual assistance," said former first
lady Graça Machel of Mozambique.
Buddhist monk Shojun Bando in To-
kyo agreed, detailing three different
kinds of love and insisting that "it
shouldn't be that *others* should tell
you to love others: It should just
come of its own will, spontane-
ously." Or, as author Nien Cheng
from China put it, "You cannot
guide without love."

For tribal chief Reuben Snake of
Nebraska, the central word is *com-
passion.* "We have to be compassion-
ate with one another and help one
another, to hold each other up, sup-
port one another down the road of
life," he recalled his grandfather tell-
ing him. Thinking back on her deal-
ings with a global spectrum of
cultures at the United Nations, for-
mer ambassador Jeane Kirkpatrick
in Washington noted that, no matter

how severe the political differences,
"there was a kind of assumption, on
the part of almost everyone, that
people would help one another at
the personal level."

TRUTHFULNESS

Of the four theses that form Har-
vard University ex-president Derek
Bok's code of ethics, two center on
truth. "You should not obtain your
ends through lying and deceitful
practices," he said, and you have a
"responsibility to keep [your] prom-
ises." Astrid Lindgren put it with
equal clarity when she spoke of the
need to "be honest, not lying, not
afraid to say your opinion."

Looking through the lens of sci-
ence, the late economist Kenneth
Boulding of Colorado also put "a
very high value on veracity—telling
the truth. The thing that gets you
run out of the scientific community
is being caught out telling a lie." For-
tunately, said Bangladeshi banker
Muhammad Yunus, the spread of
technology makes it increasingly dif-
ficult for the truth to be hidden. In
the future, "people will be forced to
reveal themselves," he said. "Noth-
ing can be kept hidden or secret—
not in computers, not in the halls of
government, nothing. People will
feel much more comfortable when
they're dealing in truth. You con-
verge around and in truth."

Here, however, as with many of
these global values, there was also a
residue of concern—a fear that trust,
which is central to honesty and
truthfulness, seems to be falling into
abeyance. "The idea that you ought
to be able to trust somebody is out
of fashion," worried Katharine
Whitehorn, columnist for *The Ob-
server* of London. That's a point sec-
onded by corporate executive James
K. Baker of Indiana. "Little by little,"
he said, "if we let that trust go out
of our personal dealings with one
another, then I think the system re-
ally begins to have trouble."

24 MEN AND WOMEN OF CONSCIENCE

Dame Whina Cooper: founding
president of Maori Women's Wel-
fare League in New Zealand;
presented with the Order of
Dame Commander of the British
Empire by Queen Elizabeth.

"God wants us to be one people."

Varindra Tarzie Vittachi: Sri
Lankan journalist and author; as-
sistant secretary-general of the
United Nations.

*"One man in the twentieth century
. . . led us back into morality as a
practical thing and not as a cloud-
cuckoo-land idea, and that was Mo-
handas Gandhi."*

Oscar Arias: former president of
Costa Rica; 1987 winner of the
Nobel Peace Prize.

*"The effect of one upright individ-
ual is incalculable."*

James A. Joseph: former under-
secretary of the U.S. Department
of the Interior.

*"I relate fairness to treating other
people as I would want to be
treated."*

FAIRNESS

Elevating the concept of justice to
the top of his list, philosopher and
author John W. Gardner of Stanford
University said, "I consider that
probably the number-one candidate
for your common ground." By *jus-
tice,* he meant "fair play, or some
word for even-handedness."

"Here, one could get caught up in
the very complicated theories of so-
cial justice," warned James A.
Joseph. "Or one could simply look
at the Golden Rule. I relate fairness
to treating other people as I would
want to be treated. I think that [rule]
serves humanity well. It ought to be
a part of any ethic for the future."

For many, the concern for fairness
goes hand in hand with the concept

of equality. "The pursuit of equality is basic," said columnist and editor Sergio Muñoz of Mexico City and Los Angeles. "The people who come from Mexico and El Salvador have the same values, in my point of view, as the person who comes from Minnesota or from Alabama or from California—those basic principles that are common to all civilizations."

Astrid Lindgren: Swedish author of *Pippi Longstocking*.

"Love, yes. This is the main word for what we need—love on all stages and with all people."

Graça Machel: former first lady of Mozambique.

"The base of moral behavior is first of all solidarity, love, and mutual assistance."

Shojun Bando: Japanese Buddhist monk, studied under Zen scholar D. T. Suzuki.

"[Parents'] actions speak more than words. Their everyday doings teach the kids how to behave."

Nien Cheng: author of *Life and Death in Shanghai*; suffered over six years of solitary confinement and torture at the hands of Chinese Communists.

"You cannot guide without love."

Reuben Snake: former chairman of the American Indian Movement.

"The spirit that makes you stand up and walk and talk and see and hear and think is the same spirit that exists in me."

For some, like Joseph, the concept of fairness and equality focuses strongly on racial issues. Others, like author Jill Ker Conway from Australia, see the need for "greater equity between the sexes." Still others, like UNESCO Director-General Federico Mayor of Spain, see the problem as one of international relations: Despite the groundswell of interest in democracy arising within the former East Bloc nations, Westerners "have not reacted as humans, but only as economic individuals. . . . Even equity—the most important value in all the world—has collapsed."

FREEDOM

Very early in human history, said John Gardner, "the concept of degrees of freedom of my action—as against excessive constraints on my action by a tyrant or by military conquerors—emerged." Even the earliest peoples "knew when they were subjugated"—and didn't like it. That desire for liberty, he said, persists to the present as one of the defining values of humanity.

But liberty requires a sense of individuality and the right of that individual to express ideas freely, many of the interviewees said. "Without the principle of individual conscience, every attempt to institutionalize ethics must necessarily collapse" said Oscar Arias. "The effect of one upright individual is incalculable. World leaders may see their effect in headlines, but the ultimate course of the globe will be determined by the efforts of innumerable individuals acting on their consciences."

Such action, for many of these thinkers, is synonymous with democracy. "I think democracy is a must for all over the world," said Salim El Hoss, former prime minister of Lebanon. He defined the ingredients of democracy as "freedom of expression plus accountability plus equal opportunity." While he worried that the latter two are lacking in many countries, he noted that the first condition, freedom of expression, is increasingly becoming available to "all peoples."

UNITY

As a counterbalance to the needs of individual conscience, however, stands the value that embraces the individual's role in a larger collective. Of the multitude of similar terms used for that concept in these interviews (*fraternity, solidarity, cooperation, community, group allegiance, oneness*) unity seems the most encompassing and the least open to misconstruction. For some, it is a simple *cri de coeur* in a world that seems close to coming undone. "I want unity," said Dame Whina Cooper of New Zealand, adding that "God wants us to be one people." For Tarzie Vittachi of Sri Lanka, the idea of unity embraces a global vision capable of moving humanity from "unbridled competition" to cooperation. "That is what is demanded of us now: putting our community first, meaning the earth first, and all living things."

The problem arises when the common good is interpreted "by seeing the relation between the individual and the common in individualistic terms," said Father Bernard Przewozny of Rome. Carried to the extreme, individualism is "destructive of social life, destructive of communal sharing, destructive of participation," he said, adding that "the earth and its natural goods are the inheritance of all peoples."

TOLERANCE

"If you're serious about values," said John Gardner, "then you have to add tolerance very early—*very* early. Because you have to have constraints. The more you say, 'Values are important,' the more you have to say, 'There are limits to which you can impose your values on me.'"

"It is a question of respect for the dignity of each of us," said Graça Machel. "If you have a different idea from mine, it's not because you're worse than me. You have the right to think differently." Agreeing, Derek Bok defined tolerance as "a decent respect for the right of other people to have ideas, an obligation or at least a strong desirability of listening to different points of view and attempting to understand why they are held."

"You have your own job, you eat your own food," said Vietnamese writer and activist Le Ly Hayslip.

"How you make that food is up to you, and how I live my life is up to me."

Reuben Snake traced the idea of tolerance back to a religious basis. "The spirit that makes you stand up and walk and talk and see and hear

Jeane Kirkpatrick: former U.S. ambassador to the United Nations.

"I don't think life is the supreme good. It's very nearly the supreme good, but quality of life matters a lot, too. And freedom matters a lot—prosperity, a decent standard of living, possibilities for self-development."

Derek Bok: president of Harvard University, 1971–1991.

"A decent respect for the right of other people to have ideas."

Kenneth Boulding: author of over 30 books; professor at the University of Colorado.

"[I put] a very high value on veracity—telling the truth."

Muhammad Yunus: managing director of the Grameen Bank, Dhaka, Bangladesh.

"The oneness of human beings is the basic ethical thread that holds us together."

Katharine Whitehorn: senior columnist for the London Sunday newspaper *The Observer*.

"I don't think that people habitually do anything unless they are programmed so that they are appalled with themselves when they don't."

and think is the same spirit that exists in me—there's no difference," he said. "So when you look at me, you're looking at yourself—and I'm seeing me in you."

Abstracting from the idea of tolerance the core principle of respect for variety, Kenneth Boulding linked it to the environmentalist's urgency

over the depletion of species. "If the blue whale is endangered, we feel worried about this, because we love the variety of the world," he explained. "In some sense I feel about the Catholic Church the way I feel about the blue whale: I don't think I'll be one, but I would feel diminished if it became extinct."

RESPONSIBILITY

Oxford don A. H. Halsey placed the sense of responsibility high on his list of values because of its impact on our common future. "We are responsible for our grandchildren," he explained, "and we will make [it] easier or more difficult for our grandchildren to be good people by what we do right here and now." This was a point made in a different way by Katharine Whitehorn, who noted that, while as a youth "it's fun to break away," it's very much harder to "grow up and have to put it together again."

For Nien Cheng, the spotlight falls not so much on the actions of the future as on the sense of self-respect in the present. "This is Confucius' teaching," she said. "You must take care of yourself. To rely on others is a great shame."

Responsibility also demands caring for others, Hayslip said. But, under the complex interactions of medicine, insurance, and law that exists in the West, "If you come into my house and see me lying here very sick, you don't dare move me, because you're not a doctor," she pointed out. "So where is your human obligation? Where is your human instinct to try to save me? You don't have it. You lost it, because there are too many rules."

Yet, paradoxically, "responsibility is not often mentioned in discussions of world politics or ethics," said Oscar Arias. "There, the talk is all of rights, demands, and desires." Human rights are "an unquestionable and critical priority for political societies and an indispensable lever for genuine development," he said. "But the important thing is not just

to assert rights, but to ensure that they be protected. Achieving this protection rests wholly on the principle of responsibility."

Chicago attorney Newton Minow agreed. "I believe the basic reason we got off the track was that

James K. Baker: former president of U.S. Chamber of Commerce.

"There's only one 'ethics.' . . . Let's not think you've got to adhere to one standard at home and another standard at work."

John W. Gardner: philosopher; founder of Common Cause; author; Stanford University professor.

"[Even the earliest peoples] knew when they were subjugated."

Sergio Muñoz: executive editor, *La Opinion*, the largest Spanish-language daily newspaper in the United States.

"The pursuit of equality is basic."

Jill Ker Conway: Australian author of *The Road from Coorain*; feminist historian and former president of Smith College.

"Greater equality between the sexes."

Federico Mayor: director-general of UNESCO.

"There are a lot of fundamental values that are reflected in the Universal Declaration of Human Rights that nobody opposes."

rights became more important than responsibilities, that individuals became more important than community interests. We've gotten to the point where everybody's got a right and nobody's got a responsibility."

At its ultimate, this sense of responsibility extends to the concept of the right use of force. "You shouldn't perpetrate violence," said Derek Bok simply, finding agreement with Jeane Kirkpatrick's insis-

tence that "war is always undesirable" and that "any resort to force should be a very late option, never a first option."

RESPECT FOR LIFE

Growing out of this idea of the responsible use of force, but separate from and extending beyond it, is a value known most widely in the West from the Ten Commandments: Thou shalt not kill. For Shojun Bando, it is an inflexible principle: Even if ordered in wartime to defend his homeland by killing, he said, "I would refuse. I would say, 'I cannot do this.' "

Such an idea, expressed in today's peaceable Japan, may seem almost naive when examined through the lens of such war-riddled areas as the Middle East. Yet, Salim El Hoss took much the same view. "I was a prime minister [of Lebanon] for seven and a half years. I can't imagine myself signing a death penalty for anybody in the world. I think that is completely illegitimate, and I think that is the kind of thing a code of ethics should deal with."

Reuben Snake, noting that the North American Indians have a warlike reputation, said, "Probably the most serious shortcoming of tribal governments is their inability to effectively resolve conflict within the tribe and externally." He described earlier Indian traditions, however, in which great efforts were made by the tribal elders to prevent killing. That's a point with which Tarzie Vittachi—himself from the much-bloodied nation of Sri Lanka—felt perfectly at home. The first element of the Buddhist "daily prayer" under which he was raised, he recalled, is "I shall not kill." It is also central to the Ten Commandments of the Jewish decalogue under which Newton Minow was raised and which he said he still feels form the basis for the world's code of ethics.

Salim El Hoss: former head of state of Lebanon.

"I can't imagine myself signing a death penalty for anybody in the world."

Bernard Przewozny: professor of Christology at the Pontifical Theological Faculty of St. Bonaventure in Rome.

"The earth and its natural goods are the inheritance of all peoples."

Le Ly Hayslip: survivor of Vietnam War; author; founder of the East Meets West Foundation.

"What are we here for? We're here so that we can help each other to grow."

A. H. Halsey: professor of social and administrative studies at Oxford University.

"We will make [it] easier or more difficult for our grandchildren to be good people by what we do right here and now."

Newton Minow: chairman of the Federal Communications Commission; chairman of the board of the Carnegie Corporation.

"We've gotten to the point where everybody's got a right and nobody's got a responsibility."

OTHER SHARED VALUES

There were, of course, other significant values that surfaced in these interviews. Nien Cheng, for instance, pointed to *courage*. "One should basically know what is right and what is wrong," she said, "and, when you know that, be courageous enough to stand for what is right."

Figuring strongly in Shojun Bando's pantheon was *wisdom*, which he defined as "attaining detachment, getting away from being too attached to things."

Whina Cooper put *hospitality* high on her list, recalling that her father said, "If you see any strangers going past, you call them—*Kia Ora*—that means to call them to come here."

Astrid Lindgren put an emphasis on *obedience*—a quality that runs throughout the life of her most famous character, Pippi Longstocking, though usually in reverse.

Kenneth Boulding pointed to *peace*, which he defined simply as "well-managed conflict." Thinking of peace brought Salim El Hoss to the concept of *stability*. "Peace is equivalent to stability," he said, adding that "stability means a long-term perspective of no problems." These and other values, while they don't find broad support, had firm proponents among those we interviewed and deserve serious attention.

Other values mentioned included the burning public concerns for racial harmony, respect for women's place, and the protection of the environment. Many of the interviewees touched on them, and some elevated them to high priority. Speaking of the need for racial harmony, James Joseph put at the top of his list a sense of "respect for the cultures of other communities, respect for the need to begin to integrate into our collective memory appreciation of the contributions and traditions of those who are different." Jill Conway topped her list with a warning about the "increasing exploitation of women" around the world. And of the many human rights identified by Father Bernard Przewozny, the one to which he has dedicated his life is the "right to a healthy environment."

So what good is this code of values? It gives us a foundation for building goals, plans, and tactics, where things really happen and the world really changes. It unifies us, giving us a home territory of consensus and agreement. And it gives us a way—not *the* way, but *a* way—to reply when we're asked, "Whose values will you teach?" Answering this last question, as we tumble into the twenty-first century with the twentieth's sense of ethics, may be one of the most valuable mental activities of our time.

How to Abolish War

As we come to the conclusion of the most war-ravaged century in human history—in which three times as many people fell victim to war than in all the wars of the preceding nineteen centuries combined—there are eerie parallels with the world of 100 years ago. At the end of the last century, the predominant mood in Europe was one of enormous optimism, supported by a sense of the inevitability of human progress driven by rapid technological and economical advances. The fact that war among the major powers had been absent for about three decades also seemed reason for confidence. And liberal economists further shored up this sanguine outlook, claiming that intensified international trade and finance would preclude war.

by Michael Renner

But other contemporaries grew apprehensive as the military expenditures of the six leading European powers tripled and the size of their armies doubled between 1880 and 1914. Swedish industrialist Alfred Nobel, inventor of dynamite, was deeply pessimistic, but he nevertheless banked on an idea that foreshadowed the nuclear deterrence school of thought: that the destructive power of new armaments was so immense as to render future warfare unthinkable.

Nobel was a close friend of Bertha von Suttner, a leading pacifist of the time who encouraged him to devote his wealth to the cause of peace and who became a Nobel Peace Prize recipient in 1905. Von Suttner argued passionately for the establishment of an organization like the United Nations, for the creation of what we now call peacekeeping forces, and for a "European Confederation of States." She marshaled a mixture of realism—the ability to comprehend the consequences of the trends of her time—and vision—the ability to see clearly what must be done—that embodied hope for a better future.

Von Suttner and other pacifists persuaded Czar Nicholas II of Russia, who was worried about the "crushing burden" of the "armed peace of our days," to convene the First Hague International Peace Conference in the Netherlands in 1899. This event brought together government representatives from twenty-six nations—a large proportion of the sovereign states that existed then. It was the first conference ever called to seek ways to reduce the likelihood of war rather than to distribute its spoils.

But although the 1899 conference and a follow-up gathering in 1907 succeeded in codifying some rules for conducting war, they failed to make significant headway toward preventing conflict. An arbitration court was set up, but its use remained entirely voluntary. A Russian proposal for a five-year moratorium on arms purchases was rejected, and an opportunity to ban aerial warfare was missed. (At that time, aerial warfare consisted of the discharge of projectiles and explosives from balloons; warplanes made their debut later during the Italian-Turkish war of 1911.)

The steady buildup of arms in Europe intensified after the end of the nineteenth century. But even when fighting broke out in August 1914, virtually everyone assumed that this war would be short, just as the Franco-Prussian War nearly half a century earlier had been. Still hopeful, they believed that the soldiers would be home by Christmas. Few imagined that they were on the verge of the most devastating war in history—or that it would be followed by an even larger global conflict less than three decades later.

Today, the knowledge of utter devastation wreaked by two lengthy world wars and the threat of total annihilation in a nuclear holocaust have shattered many illusions about the "glory" of war that were strongly held a century ago.

From *The Humanist*, July/August 1999, pp. 15-21. © 1999 by Michael Renner. Reprinted by permission.

The promise of a more peaceful future is once again clouded by uncertainties ahead, just as it was at the time of the Hague Peace Conference. Will the new century be as violent as the old, the most destructive age ever? Or will humanity finally summon the ability to tame the beast of war?

Having witnessed the astronomical scale of human conflict, we find ourselves facing a most unusual situation: the absence of any big-power confrontation. The leading nations of Europe, where so many wars of the past originated, today enjoy cordial relations. The world as a whole is moving rapidly toward ever-increasing economic integration, giving rise to the hope—much like that of a century ago—that economic interest will trump belligerence. And we have made halting progress toward laws governing war (the so-called humanitarian laws), arms control, peacekeeping, and institutions to help govern international relations.

Yet dangers lurk today as yesterday. The Gulf War of 1991 was an early reminder that the end of the Cold War did not signal permanent peace. And while there have been relatively few interstate wars since then, deadly internal conflicts are common, as seen most recently in the Balkans. These conflicts are primarily fought with small-caliber arms and other relatively unsophisticated weapons. But because there is no distinct battlefield, fighters range over large areas, often targeting civilian populations for killings, terror, and expulsions. Such wars visit enormous devastation upon affected territories.

Many of today's wars are the product of accumulating social, economic, demographic, and environmental pressures. In this, too, there is a similarity to the situation of a century ago: in 1914, the inescapable stresses created by population growth and the strains of rapid urbanization and industrialization were channeled into an unquestioning patriotism, which underpinned the ardor that swept Europe into war. Today, such stress factors more often lead to internal conflicts than to wars of state against state. But far from being limited in their impact, internal wars may trigger the collapse of entire societies, destabilize neighboring countries through massive outflows of refugees, and prompt foreign intervention. Somalia, Rwanda, Bosnia, and Kosovo may only be harbingers of conflicts to come.

At the threshold of the twenty-first century, we thus face a choice. Will we be overwhelmed by an endless string of internal wars capable of devastating entire countries and perhaps even re-igniting interstate confrontations, or will we build the foundations for a lasting peace? Will we seize the opportunity offered by the absence of big-power rivalries and retain control of our destinies? Or will we let unanticipated events such as the Sarajevo assassination in 1914 determine the future of peace and war, allowing the logic of military imperatives to dictate political considerations?

Governments still devote far less energy and enthusiasm to the task of conflict prevention and peace building than to war preparation and war-making. Existing international institutions—foremost among them, the U.N.—are too weak to prevent war. Humanity is ill-equipped, then, at this millennial moment, to handle either a resurgence of interstate war, should it happen, or an unending series of internal wars.

The challenge is twofold. One is to fortify the nascent infrastructure of peace—promoting disarmament, building conflict-prevention networks, advancing human rights law, and strengthening peacekeeping capacities. Of particular urgency is the need to reduce the abundance of arms of virtually all calibers—a lingering legacy of the twentieth century. As long as weapons are readily available, there will always be a temptation to rely on them to settle disputes rather than to engage in the arduous task of negotiating and arbitrating conflicting needs and interests.

The second challenge is to understand and address the underlying causes of today's conflicts, including poverty, social inequality, ethnic tensions, population growth, and environmental degradation. These pressures appear to be accelerating in many societies even as governance structures falter. Left unaddressed, it is likely that they will heighten polarization and instability, possibly leading to widespread violent conflict.

One hundred years after the first Hague conference, the Hague Appeal for Peace this past May brought together hundreds of peace, human rights, environmental, and other grass-roots and advocacy groups, as well as thousands of citizen activists to develop a twenty-first-century agenda for peace and justice. Its mission was to address the unfinished business of its predecessor: to seek the prevention and resolution of violent conflict, far-reaching disarmament, the further development of international humanitarian and human rights law, and the promotion of a worldwide culture of peace. It also signaled a new era: this time around, nongovernmental organizations (NGOs)—not governments—were meeting to set an agenda for peace in the new century.

The 1999 Hague gathering provides evidence that growing numbers of people reject the notion that went almost unchallenged in Bertha von Suttner's day—that "war," as German general von Moltke said, "is an element in God's order." By now it is clear that war is neither holy nor inevitable. Under the right circumstances—with policies that defuse rather than aggravate conflicts—war can be abolished.

A key task in developing peace and security policies in the twenty-first century will be to establish effective restraints based on three principles. These principles contrast sharply with the approaches underlying past and present policies: disarmament (as opposed to arms control), universal constraints on arms (as opposed to nonproliferation), and war prevention (as opposed to regulating warfare).

Although the world has pulled back from the nuclear brink, disarmament is needed as never before. There are still few internationally accepted norms to curb the production, possession, or trade of arms. Several decades of arms control efforts have yielded mostly weak numerical limits on the numbers of certain weapons that states may deploy, and no limits at all on many other kinds of arms.

KEY

▓ WARS
░ ARMED CONFLICTS

Shading doesn't mean the entire nation
is engaged in armed conflict; conflict
may be isolated in a specific region.

COUNTRIES IN ARMED CONFLICT, 1998-1999

The list of weapons that have actually been outlawed since 1899—when the Hague International Peace Conference decided to ban expanding, or so-called dumdum, bullets—is extremely short compared to the list of unregulated weapons. Although the use of chemical weapons was banned in 1925 (a norm violated several times), nearly another seventy years passed before the 1993 Chemical Weapons Convention outlawed their production and possession. Only in 1995 was the sale and use of so-called blinding-laser weapons banned, and a treaty prohibiting anti-personnel landmines, signed in 1997, came into force just this year (and remains unsigned by the United States).

Denuclearization—the establishment of a timetable to phase out and eventually eliminate all nuclear arms—is now what we need to turn our attention to. The nuclear "haves" not only insist that they will retain their arsenals indefinitely, they continue to pursue modernization programs and their existing arsenals remain on hairtrigger alert. But the stakes are rising: India and Pakistan have joined the "nuclear club," and it is overly optimistic to assume that others will not eventually be tempted to reevaluate their policies and to acquire nuclear weapons as well. Even if no government is contemplating starting a nuclear war intentionally, other dangers lurk, among them accidental launchings of missiles and theft of nuclear weapons or related materials and technology by terrorists or non-nuclear states.

In light of today's dominant types of conflicts, an equally urgent task is to adopt restraints on the conven-tional arms trade. Huge amounts of weapons of all calibers have been dispersed all over the planet. Among the most worrisome aspects of this buildup is the widespread proliferation of small arms—the weapon of choice in today's internal fighting.

One measure long demanded by human rights organizations and other groups is a binding code of conduct to ensure that, at the very least, weapons are not exported to governments that fail to hold free elections, that trample human rights or engage in armed aggression. A voluntary code of conduct was adopted by the European Union in June 1998, but it remains to be seen whether the region's governments will live by it or ignore it when the code proves inconvenient. Although the establishment of such codes remains a crucial step toward peace, in the next century we will need to aim for an even more ambitious goal: establishing a normative presumption against trading arms altogether so that such transfers are no longer seen as routine commercial transactions but, rather, as highly unusual events.

It is also time to rethink the utility of large standing military forces and to advance the norm that possession of an offensively armed military is unacceptable. Countries that face no obvious external adversaries may want to cut their militaries radically and refocus remaining forces on purely defensive tasks; indeed, some may want to reconsider whether they need an army at all, joining twentieth-century pioneers Costa Rica, Haiti, and Panama in abolishing their standing armed forces. Unilateral mea-

sures by individual countries could create some badly needed momentum, but far-reaching progress would likely depend on a more systematic, multilateral approach. An NGO initiative, "Global Action to Prevent War," has proposed a four-phase process over twenty to forty years to achieve major reductions in armies and their armaments. Following extensive consultations among nongovernmental experts, it was formally launched at the Hague Appeal for Peace conference in May.

The second general principle on which to base peace and security policy concerns universality of norms. That is, in order to be just and effective, constraints on armaments need to apply to all states equally. This contrasts with the nonproliferation policies that are currently in vogue in Western nations—the idea of allowing a select (and self-appointed) group of countries to hold on to certain kinds of weapons denied to all other states. Nuclear arsenals are the most prominent example. The NonProliferation Treaty prohibits the acquisition of nuclear arms by nations that don't now possess them—the vast majority of the world's countries. Yet the nuclear weapons states have shown little inclination toward fulfilling their part of the bargain and beginning serious negotiations for nuclear abolition. The advanced nations are also working hard to establish a monopoly on sophisticated arms technologies (although this goal is often contradicted by their active non-nuclear export entrepreneurship). The upshot is a kind of global security apartheid system.

This kind of lopsided approach to security is not only unacceptable from the perspective of universality, it is also unworkable in the long run. As long as one country or group of countries has access to a weapon, others will be tempted to acquire it as well. No matter what the true utility of the weapon in question may be, the very fact that one government prizes its possession signals to others that it must have direct military value, heighten a country's influence, or provide some other, less tangible advantage. This may be a fool's game, but it is one that states have played for centuries. At best, pursuing such policies into the future is an enormous waste of resources; at worst, it could spawn new arms races and trigger regional or global insecurities.

The third principle on which to base peace and security policy—preventing war—also requires dramatic change. At the 1899 Hague conference, governments expressed their "desire to diminish the evils of war so far as military necessities permit"—a desire that remained unfulfilled. Although war laws could be made more stringent, the past 100 years have demonstrated that there is an inherent limit to how effective they can be. Rather than trying in vain to make war a "chivalrous" affair, it is far more fruitful to focus on preventing violent conflict. Yet while government leaders give occasional lip service to conflict prevention, far too little is being done to make it happen. For instance, in 1997 the newly established U.N. Trust Fund for Preventive Action Against Conflicts received soaring rhetoric but scant funds.

War-Related Deaths Over the Centuries

CENTURY	DEATHS IN MILLIONS	DEATHS PER THOUSAND PEOPLE
1st to 15th	3.7	n.a.
16th	1.6	3.2
17th	6.1	11.2
18th	7.0	9.7
19th	19.4	16.2
20th(*)	109.7	44.4

(*) Up to 1995

Much could be accomplished by building an early conflict warning network, establishing permanent dispute arbitration centers in every region of the world, giving more backing to preventive diplomacy, and establishing a corps of skilled and experienced individuals to serve as roving mediators on behalf of the international community. Conflict prevention is not an exact science, to be sure; instead, it resembles a trial-and-error process. On the one hand, there will be cases when early warning of impending violent conflict turns out to be a false alarm. On the other hand, though, the international community would do well to have some redundancy built into the conflict-prevention apparatus so that a variety of efforts aimed at warding off mass violence can be launched. Preventing the eruption of disputes into full-scale hostilities is by no means an easy task, but its difficulties pale beside those of ending fighting once extensive bloodshed has occurred.

Of course, conflict prevention through mediation won't always work, so additional tools are needed. In particular, peacekeeping missions will need to be refashioned so that they can embody the true meaning of the word peacekeeping instead of serving as last-minute fire brigades. In the course of the last few years, we have come to associate peacekeeping with hapless efforts—too few people equipped too poorly and dispatched too late, unable to keep a peace that scarcely exists on the ground. What is needed is the creation of a well-trained, permanent force under U.N. auspices for preventive deployments. It would be dispatched in response to clear signs of imminent violent dispute, either along national borders or even within countries. Such an intervention should not be seen as an end in itself but, rather, be designed to provide space for mediation efforts.

In a fast-paced world that prefers lightning-quick action with decisive outcomes, there is aversion to the typically open-ended commitments that prevention and mediation require and the compromises and nuances without which conflict resolution is unlikely to succeed. Political leaders are tempted to assume that military strikes—such as those against Serbia intended to change its policy on Kosovo—

> **Conflict prevention is not only about positioning peacekeepers between would-be attackers and their intended victims but more fundamentally about recognizing and ameliorating the underlying pressures that lead to violent disputes in the first place.**

offer a quick, clear-cut alternative. But this is a questionable proposition. Even where this policy has been executed in the most straightforward manner—trying to force Iraq's Saddam Hussein to come clean on his weapons of mass destruction programs, for instance—the result is ambiguous at best. Bombing raids now preclude international monitoring of Iraqi sites suspected of harboring prohibited weapons programs. In Kosovo as well, bombing may have punished Yugoslav President Slobodan Milosevic (or, more likely, Serbia's civilian population), but it is unlikely to halt all Serb "ethnic cleansing," let alone bring about an arrangement that will allow Serbs and Kosovars to live together peacefully. Without patient and early commitment, conflicts cannot be resolved.

Far-reaching disarmament, universally applied constraints on armaments, and vigorous conflict-prevention efforts will go a long way toward addressing the more traditional aspects of a peace policy. But to be successful, these steps will need to be linked with a broader human security agenda. Conflict prevention is not only about positioning peacekeepers between would-be attackers and their intended victims (though a few successful operations of that kind could have a salutary effect) but more fundamentally about recognizing and ameliorating the underlying pressures that lead to violent disputes in the first place.

At the core, the shift toward prevention calls for policies that are geared to strengthening the fabric of society and improving its governance. Central to such a policy are goals like fair distribution of wealth and balancing of the interests of different population groups, adequate job creation, poverty eradication, and the preservation or restoration of ecosystems. These are urgent requirements in a world in which the simultaneous presence of tremendous economic growth and widespread inequity is driving environmental destruction, breeding explosive social conditions, and fueling ethnic antagonisms.

Governments will need to adopt policies better able to stem the degradation of watersheds and arable lands, to conserve and protect critical natural systems, and to pur-

sue climate stabilization policies. Key to success also are measures to boost the efficiency with which energy, materials, and water are used. In developing countries where a large share of the population depends directly on the integrity and stability of ecosystems, the benefits would not only be environmental but would also carry over into the social and political realms by helping to avoid the dislocations and distributive conflicts that now go hand in hand with wholesale environmental destruction. But industrial countries' policies are critical as well, since they consume the bulk of the world's resources and are thus, directly or indirectly, responsible for the preponderance of unsustainable mining, logging, metal smelting, fishing, and fossil fuel burning.

It is equally important that governments become more serious about fulfilling pledges to eradicate poverty, promote full employment, and reduce massive social inequality. In an age in which capital-intensive technology and planetary-wide economies of scale combine to limit the potential for job creation even as the ranks of job-seekers keep swelling, a fundamental reassessment of employment policies is overdue. This concerns questions such as the choice of appropriate technology, the need to tax energy and resource consumption rather than labor, and the design of fiscal and subsidy policies. Budgetary priorities need reexamining as well; as long as massive resources continue to be invested in the military, for example, social needs will always be given short shrift.

As the repercussions of world-market integration from Indonesia to Russia to Brazil have become unmistakable, it is clear that the orthodox free-market approach that emphasizes the supremacy of freedom of trade and capital movements over all other goals ill serves the need for social, economic, and ultimately political stability. A key task now is to minimize the disruptive features of global economic integration and, where necessary, adopt some deliberate limits to it. This doesn't mean moving from one extreme—a virtually unconditional embrace of global market forces—to another—protectionism—but, rather, underscores the need for a more selective approach, recognizing that market demands sometimes clash with the imperatives of sound social policy.

In the orthodox view, the current litmus test of governmental policy is how swiftly it proceeds with deregulation and privatization and how much it facilitates trade and capital flows. The result may well be a boosted gross national product, but these goals have been pushed far too single-mindedly. From a human security perspective, what counts is whether the general well-being of the population is served without overexploiting nature, leaving certain communities behind, or undermining local culture, customs, and norms. Global economic integration doesn't always lead to adverse outcomes, but it is time to require something that might be described as social and environmental impact statements of globalization. Global economic integration won't turn into a "race to the bottom" if strong environmental and social standards can be de-

> **Security policy will increasingly need to move beyond military issues in the next century and concern itself with the social, economic, demographic, and environmental pressures that are the root of most conflicts.**

veloped; establishing high common-denominator norms on the global level will be one of the major challenges in coming years.

Seen basically as protections against state oppression, human rights need to be understood also as tools to protect the economically and socially weak from the depredations of the strong. Human rights, broadly understood, are of growing importance in a globalizing world, as decision-making processes affect larger and larger numbers of individuals and communities in more and more profound ways. The world's political and corporate elites have been far more interested, and effective, in creating a global market structure than they have been in establishing three essential conditions that are critical to preventing globalization from becoming a continuous source of contention: making the most powerful market players more accountable; preparing the ground on which a global human community, not just a global marketplace, can flourish; and setting up sufficiently strong international institutions that can help advance global norms and safeguard the interests of the global community.

The international institutions vested with the greatest degree of authority and power—the International Monetary Fund and the World Trade Organization among them—not only lack transparency and accountability in their decision-making but sometimes devote themselves to the pursuit of economic growth even at the direct expense of social, environmental, and human rights considerations. Grassroots activists have been working hard to change the way these institutions operate, but more reform is still necessary.

Considerable expectations for achieving and safeguarding the global community are being pinned on the U.N., whose various departments and agencies are involved in many activities crucial to improving the welfare of people. Yet the U.N. receives scant resources and commands little political power. Half a century after its founding, the organization that was set up to prevent recurring war is increasingly in danger of being emasculated, particularly by the United States' reluctance to pay its dues to the organization. Because the entire U.N. system—headquarters, specialized agencies, and peacekeeping operations—is owed

about $3.6 billion in outstanding dues from member states, it has languished in financial crisis for several years now. In the new century, governments will need to provide full and generous funding to the U.N. if they want it to be a more effective voice for peace than it has been to date.

To that end, reform is as essential as new money. The U.N. Security Council, for instance, is increasingly anachronistic in its composition and central workings—particularly the veto power retained by the five permanent members. But although discussions have been held for years and there is no shortage of good reform proposals, there is no consensus on the specifics. The permanent members are highly reluctant to relinquish or water down any of their privileges, especially their veto power. If they succeed in blocking timely change, they will further increase worldwide resentment of outdated privileges. Since the council relies on the willing cooperation of the world's nations, a rejection of reform may, over time, compromise its authority and effectiveness.

Because security policy will increasingly need to move beyond military issues in the next century and concern itself with the social, economic, demographic, and environmental pressures that are at the root of most conflicts, the U.N. system as a whole will be critical to success. But like the Security Council, it needs reforming. And as is the case with council reform, no consensus has emerged from amongst an endless number of reform proposals—some intended to strengthen the U.N., others to limit its role.

One of the most important challenges is to make the U.N. less an organization of government representatives and more one of the "peoples of the United Nations," as its charter puts it. As mentioned earlier, NGOs are already playing a growing role at many international venues and conferences. But their rising influence will need to find clearer institutional expression at the U.N. itself, perhaps by moving toward a multi-chamber system and adding to the General Assembly one or more assemblies that are more broadly representative of each society. This could entail a parliamentary chamber (with representatives elected directly in each nation, as the members of the European Parliament are) and a forum of civil society that includes representatives of labor, environmental groups, and others.

Impatient with the failure of governments to promote conflict prevention and peace building, NGOs—or civil society organizations, as they are increasingly called—are playing a more and more assertive role on the local, national, and international levels. And in an age in which peace and security concerns are focused more on internal than interstate matters, it is only sensible that civil society should be an active participant.

Recent years have seen the emergence of working coalitions that, on an issue-by-issue basis, bring together NGOs with like-minded governments. The anti-personnel landmines campaign is the outstanding example of this phenomenon. With the support of countries like Canada, South Africa, Belgium, and Norway, the campaign succeeded in putting landmines on the global agenda, ham-

mering out an international treaty banning these devices, and bringing the agreement into force at a speed far faster than any other arms treaty in history.

Although the landmines campaign was in many ways unique, its stunning success naturally prompted hopes that it could be replicated in other areas. Similar themes reverberate in the efforts to establish an International Criminal Court, the gathering campaign to counter small-arms proliferation, and the Middle Powers Initiative (an endeavor to encourage nuclear-weapons states to commit to practical steps toward the elimination of their atomic arsenals). Whatever their eventual outcome, these efforts are helping to revolutionize the process of international policymaking by infusing it with human rights, humanitarian, and human-development concerns to a far greater extent than has been the case to date.

Canadian Foreign Minister Lloyd Axworthy has been a particularly vocal proponent of this new "pulpit diplomacy," which regards NGO activists as a vanguard of change; opens traditionally quiet (and often secretive and slow-moving) diplomacy to far greater scrutiny and mobilizes public opinion; and frequently takes the initiative from the big powers, putting them into the unaccustomed position of having to play catch-up. Soft power, as it is also called, is based on the notion that human security, not state security, should be the organizing principle of peace policy; it regards military force as having declining utility; and it emphasizes the power of ideas and the promulgation of new norms over the power of weapons.

NGO input may well be crucial to establishing human security. A century ago, states were in their prime. But already citizen activists like Bertha von Suttner were beginning to stir and "intrude" into what was then considered the preserve of state-craft. Although pacifists succeeded in convincing governments to convene the 1899 Hague conference, as outsiders they had little influence over its outcome. Since then, the situation has changed dramatically. Today, NGO representatives are frequent participants at intergovernmental gatherings. The 1999 Hague Appeal for Peace conference went even further: it was an attempt to set the agenda for twenty-first-century peacemaking at which government and U.N. representatives were welcome guests but not the initiators.

Notwithstanding valiant efforts to the contrary, the twentieth century was the century of warfare. The twenty-first will need to be the century of demilitarization and conflict prevention. As South African Archbishop and Nobel Prize recipient Desmond Tutu pointed out this past March, slavery once seemed like an immutable reality and yet it was abolished. "Why not war? Indeed, we have no choice."

Michael Renner holds degrees in international relations and political science from the Universities of Amsterdam, the Netherlands, and Konstanz, Germany. He is a senior researcher at the Worldwatch Institute in Washington, D.C. This article is adapted from Worldwatch Paper 146: Ending Violent Conflict.

The Grameen Bank

A small experiment begun in Bangladesh has turned into a major new concept in eradicating poverty

by Muhammad Yunus

Over many years, Amena Begum had become resigned to a life of grinding poverty and physical abuse. Her family was among the poorest in Bangladesh—one of thousands that own virtually nothing, surviving as squatters on desolate tracts of land and earning a living as day laborers.

In early 1993 Amena convinced her husband to move to the village of Kholshi, 112 kilometers (70 miles) west of Dhaka. She hoped the presence of a nearby relative would reduce the number and severity of the beatings that her husband inflicted on her. The abuse continued, however—until she joined the Grameen Bank. Oloka Ghosh, a neighbor, told Amena that Grameen was forming a new group in Kholshi and encouraged her to join. Amena doubted that anyone would want her in their group. But Oloka persisted with words of encouragement. "We're all poor—or at least we all were when we joined. I'll stick up for you because I know you'll succeed in business."

Amena's group joined a Grameen Bank Center in April 1993. When she received her first loan of $60, she used it to start her own business raising chickens and ducks. When she repaid her initial loan and began preparing a proposal for a second loan of $110, her friend Oloka gave her some sage advice: "Tell your husband that Grameen does not allow borrowers who are beaten by their spouses to remain members and take loans." From that day on, Amena suffered significantly less

physical abuse at the hands of her husband. Today her business continues to grow and provide for the basic needs of her family.

Unlike Amena, the majority of people in Asia, Africa and Latin America have few opportunities to escape from poverty. According to the World Bank, more than 1.3 billion people live on less than a dollar a day. Poverty has not been eradicated in the 50 years since the Universal Declaration on Human Rights asserted that each individual has a right to:

> A standard of living adequate for the health and well-being of himself and of his family, including food, clothing, housing and medical care and necessary social services, and the right to security in the event of unemployment, sickness, disability, widowhood, old age or other lack of livelihood in circumstances beyond his control.

Will poverty still be with us 50 years from now? My own experience suggests that it need not.

After completing my Ph.D. at Vanderbilt University, I returned to Bangladesh in 1972 to teach economics at Chittagong University. I was excited about the possibilities for my newly independent country. But in 1974 we were hit with a terrible famine. Faced with death and starvation outside my classroom, I began to question the very economic theories I was teaching. I started feeling there was a great distance between the actual life of poor

From *Scientific American*, November 1999, pp. 114-119. © 1999 by Dr. Muhammad Yunus. Reprinted by permission.

and hungry people and the abstract world of economic theory.

I wanted to learn the real economics of the poor. Because Chittagong University is located in a rural area, it was easy for me to visit impoverished households in the neighboring village of Jobra. Over the course of many visits, I learned all about the lives of my struggling neighbors and much about economics that is never taught in the classroom. I was dismayed to see how the indigent in Jobra suffered because they could not come up with small amounts of working capital. Frequently they needed less than a dollar a person but could get that money only on extremely unfair terms. In most cases, people were required to sell their goods to moneylenders at prices fixed by the latter.

This daily tragedy moved me to action. With the help of my graduate students, I made a list of those who needed small amounts of money. We came up with 42 people. The total amount they needed was $27.

I was shocked. It was nothing for us to talk about millions of dollars in the classroom, but we were ignoring the minuscule capital needs of 42 hardworking, skilled people next door. From my own pocket, I lent $27 to those on my list.

Still, there were many others who could benefit from access to credit. I decided to approach the university's bank and try to persuade it to lend to the local poor. The branch manager said, however, that the bank could not give loans to the needy: the villagers, he argued, were not creditworthy.

I could not convince him otherwise. I met with higher officials in the banking hierarchy with similar results. Finally, I offered myself as a guarantor to get the loans.

In 1976 I took a loan from the local bank and distributed the money to poverty-stricken individuals in Jobra. Without exception, the villagers paid back their loans. Confronted with this evidence, the bank still refused to grant them loans directly. And so I tried my experiment in another village, and again it was successful. I kept expanding my work, from two to five, to 20, to 50, to 100 villages, all to convince the bankers that they should be lending to the poor. Although each time we expanded to a new village the loans were repaid, the

bankers still would not change their view of those who had no collateral.

Because I could not change the banks, I decided to create a separate bank for the impoverished. After a great deal of work and negotiation with the government, the Grameen Bank ("village bank" in Bengali) was established in 1983.

From the outset, Grameen was built on principles that ran counter to the conventional wisdom of banking. We sought out the very poorest borrowers, and we required no collateral. The bank rests on the strength of its borrowers. They are required to join the bank in self-formed groups of five. The group members provide one another with peer support in the form of mutual assistance and advice. In addition, they allow for peer discipline by evaluating business viability and ensuring repayment. If one member fails to repay a loan, all members risk having their line of credit suspended or reduced.

The Power of Peers

Typically a new group submits loan proposals from two members, each requiring between $25 and $100. After these two borrowers successfully repay their first five weekly installments, the next two group members become eligible to apply for their own loans. Once they make five repayments, the final member of the group may apply. After 50 installments have been repaid, a borrower pays her interest, which is slightly above the commercial rate. The borrower is now eligible to apply for a larger loan.

The bank does not wait for borrowers to come to the bank; it brings the bank to the

HOUSEHOLD WELL-BEING BEFORE AND AFTER PARTICIPATION IN GRAMEEN

Before program After program

people. Loan payments are made in weekly meetings consisting of six to eight groups, held in the villages where the members live. Grameen staff attend these meetings and often visit individual borrowers' homes to see how the business—whether it be raising goats or growing vegetables or hawking utensils—is faring.

Today Grameen is established in nearly 39,000 villages in Bangladesh. It lends to approximately 2.4 million borrowers, 94 percent of whom are women. Grameen reached its first $1 billion in cumulative loans in March 1995, 18 years after it began in Jobra. It took only two more years to reach the $2-billion mark. After 20 years of work, Grameen's average loan size now stands at $180. The repayment rate hovers between 96 and 100 percent.

A year after joining the bank, a borrower becomes eligible to buy shares in Grameen. At present, 94 percent of the bank is owned by its borrowers. Of the 13 members of the board of directors, nine are elected from among the borrowers; the rest are government representatives, academics, myself and others.

A study carried out by Sydney R. Schuler of John Snow, Inc., a private research group, and her colleagues concluded that a Grameen loan empowers a woman by increasing her economic security and status within the family. In 1998 a study by Shahidur R. Khandker an economist with the World Bank, and others noted that participation in Grameen also has a significant positive effect on the schooling and nutrition of children—as long as women rather than men receive the loans. (Such a tendency was clear from the early days of the bank and is one reason Grameen lends primarily to women: all too often men spend the money on themselves.) In particular, a 10 percent increase in borrowing by women resulted in the arm circumference of girls—a common measure of nutritional status—expanding by 6 percent. And for every 10 percent increase in borrowing by a member the likelihood of her daughter being enrolled in school increased by almost 20 percent.

Not all the benefits derive directly from credit. When joining the bank, each member is required to memorize a list of 16 resolutions. These include commonsense items about hygiene

and health—drinking clean water, growing and eating vegetables, digging and using a pit latrine, and so on—as well as social dictums such as refusing dowry and managing family size. The women usually recite the entire list at the weekly branch meetings, but the resolutions are not otherwise enforced.

Even so, Schuler's study revealed that women use contraception more consistently after joining the bank. Curiously, it appears that women who live in villages where Grameen operates, but who are not themselves members, are also more likely to adopt contraception. The population growth rate in Bangladesh has fallen dramatically in the past two decades, and it is possible that Grameen's influence has accelerated the trend.

In a typical year 5 percent of Grameen borrowers—representing 125,000 families—rise above the poverty level. Khandker concluded that among these borrowers extreme poverty (defined by consumption of less than 80 percent of the minimum requirement stipulated by the Food and Agriculture Organization of the United Nations) declined by more than 70 percent within five years of their joining the bank.

To be sure, making a microcredit program work well—so that it meets its social goals and also stays economically sound—is not easy. We try to ensure that the bank serves the poorest: only those living at less than half the poverty line are eligible for loans. Mixing poor participants with those who are better off would lead to the latter dominating the groups. In practice, however, it can be hard to include the most abjectly poor, who might be excluded by their peers when the borrowing groups are being formed. And despite our best efforts, it does sometimes happen that the

LISA BURNETT

IMPACT OF GRAMEEN ON NUTRITIONAL MEASURES OF CHILDREN

Increase in arm circumference*

0 1 2 3 4 5 6 7 8 9 10 11 12 13 14 15
PERCENT

Increase in height*

0 1 2 3 4 5 6 7 8 9 10 11 12 13 14 15
PERCENT

▨ Girls ■ Boys

*Bars reflect changes accompanying a 10 percent increase in credit to women.

money lent to a woman is appropriated by her husband.

Given its size and spread, the Grameen Bank has had to evolve ways to monitor the performance of its branch managers and to guarantee honesty and transparency. A manager is not allowed to remain in the same village for long, for fear that he may develop local connections that impede his performance. Moreover, a manager is never posted near his home. Because of such constraints—and because managers are required to have university degrees—very few of them are women. As a result, Grameen has been accused of adhering to a paternalistic pattern. We are sensitive to this argument and are trying to change the situation by finding new ways to recruit women.

Grameen has also often been criticized for being not a charity but a profit-making institution. Yet that status, I am convinced, is essential to its viability. Last year a disastrous flood washed away the homes, cattle and most other belongings of hundreds of thousands of Grameen borrowers. We did not forgive the loans, although we did issue new ones, and give borrowers more time to repay. Writing off loans would banish accountability, a key factor in the bank's success.

Liberating Their Potential

The Grameen model has now been applied in 40 countries. The first replication, begun in Malaysia in 1986, currently serves 40,000 poor families; their repayment rate has consistently stayed near 100 percent. In Bolivia, microcredit has allowed women to make the transition from "food for work" programs to managing their own businesses. Within two years the majority of women in the program acquire enough credit history and financial skills to qualify for loans from mainstream banks. Similar success stories are coming in from programs in poor countries everywhere. These banks all target the most impoverished, lend to groups and usually lend primarily to women.

The Grameen Bank in Bangladesh has been economically self-sufficient since 1995. Similar institutions in other countries are slowly making their way toward self-reliance. A few small programs are also running in the U.S., such as in innercity Chicago. Unfortunately, because labor costs are much higher in the U.S. than in developing countries—which often have a large pool of educated unemployed who can serve as managers or accountants—the operations are more expensive there. As a result, the U.S. programs have had to be heavily subsidized.

In all, about 22 million poor people around the world now have access to small loans. Microcredit Summit, an institution based in Washington, D.C., serves as a resource center for the various regional microcredit institutions and organizes yearly conferences. Last year the attendees pledged to provide 100 million of the world's poorest families, especially their women, with credit by the year 2005. The campaign has grown to include more than 2,000 organizations, ranging from banks to religious institutions to nongovernmental organizations to United Nations agencies.

The standard scenario for economic development in a poor country calls for industrialization via investment. In this "topdown" view, creating opportunities for employment is the only way to end poverty. But for much of the developing world, increased employment exacerbates migration from the countryside to the cities and creates low-paying jobs in miserable conditions. I firmly believe that, instead, the eradication of poverty starts with people being able to control their own fates. It is not by creating jobs that we will save the poor but rather by providing them with the opportunity to realize their potential. Time and time again I have seen that the poor are poor not because they are lazy or untrained or illiterate but because they cannot keep the genuine returns on their labor.

Self-employment may be the only solution for such people, whom our economies refuse to hire and our taxpayers will not support. Microcredit views each person as a potential entrepreneur and turns on the tiny economic engines of a rejected portion of society. Once a large number of these engines start working, the stage can be set for enormous socioeconomic change.

Applying this philosophy, Grameen has established more than a dozen enterprises, often in partnership with other entrepreneurs. By assisting microborrowers and microsavers to take ownership of large enterprises and even infrastructure companies, we are trying to speed the process of overcoming poverty. Grameen Phone, for instance, is a cellular telephone company that aims to serve urban and rural Bangladesh. After a pilot study in 65 vil-

lages, Grameen Phone has taken a loan to extend its activities to all villages in which the bank is active. Some 50,000 women, many of whom have never seen a telephone or even an electric light, will become the providers of telephone service in their villages. Ultimately, they will become the owners of the company itself by buying its shares. Our latest innovation, Grameen Investments, allows U.S. individuals to support companies such as Grameen Phone while receiving interest on their investment. This is a significant step to-

ward putting commercial funds to work to end poverty.

I believe it is the responsibility of any civilized society to ensure human dignity to all members and to offer each individual the best opportunity to reveal his or her creativity. Let us remember that poverty is not created by the poor but by the institutions and policies that we, the better off, have established. We can solve the problem not by means of the old concepts but by adopting radically new ones.

The Author

MUHAMMAD YUNUS, the founder and managing director of the Grameen Bank, was born in Bangladesh. He obtained a Ph.D. in economics from Vanderbilt University in 1970 and soon after returned to his home country to teach at Chittagong University. In 1976 he started the Grameen project, to which he has devoted all his time for the past decade. He has served on many advisory committees: for the government of Bangladesh, the United Nations, and other bodies concerned with poverty, women and health. He has received the World Food Prize, the Ramon Magsaysay Award, the Humanitarian Award, the Man for Peace Award and numerous other distinctions as well as six honorary degrees.

Further Reading

GRAMEEN BANK: PERFORMANCE AND SUSTAINABILITY. Shahidur R. Khandker, Baqui Khalily and Zahed Khan. World Bank Discussion Papers, No. 306. ISBN 0-8213-3463-8. World Bank, 1995.
GIVE US CREDIT. Alex Counts. Times Books (Random House), 1996.
FIGHTING POVERTY WITH MICROCREDIT: EXPERIENCE IN BANGLADESH. Shabidur R. Khandker. Oxford University Press, 1998.
Grameen Bank site is available at www.grameenfoundation.org on the World Wide Web.

Uncharted terrain on tomorrow's genetic map

▶ Sophie Boukhari and Amy Otchet

In the post-genomic age, medical science's good intentions could lead us to the frontier of new forms of eugenics

In about three years, we should have the keys to decode our biological "ego". Through the Human Genome Project, thousands of researchers from about 50 countries are putting the final touches to a map identifying all of our roughly 100,000 genes. This information will open the way to developing a large number of innovative treatments and techniques to cure and prevent disease.

At the beginning of this "genetic age", we can expect an extensive battery of DNA tests which prospective parents will use to gain an extraordinary picture of their embryo's genetic make-up. These tests may be used in utero to reassure parents as to the health of their child-to-be. On the other hand, signs of disease or handicap might also lead to the decision to abort. This same battery of DNA tests will also be used for preimplantation diagnosis, in which prospective parents sift through and then select in vitro ("test tube") a fertilized egg (or eggs) before implantation in a woman's womb. Both of these screening approaches are part of "genetic counselling",

Reprinted with permission from the *Unesco Courier*, September 1999, pp. 18-19.

193

> # Give me the strength and the will to broaden my knowledge. Steer me from the idea that all is within my reach.
>
> Maimonides,
> Rabbi and doctor (1135–1204)

a term used to describe a very sensitive process in which people basically decide what kinds of individuals are born. We already see this selection process at work with health policies in some countries encouraging women to take prenatal tests for Down's Syndrome.

In the next phase of genetic research, geneticists will develop a range of treatments for genetic disorders, including gene therapy, now just in their very early stages. This research is raising wild hopes, from the ability to cure certain cancers to combating the 4,000 to 5,000 genetic illnesses identified so far. Some geneticists are already dreaming of germ-line therapy in which genetic changes are passed along to future generations. Indeed scientists like American Lee Silver foresee the rise of a new discipline: "reprogenetics" which will combine cloning and genetic engineering techniques to one day "enhance" in vitro embryos. Enhancement could take a variety of forms: from improving resistance to disease to modifying behavioural or physical traits with a view to producing the "child of parents' dreams".

For now, these scenarios are not only technically impossible but legally prohibited: reproductive cloning of humans and germ-line therapy are forbidden. But they are warning signs for those who fear that medicine will be used as a way of selecting and controlling "good" and "bad" genes. We are on the verge of a new eugenic age, warn the serried ranks of philosophers, priests, human rights campaigners and anti-abortion groups. Their cry has sparked a major bioethical debate on two fronts. The first revolves around the very definition of eugenics (see glossary), an emotionally charged word closely associated with the horrors of Nazism. Secondly, will advances in genetics give rise to new forms of eugenics?

Asian countries and Arab Gulf states already have laws denying the disabled the right to be born. According to Noëlle Lenoir, former president of UNESCO's International Bioethics Committee (IBC), "in societies already plagued by discrimination, genetics could become another instrument of exclusion." Can any society claim that it is untainted by this social ill? Certainly not those which deem girls inferior.

What is normality?

The debate over eugenics reminds us that there is no such thing as a "perfect" baby. The human gene pool cannot be "cleaned" up because, as scientists point out, new genetic anomalies develop with each generation. Besides, genetic engineering is an inherently risky endeavour because it is impossible to predict which genes our descendants may need in the future.

A host of fundamental ethical questions also arise. Tests to detect late onset diseases raise the problem of defining a life worth living. A genetic disease like "Huntington's chorea usually develops between the ages of 38 and 45," says French geneticist and bioethicist Axel Kahn. "Yet think of all the great artists and musicians who died before reaching 40. We see here the difficulty in saying that a life isn't worth living if it ends or suddenly deteriorates at a certain age."

Another thorny question lies in defining "normality". Imagine the discrimination directed towards handicapped people in a society accustomed to the idea of eliminating genetic "defects"? Many bioethicists such as IBC president Ryuichi Ida also see grave dangers potentially arising from the "genetic enhancement" of embryos. To begin with, new inequalities would develop between those who could afford such "treatment" and those lacking access to it.

We must also ask whether parents have the right to "design" the child of their dreams? "A child is a separate and complete individual who cannot be reduced to the expectations of his or her parents," says Kahn. "Being a parent is supposed to be about loving a child as he or she is. Parenting is not about requiring a child to be as you would like him or her to be. In this respect, children are in danger."

Yet brandishing the spectre of eugenics is simplistic and dangerous, insist many scientists, biotechnology executives, bioethicists, and feminists. Furthermore, anti-abortion groups might manipulate the debate to curtail women's hard won rights to control their own fertility.

There may also be a positive side to "laissez faire" or "utopian" eugenics—terms which are sparking a flurry of discussion in affluent Western countries. Many bioethicists and scientists maintain that these new forms of eugenics simply describe the choices individuals—not the state or the community—will be able to make about the kind of children they want to bring into the world. But how will commercial pressures and interests drive these decisions? "With sufficient advertising, the biotechnology market will make parents feel guilty if they don't consume" all the genetic tests and services available, says Lori Andrews, an American legal expert in the field.

As geneticists point out, science and medicine have always advanced by violating social taboos. Scientists should not be penalized for the ways in which society uses their discoveries. The ethical path lies in giving people time to reflect on the consequences of scientific progress.

"Individuals everywhere are faced with more and more ethical dilemmas," says Lenoir. "In some ways, it's easier when you live in an authoritarian or religious society. The rules are laid out before you. *But in culturally diverse and secular societies, where people have access to information and can stand up for their rights, it's much harder to set guidelines. This is what gave birth to bioethics.*"

Glossary

DNA: deoxyribonucleic acid, the carrier of genetic information.

ES cells: embryonic stem cells, mostly **totipotent,** i.e. capable of providing the genetic programme required to direct the development of an entire individual.

Germ cell: reproductive cell (sperm or egg cells), changes in which are passed down through generations.

Somatic cell: non-germ cell, known as an "adult" cell.

Chromosome: rod-like structure made of DNA, visible when a cell is divided.

Clones: genetically identical living things, obtained by asexual reproduction.

Eugenics: a term invented by the British scientist Francis Galton from the Greek words "eu" (good) and "genos" (birth, race). The study of how to improve human genetic heritage.

Gene: a segment of DNA which, alone or in a combination with others, determines creation of a trait. An organism's total genetic material is its **genome.**

Recessive gene: one which does not produce the character to which it is linked unless it exists on both the male and female chromosomes in the pair. A **dominant gene,** on the other hand, produces its characters by dominating the different gene carried by the other chromosome in the pair.

Genetic disease: several thousands of these have been identified. Some are **monogenic,** i.e. a single gene is responsible for the disease. Others are **multi-genic,** with several genes involved.

Gene therapy: treatment of genetic diseases by introducing genetic material into the patient's genes.

Is Life Really Getting Better?

Most people assume that "progress" means more of everything—more money, more technologies, more things to buy, bigger houses, cars, etc. But shouldn't we be asking whether "more" is better?

By Richard Eckersley

A central tenet of modern Western culture is the belief in progress, the belief that life should be (and is) getting better—healthier, wealthier, happier, more satisfying, and more interesting. Is this the case? If our answer is "yes," then we can assume society is on the right trajectory, requiring only periodic course correction by governments.

If the answer is "no," then the most fundamental assumptions about our way of life need reassessing. The task we face goes far beyond the adjustment of policy levers by government: It means having a more open and spirited debate about how we are to live in the future and about what matters in our lives.

Some commentators believe that, if we continue on our present path of economic and technological development, humanity can overcome the obstacles and threats it faces and enter a new golden age of peace, prosperity, and happiness. Others foresee an accelerating deterioration in the human condition leading to a major perturbation or discontinuity in human history, even the extinction of our species (along with many others).

One reason we remain divided on the question is that the data are incomplete or are open to differing interpretations. We do not agree on what constitutes "a better life," and we do not have good measures of many aspects of life. Another problem is that most analysts view the question through the prism of their particular expertise, giving a distorted or incomplete picture. To the economist, we are consumers making rational choices to maximize our utility or personal satisfaction; to the ecologist, we are one of millions of species, whose fate hangs on our interactions with other species and the physical environment.

However, the issue goes deeper than this. We are seeing a clash of paradigms, a confrontation between fiercely held beliefs. The paradigm of progress is being challenged by that of transformation: Are we still "on track" to a better future or are we now straying ever farther off it? Are economic, social, and en-

PHOTOS: © PHOTODISC, INC.

Child waits for mother to get off the phone. An economist may see a growing number of telephones as an indicator of national progress, but such statistics are an inadequate measure of quality of life, argues author Richard Eckersley.

vironmental problems mere "glitches" that we can iron out, or are the problems systemic, requiring whole-system change?

In developed nations, we have defined progress in mainly material terms. We equate "standard of living" with "quality of life." This view remains largely unquestioned in mainstream political debate, where our fundamental assumptions about economic growth—that it enhances well-being and is environmentally sustainable—are rarely explored.

Measuring Well-Being

The relationship among wealth, health, and well-being is less clear-cut than many assume. In the late 1980s, Chilean economist Manfred Max-Neef and his colleagues undertook a study of 19 countries, both rich and poor, and found that people in rich countries felt they were part of a deteriorating system that was affecting them personally and as a society. This led the researchers to propose a *threshold hypothesis,* which states that societies experience a period in which economic growth brings about an improvement in quality of life, but only up to a point—the threshold point—beyond which more economic growth may lead to a deterioration in quality of life.

The threshold hypothesis has been supported in recent years by new measures, such as the Genuine Progress Indicator, which adjust gross domestic product (GDP) for a wide range of social and environmental factors. The measures show that trends in GDP and social well-being, once moving together, have diverged since about the mid-1970s in all countries for which these indices have been constructed, including the United States, United Kingdom, and Australia.

American psychologists David Myers and Ed Diener have shown that wealth is a poor predictor of happiness. People have not become happier as their societies have become richer. In most countries, the correlation between income and happiness is negligible; only in the poorest countries is income a good measure of well-being. In general, people in rich countries appear to be happier than those in poorer countries, but the margin may be slim and based on factors other than wealth.

In rich nations, health seems to be influenced more by income distribution than by average income levels: The physical effects of material deprivation associated with absolute poverty are less important to health than the psychological and social consequences of relative deprivation, of living in an unequal society. British medical researcher Richard Wilkinson, a leading figure in this work, says that what seems to matter are the social meanings attached to inferior living conditions and how people feel about their circumstances and about themselves. The health data suggest, he says, that the quality of the social fabric, rather than increases in average wealth, may now be the prime determinant of the real subjective quality of human life.

Given this situation in developed nations, the current patterns of global economic growth seem perverse: The rich are getting richer much faster than are the poor, many of whom are getting poorer.

Growth and Sustainability

Advocates of economic growth argue that it is good for the environment. As countries grow richer, they reach a stage where consumer preferences and the structure of the economy change, technology becomes more efficient and cleaner, and the countries can afford to invest more in environmental improvements. However, researchers have pointed out that this has only been shown for a selected set of pollutants with local, short-term costs (for example, urban air and water pollution), not for the accumulation of waste or pollutants such as carbon dioxide, which involve long-term and more-dispersed costs.

The "pro-growth" argument is less likely to hold for resource stocks such as soils and forests, and it ignores issues such as the transfer of polluting industries to other countries. In places where emissions have declined with rising income, the reductions have been due to local institutional reforms such as environmental legislation.

Even if the argument is accepted, economic growth will worsen environmental conditions at the global level because countries with most of the world's population will, for some time to come, have average incomes below that required to invest in improving the envi-

Street person guards his belongings. In wealthy nations, the psychological stress of living in conditions that are inferior to those of other people may be more damaging than actual deprivation.

ronment. Economic growth in these countries could be expected to increase pollution, more than canceling out any reduction of pollution in more-developed countries.

Our goal should be to dematerialize society without reducing quality of life. Several leading environmental research and advocacy organizations have urged a halving of global material flows. Developed nations would need to reduce their material consumption to 10% or less of present levels, according to these organizations. They argue that this reduction, while obviously massive, is achievable using present technologies.

As things are, a wide range of environmental indicators suggest that, globally, we are still moving *away* from sustainability, not toward it. The final statement of the 1997 United Nations Earth Summit noted that participants were "deeply concerned that overall trends for sustainable development were worse today than they were in 1992" (the year of the previous summit). Despite this, they failed to reach agreement on major environmental issues.

Changing Directions

Conventional notions of growth and progress are increasingly being questioned and challenged, yet powerful sec-

Measuring *Real* Progress

The Genuine Progress Indicator (GPI) is an alternative to gross domestic product (GDP) for policy makers seeking a more realistic measure of national well-being. GPI examines not just the exchange of monetized goods and services, but adds in non-monetized activities (such as volunteer service and domestic work) that contribute to social progress and discounts those that detract from it (such as pollution and crime).

By applying these nontraditional variables, the Genuine Progress Indicator reveals that much of what contributes to a growth in GDP comes from fixing problems caused by economic growth, according to critics. For example, cleaning up the Exxon *Valdez* oil spill produced a flurry of economic activity, such as extra business for local services and new jobs. The result: The infamous environmental disaster actually led to an increase in GDP.

Similarly, GDP increased by 50% between 1973 and 1993, but, as the GPI reveals, wages declined by almost 14%. Most of the growth in income went to the top 5% of households. Clearly, critics claim, a rising tide does not lift all boats.

For more information, see: *The Genuine Progress Indicator*, available from Redefining Progress, One Kearny Street, Fourth Floor, San Francisco, California 94108. Telephone 1-415-781-1191. 1995. $10. A brief version is available on the Web site of *Ideas: A Magazine of Social Comment*, www.upstarts.net.au/site/ideas/gpi/gpi.html.

tions of society seem to be more deeply committed to them than ever. The whole of our society has been shaped by and structured around these notions. Growth is central to our economic system, and material progress lies at the heart of our culture—a culture powerfully reinforced by the mass media, marketing, and advertising.

The crux of the debate about progress is the direction of change. Will we improve the quality of life by continuing on our present path of progress—increasing average wealth to give the average consumer greater choice? Or do we need to find a new path that leads in a different direction, toward new personal and social goals?

The rationale for economic growth as we pursue it today seems flawed in several important respects: (1) it overestimates the extent to which past improvements in well-being are attributable to growth; (2) it reflects too narrow a view of human well-being and fails to explain why, after 50 years of rapid growth, so many people today appear to believe life is getting worse; and (3) it underestimates the gulf between the magnitude of the environmental challenges we face and the scale of our responses to them.

"More" does not mean "better" if, in our efforts to get more, we sacrifice what really matters to our happiness and well-being: the quality of our personal, social, and spiritual relationships that give us a sense of meaning, purpose, and belonging.

Nor can we keep getting "more" if, in doing that, we deplete the natural resources and damage the ecosystem processes on which all life on earth depends, ourselves included.

The main political justification for promoting growth is jobs. Economic expansion may be better than contraction in increasing employment, but it is also now creating more overwork and underwork, more job insecurity, and a widening income gap. All these things, like unemployment, put pressure on individuals, families, and the whole fabric of society.

We need to look much more closely at *what* is growing, what *other effects* this growth is having, and what *alternatives* might exist. We need to focus not just on wealth creation, but also on its distribution and conservation. In other words, we should pay as much attention to measures of these things as we currently do to growth in GDP.

The task is not simply to *abandon* growth; it is to move *beyond* growth. To suggest this is not necessarily to be "anti" the economy, business, or technological innovation, but to argue that these activities need to be driven by different values toward different ends.

So . . . is life getting better? If we answer "yes," then we can continue on our present path of progress and enjoy the journey. If we answer "no," then we need to pose several other questions:

● What do we want from life? (What is its purpose? What makes a better life?)

● How do we best get what we want? (Is it through continuing economic growth and material progress of the sort we now have?)

● What values will promote what we want, and what will discourage what we don't?

Ultimately, how effectively we address many of the critical issues currently facing Western societies, and indeed the world, hangs on our answers to these fundamental questions.

The decades ahead promise tectonic shifts in global civilizations—possibly cataclysmic, maybe drawn out, so that their true significance will only become apparent from a future, historical perspective. To borrow from chaos theory: How we respond in seemingly little ways today could have big outcomes tomorrow. How we choose to live affects the world—there is no escaping that—so we should choose to live to change the world.

About the Author
Richard Eckersley is currently a visiting fellow at the National Centre for Epidemiology and Population Health at the Australian National University, Canberra, ACT 0200, Australia. Telephone 61-2-6249-0681; fax 61-2-6249-0740; e-mail richard.eckersley@anu.edu.au.

He was formerly with the Resource Futures Program of CSIRO. He has edited and contributed to two books: *Measuring Progress: Is Life Getting Better?* (July 1998, CSIRO Publishing, Web site http://www.publish.csiro.au/) and *Challenge to Change: Australia in 2020*. His previous article for THE FUTURIST, "The West's Deepening Cultural Crisis," was published in November-December 1993.

A group of "Latin intellectuals and left-leaning politicians" is determined to put Latin America on a new course to prosperity and equality. "The group's goal of rolling back the Washington Consensus and ushering in a model based on productive investment and a democratized economy sounds like a pipe dream. But time and trouble may be on its side."

A Fourth Way?
The Latin American
Alternative to Neoliberalism

LUCY CONGER

Latin America weathered fairly well the initial financial shock from the Asian turbulence that began last fall, primarily because Brazil spent $8 billion to defend its currency and thereby kept the region's largest economy on course. In subsequent months, Latin America suffered a trade shock as the Asian tsunami lapped at its shores, gouging prices of key Latin commodity exports such as oil and copper and creating stiffer competition for Latin products in markets like the United States.

Hopes that the region could withstand the buffeting from Asia were dashed when Russia devalued the ruble and defaulted on its debt this August. In the last hellish week of that month, Latin American stock markets sank as much as 10 percent on investor concerns about Russia, and some of the region's leading economies suffered attacks on their currencies. Still licking their wounds, the large Latin nations were hammered again on September 3 when Moody's, the international

LUCY CONGER *is a writer based in Mexico City covering Latin American finance and economy. She is a correspondent for* Institutional Investor *magazine and writes for* U.S. News and World Report *and other publications. Some of the material in this article was originally reported for* Institutional Investor *and is included with permission.*

credit-rating agency, downgraded the ratings of Brazilian and Venezuelan debt and placed Mexico and Argentina on a "watch" for a possible debt downgrade.

Financial markets voted no confidence in Latin America despite the sweeping reforms most of the region's countries had implemented in an attempt to meet the demands of international investors. In the past decade, most Latin governments have adopted what is called the "Washington Consensus": reforms backed by the IMF and the United States Treasury Department that include lifting restrictions on trade and foreign investment, privatizing state enterprises, stabilizing local currencies, and clamping down on government spending to achieve balanced budgets.

The reforms have created a dramatic turnaround in Latin American economies, ending the state-dominated populist and protectionist regimes. Yet implementing the policy package that Latins call "neoliberalism" has been costly: millions have lost jobs because of privatization, public services including health care and education have been sharply reduced, and in many countries the number of people living below the poverty line has increased. Benefits have accrued to the reformed countries as trade and foreign investment have increased and sound finances have spurred growth. But, as the August rout proves, Latin America remains subject to recurrent crises.

Reprinted with permission from *Current History*, November 1998, pp. 380-384. © 1998 by Current History, Inc.

POINTING TO AN ALTERNATIVE

Well before the weakness in Asia drove home the vulnerability of Latin American economies, a group of Latin intellectuals and left-leaning politicians had begun to debate an alternative program that would promise development for their countries. By November 1997, after 18 months of meetings, they had forged a consensus and launched a platform called the "Latin American Alternative" (Alternative Latinoamericana). The group is spearheaded by Jorge Castañeda, a Mexican political scientist (and *Current History* contributing editor), and Roberto Mangabeira Unger, a Brazilian and professor at Harvard Law School. They have been joined in the debate by some two dozen Latin politicians, including two presidential candidates from Brazil and presidential hopefuls from Argentina, Chile, and Mexico, as well as former finance ministers, senators, governors, and mayors from throughout the region.

The alternative model endorsed by this group accepts the market economy, global economic integration, free trade, and privatization of state companies—all central tenets of the Washington Consensus. But the model proposes radical new policy directions to achieve sustained economic growth, link the poor to national and global economies, and encourage greater democratic political participation. "We can reform the market economy to tighten the link between savings and production and make money more complicit in the real economy," says Unger, who complains that the "financial casino" of stock markets and currency trading dissipates savings worldwide, and especially in emerging market countries.

A guiding principle of the alternative model is to combat the social and economic dualism that pervades life in Latin America. The region can claim the most inequitable income distribution in the world and rigid barriers to social mobility. The model would raise taxes to increase government funding for social services and education, which would improve the productive capacity of the workforce. Locally based credit institutions would be promoted to fund the upgrading and expansion of undercapitalized small businesses, which employ the majority of Latin Americans. Incentives for savings would be established to reduce the dependence of the region's emerging markets on volatile foreign capital inflows. Referendums and recall elections would be used to circumvent political impasses that blocked passage of reforms.

This effort to create a program for leftist politicians and generate an alternative to the neoliberal model is ambitious. Winning a hearing for the Latin group's vision and implementing its program will be uphill battles. "The basic objective is to establish in Latin America a movement of ideas, a current of opinion to get at economic orthodoxy and economic populism," says Unger.

Most of the politicians in the group predictably take a more optimistic and pragmatic view, believing they can win office and govern better with some of these ideas. They are also motivated by the need to build center-left political alliances strong enough to defeat the center-right elected regimes that predominate and then enact an alternative economic program. "The center-left is in a boom period" in Latin America, says

Senator Carlos Ominami of Chile, a former economy minister. Others in the group advocate the alternative model with all of its ideas, including some that may seem unrealistic. "If you ask me do we have to put forward maximum utopias, I say yes," says Graciela Fernández Meijide, a former human rights activist and now the likely presidential candidate for Argentina's center-left alliance. "You have to propose a lot to get what you get."

The group's goal of rolling back the Washington Consensus and ushering in a model based on productive investment and a democratized economy sounds like a pipe dream. But time and trouble may be on its side. "The present world financial crisis has strengthened the need for such a debate and ultimately strengthened the readiness to hear this message," argues Unger. Certainly, the Asian crisis puts the IMF's credibility to the test and may overturn the conventional wisdom favoring unrestricted movements of capital. For market watchers willing to open their minds to other doubts, here are the ideas that these Latin Americans propose.

BUILDING THE MODEL

Supporters of the Latin American Alternative aim to correct the errors of both neoliberalism and populism. Neoliberalism has failed in Latin America, they argue, because it has not achieved sustained economic growth and it condemns large parts of the population to social and economic misery. The social programs of neoliberalism are inadequately funded and cannot reduce inequities because they are combined with orthodox economic structures that reinforce the highly unequal distribution of income that typifies Latin economies. Populism, meanwhile, is "merely distributive" and has failed to spawn deep reforms of the productive structure, says Unger.

"Alternative Latinoamericana" promises a democratized market economy that would bridge the gap between technologically advanced industries and undercapitalized, inefficient small and microbusinesses; it also promises a strong federal government with increased revenues that would support social and educational services to narrow the chasm separating the rich from the poor (who make up 40 percent of the population in many Latin countries).

A basic underpinning of the model is an increase in taxes and tax collection so that state revenues top 30 percent of gross domestic product. "In no country in the world has it been possible to generate solid social equilibrium with [government] spending levels below 30 percent of GDP," according to Alternative Latinoamericana. This poses an enormous challenge in Latin America, where tax collection averages about 12 percent of GDP and tax evasion is a national pastime. The increase in revenues would come from raising taxes on consumption, known as a value-added tax. At the outset, an increase in income taxes is not foreseen. The tax hike to all consumers, rich and poor alike, would be compensated for by social spending that would redistribute income and opportunities. In addition, the proceeds from the privatization of state companies would be used to pay off domestic public debt and reduce domestic

> *The group argues that speculative short-term capital flows threaten the sovereignty of states.*

interest rates to levels competitive with those in the industrialized nations.

To combat social inequities, state spending would guarantee equal access to quality education for all citizens and would provide meals and medical care to all children. Workers' salaries would be increased so that they made up a greater percentage of national income.

The model would attempt to reduce the predominance of what Unger dubs the "financial casino." The group proposes to adopt controls on short-term capital flows by imposing taxes or requiring reserve deposits. The controls would help stimulate domestic savings and create incentives to channel investment to productive uses. "Financial logic tends to impose itself over productive logic," the group's proposal notes. The group argues that speculative short-term capital flows threaten the sovereignty of states because international financial markets pressure governments to lift regulations and throw open their borders to stateless private capital. They have gained some powerful allies on their point recently. In late September, IMF officials indicated that the fund may encourage the use of controls on short-term volatile capital flows.

Alternativa Latinoamericana also proposes that savings be increased to exceed 30 percent of the national economy; this would be accomplished principally by creating private pension funds. To encourage the use of these savings for productive purposes, special investment funds would be set up, and incentives would be created for investing in undercapitalized small and medium-sized firms. The investment funds are meant to offer an alternative to conventional stock market and banking investments that fuel the financial sector but fail to create employment or goods and services for unskilled and poor workers. A key would be to make financial services, especially credit, available to all citizens. The traditional financial system should expand its coverage through the formation of credit unions, savings and loans, microcredit lending groups, and other locally based finance agencies scattered throughout the countryside.

The model must attempt to overcome the separation between the productive niches Unger calls the "vanguard" and the "rear guard." The vanguard includes innovative, technologically sophisticated, internationally competitive industries; in most emerging markets they capture a huge share of profits but represent a small slice of employment and the production of goods and services consumed by the poor domestically. The rear guard includes the legions of unproductive, undercapitalized small and medium-sized firms and cottage industries that work with obsolete technology and are not linked to the global economy. In Latin America, most employment is generated by firms in the rear guard, and typically the jobs lack social benefits for the workers.

Bridging the gulf between the vanguard and the rear guard would require a new type of linkage between government and private industry to allow flexible and decentralized coordination with small and medium-scale firms at a local level. The alternative model proposes to group small firms together in networks to gain access to investment funds, public and private bank credits, and assistance programs. These relationships would create channels to transmit vanguard practices, especially permanent innovation, reduction of the layers of hierarchy among personnel, and the mixing of cooperation and competition, to the rear guard.

The model would make big business play by the rules of market competition instead of reaping benefits from government support and protection. Policy reform to level the playing field in Latin market economies would include reorienting government support programs toward small and medium-sized companies, advancing stiff antimonopoly laws, ensuring protection for minority shareholders, and eliminating nonvoting shares in companies. The principle of "free trade without dogma" would include adopting selective temporary tariffs to encourage long-term, high-risk investment and reduce the favoritism often shown to big business.

The left also argues that political institutions must be modified so that frequent change is easier. The model proposes giving presidents and congresses the power to call a new election for both executive and legislative branches when reform is blocked. Presidents would be granted "fast-track" procedures to speed decisions on strategic issues.

DEMOCRACY: A KEY INGREDIENT

Deepening democracy in Latin America is a pillar of the model to bridge the region's social and economic divide. Honest elections and constant civic mobilization are but the first steps to this goal. Unger takes a dim view of recent constitutional changes in several Latin countries that allow for the reelection of the president. The reforms have given a second term to Carlos Menem in Argentina and Alberto Fujimori in Peru and returned Brazil's Fernando Henrique Cardoso to power in elections in October. "The development of the reelection system threatens to return Latin America to the era of civilian caudillos," or strongmen, says Unger.

Additional proposals aim to reduce the influence of money in politics through public financing of campaigns, disclosure of private contributions, and the expansion of free access to television for political parties and social movements. To hold governments accountable for their acts, instruments must be created that allow citizens and legislators to call bureaucrats to task. These instruments would include popularly initiated recall votes, referendums, congressional oversight of government agencies, independent accounting offices to combat corruption, and citizen selection and supervision of public works projects.

Democratization of information is also required in the vision of a strengthened society and a transparent government. Practical means must be found to inform constituents of their rights as citizens, as men and women, and as members of ethnic groups, and to encourage them to defend their rights. Private monopolies that control the policy and content of mass media, especially television, must be broken up by limiting the concentration of concessions or frequencies. Television cries out most urgently for this reform because across Latin America it is the leading source of news for most people. In Brazil, for example, 80 percent of adults never read newspapers. The power of Latin media magnates and the ongoing wave of privatizations of media-related industries such as telecommunications companies combine to create strong allegiances between the information industry and government, says Unger.

PUTTING THE PLAN TO THE POLITICAL TEST

While some elements of this model may seem far-fetched, more than a few are gaining currency among economists and government and development officials. "What seemed fringe ideas two to three years ago are becoming more mainstream," Castañeda observes. In particular, creating controls to regulate flows of short-term capital seems like an idea whose time has come. To reduce the volatility that afflicts emerging markets, controls on short-term capital have been endorsed since the Asian crisis by prominent figures including billionaire hedge fund investor George Soros, World Bank chief economist Joseph Stiglitz, and Goldman Sachs managing director E. Gerald Corrigan. Stiglitz condemns free movement of capital, citing economic research that shows there is no relationship between unrestricted capital flows and economic growth.

Long a taboo in Latin America, tax reform designed to increase government revenues by raising taxes and broadening the tax base is being put before legislatures across the region. Latin governments, the World Bank, and regional development banks such as the Inter-American Development Bank are now taking a closer look at poverty. There is a growing consensus that attacking poverty requires broad social programs beyond the transfer payments and slim subsidies widespread today. Finally, Castañeda points out, the dangers of maintaining an overvalued currency and monetary instability are widely accepted in financial circles.

PROMISING RESULTS

The politicians in the group have led innovative programs with successful results that show how the model could work. In Brazil, Workers' Party leader Tarso Genro is a case in point. While serving as mayor of the southern city of Porto Alegre, he established a partnership between the municipal government and the private sector to finance a fund to make small loans to small-scale businesses. He created participatory budgeting by dividing the city into 16 districts, each with an elected council that set priorities on public works projects such as schools, community health clinics, and roads. Citizen groups managed the budget and supervised the construction of projects in their neighborhoods. The result: money was spent carefully and about one-third more projects than usual were completed. Genro also raised municipal revenues by 25 percent by taxing undeveloped urban land being held for speculation and placing a levy on urban services. At the end of his four-year term in 1997, he boasted a 75 percent approval rating.

Vicente Fox, the governor of Guanajuato state in central Mexico and presidential hopeful from the conservative National Action Party, is promoting microlending. He used $5 million from state funds and raised an equal amount from the private sector to create the initial capital for the nonprofit Banco Santa Fé de Guanajuato. Modeled after the Grameen Bank of Bangladesh, the bank grants microcredits of as little as $100 to tiny enterprises such as pig-raising in a backyard stable and sidewalk food-stands. The bank has made many loans to working women who often are the mainstay of the family, since Guanajuato sends many migrant workers to the United States.

Also in Mexico, a recent referendum on national economic issues has strengthened the opposition mandate to hold the government accountable for federal spending. Opposition politicians have seized on a government bank bailout scheme—which would have cost taxpayers $65 billion in public debt—to mobilize citizen demands for greater control over the budget. Andrés Manuel López Obrador, president of the left-wing Democratic Revolution Party (PRD), led the referendum, which drew more than 3 million votes nationwide on August 31. The PRD referendum marked the first time since the economic reforms began that the citizenry has been consulted on economic policy. More than 95 percent of those voting opposed the government's proposal to assume bad bank loans as public debt.

The referendum provided overwhelming support for PRD proposals to audit large corporate loans, which make up about half the bad debt; provide aid to small debtors; and restrict foreign investment in banks. Although government and banking officials discredited the referendum, saying it was skewed to favor PRD positions, it nevertheless strengthened the opposition mandate to demand that banks shoulder more of the burden of the bailout.

The mechanisms for combating neoliberalism and the possibilities of forming center-left alliances will vary with each country. But there is agreement that the Alternativa group provides a prized function as a forum for exchanging ideas and practical experiences to improve Latin American societies. "It can contribute to the formation of a bloc that is political, democratic, anti-neoliberal, and is occupying spaces in Latin America," Brazil's Genro said in a recent interview. This group is preparing to influence regional issues, in particular to set an agenda for labor and social issues in the negotiations of the Free Trade Area of the Americas, the hemisphere-wide free trade area that is to be set up in the next seven years. The debate over center-left alliances has been maturing with the group's deliberations. "Our countries require great transforma-

tions [that] cannot be made without wide citizen backing and that require alliances, and that requires pluralism," said Gabriel Gaspar, a research fellow at Flacso, a research institution in Santiago, Chile.

It was not possible to build such an alliance for the October 4 presidential race in Brazil, the first of a wave of elections in Latin America between now and mid-2000. "That was not due to the impotence of the group, it was due to objective conditions of the Brazilian political process," says Genro. Brazil's Workers' Party backed its two-time presidential candidate, Luis Inácio "Lula" da Silva, because the traditional left within his party resisted an alliance with centrist Ciro Gomes and hoped to win congressional seats on Lula's coattails.

In other countries, however, the chances for center-left alliances are strong and the coalitions might defeat neoliberal regimes in coming elections. In El Salvador, the guerrilla force turned political party, the Farabundo Martí National Liberation Front, is seen as the front-runner in the March 1999 presidential race it will run in an alliance with a range of civic organizations. In Argentina, the Alianza, a political grouping made up of the Frepaso and Unión Cívica Radical parties, is a strong contender in the 1999 presidential race. In Chile, the ruling center-left coalition is expected to keep the presidency in December 1999 elections with front-runner candidate Ricardo Lagos, a moderate socialist, backed by the Christian Democrats. The Mexican election in July 2000 is too far off to call, but the Alternative's meetings have provided a setting for dialogue between the two most likely opposition candidates, Mexico City mayor Cuauhtémoc Cárdenas and Vicente Fox.

The model has yet to be adopted by Latin America's conventional leftist parties. However, it is gaining ground as left-wing and center politicians search for a program to offer constituents in the postcommunist era. For some leftist parties in Latin America, the model fuels splits that were already brewing by providing ideas for those who have accepted the inevitability of globalization. The aim of Alternativa Latinoamericana is to stimulate a process of gradual economic, political, and societal change to combat a destiny that the continent does not deserve.

By Robert W. Fisher

The Future of Energy

Changing our fuel sources requires changing our values, but it's happened before and may already be happening again.

Since the first Earth Day in 1970, we have made important moves to clean up energy production and use: Drilling for oil and gas and mining coal are now done less harmfully, power plants burn coal more cleanly, and vehicles get better gas mileage and emit far fewer pollutants. But these changes do not get at the root of the problem—our use of "dirty" fossil fuels.

The numbers tell the story: In 1971, the world consumed 4,722 million tons of oil equivalent (MTOE). Twenty years later, consumption was up to 7,074 MTOE, and it still was almost all fossil fuels—97% in 1971 and 90% in 1991. The 7% drop was captured by nuclear power. By 2010, consumption is projected to rise to 11,500 MTOE, with fossil fuels still accounting for 90% of that demand. Our energy choices simply do not reflect our concerns about the environment and sustainability of our supply.

Concerns about Fossil Fuel Supply

Many people are worried that we are going to run out of fossil fuels, especially oil and natural gas. Running out of oil has been a worry ever since people first began to use it in large quantities. In 1908, the U.S. Geological Survey (USGS) predicted that total future supply of U.S. oil would not exceed 23 billion barrels. In 1914, the U.S. Bureau of Mines was even more pessimistic, putting the limit at 5.7 billion barrels. In 1920, the USGS proclaimed the peak in U.S. oil production was almost reached. In 1939, the Department of Interior declared that there was only 13 years of production remaining. In 1977, President Jimmy Carter said,

"We are now running out of oil." Despite these gloomy projections, the United States has produced over 200 billion barrels of oil since the early 1900s.

Belying the forecasts, the oil industry keeps on finding new producing regions, developing more effective methods of finding oil fields, reducing costs, and coming up with innovative technology that lets them produce oil in places they could not even look before, such as very deep water.

The future for oil supplies looks promising as well. [Editor's note: For another viewpoint, see "Get Ready for Another Oil Shock!" by L. F. Ivanhoe in the January-February 1997 issue of THE FUTURIST.] Saudi Arabia has just begun to explore in older, deeper rocks that produce oil in surrounding countries. Iraq has the potential to surpass Saudi Arabia in oil reserves once exploration and development work is restarted there. Khazakstan and Eastern Siberia are relatively unexplored potential oil-producing giants. Deep water technology is opening up large areas of the Gulf of Mexico for exploration

From *The Futurist*, September/October 1997, pp. 43–46. © 1997 by The World Future Society, Bethesda, MD; http://www.wfs.org/wfs. Reprinted by permission.

and production. And some recent testing suggests there are oil deposits in the abyssal depths of the Atlantic Ocean. Then we have immense tar sand deposits in Canada and very heavy oil in the Orinoco Belt of Venezuela, both of which contain hundreds of billions of barrels of oil.

The industry is also improving the recovery rates from established fields. On average, producers get only 35% of the oil out of a reservoir before they abandon it. The remaining oil is either too difficult or too expensive to recover. But one producer in the North Sea now claims to be able to recover 40% and expects to recover up to 60% in a few years.

Natural gas resources have also been subjected to pessimistic forecasts, partly because, in the United States, government-controlled prices were so low that few companies were willing to explore for gas fields. Today, the conservative estimate is that there is at least a 100-year supply of standard gas resources in North America. In addition, there are large deposits of gas hydrates that the industry doesn't yet know how to use economically.

Internationally, the natural gas supply is even larger. Europe hasn't used much natural gas because it had an infrastructure in place to mine, transport, and burn coal and did not see any advantage to going to the expense of building a gas pipeline system. Southeast Asia has only recently begun to tap and use its gas resources.

Coal will last much longer than either oil or natural gas. Known deposits of coal are huge, and there is a massive infrastructure in place to mine, deliver, and burn it. And it is the cheapest of fossil fuels.

So sustainability of supply is not an issue today. Does that mean we will continue to rely on fossil fuels

for the next 30 years or longer? Unless we change our values, the answer is yes.

Changing Values and Changing Energy Sources

Before discussing that needed change in values, I want to make a historic connection between changes in value systems and shifts in energy use. The underlying motivation for technological development has primarily been to gain wealth and power—that is not to disparage the thrill of discovery or of innovation for its own sake, but to acknowledge its secondary importance.

Wood was the primary source of energy for humans up to 1880, when coal gained first place. Wind, water, and solar power were also used. What happened to trigger the switch from wood to coal to oil as our main source of energy? And why did wind and water power, which for centuries had ranked right behind wood as major sources of energy, fall so far behind?

> "The prime motivation behind energy choice has been to increase wealth and power."

The transition from wood to coal to oil began because of shifts in the economy and two shifts in thinking that occurred in late Medieval Europe: First, people who were engaged in manufacturing, trade, and creating innovative technology were

given a higher human value than those who could fight. Second, it became acceptable for the elite to become involved in devising practical applications from scientific knowledge.

The elite of the age were heavily focused on wealth and power. But people at all levels began to look with less favor on fighting, raiding, and plundering as the primary means of acquiring and enhancing wealth and power. Grain-grinding water mills became important profit centers as innovations enabled them to saw logs, make paper and gunpowder, full woolens, and perform other manufacturing tasks. People who could make machines, run mills, and engage in expanded trading were bringing in more profits than the lords could gain from maintaining a retinue of knights. The other values change that occurred about the same time was that highly educated philosophers and scientists began to get involved in developing practical mechanical devices. Up to that time, such activity was considered beneath their dignity.

Change began in earnest following these economic and value shifts. Better manufacturing processes required better machines, which needed more efficient fuels. Coke made from coal was a more efficient fuel for smelting iron than was charcoal made from wood, but the surface outcrops of coal soon became exhausted. Mines had to go deeper, and that made flooding a problem. Steam engines, which also burned coal, were developed to pump water out of mines.

The improved steam engines suggested steam-powered locomotives on iron rails as a solution to roads that were being constantly torn up from transporting coal. Railroading was born, pushing coal demand higher still, and by 1880, coal became the most used energy source. Water power and wind power for mills gave way to coal-fired steam engines that were more efficient, provided for greater flexibility of use, and produced greater profits.

B.J. NIXON/DEEPSEA VENTURES, INC. FRENCH TECHNOLOGY PRESS OFFICE/COURTESY OF VERGNET

NATIONAL COAL ASSOCIATION MODULAR SOLAR ELECTRIC POWER GENERATOR

From petroleum to wind, from coal to solar. Whether or not there is enough fossil fuel to keep us going, we should switch to renewables for the sake of the environment, says author Fisher.

Sailing ships yielded to coal-fired steam ships for the same reasons.

Steam-powered road carriages using external combustion engines were in use even before railroading began, but they required a separate furnace and boiler, making them too heavy and bulky for practical road use. Internal combustion was seen as the solution. Gunpowder, hydrogen explosions, and benzene made from coal tar were tried without much success, but gasoline distilled from oil made internal combustion a commercial success. This stimulated the development of the automobile industry, a major consumer of oil.

Better cars required better engines, which needed higher performance fuels. The performance

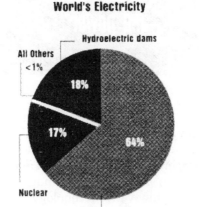

Current Power Sources for World's Electricity

All Others <1%

Hydroelectric dams

18%

17%

64%

Nuclear

Fossil Fuels

Source: International Energy Agency

spiral went up until it was possible to build a gasoline engine powerful enough but still light and small

enough to power an airplane. Air travel was born, and by 1950 oil passed coal as the most used energy source in the world.

Energy Choices Reflect Our Values

The prime motivation behind energy choice has been to increase wealth and power. We continue to rely on fossil fuels today because they are cheap, efficient, and bring the most profit to their developers. Today, 64% of the world's electricity is generated by burning fossil fuels, mostly coal; 18% comes from hydroelectric dams, 17% from nuclear power plants, and less than 1% from

all other sources, including geothermal, biomass, wind, and solar. For the next couple of decades, the outlook of the International Energy Agency is for most expansion of electrical generating capacity to be met by fossil fuels. Nuclear power use is projected to decline and to be replaced by fossil fuel plants. Hydropower and the other renewable sources are projected to increase only slightly.

Wind turbines, photovoltaic arrays on Earth and in space, solar thermal plants, ocean thermal generators, biomass, and tidal power are renewable sources of energy that we know will work. But we use these renewable sources only in special situations, because fossil fuels are cheaper when environmental and health costs are ignored.

It will take a major shift in thinking today to move us away from fossil fuels and into renewable resources. It will be a shift away from placing our highest human value on becoming rich and powerful to giving our highest esteem to those who improve how we relate to each other. That shift has begun and needs nurturing.

Signs of Change

The numerous human rights movements indicate that we are beginning to value people more highly than we have in the past. As these movements gain momentum, people as people will move higher on the priority list, while the personal ac-

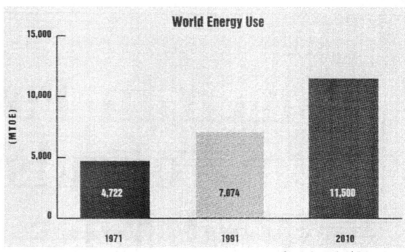

Source: International Energy Agency

cumulation of wealth and power will decline.

Another promising development is the rise of ISO 14000, a set of internationally accepted standards for environmental management systems being promoted by the International Organization for Standardization in Geneva. The drive to adopt ISO 14000 standards comes from consumers, not from government command-and-control regulations. Retailers are beginning to tell their suppliers, who are in turn telling their suppliers, that they will buy only from those who manufacture or produce in an environmentally sound manner. ISO 14000 certification assures all customers that the company not only is operating cleanly, but is committed to continual improvement of its environmental performance. The shift in thinking here is that we are beginning to accept responsibility for our part in the environmental impact of a product through its entire life cycle.

With these changes in our value system, our choices of energy sources will no longer be based solely on their ability to produce immediate profits for someone, but rather on how well they fit into the overall quality of life for everyone—employees, customers, and neighbors. But until we make such changes, the world will continue to rely most heavily on fossil fuels for its future energy needs.

About the Author

Robert W. Fisher, an energy analyst, is president of The Consortium International, Apartado Postal #1, Marfil, Guanajuato C.P. 36251, Mexico. E-mail consintl@redes.int.com.mx.

The International Energy Agency is located at 9, rue de la Federation, 75739 Paris Cedex 15, France. Telephone 33-1 4057 6554; fax 33-1 4057 6559; e-mail info@iea.org.

Women in Power: From Tokenism to Critical Mass

by Jane S. Jaquette

Never before have so many women held so much power. The growing participation and representation of woman in politics is one of the most remarkable developments of the late twentieth century. For the first time, women in all countries and social classes are becoming politically active, achieving dramatic gains in the number and kind of offices they hold. Why is political power, off limits for so long, suddenly becoming accessible to women? And what are the implications of this trend for domestic and foreign policy?

Women have been gaining the right to vote and run for office since New Zealand became the first country to authorize women's suffrage in 1893. By 1920, the year the United States amended the Constitution to allow women to vote, 10 countries had already granted women the franchise. Yet many European countries did not allow women to vote until after World War II, including France, Greece, Italy, and Switzerland. In Latin America, Ecuador was the first to recognize women's political rights, in 1929; but women could not vote in Mexico until 1953. In Asia, women voted first in Mongolia, in 1923; then, with the U.S. occupation after 1945, women secured the right to vote in Japan and South Korea. The former European colonies in Af-

JANE S. JAQUETTE *is chair of the department of diplomacy and world affairs and B. H. Orr professor of liberal arts at Occidental College. Her latest book* Women and Democracy: Latin America and Central and Eastern Europe *was published by The Johns Hopkins University Press in 1998.*

rica and Asia enfranchised women when they gained independence, from the late 1940s into the 1970s.

Historically, women began to demand the right to vote by claiming their equality: If all men are created equal, why not women? The American and British suffrage movements inspired "women's emancipation" efforts among educated female (and sometimes male) elites worldwide, and most contemporary feminist movements trace their roots to these stirrings at the turn of the century. The nineteenth-century European movements had a strong influence on the thinking of Friedrich Engels, who made gender equality a central tenet of socialist doctrine. A similar movement among the Russian intelligentsia ensured that the equality of women in political and economic life would be an important goal of the Soviet state—and subsequently of its Central and Eastern European satellites.

> *Historically, a country's level of economic development has not been a reliable indicator of women's representation.*

But if the logic existed to support women's claims to political equality, the facts on the ground did not. As educated women mobilized to demand the right to vote, men in all

countries largely resisted, with the result that most of the world's women gained this basic right of citizenship only in the last 50 years. Before women could vote, they organized to influence legislation, from the marriage and property rights acts of the mid-nineteenth century to the early twentieth century wave of Progressive legislation in the United States and Western Europe's generous maternal and protective labor laws.

However, the vote itself did not bring women into politics. On the contrary, some countries gave women the right to vote but not to run for office. In virtually every nation, women who tried to enter politics were subject to popular ridicule. Political parties routinely excluded women from decision-making positions, resisted nominating them as candidates, and denied their female candidates adequate campaign support.

Cultural factors partially explain the varying degrees of women's representation from region to region and country to country. Predictably, women in the Nordic and northern European countries, with long traditions of gender equality, have been the most successful in breaking through traditional resistance and increasing their representation. In contrast, those in Arab countries, with curbs against women in public life and contemporary pressures to abandon secular laws for religious rules, have consistently registered the lowest levels of female participation (and the lowest levels of democratization).

But "culture" does not fully explain why women in the United States and Great Britain, which rank high on various measures of gender equality, accounted for less than 7 percent of all parliamentarians as late as 1987. Nor have women been excluded from politics in all Islamic nations. The legislatures of Syria and Indonesia, while decidedly undemocratic, are composed of 10 to 12 percent women. Former prime ministers Benazir Bhutto of Pakistan and Khaleda Zia of Bangladesh have wielded major power in Muslim societies.

Historically, a country's level of development has not been a reliable indicator of women's representation. Of the 32 most developed countries that reported electoral data in 1975, 19 had fewer than 10 percent female legislators and 11 had fewer than 5 percent. In France, Greece, and Japan—all developed, industrialized countries—female members accounted for 2 percent or less of their legislatures.

Although more women than ever are working for wages, even an increase in female participation in the work force does not necessarily translate into greater political clout for women. In recent years, for example, much of the growth in participation has been in low-wage labor. And although women's managerial participation has increased dramatically in many countries, from New Zealand to Peru, women are still rarely found at the highest levels of corporate management and ownership. Their underrepresentation in top management limits the number of private sector women invited to enter government as high-level appointees; women's lower salaries, in turn, restrict an important source of financial support for female candidates.

One can, however, discern significant worldwide increases in female representation beginning in 1975, the year in which the United Nations held its first international women's conference. From 1975 to 1995, the number of women legislators doubled in the developed West; the global average rose from 7.4 percent to nearly 11 percent.

Between 1987 and 1995 in particular, women's representation registered a dramatic increase

Percent of Women in National Legislatures, by region, 1975–97

	1975	1987	1997*
Arab States	3.5	2.8	3.3
Asia	8.4	9.7	13.4
(Asia excluding China, Mongolia, N. Korea, Vietnam)†	(3.8)	(6.2)	(6.3)
Central and Eastern Europe and Former Soviet Union	23.3	23.1	11.5
Developed countries (excluding East Asia)	5.1	9.6	14.7
Latin America and the Caribbean	6.0	6.9	10.5
Nordic Countries	16.1	28.8	36.4

* 1997 statistics for lower houses and single house systems. (Mongolia excluded.)
† women's representation under party control

in the developed countries, Africa, and Latin America. Of the 32 women who have served as presidents or prime ministers during the twentieth century, 24 were in power in the 1990s. In the United States, women now make up 11.2 percent of Congress, about one-third the proportion in Nordic countries, but substantially higher than the 5 percent in 1987. And although only 23 women won seats in the Diet in Japan's 1996 elections, an unprecedented 153 women ran for office. In 1997, the Inter-Parliamentary Union reported only nine countries with no women in their legislatures. From 1987 to 1995, the number of countries without any women ministers dropped from 93 to 47, and 10 countries reported that women held more than 20 percent of all ministerial-level positions, although generally in "female" portfolios like health, education, and environment rather than the "power ministries" like finance and defense.

The only exception to the global acceleration in women's representation during the past decade is in the New Independent States of the former Soviet Union and the former members of the Eastern bloc. Here, representation has dropped from earlier highs under communist rule of 25 to 35 percent women (although they exercised little real power) to around 8 to 15 percent today, and numbers are lower in the largely Muslim states of Central Asia. Where women's representation is still under Communist Party control, as in China, North Korea, and Vietnam, women still account for about 20 percent of the national legislators.

THE GLOBALIZATION OF THE WOMEN'S MOVEMENT

Why the surge in women officeholders in the last 10 years?

Three interconnected reasons seem to stand out: First, the rise of women's movements worldwide has heightened women's awareness of their political potential and developed new issues for which women are ready to mobilize. Second, a new willingness by political parties and states to ease the constraints on women's access to politics, from increasing their recruitment pools to modifying electoral systems and adopting quotas. And third, as social issues supplant security concerns in the post–Cold War political environment, opportunities have opened for new styles of leadership and have reordered political priorities.

The recent wave of female mobilization is a response to a series of political and economic crises—and opportunities—over the last two decades. On the political front, women's groups like the Madres de la Plaza de Mayo (Argentine mothers who demonstrated on behalf of their "disappeared" husbands and children) helped to inspire the defense of human rights in Latin America and beyond. Women were also recognized as valued participants in the opposition to authoritarian rule in the former Soviet bloc, where they took up the cause of human rights when their husbands and sons were arrested—dissident Andrei Sakharov's wife, Yelena Bonner, is just one example. In Africa and Asia, women are increasingly regarded as important opposition figures. In South Africa, for example, women were among prominent anti-apartheid leaders and have helped to lead the new government-sponsored effort to develop a women's charter for the post–apartheid period. In Iran, women have played an important role in de-

Women on Women

"A man, who during the course of his life has never been elected anywhere, and who is named prime minister (it was the case with George Pompidou and Raymond Barre, who had never been elected to any position)—everyone found that absolutely normal. A woman who has been elected for 10 years at the National Assembly . . . at the regional level, who is the mayor of a city, it is as if she were coming out of nowhere."
—Edith Cresson, former prime minister of France

"I really do think that women are more cautious in adopting . . . decisions [to go to war]. . . . But I don't think that the woman will ever sacrifice the interests of the nation or the interest of the state due to . . . weakness."
—Kazimiera Prunskiene, former prime minister of Lithuania

"The traditional issues we were steered into—child care, health care, and education—have now become the sexy issues of the decade."
—Nancy K. Kopp, former speaker pro tem. of the Maryland House of Delegates

"Women cannot lead without men, but men have to this day considered themselves capable of leading without women. Women would always take men into consideration. That's the difference."
—Vigdis Finnbogadóttir, former president of Iceland

"Do I have an option?"
—Patricia Schroeder, former U.S. representative, when asked by the press if she was "running as a woman."

Sources: Laura Liswood, *Women World Leaders* (London: HarperCollins, 1994); Linda Witt, Karen M. Paget, & Glenna Matthews, *Running as a Woman: Gender and Power in American Politics* (New York: Free Press, 1994).

fining electoral outcomes, despite the conventional wisdom that they are powerless.

On the economic front, the widespread adoption of market-oriented reforms, often accompanied by austerity programs, has had a severe impact on many women, who in turn have organized against price rises and the loss of health care and other public services. Women created communal kitchens in Chile and Peru to help feed their communities. Other small-scale, self-help programs like the Grameen Bank in Bangladesh and the Self-Employed Women's Association in India were developed to meet women's needs for credit.

The Old Girls Network

Historically, one of the greatest barriers to elected office for women has been inadequate financial support. Often lacking incumbent status or access to financial networks, they have had to build their own fund-raising networks from scratch.

One of the most successful such groups has been EMILY's List (EMILY stands for Early Money is Like Yeast), the first partisan organization set up to fund women candidates in the United States. Ironically for an organization that is now America's largest political action committee (PAC), its roots lie in a political defeat. In 1982, Harriet Woods won the Democratic primary for a Senate seat in Missouri but then received only token financial backing from her party. She called on Washington, D.C., philanthropist Ellen Malcolm for help. But the money proved to be too little and too late to counter her male opponent's negative advertising campaign. Stung by this defeat, Malcolm went on to found EMILY's List in 1985 to raise money for Democratic women candidates who support abortion rights (a.k.a., "pro-choice").

EMILY's List received a major boost in 1992, when the all-male Senate Judiciary Committee confirmed Clarence Thomas to the U.S. Supreme Court despite law professor Anita Hill's accusations of sexual harassment. A torrent of female outrage turned into a record flood of financial support for female candidates in that year's elections. EMILY's List grew from 3,000 to 23,000 members and raised $6 million. It also inspired several state-level imitators, including May's List in Washington State and the Minnesota $$ Million. And EMILY's List now has a number of Republican competitors, including WISH (Women in the Senate and House), which supports pro-choice female candidates, and the Women's Leadership Fund.

According to Rutgers University's Center for the American Woman and Politics, 11 national and 47 state or local PACS and donor networks now either give money predominantly to women or receive most of their contributions from women. Organizations to fund women candidates have been established in several other nations as well. In 1993, Britain's Labour Party launched EMILY's List U.K. In 1995, the Australian Labor Party decided to form its own version of EMILY's List to meet its target of a 35 percent female Parliament by 2002.

The war in Bosnia put an international spotlight on rape as a weapon of war and led to the demand that "women's rights" be considered "human rights" rather than some different or lesser category of concern.

These efforts were reinforced by international connections, many of which were created by the U.N. Decade for Women (1976–85). Three times during the decade (in 1975, 1980, and 1985) and again in 1995, the United Nations convened official delegations from member countries to report on the status of women and to commit governments to remedy women's lack of access to political, economic, and educational resources. Not only did these conferences encourage a flurry of local and national organizing, but they produced parallel meetings of nongovernmental organizations (NGOs), including the nearly 30,000 women who participated in the NGO conference in Beijing in 1995.

The Decade for Women originally meant that women's issues were geared to the U.N. agenda, which in the 1970s focused on the creation of a "new international economic order" and a more equitable sharing of resources between North and South. By the mid-1980s, however, attention had shifted from integrating women into world development efforts to enhancing roles for women in the promotion of market economics and democracy. The turn toward democracy made it easier for women to seek explicitly political goals, and the footdragging by the U.N. and its member countries on implementing their international pledges helped to stimulate women's interest in increasing their political power.

BREAKING THE POLITICAL CLASS CEILING

Since some of the public policies holding women back from greater political power—particularly women's access to education—have been easing rapidly, attention has turned to other barriers. Chief among them have been the constraints on the pool of women available to run for office. Although women constitute a growing proportion of the rank and file in political parties, unions, and civil services, they still account for only a small proportion of the higher echelons that provide a springboard to higher political office.

Although women participate more actively in local government than they do at the national level, many more men make the jump

from local to national leadership. One problem has been a lack of campaign funds. In the United States, women began to address that obstacle in the 1980s through innovative fund-raising strategies. In other countries, women have organized voting blocs to support female candidates. Yet there is only one women's political party, in Iceland, that has succeeded over time in electing women to office. By the mid-1990s, the European-based Inter-Parliamentary Union was holding meetings twice a year for female parliamentarians aimed at improving their electoral skills as well as their abilities to perform more effectively in office. In another innovative effort, a group called Women of Russia organized to stem the decline in women's representation under the new democratic electoral rules. Women of Russia surprised everyone by gathering over 100,000 signatures and winning 8 percent of the vote in the 1993 Duma elections, but in the 1995 elections they failed to maintain the minimum level of support necessary under Russian electoral rules. As a result of Women in Russia's initial success, however, other Russian parties are nominating more women.

Research has shown that different kinds of voting systems can dramatically affect women's chances of election. The widely accepted explanation for the relatively low numbers of female legislators in the United States and Britain is their "single-member district" electoral systems. When each district elects only one candidate, minority votes are lost. Significantly more women are elected in countries with electoral systems based on proportional representation (in which candidates are elected from party lists according to the percentage of total votes the party receives) or on at-large districts ("multi-member constituencies"). Several countries have experimented with different electoral systems, including mixed single-member and multi-member district systems, to improve the participation of underrepresented groups, particularly women.

The surest way to achieve an increased number of women in national legislatures is to adopt a quota system that requires a certain percentage of women to be nominated or elected. Although the issue of quotas is scarcely open to debate in the United States—where Lani Guinier's nomination for U.S. attorney general in 1993 was torpedoed by detractors' interpretations of essays she had written in support of "group" representation—many political parties (especially on the Left) and national legislatures around the world are experimenting

with gender quotas. Quotas account for the high levels of female representation in the Nordic countries and for the recent doubling (to 18 percent) of the number of women in the House of Commons in Britain when the Labour Party swept the election. A quota law in Argentina increased the women in its house of representatives from 4 percent in 1991 to over 16 percent in 1993 and 28 percent in 1995. In Brazil, when quotas were used in the 1997 congressional elections, the number of women legislators increased by nearly 40 percent since the last elections.

Quotas are used in Taiwan, by some of the political parties in Chile, and are under active discussion in Costa Rica, Ecuador, Paraguay, South Korea, and several other countries. The Indian constitution now mandates that one-third of the seats in local government bodies be "reserved" for women, and Pakistan is debating a similar measure. In Mexico, the Institutional Revolutionary Party (PRI) and its leftist opposition have adopted quotas, while the right-of-center party accepts the goal but maintains that it can promote women as effectively without them. Japan has adopted measures to ensure that more women are appointed to ministerial posts, and Bangladesh, among other countries, is experimenting with quotas for top civil service jobs.

It is obvious that quotas increase the number of women officeholders, but why are they being adopted now? Even where quotas are not seen to violate fundamental notions of democracy, as they appear to be in the United States, there are powerful arguments against them. Some insist that they will ghettoize women legislators and their issues. Others object that quotas lead to "proxy" representation, where women legislators run as "fronts" for their husbands or other male interests. In India, for example, there are many anecdotal cases of this phenomenon, and in Argentina there are complaints that many of the women nominated by the majority Peronist Party (which pushed through the quota law) have been chosen because of their unquestioning loyalty to President Carlos Saul Menem rather than because of their qualifications as candidates—as if only women could be considered party hacks.

Despite the controversy quotas raise, they have become popular not only because women have organized to push for them, but—importantly—because more men have become convinced that quotas serve useful political goals in a more democratic environment. A sea

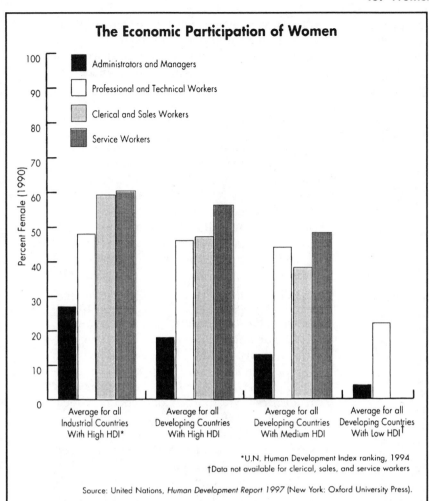

The Economic Participation of Women

■ Administrators and Managers

□ Professional and Technical Workers

▨ Clerical and Sales Workers

▦ Service Workers

Percent Female (1990)

Average for all Industrial Countries With High HDI*

Average for all Developing Countries With High HDI

Average for all Developing Countries With Medium HDI

Average for all Developing Countries With Low HDI†

*U.N. Human Development Index ranking, 1994
†Data not available for clerical, sales, and service workers

Source: United Nations, *Human Development Report 1997* (New York: Oxford University Press).

of the PRI in Mexico last July. Rightly or wrongly, many voters also associate market reforms with a rise in corruption. Despite accusations of corruption against leaders such as Pakistan's Bhutto and Tansu Ciller in Turkey, women's perceived "purity" and their status as outsiders, once considered political weaknesses, are now seen as strengths. In the last 10 years, it is not so much the case that women have come to politics; rather, politics has come to women.

If the trend continues, quotas will soon produce a quantum leap in women's political power. For the first time, women will form a "critical mass" of legislators in many countries, able to set new agendas and perhaps create new styles of leadership. How will women use their growing political influence?

One way to predict the direction of change is to look at how the political attitudes of women differ from those of men. Surveys show that one of the most persistent gender differences regards attitudes toward peace and war: Women are more pacifistic than men, less likely to favor defense spending, or to support aggressive policies abroad. Recent interviews of women heads of state show that most believe that they are more committed to peace than their male counterparts. Historically and today, women and women leaders are more interested in the so-called "soft" issues, including the environment and social welfare. On some measures, women are more conservative than men: They are less likely to vote for the parties on the Left, and rather than pursue their own self-interests, they more often mobilize for defensive reasons—namely to protect the interests of the family. As a result, these tendencies will probably place more focus on policies to support the family and to strengthen local communities.

But women are far from conservative in one important sense: Women are more likely than men to support state regulation of business to protect the consumer and the environment and to assure that the needs of society's weakest members are addressed. Because women are often more skeptical than men about the effectiveness of market reforms, the election of more women may signal a soften-

change in attitudes about women in public office is occurring at a time when the number of countries under some form of democratic governance is expanding rapidly, giving new salience to the question of whether national legislatures are truly representative of pluralistic societies. Adequate representation of all groups could strengthen the consolidation of democracies that are open and responsive—and thus make them more durable.

WHAT DO WOMEN WANT?

The post–Cold War shift in national priorities from defense and security concerns to social and environmental issues also plays to women's strong suits. So do the negative impacts of economic globalization and structural adjustment policies, which have put the need for effective social safety nets high on domestic agendas. Many observers argue that the rejection of "unbridled capitalism" and the desire to retain social welfare policies explain the victories of the Labour Party in Britain, the socialists in France, and the electoral loss

ing of some of reform's harsher aspects. The market's continued dominance in global politics will reinforce women s efforts to improve their access to the resources that count, from education and credit to the ownership of land and housing.

Women who find themselves experiencing real power for the first time may decide to try out blanket initiatives in areas that they believe male leaders have traditionally neglected: declarations banning war and legislation on children's rights and social or political morality.

However, radical change is unlikely. Predictions that women will act as a bloc have never been borne out in the past. Like their male counterparts, female officeholders come from all parts of the ideological spectrum and depend on the support of diverse and often divided constituencies. Women leaders are not necessarily pacificists or environmentally oriented. While former prime minister Gro Harlem Brundtland of Norway or Ireland's president Mary Robinson may support the "soft" issues, Indira Gandhi or Margaret Thatcher is capable of using force to achieve her ends.

Further, few of the initiatives on those social issues mobilizing women today directly confront male power. Global support for efforts to stem violence against women is an important exception. Antidiscrimination legislation has been developed at the international level through the U.N. Convention on the Elimination of All Forms of Discrimination Against Women—which has been ratified by 160 countries, but not the United States. The implementation of the instrument by signatories, however, lags far behind. And women leaders themselves disagree on many of the issues affecting women most, from reproductive rights and family law to genital mutilation.

Today, women are recruited aggressively into politics not to right past inequities or to recognize their equal citizenship—but to bring a different, explicitly female perspective to the political arena and to appeal to the women's vote. Whether the rationale for increasing female representation is equality or

difference, women will have an unprecedented opportunity to put their stamp on politics and to increase the range of alternatives available to policymakers across the globe.

WANT TO KNOW MORE?

Merilee Karl's compendium *Women and Empowerment: Participation and Decision-Making* (London: Zed Books, 1995) discusses women's participation in a range of institutional settings from an activist perspective. A rich and thoughtful treatment of women's political participation covering a variety of cases is *Women and Politics Worldwide*, Barbara Nelson & Najma Chowdhury, eds. (New Haven: Yale University Press, 1994). Laura Liswood interviews 15 female politicians in *Women World Leaders* (London: Pandora, 1994). For information on the impact of electoral systems, consult Wilma Rule & Joseph F. Zimmerman's *Electoral Systems in Comparative Perspective: Their Impact on Women and Minorities* (Westport, Connecticut: Greenwood Press, 1994). The story of women's ascent into U.S. politics is found in Linda Witt, Karen M. Paget, & Glenna Matthews' *Running as a Woman: Gender and Power in American Politics* (New York: The Free Press, 1994). Nancy Adler & Dafna Izraeli, on the other hand, present notable research on women in the private sector in *Competitive Frontiers: Women Managers in a Global Economy* (Cambridge: Blackwell, 1994).

A key source for data on women in power is the United Nations' *Human Development Report 1995* (New York: Oxford University Press, 1995), which is dedicated to gender comparisons. For some historical statistics, see *The World's Women, 1970–1990: Trends and Statistics* (New York: United Nations, 1991). Updates and special studies on women's political participation are available through the Inter-Parliamentary Union's Web page. Access this site and others on women in political and economic power through **www.foreignpolicy.com.**

the sacred warrior

By Nelson Mandela

The liberator of South Africa looks at the seminal work of the liberator of India

India is Gandhi's country of birth; South Africa his country of adoption. He was both an Indian and a South African citizen. Both countries contributed to his intellectual and moral genius, and he shaped the liberatory movements in both colonial theaters.

He is the archetypal anticolonial revolutionary. His strategy of noncooperation, his assertion that we can be dominated only if we cooperate with our dominators, and his nonviolent resistance inspired anticolonial and antiracist movements internationally in our century.

Both Gandhi and I suffered colonial oppression, and both of us mobilized our respective peoples against governments that violated our freedoms.

The Gandhian influence dominated freedom struggles on the African continent right up to the 1960s because of the power it generated and the unity it forged among the apparently powerless. Nonviolence was the official stance of all major African coalitions, and the South African A.N.C. remained implacably opposed to violence for most of its existence.

Gandhi remained committed to nonviolence; I followed the Gandhian strategy for as long as I could, but then there came a point in our struggle when the brute

THE GOOD SHEPHERD Ghandi at the beginning of his crusade

Mandela served as South Africa's first democratically elected President from 1994 to '99.

force of the oppressor could no longer be countered through passive resistance alone. We founded *Unkhonto we Sizwe* and added a military dimension to our struggle. Even then, we chose sabotage because it did not involve the loss of life, and it offered the best hope for future race relations. Militant action became part of the African agenda officially supported by the Organization of African Unity (O.A.U.) following my address to the Pan-African Freedom Movement of East and Central Africa (PAF-MECA) in 1962, in which I stated, "Force is the only language the imperialists can hear, and no country became free without some sort of violence."

Gandhi himself never ruled out violence absolutely and unreservedly. He conceded the necessity of arms in certain situations. He said, "Where choice is set between cowardice and violence, I would advise violence . . . I prefer to use arms in defense of honor rather than remain the vile witness of dishonor. . . ."

Violence and nonviolence are not mutually exclusive; it is the predominance of the one or the other that labels a struggle.

Gandhi arrived in South Africa in 1893 at the age of 23. Within a week he collided head on with racism. His immediate response was to flee the country that so degraded people of color, but then his inner resilience overpowered him with a sense of mission, and he stayed to redeem the dignity of the racially exploited, to pave the way for the liberation of the colonized the world over and to develop a blueprint for a new social order.

He left 21 years later, a near *maha atma* (great soul). There is no doubt in my mind that by the time he was violently removed from our world, he had transited into that state.

From *Time*, December 31, 1999, pp. 124-125. © 1999 by Time, Inc. Magazine Co. Reprinted by permission.

No Ordinary Leader—divinely inspired He was no ordinary leader. There are those who believe he was divinely inspired, and it is difficult not to believe with them. He dared to exhort nonviolence in a time when the violence of Hiroshima and Nagasaki had exploded on us; he exhorted morality when science, technology and the capitalist order had made it redundant; he replaced self-interest with group interest without minimizing the importance of self. In fact, the interdependence of the social and the personal is at the heart of his philosophy. He seeks the simultaneous and interactive development of the moral person and the moral society.

His philosophy of Satyagraha is both a personal and a social struggle to realize the Truth, which he identifies as God, the Absolute Morality. He seeks this Truth, not in isolation, self-centeredly, but with the people. He said, "I want to find God, and because I want to find God, I have to find God along with other people. I don't believe I can find God alone. If I did, I would be running to the Himalayas to find God in some cave there. But since I believe that nobody can find God alone, I have to work with people. I have to take them with me. Alone I can't come to Him."

He sacerises his revolution, balancing the religious and the secular.

Awakening His awakening came on the hilly terrain of the so-called Bambata Rebellion, where as a passionate British patriot, he led his Indian stretcher-bearer corps to serve the Empire, but British brutality against the Zulus roused his soul against violence as nothing had done before. He determined, on that battlefield, to wrest himself of all material attachments and devote himself completely and totally to eliminating violence and serving humanity. The sight of wounded and whipped Zulus, mercilessly abandoned by their British persecutors, so appalled him that he turned full circle from his admiration for all things British to celebrating the indigenous and ethnic. He resuscitated the culture of the colonized and the fullness of Indian resistance against the British; he revived Indian handicrafts and made these into an economic weapon against the colonizer in his call for *swadeshi*—the use of one's

own and the boycott of the oppressor's products, which deprive the people of their skills and their capital.

A great measure of world poverty today and African poverty in particular is due to the continuing dependence on foreign markets for manufactured goods, which undermines domestic production and dams up domestic skills, apart from piling up unmanageable foreign debts. Gandhi's insistence on self-sufficiency is a basic economic principle that, if followed today, could contribute significantly to alleviating Third World poverty and stimulating development.

Gandhi predated Frantz Fanon and the black-consciousness movements in South Africa and the U.S. by more than a half-century and inspired the resurgence of the indigenous intellect, spirit and industry.

Gandhi rejects the Adam Smith notion of human nature as motivated by self-interest and brute needs and returns us to our spiritual dimension with its impulses for nonviolence, justice and equality. He exposes the fallacy of the claim that everyone can be rich and successful provided they work hard. He points to the millions who work themselves to the bone and still remain hungry. He preaches the gospel of leveling down, of emulating the *kisan* (peasant), not the *zamindar* (landlord), for "all can be *kisans*, but only a few *zamindars*."

He stepped down from his comfortable life to join the masses on their level to seek equality with them. "I can't hope to bring about economic equality . . . I have to reduce myself to the level of the poorest of the poor."

From his understanding of wealth and poverty came his understanding of labor and capital, which led him to the solution of trusteeship based on the belief that there is no private ownership of capital; it is given in trust for redistribution and equalization. Similarly, while recognizing differential aptitudes and talents, he holds that these are gifts from God to be used for the collective good.

He seeks an economic order, alternative to the capitalist and communist, and finds this in *sarvodaya* based on nonviolence (*ahimsa*).

He rejects Darwin's survival of the fittest, Adam Smith's laissez-faire and Karl Marx's thesis of a natural antagonism between capital and labor, and focuses on the interdependence between the two.

He believes in the human capacity to change and wages Satyagraha against the oppressor, not to destroy him but to transform him, that he cease his oppression and join the oppressed in the pursuit of Truth.

We in South Africa brought about our new democracy relatively peacefully on the foundations of such thinking, regardless of whether we were directly influenced by Gandhi or not.

Gandhi remains today the only complete critique of advanced industrial society. Others have criticized its totalitarianism but not its productive apparatus. He is not against science and technology, but he places priority on the right to work and opposes mechanization to the extent that it usurps this right. Large-scale machinery, he holds, concentrates wealth in the hands of one man who tyrannizes the rest. He favors the small machine; he seeks to keep the individual in control of his tools, to maintain an interdependent love relation between the two, as a cricketer with his bat or Krishna with his flute. Above all, he seeks to liberate the individual from his alienation to the machine and restore morality to the productive process.

As we find ourselves in jobless economies, societies in which small minorities consume while the masses starve, we find ourselves forced to rethink the rationale of our current globalization and to ponder the Gandhian alternative.

At a time when Freud was liberating sex, Gandhi was reining it in; when Marx was pitting worker against capitalist, Gandhi was reconciling them; when the dominant European thought had dropped God and soul out of the social reckoning, he was centralizing society in God and soul; at a time when the colonized had ceased to think and control, he dared to think and control; and when the ideologies of the colonized had virtually disappeared, he revived them and empowered them with a potency that liberated and redeemed.

Absolute poverty: The condition of people whose incomes are insufficient to keep them at a subsistence level.

Adjudication: The legal process of deciding an issue through the courts.

African, Caribbean, and Pacific Countries (ACP): Fifty-eight countries associated with the European Community.

African National Congress (ANC): South African organization founded in 1912 in response to the taking of land from Africans and the restrictions on their employment and movement. Following attempts at peaceful resistance, its leaders were tried for treason and imprisoned. In 1990, ANC de facto leader Nelson Mandela was released from prison, and a continued resistance against the apartheid state grew. The ANC was legalized in 1991.

Airborne Warning and Control System (AWACS): Flying radar stations that instantaneously identify all devices in the air within a radius of 240 miles and detect movement of land vehicles.

Air-launched cruise missile (ALCM): A cruise missile carried by and launched from an aircraft.

Antiballistic missile (ABM): A missile that seeks out and destroys an incoming enemy missile in flight before the latter reaches its target. It is not effective against MIRVs.

Apartheid: A system of laws in the Republic of South Africa that segregate and politically and economically discriminate against non-European groups.

Appropriate technology: Also known as intermediate technology. It aims at using existing resources by making their usage more efficient or productive but adaptable to the local population.

Arms control: Any measure limiting or reducing forces, regulating armaments, and/or restricting the deployment of troops or weapons.

Arms race: The competitive or cumulative improvement of weapons stocks (qualitatively or quantitatively), or the buildup of armed forces based on the conviction of two or more actors that only by trying to stay ahead in military power can they avoid falling behind.

Association of Southeast Asian Nations (ASEAN): A regional grouping made up of Indonesia, the Philippines, Singapore, and Thailand.

Atomic bomb: A weapon based on the rapid splitting of fissionable materials, thereby inducing an explosion with three deadly results: blast, heat, and radiation.

Autarky: Establishing economic independence.

Balance of payments: A figure that represents the net flow of money into and out of a country due to trade, tourist expenditures, sale of services (such as consulting), foreign aid, profits, and so forth.

Balance of trade: The relationship between imports and exports.

Ballistic missile: A payload propelled by a rocket, which assumes a free-fall trajectory when thrust is terminated. Ballistic missiles could be of short range (SRBM), intermediate range (IRBM), medium range (MRBM), and intercontinental (ICBM).

Bantustans: Ten designated geographical areas or "homelands" for each African ethnic group created under the apartheid government of South Africa. Beginning in the late 1970s, South Africa instituted a policy offering "independence" to the tribal leaders of these homelands. The leaders of four homeland governments accepted independent status, but no outside actors recognized these artificial entities as independent nation-states. Under the terms of the new constitution, all homeland citizens are now considered to be citizens of South Africa.

Barrel: A standard measure for petroleum, equivalent to 42 gallons or 158.86 liters.

Basic human needs: Adequate food intake (in terms of calories, proteins, and vitamins), drinking water free of disease-carrying organisms and toxins, minimum clothing and shelter, literacy, sanitation, health care, employment, and dignity.

Bilateral diplomacy: Negotiations between two countries.

Bilateral (foreign) aid: Foreign aid given by one country directly to another.

Binary (chemical) munitions/weapons: Nerve gas canisters composed of two separate chambers containing chemicals that become lethal when mixed. The mixing is done when the canister is fired. Binary gas is preferred for its relative safety in storage and transportation.

Biosphere: The environment of life and living processes at or near Earth's surface, extending from the ocean floors to about 75 kilometers into the atmosphere. It is being endangered by consequences of human activities such as air and water pollution, acid rain, radioactive fallout, desertification, toxic and nuclear wastes, and the depletion of nonrenewable resources.

Bipolar system: A world political system in which power is primarily held by two international actors.

Buffer stocks: Reserves of commodities that are either increased or decreased whenever necessary to maintain relative stability of supply and prices.

Camp David Agreements/Accords: Agreements signed on September 17, 1978, at Camp David—a mountain retreat for the U.S. president in Maryland—by President Anwar al-Sadat of Egypt and Prime Minister Menachem Begin of Israel, and witnessed by President Jimmy Carter.

Capitalism: An economic system based on the private ownership of real property and commercial enterprise, competition for profits, and limited government interference in the marketplace.

Cartel: An international agreement among producers of a commodity that attempts to control the production and pricing of that commodity.

CBN weapons: Chemical, biological, and nuclear weapons.

Chemical Weapons Convention Treaty: Signed in 1993, the treaty requires its 130 signatories to eliminate all chemical weapons by the year 2005 and to submit to rigorous inspection.

Cold war: A condition of hostility that existed between the U.S. and the Soviet Union in their struggle to dominate the world scene following World War II. It ended with the collapse of the Soviet Union in 1991.

Collective security: The original theory behind UN peacekeeping. It holds that aggression against one state is aggression against all and should be defeated by the collective action of all.

Commodity: The unprocessed products of mining and agriculture.

Common Heritage of Mankind: A 1970 UN declaration that states that the "seabed and ocean floor, and the subsoil thereof, beyond the limits of national jurisdiction . . . , as well as the resources of the area, are the common heritage of mankind."

Common Market: A customs union that eliminates trade barriers within a group and establishes a common external tariff on imports from nonmember countries.

Commonwealth of Independent States (CIS): In December 1991 the Soviet Union was dissolved and fif-

teen independent countries were formed: Armenia, Azerbaijan, Byelorussia (Belarus), Estonia, Georgia, Kazakhstan, Kirghizia (Kyrgyzstan), Latvia, Lithuania, Moldavia (Moldova), Russia, Tadzhikistan (Tajikistan), Turkmenistan, Ukraine, and Uzbekistan. Some of the republics have since changed their names. CIS represents a collective term for the group of republics.

Compensatory Financing Facility: An IMF program established in 1963 to finance temporary export shortfalls, as in coffee, sugar, or other cyclically prone export items.

Concessional loans: Loans given to LLDCs by MBDs that can be repaid in soft (nonconvertible) currencies and with nominal or no interest over a long period of time.

Conditionality: A series of measures that must be taken by a country before it could qualify for loans from the International Monetary Fund.

Conference on International Economic Cooperation (CIEC): A conference of 8 industrial nations, 7 oil-producing nations, and 12 developing countries held in several sessions between December 1975 and June 1977. It is composed of four separate commissions (energy, raw materials, development, and financing). It is the forum of the North-South dialogue between rich and poor countries.

Conference on Security and Cooperation in Europe (CSCE): Series of conferences among 51 NATO, former Soviet bloc, and neutral European countries (52 counting Serbia or rump Yugoslavia). Established by the 1976 Helsinki Accords. There are plans to establish a small, permanent CSCE headquarters and staff.

Consensus: In conference diplomacy, a way of reaching agreements by negotiations and without a formal vote.

Counterforce: The use of strategic nuclear weapons for strikes on selected military capabilities of an enemy force.

Countervalue: The use of strategic nuclear weapons for strikes on an enemy's population centers.

Cruise missile: A small, highly maneuverable, low-flying, pilotless aircraft equipped with accurate guidance systems that periodically readjusts its trajectory. It can carry conventional or nuclear warheads, can be short-range or long-range, and can be launched from the air (ALLUM), the ground (GLCM), or the sea (SLCM).

Cultural imperialism: The attempt to impose your own value systems on others, including judging others by how closely they conform to your norms.

Current dollars: The value of the dollar in the year for which it is being reported. Sometimes called inflated dollars. Any currency can be expressed in current value. *See* **Real dollars.**

Decision making: The process by which humans choose which policy to pursue and which actions to take in support of policy goals. The study of decision making seeks to identify patterns in the way that humans make decisions. This includes gathering information, analyzing information, and making choices. Decision making is a complex process that relates to personality and other human traits, to the sociopolitical setting in which decision makers function, and to the organizational structures involved.

Declaration of Talloires: A statement issued in 1981 by Western journalists who opposed the UNESCO-sponsored New World Information and Communication Order, at a meeting in Talloires, France.

Delivery systems or vehicles or launchers: Land-based missiles (ICBMs), submarine-launched missiles (SLBMs), and long-range bombers capable of delivering nuclear weapons.

Dependencia model: The belief that the industrialized North has created a neocolonial relationship with the South in which the LDCs are dependent on and disadvantaged by their economic relations with the capitalist industrial countries.

Deployment: The actual positioning of weapons systems in a combat-ready status.

Détente: A relaxation of tensions or a decrease in the level of hostility between opponents on the world scene.

Deterrence: Persuading an opponent not to attack by having enough forces to disable the attack and/or launch a punishing counterattack.

Developed countries (DCs): Countries with relatively high per capita GNP, education, levels of industrial development and production, health and welfare, and agricultural productivity.

Developing countries (also called less developed countries): These countries are mainly raw materials producers for export with high growth rates and inadequate infrastructures in transportation, educational systems, and the like. There is, however, a wide variation in living standards, GNPs, and per capita incomes among LCDs.

Development: The process through which a society becomes increasingly able to meet basic human needs and ensure the physical quality of life of its people.

Direct investment: Buying stock, real estate, and other assets in another country with the aim of gaining a controlling interest in foreign economic enterprises. Different from portfolio investment, which involves investment solely to gain capital appreciation through market fluctuations.

Disinformation: The spreading of false propaganda and forged documents to confuse counterintelligence or to create political confusion, unrest, and scandal.

Dumping: A special case of price discrimination, selling to foreign buyers at a lower price than that charged to buyers in the home market.

Duty: Special tax applied to imported goods, based on tariff rates and schedules.

East (as in the East–West struggle): A shorthand, nongeographic term that included nonmarket, centrally planned (communist) countries.

East–West axis: The cold war conflict between the former Soviet Union and its allies and the United States and its allies.

Economic Cooperation among Developing Countries (ECDC): Also referred to as intra-South, or South-South cooperation, it is a way for LCDs to help each other with appropriate technology.

Economic statecraft: The practice of states utilizing economic instruments, such as sanctions, to gain their political ends. Economic statecraft is closely related to "mercantilism," or the use of political power to advance a country's economic fortunes.

Economically developing countries (EDCs): The relatively wealthy and industrialized countries that lie mainly in the Northern Hemisphere (the North).

Escalation: Increasing the level of fighting.

Essential equivalence: Comparing military capabilities of two would-be belligerents, not in terms of identical mix of forces, but in terms of how well two dissimilarly organized forces could achieve a strategic stalemate.

Euro: The single European currency among the majority of European Union members.

Eurodollars: U.S. dollar holdings of European banks; a liability for the U.S. Treasury.

Euromissiles: Shorthand for long-range theatre nuclear forces stationed in Europe or aimed at targets in Europe.

Europe 1992: A term that represents the European Community's decision to eliminate by the end of 1992 all internal barriers (between member countries) to the movement of trade, financial resources, workers, and services (banking, insurance, etc.).

European Community (EC): The Western European regional organization established in 1967 that includes the European Coal and Steel Community (ECSC), the European Economic Community (EEC), and the European Atomic Energy Community (EURATOM).

European Currency Unit (ECU): The former common unit of valuation among the eight members of the European Monetary System (EMS); it was replaced by the euro in January 1999.

European Economic Community (EEC). *See* **European Union.**

European Free Trade Association (EFTA): Austria, Finland, Iceland, Liechtenstein, Norway, Portugal, Sweden, and Switzerland. Each member keeps its own external tariff schedule, but free trade prevails among the members.

European Monetary System (EMS): Established in 1979 as a preliminary stage toward an economic and monetary union in the European Community. Fluctuations in the exchange rate value of the currencies of the participating countries are kept with a $2\frac{1}{4}$ percent limit of divergence from the strongest currency among them. The system collapsed in 1993, thus slowing progress toward monetary integration in Europe.

European Union: Known as the European Economic Community, and also the Common Market, until 1994, the European Union has 15 full members: Austria, Belgium, Denmark, Finland, France, Germany, Greece, Ireland, Italy, Luxembourg, The Netherlands, Portugal, Spain, Sweden and the United Kingdom. Originally established by the Treaty of Rome in 1958, the Union nations work toward establishing common defense and foreign policies and a common market.

Exchange rate: The values of two currencies relative to each other—for example, how many yen equal a dollar or how many lira equal a pound.

Export subsidies: Special incentives, including direct payments to exporters, to encourage increased foreign sales.

Exports: Products shipped to foreign countries.

Finlandization: A condition of nominal neutrality, but one of actual subservience to the former Soviet Union in foreign and security policies, as was the case with Finland during the cold war.

First strike: The first offensive move of a general nuclear war. It implies an intention to knock out the opponent's ability to retaliate.

Fissionable or nuclear materials: Isotopes of certain elements, such as plutonium, thorium, and uranium, that emit neutrons in such large numbers that a sufficient concentration will be self-sustaining until it explodes.

Foreign policy: The sum of a country's goals and actions on the world stage. The study of foreign policy is synonymous with state-level analysis and examines how countries define their interests, establish goals, decide on specific policies, and attempt to implement those policies.

Forward-based system (FBS or FoBS): A military installation, maintained on foreign soil or in international waters, and conveniently located near a theatre of war.

Fourth World: An expression arising from the world economic crisis that began in 1973–74 with the quadrupling in price of petroleum. It encompasses the least developed countries (LLDCs) and the most seriously affected countries (MSAs).

Free trade: The international movement of goods unrestricted by tariffs or nontariff barriers.

Functionalism: International cooperation in specific areas such as communications, trade, travel, health, or environmental protection activity. Often symbolized by the specialized agencies, such as the World Health Organization, associated with the United Nations.

General Agreement on Tariffs and Trade (GATT): Created in 1947, this organization is the major global forum for negotiations of tariff reductions and other measures to expand world trade. Its members account for four-fifths of the world's trade.

General Assembly: The main representative body of the United Nations, composed of all member states.

Generalized System of Preferences (GSP): A system approved by GATT in 1971, which authorizes DCs to give preferential tariff treatment to LCDs.

Global: Pertaining to the world as a whole; worldwide.

Global commons: The Antarctic, the ocean floor under international waters, and celestial bodies within reach of planet Earth. All of these areas and bodies are considered the common heritage of mankind.

Global negotiations: A new round of international economic negotiations started in 1980 over raw materials, energy, trade, development, money, and finance.

Golan Heights: Syrian territory adjacent to Israel, which has occupied it since the 1967 war and that annexed it unilaterally in 1981.

Gross domestic product (GDP): A measure of income within a country that excludes foreign earnings.

Gross national product (GNP): A measure of the sum of all goods and services produced by a country's nationals, whether they are in the country or abroad.

Group of Seven (G-7): The seven economically largest free market countries: Canada, France, Great Britain, Italy, Japan, the United States, and Germany.

Group of 77: Group of 77 Third World countries that co-sponsored the Joint Declaration of Developing Countries in 1963 calling for greater equity in North-South trade. This group has come to include more than 120 members and represents the interests of the less developed countries of the South.

Hegemonism: Any attempt by a larger power to interfere, threaten, intervene against, and dominate a smaller power or a region of the world.

Hegemony: Domination by a major power over smaller, subordinate ones within its sphere of influence.

Helsinki Agreement. *See* **Conference on Security and Cooperation In Europe.**

Horn of Africa: The northeast corner of Africa that includes Ethiopia, Djibouti, and Somalia. It is separated from the Arabian peninsula by the Gulf of Aden and the Red Sea. It is plagued with tribal conflicts between Ethiopia and Eritrea, and between Ethiopia and Somalia over the Ogaden desert. These conflicts generated a large number of refugees who faced mass starvation.

Human rights: Rights inherent to human beings, including but not limited to the right of dignity; the integrity of the person; the inviolability of the person's body and mind; civil and political rights (freedom of religion, speech, press, assembly, association, the right to privacy, habeas corpus, due process of law, the right to vote or not to vote, the right to run for election, and the right to be protected from reprisals for acts of peaceful dissent); social, economic, and cultural

rights. The most glaring violations of human rights are torture, disappearance, and the general phenomenon of state terrorism.

Imports: Products brought into a country from abroad.

Inkatha Freedom Party (IFP): A Zulu-based political and cultural movement dedicated to the building and reconstruction of South Africa.

Innocent passage: In a nation's territorial sea, passage by a foreign ship is innocent so long as it is not prejudicial to the peace, good order, or security of the coastal state. Submarines must surface and show their flag.

Intercontinental ballistic missile (ICBM): A land-based, rocket-propelled vehicle capable of delivering a warhead to targets at 6,000 or more nautical miles.

Interdependence (economic): The close interrelationship and mutual dependence of two or more domestic economies on each other.

Intergovernmental organizations (IGOs): International/transnational actors comprised of member countries.

Intermediate-range ballistic missile (IRBM): A missile with a range from 1,500 to 4,000 nautical miles.

Intermediate-range nuclear forces: Nuclear arms that are based in Europe with a deployment range that easily encompasses the former USSR.

Intermediate-range Nuclear Forces (INF) Treaty: The treaty between the former USSR and the United States that limits the dispersion of nuclear warheads in Europe.

International: Between or among sovereign states.

International Atomic Energy Agency (IAEA): An agency created in 1946 by the UN to limit the use of nuclear technology to peaceful purposes.

International Court of Justice (ICJ): The World Court, which sits in The Hague with 15 judges and which is associated with the United Nations.

International Development Association (IDA): An affiliate of the World Bank that provides interest-free, long-term loans to developing countries.

International Energy Agency (IEA): An arm of OECD that attempts to coordinate member countries' oil imports and reallocate stocks among members in case of disruptions in the world's oil supply.

International Finance Corporation: Created in 1956 to finance overseas investments by private companies without necessarily requiring government guarantees. The IFC borrows from the World Bank, provides loans, and invests directly in private industry in the development of capital projects.

International Monetary Fund (IMF): The world's primary organization devoted to maintaining monetary stability by helping countries fund balance-of-payments deficits. Established in 1947, it now has 170 members.

International political economy (IPE): A term that encapsulates the totality of international economic interdependence and exchange in the political setting of the international system. Trade, investment, monetary relations, transnational business activities, aid, loans, and other aspects of international economic interchange (and the reciprocal impacts between these activities and politics) are all part of the study of IPE.

Interstate: International, intergovernmental.

Intifada (literally, resurgence): A series of minor clashes between Palestinian youths and Israeli security forces that escalated into a full-scale revolt in December 1987.

Intra-South. *See* **Economic Cooperation among Developing Countries.**

Islamic fundamentalism: Early nineteenth-century movements of fundamentalism sought to revitalize Islam through internal reform, thus enabling Islamic societies to resist foreign control. Some of these movements sought peaceful change, while other were more militant. The common ground of twentieth-century reform movements and groups is their fundamental opposition to the onslaught of materialistic Western culture and their desire to reassert a distinct Islamic identity for the societies they claim to represent.

Kampuchea: The new name for Cambodia since April 1975.

KGB: Security police and intelligence apparatus in the former Soviet Union, engaged in espionage, counterespionage, antisubversion, and control of political dissidents.

Khmer Rouge: Literally "Red Cambodians," the communist organization that ruled Kampuchea between April 1975 and January 1979 under Pol Pot and Leng Saray.

Kiloton: A thousand tons of explosive force. A measure of the yield of a nuclear weapon equivalent to 1,000 tons of TNT (trinitrotoluene). The bomb detonated at Hiroshima in World War II had an approximate yield of 14 kilotons.

Launcher. *See* **Delivery systems.**

League of Nations: The first true general international organization. It existed between the end of World War I and the beginning of World War II and was the immediate predecessor of the United Nations.

Least developed countries: Those countries in the poorest of economic circumstances. Frequently it includes those countries with a per capita GNP of less than $400 in 1985 dollars.

Less developed countries (LDCs): Countries, located mainly in Africa, Asia, and Latin America, with economies that rely heavily on the production of agriculture and raw material and whose per capita GNP and standard of living are substantially below Western standards.

Linkage diplomacy: The practice of considering another country's general international behavior as well as the specifics of the question when deciding whether or not to reach an agreement on an issue.

Lisbon Protocol: Signed in 1992, it is an agreement between ex-Soviet republics Kazakhstan and Belarus to eliminate nuclear weapons from their territories.

Lome Convention: An agreement concluded between the European Community and 58 African, Caribbean, and Pacific countries (ACP), allowing the latter preferential trade relations and greater economic and technical assistance.

Long-range theatre nuclear forces (LRTNF): Nuclear weapon systems with a range greater than 1,000 kilometers (or 600 miles), such as the U.S. Pershing II missile or the Soviet SS-20.

Maastricht Treaty: Signed by the European Community's 12 member-countries in December 1991, the Maastricht Treaty outlines steps toward further political/economic integration. At this time, following several narrow ratification votes and monetary crises, it is too early to foretell the future evolution of EC political integration.

Medium-range ballistic missile (MRBM): A missile with a range from 500 to 1,500 nautical miles.

Megaton: The yield of a nuclear weapon equivalent to 1 million tons of TNT (approximately equivalent to 79 Hiroshima bombs).

Microstates: Very small countries, usually with a population of less than one million.

Missile experimental (MX): A mobile, land-based missile that is shuttled among different launching sites, making it more difficult to locate and destroy.

Most favored nation (MFN): In international trade agreements, a country grants most-favored-nation status to another country in regard to tariffs and other trade regulations.

Multilateral: Involving many nations.

Multinational: Doing business in many nations.

Multinational corporations (MNCs): Private enterprises doing business in more than one country.

Multiple independently targetable reentry vehicle (MIRV): Two or more warheads carried by a single missile and capable of being guided to separate targets on reentry.

Munich syndrome: A lesson that was drawn by post–World War II leaders that one should not compromise with aggression.

Mutual and Balanced Force Reductions (MBFR): The 19-nation Conference on Mutual Reduction of Forces and Armaments and Associated Measures in Central Europe that was been held intermittently from 1973 to the end of the 1980s.

Mutual Assured Destruction (MAD): The basic ingredient of the doctrine of strategic deterrence that no country can escape destruction in a nuclear exchange even if it engages in a preemptive strike.

Namibia: African name for South-West Africa.

National Intelligence Estimate (NIE): The final assessment of global problems and capabilities by the intelligence community for use by the National Security Council and the president in making foreign and military decisions.

Nation-state: A political unit that is sovereign and has a population that supports and identifies with it politically.

Nautical mile: 1,853 meters.

Neocolonialism: A perjorative term describing the economic exploitation of Third World countries by the industrialized countries, in particular through the activities of multinational corporations.

Neutron bomb: Enhanced radiation bomb giving out lower blast and heat but concentrated radiation, thus killing people and living things while reducing damage to physical structures.

New International Economic Order (NIEO): The statement of development policies and objectives adopted at the Sixth Special Session of the UN General Assembly in 1974. NIEO calls for equal participation of LDCs in the international economic policy-making process, better known as the North-South dialogue.

New world order: A term that refers to the structure and operation of the post–cold war world. Following the Persian Gulf War, President George Bush referred to a world order based on nonaggression and on international law and organization.

Nonaligned movement (NAM): A group of Third World countries interested in promoting economic cooperation and development.

Nongovernmental organizations (NGOs or INGOs): Transnational (international) organizations made up of private organizations and individuals instead of member states.

Nonproliferation of Nuclear Weapons Treaty (NPT): Nuclear weapon states, party to the NPT, who pledge not to transfer nuclear explosive devices to any recipient and not to assist any nonnuclear weapon state in the manufacture of nuclear explosive devices.

Nontariff barriers (NTB): Subtle, informal impediments to free trade designed for the purpose of making importation of foreign goods into a country very difficult on such grounds as health and safety regulations.

Normalization of relations: The reestablishment of full diplomatic relations, including de jure recognition and the exchange of ambassadors between two countries that either did not have diplomatic relations or had broken them.

North (as in North-South dialogue): (a) A shorthand, nongeographic term for the industrialized countries of high income, both East and West; (b) Often means only the industrialized, high-income countries of the West.

North Atlantic Cooperation Council (NACC): Consists of 37 members, including all members of NATO, the former Warsaw Pact members, and former Soviet republics (Russia, Ukraine, Belarus, Georgia, Moldova, Armenia, Azerbaijan, Kazakhstan, Uzbekistan, Kyrgyzstan, Turkmentistan, and Tajikstan), the Czech Republic, Slovakia, Poland, Hungary, Romania, Bulgaria, Estonia, Latvia, Lithuania, and Albania.

North Atlantic Treaty Organization (NATO): Also known as the Atlantic Alliance, NATO was formed in 1949 to provide collective defense against the Soviet threat to Western Europe. It consists of the United States, Canada, 13 Western European countries, and Turkey.

North-South axis: A growing tension that is developing between the North (economically developed countries) and the South (economically deprived countries). The South is insisting that the North share part of its wealth and terminate economic and political domination.

Nuclear proliferation: The process by which one country after another comes into possession of some form of nuclear weaponry, and with it develops the potential of launching a nuclear attack on other countries.

Nuclear reprocessing: The separation of radioactive waste (spent fuel) from a nuclear-powered plant into its fissile constituent materials. One such material is plutonium, which can then be used in the production of atomic bombs.

Nuclear terrorism: The use (or threatened use) of nuclear weapons or radioactive materials as a means of coercion.

Nuclear Utilization Theory (NUT): Advocates of this nuclear strategy position want to destroy enemy weapons before the weapons explode on one's own territory and forces. The best way to do this, according to this theory, is to destroy an enemy's weapons before they are launched.

Nuclear-free zone: A stretch of territory from which all nuclear weapons are banned.

Official Development Aid (ODA): Government contributions to projects and programs aimed at developing the productivity of poorer countries. This is to be distinguished from private, voluntary assistance, humanitarian assistance for disasters, and, most importantly, from military assistance.

Ogaden: A piece of Ethiopian desert populated by ethnic Somalis. It was a bone of contention between Ethiopia and Somalia that continued until 1988 when a peace agreement was reached.

Organization of Arab Petroleum Exporting Countries (OAPEC): A component of OPEC, with Saudi Arabia, Kuwait, the United Arab Emirates, Qatar, Iraq, Algeria, and Libya as members.

Organization of Economic Cooperation and Development (OECD): An organization of 24 members that

serves to promote economic coordination among the Western industrialized countries.

Organization of Petroleum Exporting Countries (OPEC): A producers' cartel setting price floors and production ceilings of crude petroleum. It consists of Venezuela and others such as Ecuador, Gabon, Nigeria, and Indonesia, as well as the Arab oil-producing countries.

Palestine: "Palestine" does not exist today as an entity. It refers to the historical and geographical entity administered by the British under the League of Nations mandate from 1918 to 1947. It also refers to a future entity in the aspirations of Palestinians who, as was the case of the Jews before the founding of the State of Israel, are stateless nationalists. Whether Palestinians will have an autonomous or independent homeland is an ongoing issue.

Palestine Liberation Organization (PLO): A coalition of Palestinian groups united by the goal of a Palestinian state.

Partnership for Peace Program: A U.S.–backed policy initiative for NATO formulated by the Clinton administration in 1994. The proposal was designed to rejuvenate the Atlantic Alliance and contribute to the stability of recent independent countries in Eastern Europe and the former Soviet Union. No NATO security guarantees or eventual membership in the alliance are specifically mentioned.

Payload: Warheads attached to delivery vehicles.

Peacekeeping: Occurs when an international organization such as the United Nations uses military means to prevent hostilities, usually by serving as a buffer between combatants. This international force will remain neutral between the opposing forces and must be invited by at least one of the combatants. *See* **Collective security.**

People's Republic of China (PRC): Communist or mainland China.

Petrodollars: U.S. dollar holdings of capital-surplus OPEC countries; a liability for the U.S. Treasury.

Physical Quality of Life Index (PQLI): Developed by the Overseas Development Council, the PQLI is presented as a more significant measurement of the well-being of inhabitants of a geographic entity than the solely monetary measurement of per capita income. It consists of the following measurements: life expectancy, infant mortality, and literacy figures that are each rated on an index of 1–100, within which each country is ranked according to its performance. A composite index is obtained by averaging these three measures, giving the PQLI.

Polisario: The liberation front of Western Sahara (formerly Spanish Sahara). After years of bitter fighting over Western Sahara, Polisario guerrillas signed a cease-fire agreement with Morocco in 1990. The UN has yet to conduct a referendum in Western Sahara on whether the territory should become independent or remain part of Morocco.

Postindustrial: Characteristic of a society where a large portion of the workforce is directed to nonagricultural and nonmanufacturing tasks such as servicing and processing.

Precision-guided munitions (PGM): Popularly known as "smart bombs." Electronically programmed and controlled weapons that can accurately hit a moving or stationary target.

Proliferation: Quick spread, as in the case of nuclear weapons.

Protectionism: Using tariffs and nontariff barriers to control or restrict the flow of imports into a country.

Protocol: A preliminary memorandum often signed by diplomatic negotiators as a basis for a final convention or treaty.

Quota: Quantitative limits, usually imposed on imports or immigrants.

Rapprochement: The coming together of two countries that had been hostile to each other.

Real dollars (uninflated dollars): The report of currency in terms of what it would have been worth in a stated year.

Regionalism: A concept of cooperation among geographically adjacent states to foster region-wide political, military, and economic interests.

Reprocessing of nuclear waste: A process of recovery of fissionable materials, among which is weapons-grade plutonium.

Resolution: Formal decisions of UN bodies; they may simply register an opinion or may recommend action to be taken by a UN body or agency.

Resolution 242: Passed by the UN Security Council on November 22, 1967, calling for the withdrawal of Israeli troops from territories they captured from Egypt (Sinai), Jordan (West Bank and East Jerusalem), and Syria (Golan Heights) in the 1967 war, and for the right of all nations in the Middle East to live in peace in secure and recognized borders.

Resolution 435: Passed by the UN Security Council in 1978, it called for a cease-fire between belligerents in the Namibian conflict (namely SWAPO, Angola and other front-line states on the one side, and South Africa on the other) and an internationally supervised transition process to independence and free elections.

Resolution 678: Passed by the UN in November 1990 demanding that Iraq withdraw from Kuwait. It authorized the use of all necessary force to restore Kuwait's sovereignty after January 15,1991.

SALT I: The Strategic Arms Limitation Treaty that was signed in 1972 between the U.S. and the former Soviet Union on the limitation of strategic armaments.

SALT II: The Strategic Arms Limitation Treaty signed in 1979. SALT II was to limit the number and types of former Soviet Union and U.S. strategic weapons. It never went into effect, as it was not ratified by the U.S. Senate.

Second strike: A nuclear attack in response to an adversary's first strike. A second-strike capability is the ability to absorb the full force of a first strike and still inflict heavy damage in retaliation.

Secretariat: (a) The administrative organ of the United Nations, headed by the secretary-general; (b) An administrative element of any IGO; this is headed by a secretary-general.

Short-range ballistic missiles (SRBM): A missile with a range up to 500 nautical miles.

Solidarity: Independent self-governing trade union movement started in Poland in 1980. It was terminated in December 1981 after radical members of its Presidium passed a resolution calling for a national referendum to determine if the communist government of Poland should continue to govern.

South (as in North-South axis): A shorthand, nongeographic term that includes economically less developed countries, often represented by the Group of 77.

Sovereignty: The ability to carry out laws and policies within national borders without interference from outside.

Special Drawing Rights (SDRs): Also known as paper gold. A new form of international liquid reserves to be used in the settlement of international payments among member governments of the International Monetary Fund.

State: Regarding international relations, it means a country having territory, population, government, and sovereignty, e.g., the United States is a state, while California is not a state in this sense.

State terrorism: The use of state power, including the police, the armed forces, and the secret police to throw fear among the population against any act of dissent or protest against a political regime.

"Stealth": A code name for a proposed "invisible" aircraft, supposedly not detectable by hostile forces, that would be the main U.S. strategic fighter-bomber of the 1990s.

Strategic Arms Limitation Talks. *See* **SALT I** and **SALT II.**

Strategic Defense Initiative (SDI): A space-based defense system designed to destroy incoming missiles. It is highly criticized because the technological possibility of such a system is questionable, not to mention the enormous cost.

Strategic minerals: Minerals needed in the fabrication of advanced military and industrial equipment. Examples are uranium, platinum, titanium, vanadium, tungsten, nickel, chromium, etc.

Strategic nuclear weapons: Long-range weapons carried on either intercontinental ballistic missiles (ICBMs) or submarine-launched ballistic missiles (SLBMs) or long-range bombers.

Strategic stockpile: Reserves of certain commodities established to ensure that in time of national emergency such commodities are readily available.

Structural Adjustment Program. *See* **Conditionality.**

Submarine-launched ballistic missile (SLBM): A ballistic missile carried in and launched from a submarine.

Superpowers: Countries so powerful militarily (the United States and Russia), demographically (Pacific Rim countries), or economically (Japan) as to be in a class by themselves.

Supranational: Above nation-states.

Tactical nuclear weapons: Kiloton-range weapons for theatre use. The bomb dropped on Hiroshima would be in this category today.

Tariff: A tax levied on imports.

Technetronic: Shorthand for technological-electronic.

Territorial sea: The territorial sea, air space above, seabed, and subsoil are part of sovereign territory of a coastal state, except that ships (not aircraft) enjoy right of innocent passage. As proposed, a coastal state's sovereignty would extend 12 nautical miles beyond its land territory.

Terrorism: The systematic use of terror as a means of coercion.

Theatre: In nuclear strategy, it refers to a localized combat area such as Europe, as opposed to global warfare that would have involved the United States and the former Soviet Union in a nuclear exchange.

Theatre nuclear forces (TNF): Nuclear weapons systems for operations in a region such as Europe, including artillery, cruise missiles, SRBMs, IRBMs, and MRBMs.

Third World: Often used interchangeably with the terms less developed countries, developing countries, or the South, its two main institutions are the nonaligned movement (which acts primarily as the political caucus of the Third World) and the Group of 77 (which functions as the economic voice of the Third World).

Tokyo Round: The sixth round of GATT trade negotiations, begun in 1973 and ended in 1979. About 100 nations, including nonmembers of the GATT, participated.

Torture: The deliberate inflicting of pain, whether physical or psychological, to degrade, intimidate, and induce submission of its victims to the will of the torturer. It is a heinous practice used frequently in most dictatorial regimes in the world, irrespective of their ideological leanings.

Transnational: An adjective indicating that a nongovernmental movement, organization, or ideology transcends national borders and is operative in dissimilar political, economic, and social systems.

Transnational enterprise (TNE) or corporation (TNC). *See* **Multinational corporations.**

Triad (nuclear): The three-pronged U.S. strategic weapons arsenal, composed of land-based ICBMs, underwater SLBMs, and long-range manned bombers.

Trilateral: Between three countries or groups of countries, e.g., United States, Western Europe, and Japan; United States, Russia, and China.

Unilateral: One-sided, as opposed to bilateral or multilateral.

United Nations Conference on Trade and Development (UNCTAD): A coalition of disadvantaged countries that met in 1964 in response to their effort to bridge the standard-of-living gap between themselves and developed countries.

Verification: The process of determining that the other side is complying with an agreement.

Vietnam syndrome: An aversion to foreign armed intervention, especially in Third World conflicts involving guerrillas. This is an attitude that is especially common among those who opposed U.S. participation in the Vietnam War.

Visegrad Group: Term used to refer to Poland, Hungary, Slovakia, and the Czech Republic. These countries were subject to the same conditions and status in their recent application to participate in NATO's Partnership for Peace initiative.

Walesa, Lech: Leader of the independent trade union movement known as *Solidarity*, which came into existence in August 1980 and was dissolved in December 1981 by martial law decree. He was elected president of Poland in December 1990.

Warhead: That part of a missile, projectile, or torpedo that contains the explosive intended to inflict damage.

Warsaw Pact or Warsaw Treaty Organization: Established in 1955 by the Soviet Union to promote mutual defense. It was dissolved in July 1991. Member countries at time of dissolution were: the Soviet Union, Bulgaria, Czechoslovakia, Hungary, Poland, and Romania.

West (as in the East-West conflict): Basically the market-economy, industrialized, and high-income countries that are committed to a political system of representative democracy. The three main anchors of the West today are North America, Western Europe, and Japan, also known as the Trilateral countries. Australia and New Zealand are also parts of the West.

"Window of vulnerability": An expression often used, but not consistently defined, by President Ronald Reagan and his administration during the 1980s. Military specialists used the word to refer to a period of time in the late 1980s when it was predicted that the United States' silo-based ICBMs could be accurately hit by So-

viet missiles while the mobile MX system (now scrapped) would not yet be operational, and when the aging B-52 bombers would no longer be serviceable while the Stealth aircraft would not yet be operational. President Reagan planned to close this "window" by MIRVing the silo-based ICBMs, by hardening their concrete covers, by building B-1 bombers, and by the "Star Wars" initiative.

World Bank (International Bank for Reconstruction and Development [IBRD]): Makes loans, either directly to governments or with governments as the guarantors, and through its affiliates, the International Finance Corporation and the International Development Association.

Xenophobia: A dislike, fear, or suspicion of other nationalities.

Yield: The explosive force, in terms of TNT equivalence, of a warhead.

Zimbabwe: Formerly Rhodesia.

Zionism: An international movement for the establishment of a Jewish nation or religious community in Palestine and later for the support of modern Israel.

SOURCES

International Politics on the World Stage, Seventh Edition, 1999, Dushkin/McGraw-Hill.

Global Studies: Africa, Eighth Edition, 1999, Dushkin/McGraw-Hill.

Global Studies: Russia, The Eurasian Republics, and Central/Eastern Europe, Seventh Edition, 1998, Dushkin/McGraw-Hill.

Global Studies: The Middle East, Eighth Edition, 2000, Dushkin/McGraw-Hill.

AE Article Review Form

We encourage you to photocopy and use this page as a tool to assess how the articles in **Annual Editions** expand on the information in your textbook. By reflecting on the articles you will gain enhanced text information. You can also access this useful form on a product's book support Web site at ***http://www.dushkin.com/online/.***

NAME: DATE:

TITLE AND NUMBER OF ARTICLE:

BRIEFLY STATE THE MAIN IDEA OF THIS ARTICLE:

LIST THREE IMPORTANT FACTS THAT THE AUTHOR USES TO SUPPORT THE MAIN IDEA:

WHAT INFORMATION OR IDEAS DISCUSSED IN THIS ARTICLE ARE ALSO DISCUSSED IN YOUR TEXTBOOK OR OTHER READINGS THAT YOU HAVE DONE? LIST THE TEXTBOOK CHAPTERS AND PAGE NUMBERS:

LIST ANY EXAMPLES OF BIAS OR FAULTY REASONING THAT YOU FOUND IN THE ARTICLE:

LIST ANY NEW TERMS/CONCEPTS THAT WERE DISCUSSED IN THE ARTICLE, AND WRITE A SHORT DEFINITION:

ANNUAL EDITIONS revisions depend on two major opinion sources: one is our Advisory Board, listed in the front of this volume, which works with us in scanning the thousands of articles published in the public press each year; the other is you—the person actually using the book. Please help us and the users of the next edition by completing the prepaid article rating form on this page and returning it to us. Thank you for your help!

ANNUAL EDITIONS: Global Issues 00/01

ARTICLE RATING FORM

Here is an opportunity for you to have direct input into the next revision of this volume. We would like you to rate each of the 44 articles listed below, using the following scale:

1. Excellent: should definitely be retained
2. Above average: should probably be retained
3. Below average: should probably be deleted
4. Poor: should definitely be deleted

Your ratings will play a vital part in the next revision. So please mail this prepaid form to us just as soon as you complete it. Thanks for your help!

We Want Your Advice

RATING

ARTICLE

1. A Special Moment in History
2. The Many Faces of the Future
3. Life Is Unfair: Inequality in the World
4. World Prisms: The Future of Sovereign States and International Order
5. Before the Next Doubling
6. Breaking *Out* or Breaking *Down*
7. The Misery behind the Statistics: Women Suffer Most
8. How Much Food Will We Need in the 21st Century?
9. Angling for 'Aquaculture'
10. The Global Challenge
11. Climatic Changes That Make the World Flip
12. Stumped by Trees
13. Invasive Species: Pathogens of Globalization
14. We *Can* Build a Sustainable Economy
15. The Complexities and Contradictions of Globalization
16. The Invention of Development
17. The Crisis of Globalization
18. Beyond the Transition: China's Economy at Century's End
19. The Russian Devolution
20. What Pacific Century?
21. How Far, How Fast? Is Central Europe Ready to Join the EU?

RATING

ARTICLE

22. A New Tiger
23. Life after Pax Americana
24. The Post-Modern State and the World Order
25. Europe at Century's End: The Challenge Ahead
26. Ethnic Conflict: Think Again
27. The Kalashnikov Age
28. Birth of a Superpower
29. Stepping Back from the Nuclear Cliff
30. Justice Goes Global
31. Enforcing Human Rights
32. The Globalization of Tourism
33. Ecotourism without Tears
34. Peace Prize Goes to Land-Mine Opponents
35. Child Labour: Rights, Risks, and Realities
36. Universal Human Values: Finding an Ethical Common Ground
37. How to Abolish War
38. The Grameen Bank
39. Uncharted Terrain on Tomorrow's Genetic Map
40. Is Life Really Getting Better?
41. A Fourth Way? The Latin American Alternative to Neoliberalism
42. The Future of Energy
43. Women in Power: From Tokenism to Critical Mass
44. The Sacred Warrior

(Continued on next page)

BUSINESS REPLY MAIL
FIRST-CLASS MAIL PERMIT NO. 84 GUILFORD CT

POSTAGE WILL BE PAID BY ADDRESSEE

Dushkin/McGraw-Hill
Sluice Dock
Guilford, CT 06437-9989

ABOUT YOU

Name _____ Date _____

Are you a teacher? ☐ A student? ☐
Your school's name

Department

Address _____ City _____ State ____ Zip ____

School telephone # _____

YOUR COMMENTS ARE IMPORTANT TO US !

Please fill in the following information:
For which course did you use this book?

Did you use a text with this *ANNUAL EDITION*? ☐ yes ☐ no
What was the title of the text?

What are your general reactions to the *Annual Editions* concept?

Have you read any particular articles recently that you think should be included in the next edition?

Are there any articles you feel should be replaced in the next edition? Why?

Are there any World Wide Web sites you feel should be included in the next edition? Please annotate.

May we contact you for editorial input? ☐ yes ☐ no
May we quote your comments? ☐ yes ☐ no